New York *festivals*

New York *festivals*

The World's Best Work®

ANNUAL

13

DESIGN, OUTDOOR & PRINT ADVERTISING AWARDS

THE MIDAS AWARDS
THE BEST IN FINANCIAL SERVICES COMMUNICATIONS

THE GLOBAL AWARDS
THE BEST IN HEALTHCARE COMMUNICATIONS

For additional information, or to learn how your work may be submitted to

NEW YORK FESTIVALS INTERNATIONAL ADVERTISING AWARDS

for possible inclusion in subsequent Annuals, please address inquiries to:

NEW YORK FESTIVALS

7 West 36th, 14th floor
New York, New York 10018
PHONE: 212.643.4800
FAX: 212.643.0170
EMAIL: info@newyorkfestivals.com
WEBSITE: www.newyorkfestivals.com

ISBN : 0-9655403-9-1

PUBLISHED BY

THE NEW YORK FESTIVALS

7 West 36th Street • 14th floor
New York, NY 10018
PHONE: 212.643.4800
FAX: 212.643.0170

DISTRIBUTED WORLDWIDE BY

COLLINS DESIGN

An Imprint of HarperCollinsPublishers
10 East 53rd Street
New York, NY 10022-5299
FAX: 212.207-7654
www.harpercollins.com

ART DIRECTION

FLOW CREATIVE

www.flowcreative.net

JACKET PHOTO

TOM MAYDAY

Chicago, IL

BOOK DESIGN AND PRODUCTION

STUDIO 31

www.studio31.com

MANUFACTURED BY PHOENIX OFFSET
PRINTED IN CHINA

TABLE OF CONTENTS

OFFICIAL REPRESENTATIVES

ARGENTINA and URUGUAY

Barbara Sousa

EDITORIAL DOSSIER

Av. Belgrano 367, 3er Piso

Capital Federal, 1092

Argentina

Tele: 541-14-343-4288

Fax: 541-14-343-4228 ext 217

Email: barbarasousa@fibertel.com.ar

Web Site: www.dossiernet.com.ar

AUSTRALIA and NEW ZEALAND

Jenny Bates

Bates & Partners

65 Hume Street

Crows Nest, NSW 2065

Australia

Tel 61-2-9954-9900

Fax 61-2-9954-9099

Email jenny@bates.com.au

BRAZIL

Marcello Queiroz

Editora Referencia Ltda

Rua Francois Coty 228

Cambuci, 10524-03

Sao Paulo, 01524-030

Brazil

Tele: 5511-61650771

Fax: 5511-6163-4227

Email: mqueiroz@propmark.com.br

Web Site: www.propmark.com.br

CENTRAL AMERICA

COSTA RICA, EL SALVADOR, GUATEMALA, HONDURAS and NICARAGUA

Claudia Feldmar

ARIMA

12 Calle 6-49, Zona 6, Edif. Plazuela Oficina 405

Guatemala City 01009

Tele: 502-339-4727

Fax: 502-331-5929

Email: arima@intelnet.net.gt

CHILE, COLOMBIA, ECUADOR and PARAGUAY

Edgardo Mermet Ovalle

Estrella Mermet

Augusto Leguía Norte 255, Of. 72,

Las Condes

Santiago de Chile, 7550035

Chile

Tele: 56-2-458-9353

Fax: 56-2-632-4609

Email: nyfestschile@hotmail.com

CHINA

Gao Jun

Shanghai Meikao Creative & Consulting Co., Ltd.

Fl 25 Shanghai Kerry Center

1515 Nanjing West Road

Shanghai, 200040

China

Tele: 0118621-5298-6622

Fax: 86-21-5298-6633

Email: junkao@meikao.com

EAST EUROPE

Nastja Mulej

New Moment - New Ideas Company

Ob dolenjski zeleznici 182

Ljubljana, 1000

Slovenia

Tele: 386-1-428-9588

Fax: 386-1-428-9589

Email: info@newmoment.si

Web Site: newmoment-ideascampus.com

FINLAND

Sinikka Virkkunen

Markkinointiviestinnan Toimistojen Litto (MTL)

Vuorikatu 22A

Helsinki, 00100

Finland

Tele: 358-9-625-300

Fax: 358-9-625-305

Email: sinikka.virkkunen@mtl.fi

Web Site: mtl.fi

FRANCE

Dominique Boischot

Les Films De La Perrine

6 Cite Paradis

Paris, 75010

France

Tele: 33-1-5603-9030

Fax: 33-1-5603-9038

Email: lesfilmsdelaperrine@wanadoo.fr

GERMANY, AUSTRIA and SWITZERLAND

Peter Strahlendorf

New Business

Eidelsteder Weg 22

Hamburg, D-22359

Germany

Tele: +49-40-6090-0910

Fax: +49-40-6090-0915

Email: strahlendorf@new-business.de

Web Site: www.new-business.de

GREECE/CYPRUS

Frini Latou

Direction S.A.

Fokidos 26, Ambelokipi

Athens, 115 26

Greece

Tele: 30-210-771-2400

Fax: 30-210-778-5097

Email: latou@direction.gr

Web Site: direction.gr

HONG KONG/MACAU

Yvonne Yeung

Longyin Review

23/F, Tai Sang Commercial Bldg.,

24 – 34 Hennessy Road

Wanchai

Hong Kong

Tele: 852-2824-9999

Fax: 852-2824-9998

Email: info@longyinreview.com

Web Site: longyinreview.com

INDIA

Rtn. Calwyn D'Abreo

Global Media Network

Paramel, Suite # 5,577 St Cyril Road Extn

Bandra West,

Mumbai, 400050

Tele: 001 91 22 2 6402729

Fax: 011 91 22 2 6401818

Email: webetta@bom3.vsnl.net.in

INDONESIA

Gunawan Alif

PT Dutamedia Internusa

Jalan H.R. Rasuna Said Kav. H 1-2

Jakarta, 12920

Indonesia

Tele: 62-21-526-1078

Fax: 62-21-525-6440

Email: gunawan@cakram.co.id

Web Site: cakram.co.id

ISRAEL

Billie Laniado

Laniado Marketing Communication Ltd.

Gibor Bldg, 3rd Fl, 6 Kaufman St

Tel Aviv, 68012

Israel

Tele: 972-3-517-7977

Fax: 972-3-517-0258

Email: billie@laniado.co.il

OFFICIAL REPRESENTATIVES

ITALY
Maria Stella Gallo
Gruppo Pubblicita Italia
Via Gorki 69
Cinisello Balsamo
Milan, 20092
Italy
Tele: 39-02-660-341
Fax: 39-02-660-34404
Email: mariastella.gallo@pubblicitaitalia.it
Web Site: www.pubblicitaitalia.it

JAPAN
Soji George Tanaka
TanakaPlus
3-1-7, Mure, Mitaka-shi
Tokyo, 181-0002
Japan
Tele: 81-422-45-1774
Fax: 81-422-44-5634
Email: tanakaplus@ybb.ne.jp

KOREA
Seog Bong Bae
Lee Byung Ihn
c/o KCU
5F Yimbo Bldg
195-11 Yeongun-ding, Chongro-ku
Seoul, 110-460
Korea
Tele: 82-2-3675-4561
Fax: 82-2-3675-4563
Email: bsbong@koreacf.or.kr
Web Site: www.koreacf.or.kr

MALAYSIA
Harmandar (Ham) Singh
Sledgehammer Communication
22B Jalan Tun Mohd Fuad Satu
Taman Tun Dr. Ismail
Kuala Lumpur, 60000
Malaysia
Tel: 603-7726-2588
Fax: 603-7726-2598
Email: ham@pop.jaring.my

MEXICO
Cecilia Bouleau
Bouleau Comunicaciones S.A. de C.V.
Homero 527-PH, Col. Polanco
Mexico City, DF, 11560
Mexico
Tele: 52-80-4048 / 52-80-4415
Fax: 52-80-4048 / 52-80-4415
Email: cbouleau@revistaneo.com
Web Site: revistaned.com

MIDDLE EAST
Arvind Soni
MBR Bookshop LLC
PO Box 34263
Dubai
United Arab Emirates
Tele: 9714-396-4141
Fax: 9714-369-4052
Email: asoni@emirates.net.ae
Web Site: mbrworldwide.com

NETHERLANDS and BELGIUM
Peter Kanters
Studio Honingstraat
Honingstraat 14b
Hilversum, 1211 AW
The Netherlands
Tele: 31-35-62381-85
Fax: 31-35-62382-08
Email: peter@studiohoningstraat.nl
Web Site: Studiohoningstraat.nl

PERU
Teresa Barrenechea
APAP
Avenida 2 de Mayo, 655 Miraflores
Lima, 18
Peru
Tele: 511-445-4903
Fax: 511-445-4903
Email: teresaapap@infonegocio.net.pe
Web Site: apap.org.pe

PHILIPPINES
Roger Pe
Awards Unlimited
c/o DDB Philippines
11th Fl, JMT Corporate Condo
ADB Avenue, Ortigas Centre
Pasig City, Metro Manila,
Philippines
Tele: 632-633-7458
Fax: 632-633-8732
Email: rogerpe@ddbphil.com

RUSSIA
Vitaly Rasnitsyn
Business League Communications Group
21, bdl.1, office 1144
Novyi Arbat st.
Moscow, 119019
Russia
Tele: 7-095-363 0963
Fax: 7-095-363 0963
Email: vr@bizleag.ru
Web Site: http://bizleag.ru/liga/english.php

SCANDINAVIA (SWEDEN/DENMARK/NORWAY)
Lars Grunberger
L. Grünberger Marketing KB
Skogsovagen 99
Saltsjobaden, S-133-33
Sweden
Tele: +46-8-5562-6420
Fax: +46-8-5562-6421
Email: lars.grunberger@lgmarketing.se

SINGAPORE
Patsy Ee
SIAC Events Pte Ltd
51 Anson Road
03-53 Anson Centre
Singapore, 079904
Singapore
Tele: +65-6-220-8382
Fax: +65-6-220-7187
Email: patsyee@singnet.com.sg
Web Site: www.ias.org.se

SPAIN and PORTUGAL
Pedro Solana
c/o Clouseau
Caravela La Nina 24, Local 8
Sant Pol de Mar
Barcelona, 08017
Spain
Tele/Fax: +34-93-760-1235
Email: psolana@telefonica.net

TAIWAN
Tomming Lai
United Advertising Company
10th Fl, 83 Sec 1, Chungking S. Road
Taipei, Taiwan
Tele: 886-2-2314-3366
Fax: 886-2-2314-3314
Email: candy.chiang@ua.com.tw

TURKEY
Günseli Ozen Ocakoglu
Marketing Turkiye
Prof. N. Mashar Okten Sok. No. 1
Sisli, Istanbul,
Turkey
Tele: 90-212-224-0144
Fax: 90-212-233-7243
Email: gunseli.ocakoglu@rotayayin.com.tr
Web Site: www.marketingturkiye.com

VENEZUELA
Thais Hernandez
A.N.D.A.
1ra Av. De Santa Eduvigis,
Residencias Primavera, Apdo 61762
Urb Santa Eduvigis
Caracas, Venezuela
Tele: 58-21-284-1163
Fax: 58-21-283-6553
Email: anda@andaven.org

A SALUTE TO THE WORLD'S BEST WORK

According to Arthur C. Clark, "Every revolutionary idea seems to evoke three stages of reaction: 1. It's completely impossible; 2. It's possible, but it's not worth doing; 3. I said it was a good idea all along." During my agency years, I usually heard a version that went more like this: 1. It won't work; 2. The client won't buy it; 3. Of course, was there ever another option?

Big ideas — well executed — are disarmingly simple in retrospect, leading many to believe they were also easy to create, sell and produce. The welcome addition of many new players seeking these "easy answers" in the global marketplace has put increased pressure on international award shows to find ways to ensure all work entered into competitions be evaluated fairly, regardless of the originating country.

To that end, NY/ will continue to embrace the Internet to get more award-winning judges from more countries to evaluate the work. This broader participation by more countries, as well as our continued relationship with the United Nations Department of Public Information, will allow NY/ to continue to identify and showcase the "World's Best Work."

A huge debt of gratitude is owed to the award-winning judges who evaluated entries online and in major advertising centers throughout the world to determine the recipients of the coveted World Medals, Global Awards, and Midas Awards. We also owe our thanks to the respective Board Chairmen of each of those competitions: Jim Ferguson of Temerlin McClain, Mike Lazur of Torre Lazur McCann and Ian Henderson of masius. Their support and advice, together with that of the international members of the NY/, Globals and Midas Boards of Judges & Advisors, helped select the winners of the Grand Award Trophies.

Finally, this book is dedicated to those members of the international creative community who dared to "THINKBIG®." Tremendous amounts of talent, hard work and courage are required to create the kind of work worthy of being submitted to an international award show in the first place. Still more courage is required to subject those best efforts of your creative labor to tough international scrutiny.

The reward for all that effort is in your hands: a spotlight for the work and a beacon of inspiration for the rest of us. I hope you enjoy it.

Gregory A. Sonbuchner

Greg Sonbuchner
President, New York *festivals*

For close to 50 years, New York Festivals (NY⨍) has honored excellence in communications media: work that has touched the hearts and minds of readers, listeners and viewers worldwide. Founded in 1957 as an international awards competition designed primarily to reward outstanding achievements in non-broadcast media, NY⨍ achieved pre-eminence in industrial and educational communications in the second half of the Twentieth Century.

Over the last three decades, NY⨍ has grown to include more international awards competitions, reflecting the growth and development of the media industry itself. In addition to the original Film and Video, Television Programming and Television Advertising were added in the Seventies. Competitions for international radio programming and radio advertising were launched in 1982; and for print advertising, design, photography and illustration in 1984.

Keeping pace with changing trends and technologies, a competition for web-based and digital media was added in 1992. The Global Awards for healthcare communications were added to the roster in 1994. In 1995 the AME Awards for Advertising and Marketing Effectiveness were added; and in 2001, the Midas Awards were launched to recognize the world's best work in financial services communications. Industry acceptance and participation in each of these competitions is evidenced by the prestigious roll call of judges and advisors, a veritable "Who's Who" of world leaders in communications.

The first New York Festivals Annual of Advertising was published in 1991 and became an immediate hit as a tangible showcase of all the winning work in NY⨍ competitions. Annual Thirteen features the winners and finalists in the 2004 International Design, Print & Outdoor Advertising Awards, the 2004 Global Awards for Healthcare Communications, and the 2004 Midas Awards for Financial Services Communications.

In 2003, the NY⨍ TV, Cinema & Radio Advertising Awards became the first international awards competition to enable all transactions – entering, uploading short-form entries, and even judging — to be handled online. This facility is now available for all NY⨍ competitions. As a result, participants in the New York Festivals, and members of our international Boards of Judges and Advisors, are now as diverse as the citizens of New York itself. Winning work in each competition is now showcased on the website; and winners' reels, DVDs, duplicate awards and even this Annual of Advertising can all be ordered and purchased online.

The New York Festivals has grown over the years from just 1,000 entries in the late Seventies to more than 16,000 entries in all media at the beginning of the new millennium, providing a lens through which the world's creative community can discover a new and valuable focus. Showcasing the world's newest and most exciting ideas, the NY⨍ annuals and websites provide reference tools that inform the industry and provide the inspiration to always "THINK BIG®."

2004 UNITED NATIONS
DEPARTMENT OF PUBLIC INFORMATION AWARDS

The United Nations Awards were established in 1990 and are presented annually to honor public service advertising that best exemplifies the ideals and goals of the United Nations. Public Service entries which achieve Finalist status in all three of The New York Festivals international print, radio and television advertising competitions are automatically eligible for these prestigious awards.

The 2004 Gold, Silver and Bronze United Nations Awards were selected by a blue ribbon panel of judges (see below) convened by the United Nations Department of Public Information (UNDPI) and The New York Festivals on December 22, 2004 in New York. The winning ads/spots reflect issues of concern to the United Nations such as health, human rights (exploitation of children, racial discrimination), women's issues, literacy, the fight against poverty, sustainable development and the environment.

2004 JUDGES

Isabelle Broyer
OFFICER IN CHARGE,
SPECIAL PROJECT UNIT
UNITED NATIONS

Dawn Johnston-Britton
CHIEF, PUBLIC INQUIRIES UNIT
UNITED NATIONS

Kimberly Mann
INFORMATION OFFICER
UNITED NATIONS

Narendra Nandoe
INFORMATION OFFICER
UNITED NATIONS

E.R. Shipp
JOURNALIST

Hiro Ueki
INFORMATION OFFICER
UNITED NATIONS

GERMANY

MARKENFILM GMBH

WEDEL

CLIENT Lesen & Schreiben

DIRECTOR BERNARD LANDEN

CREATIVE DIRECTOR André Aimaq/
AimaqRappStolle

COPYWRITER Jörn Schwarz/AimaqRappStolle

PRODUCER Frank Siegl/Markenfilm Berlin

CAMERA Sebastian

OFFLINE EDITOR Matthias Morrick

MUSIC Matthias Rewig

MEDIUM Television

UNITED NATIONS FINALISTS

USA

UNITED NATIONS FINALIST

ARNOLD WORLDWIDE

BOSTON, MA

MEDIUM TV

CLIENT American Legacy
Foundation

USA

UNITED NATIONS FINALIST

GSP

NEW YORK, NY

MEDIUM TV

CLIENT Ad Council

GERMANY

UNITED NATIONS FINALIST

J. WALTER THOMPSON
GMBH & CO.

FRANKFURT

MEDIUM Radio

CLIENT Karuna e.V.

AUSTRIA

UNITED NATIONS FINALIST

LOWE GGK

VIENNA

MEDIUM Print

CLIENT Aktion Mensch

GERMANY

UNITED NATIONS FINALIST

MICHAEL CONRAD
& LEO BURNETT

FRANKFURT

MEDIUM Print

CLIENT UNICEF

SOUTH AFRICA

UNITED NATIONS FINALIST

SUBURBAN FILMS

CAPE TOWN

MEDIUM TV

CLIENT AIDS

SOUTH AFRICA

UNITED NATIONS FINALIST

THE JUPITER DRAWING ROOM
SOUTH AFRICA

JOHANNESBURG

MEDIUM TV

CLIENT Lifeline

FVO — old Asian voice

This is an important message for all of you planning to take your children away on a holiday to visit family back home in Asia. If you want to save yourself hassle and money ... don't take them away during school term time!

I know you may think it's cheaper to go out of peak season and that your children will catch up on the work they miss ... both wrong.

They will not catch up, especially if you're taking them off for weeks or maybe months. I know that family is very important, but what use can your children be to the family if they never learn how to do anything?

I know that money is important too, but believe me, the money you will save by going during term time is nothing compared to the fines you will get for taking your children out of school.

We all want the best for our children, so why not give them a chance to get it? Give them everything they want in life ... get them to school.

ENGLAND

UNITED NATIONS SILVER PLAQUE
THIS RADIO COMMERCIAL ALSO WON A FINALIST CERTIFICATE IN
THE NEW YORK FESTIVALS RADIO ADVERTISING COMPETITION
CHRYSALIS CREATIVE
MANCHESTER

CLIENT **Excellence In Cities**
CREATIVE DIRECTOR **Dave Baird**
CREATIVE PRODUCER **Gavin Matthews**

MEDIUM **Radio**

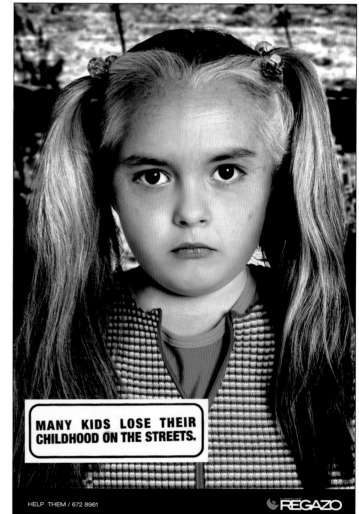

CHILE

UNITED NATIONS BRONZE PLAQUE
THIS PRINT AD ALSO WON A FINALIST CERTIFICATE IN
THE NEW YORK FESTIVALS PRINT ADVERTISING COMPETITION
LECHE LOWE WORLDWIDE
SANTIAGO

CLIENT **Fundacion Regazo**
CREATIVE DIRECTOR **Francisco Guarello/
Lorena Hola**
COPYWRITER **Lorena Hola**
ART DIRECTOR **José Luis Estévez**

MEDIUM **Print**

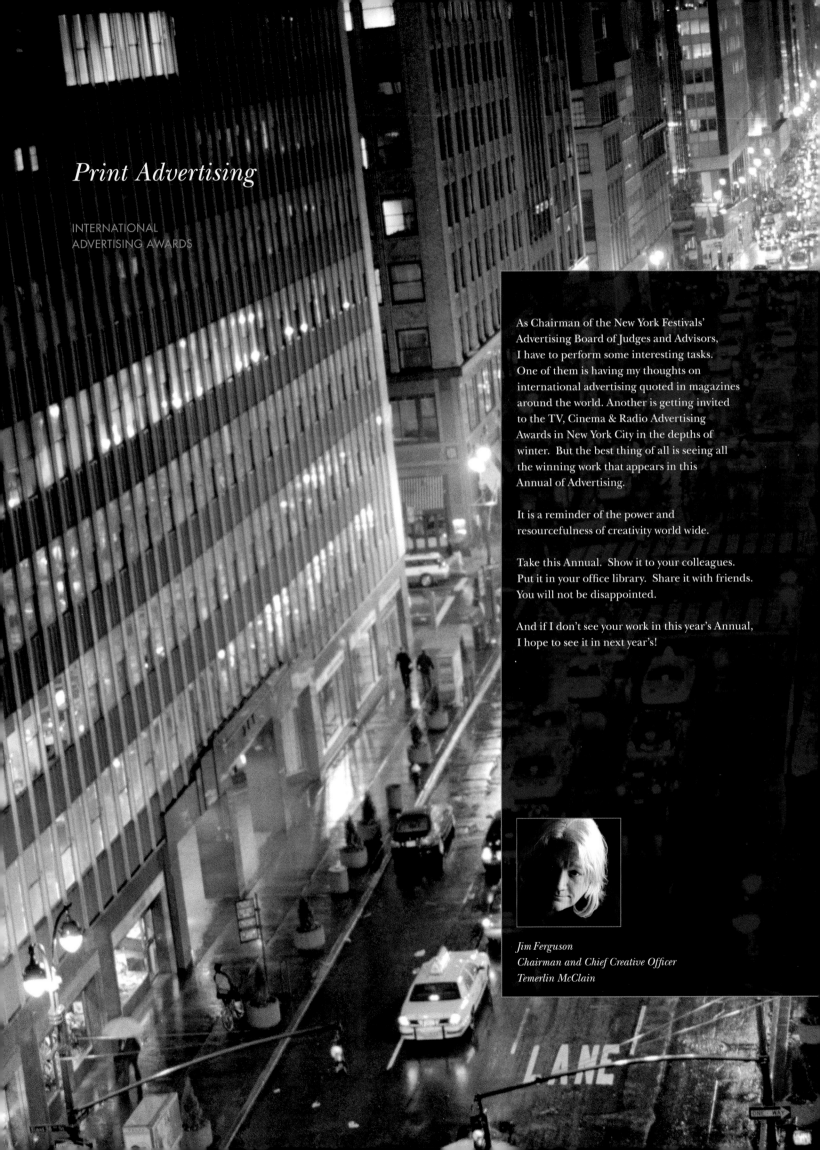

Print Advertising

As Chairman of the New York Festivals'
Advertising Board of Judges and Advisors,
I have to perform some interesting tasks.
One of them is having my thoughts on
international advertising quoted in magazines
around the world. Another is getting invited
to the TV, Cinema & Radio Advertising
Awards in New York City in the depths of
winter. But the best thing of all is seeing all
the winning work that appears in this
Annual of Advertising.

It is a reminder of the power and
resourcefulness of creativity world wide.

Take this Annual. Show it to your colleagues.
Put it in your office library. Share it with friends.
You will not be disappointed.

And if I don't see your work in this year's Annual,
I hope to see it in next year's!
.

Jim Ferguson
Chairman and Chief Creative Officer
Temerlin McClain

BOARD OF DISTINGUISHED JUDGES & ADVISORS

BOARD OF DISTINGUISHED JUDGES & ADVISORS

Maurizio Sala
ARMANDO TESTA AGENCY

MEXICO

Chairman
Clemente Camara Rojas
CLEMENTE CAMARA Y ASOCIADOS S.A. DE C.V.

Yuri Alvarado
FCB MEXICO

Jose Beker
BETANCOURT BARBA BEKER EURO RSCG

Simon Bross
GARCIA BROSS Y ASOCIADOS

Rodolfo Cavalcanti Bezerra
BBDO MEXICO, S.A. DE C.V.

Eduardo Contreras
CLEMENTE CAMARA Y ASOCIADOS

Tony Hidalgo
LEO BURNETT MEXICO

Santiago Pando
LA PANDIYA

Pedro Torres
PEDRO TORRES Y ASOCIADOS

PAN CARRIBEAN

Chairman
Roberto R. Coimbra A.
J. WALTER THOMPSON DE VENEZUELA C.A.
VENEZUELA

Damaris Defillo de Pena
YOUNG & RUBICAM/DAMARIS
DOMINICAN REPUBLIC

Alejandro Fernandez
FERGO/SAATCHI & SAATCHI
PANAMA

Ricardo E. Mendez
MENDEZ & DIEZ INTEGRATED
COMMUNICATION
PANAMA

Alberto Quiroz
JBQ/GREY
COSTA RICA

Hugo Vazquez
MARCA:LINTAS
COLUMBIA

SOUTH AFRICA

Cal Bruns
SONNENBURG MURPHY LEO BURNETT

Matthew Bull
LOWE BULL CALVERT PACE

Stephen Burke
BESTER BURKE

Louis Gavin
GAVIN REDDY HAWN

Stefania Ianigro Johnson
FCB BOSMAN JOHNSON

Alistair King
KINGJAMES

Robyn Putter
OGILVY & MATHER RIGHTFORD SEARLE-TRIPP
& MAKIN

Mike Schalit
NET#WORK

Graham Warsop
THE JUPITER DRAWING ROOM

SPAIN

Ferran Blanch
TIEMPO/BBDO

Diego Borbolan
EURO RSCG BARCELONA

Agustin Elbaile
McCANN-ERICKSON

Arcadi Moradell
INSTITUTO INTERNACIONAL DISENO IMAGEN

Ernest Moradell
INSTITUTO INTERNACIONAL DISENO IMAGEN

Manuel Salcedo
PHINEAS TAYLOR BARNUM

UNITED KINDGOM

Chairman
David Lyle
LYLE BAILE INTERNATIONAL

Trevor Beattie
TBWA

Bruce Crouch
SOUL ADVERTISING

Tony Green
RAINMAKER ADVERTISING LIMITED

Kate Stunners
ST. LUKES

2004 PRELIMINARY JUDGES

Scott A. Lynch
NONBOX
HALES CORNERS, WI

Andre Aimaq
AIMAQ RAPP STOLLE
BERLIN, GERMANY

Sam Ajluni
BBDO DETROIT
TROY, MI

Junichiro Akiyoshi
CREATORS MAC
TOKYO, JAPAN

Adam Albrecht
CRAMER-KRASSELT
MILWAUKEE, WI

Antonio Alvarez
BBDO MEXICO
MEXICO CITY, MEXICO

Gideon Amichay
SHALMOR AVNON AMICHAY Y & R
TEL AVIV, ISRAEL

John Anicker
HORNALL ANDERSON DESIGN WORKS
SEATTLE, WA

Rafa Anton
VITRUVIO / LEO BURNETT
MADRID, SPAIN

Jaime Atria
LEO BURNETT CHILE
SANTIAGO, CHILE

Joe Ban
BOELTER & LINCOLN
MILWAUKEE, WI

Jorge Barrote
JWT
LISBON, PORTUGAL

Mithat Basoglu
LEON
ISTANBUL, TURKEY

Alejandro Benavides
SANCHO/BBDO
BOGOTA, COLOMBIA

Matthias Berger
BERGER BAADER HERMES /DIGITAL
MUNICH, GERMANY

Andy Berlin
BERLIN CAMERON RED CELL
NEW YORK, NY

Kim Berlin
STERLING GROUP
NEW YORK, NY

Nancy Bernstein
FASTCHANNEL NETWORK, INC
CHICAGO, IL

Raghu Bhat
AMBIENCE PUBLICIS
MUMBAI, INDIA

Ferran Blanch
TIEMPO BBDO
BARCELONA, SPAIN

Frank Bodin
EURO RSCG SWITZERLAND
ZURICH, SWITZERLAND

Jaime Brash Espinoza
BBDO MEXICO
MEXICO CITY, MEXICO

Jorge Carreño
BDDP ET FILS
BOULOGNE BILLANCOURT, FRANCE

Maureen Carter
REFINERY
HUNTINGDON VALLY, PA

Christina Carvalho Pinto
FULL JAZZ
SAO PAULO, BRAZIL

Michael Caughill
THIRD PERSON, INC.
MILWAUKEE, WI

Frank Chang
DRAFT
NEW YORK, NY

Edmund Choe
SAATCHI & SAATCHI
KUALA LUMPUR, MALAYSIA

Sam Chung
GREY WORLDWIDE CHINA SHANGHAI OFFICE
SHANGHAI, CHINA

Tore Claesson
OGILVY & MATHER
NEW YORK, NY

Sean Colaco
SAATCHI & SAATCHI, MUMBAI
MUMBAI, MAHARASHTRA, INDIA

Marco Colin
OGILVY & MATHER
MEXICO CITY, MEXICO

Andrea Costa
TIME MAGAZINE
NEW YORK, NY

Geoff Council
DRAFT
NEW YORK, NY

Jeremy Creighton
WALLACE CHURCH
NEW YORK, NY

Nadia Cruz Camit
HK McCANN
MAKATI CITY, PHILIPPINES

Anique de Graaf
STUDIO HONINGSTRAAT
HILVERSUM, THE NETHERLANDS

Manny de Paz
ASPAC COMMUNICATORS

Tina de Torres
McCANN-ERICKSON
MAKATI CITY, PHILIPPINES

Pablo Del Campo
DEL CAMPO NAZCA SAATCHI & SAATCHI
BUENOS AIRES, ARGENTINA

Greg Delaney
DELANEY LUND KNOX WARREN & PARTNERS
LONDON, ENGLAND

Jose Luis Rosales Delgado
BBDO MEXICO
MEXICO CITY, MEXICO

Alvaro Diaz
PUBLICIS IMPETU
MONTEVIDEO, URUGUAY

Kurt Georg Dieckert
TBWA - BERLIN
BERLIN, GERMANY

Tom Dixon
MEYER & WALLIS
MILWAUKEE, WI

Gilles Dblon
MARKETEL
MONTREAL, QUEBEC, CANADA

Jeff Ericksen
BVK
MILWAUKEE, WI

Joao Espirito Santo
J. WALTER THOMPSON LISBON
LISBON, PORTUGAL

Bojana Fajmut
BOJANA FAJMUT
LJUBLJANA, SLOVENIA

Pete Favat
ARNOLD WORLDWIDE
BOSTON, MA

Jim Ferguson
TEMERLIN McCLAIN
IRVING, TX

Joao Fernandes
VIEW.
CASCAIS, PORTUGAL

Josep Maria Ferrara
PAVLOV
BARCELONA, SPAIN

Bernd Fliesser
FCB KOBZA WERBEAGENTUR GES.M.B.H.
WIEN, AUSTRIA

Bradut Florescu
DDB BUCHAREST
BUCHAREST, ROMANIA

John Follis
FOLLIS/NY
NEW YORK, NY

Michael Fromowitz
BBDO NEW YORK
NEW YORK, NY

Stephan Ganser
JUNG VON MATT/SPREE
BERLIN, GERMANY

Ewan Gee
RAINMAKER ADVERTISING
LONDON, ENGLAND

Jimmy Geeraerts
GOLDSUN AGENCY
HO CHI MINH CITY, VIETNAM

2004 PRELIMINARY JUDGES

Lucian Georgescu
TOTAL
BUCHAREST, ROMANIA

Madeline Gleason
A&E TELEVISION NETWORKS
NEW YORK, NY

Pancho Gonzalez
WUNDERMAN
SANTIAGO, CHILE

K.S. Gopal
QUADRANT COMMUNICATION LTD. (MUMBAI)
MUMBAI, INDIA

Mitch Gordon
OGILVY & MATHER
CHICAGO, IL

Andreas Grabarz
GRABARZ & PARTNER
HAMBURG, GERMANY

Tom B. Gumba
BLUE BOTTLE

Ken Hagan
CRAMER-KRASSELT
MILWAUKEE, WI

Lawrence Haggerty
WALLACE CHURCH INC.
NEW YORK, NY

Oystein Halvorsen
TRY
OSLO, NORWAY

Garrick Hamm
WILLIAMS MURRAY HAMM
LONDON, ENGLAND

Carla Hansen
GREY DIRECT
NEW YORK, NY

Uschi Henkes
ZAPPING MADRID
MADRID, SPAIN

Matt Herrmann
CRAMER-KRASSELT
MILWAUKEE, WI

Thomas Hoffmann
& CO.
COPENHAGEN, DENMARK

Bernie Hogya
LOWE
NEW YORK, NY

Michael Hoinkes
HE SAID SHE SAID
HAMBURG, GERMANY

Markus Hübner
WORLD-DIRECT EBUSINESS SOLUTIONS
WIEN, AUSTRIA

Mike Iadawza
TIME MAGAZINE
NEW YORK, NY

Milos Ilic
LEO BURNETT BUDAPEST
BUDAPEST, HUNGARY

Benjamin Ivancic
McCANN ERICKSON
CROATIA

Chris Jetko
DRAFT
NEW YORK, NY

Carl Jones
BBDO MEXICO
MEXICO CITY, MEXICO

Prasoon Joshi
McCANN ERICKSON
MUMBAI, INDIA

Vossen Jurgen
HEIMAT
BERLIN, GERMANY

Peter Kanters
STUDIO HONINGSTRAAT
HILVERSUM, THE NETHERLANDS

Marjolejn Kanters
INTOMART GFK
HILVERSUM, THE NETHERLANDS

Amir Kassaei
DDB GERMANY
BERLIN, GERMANY

Hartwig Keuntje
PHILIPP UND KEUNTJE
HAMBURG, GERMANY

Andrew Kibble
G2 WORLDWIDE
NEW YORK, NY

Marnie Kilates
BRANDWORKS

J. Margus Klaar
BATES
TALLINN, ESTONIA

Dan Koel
CRAMER-KRASSELT
MILWAUKEE, WI

Vladimir Konstantin
McCANN ERICKSON
RUSSIA

Peter Koperdraad
EYES OPEN CREATIVES
KORTENHOEF, THE NETHERLANDS

Karen Kovach
FASTCHANNEL
CHICAGO, IL

Jungwon Lee
POSTVISUAL.COM
SEOUL, KOREA

Larry Lettera
CAMERA ONE
NEW YORK, NY

Sylvia Lezama
McCANN ERICKSON
MADRID, SPAIN

Sheung Yan Lo
J. WALTER THOMPSON-BRIDGE ADVERTISING CO
SHANGHAI, CHINA

Antonio Lopez
CONILL
NEW YORK, NY

Patrick Low
YOUNG & RUBICAM
SINGAPORE, SINGAPORE

Frank Lübke
EURO RSCG LÜBKE PREY
MUNICH, GERMANY

Melvin Mangada
TBWA\SANTIAGO MANGADA PUNO
MAKATI CITY, PHILIPPINES

Alex Martinez
J. WALTER THOMPSON
BARCELONA, SPAIN

Rochelle Martyn
PEARLFISHER INC.
NEW YORK, NY

Deb Mayo
FASTCHANNEL
CHICAGO, IL

Paulette McLeod
A&E TELEVISION NETWORKS
NEW YORK, NY

Ryan Menezes
SSC&B LINTAS
MUMBAI, MAHARASHTRA, INDIA

Tomaz Mok
McCANN-ERICKSON GUANGMING LTD.
BEIJING, CHINA

Edwin Mon
PUBLICUATRO
PANAMA, PANAMA

Antonio Montero
CONTRAPUNTO
BARCELONA, SPAIN

Do Cao (Hien) Nguyen
CLIPPER CI
HO CHI MINH CITY, VIETNAM

Pawel Nizinski
YOUNG & RUBICAM
POLAND

Mads Ohrt
OGILVY & MATHER COPENHAGEN
COPENHAGEN, DENMARK

Santosh Padhi
LEO BURNETT (INDIA)
PAREL, MUMBAI, INDIA

2004 PRELIMINARY JUDGES

Joanina Pastoll
CROSS COLOURS
JOHANNESBURG, SOUTH AFRICA

Roger Pe
DDB PHILIPPINES
PASIG CITY, METRO MANILA, PHILIPPINES

Kelvin Pereira
CRUSH
SINGAPORE, SINGAPORE

Lenín Pérez Pérez
ELIASCHEV PUBLICIDAD
CARACAS, VENEZUELA

Piebe Piebenga
AMSTERDAM ADVERTISING
AMSTERDAM, THE NETHERLANDS

Anders Pihlstrom
PIHLSTROM BRANDLAB
STOCKHOLM, SWEDEN

Markus Ravenhorst
MOMENTUM NL
AMSTELVEEN, THE NETHERLANDS

John Ravinder Mani
CLASSIC PARTNERSHIP ADVERTISING
DUBAI, UNITED ARAB EMIRATES

Torsten Rieken
McCANN ERICKSON BERLIN
BERLIN, GERMANY

Fadjar Rusli
PT FORTUNE INDONESIA, TBK.
JAKARTA, INDONESIA

Richard Russell
WIEDEN+KENNEDY
LONDON, ENGLAND

Koh Sakata
COMMONS CO.,LTD
TOKYO, JAPAN

Laura Samuels Lutze
CRAMER-KRASSELT
MILWAUKEE, WI

Marc Sasserath
PUBLICIS SASSERATH
FRANKFURT AM MAIN, GERMANY

Tatsuro Sato
ASATSU-DK INC.
TOKYO, JAPAN

Sabine Schmidt
SCHOLZ & VOLKMER GMBH
WIESBADEN, GERMANY

Guenter Sendlmeier
McCANN ERICKSON HAMBURG
HAMBURG, GERMANY

Euna Seol
POST VISUAL
SEOUL, KOREA

Lynn Shuster
CRAMER-KRASSELT
MILWAUKEE, WI

Eric Silver
BBDO
NEW YORK, NY

Jorge Soldevila
BBDO MEXICO
MEXICO CITY, MEXICO

Kristian Sumners
TBWA/ RAAD MIDDLE EAST
DUBAI, UNITED ARAB EMIRATES

Leo Teck Chong
AD PLANET
SINGAPORE, SINGAPORE

Todd Tilford
TEMERLIN McCLAIN ADVERTISING
IRVING, TX

Dave Tutin
DARKGREY-A DIVISION OF GREY WORLDWIDE
NEW YORK, NY

Noah S. Valdez
DDB PHILIPPINES
PASIG CITY, METRO MANILA, PHILIPPINES

Dominique Van Doormaal
DDB BRUSSELS
BRUSSELS, BELGIUM

Barth van Doorn
MOMENTUM
AMSTELVEEN, THE NETHERLANDS

Rob Van Vijfeijken
McCANN ERICKSON NETHERLANDS
AMSTELVEEN, THE NETHERLANDS

Conchi Vazquez
CONTRAPUNTO
MADRID, SPAIN

Michael Volkmer
SCHOLZ & VOLKMER GMBH
WIESBADEN, GERMANY

Graham Warsop
THE JUPITER DRAWING ROOM (SOUTH AFRICA)
JOHANNESBURG, SOUTH AFRICA

Daniela Weinstein
CYBERCENTER
SANTIAGO, CHILE

Ian White
URBAN MAPPING
NEW YORK, NY

Julian Wild
START CREATIVE
LONDON, ENGLAND

Gusta Winnubst
PPGH/JWT
AMSTERDAM, THE NETHERLANDS

Alan Wolstencroft
CRAMER-KRASSELT
MILWAUKEE, WI

Spencer Wong
OGILVY & MATHER ADVERTISING
HONG KONG, HONG KONG

Michael Wong
TBWA SHANGHAI
SHANGHAI, CHINA

James Woollett
J. WALTER THOMPSON KOREA
JONGRO-GU, SEOUL, KOREA

Zhang Xiao Ping
BLACK HORSE ADVERTISING
GUANGZHOU, CHINA

Chat P. Zagala
AMA-DDB PHILIPPINES, INC.
PASIG CITY, PHILIPPINES

GRAND
AWARD

Magazine and
Newspaper

SPAIN

GRAND AWARD

BEST MAGAZINE ADVERTISEMENT

DDB ESPANA

MADRID

CLIENT TMB Barcelona Metropolitan Transport
CREATIVE DIRECTOR Fidel del Castillo
ART DIRECTOR Marc Conca
COPYWRITER Dani Campmany
PHOTOGRAPHER Javiertles

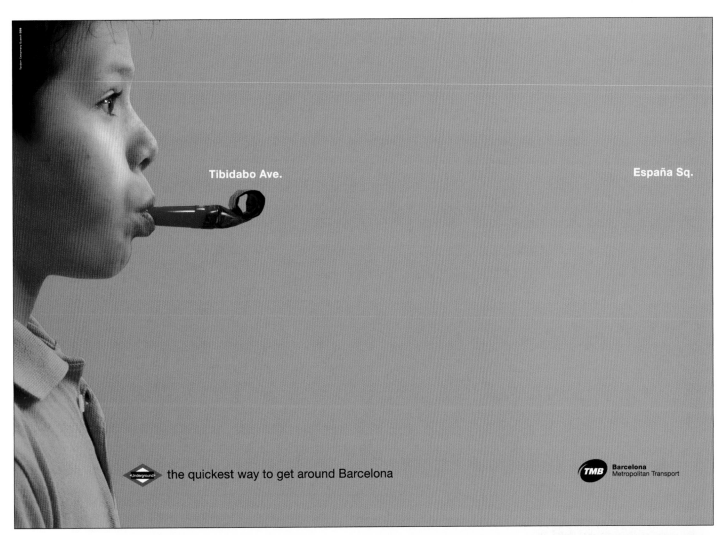

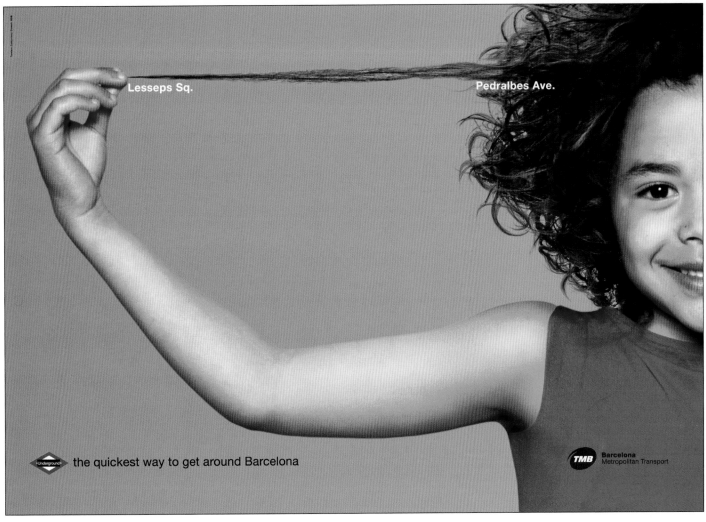

PRODUCTS & SERVICES

APPAREL

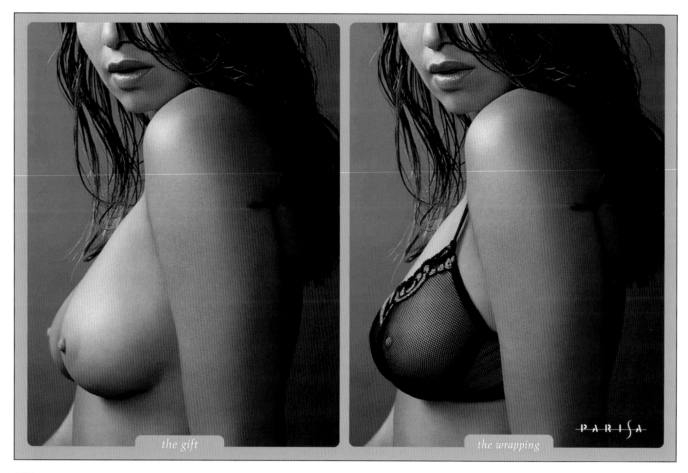

the gift

the wrapping

PARISA

USA

SILVER WORLD MEDAL, SINGLE
DDB LOS ANGELES
VENICE, CA

CLIENT **Parisa**
CREATIVE DIRECTOR **Mark Monteiro**
ART DIRECTOR **Christianne Brooks**
COPYWRITER **Rick Bursky**
PHOTOGRAPHER **Steven Lippman**

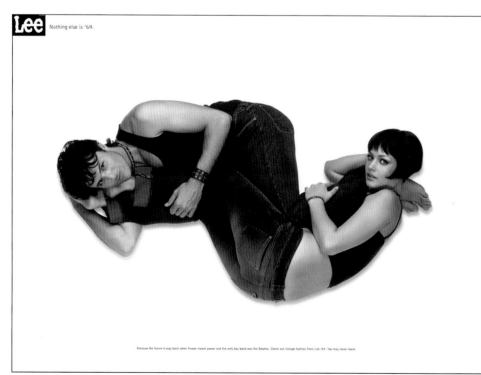

Lee Nothing else is '69.

INDIA

FINALIST, SINGLE
GREY WORLDWIDE
PAREL, MUMBAI

CLIENT **Lee**
CREATIVE DIRECTOR **Sanjay Menon**
ASSOCIATE CREATIVE DIRECTOR-ART **Padmaja Chandrasekhar**
ASSOCIATE CREATIVE DIRECTOR-COPY **Sangeeta Velegar**
PHOTOGRAPHER **Atul Kasbekar**

Every story has two sides.
For the Arabic version, read from right to left.

Stori
Clothes with a twist

Corporate Office: Chaya Garments Private Limited, #2/6, 3rd Cross, Opp. Old Toll Gate, Mysore Road, Bangalore 560026, Ph: 080 6742545/85, E mail: info@storiapparels.com.

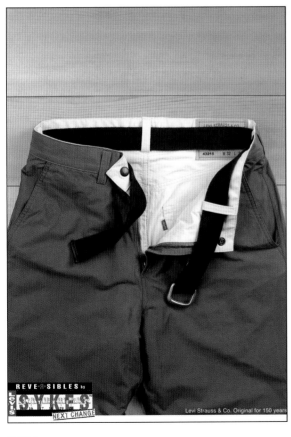

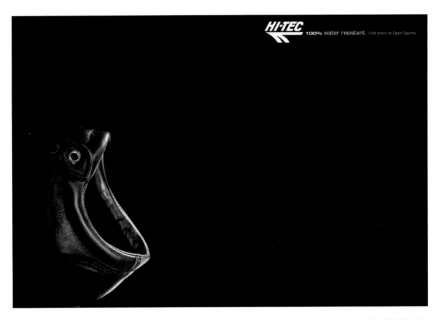

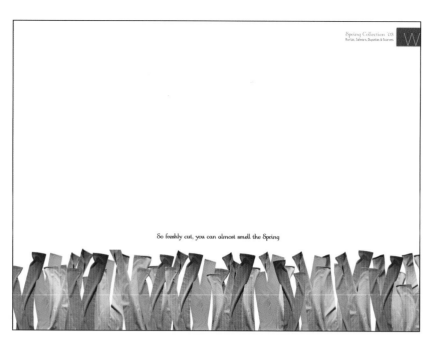

So freshly cut, you can almost smell the Spring

INDIA

FINALIST, SINGLE
REDIFFUSION-DENTSU YOUNG & RUBICAM PVT. LTD.
NEW DELHI

CLIENT W: Womens Wear
SENIOR CREATIVE DIRECTOR Nitin Suri
ASSOCIATE CREATIVE DIRECTOR Chraneeta Mann
CLIENT SERVICES DIRECTOR Prince Arora
PHOTOGRAPHER Sanjoy Chatterjee

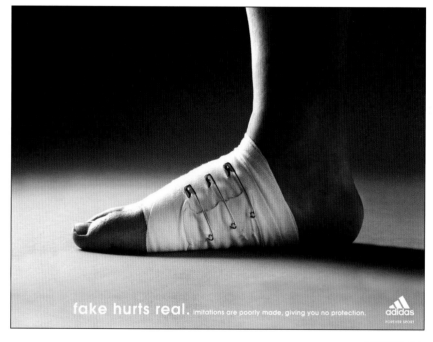

fake hurts real. imitations are poorly made, giving you no protection.

PHILIPPINES

FINALIST, SINGLE
TBWA\SANTIAGO MANGADA PUNO
MAKATI

CLIENT adidas
WRITER Melvin M. Mangada/Joey Campillo
ART DIRECTOR Evans Sator
PHOTOGRAPHER Jeanne Young
PRINT PRODUCER May Dalisay

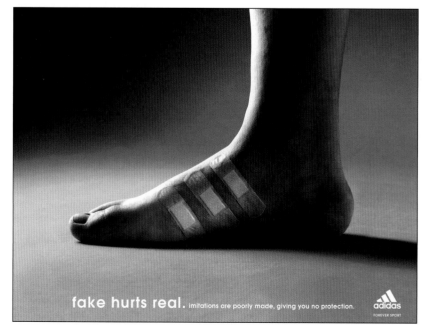

fake hurts real. imitations are poorly made, giving you no protection.

PHILIPPINES

FINALIST, SINGLE
TBWA\SANTIAGO MANGADA PUNO
MAKATI

CLIENT adidas
WRITER Melvin M. Mangada/Joey Campillo
ART DIRECTOR Evans Sator
PHOTOGRAPHER Jeanne Young
PRINT PRODUCER May Dalisay

BOCAGE
SHOES

BOCAGE
SHOES

FRANCE
GOLD WORLD MEDAL, CAMPAIGN
DEVARRIEUXVILLARET
PARIS

CLIENT Bocage
COPYWRITER Pierre-Dominique Burgaud
ART DIRECTOR Stéphane Richard
PHOTOGRAPHER Camille Vivier
ACCOUNT EXECUTIVE Bénédicte Chalumeau

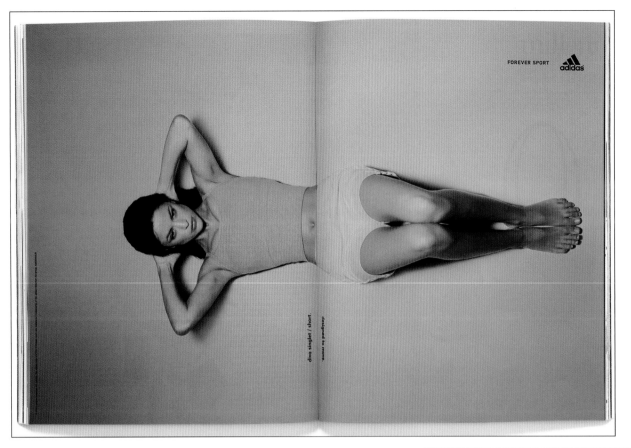

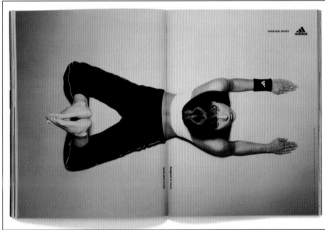

HONG KONG

SILVER WORLD MEDAL, CAMPAIGN

TBWA\HONG KONG

HONG KONG

CLIENT **adidas**
EXECUTIVE CREATIVE DIRECTOR **Stephen Ward**
COPYWRITER **Simon Handford**
ART DIRECTOR **Karen Lai**

INDIA

FINALIST, CAMPAIGN

REDIFFUSION-DENTSU
YOUNG & RUBICAM PVT. LTD.

NEW DELHI

CLIENT **W: Womens Wear**
SENIOR CREATIVE DIRECTOR **Nitin Suri**
ASSOCIATE CREATIVE DIRECTOR **Chraneeta Mann**
CLIENT SERVICE DIRECTOR **Prince Arora**
PHOTOGRAPHER **Sanjoy Chatterjee**

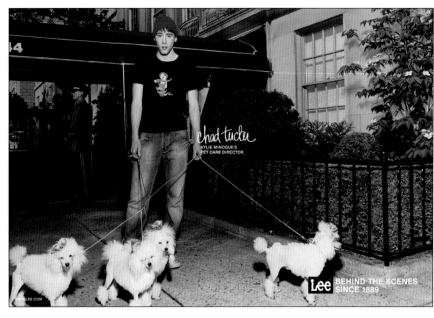

SWEDEN

FINALIST, CAMPAIGN

STORÅKERS McCANN
STOCKHOLM

CLIENT Lee Jeans
ACCOUNT DIRECTOR Maria Bergkvist
ACCOUNT MANAGER Ylva Abrahamsson
COPYWRITER Martin Marklund/Edwin von Werder
ART DIRECTOR P. Eriksson/M. Falk/J. Lagache

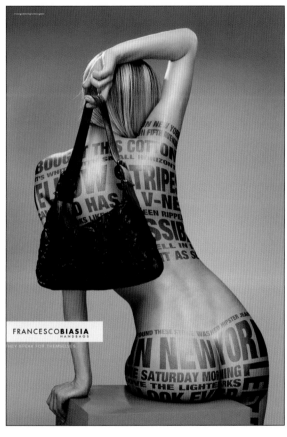

ITALY

FINALIST, CAMPAIGN

D'ADDA, LORENZINI, VIGORELLI, BBDO
MILAN

CLIENT BIASIA
CREATIVE DIRECTOR Gianpietro Vigorelli
ART DIRECTOR Gianpietro Vigorelli/Vincenzo Gasbarro
COPYWRITER Vicky Gitto
PHOTOGRAPHER Karina Taira

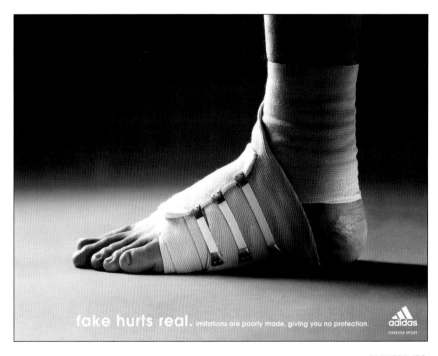

PHILIPPINES

FINALIST, CAMPAIGN

TBWA\SANTIAGO MANGADA PUNO
MAKATI

CLIENT adidas
WRITER Melvin M. Mangada/Joey Campillo
ART DIRECTOR Evans Sator
PHOTOGRAPHER Jeanne Young
PRINT PRODUCER May Dalisay

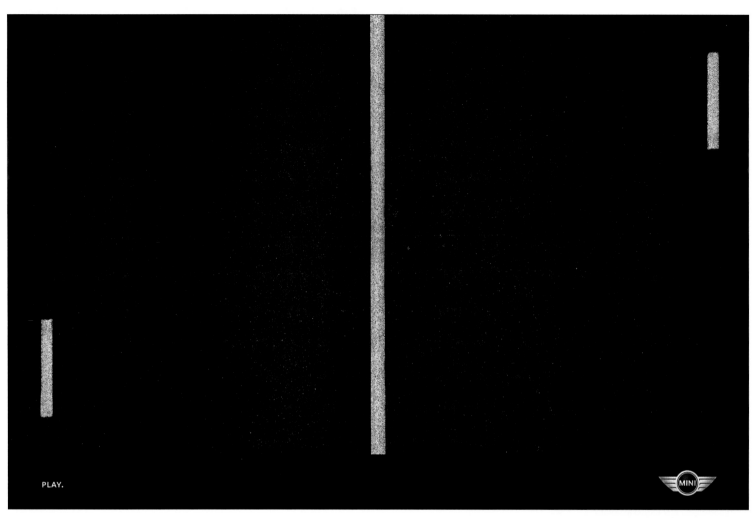

PLAY.

FRANCE

GOLD WORLD MEDAL, SINGLE
BDDP & FILS
BOULOGNE-BILLANCOURT

CLIENT MINI BMW
CREATIVE DIRECTOR Olivier Altmann
COPYWRITER Patrice Lucet
ART DIRECTOR Charles Guillemant
PHOTOGRAPHER Yann Lepape
ART BUYER Sylvie Etchemaïté
RETOUCHES Question d'Edition

SINGAPORE

FINALIST, SINGLE
AD PLANET GROUP SINGAPORE
SINGAPORE

CLIENT Honda Stream
CREATIVE DIRECTOR Leo Teck Chong/Calvin Loo
ART DIRECTOR Kim Tan/Khoo Meng Hau
COPYWRITER Sheenu Kapoor
AGENCY PRODUCER Eddie Eng
ACCOUNT MANAGER Mathew Qwah
PRODUCTION MANAGER James Tan
PHOTOGRAPHER One-Twenty-One Studio
ILLUSTRATOR One-Twenty-One Imaging

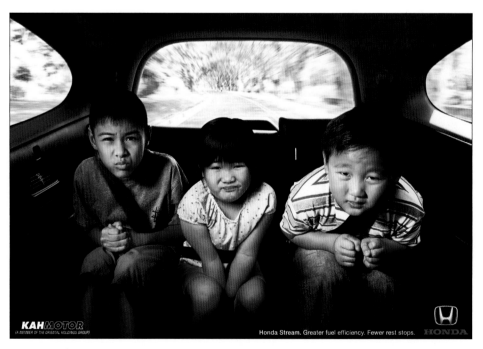

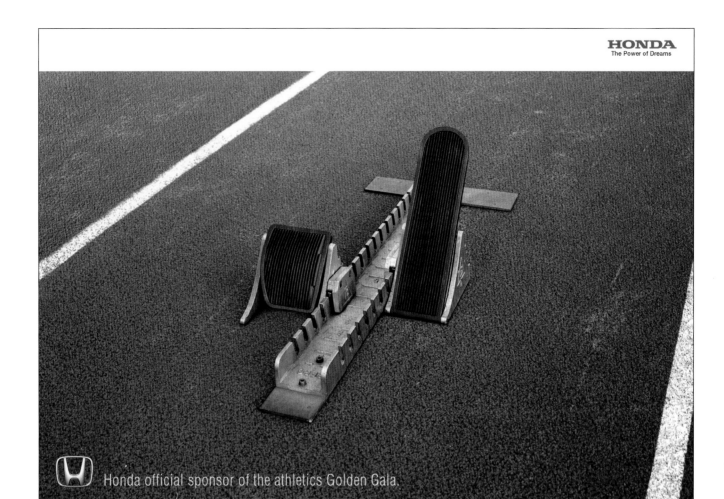

Honda official sponsor of the athletics Golden Gala.

ITALY

SILVER WORLD MEDAL, SINGLE
ATA DE MARTINI LC
MILAN

CLIENT Honda Automobili
CREATIVE DIRECTOR Stefano Rosselli/Maurizio Maresca
ART DIRECTOR Stefano Rosselli/Alberto Berton
COPYWRITER Angelo Pannofino

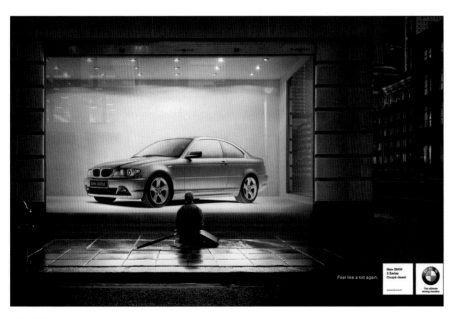

Feel like a kid again.

New BMW
3 Series
Coupé diesel

The ultimate
driving machine

FRANCE

FINALIST, SINGLE
BDDP & FILS
BOULOGNE-BILLANCOURT

CLIENT BMW Série 3 Coupé Diesel
CREATIVE DIRECTOR Olivier Altmann
COPYWRITER Thierry Albert
ART DIRECTOR Damien Bellon
PHOTOGRAPHER Andy Glass
ART BUYER Sylvie Etchemaïté

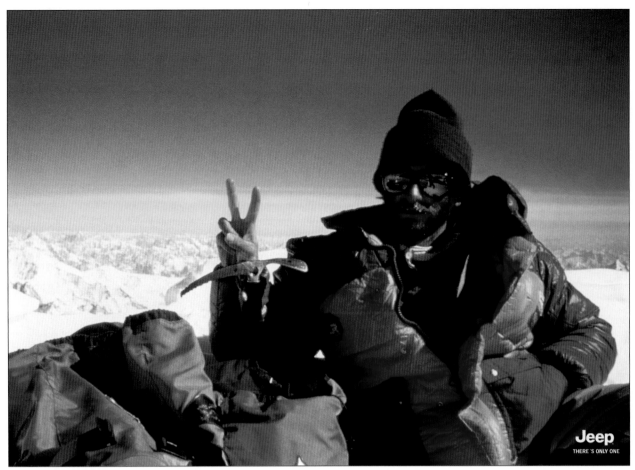

SPAIN
SILVER WORLD MEDAL, SINGLE
CONTRAPUNTO
MADRID

CLIENT Chrysler Jeep
GENERAL CREATIVE DIRECTOR
Antonio Montero
EXECUTIVE CREATIVE DIRECTOR
Carlos Sanz de Andino
CREATIVE DIRECTOR
Carlos Jorge
CREATIVE SUPERVISOR
Félix del Valle

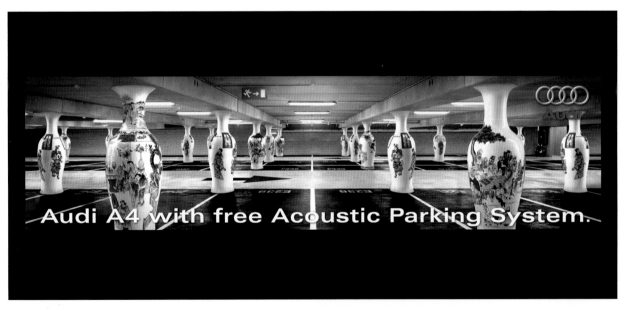

BELGIUM
BRONZE WORLD MEDAL, SINGLE
DDB BRUSSELS
BRUSSELS

CLIENT Audi A4
CREATIVE DIRECTOR Dominique van Doormaal
COPYWRITER Virginie Lepère
ART DIRECTOR Fred Van Hoof
MARKETING MANAGER Audi Marc Donner
CREATIVE PLANNING DIRECTOR Karen Corrigan
ACCOUNT TEAM Xavier Caytan/Maria Randisi
ART BUYER Brigitte Verduyckt/Gisèle Kuperman
ADVERTISING Manager Audi Marc Donner
PHOTOGRAPHER Christophe Gilbert

JEEP WISHES YOU A PLEASANT EVENING AT THE HUNTERS BALL

ONLY IN A
Jeep
www.jeep.at

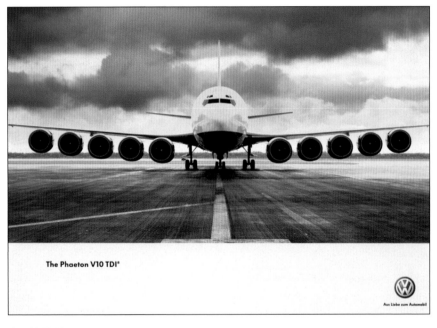

The Phaeton V10 TDI®

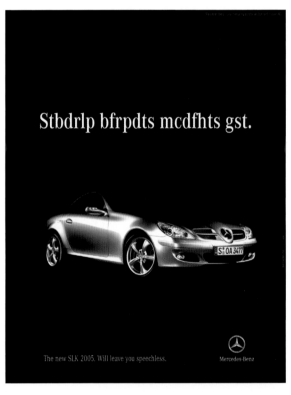

MEXICO
FINALIST, SINGLE
BBDO/MEXICO
MEXICO CITY

CLIENT SLK
CREATIVE DIRECTOR Hector Fernandez
ART DIRECTOR Iliana Escalona
COPYWRITER Hector Fernandez

GERMANY
FINALIST, SINGLE
EURO RSCG THOMSEN ROEHLE KOERNER
DUESSELDORF

CLIENT Citroën Deutschland AG
CCO Andreas Thomsen
CREATIVE DIRECTOR Martin Breuer
ART DIRECTOR Joerg Bruns
COPYWRITER Martin Venn
MANAGEMENT SUPERVISOR Daniel Grube

GERMANY
FINALIST, SINGLE
GRABARZ & PARTNER
HAMBURG

CLIENT Volkswagen Phaeton V10 TDI
CREATIVE DIRECTOR P. Pätzold/R. Nolting
CHIEF CREATIVE OFFICER R. Heuel
ART DIRECTOR Maik Kähler
COPYWRITER Christoph Nann
PHOTO Getty Images Deutschland GmbH/München
CLIENT Volkswagen AG

MEXICO
FINALIST, SINGLE
BBDO/MEXICO
MEXICO CITY

CLIENT SLK
CREATIVE DIRECTOR Hector Fernandez
ART DIRECTOR Iliana Escalona
COPYWRITER Hector Fernandez

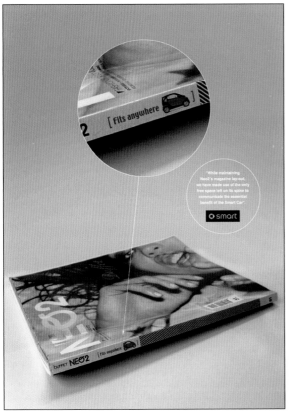

SPAIN

FINALIST, SINGLE

CONTRAPUNTO
MADRID

CLIENT Mercedes Benz Smart
GENERAL CREATIVE DIRECTOR Antonio Montero
EXECUTIVE CREATIVE DIRECTOR Juan Silva
CREATIVE DIRECTOR Carlos Jorge/Felix del Valle
ART DIRECTOR Carlos Jorge
COPYWRITER Felix del Valle

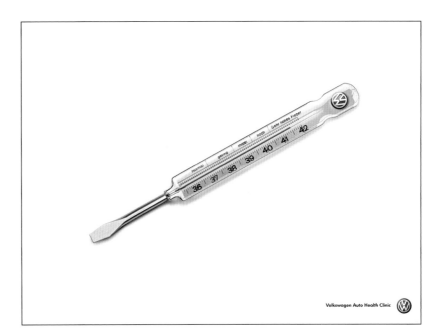

THAILAND

FINALIST, SINGLE

FAR EAST DDB PLC
BANGKOK

CLIENT Volkswagen
CREATIVE DIRECTOR Prakit Kobkijwattana
COPYWRITER Jirut Subbhakarn
ART DIRECTOR Durongrist Pornsirianan

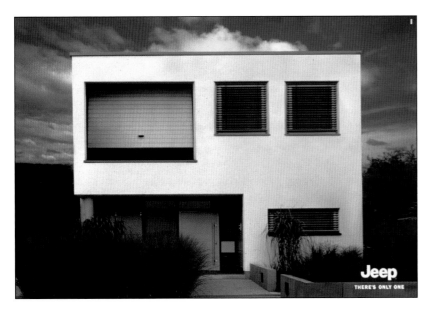

GERMANY

FINALIST, SINGLE

KNSK WERBEAGENTUR GMBH
HAMBURG

CLIENT DaimlerChrysler Jeep
CREATIVE DIRECTOR Tim Krink/Ulrike Wegert/
Anke Winschewski/Vappu Singer
ART DIRECTOR Stefan Schulte/Maren Fick
COPYWRITER Dirk Henkelmann

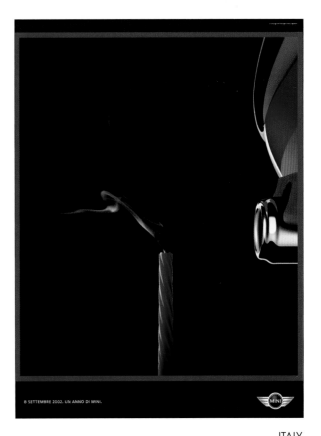

ITALY

FINALIST, SINGLE

D'ADDA,LORENZINI,VIGORELLI,BBDO
MILAN

CLIENT MINI
CREATIVE DIRECTOR Luca Scotto di Carlo/Giovanni Porro
ART DIRECTOR Emily Biella
COPYWRITER Nicola Lampugnan
PHOTOGRAPHER Luca Perazzoli

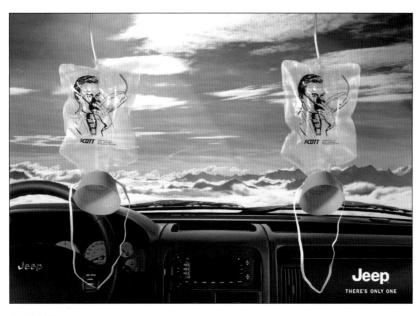

GERMANY

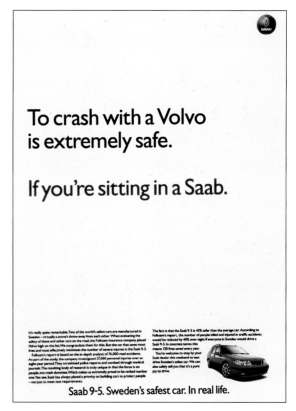

To crash with a Volvo is extremely safe.

If you're sitting in a Saab.

Saab 9-5. Sweden's safest car. In real life.

SWEDEN

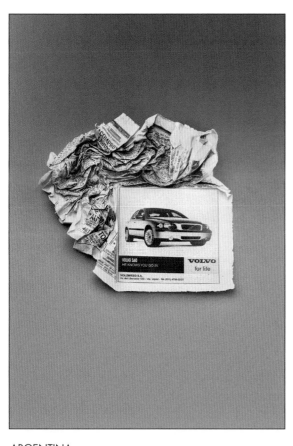

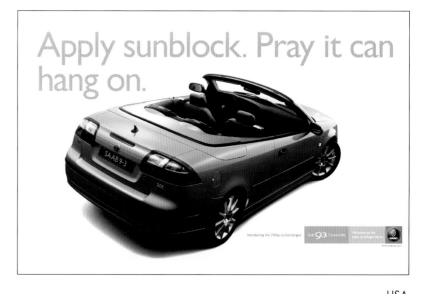

USA

ARGENTINA

CHILE

FINALIST, SINGLE
LOWE PORTA S.A.
SANTIAGO

CLIENT Renault Chile S.A.
CREATIVE DIRECTOR Daniel Molina
ART DIRECTOR Rodrigo Aguilera

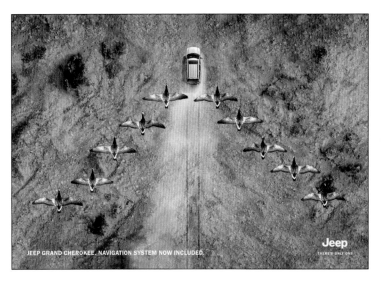

SWITZERLAND

FINALIST, SINGLE
MATTER & PARTNER AG FÜR KOMMUNIKATION
ZURICH

CLIENT Jeep Grand Cherokee
CREATIVE DIRECTOR Daniel Matter/Philipp Skrabal
COPYWRITER Michael Kathe
ART DIRECTOR Sabine Ries
PHOTOGRAPHER Julien Vonier/Matthieu Simonet
TYPOGRAPHER Philippe Rérat
ACCOUNT SUPERVISOR Barbara Litschi/Ivo Schneider
ADVERTISER'S SUPERVISOR Claudia C. Meyer

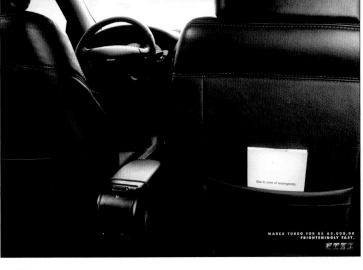

BRAZIL

FINALIST, SINGLE
OGILVY BRASIL
SÃO PAULO

CLIENT Fiat Car Dealers
CREATIVE DIRECTOR Virgilio Neves/
Ricardo Ribeiro/Adriana Cury
COPYWRITER Ricardo Ribeiro
ART DIRECTOR Eric Sulzer
PHOTOGRAPHER Giacomo Favretto

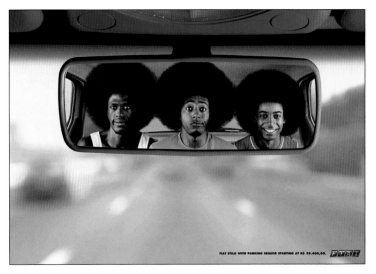

BRAZIL

FINALIST, SINGLE
OGILVY BRASIL
SÃO PAULO

CLIENT Fiat Car Dealers
CREATIVE DIRECTOR Virgilio Neves/
Lilian Lovisi/Adriana Cury
COPYWRITER Ricardo Crucelli
ART DIRECTOR Fernando Saú
PHOTOGRAPHER Edu Rodrigues

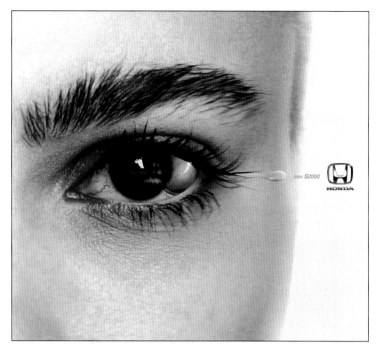

KOREA

FINALIST, SINGLE
ORICOM
SEOUL

CLIENT Honda S-200

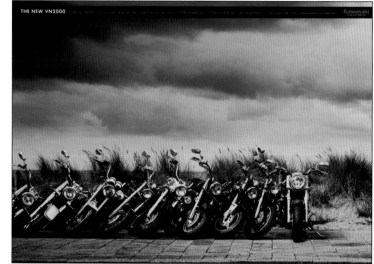

THE NETHERLANDS

FINALIST, SINGLE
PUBLICIS B.V.
AMSTELVEEN

CLIENT Kawasaki
CREATIVE DIRECTOR Joep de Kort/
Massimo van der Plas
PHOTOGRAPHER Simon Warmer

GERMANY

FINALIST, SINGLE
PUBLICIS WERBEAGENTUR GMBH
FRANKFURT

CLIENT Renault Mégane
ART DIRECTOR Alexander Gockel
COPYWRITER Benito Babuscio
CREATIVE DIRECTOR Dirk Bugdahn/Hadi Geiser
CHIEF CREATIVE OFFICER Michael Boebel
BRAND DIRECTOR Georg Esterhues
CLIENT SERVICE DIRECTOR Gerald Heinecke
ACCOUNT DIRECTOR Jens Helfrich
MANAGER MARKETING COMM. Joerg Alexander Ellhof
ADVERTISING MANAGER Astrid Kauffmann
MARKETING DIRECTOR Frank Lagarde

GERMANY

PUBLICIS WERBEAGENTUR GMBH
FRANKFURT

CLIENT Renault Safety
CREATIVE DIRECTOR Harald Schmitt/Tom Tilliger
ART DIRECTOR Denise Overkamp
COPYWRITER Nicole Schneider
CHIEF CREATIVE OFFICER Michael Boebel
PHOTOGRAPHER Peter Duettmann
GROUP ACCOUNT DIRECTOR Daniel Dormeyer
BRAND DIRECTOR Georg Esterhues
CLIENT SERVICE DIRECTOR Gerald Heinecke
MANAGER MARKETING COMMUNICATION Joerg Alexander Ellhof
ADVERTISING MANAGER Astrid Kauffmann
MARKETING DIRECTOR Frank Lagarde

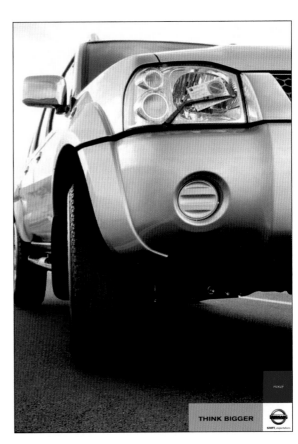

HONG KONG

T.P. ADVERTISING CO. LTD
HONG KONG

CLIENT Audi
CREATIVE DIRECTOR Nui Sea Ok Alex/Bon Chiu
ART DIRECTOR Manfred Chung

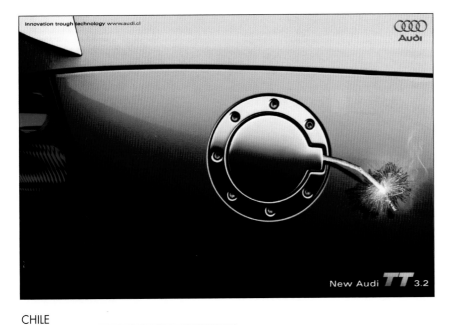

CHILE

SEPIA
SANTIAGO

CLIENT Audi
CREATIVE DIRECTOR Jaime Navarro/Alberto Osorio
PHOTOGRAPHER Rodrigo Araneda
CLIENT Gonzalo de la Barra
GENERAL MANAGER Alberto Valdes
ART DIRECTOR Jaime Navarro
COPYWRITER Alberto Osorio

GERMANY

TBWA
BERLIN

CLIENT Nissan Pick Up
CREATIVE DIRECTOR Kai Röffen/Knut Burgdorf
ART DIRECTOR Rainer Schmidt
COPYWRITER Donald Tursman
ACCOUNT Heike Beckmann
CLIENT/ADVERTISING MANAGER Michael Freund

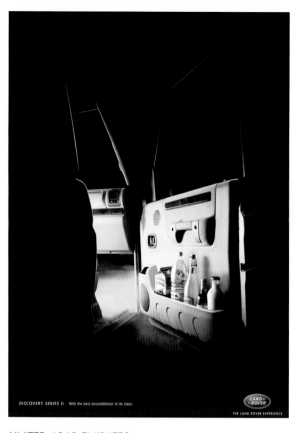

DISCOVERY SERIES II With the best airconditioner in its class.

THE LAND ROVER EXPERIENCE

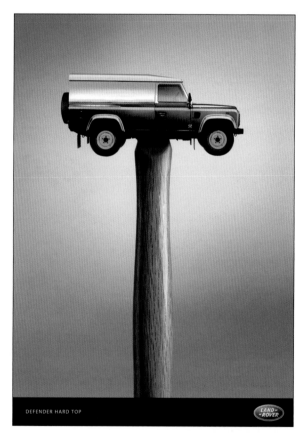

DEFENDER HARD TOP

UNITED ARAB EMIRATES

FINALIST, SINGLE

TEAM YOUNG & RUBICAM
DUBAI

CLIENT Land Rover
EXECUTIVE CREATIVE DIRECTOR Sam Ahmed
ART DIRECTOR Rupesh Vethanayagam
COPYWRITER Anthony D'souza
ILLUSTRATOR Anil Palyekar

SPAIN

FINALIST, SINGLE

TBWA\ESPAÑA
BARCELONA

CLIENT Nissan Patrol GR
CREATIVE DIRECTOR X. Munill/C. Garbutt/J. Teixidó
COPY Xavier Munill/Miquel Sales
ART DIRECTOR Tomás Descals/Alex Martín
PHOTOGRAPHER Jaume Diana

www.nissan4x4.com

SPAIN

FINALIST, SINGLE

TBWA\ESPAÑA
BARCELONA

CLIENT Nissan 4x4
CREATIVE DIRECTOR X. Munill/C. Garbutt/J. Teixidó
COPYWRITER Xavi Munill/Miquel Sales
ART DIRECTOR Tomás Descals/Alex Martín
PHOTOGRAPHER Jaume Diana

UNITED ARAB EMIRATES

FINALIST, SINGLE

TEAM YOUNG & RUBICAM
DUBAI

CLIENT Land Rover
EXECUTIVE CREATIVE DIRECTOR Sam Ahmed
CREATIVE DIRECTOR Mark Lineveldt
ART DIRECTOR Peter Walker
COPYWRITER James Wareham

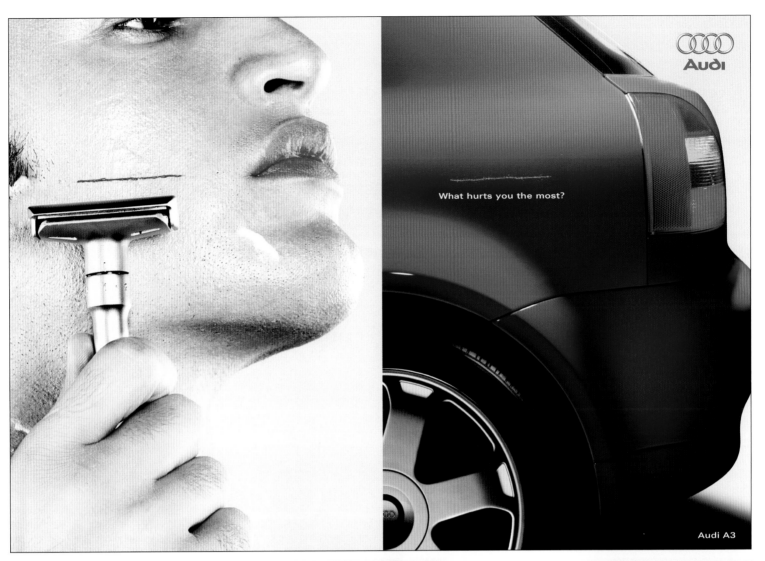

What hurts you the most?

Audi A3

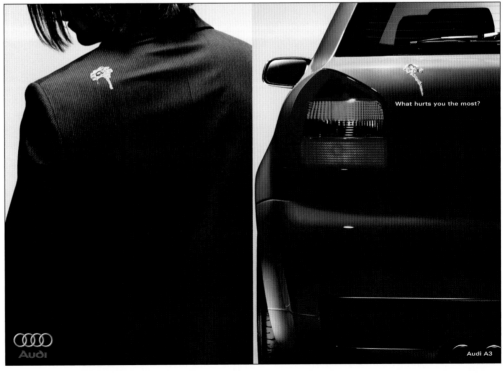

What hurts you the most?

Audi A3

SPAIN

GOLD WORLD MEDAL, CAMPAIGN
DDB ESPANA
MADRID

CLIENT Audi A3
CREATIVE DIRECTOR Danny Ilario/Alberto Astorga
ART DIRECTOR Fernando Codina
COPYWRITER Javier Valero

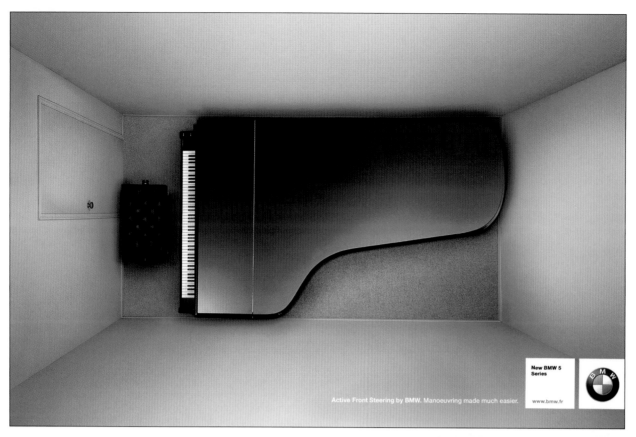

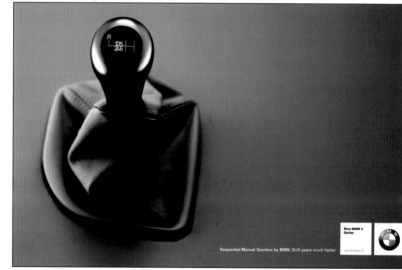

FRANCE

SILVER WORLD MEDAL, CAMPAIGN

BDDP & FILS

BOULOGNE-BILLANCOURT

CLIENT **BMW**
CREATIVE DIRECTOR **Olivier Altmann**
ART DIRECTOR **Laurent Bodson/Eric Thomé**
COPYWRITER **Olivier Camensuli/Kim Lai**
PHOTOGRAPHER **Olivier Rheindorf**
ART BUYER **Sylvie Etchemaïté**

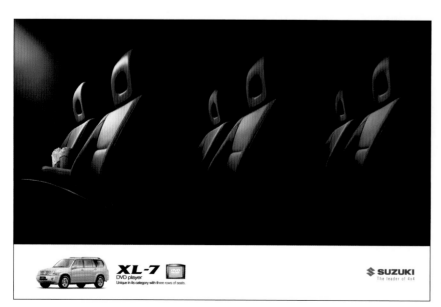

CHILE

FINALIST, SINGLE

ZEGERS DDB

SANTIAGO

CLIENT **Suzuki/XL7**
CREATIVE DIRECTOR **Jaime Rodriguez**
ART DIRECTOR **Jaime Rodriguez**
COPYWRITER **Jaime Rodriguez**
ART DIRECTOR **Chstrian Strich**
ACCOUNT EXECUTIVE **Carolina Velasco**
AGENCY PRODUCER **Lorena Tapia**

SOUTH AFRICA

BRONZE WORLD MEDAL, CAMPAIGN
NET#WORK BBDO
JOHANNESBURG

CLIENT Delta Motor Corporation/Opel Astra Grand Prix Campaign
CREATIVE DIRECTOR Mike Schalit
ART DIRECTOR Graeme Jenner
COPYWRITER Brad Reilly
ILLUSTRATOR Map Studio
ACCOUNT EXECUTIVE Jason Slinger
PRODUCTION MANAGER Clinton Mitri

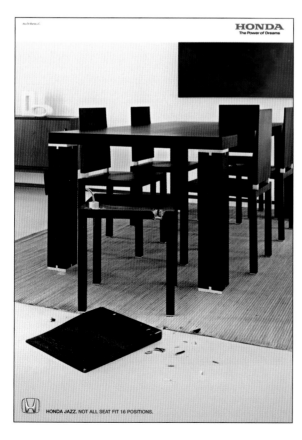

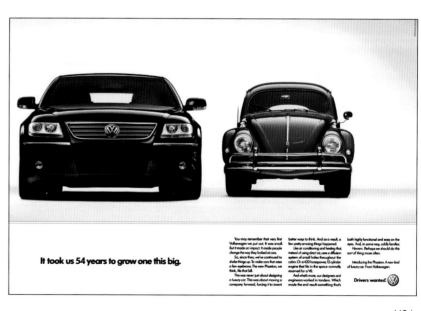

USA

FINALIST, CAMPAIGN
ARNOLD WORLDWIDE
BOSTON, MA

CLIENT Volkswagen
ART DIRECTOR Alan Pafenbach/Steve Yaffe
COPYWRITER Dave Weist/Alex Russell
CHIEF CREATIVE OFFICER Ron Lawner
EXECUTIVE CREATIVE DIRECTOR Alan Pafenbach
CREATIVE DIRECTOR Dave Weist

ITALY

FINALIST, CAMPAIGN
ATA DE MARTINI LC
MILAN

CLIENT Honda Jazz
CREATIVE DIRECTOR Stefano Rosselli/
Maurizio Maresca
ART DIRECTOR Stefano Rosselli/
Eustachio Ruggieri
COPYWRITER Michelangelo Cianciosi

SPAIN

FINALIST, CAMPAIGN
CONTRAPUNTO
MADRID

CLIENT Chrysler Jeep
GENERAL CREATIVE DIRECTOR Antonio Montero
EXECUTIVE CREATIVE DIRECTOR Carlos Sanz de Andino
CREATIVE DIRECTOR Carlos Jorge/Félix Del Valle
ART DIRECTOR Santiago Winer/Miguel Madariaga
COPYWRITER Santiago Winer/Miguel Madariaga

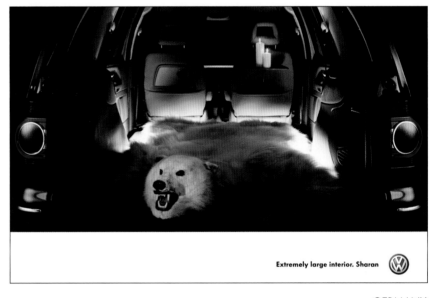

Extremely large interior. Sharan

GERMANY

FINALIST, CAMPAIGN
DDB GERMANY
BERLIN

CLIENT VW Sharan
CREATIVE DIRECTOR Mathias Stiller/
Wolfgang Schneider
SENIOR ART DIRECTOR Craige Lovelidge
COPYWRITER Max Ströbel
ACCOUNT DIRECTOR Levent Akinci

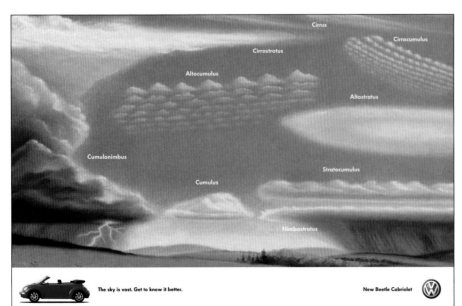

The sky is vast. Get to know it better. New Beetle Cabriolet

PORTUGAL

FINALIST, CAMPAIGN
DDB LISBON
LISBON

CLIENT Volkswagen
CREATIVE DIRECTOR Duarte Pinheiro Melo
WRITER Tomás Mayer
ART DIRECTOR Max Souzedo/Duarte Pinheiro Melo

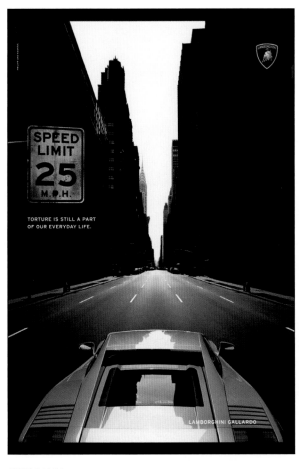

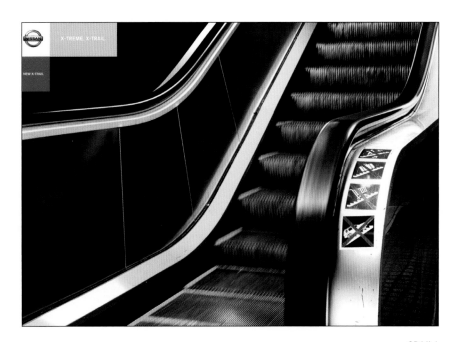

SPAIN

FINALIST, CAMPAIGN

TBWA\ESPAÑA
BARCELONA

CLIENT Nissan X-Trail
CREATIVE DIRECTOR X. Munill/C. Garbutt/J. Teixidó
COPY Xavi Munill/Miquel Sales
ART DIRECTOR Tomás Descals/Alex Martín
PHOTOGRAPHER Ralph Baiker

GERMANY

FINALIST, CAMPAIGN

PHILIPP UND KEUNTJE GMBH
HAMBURG

CLIENT Automobili Lamborghini S.P.A.
CREATIVE DIRECTOR Diether Kerner/Oliver Handlos
ART DIRECTOR Elke von Ditfurth-Siefken
COPYWRITER Oliver Gill/Jakob Eckstein

AUTOMOTIVE PRODUCTS

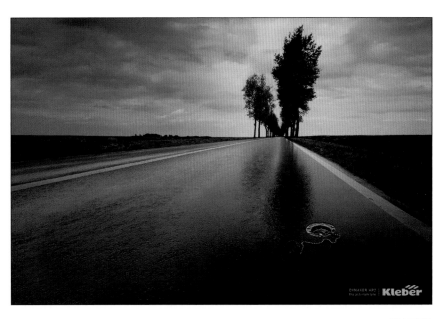

FRANCE

FINALIST, SINGLE

BDDP & FILS
BOULOGNE-BILLANCOURT

CLIENT Kleber
CREATIVE DIRECTOR Olivier Altmann
COPYWRITER Pierre-Philippe Sardon
ART DIRECTOR Antoine Mathon-Recalde
PHOTOGRAPHER George Logan
PHOTOGRAPHER Agent Laurence Bonduel
ART BUYER Sylvie Etchemaïté
RETOUCHES Keep Coul

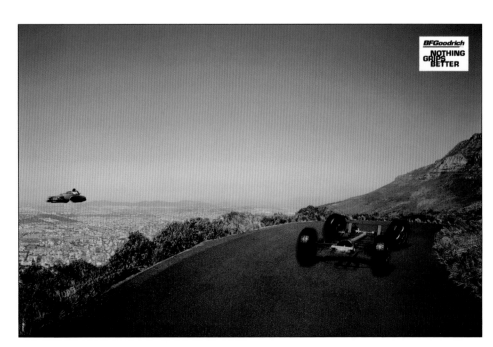

Because rust occurs where you least expect it. If you would like more information about rust a'd preventing it, please go to www.total.co.za or contact our customer care centre on 0850 111 111.

TOTAL

Pioneer sound.vision.soul

DISTURB

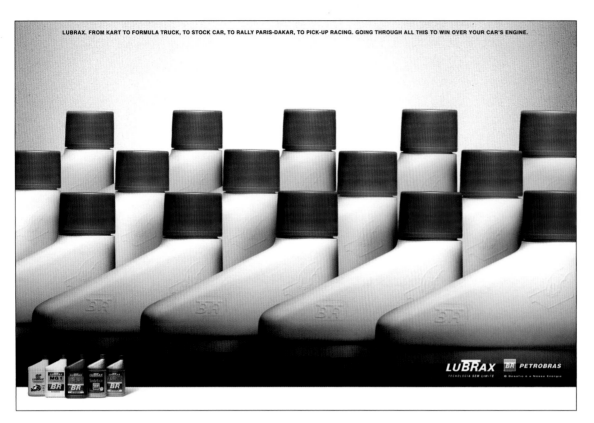

LUBRAX. FROM KART TO FORMULA TRUCK, TO STOCK CAR, TO RALLY PARIS-DAKAR, TO PICK-UP RACING. GOING THROUGH ALL THIS TO WIN OVER YOUR CAR'S ENGINE.

BRAZIL

BRONZE WORLD MEDAL, SINGLE

DPZ PROPAGANDA
RIO DE JANEIRO

CLIENT **Petrobras Petroleum**
ART DIRECTOR **Reuber Marchezini**
COPYWRITER **Fred Coutinho**
CREATIVE DIRECTOR **Luiz Vieira**

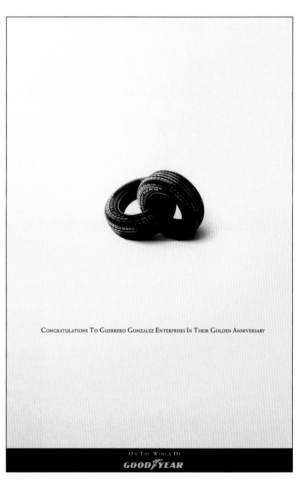

CONGRATULATIONS TO GUERRERO GONZALEZ ENTERPRISES IN THEIR GOLDEN ANNIVERSARY

ON THE WINGS OF
GOOD YEAR

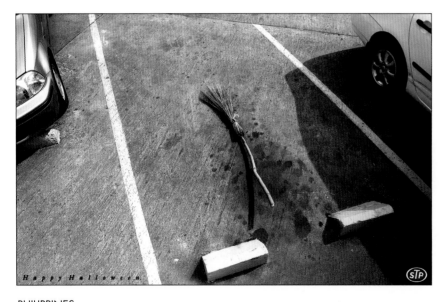

COLOMBIA

FINALIST, SINGLE
McCANN-ERICKSON COLOMBIA
BOGOTA

CLIENT **Goodyear**
CREATIVE DIRECTOR **Martha Quintero**

PHILIPPINES

FINALIST, SINGLE
DDB PHILIPPINES, INC.
PASIG CITY

CLIENT **STP**

CANADA
FINALIST, SINGLE
DUE NORTH COMMUNICATIONS
TORONTO, ONTARIO

CLIENT Goodyear Canada
CREATIVE DIRECTOR Karen Howe
ART DIRECTOR Carson Ting
WRITER Dan Zimerman
PHOTOGRAPHER Shin Sugino
DIGITAL ARTIST Chris Smith

ARGENTINA
FINALIST, SINGLE
GRAFFITI D ARCY
BUENOS AIRES

CLIENT Osram
CREATIVE DIRECTOR Fernando Tchechenistky
ART DIRECTOR Lisandro Grandal
COPYWRITER Santiago Maiz
GROUP ACCOUNT DIRECTOR Nicolás Díaz
ACCOUNT EXECUTIVE Juan Manuel Budelli
PHOTOGRAPHER Freddy Fabris

ARGENTINA
FINALIST, SINGLE
SAVAGLIO TBWA
BUENOS AIRES

CLIENT Casa Pesqueira
CREATIVE DIRECTOR Ernesto Savaglio
COPYWRITER Ariel Gil
ART DIRECTOR Ruben Carrión
ACCOUNT SUPERVISOR Dolores Caballero
PHOTOGRAPHER Abadi Coscia

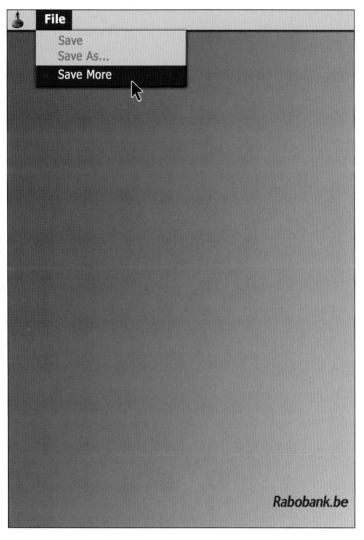

Rabobank.be

BELGIUM

BRONZE WORLD MEDAL, SINGLE
QUATTRO SAATCHI & SAATCHI
BRUSSELS

CLIENT RaboBank.be

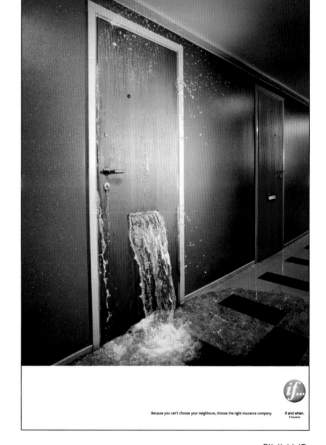

FINLAND

FINALIST, SINGLE
HASAN & PARTNERS OY
HELSINKI

CLIENT If Insurance
ART DIRECTOR Juha Larsson
COPYWRITER Anu Niemonen
ACCOUNT MANAGER Sirkka Norha
CREATIVE DIRECTOR Timo Everi
ACCOUNT EXECUTIVE Tarja Malka
AD ASSISTANT Jochum von Veh

KOREA

FINALIST, SINGLE
DIAMOND AD., LTD.
SEOUL

CLIENT Hyundai Marine & Fire Insurance Co., Ltd.

ART NOT AVAILABLE

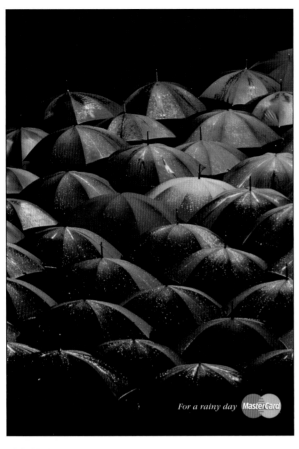

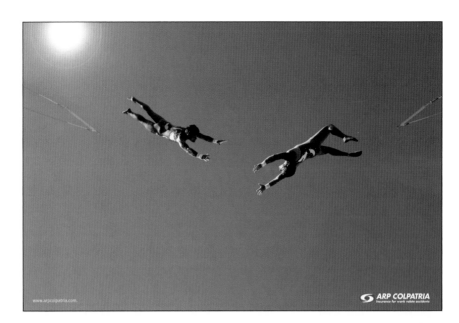

ICELAND

FINALIST, SINGLE
THE WHITE HOUSE
REYKJAVIK

CLIENT **MasterCard**
CREATIVE DIRECTOR **Stefan Einarsson/Sverrir Bjornsson**
ART DIRECTOR **Stefan Einarsson**
COPYWRITER **Stefan Einarsson**

COLOMBIA

FINALIST, SINGLE
LOWE/SSPM
BOGOTA, CUNDINAMARCA

CLIENT **Colpatria**
COPYWRITER **Juan Pablo Navas/Juan Carlos Palma**
ART DIRECTOR **Alejandro Benavides**
CREATIVE DIRECTOR **Jose Miguel Sokoloff**

BEVERAGES: ALCOHOLIC

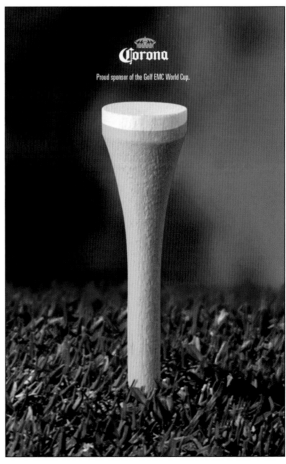

MEXICO

FINALIST, SINGLE
LEO BURNETT MEXICO, S.A. DE C.V.
MEXICO CITY

CLIENT **Corona Beer**
VP & CREATIVE SERVICES DIRECTOR **Humberto Lopardo**
CREATIVE GROUP DIRECTOR **Miguel A. Ponce de Leon**
ASSOCIATE CREATIVE DIRECTOR **Juan Jose Garduno/
Raul Rivera**
ACCOUNT DIRECTOR **Luis Perujo**

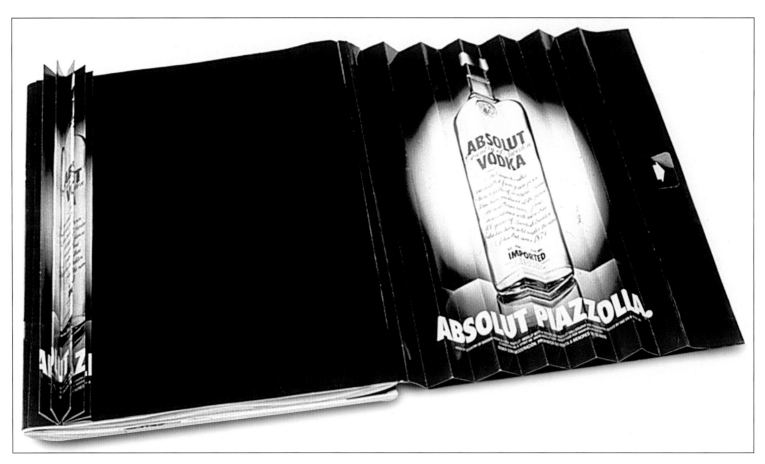

ARGENTINA

GOLD WORLD MEDAL, SINGLE
SAVAGLIO TBWA
BUENOS AIRES

CLIENT **Absolut Vodka**
CREATIVE DIRECTOR **Ernesto Savaglio**
COPYWRITER **Vicki Santiso**
ART DIRECTOR **Diego Lipser**
ACCOUNT SUPERVISOR **Luciano Tidone**

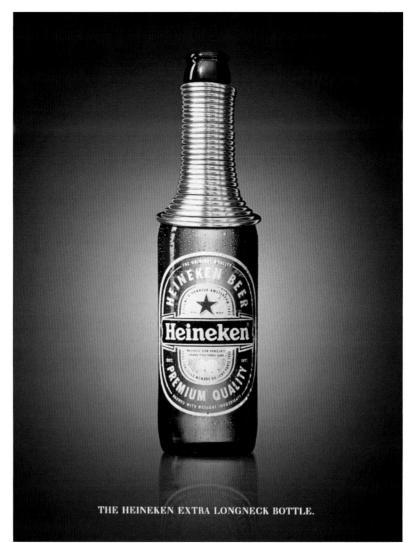

GERMANY

BRONZE WORLD MEDAL, SINGLE
AIMAQ RAPP STOLLE
BERLIN

CLIENT **Heineken**
CREATIVE DIRECTOR **Oliver Frank**
ART DIRECTOR **Oliver Froehnel**
COPYWRITER **Sebastian Nitsch**
PHOTOGRAPHY **Wilbert Weigend**
POSTPRODUCTION **Stefan Kessner**
ACCOUNT SUPERVISOR **Stafanie Gebhardt**
ART BUYING **Andrea Wendt**

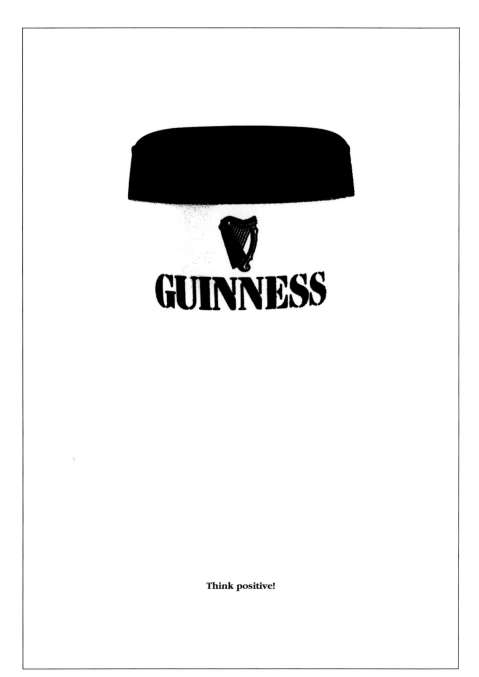

Think positive!

ROMANIA

SILVER WORLD MEDAL, SINGLE
GRAFFITI BBDO
BUCHAREST

CLIENT Guinness
CREATIVE DIRECTOR Adrian Preda
ART DIRECTOR Cosmin Ezaru
COPYWRITER Cosmin Ezaru
ACCOUNT MANAGER Diana Pojoga
EXECUTIVE CREATIVE DIRECTOR Lucian Georgescu

Proud sponsor

MEXICO

FINALIST, SINGLE
LEO BURNETT MEXICO, S.A. DE C.V.
MEXICO CITY

CLIENT Modelo Especial Beer
VP & CREATIVE SERVICES DIRECTOR Humberto Lopardo
CREATIVE SERVICES DIRECTOR Jorge Aguilar
CREATIVE GROUP DIRECTOR Marco Antonio Davila
ART DIRECTOR Armando Zuniga
ACCOUNT DIRECTOR Luis Perujo

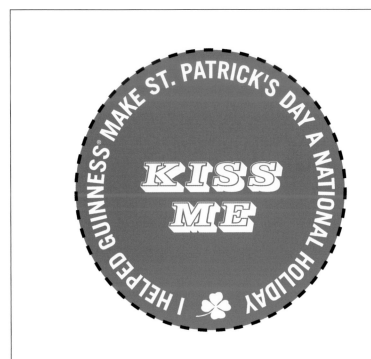

BADGE OF HONOR:

SIGN THE ONLINE PETITION AT GUINNESS.COM.
CUT OUT BADGE. GLUE TO CLOTHING.

Celebrate St. Patrick's Day responsibly. Cheers. © 2003. Guinness® stout is imported by the Guinness Bass Import Co., Stamford, CT 06901.

USA

SILVER WORLD MEDAL, CAMPAIGN
BBDO NEW YORK
NEW YORK, NY

CLIENT **Guinness**

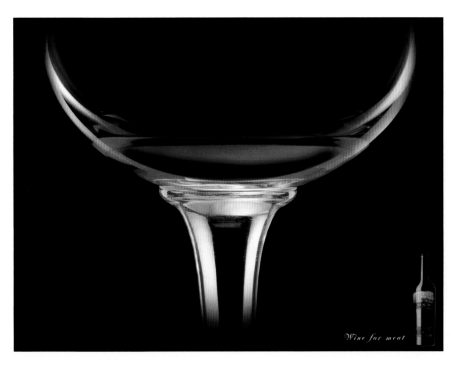

CHILE

FINALIST, SINGLE
LOWE PORTA S.A.
SANTIAGO

CLIENT Viña San Pedro
CREATIVE DIRECTOR Kiko Carcavilla
COPYWRITER Raul Vidal
ART DIRECTOR Rene Moraga
ILLUSTRATOR Rene Moraga

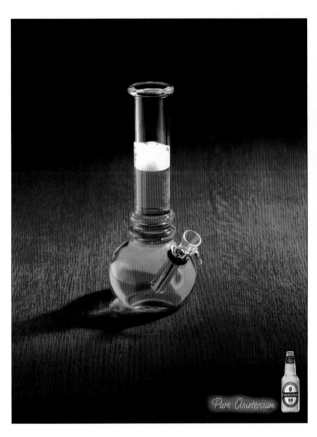

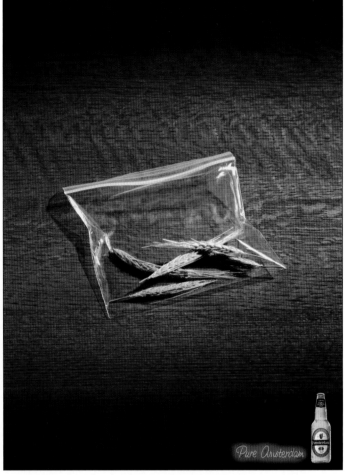

CANADA
BRONZE WORLD MEDAL, CAMPAIGN
PUBLICIS TORONTO
TORONTO

CLIENT Amsterdam Beer
CREATIVE DIRECTOR Duncan Bruce/Pat Pirisi
ART DIRECTOR Duncan Bruce/Paul Riss
COPYWRITER Pat Pirisi/Matt Antonello
PHOTOGRAPHER Janet Bailey
PRINT PRODUCER Pat McKeen
RETOUCHER Elizabeth Macaulay/Catherine Mazerolle
ACCOUNT DIRECTOR Dave Lafond

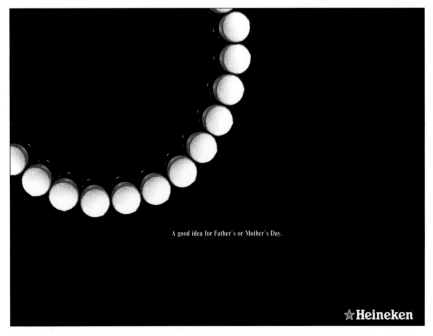

COLOMBIA
FINALIST, SINGLE
McCANN-ERICKSON COLOMBIA
BOGOTA

CLIENT Heineken
VP CREATIVE Camilo Pradilla
ART DIRECTOR Miguel Camargo
COPYWRITER Jaime Ruíz

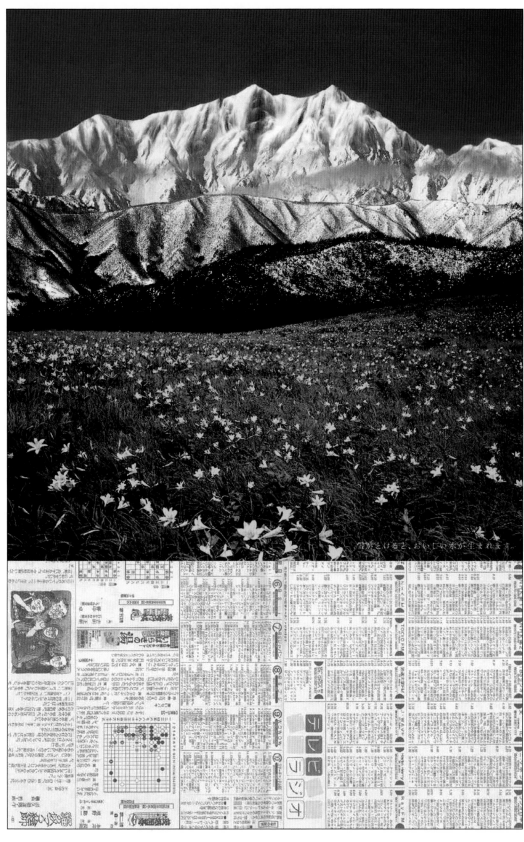

JAPAN

GOLD WORLD MEDAL, SINGLE

DENTSU INC.

TOKYO

CLIENT Suntorys Natural Southern Alps Water
CREATIVE DIRECTOR Hideo Kato/Konosuke Kamitani
COPYWRITER Yutaka Tsujino
ART DIRECTOR Takeru Kawai
ACCOUNT EXECUTIVE Kenichi Abe
PHOTOGRAPHER Tomoki Uehara
DESIGNER Kazuaki Aikawa/Tomoki Uematsu

PERU

SILVER WORLD MEDAL, SINGLE

MAYO/FCB
LIMA

CLIENT Anchor
CREATIVE DIRECTOR Miguel Leon
COPYWRITER Cinthia Delgado
ART DIRECTOR Gustavo San Cristobal
COPYWRITER María Pía Balestra
AGENCY PRODUCER Isabel Noriega
PHOTOGRAPHER Leonel Ortiz
ACCOUNT SUPERVISOR Maria Beatriz Rodo
CLIENT SUPERVISOR Ivan Lopez

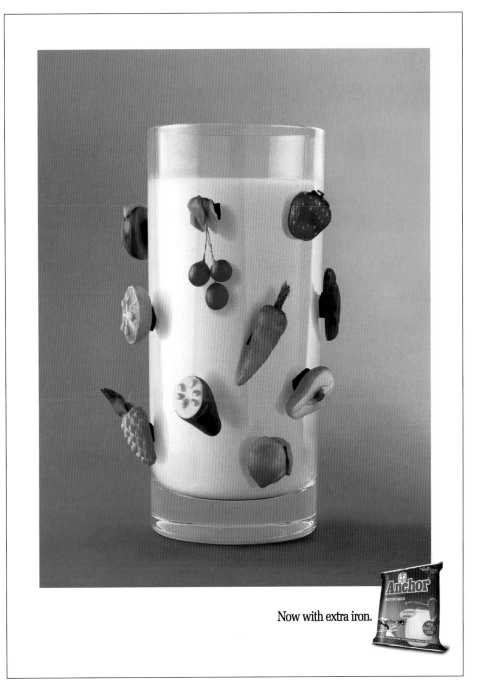

Now with extra iron.

MEXICO

FINALIST, SINGLE

GREY MÉXICO, S.A. DE C.V.
MÉXICO CITY

CLIENT Slim Fast
CREATIVE DIRECTOR Andrés Cedillo/Alan
Zabicky/Angel Beltrán
COPYWRITER Miguel Fragoso
ART DIRECTOR Angel Beltrán/Ingrid Díaz
PHOTOGRAPHER Diego Peréz

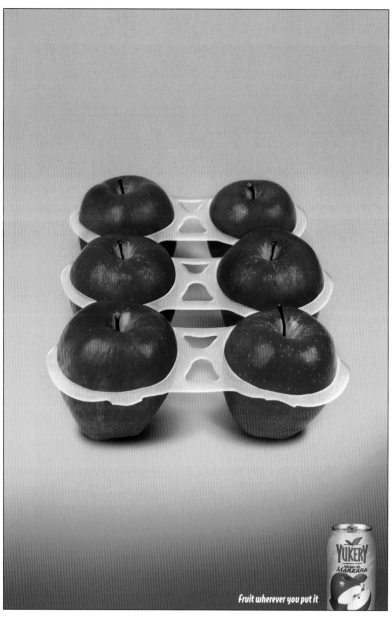

Fruit wherever you put it

VENEZUELA

BRONZE WORLD MEDAL, SINGLE
LOWE CONCEPT
CARACAS

CLIENT Yukery Juice
CREATIVE DIRECTOR Matilde Neuman
ART DIRECTOR Jonathan Pagano
COPYWRITER Gustavo Rubel
ACCOUNT DIRECTOR Sonia Echeverria
BRAND MANAGER Tatiana Pérez
PHOTOGRAPHER Rodolfo Benitez

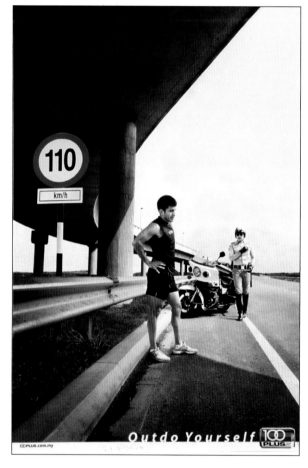

Outdo Yourself

MALAYSIA

FINALIST, SINGLE
BATES (MALAYSIA) SDN BHD
KUALA LUMPUR

CLIENT 100 Plus
EXECUTIVE CREATIVE DIRECTOR Ajay Thrivikraman
ART DIRECTOR Yeoh Oon Hoong
COPYWRITER Joseph Anthony
PHOTOGRAPHER Mak Kah Heng
SENIOR ACCOUNT DIRECTOR Nicola Tiong
ACCOUNT EXECUTIVE Aprel Lim
SENIOR MANAGER-PRODUCTION OPERATIONS Wong Chee Mun

TAIWAN

FINALIST, SINGLE
BATEY TAIWAN
TAIPEI

CLIENT Karihome
EXECUTIVE CREATIVE DIRECTOR Vincent Yeh
COPY Vincent Yeh
ART DIRECTOR Kevin Wu

ART NOT AVAILABLE

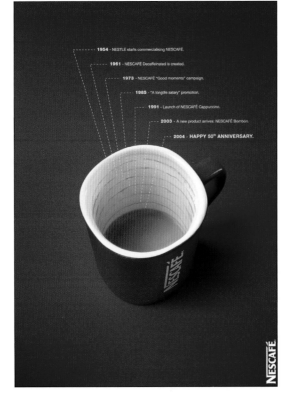

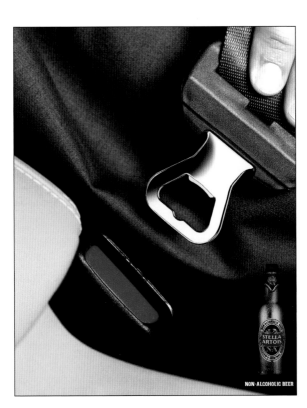

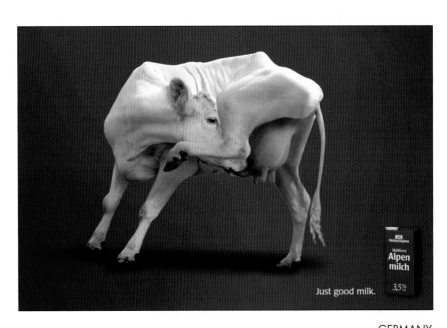

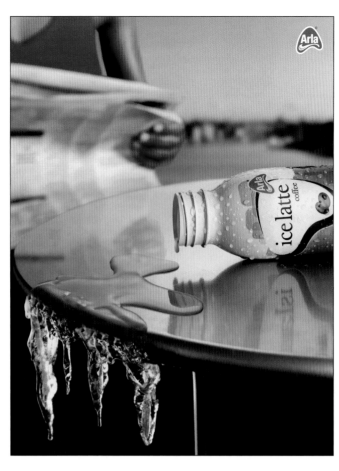

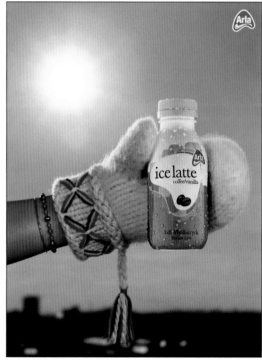

SWEDEN
BRONZE WORLD MEDAL, CAMPAIGN
FORSMAN & BODENFORS
GOTHENBURG

CLIENT Arla Foods
COPYWRITER Fredrik Jansson
ART DIRECTOR Johan Eghammer
PHOTOGRAPHER Erik Hagman
ACCOUNT SUPERVISOR
Ann Spennare Bengtsson
ACCOUNT EXECUTIVE Lena Olander

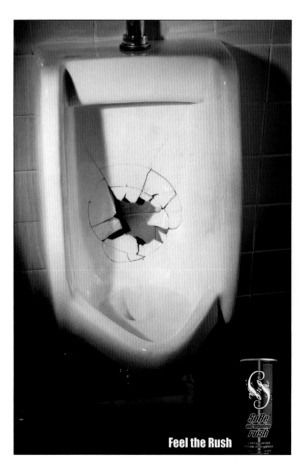

MEXICO
FINALIST, CAMPAIGN
BBDO/MEXICO
MEXICO CITY

CLIENT Sobe
CREATIVE DIRECTOR Hector Fernandez
COPYWRITERS Hector Fernandez/Miguel Moreno
ART DIRECTOR Sindo Ingelmo

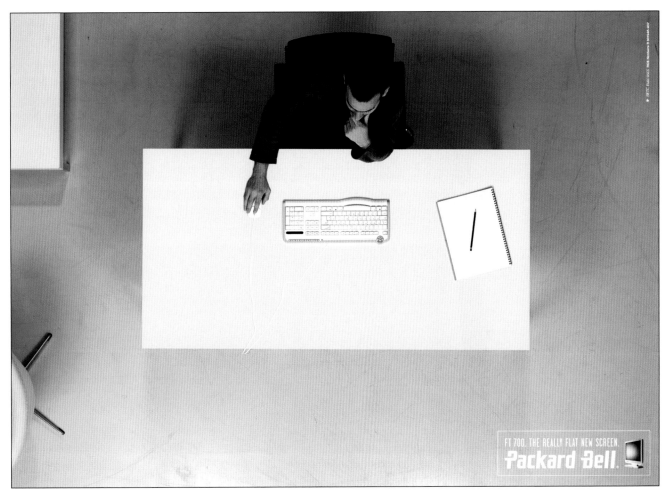

FRANCE

SILVER WORLD MEDAL, SINGLE
BETC EURO RSCG
PARIS

CLIENT Packard Bell
CREATIVE DIRECTOR Stephane Xiberras
ART DIRECTOR Thomas Birch
COPYWRITER Stephane Rochais
PHOTOGRAPHER Olivier Reindorf

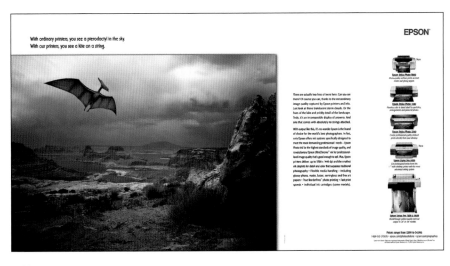

USA

FINALIST, SINGLE
DDB LOS ANGELES
VENICE, CA

CLIENT Epson
CREATIVE DIRECTOR Mark Monteiro
COPYWRITER Philip Nicholas
ART DIRECTOR Serafin Canchola/Ralph Palamidessi

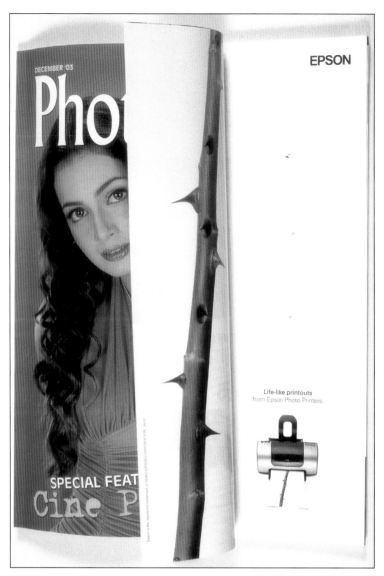

INDIA

BRONZE WORLD MEDAL, SINGLE

MUDRA COMMUNICATIONS PRIVATE LIMITED
BANGALORE, KARNATAKA

CLIENT Epson
ART DIRECTOR Saurabh V. Doke
PHOTOGRAPHER Harmit Singh
DIRECTOR BRAND COMMUNICATIONS Sharad Kadkol
EXECUTIVE BRAND COMMUNICATIONS
Harish Krishnamurthy

MEXICO

FINALIST, SINGLE

GREY MÉXICO, S.A. DE C.V.
MEXICO CITY

CLIENT Post-it
CREATIVE DIRECTOR Andrés Cedillo/Alan Zabicky
COPYWRITER Diego Morel
ART DIRECTOR Alejandro Beltrán
PHOTOGRAPHER Diego Peréz

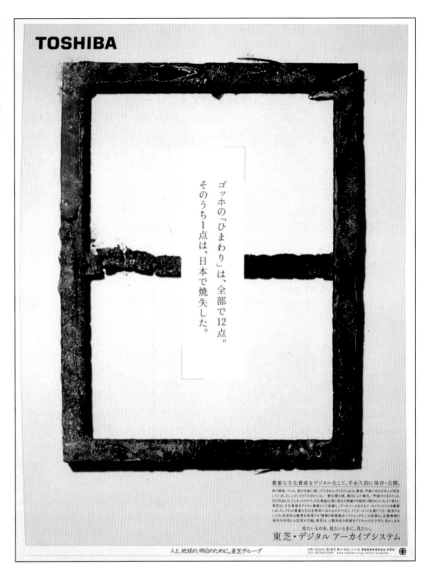

TOSHIBA

ゴッホの「ひまわり」は、全部で12点。そのうち1点は、日本で焼失した。

東芝・デジタル アーカイブシステム

人と、地球の、明日のために。東芝グループ

JAPAN

BRONZE WORLD MEDAL, CAMPAIGN

ADK INC.

TOKYO

CLIENT Toshibas Digital Archive System
CREATIVE DIRECTOR Yasuo Fukuda
COPYWRITER Hiroyuki Watanabe
ART DIRECTOR Osamu Fukushima
PHOTOGRAPHER Tetsuo Takai

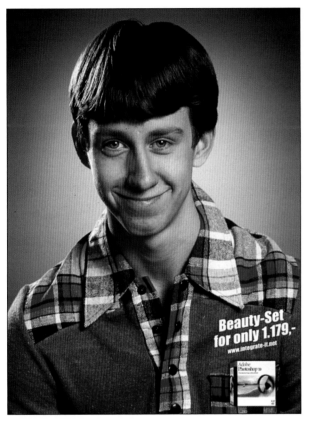

Beauty-Set
for only 1.179,-
www.integrate-it.net

Adobe Photoshop 7.0

GERMANY

FINALIST, CAMAPAIGN

AIMAQ RAPP STOLLE

BERLIN

CLIENT Integrate-it
CREATIVE DIRECTOR Oliver Frank
ART DIRECTOR Oliver Froehnel/Christian Feldhusen
PHOTOGRAPHY Sven Glage
ACCOUNT SUPERVISOR Soeren Hagge
ART BUYING Andrea Wendt

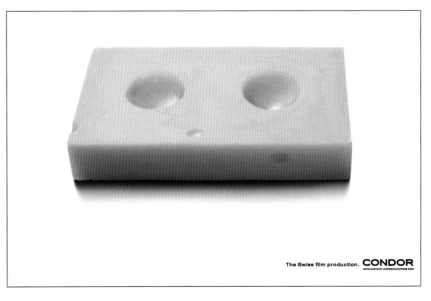

The Swiss film production. **CONDOR**
WWW.CONDOR-COMMUNICATIONS.COM

SWITZERLAND

FINALIST, SINGLE

RUF LANZ WERBEAGENTUR AG

ZÜRICH

CLIENT Condor Communications
CREATIVE DIRECTOR Danielle Lanz/Markus Ruf
COPYWRITER Markus Ruf
ART DIRECTOR Katja Puccio
PHOTOGRAPHER Andrea Vedovo
PICTURE EDITOR Felix Schregenberger
ACCOUNT SUPERVISOR Martina Schoerghofer
ADVERTISER'S SUPERVISOR Martin A. Fueter

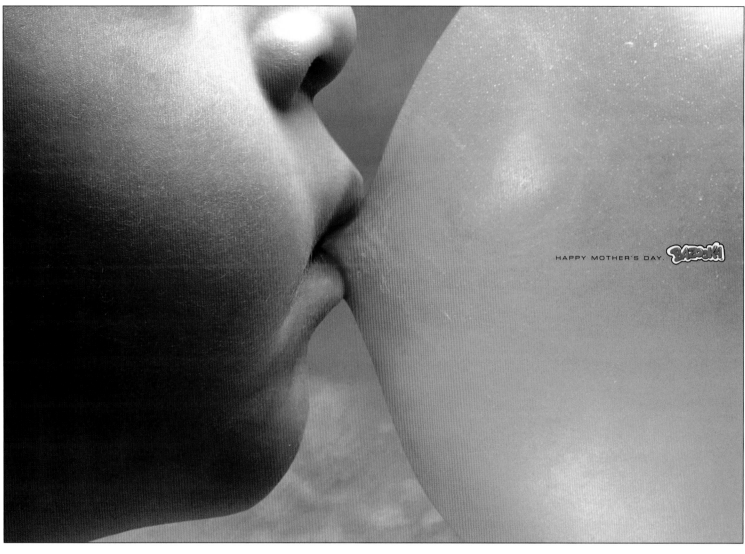

HAPPY MOTHER'S DAY. BAZOOKA

ARGENTINA

GOLD WORLD MEDAL, SINGLE
CRAVEROLANIS EURO RSCG
BUENOS AIRES

CLIENT Bazooka
GENERAL CREATIVE DIRECTOR Juan Cravero/Darío Lanis
COPYWRITERS Rodrigo Villarruel/Toto Marelli
ART DIRECTOR Toto Marelli/Rodrigo Villarruel
PHOTOGRAPHER Martín Kohler
ILLUSTRATOR Victor Bustos

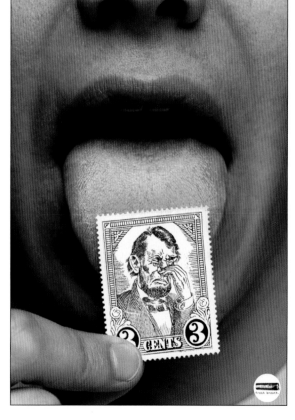

ARGENTINA
FINALIST, SINGLE
CRAVEROLANIS EURO RSCG
BUENOS AIRES

CLIENT Kissmint
GENERAL CREATIVE DIRECTOR Juan Cravero/
Darío Lanis
COPYWRITER Ariel Serkin
ART DIRECTOR Guadalupe González Arias
PHOTOGRAPHER Martín Kohler

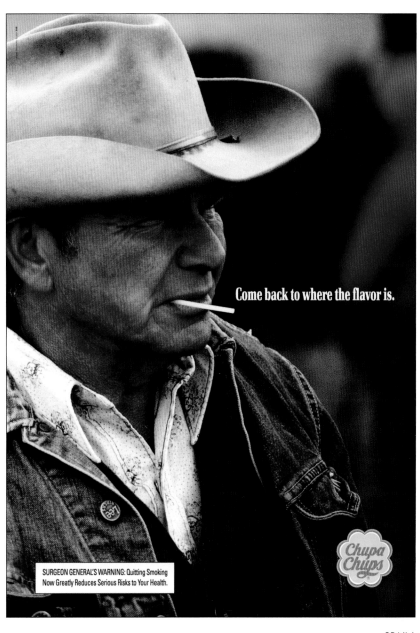

Come back to where the flavor is.

SURGEON GENERAL'S WARNING: Quitting Smoking Now Greatly Reduces Serious Risks to Your Health.

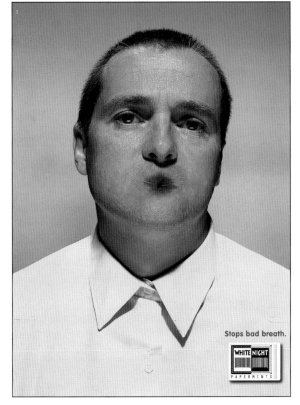

Stops bad breath.

SPAIN

BRONZE WORLD MEDAL, SINGLE
DDB ESPANA
MADRID

CLIENT Chupa Chups
CREATIVE DIRECTOR Mario Gascon
ART DIRECTOR Bernat Sanroma
COPYWRITER David Perez

BELGIUM

FINALIST, CAMPAIGN
DDB BRUSSELS
BRUSSELS

CLIENT White Night
CREATIVE DIRECTOR Dominique van Doormaal
COPYWRITER Virginie Lepère
ART DIRECTOR Fred Van Hoof/Sebastian Piacentini
CLIENT Jean-François Nève de Mévergnies
ACCOUNT DIRECTOR Yves Baudechon
CREATIVE PLANNING DIRECTOR Karen Corrigan
PHOTOGRAPHERS F. Uyttenhove/L. Scheers/C. Aschman
ART BUYER Gisèle Kuperman

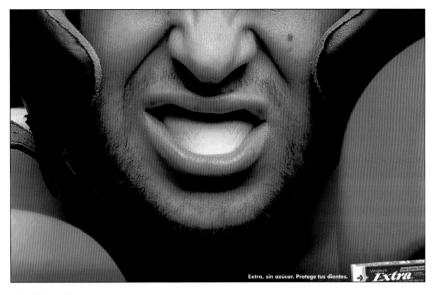

COSTA RICA

FINALIST, SINGLE

HARRISON COMMUNICATIONS COSTA RICA

SAN JOSÉ

CLIENT Wriggleys
CREATIVE DIRECTOR Byron Balmaceda
COPYWRITER Byron Balmaceda/Carolina Mena
ART DIRECTOR Gustavo Solìs
PHOTOGRAPHER Ricardo QuirÛs
TALENS Carlos Herrera

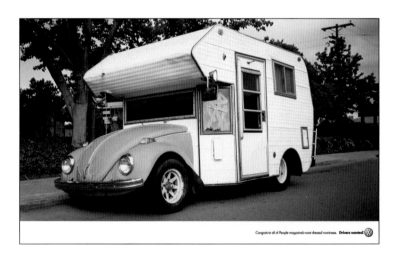

<div align="right">

ITALY

FINALIST, CAMPAIGN

J. WALTER THOMPSON ITALIA SPA

MILAN

CLIENT Kit Kat
EXECUTIVE CREATIVE DIRECTOR Pietro Maestri
COPYWRITER Alberto Citterio
ART DIRECTOR Marco Parisella
PHOTOGRAPHER Davide Bodini

</div>

CORPORATE IMAGE

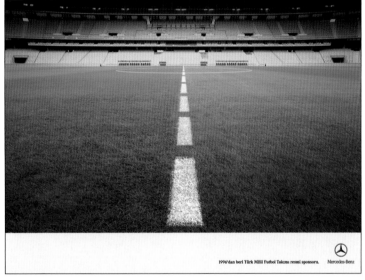

TURKEY

FINALIST, SINGLE

ALICE BBDO

ISTANBUL

CLIENT Mercedes-Benz
CREATIVE DIRECTOR Ozan Varisli
COPYWRITER Emrah Karpuzcu
ART DIRECTOR Davut Kose

<div align="right">

USA

FINALIST, SINGLE

ARNOLD WORLDWIDE

BOSTON, MA

CLIENT Volkswagen
ART DIRECTOR Adele Ellis
COPYWRITER Alex Russell
CHIEF CREATIVE OFFICER Ron Lawner
EXECUTIVE CREATIVE DIRECTOR Alan Pafenbach
PRODUCTION MANAGER John Gray
ART PRODUCER Andrea Ricker

</div>

PERU

SILVER WORLD MEDAL, SINGLE

YOUNG & RUBICAM

LIMA

CLIENT Repsol Gas GLP
CREATIVE DIRECTOR Francisco Torrico
ACCOUNT DIRECTOR Eduardo Grisolle
ART DIRECTOR Andres Ocampo
PRODUCER Leoni Lizarzaburu
REDACTOR Andres Ocampo

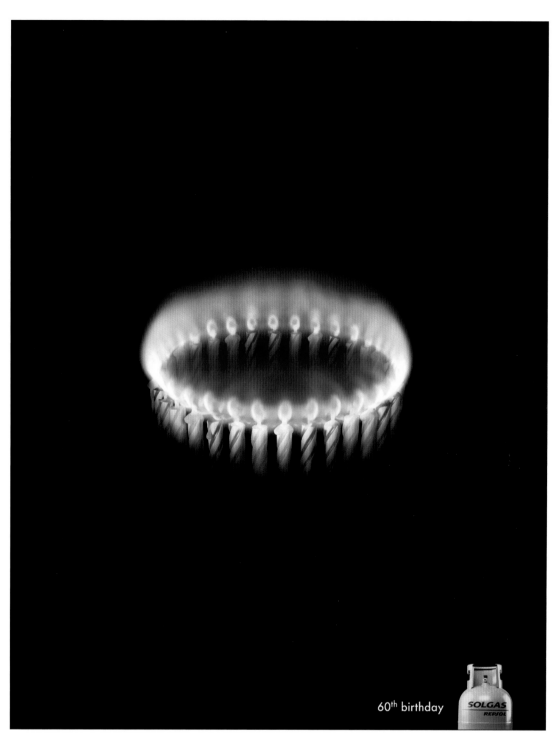

60th birthday

USA

FINALIST, SINGLE

ARNOLD WORLDWIDE

BOSTON, MA

CLIENT Volkswagen
ART DIRECTOR Julian Newman
COPYWRITER Alex Russell
CHIEF CREATIVE OFFICER Ron Lawner
EXECUTIVE CREATIVE DIRECTOR Alan Pafenbach
DESIGNER Julian Newman
PHOTOGRAPHER Craig Orsini
PRODUCTION MANAGER John Gray
ART PRODUCER Kathy McMann

Happy Easter

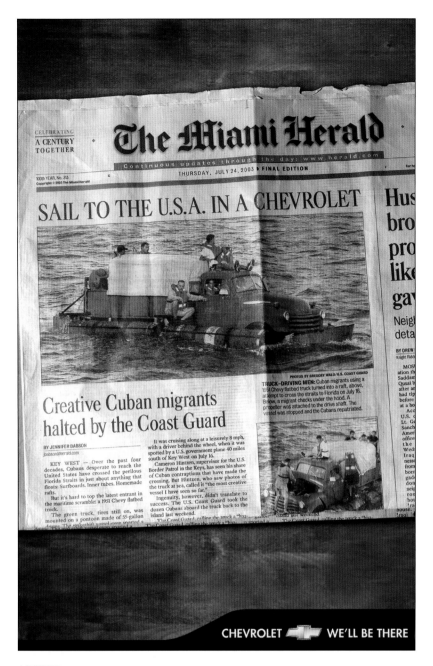

CROATIA
FINALIST, SINGLE
BRUKETA&ZINIC
ZAGREB

CLIENT Podravka
CREATIVE & ART DIRECTOR/DESIGNER
Davor Bruketa/Nikola Zinic
PHOTOGRAPHER Marin Topic/
Domagoj Kunic

MEXICO
BRONZE WORLD MEDAL, SINGLE
McANN ERICKSON MÉXICO
MÉXICO CITY

CLIENT Chevrolet
CREATIVE DIRECTOR Rodrigo Cortes

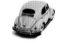

Thank you and goodnight.
After 55 years and over 21.5 million sold, the original Beetle bids us a fond farewell. **Drivers wanted.**

USA
FINALIST, SINGLE
ARNOLD WORLDWIDE
BOSTON, MA

CLIENT Volkswagen

UNITED ARAB EMIRATES
FINALIST, SINGLE
CLASSIC PARTNERSHIP ADVERTISING
DUBAI

CLIENT Berger
CREATIVE DIRECTOR John Mani/Vitthal Deshmukh
COPYWRITER John Mani
ART DIRECTOR Joby George
PHOTOGRAPHER Sunil Raju
ILLUSTRATOR Abhijit Vartak

UNITED ARAB EMIRATES
FINALIST, SINGLE
CLASSIC PARTNERSHIP ADVERTISING
DUBAI

CLIENT Home Centre
CREATIVE DIRECTOR John Mani/Vitthal Deshmukh
ART DIRECTOR Prasad Pradhan
COPYWRITER Vidya Manmohan
PHOTOGRAPHER Sunil Raju

BRAZIL
FINALIST, SINGLE
DPZ
SAO PAULO

CLIENT MAM
CREATIVE DIRECTOR Jose Zaragoza/Carlos Rocca
ART DIRECTOR Giuliano Cesar
COPYWRITER Carlos Schleder

BRAZIL
FINALIST, SINGLE
DPZ
SAO PAULO

CLIENT MAM
CREATIVE DIRECTOR Jose Zaragoza/Carlos Rocca
ART DIRECTOR Giuliano Cesar
COPYWRITER Carlos Schleder

FINALIST, SINGLE
DPZ PROPAGANDA
RIO DE JANEIRO

CLIENT Petrobras Petroleum
ART DIRECTOR Filipe Raposo/
Reuber Marchezini
COPYWRITER Rodrigo Strozenberg
CREATIVE DIRECTOR Luiz Vieira
PHOTOGRAPHER Platinum Studio

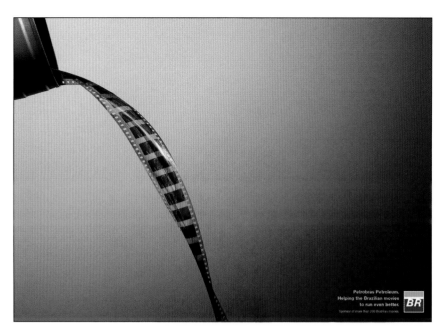

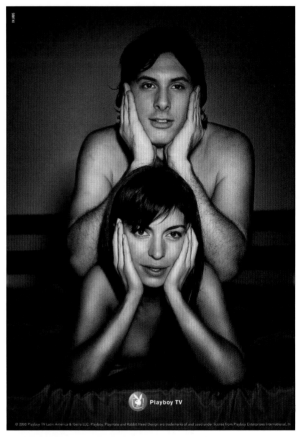

ARGENTINA

FINALIST, SINGLE
IN JAUS
BUENOS AIRES

CLIENT Playboy TV
GENERAL CREATIVE DIRECTOR Gabriel Sagel
CREATIVE DIRECTOR Esteban Pigni
ART DIRECTOR Juan Manuel Montero
COPYWRITER Diego Medvedocky

BELGIUM

FINALIST, SINGLE
LEO BURNETT BRUSSELS
BRUSSELS

CLIENT Leo Burnett
CREATIVE DIRECTOR André Rysman
COPYWRITER Gregory Ginterdaele
ART DIRECTOR Marie-Laure Cliquennois
MANAGING DIRECTOR Stéphane Buisseret

oLe urBttne si mvogni ot laPce gyFale

(everything will be in place for Oct. 21, promised)

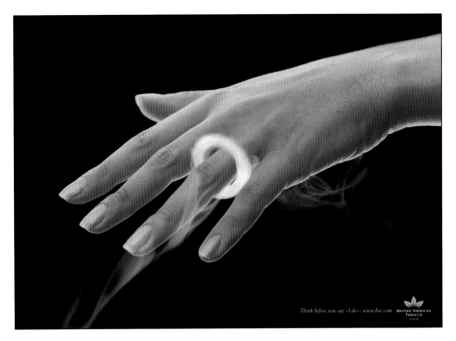

SWITZERLAND

FINALIST, SINGLE

LESCH & FREI WERBEAGENTUR AG
ZURICH

CLIENT British American Tobacco
CREATIVE DIRECTOR Thomas Lueber
ART DIRECTOR Nicolas Vontobel
COPYWRITER Barbara Hutter
PHOTOGRAPHER Franz Rindlisbacher
ACCOUNT EXECUTIVE Eveline Stocker

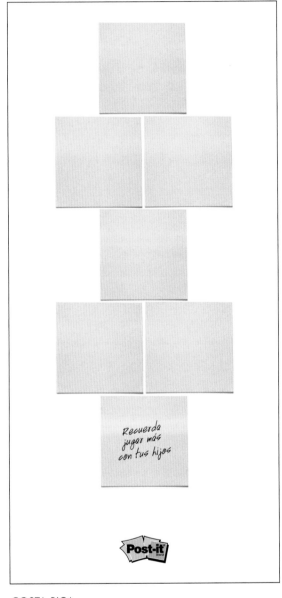

COSTA RICA

FINALIST, SINGLE

McCANN ERICKSON COSTA RICA
SAN PEDRO

CLIENT Post-It
CREATIVE VP Ignacio Gómez
CREATIVE DIRECTOR Alan Carmona
ART DIRECTOR Ronny Villalobos
ACCOUNT EXECUTIVE Viviana Batalla

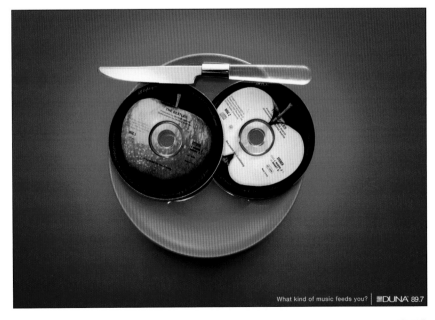

CHILE

FINALIST, SINGLE

LOWE PORTA S.A.
SANTIAGO

CLIENT Radio Duna
CREATIVE DIRECTOR Pablo Gallardo/Kiko Carcavilla
COPYWRITER Pablo Gallardo
ART DIRECTOR Cadillac/Mariano Perez

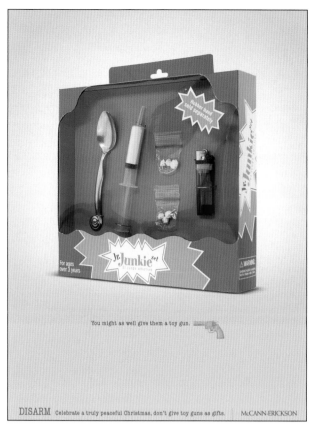

USA

FINALIST, SINGLE
McCANN-ERICKSON P.R.
GUAYNABO, PR

CLIENT Self-Promotion
ART DIRECTOR Jason Seda
COPYWRITER Ricardo Martì

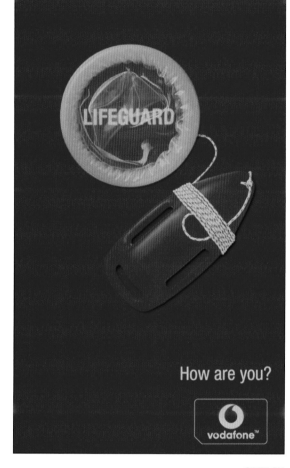

GREECE

FINALIST, SINGLE
SPOT THOMPSON TOTAL COM. GROUP S.A.
MAROUSSI

CLIENT Social Ad
VICE PRESIDENT/EXECUTIVE CREATIVE DIRECTOR
Takis Liarmakopoulos
CREATIVE DIRECTOR Kostas Niotis
COPYWRITER Christine Kopana
ART DIRECTOR Anthi Tsouvala
GENERAL MANAGER Dimitris Kordas
CLIENT SERVICE DIRECTOR Leonidas Spanos
ACCOUNT DIRECTOR Christine Sarri

TAIWAN

FINALIST, SINGLE
OGILVY & MATHER ADVERTISING
TAIWAN
TAIPEI

CLIENT Kotex
EXECUTIVE CREATIVE DIRECTOR Murphy Chou
CREATIVE DIRECTOR Murphy Chou

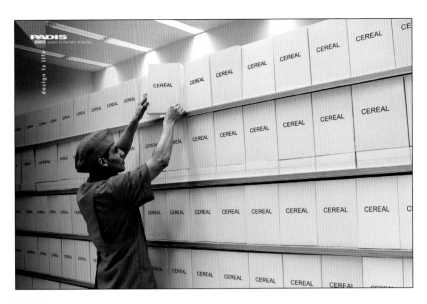

PERU

FINALIST, SINGLE

PRAGMA DDB

LIMA

CLIENT Toulouse Lautrec
CREATIVE DIRECTOR José Rázuri
COPYWRITER Javier Graña
ART DIRECTOR Piero Oliveri
PHOTOGRAPHER Silvia Rosas

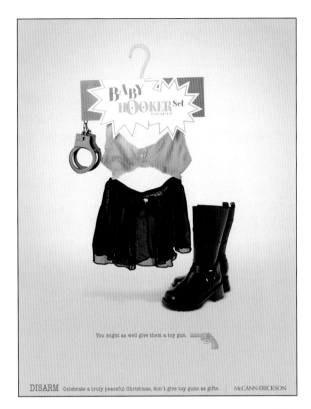

USA

FINALIST, SINGLE

McCANN-ERICKSON P.R.

GUAYNABO, PR

CLIENT Self-Promotion
ART DIRECTOR Jason Seda
COPYWRITER Ricardo Martì

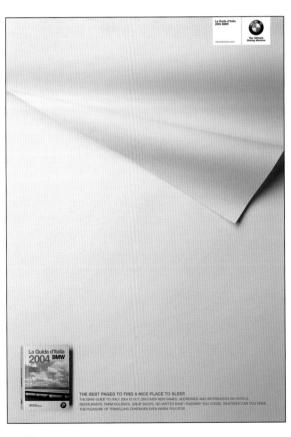

ITALY

FINALIST, CAMPAIGN

D'ADDA, LORENZINI, VIGORELLI, BBDO

MILAN

CLIENT BMW
CREATIVE DIRECTOR Vicky Gitto
ART DIRECTOR Serena di Bruno
COPYWRITER Vicky Gitto
PHOTOGRAPHER Roberto Pirchio

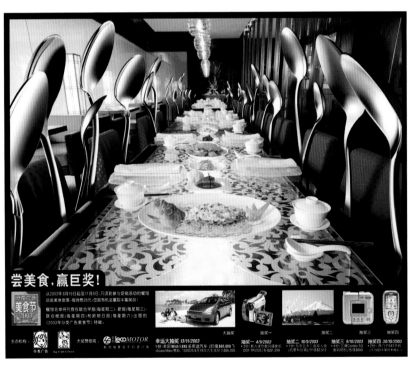

SINGAPORE

FINALIST, CAMPAIGN

SINGAPORE PRESS HOLDINGS LIMITED

SINGAPORE

CLIENT Lianhe Zaobao Classified Food Festival 2003
ASSOCIATE CREATIVE DIRECTOR Suherman Ismail
ART DIRECTOR Anthony Lam
COPYWRITER Puay Sze
PHOTOGRAPHER Sebastian Siah

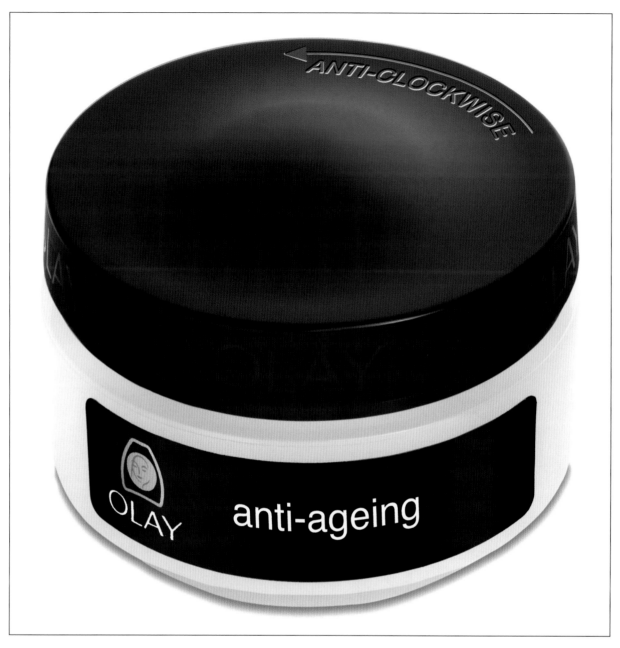

SPAN

GOLD WORLD MEDAL, SINGLE

SAATCHI & SAATCHI
MADRID

CLIENT **Olay Procter & Gamble**
EXECUTIVE CREATIVE DIRECTOR **Carlos Anuncibay**
ART DIRECTOR **Vicente Navarro**
COPYWRITERS **P. Conde/A. Uscola/C. Pacheco**
ACCOUNT DIRECTOR **Liana Poggi**
PRODUCERS **Javier Fernández/Marga Escribano**
PHOTOGRAPHER **Carlos Yebra**
FINISHING TOUCHES PHOTOGRAPHIC **Rober García**

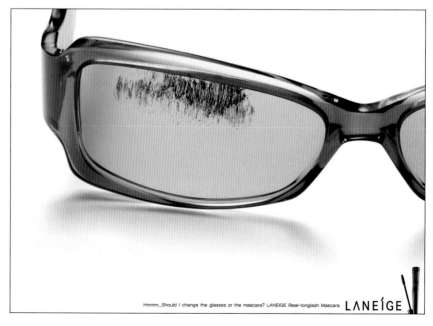

Hmmm...Should I change the glasses or the mascara? LANEIGE Real-longlash Mascara LANEÍGE

KOREA

FINALIST, SINGLE

BBDO KOREA
SEOUL

CLIENT **Laneige**
CREATIVE DIRECTOR **JinSang Park**
COPYWRITER **Sohee Lim**
ART DIRECTOR **JinWhan Go**

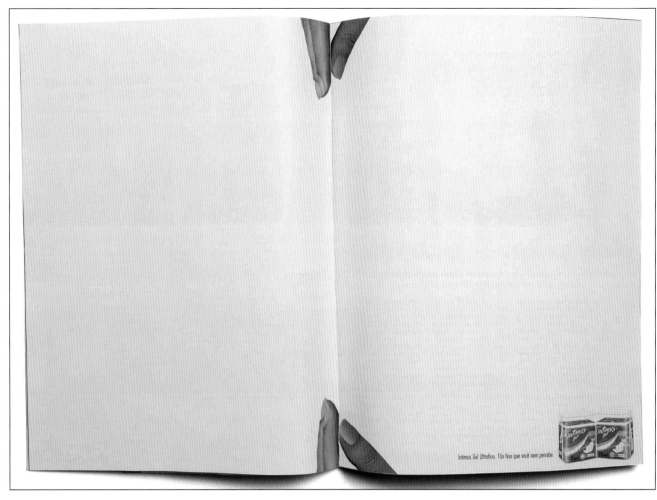

BRAZIL
SILVER WORLD MEDAL, SINGLE
OGILVY BRASIL
SÃO PAULO

CLIENT **Intimus Days Ultraslim**
CREATIVE DIRECTOR **Danilo Janjacomo/**
Ana Clélia Quarto
COPYWRITER **Leandro Lourenção**
ART DIRECTOR **Mariana Valladares**
CREATIVE DIRECTOR **Adriana Cury**
PHOTOGRAPHER **Rafael Assef**

CHILE

FINALIST, SINGLE
IDB/FCB S.A.
SANDIAGO

CLIENT **Dento**
EXECUTIVE CREATIVE DIRECTOR **Rodrigo Gómez**
CREATIVE DIRECTOR **Cristián Vásquez**
ART DIRECTOR **Aliro Jara**
COPYWRITER **Laura Charpantier**

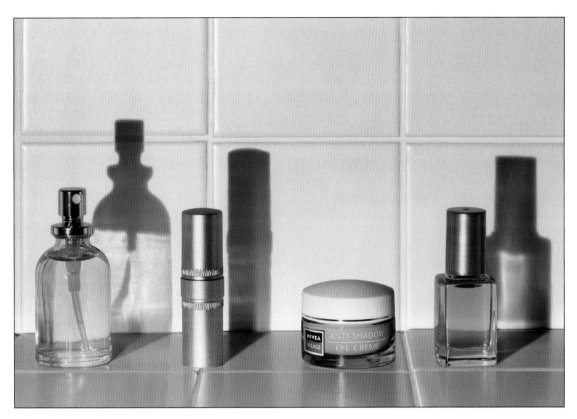

GERMANY

BRONZE WORLD MEDAL, SINGLE
TBWA
BERLIN

CLIENT Nivea Visage Anti Shadow Eye
CREATIVE DIRECTOR Gerti Eisele
ART DIRECTOR Susanne Maschauer
COPYWRITER Susen Gehle
CREATIVE DIRECTOR Manu Salewski
ACCOUNT Christiane Doss
MARKETING DIRECTOR Ralph Gusko
RETOUCHING Helmut Gass

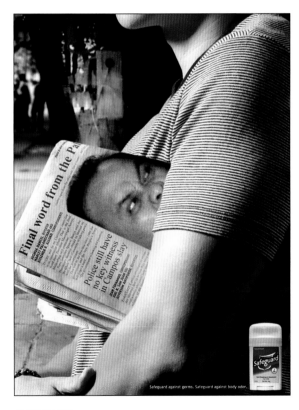

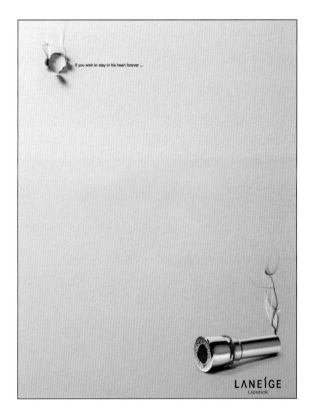

If you wish to stay in his heart forever ...

LANEÍGE
Lipstick

KOREA

FINALIST, SINGLE
BBDO KOREA
SEOUL

CLIENT Laneige
CREATIVE DIRECTOR JunChul Chung
COPYWRITER HyunKyoon Kim
ART DIRECTOR YoungPyo Lee

PHILIPPINES

FINALIST, SINGLE
ACE SAATCHI AND SAATCHI
MAKATI CITY

CLIENT Safeguard Deodorant
EXECUTIVE CREATIVE DIRECTOR Merlee C. Jayme
CREATIVE DIRECTOR Dino Ocampo
ART DIRECTOR Connie Lazaro

SPAIN

FINALIST, SINGLE

J. WALTER THOMPSON BARCELONA
BARCELONA

CLIENT Lubriderm Moisturising
CREATIVE EXECUTIVE DIRECTOR Àlex Martinez
CREATIVE DIRECTOR Jaime Chávarri
ART DIRECTOR Carles Puig

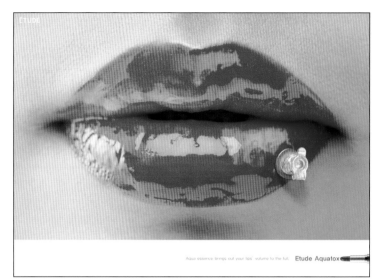

KOREA

FINALIST, SINGLE

BBDO KOREA
SEOUL

CLIENT Aquatox
CREATIVE DIRECTOR JinSang Park
COPYWRITER SoHee Lim
ART DIRECTOR JinWhan Go

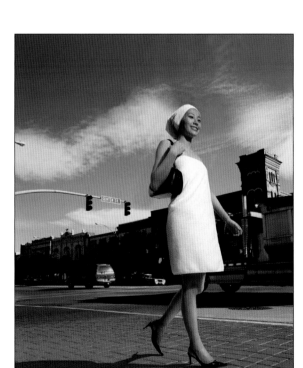

TAIWAN

FINALIST, SINGLE

OGILVY & MATHER ADVERTISING TAIWAN
TAIPEI

CLIENT Kotex Shower Fresh
EXECUTIVE CREATIVE DIRECTOR Murphy Chou
CREATIVE DIRECTOR Sean Liang
ART DIRECTOR Lean Sun
COPYWRITER Popo Wu

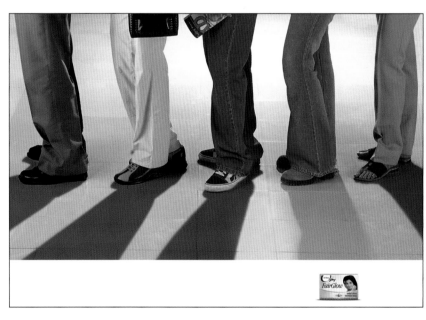

INDIA

FINALIST, SINGLE

MUDRA COMMUNICATIONS PVT. LTD.
NEW DELHI, DELHI

CLIENT Fair Glow Soap
COPYWRITER Kapil Dhawan
ART DIRECTOR Arnab Chatterjee
PHOTOGRAPHER Ashish Chawla

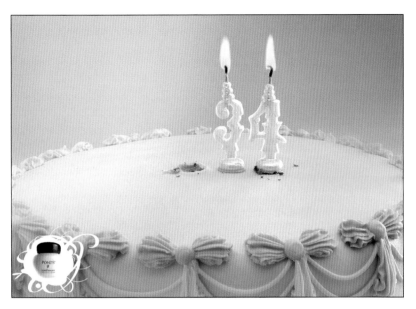

ARGENTINA

FINALIST, SINGLE

OGILVY & MATHER ARGENTINA
BUENOS AIRES

CLIENT Ponds

GENERAL CREATIVE DIRECTOR Gustavo Reyes

CREATIVE DIRECTOR Campopiano/Aregger/Duhalde/Sanchez Correa

ART DIRECTOR Maximiliano Sanchez Correa

COPYWRITER Johanna Kassir

GENERAL ART DIRECTOR Maximiliano Sanchez Correa

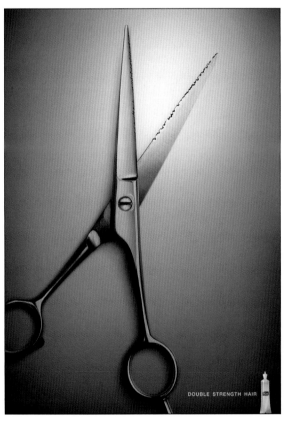

Nature takes care of your mouth

Kin Nature
Take care of your mouth naturally.

SPAIN

FINALIST, SINGLE

TBWA\ESPAÑA
BARCELONA

CLIENT Kin Nature

DOUBLE STRENGTH HAIR

SINGAPORE

FINALIST, SINGLE

T AND T ADVERTISING
SINGAPORE

CLIENT VO5 Hot Oil

ASSOCIATE CREATIVE DIRECTOR Khor Tuck Kuan

ART DIRECTOR Johnny Leung

COPYWRITER Tommy Chua

DIGITAL IMAGING Rhapsodi Digital Art

PHOTOGRAPHER Raymond Lee

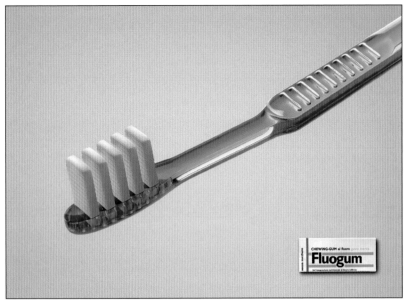

ITALY

FINALIST, SINGLE
RED CELL SPA
MILAN

CLIENT Fluogum
CREATIVE DIRECTOR Pino Rozzi/
Roberto Battaglia
ART DIRECTOR Bert Rosenbrand
COPYWRITER Rossella Conti
PHOTOGRAPHER Luca Perazzoli

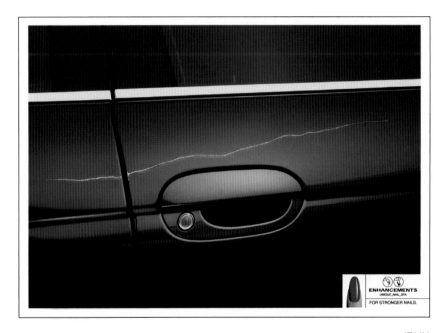

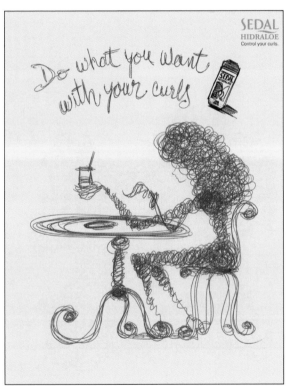

ITALY

FINALIST, CAMPAIGN
McCANN-ERICKSON S.P.A
MILAN

CLIENT Enhancements
CREATIVE DIRECTOR Dario Neglia
ART DIRECTOR Gaetano del Pizzo
COPYWRITER Francesca Pagliarini
PHOTOGRAPHER Lorenzo Scolari

ARGENTINA

FINALIST, CAMPAIGN
J. WALTER THOMPSON
BUENOS AIRES

CLIENT Unilever/Sedal Hidraloe
EXECUTIVE CREATIVE DIRECTOR Leandro Raposo/Pablo Stricker
ART DIRECTOR Ariel Abadi
COPYWRITER Sebastian Magariños
ACCOUNT DIRECTOR Carol Rappazzo

CHINA

SILVER WORLD MEDAL, CAMPAIGN
EURO RSCG
GREAT OCEAN SHANGHAI BRANCH
SHANGHAI

CLIENT Maestro Hair Gel
EXECUTIVE CREATIVE DIRECTOR/ COPYWRITER Fred Tong
ASSISTANT CREATIVE DIRECTOR Terence Yuen
ART DIRECTOR Rongrong Liu
COPYWRITER Hong Xu
DESIGNER Yiding Xie

ART NOT AVAILABLE

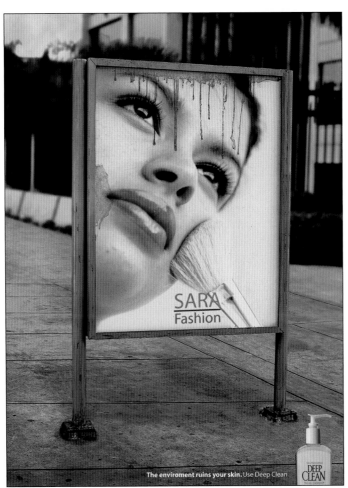

PERU

FINALIST, CAMPAIGN
McCANN-ERICKSON PERU
LIMA

CLIENT Deep Clean
ASSOCIATE CREATIVE DIRECTOR Ricardo Mares/
Alejandro Cortes
ART DIRECTOR Jose Luis Delgado
COPYWRITER Alejandro Cortes
ACCOUNT DIRECTOR Kathiana Castillo
AGENCY PRODUCER Julieta Kropivka
PHOTOGRAPHER Bernardo Aja

CRAFTS/HOBBIES

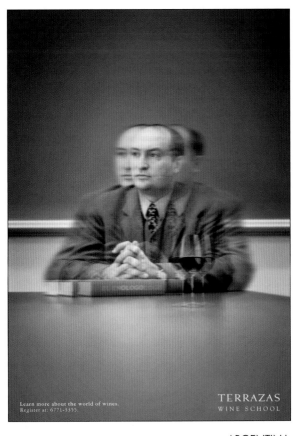

ARGENTINA

FINALIST, SINGLE
GRAFFITI D ARCY
BUENOS AIRES

CLIENT Terrazas de los Andes
CREATIVE DIRECTOR Fernando Tchechenistky
ART DIRECTOR Alejandro Marzullo
COPYWRITER Claudio Fasciotti
GROUP ACCOUNT DIRECTOR Nicolás Díaz
ACCOUNT DIRECTOR Ana Castilla

DOT.COM

BRAZIL

FINALIST, SINGLE
EUGENIODDB
SÃO PAULO

CLIENT Super iG
CREATIVE DIRECTOR Marcos Pamplona/Marcelo Romko
COPYWRITERS Marcelo Romko/André Pessoa
ART DIRECTOR Pedro Pletitsch

www.radiodos.com

RADIO 2
99.5 FM

COSTA RICA
SILVER WORLD MEDAL, SINGLE
TRIBU/NAZCA SAATCH & SAATCHI
SAN JOSÉ

CLIENT Radio Dos
CREATIVE DIRECTOR Javier Mora
DESIGNER Andrei Bonilla
ART DIRECTOR Andrei Bonilla
ACCOUNT EXECUTIVE Julieta Bonilla
PHOTOGRAPHER Alex Zúñiga

.Heineken®.com

COLOMBIA
BRONZE WORLD MEDAL, SINGLE
McCANN-ERICKSON COLOMBIA
BOGOTA

CLIENT Heineken
VP CREATIVE Camilo Pradilla
ART DIRECTOR Jaime Duque
COPYWRITER Victor Osorio

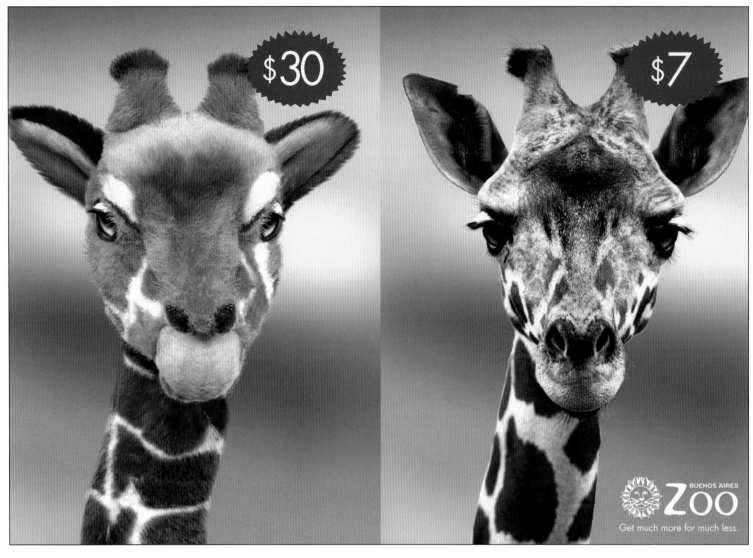

ARGENTINA

GOLD WORLD MEDAL, SINGLE

DEL CAMPO NAZCA SAATCHI & SAATCHI
BUENOS AIRES

CLIENT Buenos Aires Zoo
CREATIVE DIRECTOR Chavo D´Emilio/Chanel Basualdo
ART DIRECTOR Iñaki G. del Solar/Daniel Fierro
COPYWRITER Mariano Serkin
ACCOUNT DIRECTOR Pablo Ordoñez
AGENCY PRODUCER Cosme Argerich
PHOTOGRAPHER Julieta García Vazquez
ADVERTISER'S SUPERVISOR Fernando Chaín

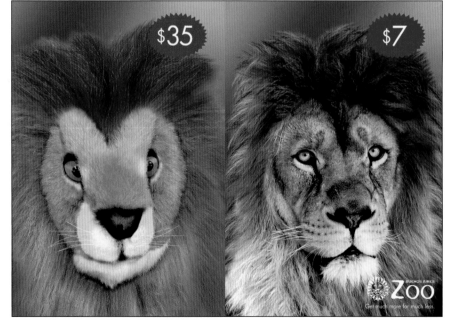

ARGENTINA

FINALIST, SINGLE

DEL CAMPO NAZCA SAATCHI & SAATCHI
BUENOS AIRES

CLIENT Buenos Aires Zoo
CREATIVE DIRECTOR Chavo D´Emilio/Chanel Basualdo
ART DIRECTOR Iñaki G. del Solar/Daniel Fierro
COPYWRITER Mariano Serkin
ACCOUNT DIRECTOR Pablo Ordoñez
AGENCY PRODUCER Cosme Argerich
PHOTOGRAPHER Julieta García Vazquez
ADVERTISER'S SUPERVISOR Fernando Chaín

SWITZERLAND

SILVER WORLD MEDAL, SINGLE

JUNG VON MATT AG
ZURICH

CLIENT Imagine/Terre Des Hommes
CREATIVE DIRECTOR Alexander Jaggy/Urs Schrepfer
ART DIRECTOR Michael Rottmann
COPYWRITER Alexander Jaggy
GRAPHIC DESIGN Stefanie Ledermann
ACCOUNT MANAGER David Schärer/Martin Schmitt
PRODUCTION Marco Giardina
CLIENT MANAGER Michèle Hürner

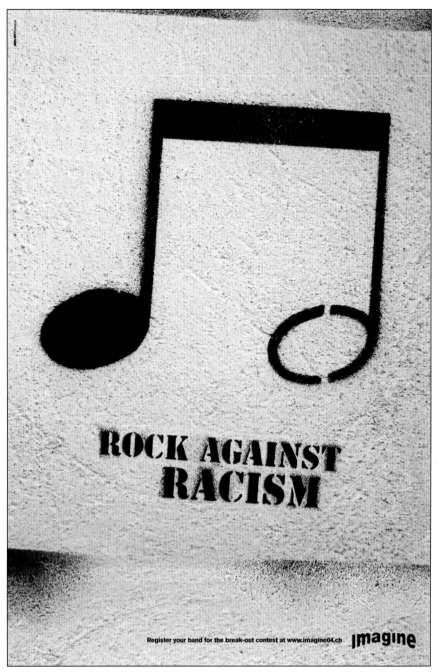

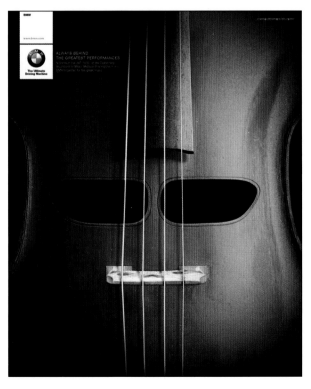

ITALY

FINALIST, SINGLE

D'ADDA, LORENZINI, VIGORELLI, BBDO
MILAN

CLIENT BMW
CREATIVE DIRECTOR Vicky Gitto
ART DIRECTOR Pier Giuseppe Gonni
COPYWRITER Bruno Vohwinkel

CANADA

FINALIST, SINGLE

FOOTE CONE & BELDING
TORONTO
TORONTO, ONTARIO

CLIENT Food Network

GROUP CREATIVE DIRECTOR
Rick Pregent

ART DIRECTOR Annie Lee/
Niall Kelly

EXECUTIVE V.P., CREATIVE DIRECTOR
Robin Heisey

VICE PRESIDENT/BUSINESS DIRECTOR
Sunil Sekhar

AUSTRIA

FINALIST, SINGLE

FCB KOBZA
ADVERTISING AGENCY
VIENNA

CLIENT
Wiener Volksbildungswerk

CREATIVE DIRECTOR
Christian Wurzer

COPYWRITER Goran Golik/
Patrik Partl

GRAPHIC Goran Golik/
Sophie Matysek

CANADA

FINALIST, SINGLE

JWT TORONTO
TORONTO, ONTARIO

CLIENT Fashion Week Wrap Party

CREATIVE DIRECTOR Martin Shewchuk/Brett Channer

WRITER Jason Buback

ART DIRECTOR Judy Townson

SWITZERLAND

FINALIST, SINGLE

MATTER & PARTNER AG FÜR KOMMUNIKATION
ZURICH

CLIENT Zurich Openair Theatre Spectacular

CREATIVE DIRECTOR Philipp Skrabal/Daniel Matter

COPYWRITER Michael Kathe

ART DIRECTOR Philipp Skrabal

PHOTOGRAPHER Nicolas Monkewitz

TYPOGRAPHER Ondrej Maczko

ACCOUNT SUPERVISOR Anita Haberthür/Isabel Baer

ADVERTISER'S SUPERVISOR Gabi Wettstein

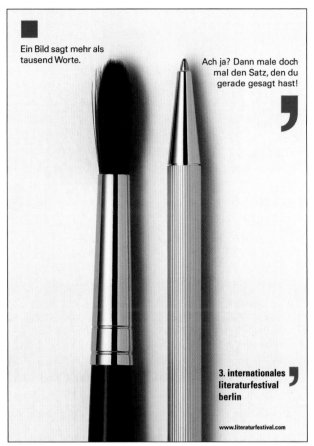

GERMANY

FINALIST, SINGLE
TBWA
BERLIN

CLIENT 3rd International Festival Of Literature
CREATIVE DIRECTOR Kurt Georg Dieckert/Stefan Schmidt
ART DIRECTOR Stefan Schmidt
COPYWRITER Stefan Schmidt
DESIGNER Christine Taylor
GRAPHIK Diane Bergmann
PRODUCTION MANAGER Ulrich Schreiber

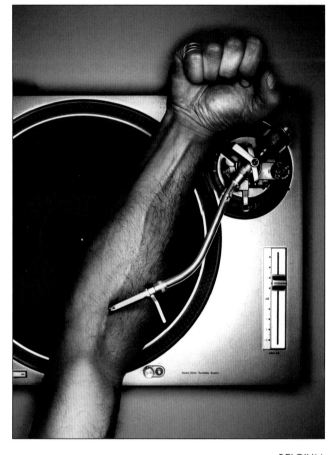

BELGIUM

FINALIST, SINGLE
OGILVY & MATHER
BRUSSELS

CLIENT PIAS
CREATIVE DIRECTOR Phil Van Duynen
COPY/ACCOUNT DIRECTOR Barbara Vangheluwe
PHOTOGRAPHER Christoph Gilbert
ART DIRECTOR Phil Van Duynen

SPAIN

FINALIST, SINGLE
TBWA\ESPAÑA
BARCELONA

CLIENT X Fina World Championships
CREATIVE DIRECTOR R. Sala/J. Sebastià/J. Teixidó
COPYWRITER Ramón Sala
ART DIRECTOR Jordi Sebastià

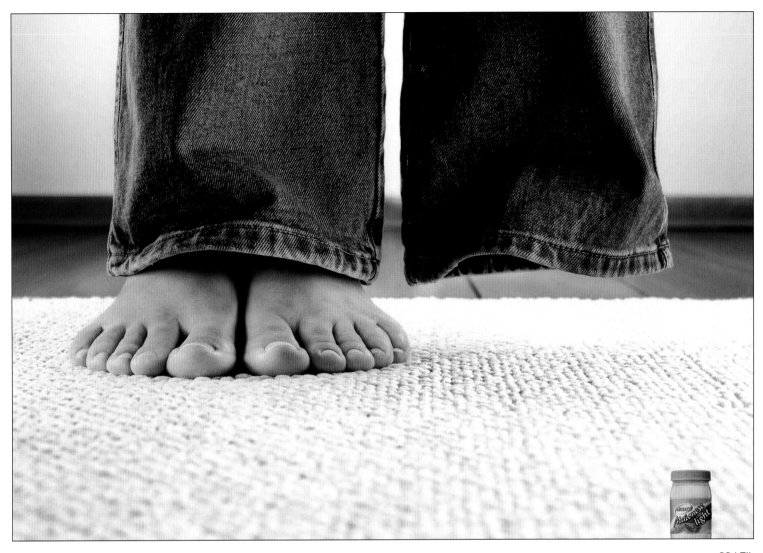

GOLD WORLD MEDAL, SINGLE

OGILVY BRASIL
SÃO PAULO

CLIENT **Arisco Lite Mayonnaise**
CREATIVE DIRECTOR **Virgilio Neves/Manir Fadel**
COPYWRITER **Luciana Cardoso**
ART DIRECTOR **Marcelo Vaccari**
CREATIVE DIRECTOR **Adriana Cury**
PHOTOGRAPHER **Richard Kohout**

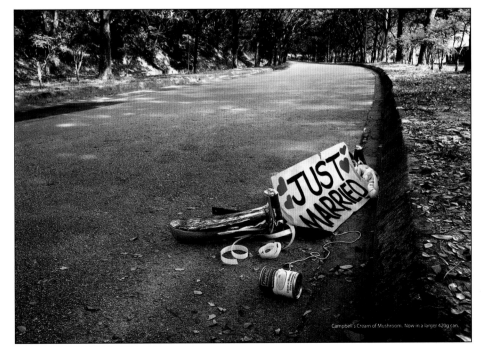

MALAYSIA

FINALIST, SINGLE

DENTSU YOUNG & RUBICAM SDN BHD
KUALA LUMPUR

CLIENT **Campbell Southeast Asia Sdn Bhd/
Campbells Mushroom Soup**
CREATIVE DIRECTOR **Gavin Simpson**
COPYWRITER **May Yong**
ART DIRECTOR **Angie Sim/Gavin Simpson**
PHOTOGRAPHER **Thomas Chiang of Character Studio**

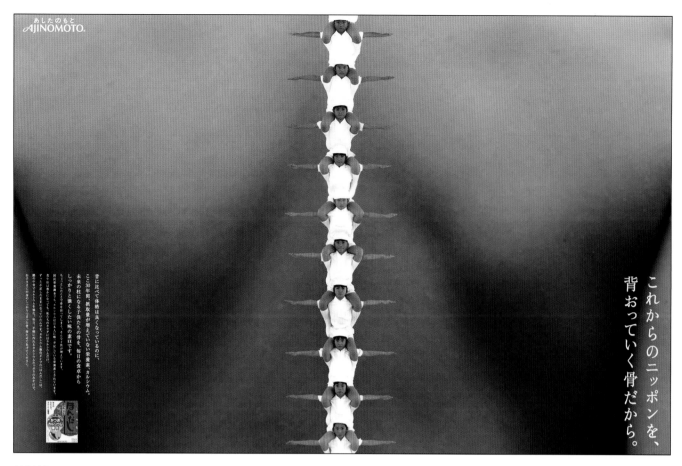

AJINOMOTO.
あしたのもと

これからのニッポンを、
背おっていく骨だから。

昔に比べて体格は良くなっているのに、
ここ30年間、摂取量が増えていない栄養素、カルシウム。
未来の柱になる子供たちの骨を、毎日の食卓から
しっかりと強くしたい味の素の願いです。

JAPAN

SILVER WORLD MEDAL, SINGLE
DENTSU INC.
TOKYO

CLIENT Seasoning With Calcium Additive
CREATIVE DIRECTOR Kenichi Yatani/Taihei Okura
COPYWRITER Hiroyuki Hara/Hideki Ichihara
ART DIRECTOR Taihei Okura/Akira Shikiya/Takayuki Murano
AGENCY PRODUCER Yoji Fujii/Takashi Miyano
DESIGNER Yoshiyuki Fujikawa/Masato Iida/
Takashi Yasunaga/Naoyuki Matakawa
ACCOUNT EXECUTIVE Kazuo Miike

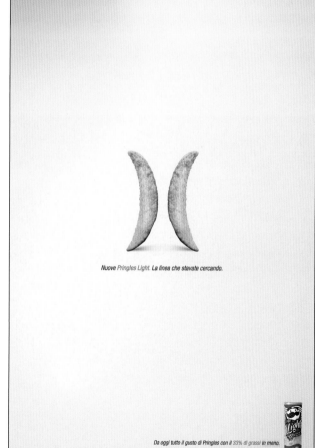

Nuove Pringles Light. La linea che stavate cercando.

Da oggi tutto il gusto di Pringles con il 33% di grassi in meno.

ITALY

FINALIST, SINGLE
GREY WORLDWIDE ITALIA
MILANO

CLIENT Pringles Light
EXECUTIVE CREATIVE DIRECTOR Antonio Maccario
CREATIVE DIRECTOR V. Gasbarro/F. Ghiso
COPYWRITER Federico Ghiso
ART DIRECTOR Massimo Francesconi

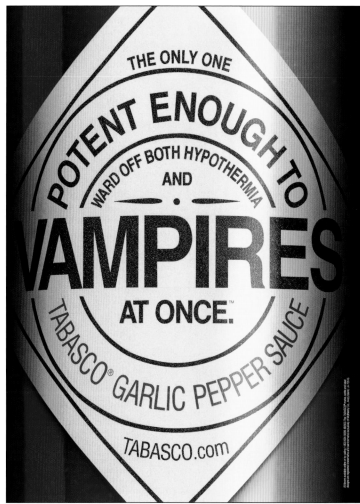

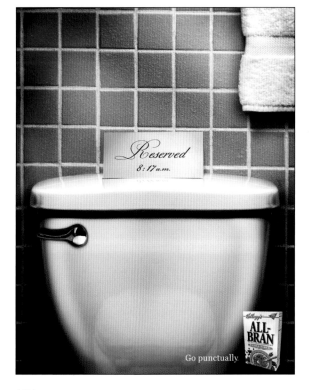

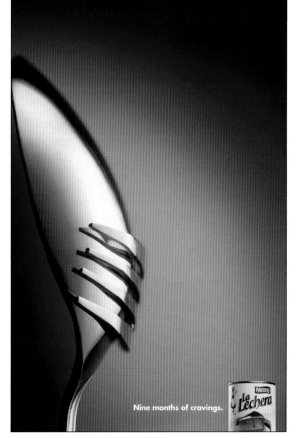

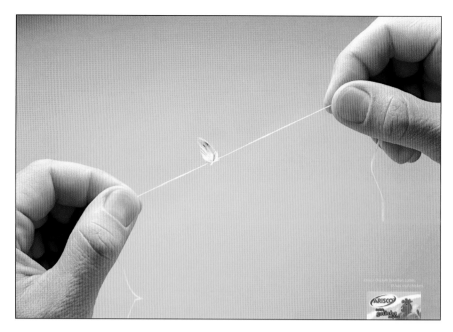

BRAZIL

FINALIST, SINGLE

OGILVY BRASIL
SÃO PAULO

CLIENT Arisco Chicken Bouillon Cubes
CREATIVE DIRECTOR Danilo Janjacomo/
Ana Clélia Quarto
COPYWRITER Ricardo Ribeiro
ART DIRECTOR Eric Sulzer
CREATIVE DIRECTOR Adriana Cury
PHOTOGRAPHER Fábio Bataglia

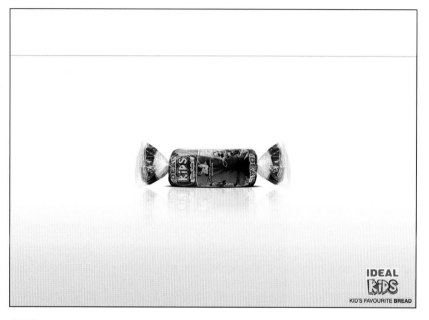

CHILE

FINALIST, SINGLE

McCANN-ERICKSON S.A. DE PUBLICIDAD
SANTIAGO

CLIENT Ideal
GENERAL CREATIVE DIRECTOR Guido Puch
COPYWRITER Miguel Alvarez
ART DIRECTOR Pepeta
ACCOUNT DIRECTOR Samuel Abarca

BRAZIL

FINALIST, SINGLE

OGILVY BRASIL
SÃO PAULO

CLIENT Arisco Onion Puree
CREATIVE DIRECTOR Adriana Cury
COPYWRITER Cristiane Parede
ART DIRECTOR Claudia Bortolotti/
Adriana Guimarães
CREATIVE DIRECTOR Virgilio Neves
PHOTOGRAPHER André Brandão

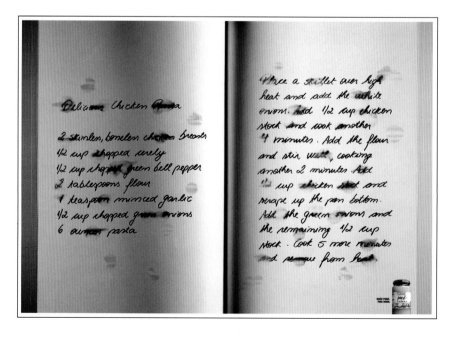

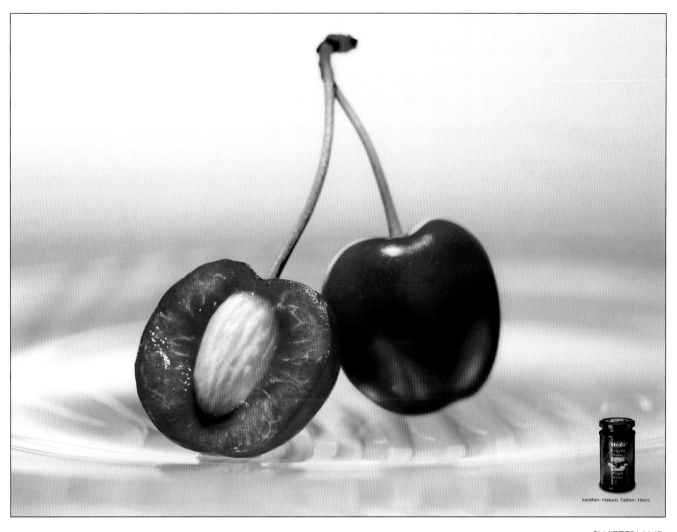

Mother: Nature. Father: Hero.

SWITZERLAND

MATTER & PARTNER AG FÜR KOMMUNIKATION

ZÜRICH

CLIENT Hero Jam
CREATIVE DIRECTOR Daniel Matter/Philipp Skrabal
COPYWRITER Michael Kathe
ART DIRECTOR Sascha Fanetti
PHOTOGRAPHER Patrick Rohner
TYPOGRAPHER Marcel Jäger
ACCOUNT SUPERVISOR Vanessa Rubinick
ADVERTISER'S SUPERVISOR Philipp Dous

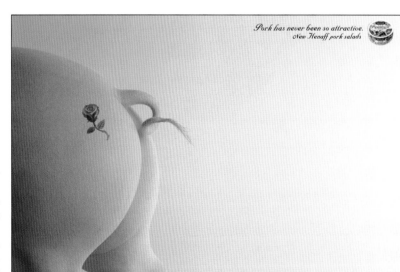

Pork has never been so attractive.
New Hénaff pork salads

FRANCE

FINALIST, CAMPAIGN

BDDP & FILS

BOULOGNE-BILLANCOURT

CLIENT Hénaff
CREATIVE DIRECTOR Olivier Altmann
ART DIRECTOR Laurent Duvoux/Eric Thomé
COPYWRITER Laurent Duvoux/Eric Thomé
PHOTOGRAPHER Renaud Loisy
ART BUYER Sylvie Etchemaïté

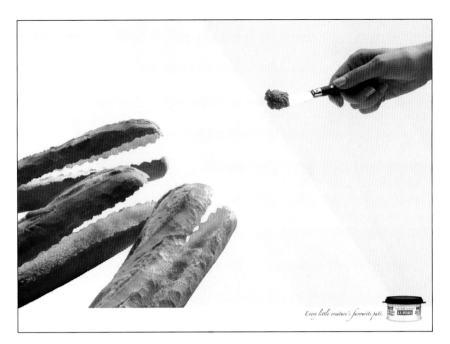

SPAIN

FINALIST, SINGLE
VOLTEA
BARCELONA

CLIENT La Piara
CREATIVE DIRECTOR Manel Rodrigo
ART DIRECTOR Josep Manel Sicart
PHOTOGRAPHER Enric Climent
PLANNER Angel Vila/Angel Pardo

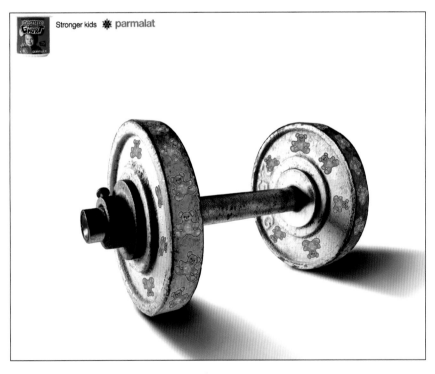

CHILE

FINALIST, SINGLE
ZEGERS DDB
SANTIAGO

CLIENT Parmalat/Mamiferoghurt
CREATIVE DIRECTOR Rodrigo Duarte
COPYWRITER Rodrigo Duarte
ART DIRECTOR Jaime Millán
ACCOUNT EXECUTIVE Viviana Ahumada
PHOTOGRAPHY Studio Eseis
PHOTOGRAPHER Hugo Contreras
AGENCY PRODUCER Lorena Tapia

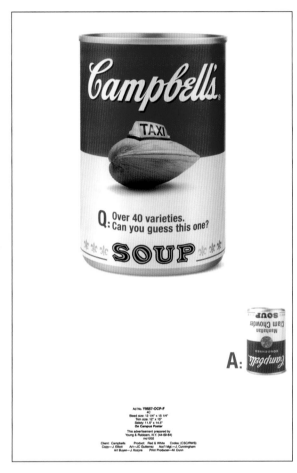

USA

FINALIST, SINGLE
YOUNG & RUBICAM NEW YORK
NEW YORK, NY

CLIENT Campbell Soup Company
CREATIVE DIRECTOR James Caporimo/Bob Potesky
ART DIRECTOR Juan Carlos Gutierrez Zorrilla
COPYWRITER Jared Elliott
ILLUSTRATOR Simon Alicea
PHOTOGRAPHER Dennis Blachut

Two year old Patricia Puia sat on her mother's lap, unable to hear the gentle voice that tried to comfort her. Deaf from birth, her life in Romania was lived in silence. But a month after undergoing cochlear implant surgery at Mount Sinai, the silence was filled

MOUNT
SINAI

with the sounds of a world Patricia never knew existed. "I feel like I've just given birth to this child for the second time," her mother said tearfully. "But this time she hears." 1-800-MD-SINAI • www.mountsinai.org
Another day, another breakthrough.

WE TURNED

A CHILD WHO COULDN'T HEAR INTO A TYPICAL 2 YEAR OLD WHO DOESN'T LISTEN.

USA

GOLD WORLD MEDAL, SINGLE
DEVITO/VERDI
NEW YORK, NY

CLIENT Mount Sinai Medical Center
COPYWRITER Wayne Winfield
ART DIRECTOR Brad Emmett/Jim Wood
CREATIVE DIRECTOR Sal DeVito
PRESIDENT Ellis Verdi
VP OF PROGRAM DEVELOPMENT Marianne Coughlin

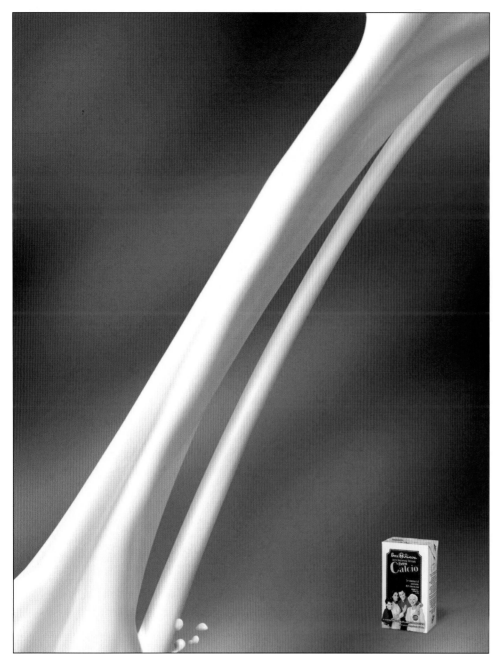

COSTA RICA

SILVER WORLD MEDAL, SINGLE

GARNIER BBDO
SAN JOSÉ

CLIENT Dos Pinos
HEAD OF CREATIVE Mauricio Garnier
CREATIVE DIRECTOR Rodrigo Lobo
ART DIRECTOR Rodrigo Fallas

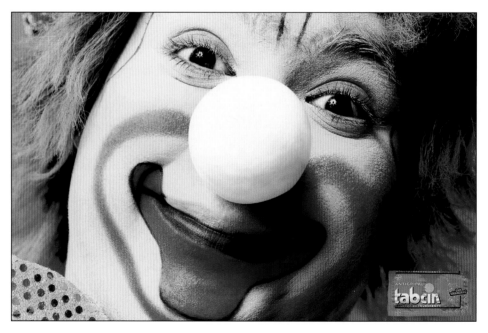

COSTA RICA

FINALIST, SINGLE

GARNIER BBDO
SAN JOSÉ

CLIENT Bayer
HEAD OF CREATIVE Mauricio Garnier
ART DIRECTOR Guiselle Camacho
CREATIVE José Andrés Antillón
DESIGNER Marvin Leiva

PERU

BRONZE WORLD MEDAL, SINGLE

MAYO/FCB
LIMA

CLIENT Ginseng Tea
CREATIVE DIRECTOR Miguel Leon
COPYWRITER Daniel Stewart
ART DIRECTOR Gustavo San Cristobal
ILLUSTRATOR Marco Chocare
PHOTOGRAPHER Javier Ferrand

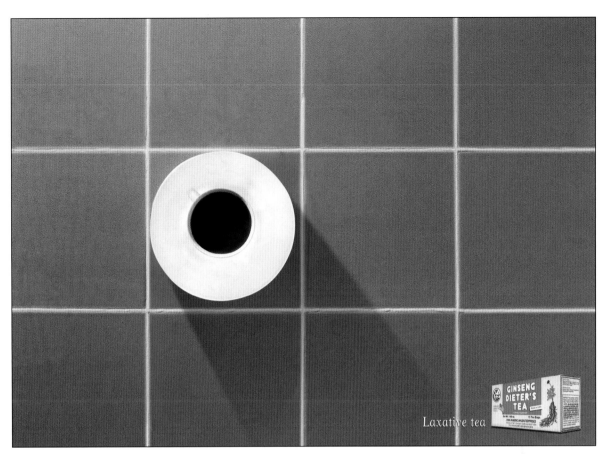

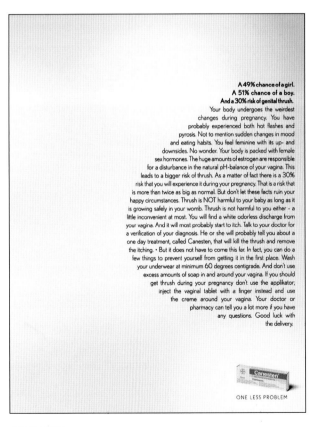

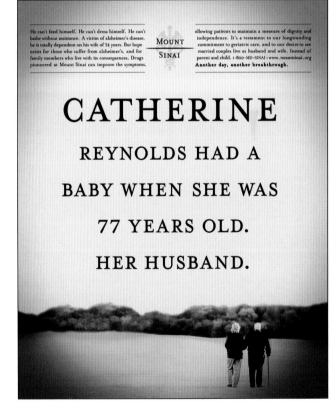

DENMARK

FINALIST, SINGLE

BBDO DENMARK
COPENHAGEN

CLIENT Canesten
COPYWRITER Jesper Hansen
ART DIRECTOR Ulrik Michelsen
ACCOUNT EXECUTIVE Camilla Mahncke
CLIENT Pia Olesen

USA

FINALIST, SINGLE

DEVITO/VERDI
NEW YORK, NY

CLIENT Mount Sinai Medical Center
COPYWRITER Wayne Winfield
ART DIRECTOR Brad Emmett/Jim Wood
CREATIVE DIRECTOR Sal DeVito
PRESIDENT Ellis Verdi
VP OF PROGRAM DEVELOPMENT Marianne Coughlin

SPAIN

FINALIST, SINGLE

J. WALTER THOMPSON BARCELONA
BARCELONA

CLIENT **Rovi Suppositories**
EXECUTIVE CREATIVE DIRECTOR **Àlex Martinez**
CREATIVE DIRECTOR **Enric Fortea**
ART DIRECTOR **Marc Cardona**
PHOTOGRAHER **Marc Cardona**

PORTUGAL

FINALIST, SINGLE

J. WALTER THOMPSON PUBLICIDADE
MIRAFLORES

CLIENT **Listerine**
CREATIVE DIRECTOR **João Espírito Santo**
ART DIRECTOR **Jorge Barrote**
COPYWRITER **Gabriela Hunnicutt**
TYPOGRAPHER **Irene Bandeira**
PHOTOGRAPHER **Francisco Prata (Picto)**
ACCOUNT DIRECTOR **Susana Fernandes**

GERMANY

FINALIST, SINGLE

M.E.C.H. McCANN-ERICKSON
COMMUNICATIONS HOUSE BERLIN
BERLIN

CLIENT **Slim Fast Germany**
EXECUTIVE CREATIVE DIRECTOR **Torsten Rieken**
ACCOUNT DIRECTOR **Katja Metz**
ART DIRECTOR **Alice Rzepka**
COPYWRITER **Marcel Linden**
ART ASSISTANT **Tina Koehler**
PHOTOGRAPHER **Stefan Boekels**

GERMANY

FINALIST, SINGLE

M.E.C.H. McCANN-ERICKSON
COMMUNICATIONS HOUSE BERLIN
BERLIN

CLIENT **Ohropax GmbH**
EXECUTIVE CREATIVE DIRECTOR **Torsten Rieken**
CREATIVE DIRECTOR **Britta Poetzsch**
ART DIRECTOR **Gen Sadakane**
COPYWRITER **Anja Godzinski**
ACCOUNT DIRECTOR **Christiane Thilo**
PHOTOGRAPHER **Stefan Deckner**

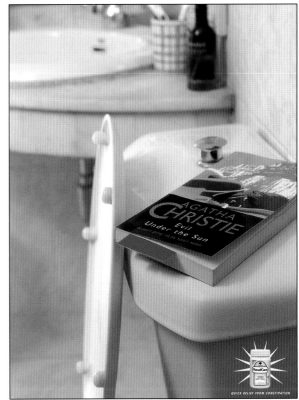

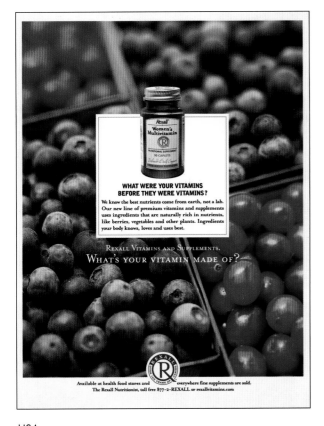

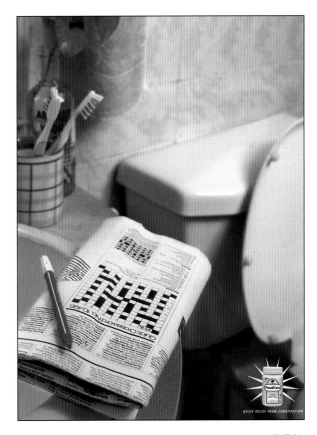

HOME ENTERTAINMENT

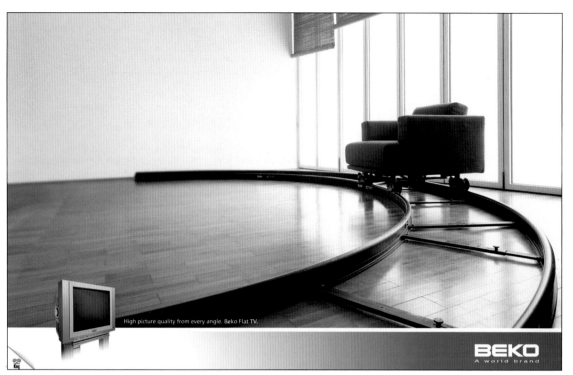

High picture quality from every angle. Beko Flat TV.

TURKEY

BRONZE WORLD MEDAL, SINGLE

TBWA\ISTANBUL
ISTANBUL

CLIENT Beko Flat TV
CREATIVE DIRECTOR Derya Tambay
ART DIRECTOR Mustafa Baripoglu
COPYWRITER Derya Tambay
PHOTOGRAPHER Suleyman Kacar
BRAND GROUP DIRECTOR Ahmet Akin
BRAND MANAGER Rahsan Tuncel
CLIENT SUPERVISOR Ahmet Nuri Oz
AGENCY TV PRODUCER Dilek Aygun/
A. Umut Tangor
BRAND EXECUTIVE Berk Guven
GRAPHIC STUDIO DIRECTOR Hakan Tahan
GRAPHIC DESIGNER Kaan Tanman

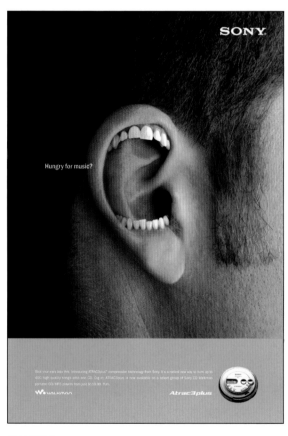

Hungry for music?

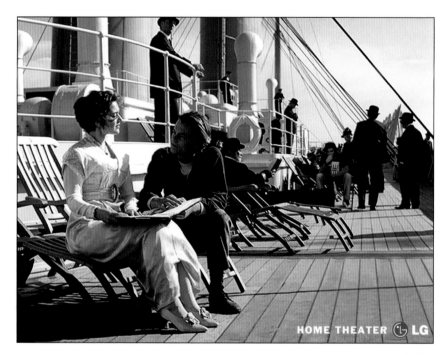

CANADA

FINALIST, SINGLE

DUE NORTH COMMUNICATIONS
TORONTO, ONTARIO

CLIENT Sony Canada
CREATIVE DIRECTOR Karen Howe
ART DIRECTOR Carson Ting
WRITER Dan Zimerman
PHOTOGRAPHER Shin Sugino

CHILE

FINALIST, SINGLE

LOWE PORTA S.A.
SANTIAGO

CLIENT LG
CREATIVE DIRECTOR Kiko Carcavilla
ART DIRECTOR Rene Moraga
COPYWRITER Raul Vidal
ILLUSTRATOR Rene Moraga

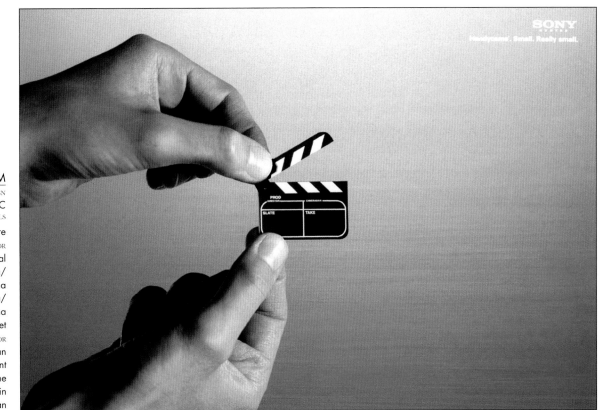

Handycams. Small. Really small.

BELGIUM

SILVER WORLD MEDAL, CAMPAIGN

MPRC

BRUSSELS

CLIENT **Sony Centre**

CREATIVE DIRECTOR

Dominique Van Doormaal

ART DIRECTOR **Gregory Titeca/**
Mohamed Oudaha

COPYWRITER **Gregory Titeca/**
Mohamed Oudaha

ADVERTISING MANAGER **Steven De Smet**

CREATIVE PLANNING DIRECTOR

Karen Corrigan

ACCOUNT DIRECTOR **Yves Van Lent**

PHOTOGRAPHER **Gregor Collienne**

IMAGE MANIPULATOR **Wilfrid Morin**

ART BUYER **Gisele Kuperman**

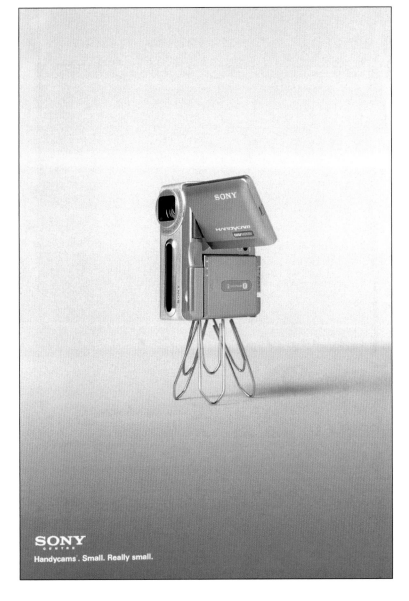

SONY
CENTRE

Handycams. Small. Really small.

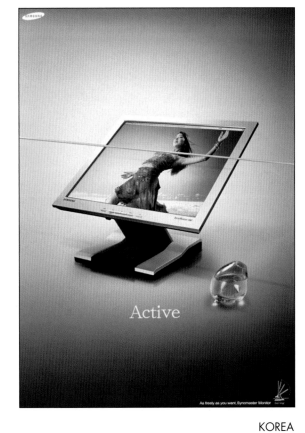

Active

As freely as you want. Syncmaster Monitor

KOREA

FINALIST, CAMPAIGN

CHEIL COMMUNICATIONS INC.

SEOUL

CLIENT **Samsung Syncmaster**

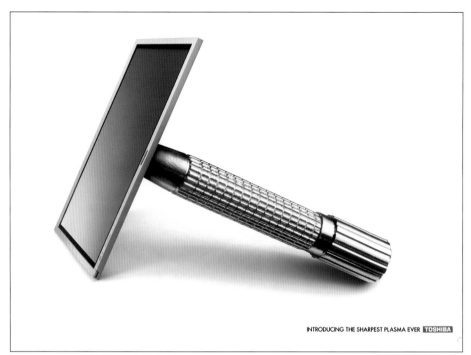

INTRODUCING THE SHARPEST PLASMA EVER TOSHIBA

ISRAEL
BRONZE WORLD MEDAL, CAMPAIGN

SHALMOR AVNON AMICHAY/Y&R
TEL AVIV

CLIENT Toshiba
CHIEF CREATIVE OFFICER Gideon Amichay
CREATIVE DIRECTOR Asi Shavit
ART DIRECTOR Zeev Ravid
COPYWRITER Dudy Hevron
PHOTOGRAPHER Yoram Aschheim
ACCOUNT SUPERVISOR Ilana Monka Goldshtain
ADVERTISER'S SUPERVISOR Keren Yemini

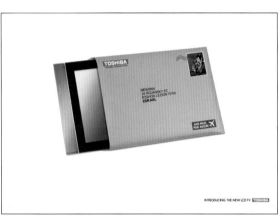

INTRODUCING THE NEW LCD TV TOSHIBA

HOUSEHOLD APPLIANCES/FURNISHINGS

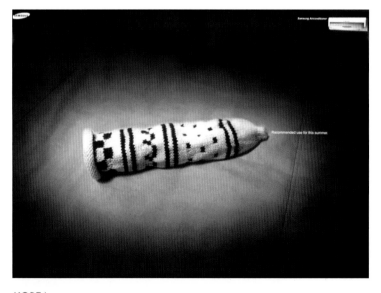

Recommended use for this summer.

KOREA
FINALIST, SINGLE

CHEIL COMMUNICATIONS INC.
SEOUL

CLIENT Samsung AirConditioner

AKIRA
air conditioners

MALAYSIA
FINALIST, SINGLE

BOZELL WORLDWIDE
PETALING JAYA, SELANGOR

CLIENT Akira Air Conditioners
CREATIVE DIRECTOR Dharma Somasundram
COPYWRITER Dharma Somasundram
ART DIRECTOR Mag's Lim/Lam Wai Cheong
VISUALISER Norman Khek
PHOTOGRAPHER Mak Kah Heng

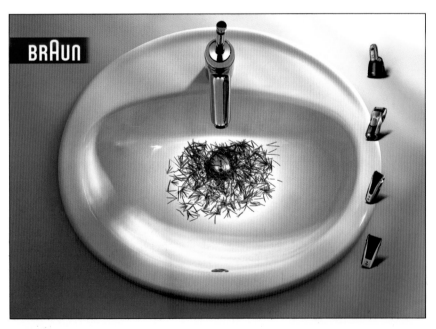

INDIA

FINALIST, SINGLE

MUDRA COMMUNICATIONS PRIVATE LIMITED
BANGALORE, KARNATAKA

CLIENT Duroflex
CREATIVE DIRECTOR Pavi Krishnan
PHOTOGRAPHER D. Radhakrishnan
EXECUTIVE VICE PRESIDENT - SOUTH S. Radhakrishnan
EXECUTIVE BRAND COMMUNICATIONS M. G. Raghavendra

KOREA

FINALIST, CAMPAIGN

McCANN-ERICKSON KOREA
SEOUL

CLIENT Natural Floor
EXECUTIVE CREATIVE DIRECTOR Jino Oh
CREATIVE DIRECTOR YC Kim
COPYWRITER Ji-Eun Kang

TURKEY

FINALIST, SINGLE

OGILVY& MATHER ISTANBUL
ISTANBUL

CLIENT Braun
CREATIVE DIRECTOR Tibet Sanliman
COPYWRITER Ergin Binyildiz
ART DIRECTOR Burcin Tortop
ACCOUNT DIRECTOR Zeynep Demirkol

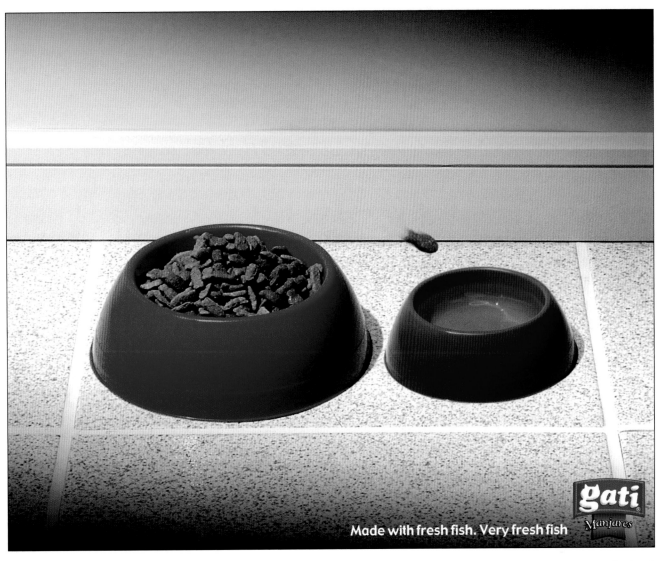

Made with fresh fish. Very fresh fish

gati
Manjares

CHILE

GOLD WORLD MEDAL, SINGLE
McCANN-ERICKSON S.A. DE PUBLICIDAD
SANTIAGO

CLIENT Nestlé/Gati
CREATIVE DIRECTOR Juan Pablo Riesco
COPYWRITER Cristián León
ART DIRECTOR Eduardo Molina
ACCOUNT DIRECTOR Joyce Kahn

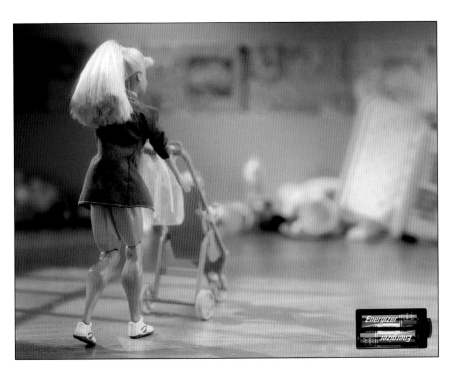

COLOMBIA

FINALIST, SINGLE
DDB COLOMBIA
MEDELLIN, ANTIOQUIA

CLIENT Everyready Of
Colombia/Energizere
CREATIVE DIRECTOR Herbert Quiceno
CREATIVE Carlos Oviedo/Edgar Vergara

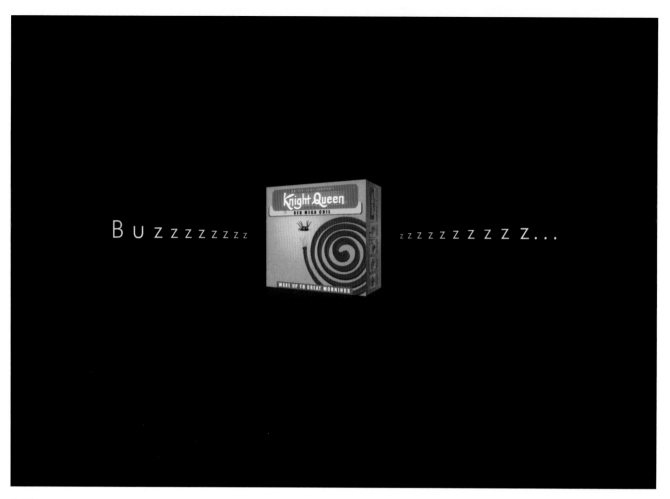

BUZZZZZZZz zzzZZZZZZZ...

INDIA

SILVER WORLD MEDAL, SINGLE
BATES INDIA PRIVATE LIMITED
NEW DELHI

CLIENT Knight Queen
COPYWRITER Vishal Chemjong
ART DIRECTOR Ashish Rehi
CREATIVE DIRECTOR Radharani Mitra

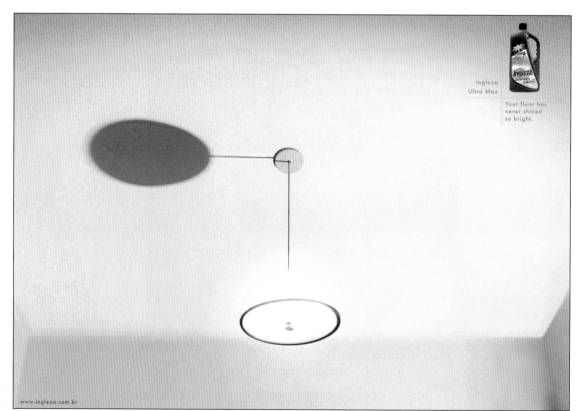

BRAZIL

BRONZE WORLD MEDAL, SINGLE
SMPB COMUNICAÇÃO
BELO HORIZONTE

CLIENT Uau UltraMax

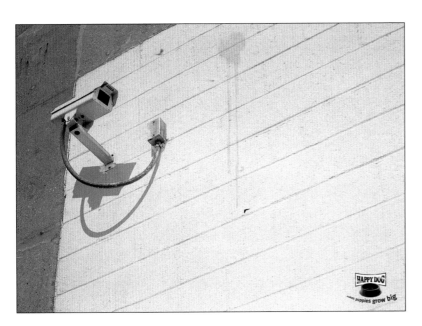

GERMANY

FINALIST, SINGLE

McCANN-ERICKSON FRANKFURT/
M., GERMANY
FRANKFURT

CLIENT Interquell GmbH (Happy Dog)
CREATIVE DIRECTOR Erich Reuter
ART DIRECTOR Suzanne Förch
ACCOUNT MANAGER Ramona Stumpf

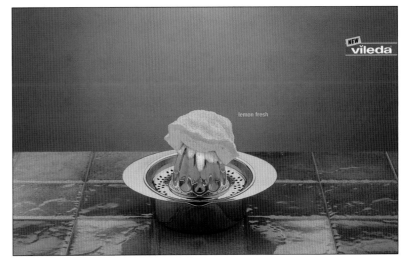

SLOVENIA

FINALIST, SINGLE

MEDIAMIX
MARIBOR

CLIENT Vileda
CREATIVE DIRECTOR Toni Tomasek
ART DIRECTOR Nenad Cizl
DESIGNER Vlado Trifkovic
PHOTOGRAPHER Andrej Cvetnic

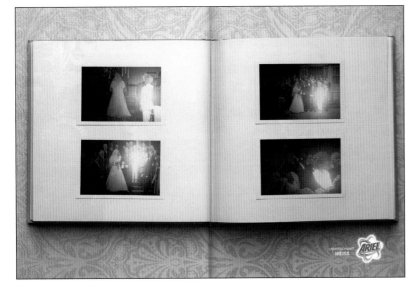

GERMANY

FINALIST, SINGLE

SAATCHI & SAATCHI GMBH
FRANKFURT

CLIENT Ariel Non-Color
ART DIRECTOR Sibylle Seifert
COPYWRITER Stephan Dietrich
CREATIVE DIRECTOR Eberhard Kirchhoff
ACCOUNT EXECUTIVE Li Jessica Lorenz
MARKETING DIRECTOR P&G Ariel Matthias Becker
PHOTOGRAPHER Thomas Balzer
ART BUYING Julia Kallmeyer

USA

FINALIST, SINGLE
J WALTER THOMPSON PUERTO RICO
SAN JUAN, PR

CLIENT Energizer
CREATIVE DIRECTOR Jaime Rosado
ART DIRECTOR Javier Claudio

ART NOT AVAILABLE

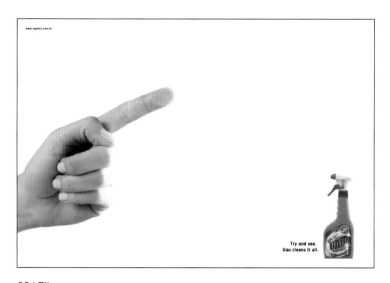

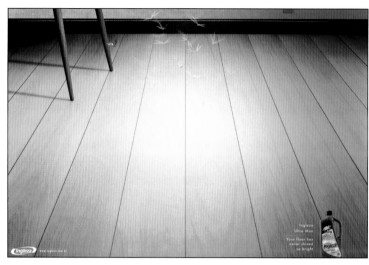

BRAZIL

FINALIST, SINGLE

SMPB COMUNICAÇÃO
BELO HORIZONTE

CLIENT Uau Ingleza
CREATIVE DIRECTOR Augusto Coelho
ART DIRECTOR Rení Bionor
COPYWRITER Flávio Chubes Faria
PHOTOGRAPHER Fernando Martins

BRAZIL

FINALIST, SINGLE

SMPB COMUNICAÇÃO
BELO HORIZONTE

CLIENT Uau Ultramax
CREATIVE DIRECTOR Augusto Coelho
ART DIRECTOR Waldemar França
COPYWRITER Augusto Coelho
PHOTOGRAPHER Fernando Martins

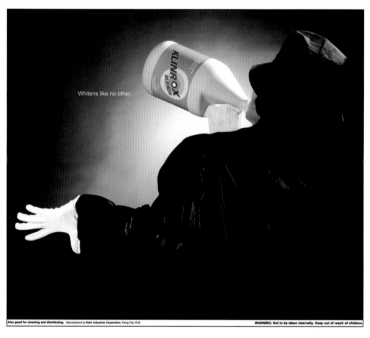

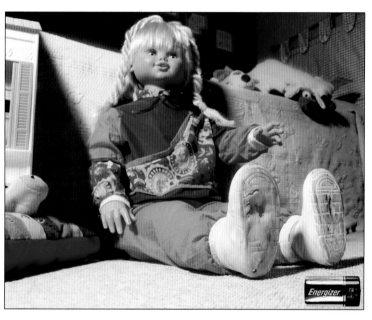

PHILIPPINES

FINALIST, SINGLE

TBWA\SANTIAGO MANGADA PUNO
MAKATI

CLIENT Klinrox
CREATIVE DIRECTOR Melvin M. Mangada
COPYWRITER Tanke Tankeko
ART DIRECTOR Louie Cale
PHOTOGRAPHER Jeanne Young
PRINT PRODUCER May Dalisay

CHILE

FINALIST, SINGLE

ZEGERS DDB
SANTIAGO

CLIENT Energizer/Eveready
CREATIVE DIRECTOR Victor Mora
CREATIVE DIRECTOR/COPYWRITER Rodrigo Duarte
ART DIRECTOR Victor Mora
ACCOUNT EXECUTIVE Carmen Gloria Vasquez
PHOTOGRAPHY STUDIO Eseis
PHOTOGRAPHER Hugo Contreras
ILLUSTRATOR José Carrasco
AGENCY PRODUCER Lorena Tapia

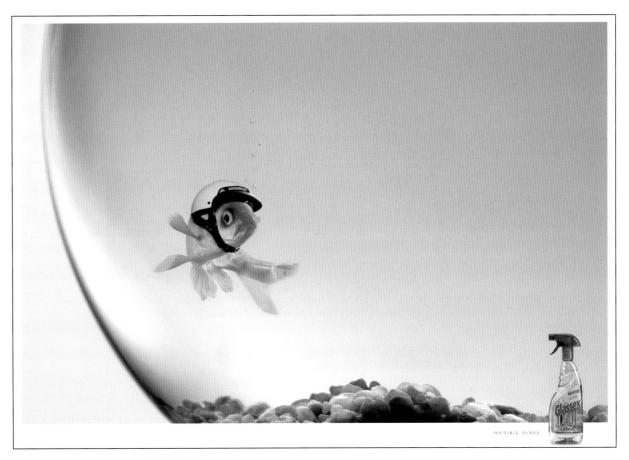

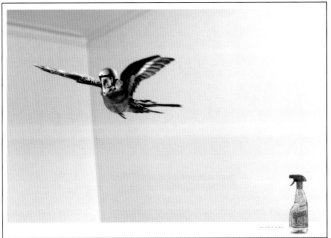

SPAIN

SILVER WORLD MEDAL, CAMPAIGN
J. WALTER THOMPSON BARCELONA
BARCELONA

CLIENT Glassex Cleaner Glass
EXECUTIVE CREATIVE DIRECTOR Àlex Martinez
CREATIVE DIRECTOR Jaime Chávarri
ART DIRECTOR Napi Rivera
PHOTOGRAPHER Garrigosa Estudio

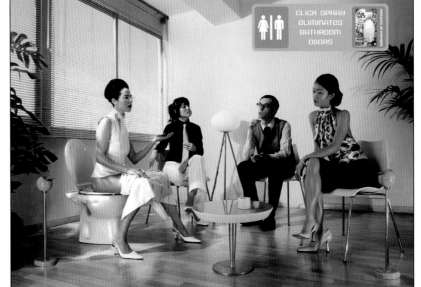

SPAIN

FINALIST, CAMPAIGN
EURO RSCG PARTNERS
MADRID

CLIENT Click Spray
CREATIVE DIRECTOR Josep Maria Batalla/
Alex Ripolles
COPYWRITER Ana Navarro
ART DIRECTOR Alex Morell

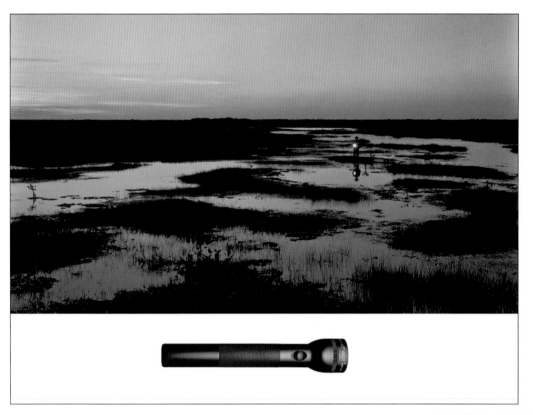

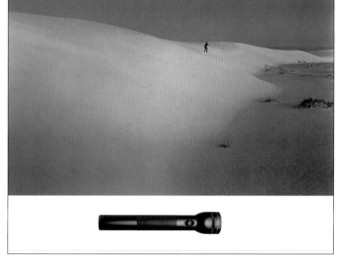

JAPAN

BRONZE WORLD MEDAL, CAMPAIGN
TUGBOAT
TOKYO

CLIENT Mag-Lite
CREATIVE DIRECTOR Seijo Kawaguchi/Tugboat
ART DIRECTOR Seijo Kawaguchi/Tugboat
COPYWRITER Sho Akiyama
PHOTOGRAPHER Tamotsu Fujii
AGENCY PRODUCER Runako Satoh
DESIGNER Toshihiro Hyodo/Minoru Fuwa

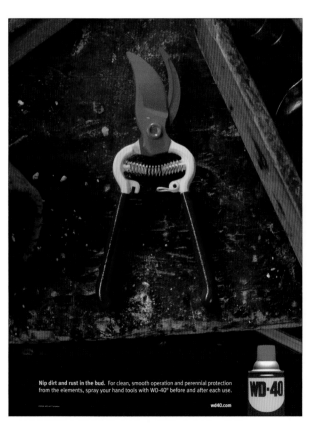

USA

FINALIST, CAMPAIGN
CRAMER-KRASSELT CO
MILWAUKEE, WI

CLIENT WD 40
CREATIVE DIRECTOR Mike Bednar
ART DIRECTOR Matt Herrmann
WRITER Brian Ganther

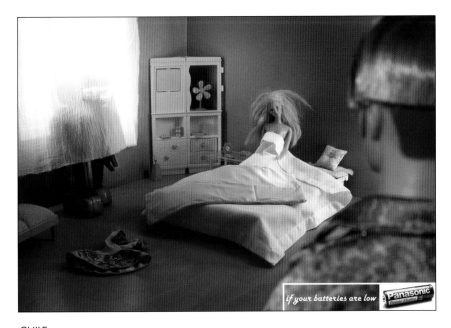

if your batteries are low Panasonic

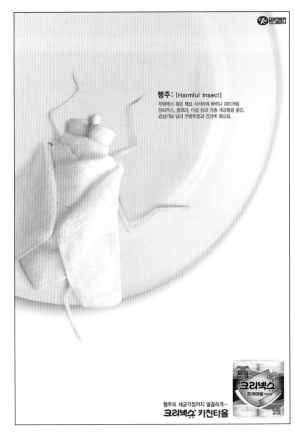

행주: [Harmful Insect]

SPAIN

FINALIST, CAMPAIGN

McCANN-ERICKSON
MADRID

CLIENT Bruguer Pinturas
GENERAL CREATIVE DIRECTOR Nicolás Hollander
ART DIRECTOR Raquel Martínez
COPYWRITER Mónica Moro
PRINT PRODUCTION MANAGER Sara Fernández

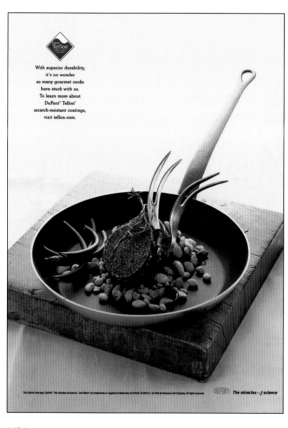

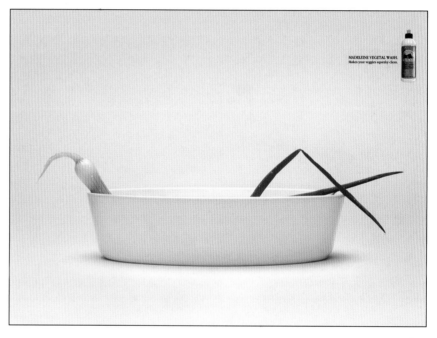

UNITED ARAB EMIRATES

FINALIST, CAMPAIGN

TEAM YOUNG & RUBICAM
DUBAI

CLIENT Vegetal Wash
EXECUTIVE CREATIVE DIRECTOR Sam Ahmed
ART DIRECTOR Syam
COPYWRITER Shahir Ahmed
PHOTOGRAPHER Suresh Subramaniam
ILLUSTRATOR Anil Palyekar/Jomy Varghese

USA

FINALIST, CAMPAIGN

YOUNG & RUBICAM NEW YORK
NEW YORK, NY

CLIENT Dupont/Teflon
CREATIVE DIRECTOR Ross Sutherland
ART DIRECTOR Marwan Khuri
COPYWRITER Jill Applebaum
PHOTOGRAPHER Lisa Charles Watson

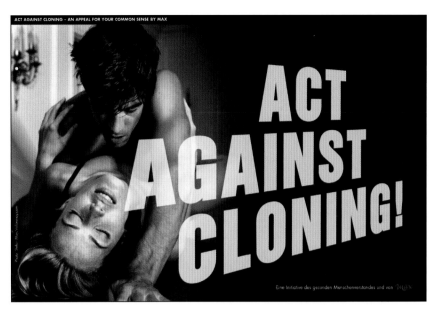

GERMANY

FINALIST, SINGLE

EILER & RIEMEL GMBH

MUNICH

CLIENT MAX
CREATIVE DIRECTOR Robert Schenk
COPYWRITER Fred Riemel
ART DIRECTOR Michael Matzke

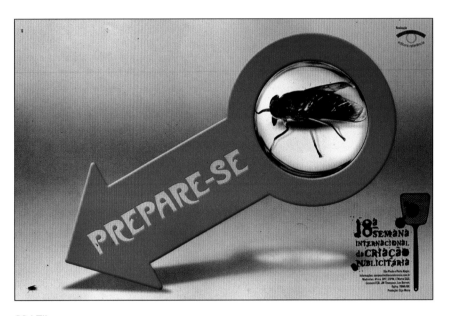

BRAZIL

FINALIST, SINGLE

DPZ

SAO PAULO

CLIENT Editora Referência
CREATIVE DIRECTOR Jose Zaragoza/Carlos Rocca
ART DIRECTOR Robson Oliveira
COPYWRITER Mauricio Machado

PERU

FINALIST, SINGLE

LEO BURNETT DEL PERU

LIMA

CLIENT El Comercio Coleccionable
CREATIVE DIRECTOR Jose Luis Rivera y Pierola
CREATIVE REDACTOR Emilio Diaz
ART DIRECTOR Ximena Castañeda
ACCOUNT DIRECTOR Silvia Vargas
PRODUCER Jimena Garcia
ACCOUNT EXECUTIVE Andrea Aguila-Pardo
PHOTOGRAPHER Javier Ferrand

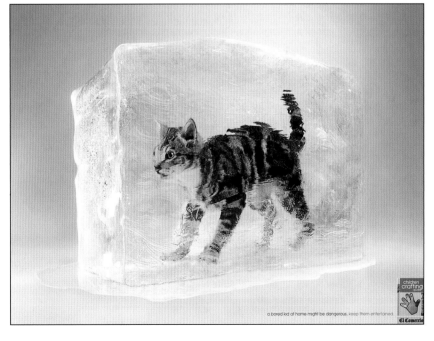

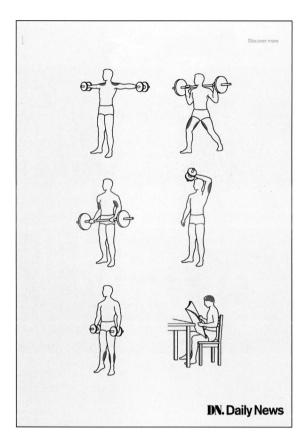

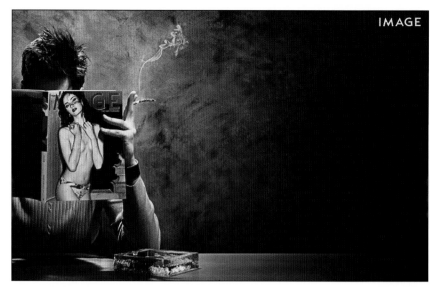

SWEDEN

FINALIST, SINGLE
LOWE BRINDFORS
STOCKHOLM

CLIENT Daily News
ART DIRECTOR Kristofer Mårtensson
COPYWRITER Martin Stadhammar
ACCOUNT EXECUTIVE Charlotte Cederström
ILLUSTRATOR/TYPOGRAPHER Jakob Brumdin

THAILAND

FINALIST, SINGLE
LOWE BANGKOK
BANGKOK

CLIENT Image Magazine
EXECUTIVE DIRECTOR Kamron Pramoj
ART DIRECTOR Vancelee Teng
COPYWRITERS Subun Khow/Veradis Vinyarath
ILLUSTRATOR illusion
CREATIVE DIRECTOR Jeffrey Curtis/Adrian Holmes
ACCOUNT EXECUTIVE Somkiat Larptanunchaiwong
PHOTOGRAPHER Amat Nimitpark
PRINT PRODUCER Nuch Lertviwatchai

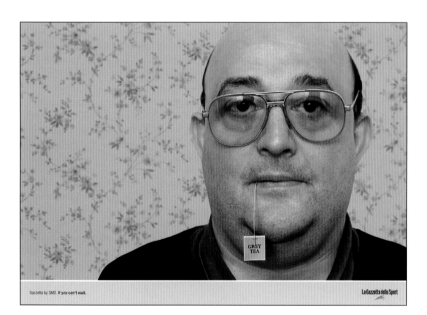

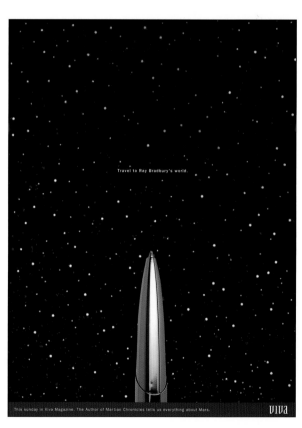

ITALY

FINALIST, CAMPAIGN
ATA DE MARTINI LC
MILAN

CLIENT La Gazzetta Dello Sport
CREATIVE DIRECTOR Stefano Rosselli/Maurizio Maresca
ART DIRECTOR Aureliano Fontana
COPYWRITER Sonia Cosentino/Marco D'Alfonso

ARGENTINA

FINALIST, SINGLE
SAVAGLIO TBWA
BUENOS AIRES

CLIENT Clarin Viva Newspaper
CREATIVE DIRECTOR Ernesto Savaglio/Martin Mercado
COPYWRITER Alexis Alvarez
ART DIRECTOR Santiago Climent/Pablo Russo

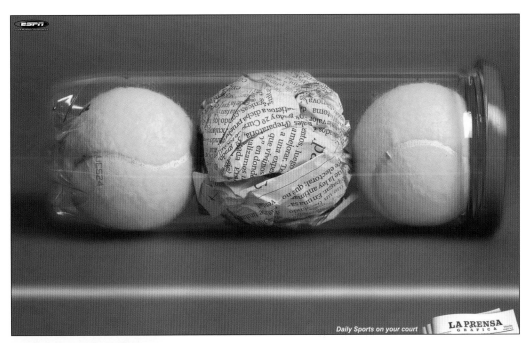

Daily Sports on your court

LA PRENSA GRAFICA

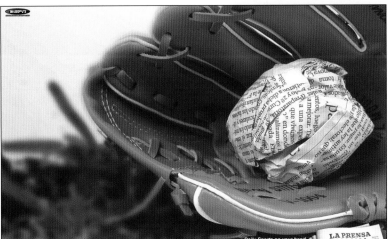

Daily Sports on your hand

LA PRENSA GRAFICA

EL SALVADOR

BRONZE WORLD MEDAL, CAMPAIGN

APEX BBDO

SAN SALVADOR

CLIENT La Prensa Gráfica
CREATIVE VICE-PRESIDENT Salvador Martínez
CREATIVE DIRECTOR Gerardo Guevara

WHAT DRAWS US TO POETRY? THE RHYMES? THE INTELLECTUALISM? THE ROMANCE? IS IT THAT INITIAL LUMP IN THE THROAT? THE FIRST GOOSEBUMP? OR SIMPLY, THE MAGICAL FACT THAT A WELL-WRITTEN POEM, READ WELL, HAS THE ABILITY TO CREATE A SMILE SO POWERFUL IT LEADS TO TEARS?

APRIL 11TH, 2003, IS POEM IN YOUR POCKET DAY
TO CELEBRATE NATIONAL POETRY MONTH, PUT A POEM IN YOUR POCKET AND SHARE IT THROUGHOUT THE DAY.

HYPERION SCHOLASTIC The New York Times KNOWLEDGE NETWORK

USA

FINALIST, SINGLE

LOWE

NEW YORK, NY

CLIENT The New York Times
COPYWRITER Bob Cohen
ART DIRECTOR/ILLUSTRATOR Eider Suso
CREATIVE DIRECTOR Lisa Bransom/Mark Ronquillo
EXECUTIVE CREATIVE DIRECTOR Dean Hacohen
CHIEF CREATIVE OFFICER Gary Goldsmith

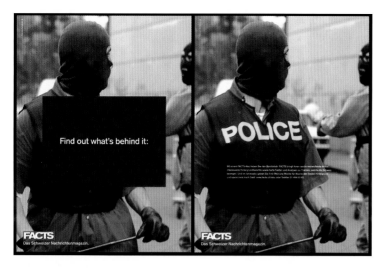

SWITZERLAND

FINALIST, CAMPAIGN

EURO RSCG SWITZERLAND
ZURICH

CLIENT Facts Verlag/Tamedia AG
CREATIVE DIRECTOR Jürg Aemmer/Frank Bodin
JUNIOR ART DIRECTOR Michèle Müller
COPYWRITER Patrick Suter
PRODUCER Edi Burri

GERMANY

FINALIST, CAMPAIGN

GBK, HEYE
MUNICH

CREATIVE DIRECTOR Alexander Bartel/Martin Kiessling
COPYWRITER Thorsten Meier
ART DIRECTOR Katrin Busson/Emil Möller/Corinna Falusi
PHOTOGRAPHER Jan Willem Scholten
ACCOUNT SUPERVISOR Markus Goetze
ACCOUNT SUPERVISORS André Musalf/Haike Feith

GERMANY

FINALIST, CAMPAIGN

KNSK WERBEAGENTUR GMBH
HAMBURG

CLIENT Mens Health
CREATIVE DIRECTOR Tim Krink/Ulrike Wegert
ART DIRECTOR Christoph Stricker/Stefan Schulte
COPYWRITER Niels Holle
PHOTOGRAPHER D. Hiepler/F. Brunier/F. Mohnheim

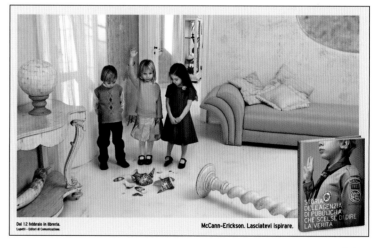

ITALY

FINALIST, CAMPAIGN

McCANN-ERICKSON S.P.A
MILAN

CLIENT McCann Erickson
CREATIVE DIRECTOR Federica Ariagno/
Giorgio Natale
ART DIRECTOR Emanuele Basso
COPYWRITER Chiara Castiglioni
PHOTOGRAPHER LSD

DOMINICAN REPUBLIC

BRONZE WORLD MEDAL, SINGLE
Y&RD
SANTO DOMINGO

CLIENT La 91 fm
GENERAL CREATIVE DIRECTOR Matías Robeson
ART DIRECTOR Eduardo Sosa
COPYWRITER Pablo Jiménez
PHOTOGRAPHY Alex Otero

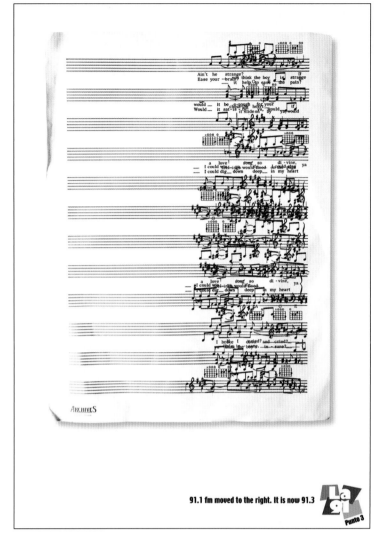

SPAIN

FINALIST, SINGLE
CONTRAPUNTO
MADRID

CLIENT Sogecable Canal Plus
GENERAL CREATIVE DIRECTOR Antonio Montero
CREATIVE DIRECTOR Tomas Oliva
ART DIRECTOR/COPY Carla Romeu/Sara Piñana
PRODUCER Andrés Espinosa

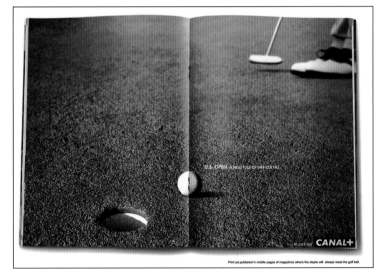

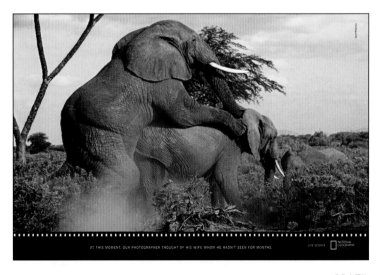

BRAZIL

FINALIST, SINGLE
DUEZT EURO RSCG COMUNICAÇÕES
SAO PAULO

CLIENT National Geographic Channel
CREATIVE DIRECTOR Zuza Tupinambá
ART DIRECTOR Martan
ACCOUNT DIRECTOR Luiz Sarli
BANK IMAGES Keystone

PLACEBONJOVILLAGEPEOPLEDZEPELL
INTIILLIMANICKCARTERAUSUREMINE
MANUELECTRICLIGHTORCHESTANTRI
CECUBEEGEESOUNDGARDENVERICC
LAPTONYBENNETALKINGHEADSTING
ROOVEARMADAVIDBYRNEILYOUNGU
NSANDROSESPIRITUALIZEDEPECHEM
ODEFTONESTEREOLABARRYWHITEST
RIPESUPERTRAMPORTISHEADAMOLO
TOVIOLENTFEMMESANTANATALIEIM
BRUGLIAEROSMITHEBEATLESRITAMIT
SOUKOASISTEMOFADOWNINEINCH
NAILSMASHINGPUMPKINSPIRALCAR
PETSHOPBOYSTIVIEWONDEROSRAM
AZZOTINATURNERADIOHEADIDOCT
ORDREEMERSONLAKEANDPALMERO
DSTEWARTOFNOISEPULTURAMONES
CORPIONSTONEROSESTROKESPINNE
TALKTALKISSIMPLEREDHOTCHILIPEPP
ERSODASTEREOZZYOSBOURNELLYFU
RTADOGMADONNATKINGCOLENNY
KRAVITZZTOPUSILVERCHAIRSUPPLYO
LATANGORILAZWANDRESCALAMA
ROXYMUSICMIXEDAT97.7 ● RADIOZERO

CHILE

FINALIST, SINGLE
LECHE LOWE WORLDWIDE
SANTIAGO

CLIENT Radio Zero
CREATIVE DIRECTOR Francisco Guarello/Leo Farfán
COPYWRITER Sebastián Arteaga/Sergio Rosati
ART DIRECTOR Sergio Rosati/Javier Valdivieso

INDIA

FINALIST, SINGLE
MUDRA COMMUNICATIONS PVT. LTD.
NEW DELHI

CLIENT HBO
COPYWRITER Kapil Dhawan
ART DIRECTOR Arnab Chatterjee
ILLUSTRATOR Sanjay Sahai

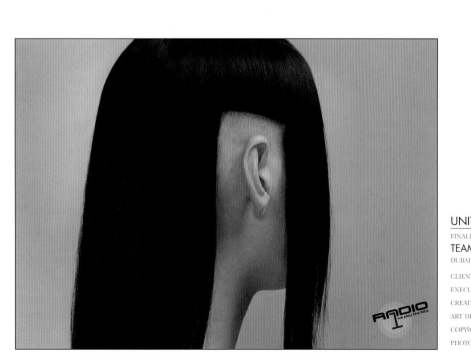

UNITED ARAB EMIRATES

FINALIST, SINGLE
TEAM YOUNG & RUBICAM
DUBAI

CLIENT Radio 1
EXECUTIVE CREATIVE DIRECTOR Sam Ahmed
CREATIVE DIRECTOR Mark Lineveldt
ART DIRECTOR Peter Walker
COPYWRITER James Wareham
PHOTOGRAPHER Jillian Lochner

EVERY PASSENGER HAS A STORY

(Thank goodness for headphones)

A&E
The art of Entertainment™

AIRLINE
We all have our baggage

Series Premiere
MONDAY, JAN. 5th at 10pm/9c

You'll see Halloween everywhere.

SKY
Imagine that...

The greatest stuff rolled in Hollywood in the 70's.

The pacifists who declared war on Hollywood in the 70's.

ITALY

BRONZE WORLD MEDAL, CAMPAIGN

D'ADDA,LORENZINI,VIGORELLI,BBDO
MILAN

CLIENT Studio Universal
CREATIVE DIRECTOR Gianpietro Vigorelli/Stefano Campora
ART DIRECTOR Vincenzo Gasbarro
COPYWRITER Federico Ghiso

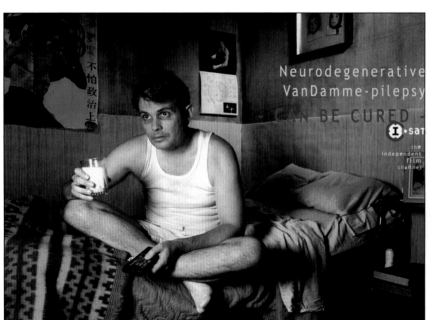

ARGENTINA

FINALIST, CAMPAIGN

OGILVY & MATHER ARGENTINA
BUENOS AIRES

CLIENT I-Sat/Claxon S.A.
GENERAL CREATIVE DIRECTOR Gustavo Reyes
CREATIVE DIRECTOR Sanchez Correa/
Campopiano/Aregger/Duhalde
ART DIRECTOR Juan Donalisio
COPYWRITER J. C. Keller/N. Gomez
GENERAL ART DIRECTOR Maximiliano Sanchez Correa
PHOTOGRAPHY STUDIO Salvarredi
AGENCY PRODUCER Osvaldo Bianco

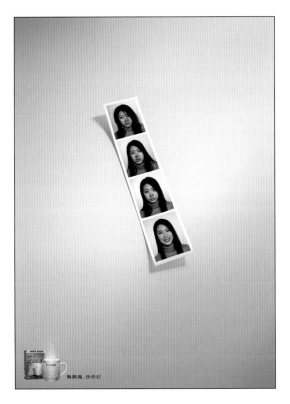

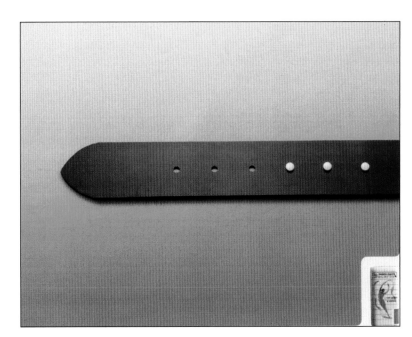

TAIWAN

FINALIST, SINGLE

OGILVY & MATHER ADVERTISING TAIWAN
TAIPEI

CLIENT Panadol Hot Remedy
EXECUTIVE CREATIVE DIRECTOR Murphy Chou
CREATIVE DIRECTOR Rich Shiue
COPYWRITER Kurt Lu
ART DIRECTOR Kit Koh

CHILE

FINALIST, SINGLE

J. WALTER THOMPSON CHILENA SAC.
SANTIAGO

CLIENT Sacarina Parke Davis
EXECUTIVE CREATIVE DIRECTOR Rodrigo Richards
CREATIVE DIRECTOR Carlos Núñez
COPYWRITER Sergio Liberona
ART DIRECTOR Aliro Jara

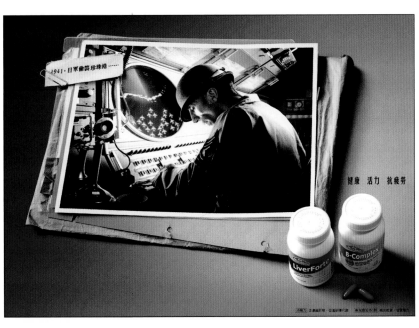

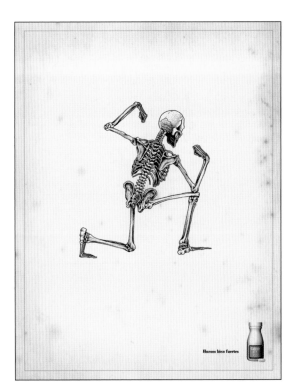

TAIWAN

FINALIST, SINGLE

McCANN-ERICKSON TAIWAN
TAIPEI

CLIENT NutriMate
CREATIVE DIRECTOR Awei Chen
EXECUTIVE CREATIVE DIRECTOR Jerry Kan
ART DIRECTOR Awei Chen
COPYWRITER Amber Lin

COSTA RICA

FINALIST, CAMPAIGN

McCANN ERICKSON COSTA RICA
SAN JOSE

CLIENT Caltrate
VP CREATIVE Ignacio Gómez
CREATIVE DIRECTOR Alan Carmona
ART DIRECTOR Ronny Villalobos
ILLUSTRATION Rodrigo Valverde
EXECUTIVE ACCOUNT Giorogos Katsavabaski

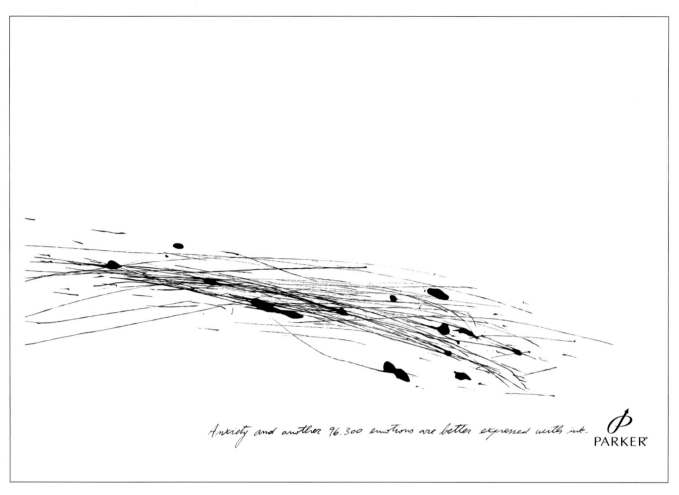

Anxiety and another 96.300 emotions are better expressed with ink.

PARKER

ARGENTINA

SILVER WORLD MEDAL, SINGLE

OGILVY & MATHER ARGENTINA
BUENOS AIRES

CLIENT **Parker**
GENERAL CREATIVE DIRECTOR **Gustavo Reyes**
CREATIVE DIRECTOR **Aregger/Campopiano/ Duhalde/Sanchez Correa**
ART DIRECTOR **F. Zagales/M. Sanchez Correa**
COPYWRITER **Mariano Duhalde**
GENERAL ART DIRECTOR **M. Sanchez Correa**
HEAD ACCOUNT **Yayo Enriquez**

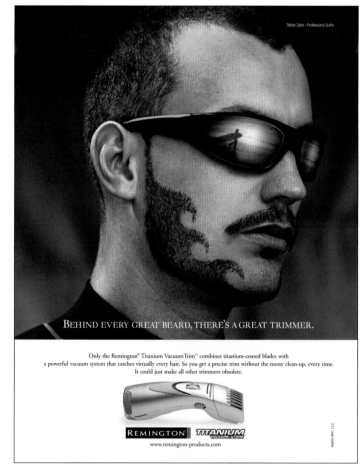

BEHIND EVERY GREAT BEARD, THERE'S A GREAT TRIMMER.

Only the Remington® Titanium Vacuum Trim™ combines titanium-coated blades with a powerful vacuum system that catches virtually every hair. So you get a precise trim without the messy clean-up, every time. It could just make all other trimmers obsolete.

REMINGTON **TITANIUM** VACUUM TRIM
www.remington-products.com

USA

FINALIST, SINGLE

GREY WORLDWIDE
NEW YORK, NY

CLIENT **Remington**
CREATIVE DIRECTOR **Frank Krimmel/Jonathan Mandell**

HOSPITAL

H242804
CRESPO BLASCO, JOAQUIN CIP CRMI0720827007
27-08-1972

CREHUERAS ST. 15 1-A
08023 BARCELONA
T. 08/100701156707 DATE 16/03/2003

℞ _____

PROFLOXIN 100 mg

Take a tablet after meals for the first 7 days. From the second week onwards, reduce the dose to half a tablet and continue treatment for 15 days.

Dr. E. VC
Association Member No. 27426

Signature,
E. Vendrell

– This prescription is only valid for 10 days after it has been prescribed.
– Prescribed medication must not in any event entail treatment for over 3 months.

Pilot **Super Grip**. Improve your handwriting [Pilot Super Grip (M)]

SPAIN

BRONZE WORLD MEDAL, SINGLE

GREY & TRACE
BARCELONA

CLIENT Pilot Super Grip
EXECUTIVE CREATIVE DIRECTOR Jürgen Krieger
CREATIVE DIRECTOR Gumer Díaz
COPYWRITER Quim Crespo
ART DIRECTOR Jesús Urzanqui
ACCOUNT DIRECTOR Domenech Salvia
AGENCY PRODUCTION Clemente Bielsa

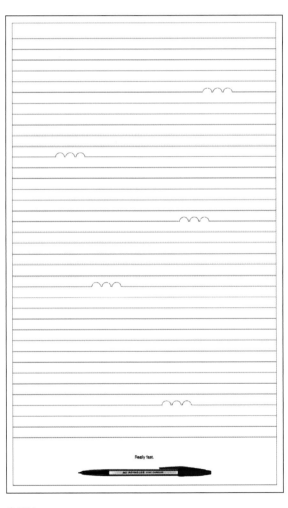

Really fast.

INDIA

FINALIST, SINGLE

J. WALTER THOMPSON
CHENNAI

CLIENT Reynolds 045
CREATIVE DIRECTOR Niranjan Natarajan
COPYWRITER Niranjan Natarajan
ART DIRECTOR Jaju Krishnankutty
ACCOUNT DIRECTOR Ranji Cherian

FRANCE

SILVER WORLD MEDAL, CAMPAIGN

DEVARRIEUXVILLARET
PARIS

CLIENT Alain Mikli
COPYWRITER Pierre-Dominique Burgaud
ART DIRECTOR Stéphane Richard
PHOTOGRAPHER Pascal Richon
ACCOUNT EXECUTIVE Bénédicte Chalumeau

CANADA

FINALIST, CAMPAIGN

JWT TORONTO
TORONTO, ONTARIO

CLIENT Diamond Trading Company
CREATIVE DIRECTOR Martin Shewchuk
WRITER Dan Saynor

SPAIN

BRONZE WORLD MEDAL, CAMPAIGN

BASSAT OGILVY BARCELONA
BARCELONA

CLIENT DeBolsillo Pocket Books
CREATIVE DIRECTOR Jaume Monés
ART DIRECTOR Francesc Talamino
COPYWRITER Sergi Coulibaly
EXECUTIVE CREATIVE DIRECTOR Angel Sánchez
ACCOUNT DIRECTOR Sergi Prieto

POLITICAL

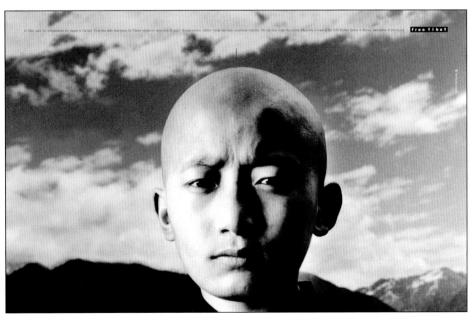

SWITZERLAND

FINALIST, SINGLE

EURO RSCG SWITZERLAND
ZURICH

CLIENT www.games-of-beijing.org
CREATIVE DIRECTOR Jürg Aemmer/Frank Bodin
ART DIRECTOR Urs Hartmann
COPYWRITER Patrick Suter
PHOTOGRAPHER Phil Borges
PRODUCER Edi Burri

PROFESSIONAL SERVICES

ACROSS 1. (conj.) Supposing that. **2.** (pron.) The one. **3.** Lives, breathes. **4.** How's _____ day going? **5.** Grin, smirk. **6.** Shout. **7.** At this time.

ÂSPENDENTAL™
aspendent.com

AUBURN (315) 253-6211 SYRACUSE (315) 472-4867 N. SYRACUSE (315) 455-2411 UTICA (315) 798-1319

USA

BRONZE WORLD MEDAL, SINGLE

AMP
COSTA MESA, CA

CLIENT Aspen Dental
CREATIVE DIRECTOR Luis Camano
ART DIRECTOR Luis Camano
COPYWRITER Carlos Musquez

*It's amzinag abuot how bdaly
we cna msasacre the Engilsh langugae.
And get away with it.*

As long as the first and last letter of a word is in the correct position, most people can still read the word. To learn more about English, join the NUS Linguistics Society. | **LINGUISTICSOCIETY**

SINGAPORE

FINALIST, SINGLE

ADCOM SINGAPORE
SINGAPORE

CLIENT Linguistics Society
ART DIRECTOR Deniz Law
COPYWRITER Kestrel Lee Ri Qiang

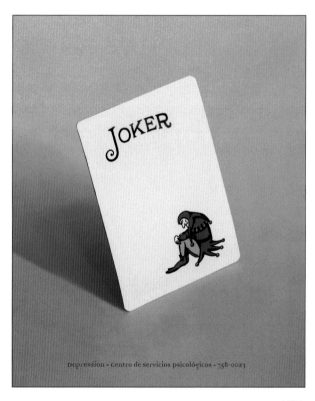

Depression • Centro de servicios psicológicos • 758-0023

USA

FINALIST, SINGLE
CONCEPTO UNO
BAYAMON, PR

CLIENT Centro de Servicios Psicologicos
CREATIVE DIRECTOR Victor LLeras/
Francisco Fernandez
COPYWRITER Adolfo Valdes
ART DIRECTOR Javier O'Neill
PHOTOGRAPHY Concepto UNO

FINALIST, CAMPAIGN

GREY WORLDWIDE ITALIA
MILANO

CLIENT Tony & Guy Hairstylist
EXECUTIVE CREATIVE DIRECTOR Antonio Maccario
CREATIVE DIRECTOR F. Ghiso/V. Gasbarro
COPYWRITER F. Ghiso/Fabio Andreini
ART DIRECTOR V. Gasbarro/Marco Bertolini

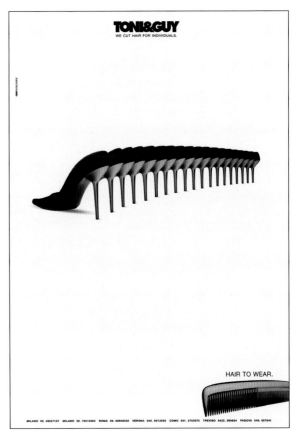

RECREATION/SPORTING GOODS

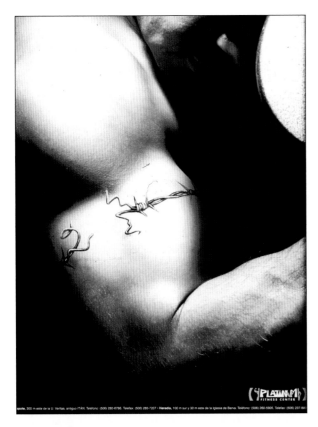

COSTA RICA
FINALIST, SINGLE
JOTABEQU GREY, COSTA RICA
SAN JOSE

CLIENT Platinum Gym
COPYWRITER Diego Vásquez
DESIGNER Manuel Méndez
ACCOUNT MANAGER/CREATIVE DIRECTOR Alberto Quirós
ILLUSTRATOR Mario Espinoza

CHILE
SILVER WORLD MEDAL, SINGLE
WUNDERMAN
SANTIAGO

CLIENT Diadora Soccer Gloves
CREATIVE DIRECTOR Daslav Maslov
COPYWRITER Renato Córdoba
ART DIRECTOR Emerson Navarrete

ART NOT AVAILABLE

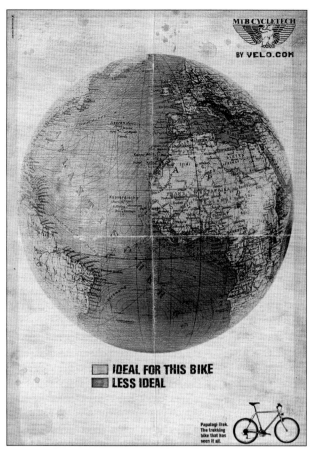

SWITZERLAND

FINALIST, SINGLE

EURO RSCG SWITZERLAND
ZURICH

CLIENT velo.com
CREATIVE DIRECTOR Jürg Aemmer/Frank Bodin
ART DIRECTOR Marcel Schlaefle
COPYWRITER Jürg Waeber
PRODUCER Edi Burri

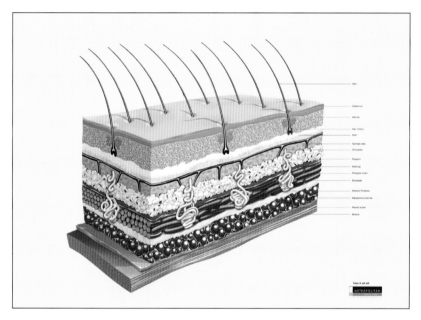

SPAIN

FINALIST, SINGLE

ZAPPING MADRID
MADRID

CREATIVE DIRECTOR/ART DIRECTOR Uschi Henkes
CREATIVE DIRECTOR/COPYWRITER Manolo Moreno
CREATIVE DIRECTOR Urs Frick

AUSTRALIA

FINALIST, CAMPAIGN

LOUD PTY LTD
SYDNEY, NSW

CLIENT Maxfli
ART DIRECTOR Alex Booker
COPYWRITERS Andy Firth & Alex Booker
CREATIVE DIRECTOR Andy Firth
PHOTOGRAPHER George Mourtzakis
RETOUCHERS Cream

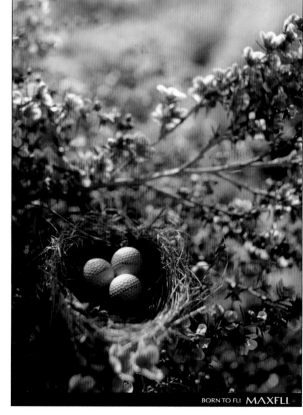

GERMANY

BRONZE WORLD MEDAL, CAMPAIGN

MICHAEL CONRAD &
LEO BURNETT

FRANKFURT

CLIENT Dunlop Green Flash
Shoe Company

CREATIVE DIRECTOR

Andreas Heinzel/Peter Steger

ART DIRECTOR Klaus Trapp

COPYWRITER Mathias Henkel

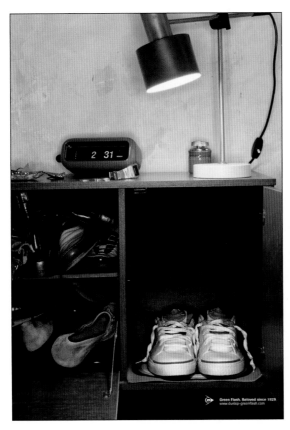

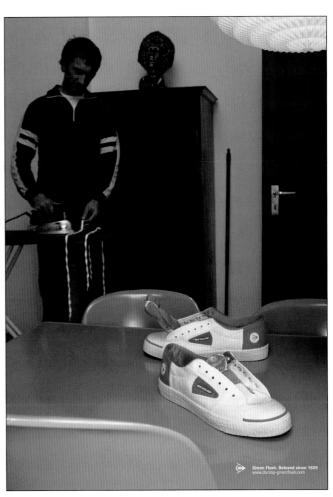

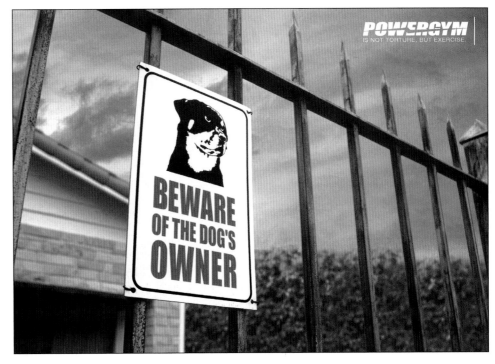

ARGENTINA

BRONZE WORLD MEDAL, SINGLE

CRAVEROLANIS EURO RSCG

BUENOS AIRES

CLIENT Power Gym

GENERAL CREATIVE DIRECTOR Juan Cravero/Darío Lanis

COPYWRITERS Ramiro Bernardo/Diego Sánchez

ART DIRECTOR Diego Sánchez

PHOTOGRAPHER Fernando Romero

ILLUSTRATOR Diego Sánchez

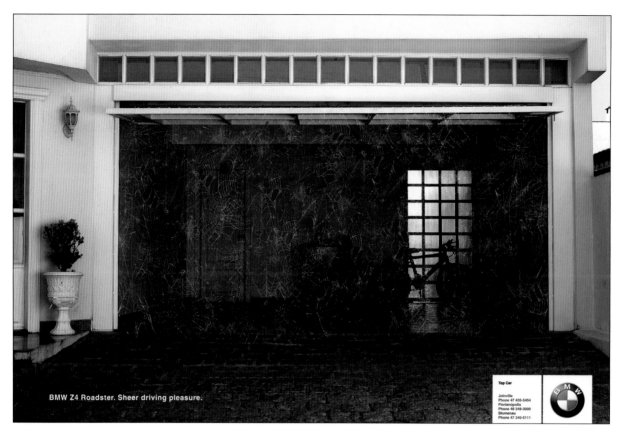

BMW Z4 Roadster. Sheer driving pleasure.

Top Car
Joinville
Phone 47 435-5454
Florianópolis
Phone 48 348-3000
Blumenau
Phone 47 340-6111

BMW

BRAZIL
BRONZE WORLD MEDAL, SINGLE
PROPAGUE
FLORIANOPOLIS

CLIENT **Top Car BMW**
CREATIVE DIRECTOR **Rogério Alves**
ART DIRECTOR **Gilberto Cunha**
COPYWRITER **Rogério Alves**
PHOTOGRAPHER **Fernando Ziviani**

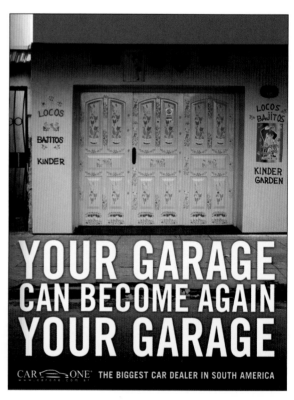

YOUR GARAGE CAN BECOME AGAIN YOUR GARAGE

CAR ONE° THE BIGGEST CAR DEALER IN SOUTH AMERICA

ARGENTINA
FINALIST, SINGLE
FCB ARGENTINA
BUENOS AIRES

CLIENT **Car One**
GENERAL CREATIVE DIRECTOR **Pablo Poncini**
CREATIVE DIRECTOR **G. Castañeda/J.C Bazterrica**
COPYWRITER **Christian Oneto Gaona**
ART DIRECTOR **Jorge Martinez**

ITALY

J.WALTER THOMPSON ITALIA SPA

MILAN

CLIENT Ba-Ba Reeba Restaurant
EXECUTIVE CREATIVE DIRECTOR Pietro Maestri
ART DIRECTOR Flavio Mainoli
COPYWRITER Paolo Cesano
PHOTOGRAPHER Andrea Garuti

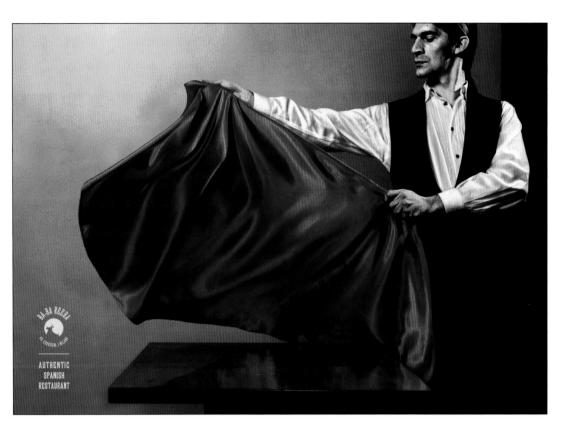

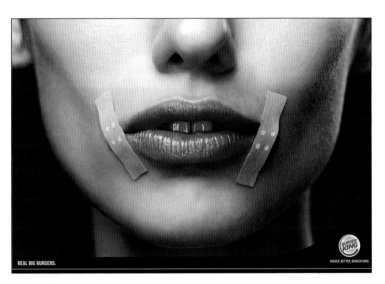

GERMANY

FINALIST, SINGLE

.START GMBH

MUNICH, BAVARIA

CLIENT Burger King GmbH
CREATIVE DIRECTOR Marco Mehrwald/Thomas Pakull
ART DIRECTOR Sven Achatz
COPYWRITERS Marcel Koop/Beate Bogensperger
PHOTOGRAPHY Yorck Dertinger

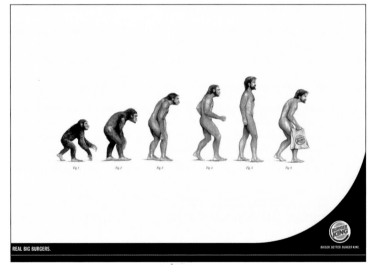

GERMANY

FINALIST, SINGLE

.START GMBH

MUNICH, BAVARIA

CLIENT Burger King GmbH
CREATIVE DIRECTOR Marco Mehrwald/Thomas Pakull
ART DIRECTOR Tina Dompert/Tatjana Bruns
COPYWRITER J. Heerdegen/M. Koop/B. Bogenspeger
ILLUSTRATOR Anton Danner

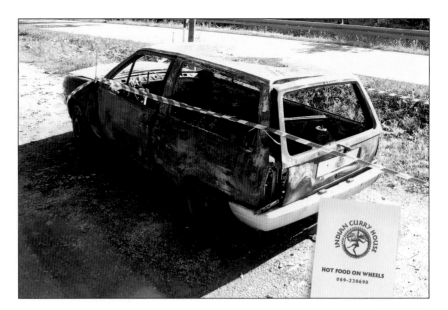

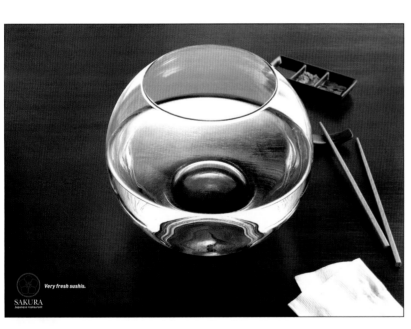

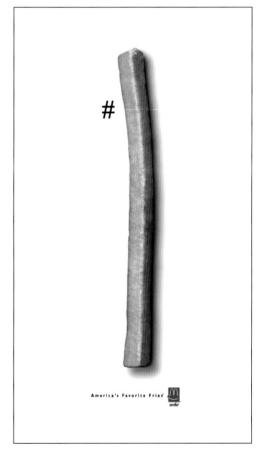

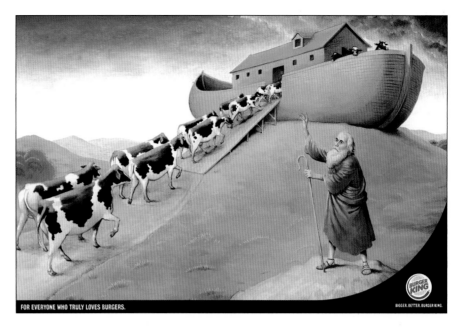

FOR EVERYONE WHO TRULY LOVES BURGERS.

GERMANY

FINALIST, SINGLE

.START GMBH

MUNICH, BAVARIA

CLIENT Burger King GmbH

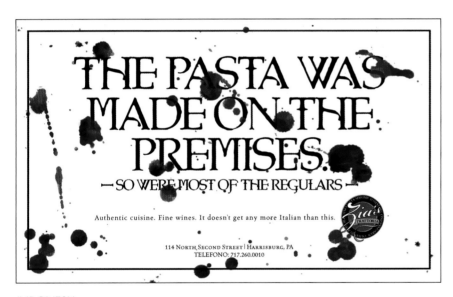

THE PASTA WAS MADE ON THE PREMISES.
— SO WERE MOST OF THE REGULARS —

Authentic cuisine. Fine wines. It doesn't get any more Italian than this.

114 NORTH SECOND STREET | HARRISBURG, PA
TELEFONO: 717.260.0010

INDONESIA

FINALIST, SINGLE

LEO BURNETT KREASINDO INDONESIA

JAKARTA

CLIENT Lembur Kuring Restaurant
EXECUTIVE CREATIVE DIRECTOR Chris Chiu
ART DIRECTOR Adi Karnajaya/Tan BB/Tay Guan Hin
COPYWRITER Chris Chiu
JUNIOR PRINT PRODUCER Farrisca Piscandari

USA

FINALIST, SINGLE

NEIMAN GROUP

HARRISBURG, PA

CLIENT Zias Trattoria
COPYWRITER/GROUP CREATIVE DIRECTOR
Buffy McCoy Kelly
ART DIRECTOR James Madsen
EXECUTIVE CREATIVE DIRECTOR Rudy Banny
AGENCY PRODUCER Jen Webb

In 1974, we opened our first restaurant.

In 1979, we introduced cutlery.

Serving Sundanese cuisine from a time gone by. In a setting where time stands still.

Lembur Kuring.

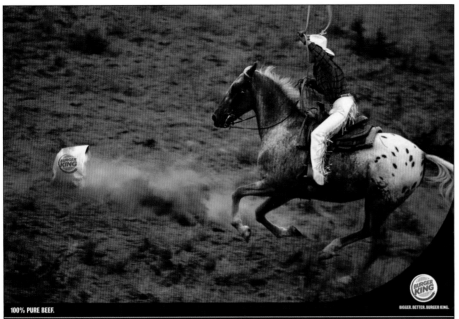

100% PURE BEEF.

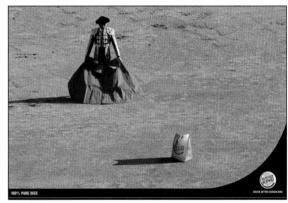

GERMANY

BRONZE WORLD MEDAL, CAMPAIGN

.START GMBH

MUNICH, BAVARIA

CLIENT Burger King GmbH
CREATIVE DIRECTOR Marco Mehrwald/Thomas Pakull
ART DIRECTOR Sven Achatz/Tina Dompert
COPYWRITER Marcel Koop/Beate Bogensperger
PHOTOGRAPHY Ralf Gellert (Fox)

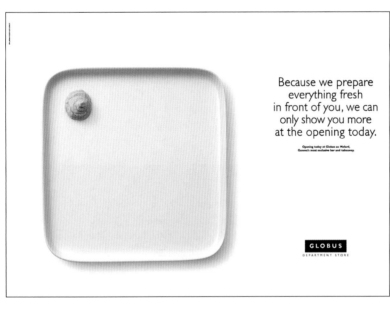

Because we prepare
everything fresh
in front of you, we can
only show you more
at the opening today.

Opening today at Globus on Molard,
Geneva's most exclusive bar and takeaway.

GLOBUS
DEPARTMENT STORE

Filet-O-Fish
CATCH OF THE DAY

SWITZERLAND

FINALIST, CAMPAIGN
SPILLMANN/FELSER/LEO BURNETT
ZURICH

CLIENT Globus
CREATIVE DIRECTOR Martin Spillmann
COPYWRITER Stefan Ehrler
ART DIRECTOR Hélène Forster
PHOTOGRAPHER Felix Streuli
GRAPHIC Tabea Guhl
ACCOUNT DIRECTOR Pam Hügli/Martina Glaser
ART BUYING Sebahat Derdiyok

INDIA

FINALIST, CAMPAIGN
MUDRA COMMUNICATIONS PVT. LTD.
NEW DELHI

CLIENT McDonalds India
COPYWRITER Kapil Dhawan
ART DIRECTOR Arnab Chatterjee

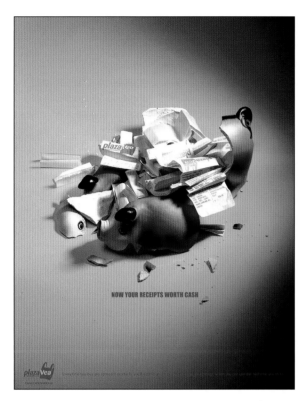

PERU

FINALIST, SINGLE

YOUNG & RUBICAM

LIMA

CLIENT Plaza Vea
CREATIVE DIRECTOR Francisco Torrico
ACCOUNT DIRECTOR Eduardo Grisalle
ART DIRECTOR Andres Acampo
PRODUCERS Felipe Valle Riestra/Javier de la Flor
REDACTOR Andres Ocampo

BRAZIL

FINALIST, SINGLE

DPZ

SAO PAULO

CLIENT Supermarkets
CREATIVE DIRECTOR Jose Zaragoza/
Ricardo Velloso
ART DIRECTOR Celio Salles
COPYWRITER Fabio Pinheiro

RETAIL STORES

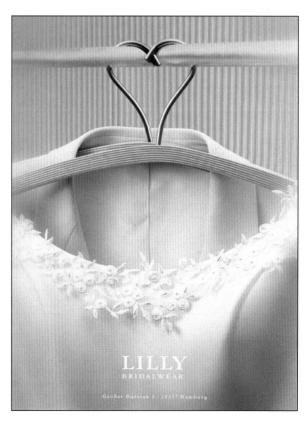

GERMANY

FINALIST, SINGLE

AIMAQ RAPP STOLLE

BERLIN

CLIENT Lilly Bridal Wear
CREATIVE DIRECTOR Oliver Frank
ART DIRECTOR Ramona Stoecker
COPYWRITER Ole Vinck
PHOTOGRAPHY Benjamin Ochs
ACCOUNT SUPERVISOR Soeren Hagge/
Sarah Guertler
ART BUYING Andrea Wendt

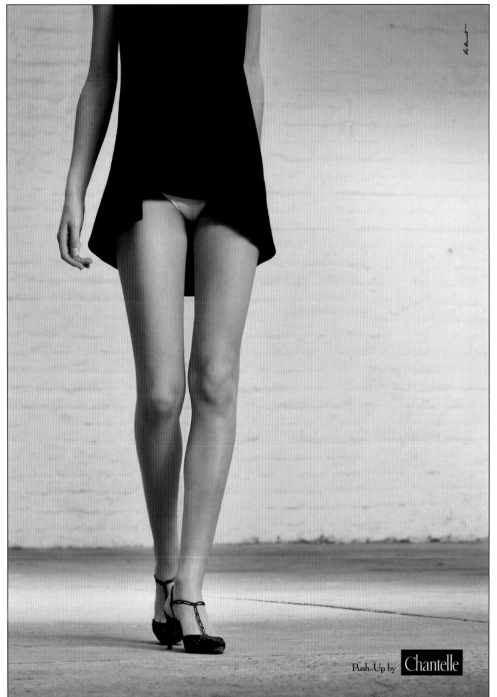

Push-Up by Chantelle

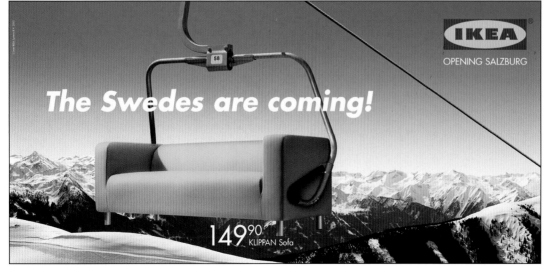

IKEA
OPENING SALZBURG

The Swedes are coming!

149.90 KLIPPAN Sofa

ARGENTINA
BRONZE WORLD MEDAL, SINGLE
GRAFFITI D ARCY
BUENOS AIRES

CLIENT Topper
CREATIVE DIRECTOR Fernando Tchechenistky
ART DIRECTOR Lisandro Grandal
COPYWRITER Santiago Maiz
GROUP ACCOUNT DIRECTOR Nicolás Díaz
ACCOUNT EXECUTIVE Juan Manuel Budelli
PHOTOGRAPHER Gaby Messina

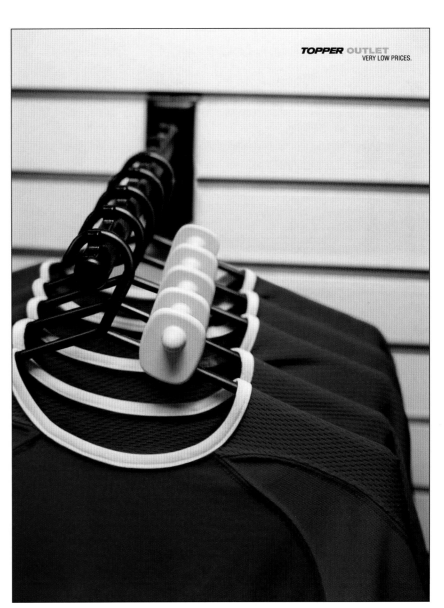

SPAIN
FINALIST, SINGLE
LOWE
MADRID

CLIENT Mothercare
EXECUTIVE CREATIVE DIRECTOR
Luis López de Ochoa
COPYWRITER Idoia González
ART DIRECTOR Rubén Señor
ACCOUNT SUPERVISOR
Pieter Schets
ADVERTISER'S SUPERVISOR
Francisco Bueno

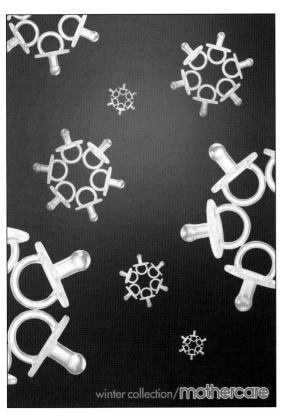

PORTUGAL
FINALIST, CAMPAIGN
GREYHOME
LISBOA

CLIENT Sneakers

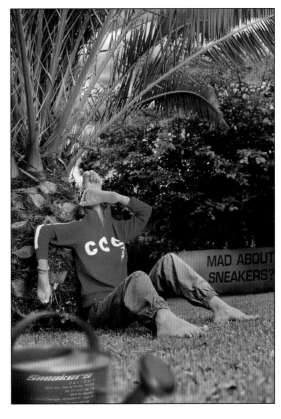

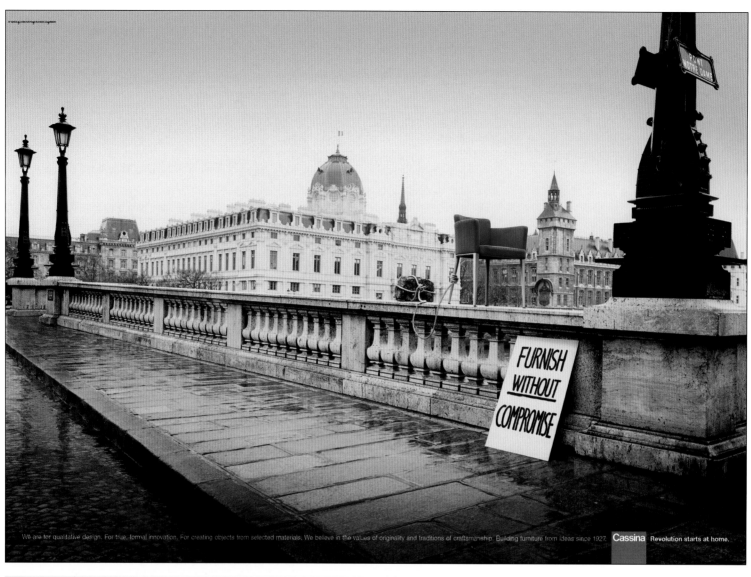

We are for qualitative design. For true, formal innovation. For creating objects from selected materials. We believe in the values of originality and traditions of craftsmanship. Building furniture from ideas since 1927. **Cassina** Revolution starts at home.

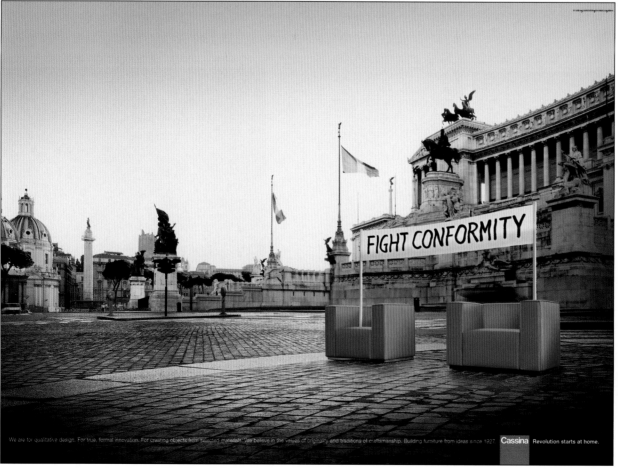

We are for qualitative design. For true, formal innovation. For creating objects from selected materials. We believe in the values of originality and traditions of craftsmanship. Building furniture from ideas since 1927. **Cassina** Revolution starts at home.

ITALY

GOLD WORLD MEDAL, CAMPAIGN
**D'ADDA,LORENZINI,
VIGORELLI,BBDO**
MILAN

CLIENT **Cassina**

CREATIVE DIRECTOR/ART DIRECTOR
Giovanni Porro

CREATIVE DIRECTOR/COPYWRITER
Stefano Campora

PHOTOGRAPHER
Pier Paolo Ferrari

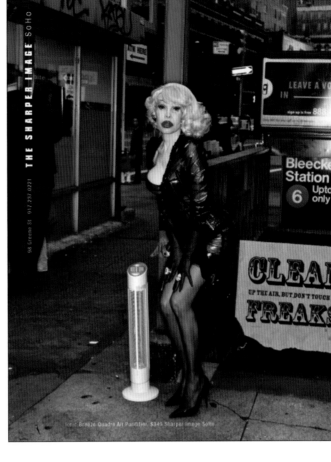

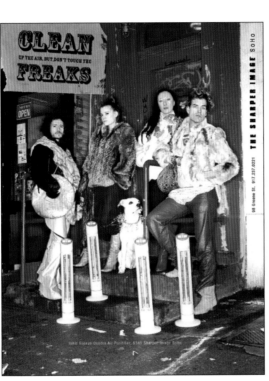

USA

CAMPAIGN

ANDREWS BIRT
ADVERTISING

DENVER, CO

CLIENT

The Sharper Image

EXECUTIVE CREATIVE

DIRECTOR Chris Birt

SENIOR ART DIRECTOR

Doug Novak

SENIOR ACCOUNT EXECUTIVE

Nicole Asselin

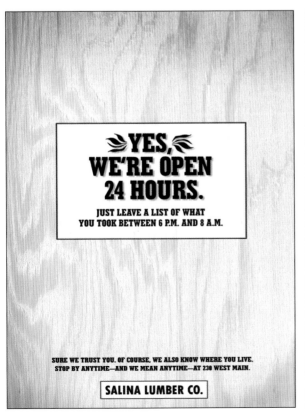

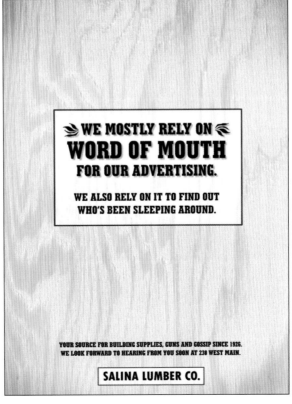

USA

RICHTER7

SALT LAKE CITY, UT

CLIENT Salina Lumber

ART DIRECTOR Ryan Anderson

COPYWRITER/CREATIVE DIRECTOR

Gary Sume

EXECUTIVE CREATIVE DIRECTOR

Dave Newbold

SOFT DRINKS

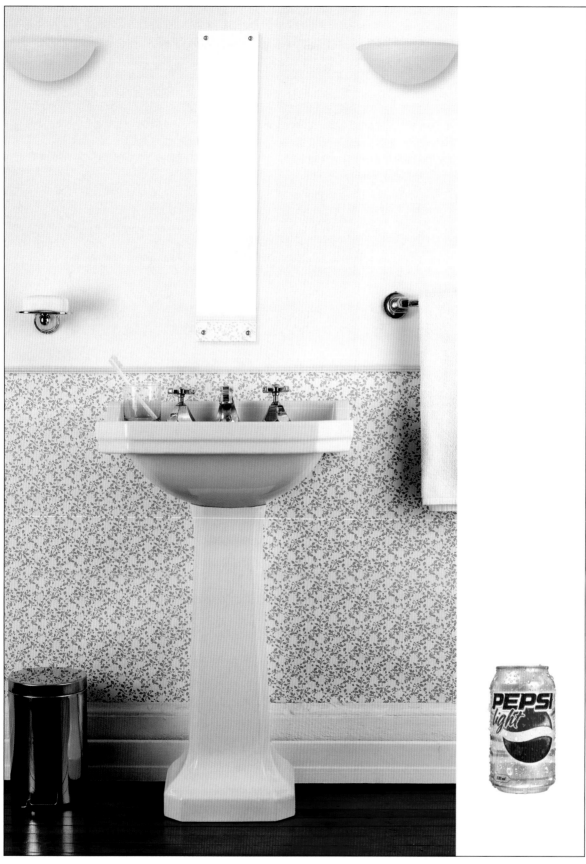

COLOMBIA

GOLD WORLD MEDAL, SINGLE

SANCHO/BBDO

BOGATA

CLIENT Pepsi-Light
ART DIRECTOR Nestor Villegas
COPYWRITER Mario Bertieri
CREATIVE DIRECTOR Nestor Villegas/Mario Bertieri
PHOTOGRAPHER Alfonso Torres

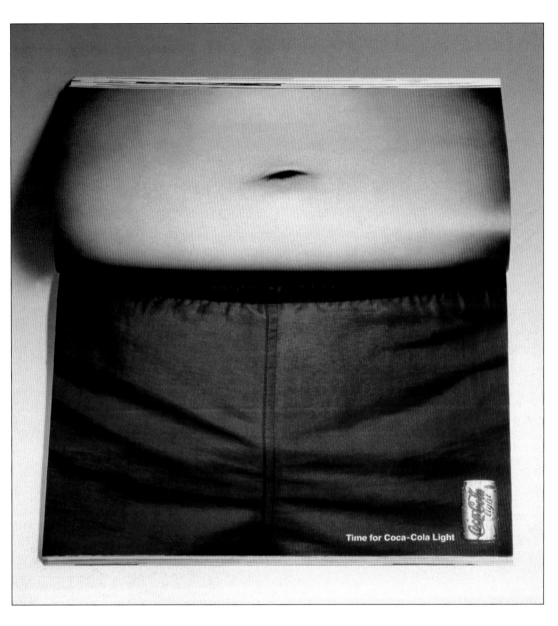

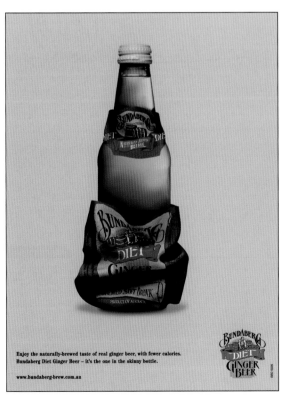

GERMANY
BRONZE WORLD MEDAL, SINGLE
BBDO CAMPAIGN GMBH
DUESSELDORF

CLIENT Pepsi Cola
CREATIVE DIRECTOR Marco Pupella
ART DIRECTOR Bernd Rose
COPYWRITER Christopher Neumann
PHOTOGRAPH Kay Schiefer
GRAPHIC DESIGN Nicole Hasenkamp

INDIA
FINALIST, SINGLE
McCANN ERICKSON INDIA
MAHARASHTRA, MUMBAI

CLIENT Coca-Cola
NATIONAL CREATIVE DIRECTOR Prasoon Joshi
COPYWRITER Prasoon Joshi
ART DIRECTOR Puneet Kapoor
PHOTOGRAPHER Altaf Khan
BUSINESS DIRECTOR Vishal Mehta
ACCOUNT EXECUTIVE Manokamna Chawla
PRODUCTION HEAD Robert Joseph

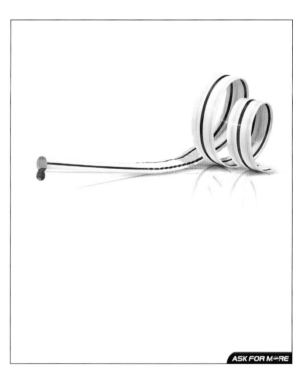

ASK FOR M RE

SAUDI ARABIA
FINALIST, SINGLE
IMPACT/BBDO
JEDDAH, MECCA

CLIENT Pepsi
CREATIVE DIRECTOR Walid Kanaan
ART DIRECTOR Mario Daou
DESIGNER Diody Cappelan
ACCOUNT DIRECTOR Peter Stewart

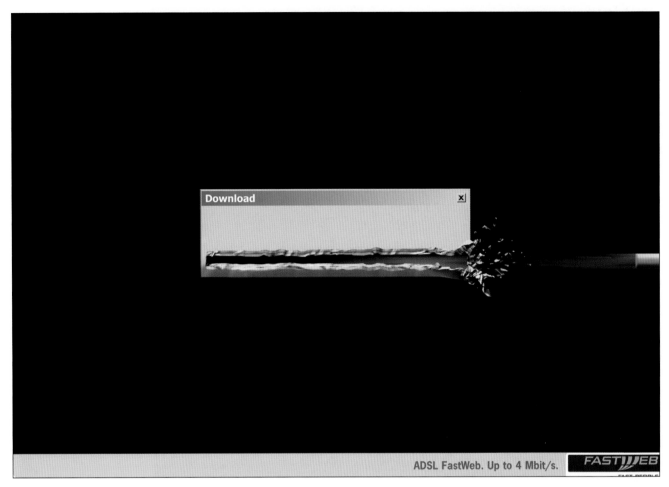

ADSL FastWeb. Up to 4 Mbit/s.

FAST||EB

ITALY

SILVER WORLD MEDAL, SINGLE
ATA DE MARTINI LC
MILAN

CLIENT Fastweb
CREATIVE DIRECTOR Stefano Rosselli/
Maurizio Maresca
ART DIRECTOR Eustachio Ruggieri
COPYWRITER Michelangelo Cianciosi

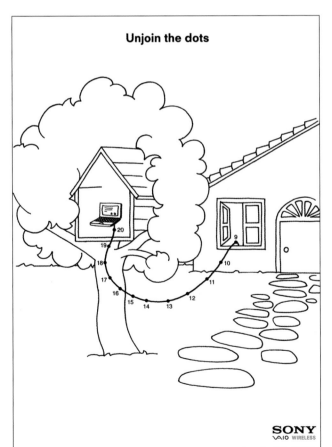

Unjoin the dots

SONY
VAIO WIRELESS

SPAIN

FINALIST, SINGLE
SAATCHI & SAATCHI
MADRID

CLIENT Sony
EXECUTIVE CREATIVE DIRECTOR Carlos Anuncibay
COPYWRITERS Amaya Uscola/Carmen Pacheco
ART DIRECTOR Amaya Uscola/Carmen Pacheco
ACCOUNT MANAGER Sonia Garcia

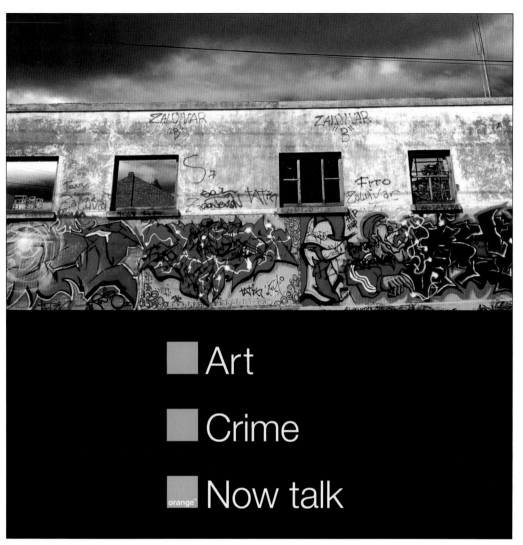

Art

Crime

orange Now talk

AUSTRALIA

BRONZE WORLD MEDAL, SINGLE
EURO RSCG PARTNERSHIP
NORTH SYDNEY

CLIENT Orange Now Talk
EXECUTIVE CREATIVE DIRECTOR Dale Rhodes
COPYWRITER Carolyn Diamond
ART DIRECTOR Bettina Clark
ACCOUNT DIRECTOR Harvey Cassie

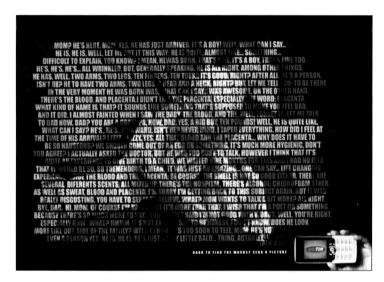

BRAZIL

FINALIST, SINGLE
MASTER COMUNICAÇÃO
CURITIBA, PARANA

CLIENT Tim Sul
COPYWRITER Luiz Trevisani
ART DIRECTOR Marcos René
CREATIVE DIRECTOR Flávio Waiteman

TAIWAN

FINALIST, SINGLE
OGILVY & MATHER ADVERTISING TAIWAN
TAIPEI

CLIENT Motorola MS100
EXECUTIVE CREATIVE DIRECTOR Murphy Chou
CREATIVE DIRECTOR Oliver Chiu
ART DIRECTOR Vivien Chou/Sam Huang
COPYWRITER Angus Tsai/Janus Peng

SINGAPORE

FINALIST, SINGLE

T AND T ADVERTISING
SINGAPORE

CLIENT Djarum Original
CREATIVE DIRECTOR Michael Tan
ART DIRECTOR Bob Tay
COPYWRITER N. Guruprasad
DIGITAL IMAGING Rhapsodi Digital Art
PHOTOGRAPHER Jason

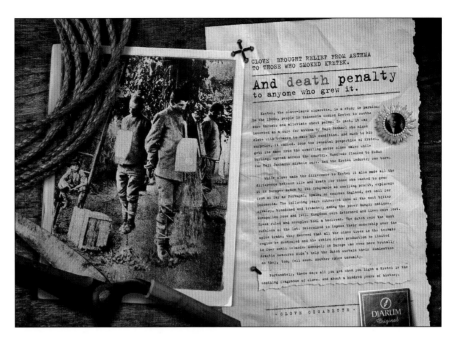

TOYS/GAMES

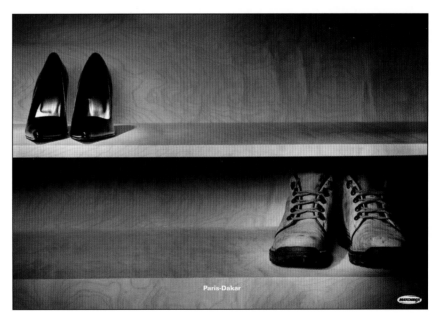

BRAZIL

FINALIST, SINGLE

OGILVY BRASIL
SÃO PAULO

CLIENT Matchbox
CREATIVE DIRECTOR Virgilio Neves/
Manir Fadel/Adriana Cury
COPYWRITER Leandro Lourenção
ART DIRECTOR Mariana Valladares
PHOTOGRAPHER Jair Lanes

ITALY

FINALIST, SINGLE

ATA DE MARTINI LC
MILAN

CLIENT La Gazzetta Dello Sport
CREATIVE DIRECTOR Stefano Rosselli/
Maurizio Maresca
ART DIRECTOR Velia Mastropietro
COPYWRITER Andrea Rosagni

SPAIN

GOLD WORLD MEDAL, SINGLE

T.B.W.A\SPAIN
MADRID

CLIENT Sony Playstation
GROUP CREATIVE DIRECTOR Agustin Vaquero
EXECUTIVE CREATIVE DIRECTOR Angel Iglesias/
Guillermo Gines

SPAIN

BRONZE WORLD MEDAL, SINGLE

T.B.W.A\SPAIN

MADRID

CLIENT Sony Playstation
GROUP CREATIVE DIRECTOR Agustin Vaquero
EXECUTIVE CREATIVE DIRECTOR Angel Iglesias/
Guillermo Gines

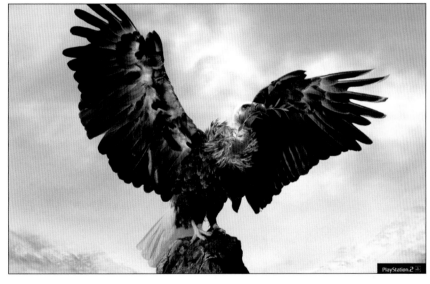

BELGIUM

FINALIST, SINGLE

TBWA\BRUSSELS

BRUSSELS

CLIENT PlayStation
ART DIRECTOR Massimo De Pascale
COPYWRITER François Massinon
CREATIVE DIRECTOR Jan Macken/
François Daubresse
ACCOUNT EXECUTIVE Jochen De Greef
ACCOUNT DIRECTOR Geert Potargent
BRAND MANAGER Ronald Van de Zande

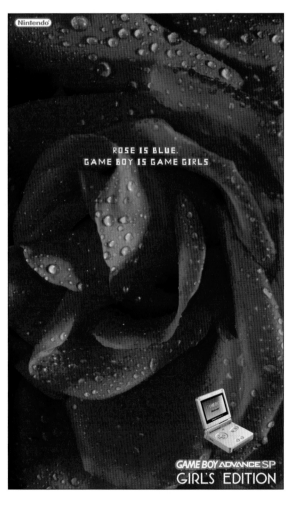

ROSE IS BLUE.
GAME BOY IS GAME GIRLS

GAME BOY ADVANCE SP
GIRL'S EDITION

SPAIN

FINALIST, SINGLE

SR. LOBO

MADRID

CLIENT Nintendo Game Boy
CREATIVE DIRECTOR Nacho Martínez
COPYWRITER Juan Adrián
ART DIRECTOR Fernando Martín

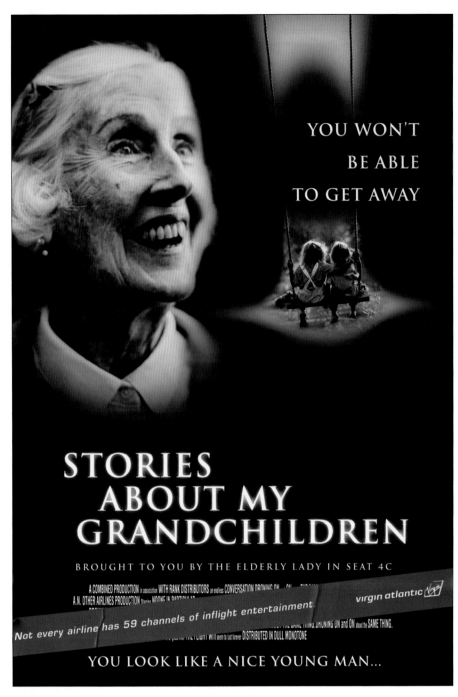

SOUTH AFRICA

SILVER WORLD MEDAL, SINGLE
NET#WORK BBDO
JOHANNESBURG

CLIENT Virgin Atlantic
CREATIVE DIRECTOR Mike Schalit
ART DIRECTOR Philip Ireland
COPYWRITER John Davenport
PHOTOGRAPHERS Kim Steele/Lawrence Lawry
PRODUCTION MANAGER Clinton Mitri
ACCOUNT EXECUTIVE Joy Turnbull

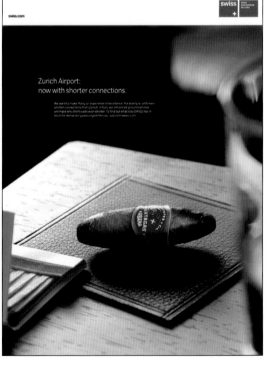

SWITZERLAND

FINALIST, SINGLE
JUNG VON MATT AG
ZURICH

CLIENT Swiss International Air Lines

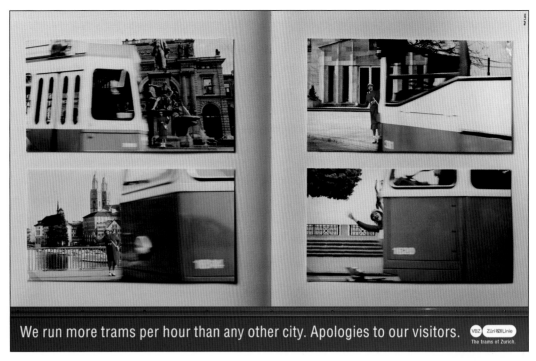

We run more trams per hour than any other city. Apologies to our visitors. VBZ Züri Linie The trams of Zurich.

TRAVEL/TOURISM

"WORLD'S BEST LARGE-SHIP CRUISE LINE" *Travel + Leisure and Condé Nast Traveler* 1 800 391 4422 www.crystalcruises.com

The world's best entertainment awaits you on board the world's best cruise line. CRYSTAL CRUISES

Spend three nights for the price of two this Easter.

Edsa Shangri-La
MANILA

PHILIPPINES
SILVER WORLD MEDAL, SINGLE
TBWA\SANTIAGO
MANGADA PUNO
MAKATI

CLIENT Shangri-la Hotels
& Resorts
CREATIVE DIRECTOR
Melvin M. Mangada/
Joey Campillo
ART DIRECTOR Evans Sator
COPYWRITER Angie Tijam
PHOTOGRAPHER Jeanne Young

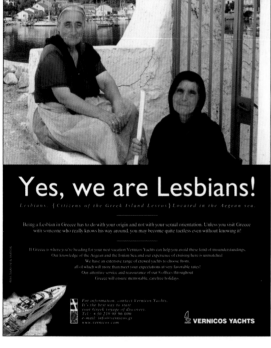

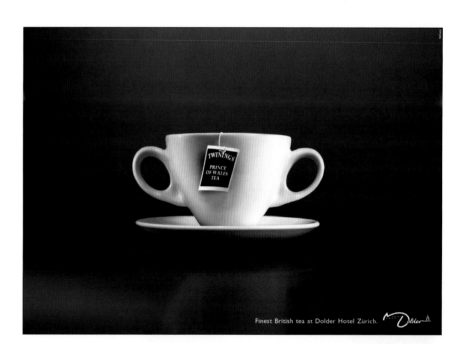

GREECE
FINALIST, SINGLE
ADEL/SAATCHI & SAATCHI
ATHENS

CLIENT Vernicos Yachts

SWITZERLAND
FINALIST, SINGLE
RUF LANZ WERBEAGENTUR AG
ZÜRICH

CLIENT Waldhaus Dolder Zurich
CREATIVE DIRECTOR Danielle Lanz/ Markus Ruf
COPYWRITER Markus Ruf
ART DIRECTOR Danielle Lanz
PHOTOGRAPHER Herzog Geissler
TYPOGRAPHER Katja Puccio
ACCOUNT SUPERVISOR Martina Schoerghofer
ADVERTISER'S SUPERVISOR Tanja Dornbach

BRONZE WORLD MEDAL, SINGLE

J. WALTER THOMPSON BARCELONA

BARCELONA

CLIENT Viajes Century Travels
EXECUTIVE CREATIVE DIRECTOR Àlex Martinez
COPYWRITER Àlex Martinez
ART DIRECTOR Napi Rivera/Paco González

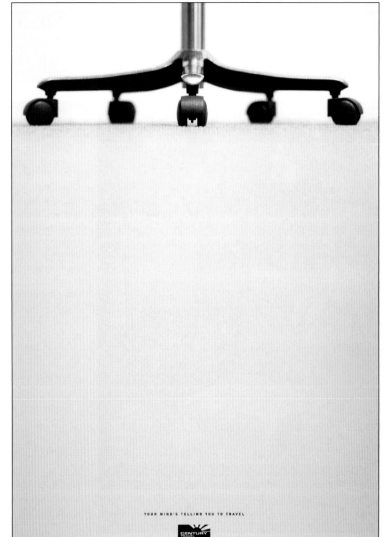

YOUR MIND'S TELLING YOU TO TRAVEL

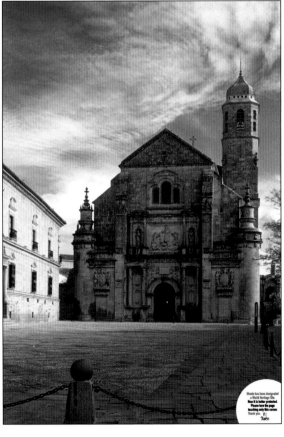

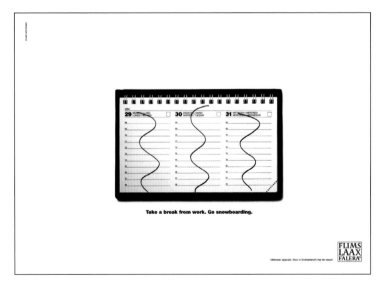

SPAIN

FINALIST, CAMPAIGN

J. WALTER THOMPSON MADRID

MADRID

CLIENT Diputacion de Jaen
EXECUTIVE CREATIVE DIRECTOR Cesar Garcia
COPY Gustavo Leon
ART DIRECTOR Ana Jimeno

SWITZERLAND

FINALIST, SINGLE

SPILLMANN/FELSER/LEO BURNETT

ZURICH

CLIENT Alpenarena.ch
CREATIVE DIRECTOR Martin Spillmann
COPYWRITER Peter Brönnimann
ART DIRECTOR Dana Wirz
ACCOUNT DIRECTOR Manuela Raue
ART BUYING Sebahat Derdiyok
PHOTOGRAPHY Felix Streuli

BUSINESS TO BUSINESS

BUSINESS SERVICES/EQUIPMENT

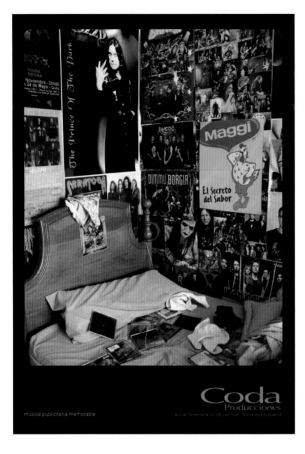

ECUADOR

FINALIST, SINGLE

McCANN ERICKSON ECUADOR

QUITO/PICHINCHA

CLIENT **Coda**

GENERAL CREATIVE DIRECTOR
Francisco Teran

CREATIVE DIRECTOR
Diego Perdomo

COPYWRITER
Diego Perdomo

ART DIRECTOR
Santiago Zumarraga

HONG KONG

FINALIST, SINGLE

McCANN ERICKSON GUANGMING LTD.

HONG KONG

CLIENT **2004 EFFIE Awards**
CHAIRMAN/EXECUTIVE CREATIVE DIRECTOR **Geoff Naus**
CREATIVE DIRECTOR/COPYWRITER **Martin Lever**
SENIOR ART DIRECTOR/TYPOGRAPHER **Andrew Foung**
GROUP ACCOUNT DIRECTOR **Jenny Leung**
ACCOUNT MANAGER **Louis Lam**
PHOTOGRAPHER **Stephen Cheung**
PRINT PRODUCTION SUPERVISOR **Lee Ying Wai**
RETOUCHING **Surreal Digital Images**

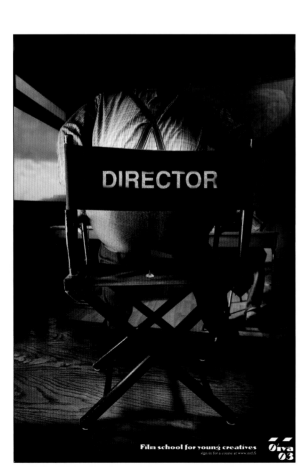

FINLAND

FINALIST, SINGLE

SEK & GREY

HELSINKI

CLIENT **Finnish Association of Marketing Communication Agencies/MTL**
COPYWRITER **Jarkko Tuuri**
ART DIRECTOR **Antero Jokinen**
ACCOUNT EXECUTIVE **Göta Ahlstedt**
PHOTOGRAPHER **Jari Riihimäki**
CLIENT SUPERVISOR **Sinikka Virkkunen**

GERMANY

GOLD WORLD MEDAL, CAMPAIGN

KOLLE REBBE WERBEAGENTUR GMBH

HAMBURG

CLIENT Bisley Office Equipment
CREATIVE DIRECTOR S. Hardieck/C. Everke
ART DIRECTOR James cè Cruickshank
COPYWRITER Klaus Huber
ACCOUNT SUPERVISOR Iris Dypka
GRAPHICS Andreas Krallmann

MEDICAL/PHARMACEUTICALS

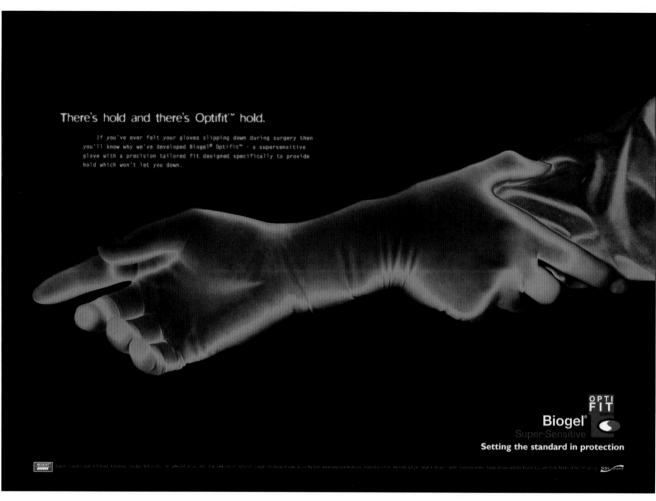

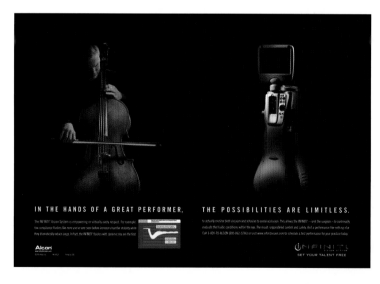

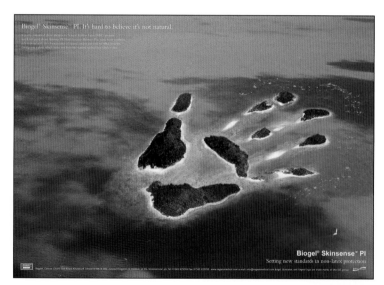

BRONZE WORLD MEDAL, SINGLE
SUDLER & HENNESSEY
MILANO

CLIENT Exelon
CREATIVE DIRECTOR Bruno Stucchi/
Angelo Ghidotti
ART DIRECTOR Sergio Terrinoni

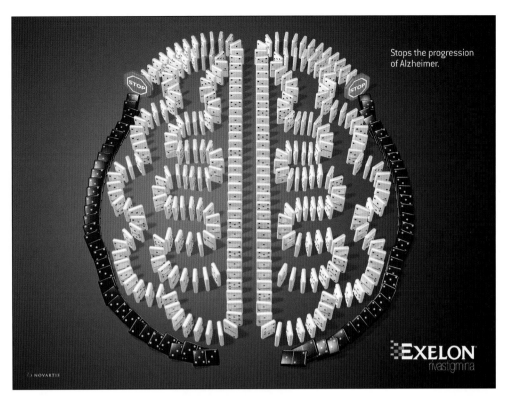

CORPORATE IMAGE

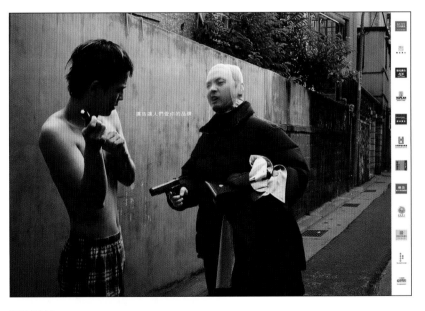

TAIWAN

FINALIST, SINGLE
OGILVY & MATHER ADVERTISING
TAIWAN
TAIPEI

CLIENT The Association Of Accredited
Advertising Agents
EXECUTIVE CREATIVE DIRECTOR Murphy Chou
CREATIVE DIRECTOR Sean Liang
COPYWRITER Popo Wu
ART DIRECTOR Lean Sun

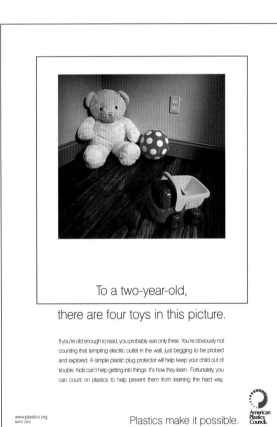

USA

FINALIST, SINGLE
GREY WORLDWIDE
NEW YORK, NY

CLIENT American Plastics
ART DIRECTOR Peter Foster
COPYWRITER Michael Vines

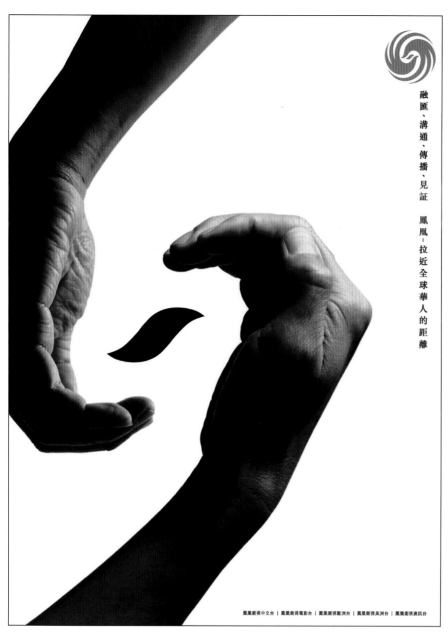

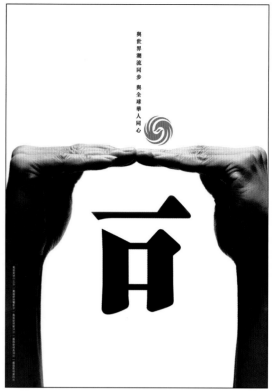

融匯、溝通、傳播、見証　鳳凰–拉近全球華人的距離

與世界潮流同步　與全球華人同心

HONG KONG
SILVER WORLD MEDAL, CAMPAIGN
STAR GROUP LTD.
KOWLOON

CLIENT **Phoenix**
ART DIRECTOR **Cat Lam**
DESIGNER **Stephen So**
PHOTOGRAPHER **Andrew Tang**

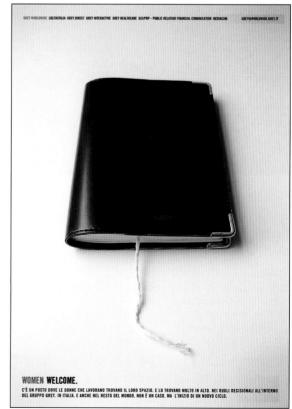

ITALY
FINALIST, SINGLE
GREY WORLDWIDE ITALIA
MILANO

CLIENT **Grey Worldwide for Bellisario Foundation**
EXECUTIVE CREATIVE DIRECTOR **Antonio Maccario**
CREATIVE DIRECTOR **F. Ghiso/V. Gasbarro**
ART DIRECTOR **Vincenzo Gasbarro**
COPYWRITER **Federico Ghiso**

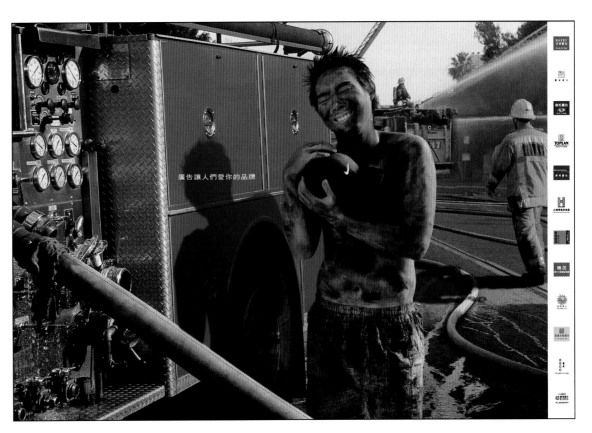

INDUSTRIAL

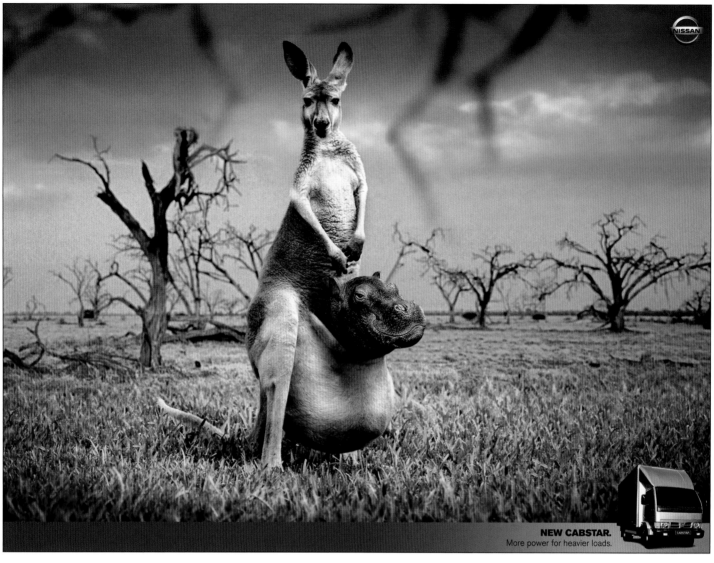

PORTUGAL

GOLD WORLD MEDAL, SINGLE
BBDO PORTUGAL
LISBON

CLIENT Entreposto/Nissan Cabstar
CREATIVE DIRECTOR Gonçalo Morais Leitão
COPYWRITER Nuno Cardoso
ART DIRECTOR Diogo Vieira de Mello
PHOTO PRODUCER Pedro Domingos
CREATIVE SUPERVISOR Marco Dias
PHOTOGRAPHY STUDIO Platinum

GERMANY

BRONZE WORLD MEDAL, SINGLE
LEONHARDT & KERN WERBUNG GMBH
STUTTGART

CLIENT Mercedes-Benz
DIRECTOR MARKETING TRUCKS Andreas Burkhart
SENIOR MANAGER COMMUNICATIONS
Trucks Manuel Torrecillas-Toso
MANAGER COMMUNICATIONS
Trucks Ingeborg Wakob
MANAGING DIRECTOR Steffen K. Schulik
CREATIVE DIRECTOR Andreas Rell

GERMANY

SILVER WORLD MEDAL, CAMPAIGN
CHANGE COMMUNICATION GMBH
FRANKFURT

CLIENT Schuhfabrik van Elten
CREATIVE DIRECTOR Julian Michalski
COPYWRITER Martin Schulz
ART DIRECTOR Boris Aue

CRAFT & TECHNIQUES

BEST ART DIRECTION

Congratulation to New Beetle for being the official car of the 2003 VW International Table Tennis Tournament.

CHINA
SILVER WORLD MEDAL, SINGLE
GREY WORLDWIDE
BEIJING

CLIENT **Volkswagen Group China**
CREATIVE DIRECTOR **Michael Wong**
ART DIRECTOR **Michael Wong/Jason Chi**
COPYWRITER **Mei Hong**
PRODUCTION MANAGER **Kevin Bi**
PHOTOGRAPHER **Ricky So**
DIGITAL RETOUCHER **Wong Chan Chou**

MALAYSIA
FINALIST, SINGLE
BATES (MALAYSIA) SDN BHD
KUALA LUMPUR

CLIENT **100 Plus**
EXECUTIVE CREATIVE DIRECTOR **Ajay Thrivikraman**
ART DIRECTOR **Khoo Choo Kian**
COPYWRITER **Mike Chin**
PHOTOGRAPHER **Khoo Choo Kian**
ACCOUNT DIRECTOR **David Soo**
ACCOUNT EXECUTIVE **Aprel Lim**
PRODUCTION MANAGER **Kuah Sin Fatt**

The biggest challenge of the year
600 km in 30 hours. 9 athletes. Non-stop from KLCC, Kuala Lumpur to City Square, Johor Bahru. Can will power triumph over fatigue? Witness it all on 14 May 2002.

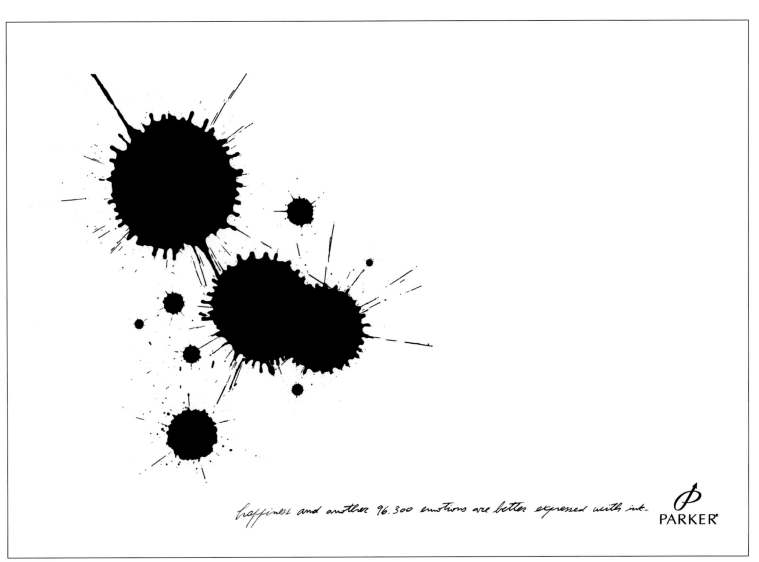

happiness and another 96.300 emotions are better expressed with ink. PARKER®

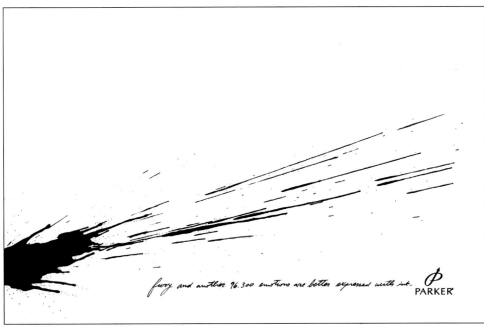

fury and another 96.300 emotions are better expressed with ink. PARKER®

ARGENTINA

GOLD WORLD MEDAL, CAMPAIGN

OGILVY & MATHER ARGENTINA

BUENOS AIRES

CLIENT Parker
GENERAL CREATIVE DIRECTOR Gustavo Reyes
CREATIVE DIRECTOR Aregger/Campopiano/Duhalde/Sanchez Correa
ART DIRECTOR F. Zagales/M. Sanchez Correa
COPYWRITER Mariano Duhalde
GENERAL ART DIRECTOR M. Sanchez Correa
HEAD ACCOUNT Yayo Enriquez

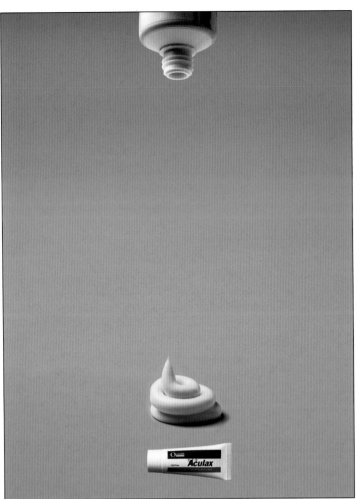

SINGAPORE

BRONZE WORLD MEDAL, SINGLE

VIBES COMMUNICATIONS PTE LTD

TOA PAYOH

CLIENT Aculax
CREATIVE DIRECTOR Ronald Wong
ART DIRECTOR Ronald Wong
COPYWRITER Juliana Sim
PHOTOGRAPHER Lee Jen (J-Studio)

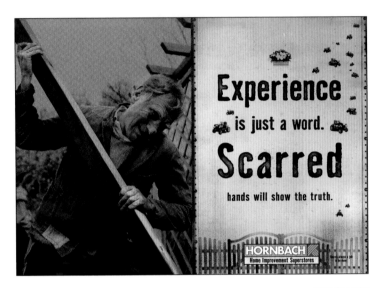

GERMANY

FINALIST, CAMPAIGN

HEIMAT WERBEAGENTUR GMBH

BERLIN

CLIENT Hornbach Home Improvement Superstores
CREATIVE DIRECTOR Guido Heffels/Jürgen Vossen
COPYWRITER Andreas Manthey/Sebastian Kainz
ART DIRECTOR Tim Schneider/Marc Wientzek
PHOTOGRAPHER Alexander Gnädinger

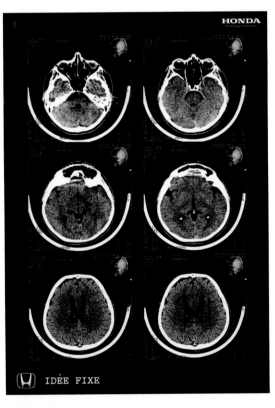

POLAND

FINALIST, SINGLE

AHA SP. Z O.O.

WARSAW

CLIENT Honda
CREATIVE DIRECTOR Agnieszka Stefaniuk
ART DIRECTOR Pawel Moszczyński
COPYWRITER Tomasz Danielewicz

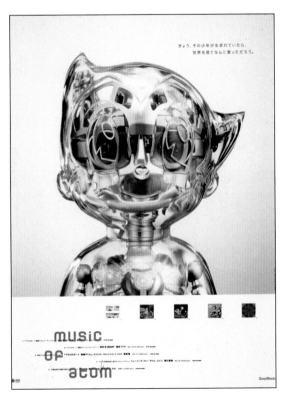

JAPAN

FINALIST, SINGLE

DENTSU.INC

MINATOKU, TOKYO

CLIENT Music Of Atom
ART DIRECTOR Noritoshi Nishioka
WRITER Keita Yamada
CREATIVE DIRECTOR Kazunori Saito
PHOTOGRAPHER Takashi Seo

SOUTH AFRICA

FINALIST, CAMPAIGN
THE JUPITER DRAWING ROOM
RIVONIA, GAUTENG

CLIENT Nike Shox
CREATIVE DIRECTOR Graham Warsop
ART DIRECTOR H. Byrne/V. Norman/S. Blyth
COPYWRITERS Gavin Williams/Brendan Jack
MARKETING DIRECTOR Michelle Wood
PHOTOGRAPHER David Prior
ACCOUNT SUPERVISOR Samantha Van Vuuren
PRODUCTION MANAGER Belinda Shea

GERMANY

FINALIST, CAMPAIGN
SAATCHI & SAATCHI GMBH
FRANKFURT

CLIENT Audi AG
COPYWRITER Eva-Kinkel-Clever
ART DIRECTOR Kirsten Hohls
CREATIVE DIRECTOR Benjamin Lommel
CREATIVE DIRECTOR Harald Wittig
PHOTOGRAPHER Stefan Minder

GERMANY

FINALIST, CAMPAIGN
SAATCHI & SAATCHI GMBH
FRANKFURT AM MAIN

CLIENT Audi AG
COPYWRITER Wolfgang Schaupp
ART DIRECTOR Birol Bayraktar
CREATIVE DIRECTOR Benjamin Lommel
CREATIVE DIRECTOR Harald Wittig

CHILE
FINALIST, SINGLE
WUNDERMAN
SANTIAGO

CLIENT Mistral
CREATIVE DIRECTOR Daslav Maslov
COPYWRITER Andrés Tampassi
ART DIRECTOR Daslav Maslov/Luis Martínez

ART NOT AVAILABLE

this is the truth

if we turn things upside down

we can't be the best country in the world

I would be lying to you if I said that

Argentina has a great future ahead

that we will be a safe country

that our economy will be strong

that our children will be healthy, get an education and have jobs

before anything you must know

our country does not deserve such things

and I am convinced of this because I know the Argentine people

corruption and hypocrisy are in our nature

I refuse to believe under any circumstances that

we could be a great country in the coming years

thanks to the people's votes

this country is sinking to new depths but

there are even more surprises to come

Argentina has only one destiny

and whether we like it or not

this is what is real

you should know I believe exactly the opposite, so please read this from bottom to top.

**LOPEZ MURPHY
PRESIDENT**

ARGENTINA

GOLD WORLD MEDAL, SINGLE
SAVAGLIO TBWA
BUENOS AIRES

CLIENT Recrear
CREATIVE DIRECTOR Ernesto Savaglio
COPYWRITERS Ernesto Savaglio/Alexis Alvarez
ART DIRECTOR Pablo Carrera
ACCOUNT SUPERVISOR Luciano Tidone

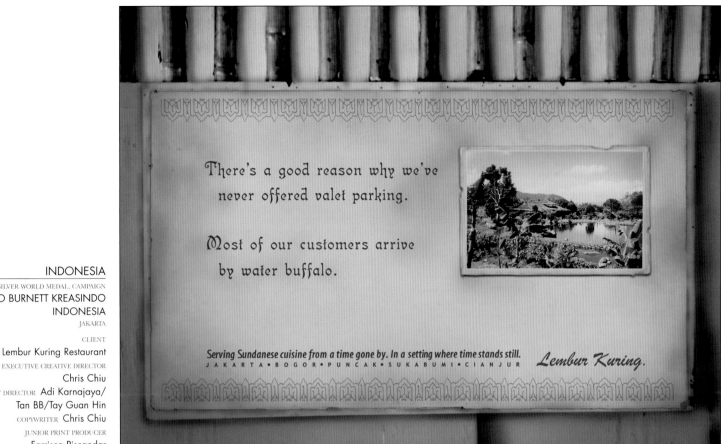

There's a good reason why we've never offered valet parking.

Most of our customers arrive by water buffalo.

Serving Sundanese cuisine from a time gone by. In a setting where time stands still. *Lembur Kuring.*
J A K A R T A • B O G O R • P U N C A K • S U K A B U M I • C I A N J U R

INDONESIA
SILVER WORLD MEDAL, CAMPAIGN
LEO BURNETT KREASINDO INDONESIA
JAKARTA

CLIENT
Lembur Kuring Restaurant
EXECUTIVE CREATIVE DIRECTOR
Chris Chiu
ART DIRECTOR Adi Karnajaya/
Tan BB/Tay Guan Hin
COPYWRITER Chris Chiu
JUNIOR PRINT PRODUCER
Farrisca Piscandar

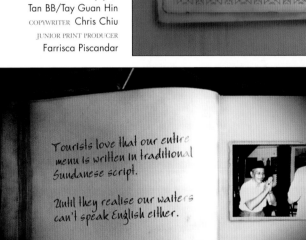

Tourists love that our entire menu is written in traditional Sundanese script.

Until they realise our waiters can't speak English either.

Serving Sundanese cuisine from a time gone by. In a setting where time stands still. *Lembur Kuring.*

CALL for ENTRIES

But don't send in any entries if you're merely an art director.

In fact, don't even bother if you're a copywriter with more than three years under your belt.

Creative directors needn't apply as well.

We already have our own judges, thank you. And they are no strangers to the D&AD, One Show, Cannes and Clio awards either. (As winners, admittedly, and not as judges. But still.)

Can't wait to send in your entries? Here's what you should take note of:

Don't submit any proofs or slides mounted on a board with a less than 1" margin over the ad's actual size. That doodle on your napkin from the other night will do nicely.

Your work need not even be published, printed or broadcast for the first time between the day you were born and today. Remember those old stuff that have been languishing forever in your bottom drawer?

And you can't choose the categories you'd like to enter. That's because there are no categories to choose from. Well, if there is one, it'll be the 'excellent' category.

There're also no entry fees to pay. No forms to fill in. No rules to remember.

Just send in your entries, and particulars, to Gosh Advertising Pte Ltd, 33 Middle Road, #05-01, Singapore 188942. Questions? Email to enquiry@goshadvertising.com

Finally, for all your efforts, we will not be awarding any Silver, Gold or Platinum medals.

But you do get to walk away with a paycheck.

A job. As a copywriter.

SINGAPORE
FINALIST, SINGLE
GOSH ADVERTISING PTE LTD
SINGAPORE

CLIENT Gosh!
CREATIVE DIRECTOR Lim Soon Huat
ART DIRECTOR Vincent Lee

 ENTRY DEADLINE: FRIDAY, 29 AUGUST 2003, 5 PM

Hey, there are worse things than p-p-p-psellismophobia.

I hope you're sitting comfortably (or, in the case of the most chronic victims of kathisophobia, at least leaning against something nice and supportive), since this may take a while. A fact which, in itself, is likely to send most macrophobia sufferers scampering from the room.

Still, if that's all you've got to worry about, you can thank your lucky stars. Because there are a lot of poor souls who are much worse off than you.

Consider, for instance, those who are blighted with the curse of geumaphobia. The very question "What's for lunch?" would probably be enough to bring them out in a cold sweat - very upsetting for any bromidrophobia sufferers in the vicinity.

Or what about the poor athazagoraphobics? Surely you've run into an athazagoraphobic at a party? He's the one who comes up and re-introduces himself every five minutes. And you thought he was just being friendly!

And what a ghastly time papyrophobics must have: No news in the morning, no books at bedtime. None of those sticky little yellow notes at the office, for heaven's sakes.

(Mind you, if you think about what they must do in the bathroom, you'll never shake hands with a papyrophobic again, I promise you.)

But the most ill-fated of all these poor folks must be those who suffer from multiple phobias. What can it be like to be a clinophobic nostophobe, for instance? There must be places that fill with them every night. Perhaps they get together with all the oneirophobic eosophobes. (Hang on...people who are afraid of going home to bed meeting up with people who are afraid of dreams and daylight? The correct scientific term for the lot of 'em is probably "drunks".)

As you can see by the list on the right, we're not making this up. But don't feel left out: Why not try on a phobia for size every now and again?

However, there is some good news (apologies, euphobics). Because no matter what gets you stressed out - from a simple bad day at the office to a case of raging zemmiphobia - there's a nice easy way to manage it.

Simply take Brand's Iron + Vitamin B Complex with Essence of Chicken.

Not only can it make you feel more energetic, the vitamins B6, B12 and folic acid also help to produce haemoglobin. And when combined with Brand's Essence of Chicken (which, as any cheery neopharmaphobic will tell you, has been around for years), they can help you feel a whole lot less tired and much better able to handle stress.

Please don't forget to tell any logophobic pals of yours about it. After all, they've probably all skipped straight to the sports pages where there are lots of nice big pictures.

Cast in order of appearance:

Psellismophobia: Fear of stuttering.

Kathisophobia: Fear of sitting down.

Macrophobia: Fear of long waits.

Geumaphobia: Fear of taste.

Bromidrophobia: Fear of bodily smells.

Athazagoraphobia: Fear of being forgotten.

Papyrophobia: Fear of paper.

Clinophobia: Fear of going to bed.

Nostophobia: Fear of returning home.

Oneirophobia: Fear of dreams.

Eosophobia: Fear of daylight.

Euphobia: Fear of good news.

Zemmiphobia: Fear of the Great Mole Rat. (Honest!)

Neopharmaphobia: Fear of new medicines.

Logophobia: Fear of words.

MALAYSIA

BRONZE WORLD MEDAL, SINGLE
DENTSU YOUNG & RUBICAM SDN BHD
KUALA LUMPUR

CLIENT Cerebos (M) Sdn Bhd
CREATIVE DIRECTOR Neil French/Ompong Remigio/Edward Ong
COPYWRITERS Mike Sutcliffe/Neil French
ART DIRECTOR Neil French/William Tee/Gavin Simpson

Thou shalt not lie, only tell the truth in thy own way.

CAtHEDRAL
The creative center

BELGIUM

FINALIST, CAMPAIGN
CATHEDRAL
HOEILAART

CLIENT CAtHEDRAL
CREATIVE DIRECTOR Marcel Ceuppens
COPYWRITER Marcel Ceuppens/Suzy Davidon
ACCOUNT MANAGER Jean Baisier

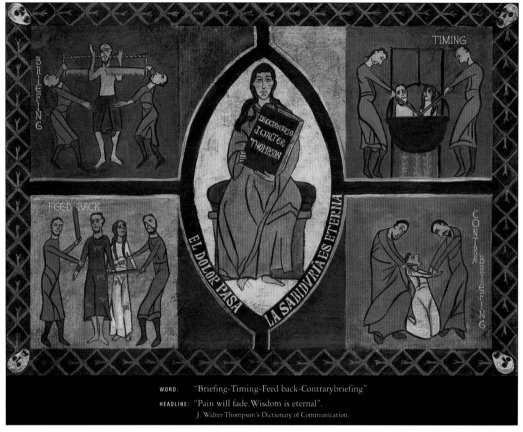

WORD: "Briefing-Timing-Feed back-Contrarybriefing"
HEADLINE: "Pain will fade. Wisdom is eternal".
J. Walter Thompson´s Dictionary of Communication.

SPAIN

BRONZE WORLD MEDAL, CAMPAIGN
J. WALTER THOMPSON MADRID
MADRID

CLIENT J.Walter Thompson Spain
EXECUTIVE CREATIVE DIRECTOR Cesar Garcia
COPYWRITER Jose Luis Alberola
ART DIRECTOR Amabel Minchan
ILLUSTRATOR Mª Mar Solis/Diego Cobo

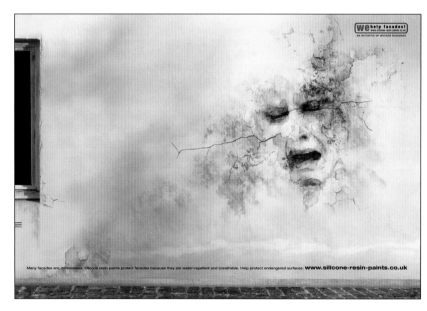

GERMANY

FINALIST, SINGLE
WÄECHTER & WÄECHTER WORLDWIDE PARTNERS GMBH
MUNICH

CLIENT Silicone Resin Emulsion Paints
CREATIVE DIRECTOR Ulrich Schmitz
ART DIRECTOR Florian V. Kornatowski/Baerbel Biwald
TEXT Wiltrud Neuber
PHOTOGRAHER Corinna Holthusen
CONSULTANT Fabian Gueldenpfennig/Martin Hubatschek

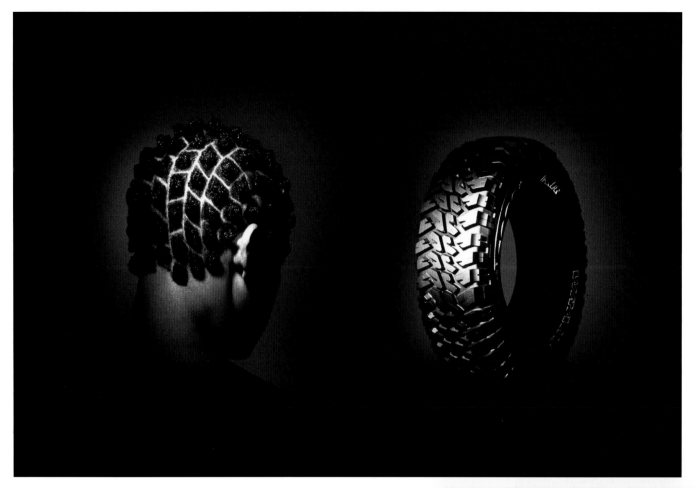

GERMANY

SILVER WORLD MEDAL, CAMPAIGN

LEAGAS DELANEY HAMBURG GMBH

HAMBURG

CLIENT **Goodyear**
CREATIVE DIRECTOR **Regine Berndt**
CREATIVE TEAM **A. Hasselager/Luckasz Brzozowski**
ADVERTISER'S SUPERVISOR **Cynthia van Landeghem**
PHOTOGRAPHER **Kai-Uwe Gundlach**
ADVERTISER'S SUPERVISOR **Cynthia van Landeghem**

SWITZERLAND

FINALIST, CAMPAIGN

LOWE SWITZERLAND

ZÜRICH

CLIENT **Orange**
CREATIVE DIRECTOR **Keith Loell**
ART DIRECTOR **Simon Staub**
COPYWRITER **Martin Stulz**
AGENCY PRODUCER **Evelyn Doessegger**
PHOTOGRAPHER **Grund Flum**
RETOUCHER **Felix Schregenberger**

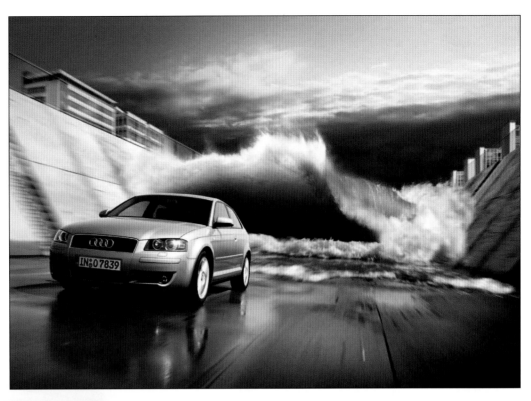

GERMANY

BRONZE WORLD MEDAL, CAMPAIGN

SAATCHI & SAATCHI GMBH

FRANKFURT

CLIENT **Audi AG**

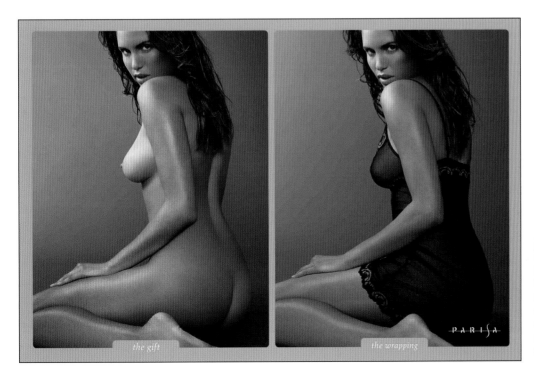

the gift

the wrapping

USA

FINALIST, CAMPAIGN

DDB LOS ANGELES

VENICE, CA

CLIENT **Parisa**

CREATIVE DIRECTOR **Mark Monteiro**

ART DIRECTOR **Christianne Brooks**

COPYWRITER **Rick Bursky**

PHOTOGRAPHER **Steven Lippman**

For the love of cars.

GERMANY

FINALIST, CAMPAIGN

DDB GERMANY
BERLIN

CLIENT VW Volkswagen AG
CREATIVE DIRECTOR Amir Kassaei
ART DIRECTOR Michael Janke/Lars Buri
TEXT Amir Kassaei/Poets*
ACCOUNT DIRECTOR Martin Kraus/Michael Lamm

AUSTRALIA

FINALIST, CAMPAIGN

HEAVEN PICTURES PTY LTD
MELBOURNE, VICTORIA

CLIENT Australian Defence Force

USA

FINALIST, CAMPAIGN

M&C SAATCHI
SANTA MONICA, CA

CLIENT Crystal Cruises
PHOTOGRAPHER Kevin Summers
ART DIRECTOR Graham Johnson
COPYWRITER Oliver Devaris
ART BUYER/PRODUCTION DIRECTOR Linda Cran
CREATIVE DIRECTOR Tom McFarlane
ACCOUNT EXECUTIVE Jason Riley
ACCOUNT DIRECTOR Liz Healy

USA

FINALIST, SINGLE

DDB LOS ANGELES

VENICE, CA

CLIENT **Parisa**
CREATIVE DIRECTOR **Mark Monteiro**
ART DIRECTOR **Christianne Brooks**
COPYWRITER **Rick Bursky**
PHOTOGRAPHER **Steven Lippman**

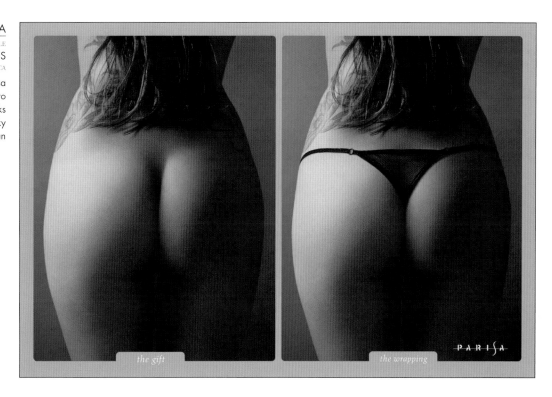

HONG KONG

FINALIST, CAMPAIGN

GARRY STUDIO

HONG KONG

CLIENT **Modelink Model Agency**
PHOTOGRAPHER **Garry Chan**
ART DIRECTOR **Lavin Kwan**
COPYWRITERS **Eliza Yick/Rudi Leung**
COMPUTER RETOUCHER **Bon Leung**
TYPOGRAPHER **Lavin Kwa**

Best Use of Medium

BEST MAGAZINE ADVERTISEMENT

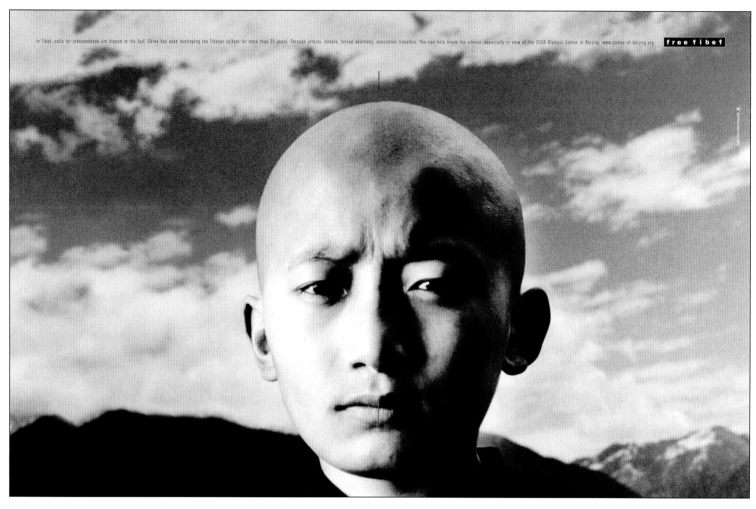

SWITZERLAND

GOLD WORLD MEDAL, SINGLE

EURO RSCG SWITZERLAND

ZURICH

CLIENT **www.games-of-beijing.org**
CREATIVE DIRECTOR **Jürg Aemmer/Frank Bodin**
ART DIRECTOR **Urs Hartmann**
COPYWRITER **Patrick Suter**
PHOTOGRAPHER **Phil Borges**
PRODUCER **Edi Burri**

AUSTRIA

FINALIST, SINGLE

McCANN-ERICKSON VIENNA

VIENNA

CLIENT **L'Oréal Solar Expertise**
CREATIVE DIRECTOR **Bernd Misske**
ART DIRECTOR **Bernhard Sassmann**
COPYWRITER **Markus Henrich**
PHOTOGRAPHER **Heinz Henninger**

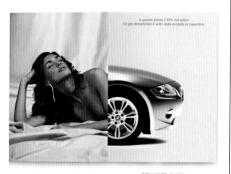

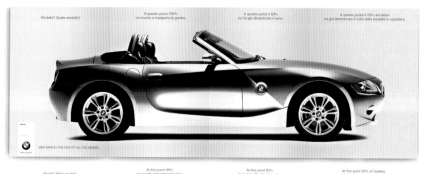

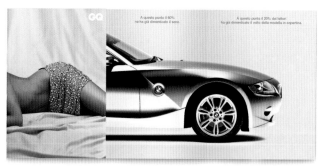

ITALY

SILVER WORLD MEDAL, SINGLE

D'ADDA, LORENZINI, VIGORELLI, BBDO
MILAN

CLIENT **BMW Z4**
CREATIVE DIRECTOR **Vicky Gitto**
ART DIRECTOR **Dario Agnello**
COPYWRITER **Vicky Gitto**

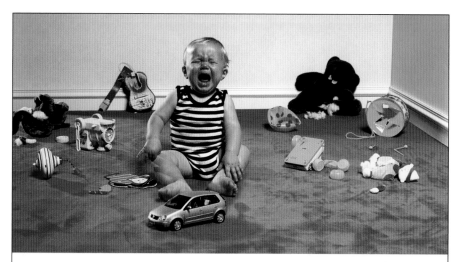

Small but tough. Polo.

GERMANY

FINALIST, SINGLE

DDB GERMANY
BERLIN

CLIENT **VW Polo**
CREATIVE DIRECTOR **Ámir Kassaei/Thomas Chudalla**
ART DIRECTOR **Michael Pfeiffer-Belli/Andreas Böhm**
ACCOUNT DIRECTOR **Levent Akinci**
PHOTO **Marijke de Gruyter**

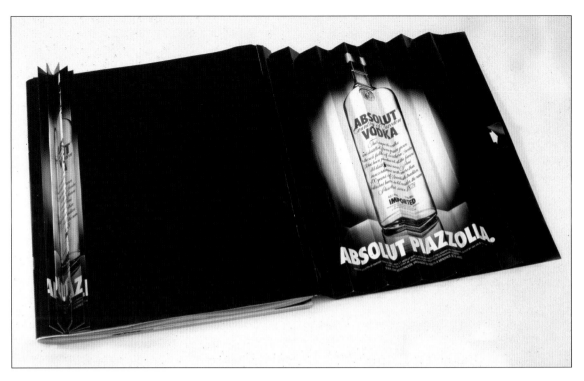

ARGENTINA

BRONZE WORLD MEDAL, SINGLE

SAVAGLIO TBWA

BUENOS AIRES

CLIENT Absolut Vodka
CREATIVE DIRECTOR Ernesto Savaglio
COPYWRITER Vicki Santiso
ART DIRECTOR Diego Lipser
ACCOUT SUPERVISOR Luciano Tidone

AUSTRIA

FINALIST, SINGLE

FCB KOBZA ADVERTISING AGENCY

VIENNA

CLIENT Wiener Volksbildungswerk
CREATIVE DIRECTOR Christian Wurzer
COPYWRITER Goran Golik/Patrik Partl
GRAPHIC Goran Golik/Sophie Matysek

BEST NEWSPAPER ADVERTISEMENT

KOREA

FINALIST, SINGLE

CHEIL COMMUNICATIONS INC.

SEOUL

CLIENT Wonderbra
ART DIRECTOR Han, Seong Wook/
Kim, Jong Min
COPYWRITER Choi, a Un
COMPUTER ILLUSTRATOR Yang Jung Suh

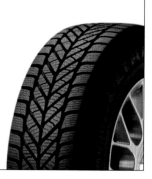

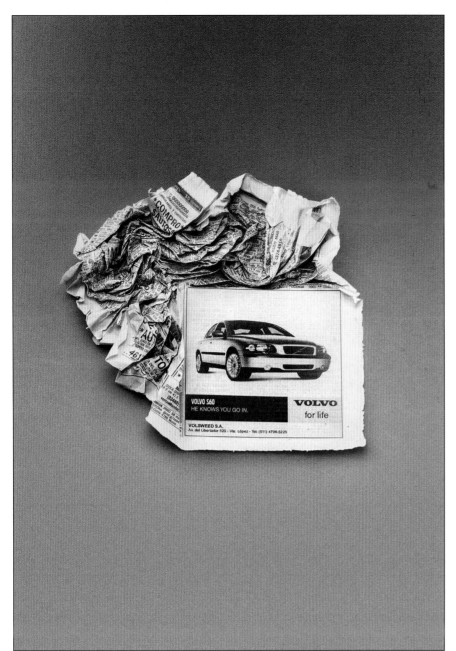

ARGENTINA

SILVER WORLD MEDAL, SINGLE

J. WALTER THOMPSON
BUENOS AIRES

CLIENT Ford Argentina/Volvo

EXECUTIVE CREATIVE DIRECTOR
Leandro Raposo/Pablo Stricker

CREATIVE DIRECTOR Christian Camean/
Ramiro Crosio/Javier Mentasti

AUSTRIA

BRONZE WORLD MEDAL, SINGLE

JUNG VON MATT/DONAU WERBEAGENTUR GMBH
VIENNA

CLIENT BMW

CREATIVE DIRECTOR Gerd Schulte-Doeinghaus

ART DIRECTOR Eva Ortner

COPYWRITER Christoph Gaunersdorfer

ACCOUNT SUPERVISOR Karin Novozamsky/Caroline Floh

PUBLIC SERVICE

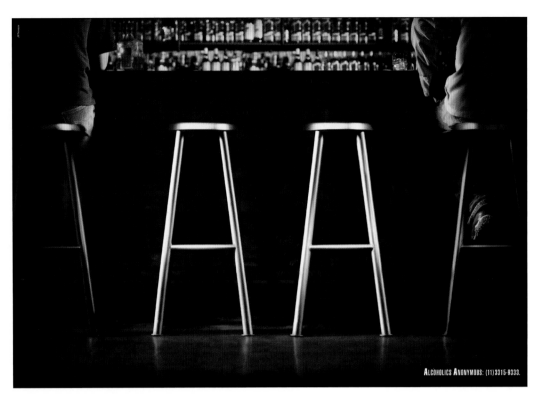

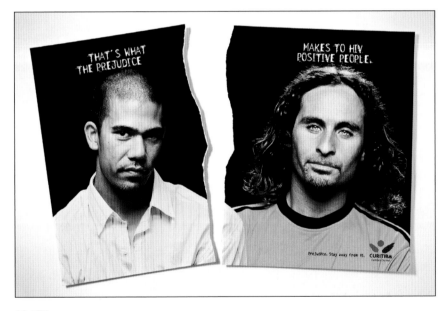

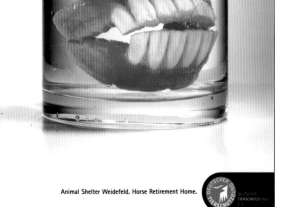

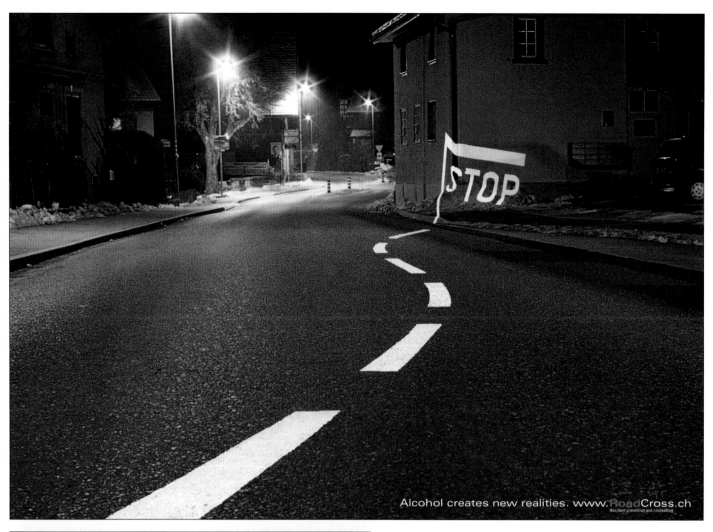

Alcohol creates new realities. www.RoadCross.ch
Accident prevention and counselling

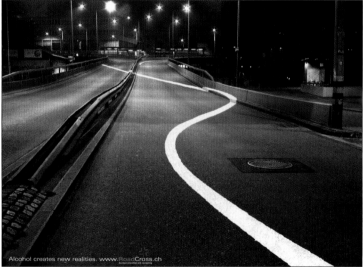

Alcohol creates new realities. www.RoadCross.ch
Accident prevention and counselling

SWITZERLAND

SOUTH AFRICA

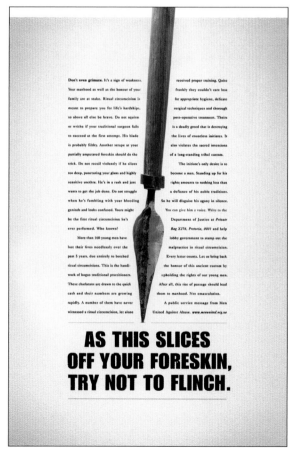

**AS THIS SLICES
OFF YOUR FORESKIN,
TRY NOT TO FLINCH.**

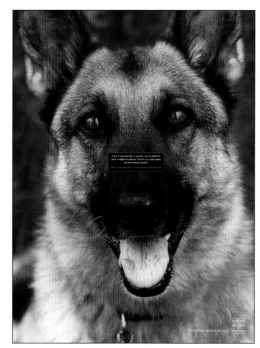

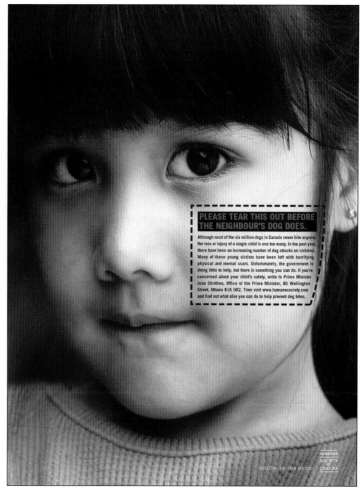

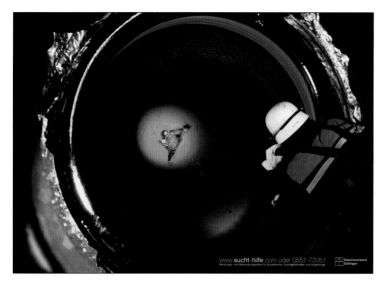

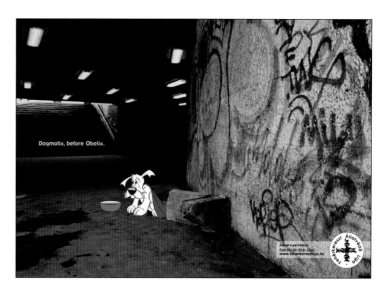

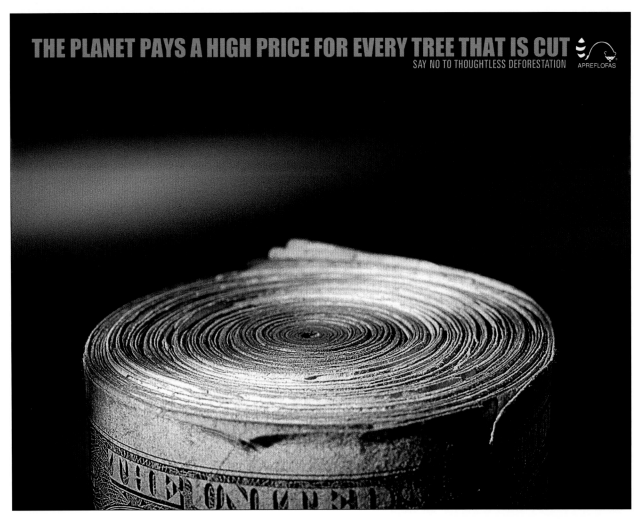

THE PLANET PAYS A HIGH PRICE FOR EVERY TREE THAT IS CUT
SAY NO TO THOUGHTLESS DEFORESTATION · APREFLOFAS

COSTA RICA

DDB COSTA RICA
SAN JOSÉ

CLIENT **Apreflofas**
EXECUTIVE CREATIVE DIRECTOR **Jaime Cueto**
CREATIVE DIRECTOR **Sebastian Coronas**
ART DIRECTOR **Juan José Ulate**
COPYWRITER **Jaime Cueto/Sebastían Coronas**
ACCOUNT SUPERVISOR **Jaime Cueto**
CLIENT **Luis Diego Marín**
PHOTOGRAPHER **Raúl Crucé**
PRODUCTION MANAGERS **F. Jiménez/O. Sánchez**

JAPAN

HAKUHODO INC.
TOKYO

CLIENT **The Mainichi Newspapers**
CREATIVE DIRECTOR **Kazuto Fukushima**
ART DIRECTOR **Kotaro Hirano**
COPYWRITER **Itaru Yoshizawa/Seiichi Okura**
ACCOUNT EXECUTIVE **Masafumi Tsumura/Jojo Shimizu**
DESIGNER **Yuichi Hosobuchi**

Spit here.

That's about all the moisture some trees need to thrive.
For a list of drought-tolerant species, visit treeutah.org or call 364-2122.

TreeUtah

PLEASE SAVE THE TIGER

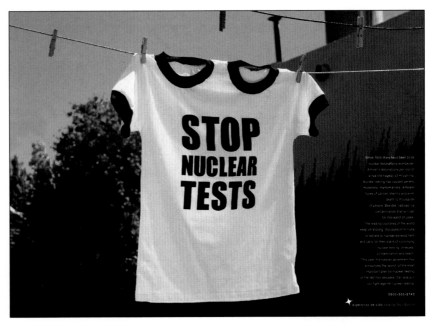

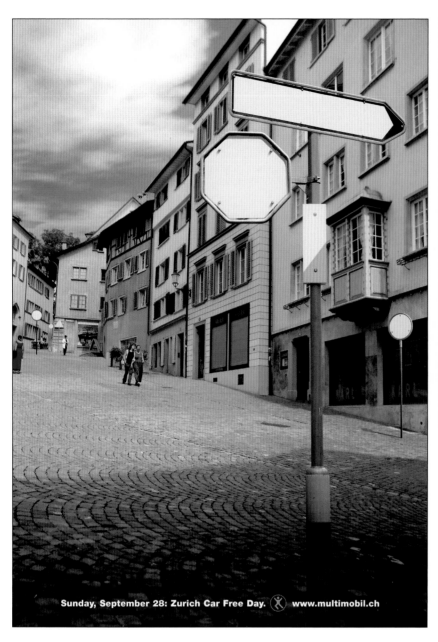

Sunday, September 28: Zurich Car Free Day. www.multimobil.ch

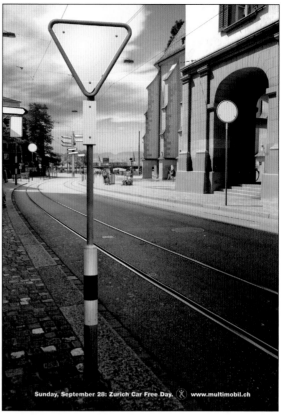

Sunday, September 28: Zurich Car Free Day. www.multimobil.ch

SWITZERLAND
SILVER WORLD MEDAL, CAMPAIGN
WYLER WERBUNG
ZUERICH

CLIENT Amt für Umwelt- und
Gesundheitsschutz, Lorenz Steinmann

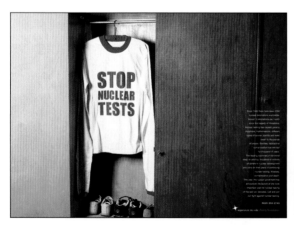

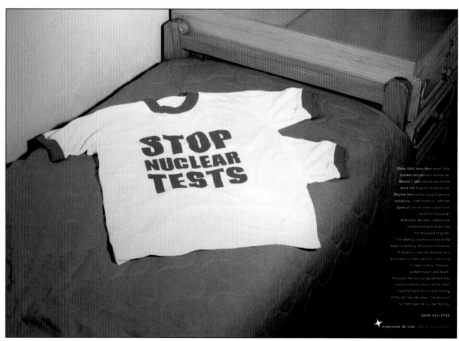

ARGENTINA
BRONZE WORLD MEDAL, CAMPAIGN
CRAVEROLANIS EURO RSCG
BUENOS AIRES

CLIENT Fundacion Esperanza De Vida
GENERAL CREATIVE DIRECTOR Juan Cravero/Darío Lanis
COPYWRITER Ariel Serkin/Juan Pablo Lufrano
ART DIRECTOR Diego Sánchez
PHOTOGRAPHER Diana Deak

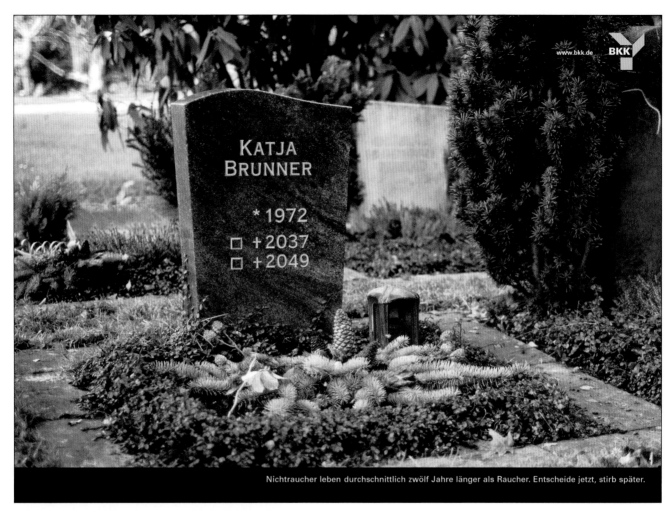

KATJA
BRUNNER

* 1972
☐ † 2037
☐ † 2049

Nichtraucher leben durchschnittlich zwölf Jahre länger als Raucher. Entscheide jetzt, stirb später.

www.bkk.de BKK

GERMANY
SILVER WORLD MEDAL, SINGLE
TILLMANNS, OGILVY & MATHER
DUESSELDORF

CLIENT BKK Bundesverband
CREATIVE DIRECTOR Volker Kuwertz
COPY Marcus Haefs
ART DIRECTOR Thomas Bullinger

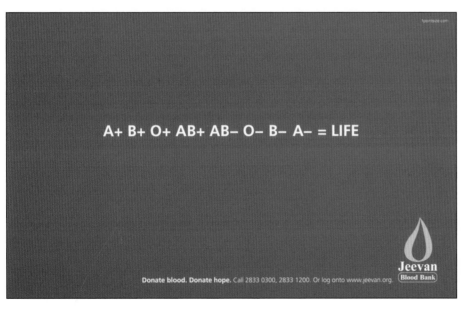

A+ B+ O+ AB+ AB– O– B– A– = LIFE

Donate blood. Donate hope. Call 2833 0300, 2833 1200. Or log onto www.jeevan.org.

INDIA
FINALIST, SINGLE
1POINTSIZE
CHENNAI, TAMIL NADU

CLIENT Jeevan Blood Bank
CREATIVE DIRECTOR Sharad Haksar
ART DIRECTOR C. P. Sajith
COPYWRITER Anantha Narayan
CREATIVE COORDINATOR Ratika Haksar

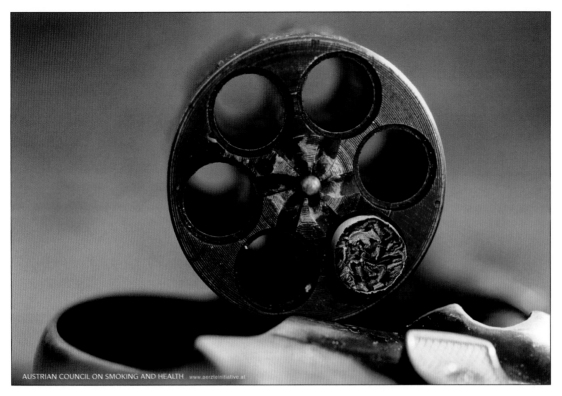

AUSTRIAN COUNCIL ON SMOKING AND HEALTH www.aerzteinitiative.at

AUSTRIA

BRONZE WORLD MEDAL, SINGLE
LOWE GGK
VIENNA

CLIENT Austrian Council On Health And Smoking
CREATIVE DIRECTOR & CONCEPT Walther Salvenmoser
PHOTOGRAPHER Dieter Brasch
STOCK AGENCY Contrastphoto
POST PRODUCTION Blaupapier & Viennapaint

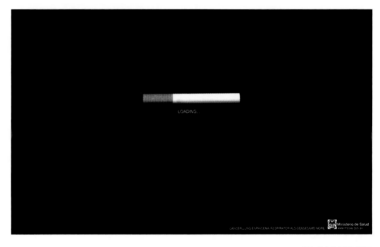

EL SALVADOR

FINALIST, SINGLE
APEX BBDO
SAN SALVADOR, SAN SALVADO

CLIENT Ministerio de Salud
CREATIVE VICE-PRESIDENT Salvador Martínez
CREATIVE DIRECTOR Gerardo Guevara

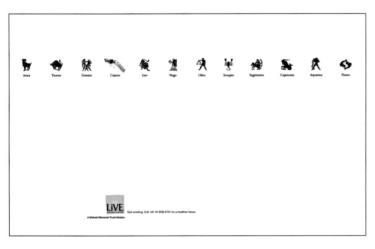

INDIA

FINALIST, SINGLE
1POINTSIZE
CHENNAI, TAMIL NADU

CLIENT Mahesh Memorial Trust
CREATIVE DIRECTOR Sharad Haksar
ART DIRECTOR C. P. Sajith
COPYWRITER Anantha Narayan
COORDINATOR Ratika Haksar

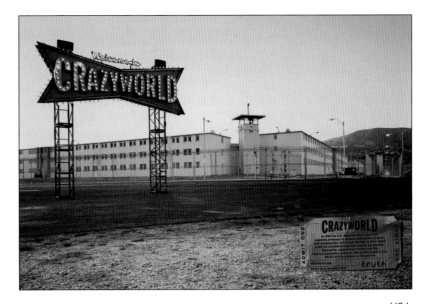

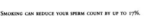
UNITED ARAB EMIRATES

FINALIST, SINGLE

BATES PANGULF

DUBAI

CLIENT Emirate - German Fertility Clinic
CREATIVE DIRECTOR Dominic Stallard
GROUP ACCOUNT DIRECTOR Aziz Memon
PHOTOGRAPHER Homi Karanjia

USA

FINALIST, SINGLE

ARNOLD WORLDWIDE

BOSTON, MA

CLIENT American Legacy Foundation
ART DIRECTOR Rob Baird/Lee Einhorn
COPYWRITER Roger Baldacci/John Kearse/Mike Howard
CHIEF CREATIVE OFFICER Ron Lawner
EXECUTIVE CREATIVE DIRECTOR Alex Bogusky/Pete Favat
CREATIVE DIRECTOR Roger Baldacci/Tom Adams

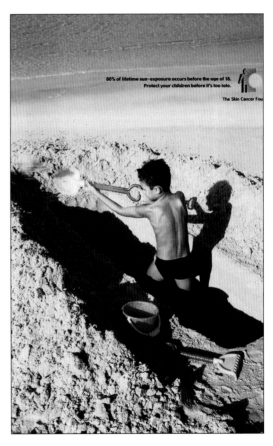

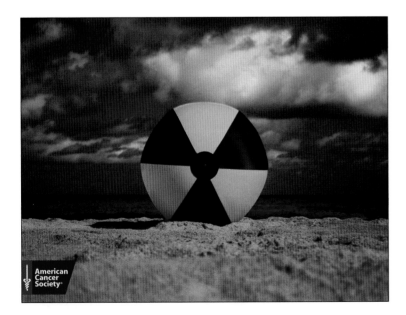

USA

FINALIST, SINGLE

CONCEPTO UNO

BAYAMON, PR

CLIENT American Cancer Society
CREATIVE DIRECTOR Victor LLeras/
Francisco Fernandez
PHOTOGRAPHY Concepto UNO

UNITED ARAB EMIRATES

FINALIST, SINGLE

TEAM YOUNG & RUBICAM

DUBAI

CLIENT Skin Cancer Foundation
EXECUTIVE CREATIVE DIRECTOR Sam Ahmed
CREATIVE DIRECTOR Marc Lineveldt
ART DIRECTOR Peter Walker
COPYWRITER James Wareham
PHOTOGRAPHER Jean Le Prini

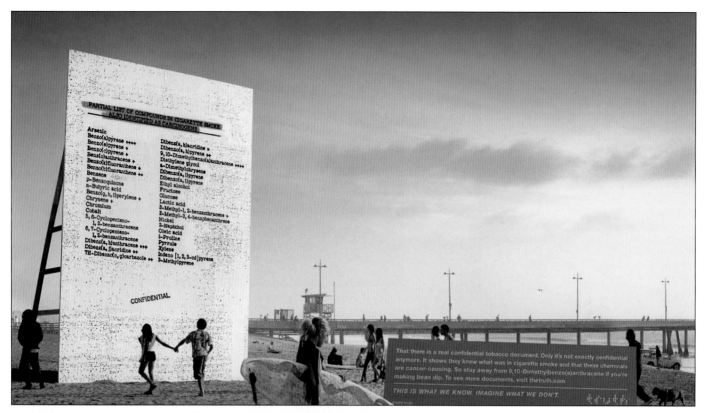

USA

GOLD WORLD MEDAL, CAMPAIGN
ARNOLD WORLDWIDE
BOSTON, MA

CLIENT American Legacy Foundation
ART DIRECTOR Rob Baird
COPYWRITER Roger Baldacci
CHIEF CREATIVE OFFICER Ron Lawner
EXECUTIVE CREATIVE DIRECTOR Alex Bogusky/Pete Favat
CREATIVE DIRECTOR Roger Baldacci/Tom Adams
PHOTOGRAPHER Chad Ress

PERSONAL SAFETY

PHILIPPINES
FINALIST, SINGLE
McCANN ERICKSON PHILIPINES
MAKATI CITY

CLIENT Gentxt
EXECUTIVE CREATIVE DIRECTOR Teeny Gonzales
CREATIVE DIRECTOR Russell Molina
ART DIRECTOR Julio Jose Malantic
COPYWRITER Mervin Ignacio
ACCOUNT EXECUTIVE Jasmin Uson/Nathan de Guzman

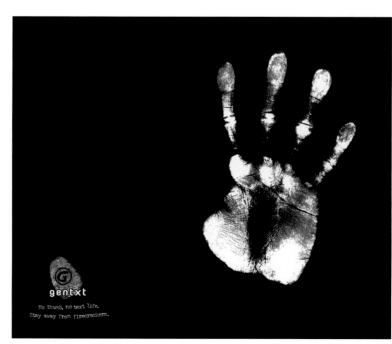

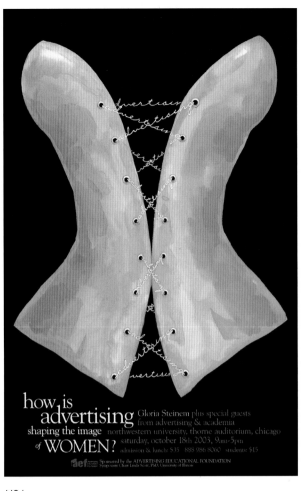

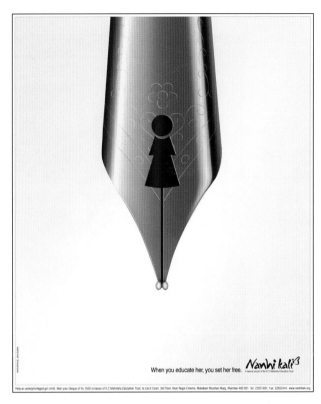

USA

FINALIST, SINGLE

BBDO CHICAGO

CHICAGO, IL

CLIENT Women In Advertising
ART DIRECTOR Angela Finney
COPYWRITER Shane Greenwood
GROUP CREATIVE DIRECTOR Gail Pollack
CHIEF CREATIVE OFFICER Marty Orzio

INDIA

FINALIST, SINGLE

INTERFACE COMMUNICATIONS

MUMBAI, MAHARASHTRA

CLIENT Nanhi Kali
CREATIVE SUPERVISOR Ashutosh Joshi
CREATIVE DIRECTOR Robby Mathew
PHOTOGRAPHER Saish Kambli

INTERPERSONAL/INTERGROUP RELATIONS

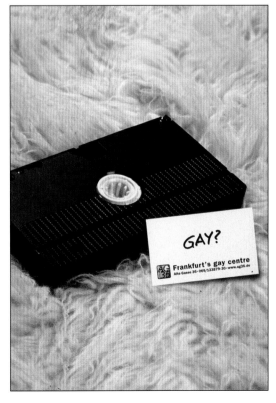

GERMANY

FINALIST, SINGLE

McCANN-ERICKSON FRANKFURT/
M., GERMANY

FRANKFURT

CLIENT Ag 36 (Aidshilfe Frankfurt E.V.)
CREATIVE DIRECTOR Thomas Auerswald/
Walter Roux
ART DIRECTOR Uli Happel
PHOTOGRAPH Frank Weinert
ACCOUNT DIRECTOR Stefan Geisse

PHILANTHROPIC APPEALS

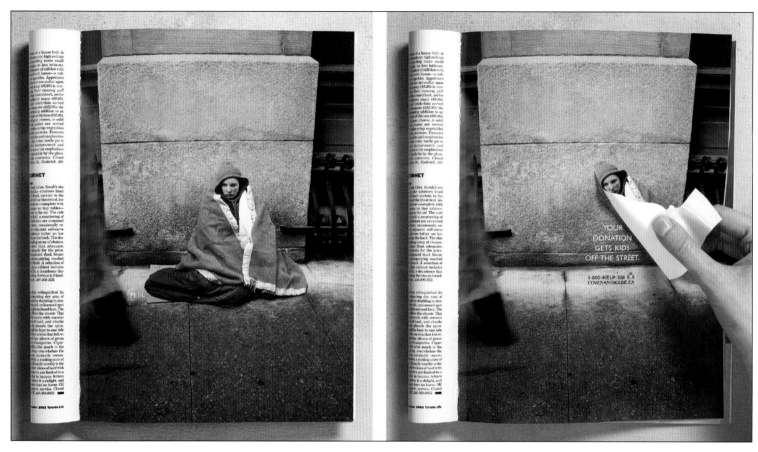

CANADA

GOLD WORLD MEDAL, SINGLE

TAXI

TORONTO, ONTARIO

CLIENT **Covenant House**
CREATIVE DIRECTOR **Zak Mroueh**
ART DIRECTOR **Alan Madill**
COPYWRITER **Terry Drummond**
PHOTOGRAPHER **Frank Hoedl**
AGENCY PRODUCER **Judy Boudreau**
TYPOGRAPHER **Peter Hodson**
ACCOUNT EXECUTIVE **Nicola Slade**

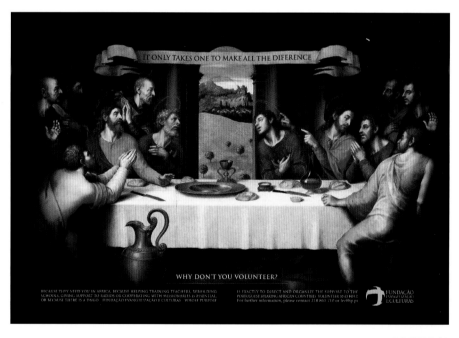

PORTUGAL

FINALIST, SINGLE

PUBLICIS

LISBON

CLIENT **FEC - Fundação Evangelização e Culturas**
CREATIVE DIRECTOR **Elizabete Vaz Mena/**
Cristiano Zancuoghi
COPYWRITER **Cristina Amorim**
ART DIRECTOR **Gito**
POST PRODUCTION **João Trabuco**
ACCOUNT SUPERVISOR **Duarte Abreu**

172 THE NEW YORK FESTIVALS

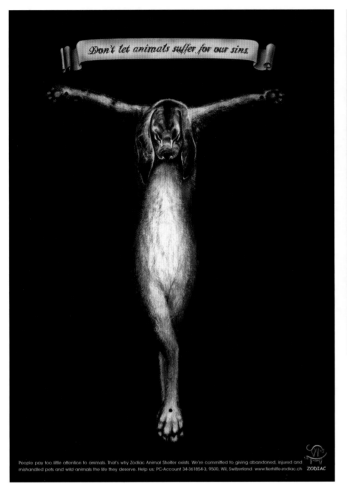

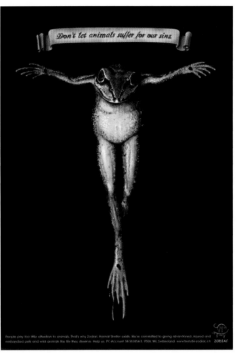

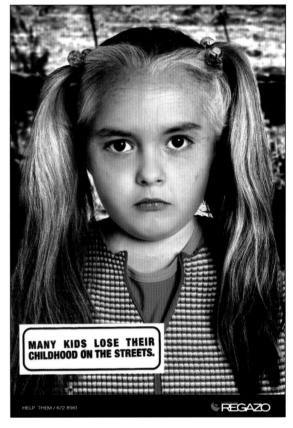

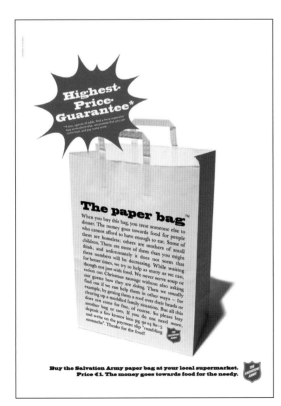

SPAIN

SILVER WORLD MEDAL, CAMPAIGN
McCANN-ERICKSON
MADRID

CLIENT Médicos Sin Fronteras
GENERAL CREATIVE DIRECTOR Nicolás Hollander
ART DIRECTOR Victor Aguilar
COPY David Moure
PRINT PRODUCTION MANAGER Sara Fernández

ITALY

FINALIST, SINGLE
McCANN-ERICKSON S.P.A
MILAN

CLIENT Convivo
CREATIVE DIRECTOR Federica Ariagno/
Giorgio Natale
ART DIRECTOR Paola Manfrin
COPYWRITER Angelo Pannofino
PHOTOGRAPHER Stefano Pandini

Amnesty International
OPENING SOON. CALL: 302 5062.

HUNGARY
GOLD WORLD MEDAL, SINGLE
OGILVY & MATHER
BUDAPEST
CLIENT Amnesty International Hungary
ART DIRECTOR/CREATIVE DIRECTOR Dalbir Singh
COPYWRITER Dalbir Singh
EXECUTIVE CREATIVE DIRECTOR Alex Szenassy

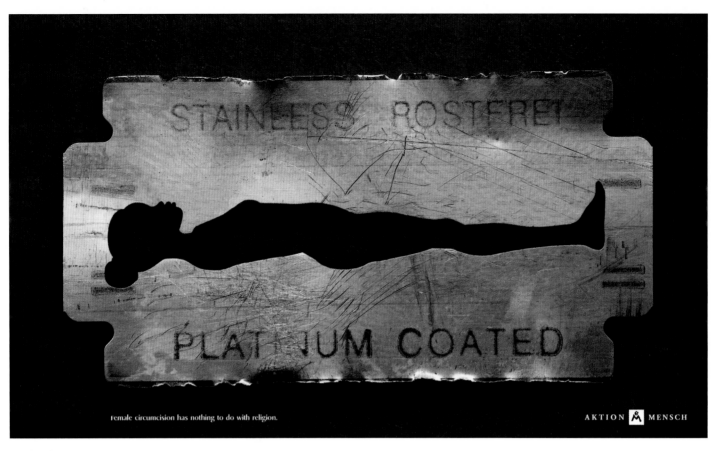

Female circumcision has nothing to do with religion.

AKTION MENSCH

AUSTRIA

SILVER WORLD MEDAL, SINGLE

LOWE GGK

VIENNA

CLIENT **Lowe GGK/Aktion Mensch**
CREATIVE DIRECTOR & CONCEPT **Walther Salvenmoser**
CREATIVE DIRECTOR & CONCEPT **Athanassios Stellatos**
PHOTOGRAPHER **Oliver Jiszda**
ILLUSTRATOR **Ken Sakurai Karner**
POST PRODUCTION **Viennapaint/Christian Ruff**

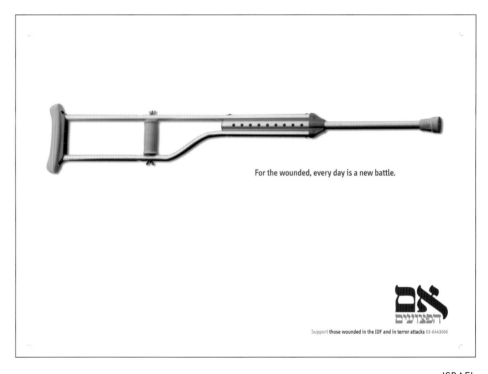

For the wounded, every day is a new battle.

Support those wounded in the IDF and in terror attacks 03-6443066

ISRAEL

FINALIST, SINGLE

SHALMOR AVNON AMICHAY/ Y&R

TEL AVIV

CLIENT **Em Haptzuim: Mother of the Wounded**
CHIEF CREATIVE OFFICER **Gideon Amichay**
CREATIVE DIRECTOR **Tzur Golan**
ART DIRECTOR **Doron Goldenberg**
COPYWRITER **Israel Gaon**
PHOTOGRAPHER **Yoram Aschheim**
ACCOUNT SUPERVISOR **Sarit Rona**
ADVERTISOR'S SUPERVISOR **Merav Perry**

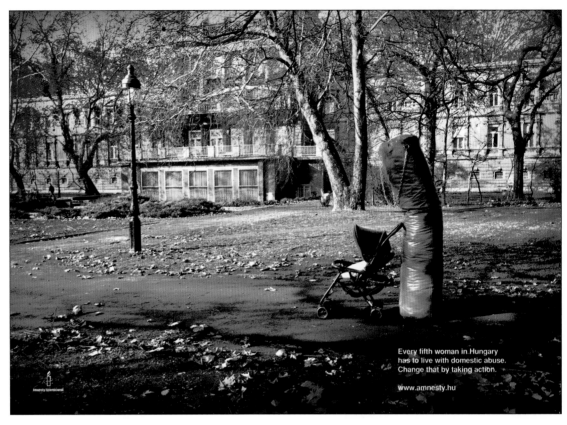

Every fifth woman in Hungary
has to live with domestic abuse.
Change that by taking action.

www.amnesty.hu

HUNGARY

BRONZE WORLD MEDAL, CAMPAIGN
LEO BURNETT BUDAPEST
BUDAPEST

CLIENT **Amnesty International**
CREATIVE DIRECTOR **Milos Ilic**
ART DIRECTOR **Milos Ilic**
COPYWRITER **Dezso Nagy/Vilmos Farkas**
PHOTOGRAPHER **Csaba Jobbagy**
STRATEGIC PLANNER **Agnes Fazakas**
ACCOUNT EXECUTIVE **Peter Laszlo**

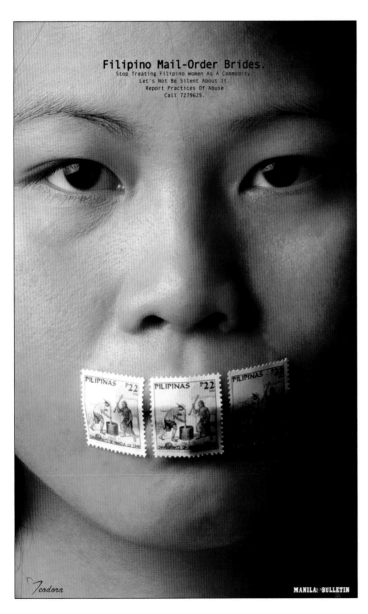

Filipino Mail-Order Brides.
Stop Treating Filipino Women As A Commodity.
Let's Not Be Silent About It.
Report Practices Of Abuse
Call 7279625.

MANILA BULLETIN

PHILIPPINES

BRONZE WORLD MEDAL, SINGLE
DDB PHILIPPINES, INC.
PASIG CITY

CLIENT **Teodora**

GRAND
AWARD

Outdoor, Poster, and Transit

SOUTH AFRICA

GRAND AWARD
BEST BILLBOARD
TEQUILA JOHANNESBURG
BENMORE, JOHANNESBURG

CLIENT **SABC 3**
ART DIRECTOR **George Rautenbach**
COPYWRITER **Samantha Koenderman**
CREATIVE DIRECTOR **Margie Backhouse/Petra Oelofse**
EXECUTIVE PRODUCTION MANAGER **Sherrol Doyle-Swallow**

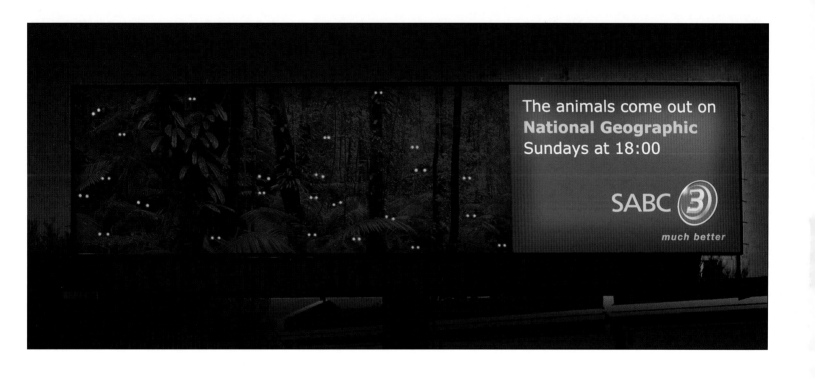

The animals come out on
National Geographic
Sundays at 18:00

SABC ③

much better

PRODUCTS & SERVICES

APPAREL

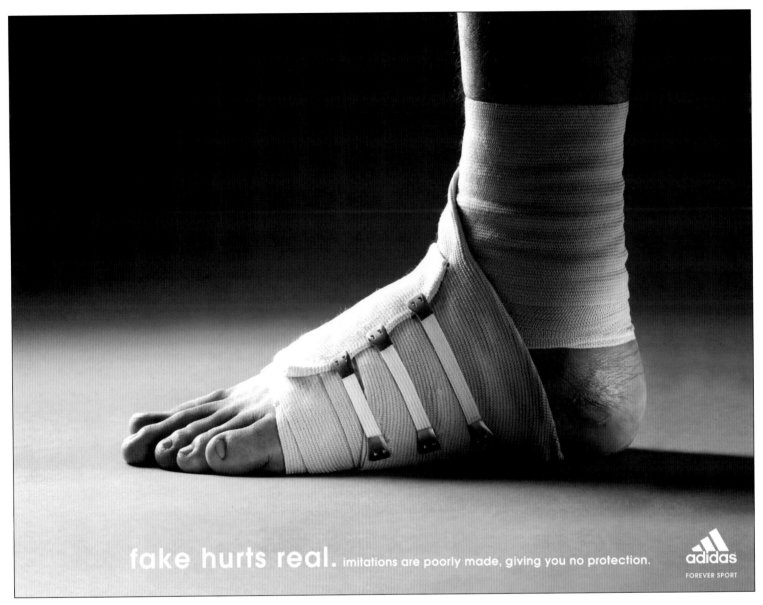

fake hurts real. imitations are poorly made, giving you no protection.

adidas
FOREVER SPORT

PHILIPPINES
GOLD WORLD MEDAL, SINGLE
TBWA\SANTIAGO MANGADA PUNO
MAKATI

CLIENT adidas
WRITER Melvin M. Mangada/
Joey Campillo
ART DIRECTOR Evans Sator
PHOTOGRAPHER Jeanne Young
PRINT PRODUCER May Dalisay

Push-up Bras. *Audrey*

MALAYSIA
FINALIST, SINGLE
DENTSU YOUNG & RUBICAM SDN BHD
KUALA LUMPUR

CLIENT Audrey International
CREATIVE DIRECTOR Barry Low/Gavin Simpson
COPYWRITER John Dorai
ART DIRECTOR/TYPOGRAPHER Karen Wong
TYPOGRAPHER Karen Wong

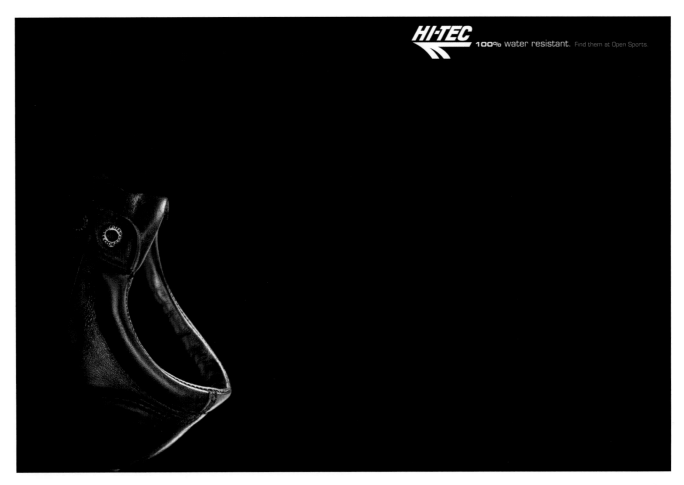

ARGENTINA

SILVER WORLD MEDAL, SINGLE

OGILVY & MATHER ARGENTINA

BUENOS AIRES

CLIENT Hi-Tec
GENERAL CREATIVE DIRECTOR Gustavo Reyes
CREATIVE DIRECTOR Campopiano/Duhalde/
Arpegger/Sanchez Correa
ART DIRECTOR Javier Busto
COPYWRITER Walter Aregger
GENERAL ART DIRECTOR Maximiliano Sanchez Correa
HEAD ACCOUNT Yayo Enriquez
PHOTOGRAPHY STUDIO Malcu

KOREA

FINALIST, SINGLE

LG AD

SEOUL

CLIENT Nike
CREATIVE DIRECTOR Bo Hyun Hwang
ART DIRECTOR Hun Jong Jang
GRAPHIC DESIGNER Jong Ho Baik
ACCOUNT EXECUTIVE Sung Woong Park

INDIA
FINALIST, SINGLE
REDIFFUSION-DENTSU
YOUNG & RUBICAM PVT. LTD.
NEW DELHI

CLIENT W Womans Wear
SENIOR. CREATIVE DIRECTOR Nitin Suri
ASSOCIATE CREATIVE DIRECTOR Chraneeta Mann
CLIENT SERVICES DIRECTOR Prince Arora
PHOTOGRAPHER Sanjoy Chatterjee

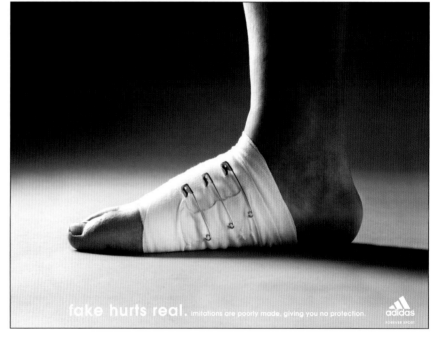

PHILIPPINES
FINALIST, SINGLE
TBWA\SANTIAGO MANGADA PUNO
MAKATI

CLIENT adidas
COPYWRITER Melvin M. Mangada/Joey Campillo
ART DIRECTOR Evans Sator
PHOTOGRAPHER Jeanne Young
PRINT PRODUCER May Dalisay

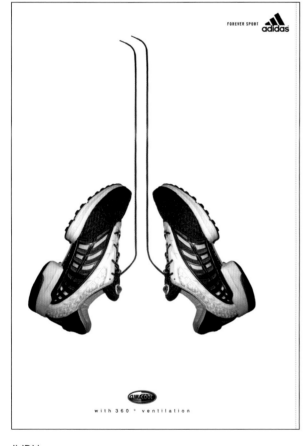

INDIA
FINALIST, SINGLE
TBWA\INDIA
NEW DELHI, NEW DELHI

CLIENT Adidas
COPYWRITER Shubhabrata Sarkar
ART DIRECTOR Sudhir Bhagat
PHOTOGRAPHER Sudhir Bhagat

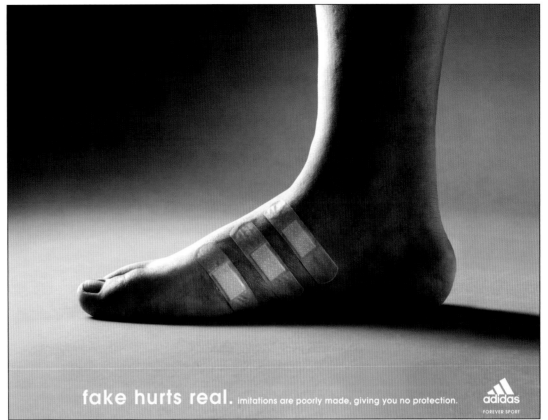

fake hurts real. imitations are poorly made, giving you no protection.

adidas FOREVER SPORT

PHILIPPINES

BRONZE WORLD MEDAL, CAMPAIGN

TBWA\SANTIAGO MANGADA PUNO

MAKATI

CLIENT adidas

COPYWRITER Melvin M. Mangada/Joey Campillo

ART DIRECTOR Evans Sator

PHOTOGRAPHER Jeanne Young

PRINT PRODUCER May Dalisay

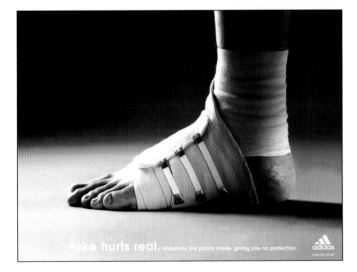

fake hurts real. imitations are poorly made, giving you no protection.

adidas FOREVER SPORT

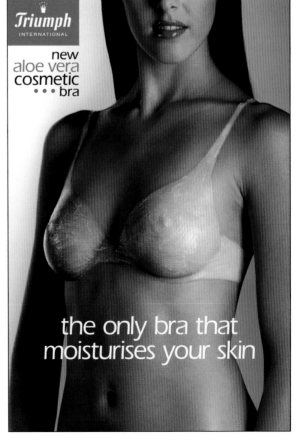

Triumph INTERNATIONAL

new aloe vera cosmetic ••• bra

the only bra that moisturises your skin

AUSTRALIA

FINALIST, CAMPAIGN

BCM PARTNERSHIP

FORTITUDE VALLEY

CLIENT Triumph International

CREATIVE DIRECTOR Greville Patterson

WRITER Nick Ikonomou

ART DIRECTOR Ian Jensen

PHOTOGRAPHER Alex Buckingham

AUTOMOTIVE

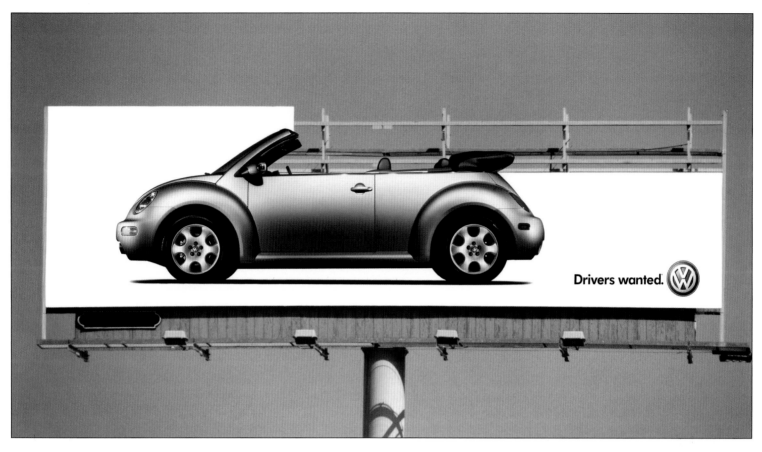

USA

GOLD WORLD MEDAL, SINGLE
ARNOLD WORLDWIDE
BOSTON, MA

CLIENT **Volkswagen**

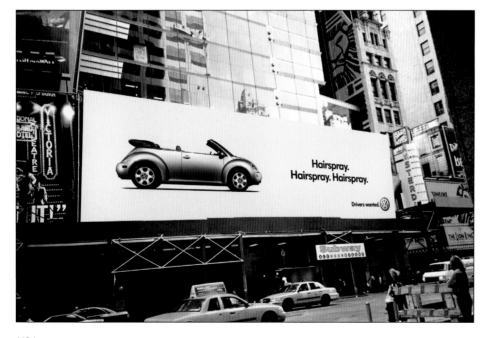

USA

FINALIST, SINGLE
ARNOLD WORLDWIDE
BOSTON, MA

CLIENT **Volkswagen**

GERMANY

SILVER WORLD MEDAL, SINGLE

TBWA \

BERLIN

CLIENT Nissan Pick Up
CREATIVE DIRECTOR Kai Röffen/Knut Burgdorf
ART DIRECTOR Rainer Schmidt
COPYWRITER Donald Tursman
ACCOUNT Heike Beckmann
CLIENT/ADVERTISING MANAGER Michael Freund

ARGENTINA

FINALIST, SINGLE

CRAVEROLANIS EURO RSCG

BUENOS AIRES

CLIENT Peugeot Boxer
GENERAL CREATIVE DIRECTOR Juan Cravero/Darío Lanis
COPYWRITER Juan Pablo Iufrano/Adolfo Rodríguez Saa
ART DIRECTOR Agustina Anguita

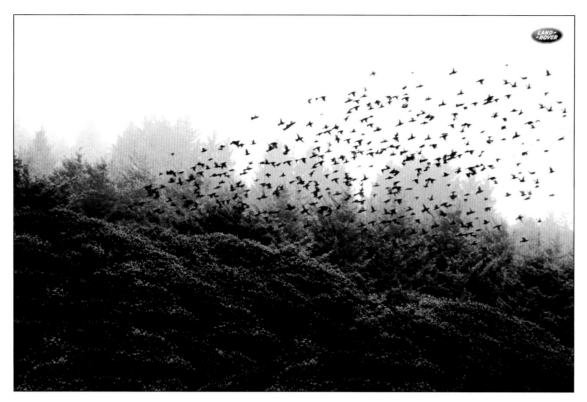

MEXICO
BRONZE WORLD MEDAL, SINGLE
OGILVY & MATHER MEXICO
MEXICO CITY

CLIENT Land Rover
CREATIVE DIRECTOR Marco Colín/Miguel Angel Ruiz

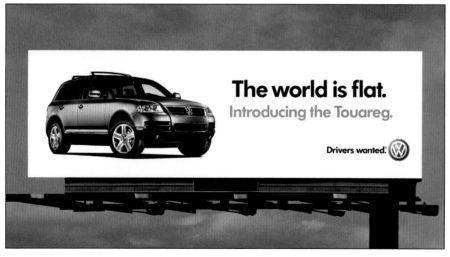

USA
FINALIST, SINGLE
ARNOLD WORLDWIDE
BOSTON, MA

CLIENT Volkswagen

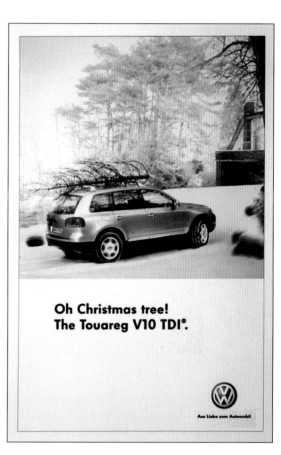

GERMANY
FINALIST, SINGLE
GRABARZ & PARTNER
HAMBURG

CLIENT Volkswagen Touareg
CREATIVE DIRECTOR P. Pätzold/R. Nolting
CHIEF CREATIVE OFFICER R. Heuel
ART DIRECTOR Maik Kähler/David-Alexander Preufl
COPYWRITER Ralf Heuel
PHOTOGRAPHER Jan van Endert/Hamburg
AGENCY Grabarz & Partner Werbeagentur GmbH

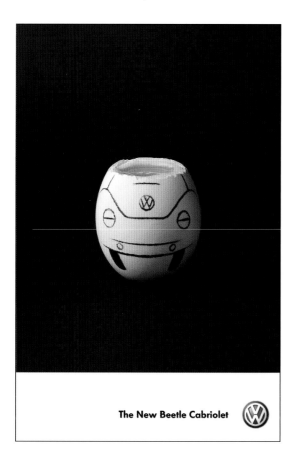

The New Beetle Cabriolet

GERMANY

FINALIST, SINGLE
DDB GERMANY
BERLIN

CLIENT VW New Beetle Cabriolet
CREATIVE DIRECTOR Text Thomas Chudalla
CREATIVE DIRECTOR Amir Kassaei
ART DIRECTOR Michael Pfeiffer-Belli/Anabel Kunitzky
ACCOUNT DIRECTOR Levent Akinci
GRAPHIC Anabel Kunitzky
PHOTOGRAPHER Jan Steinhilber

Voted world's best SUV. Touareg

JAPAN

FINALIST, SINGLE
DDB TOKYU AGENCY CREATIVE INC.
TOKYO

CLIENT Volkswagen
CREATIVE DIRECTOR Ken Trevor
COPYWRITER Ken Trevor
ART DIRECTOR Masakazu Kubota/Kengo Maeda
PHOTOGRAPHER Akio Inden
COMPUTER ARTIST Kazuma Muneto

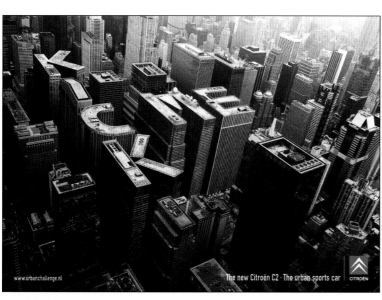

The new Citroën C2 · The urban sports car

www.urbanchallenge.nl

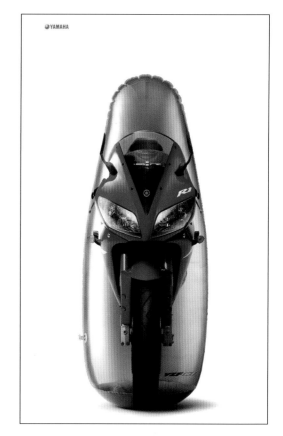

THE NETHERLANDS

FINALIST, SINGLE
EURO RSCG BLRS
AMSTELVEEN

CLIENT Citroën C2
CREATIVE DIRECTOR Martin Boomkens
ART DIRECTOR Bert Kerkhof
COPYWRITER Ivar van den Hove
PHOTOGRAPHER Jaap Vliegenthart

MALAYSIA

FINALIST, SINGLE
DENTSU YOUNG & RUBICAM SDN BHD
KUALA LUMPUR

CLIENT Hong Leong Yamaha Distributors Sdn Bhd
CREATIVE DIRECTOR Gavin Simpson
COPYWRITERS Gavin Simpson/Ong Shi Ping/Jeff Ooi
ART DIRECTOR Jeff Ooi/Ong Shi Ping/Gavin Simpson
PHOTOGRAPHER Edmund Leong of Barney Studio

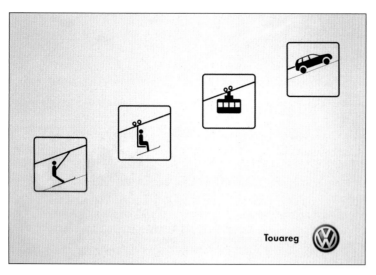

GERMANY

FINALIST, SINGLE
GRABARZ & PARTNER
HAMBURG

CLIENT Volkswagen Touareg
CREATIVE DIRECTOR R. Nolting/P. Pätzold
CHIEF CREATIVE OFFICER R. Heuel
COPYWRITER Thies Schuster
ILLUSTRATOR D. A. Preufl/G. Quittmann
AGENCY Grabarz & Partner Werbeagentur GmbH
GRAPHIC ARTIST David-Alexander Preufl

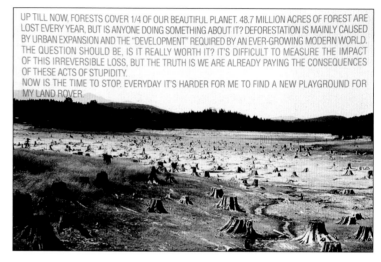

MEXICO

FINALIST, SINGLE
OGILVY & MATHER MEXICO
MEXICO CITY

CLIENT Land Rover
CREATIVE DIRECTOR Marco Colín/Miguel Ángel Ruiz
COPYWRITER Miguel Ángel Ruiz
ART DIRECTOR Iván Carrasco

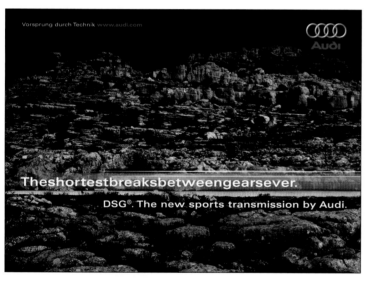

GERMANY

FINALIST, SINGLE
SAATCHI & SAATCHI GMBH
FRANKFURT

CLIENT Audi AG
COPYWRITER Stefan Craul
ART DIRECTOR Anne Henkel
CREATIVE DIRECTOR Benjamin Lommel/Harald Wittig
HEAD OF PRINT PRODUCTION Klaus Schüler

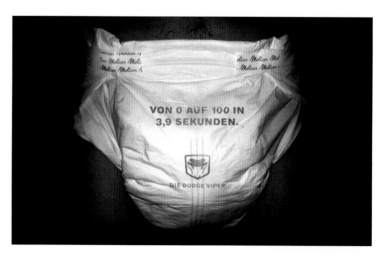

GERMANY

FINALIST, SINGLE
KNSK WERBEAGENTUR GMBH
HAMBURG

CLIENT DaimlerChrysler Dodge Viper
CREATIVE DIRECTOR Tim Krink/Ulrike Wegert
ART DIRECTOR Christoph Stricker
COPYWRITER Berend Brüdgam

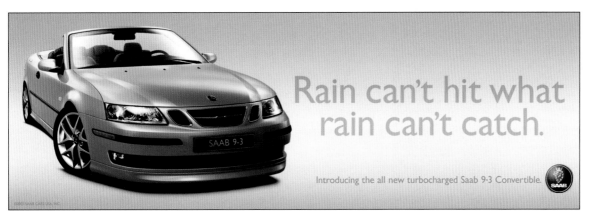

USA

FINALIST, SINGLE

LOWE
NEW YORK, NY

CLIENT Saab Cars USA, Inc.
SENIOR ART DIRECTOR John Szalay
CREATIVE DIRECTOR/ART DIRECTOR
Simon Bowden
CREATIVE DIRECTOR/COPYWRITER
Mark Ronquillo
EXECUTIVE CREATIVE DIRECTOR
Dean Hacohen
CHIEF CREATIVE OFFICER Gary Goldsmith
PHOTOGRAPHER Jonas Karlsson

USA

FINALIST, CAMPAIGN

ARNOLD WORLDWIDE
BOSTON, MA

CLIENT Volkswagen
ART DIRECTOR Adele Ellis
COPYWRITER Susan Ebling Corbo
CHIEF CREATIVE OFFICER Ron Lawner
EXECUTIVE CREATIVE DIRECTOR Alan Pafenbach
PHOTOGRAPHER Brian Garland
PRODUCTION MANAGER John Gray
ART PRODUCER Andrea Ricker

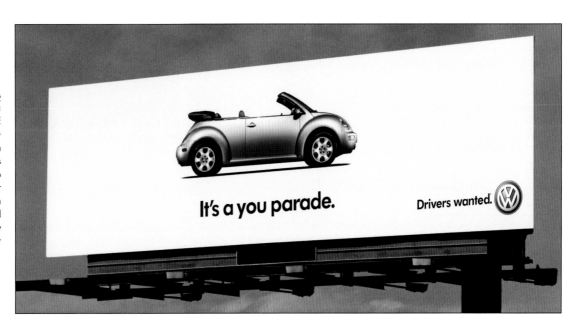

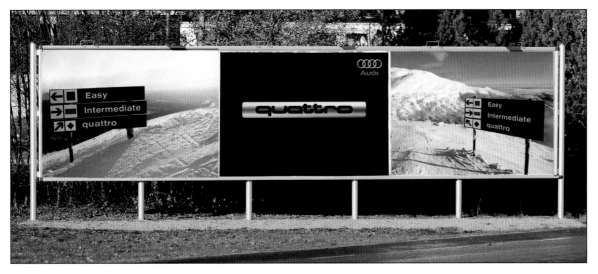

SWEDEN

FINALIST, SINGLE

STENSTROM RED CELL
STOCKHOLM

CLIENT Audi
PROJECT LEADER Greger Stenström
ART DIRECTOR Patrik Bruckner
COPYWRITER Olle Nordell

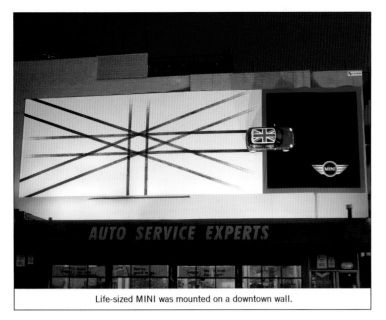

Life-sized MINI was mounted on a downtown wall.

CANADA

FINALIST, SINGLE

TAXI
TORONTO, ONTARIO

CLIENT Mini
CREATIVE DIRECTOR Zak Mroueh
ART DIRECTOR Lance Martin
COPYWRITER Zak Mroueh
PHOTOGRAPHER Steve Jackson
ILLUSTRATOR Michael Fellini
AGENCY PRODUCER Judy Boudreau
TYPOGRAPHER Brad Kumaraswamy
ACCOUNT EXECUTIVE Joe Ottorino

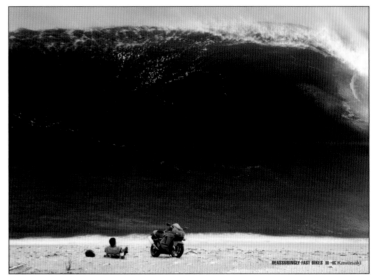

GERMANY

FINALIST, SINGLE

TBWA \
BERLIN

CLIENT Kawasaki Motors GmbH
CREATIVE DIRECTOR Kurt Georg Dieckert/
Stefan Schmidt
ART DIRECTOR Boris Schwiedrzik
COPYWRITER Helge Blöck
DESIGN Christine Taylor
PHOTOGRAPHY Getty Images
RETOUCHING Robin Preston
ACCOUNT Anika Möllemann

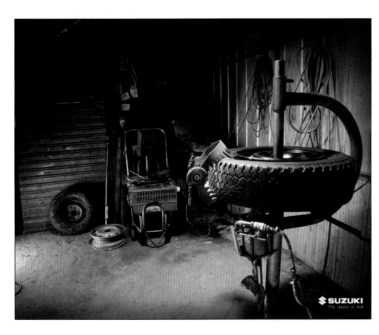

CHILE

FINALIST, SINGLE

ZEGERS DDB
SANTIAGO

CLIENT Suzuki/4X4
CREATIVE DIRECTOR/COPYWRITER Gonzalo Ricca
CREATIVE DIRECTOR/ART DIRECTOR Pablo Izzi
ART DIRECTOR Gustavo Benedetto
ACCOUNT EXECUTIVE Carolina Velasco
PHOTOGRAPHY STUDIO Eseis
PHOTOGRAPHER Hugo Contreras
AGENCY PRODUCER Lorena Tapia

USA
FINALIST, CAMPAIGN
CAMPBELL-EWALD
WARREN, MI
CLIENT Chevrolet

What would you expect from a city with a statue of a fist?

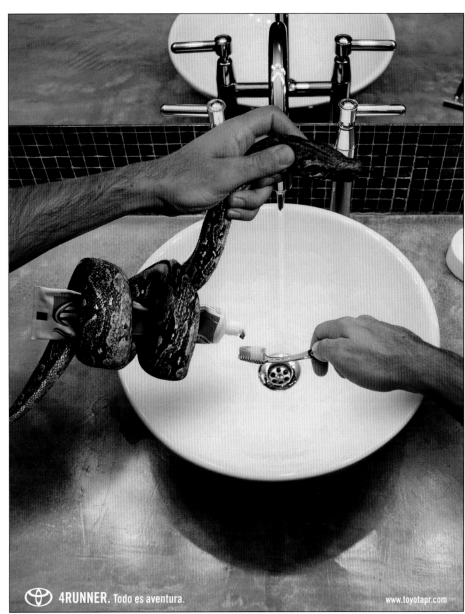

4RUNNER. Todo es aventura.
www.toyotapr.com

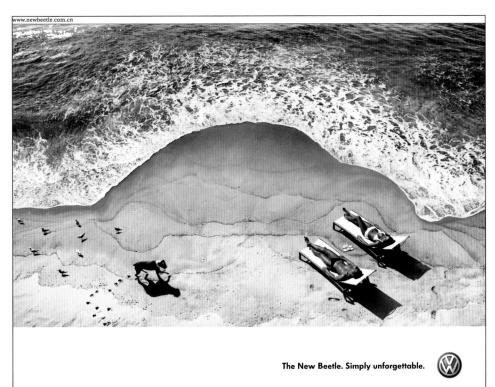

www.newbeetle.com.cn

The New Beetle. Simply unforgettable.

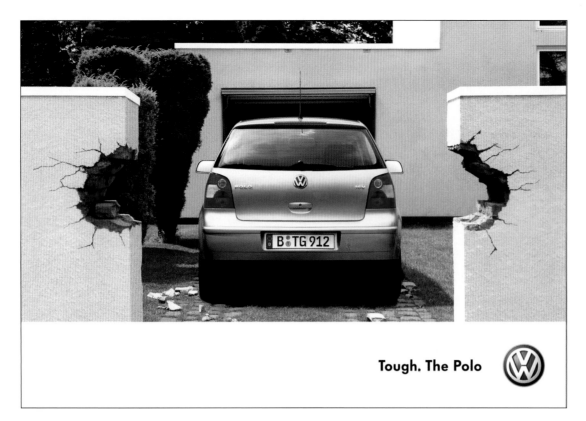

Tough. The Polo

GERMANY

BRONZE WORLD MEDAL, CAMPAIGN
DDB GERMANY
BERLIN

CLIENT VW Polo
CREATIVE DIRECTOR Thomas Chudalla/Amir Kassaei
ART DIRECTOR Michael Pfeiffer-Belli/Wiebke Bethke
TEXT Lina Jachmann/Jan Fröscher
ACCOUNT DIRECTOR Levent Akinci
PHOTO Marijke de Gruyter/Holger Wild
ART DIRECTOR Andreas Böhm/Ronald Liedmeier

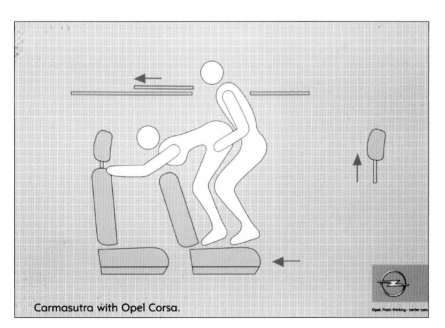

Carmasutra with Opel Corsa.

DEVELOPMENT? MODERN WORLD?
INDUSTRY CAN CALL IT WHATEVER IT WANTS, BUT THE TRUTH IS
THEY ONLY WANT TO FILL THEIR POCKETS AT ANY COST, EVEN
NATURE'S COST. DEFORESTATION IS GETTING OUT OF HAND, NOT
EVEN HALF OF WHAT IS LOST IS BEING REGENERATED. URBANIZATION
IS KILLING OUR ENVIRONMENT AND ECOSYSTEM. WE ARE LOSING
FORESTS, RIVERS, OCEANS, DESERTS AND OTHER WONDERS THIS
WORLD HAS TO OFFER. DO THEY REALLY THINK THEY ARE DOING
SOME GOOD, OR ARE THEY ACTUALLY STUPID?
WE CAN'T ALLOW THIS TO KEEP ON. NOW I CAN'T EVEN FIND ANY
TREES IN WHICH TO ZIGZAG WITH MY LAND ROVER.

GERMANY

FINALIST, CAMPAIGN
McCANN-ERICKSON FRANKFURT/M., GERMANY
FRANKFURT

CLIENT Adam Opel AG
EXECUTIVE CREATIVE DIRECTOR Rainer Bollmann
ART DIRECTOR Georg Lauble/Tim Böhm
COPYWRITER Milos Lukic
ILLUSTRATOR Debora Ducci

MEXICO

FINALIST, CAMPAIGN
OGILVY & MATHER MEXICO
MEXICO CITY

CLIENT Land Rover
CREATIVE DIRECTOR Marco Colín/
Miguel Ángel Ruiz
COPYWRITER Miguel Ángel Ruiz
ART DIRECTOR Iván Carrasco

SWITZERLAND
BRONZE WORLD MEDAL, SINGLE
RUF LANZ WERBEAGENTUR AG
ZÜRICH

CLIENT Suva Accident Insurance
CREATIVE DIRECTOR Danielle Lanz/
Markus Ruf
COPYWRITER Markus Ruf
ART DIRECTOR Danielle Lanz
PHOTOGRAPHER Stefan Minder
PICTURE EDITOR Felix Schregenberger
TYPOGRAPHER Katja Puccio
ADVERTISER'S SUPERVISOR Susan Huber/
Urs Schaad

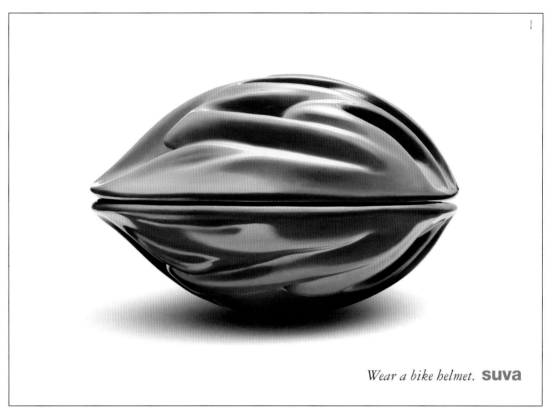

Wear a bike helmet. **suva**

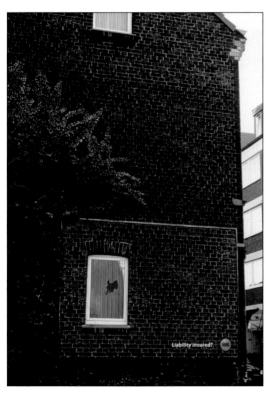

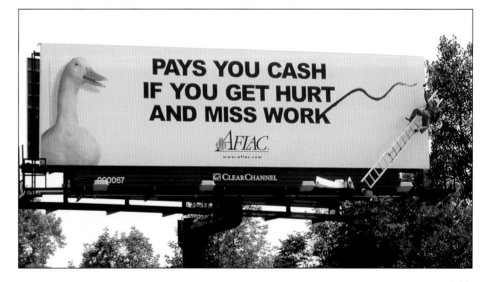

USA
FINALIST, SINGLE
THE KAPLAN THALER GROUP
NEW YORK, NY

CLIENT AFLAC
ART DIRECTOR Mike Hanley
COPYWRITER Alex Avsharian
ACCOUNT DIRECTOR Karen Cunningham
SENIOR ACCOUNT EXECUTIVE Dhiren Khemlani

GERMANY

FINALIST, CAMPAIGN
BUTTER AGENTUR FUER WERBUNG
GMBH
DUESSELDORF

CLIENT ARAG Insurances

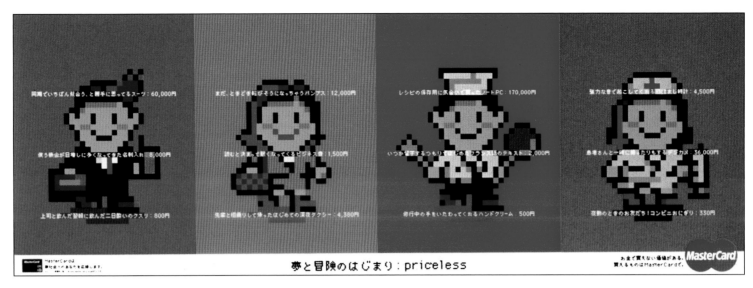

JAPAN

BRONZE WORLD MEDAL, CAMPAIGN
McCANN ERICKSON INC.
TOKYO

CLIENT MasterCard
CREATIVE DIRECTOR Kazuya Mototani
ART DIRECTOR Keiichiro Fukushima/
Masayuki Yokokawa
COPYWRITER Hiroshi Kagawa

AUTOMOTIVE PRODUCTS

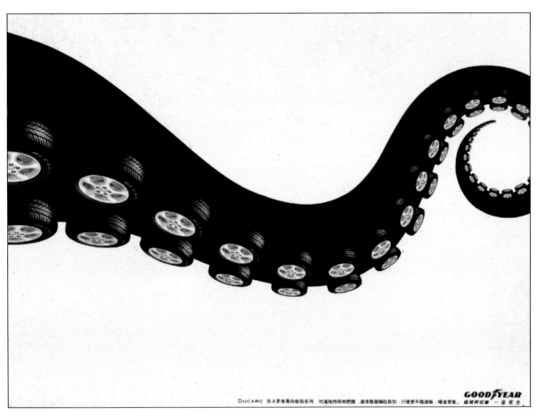

CHINA

BRONZE WORLD MEDAL, SINGLE
McCANN-ERICKSON GUANGMING LTD.
BEIJING

CLIENT Goodyear
SENIOR CREATIVE DIRECTOR Jordan Hsueh
ART DIRECTOR He Shiyang
COPYWRITER Yu Jing

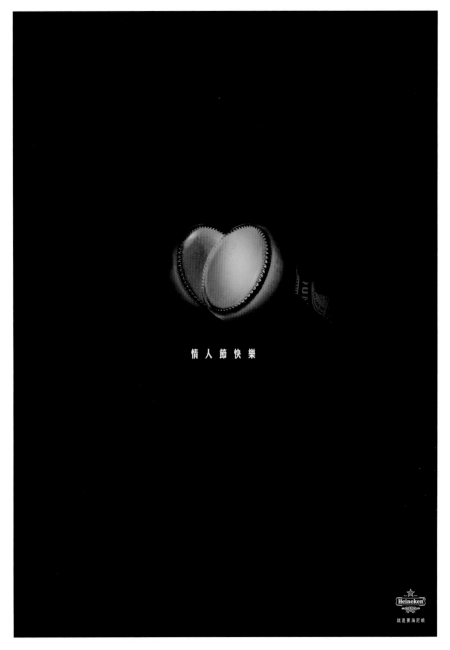

情 人 節 快 樂

TAIWAN

SILVER WORLD MEDAL, SINGLE
LEO BURNETT COMPANY LTD.
TAIPEI

CLIENT Heineken
EXECUTIVE CREATIVE DIRECTOR Violet Wang
CREATIVE DIRECTOR Jin Yang
ART DIRECTOR Kai Lu/Ada Chu
COPYWRITER Jocelyn Liao

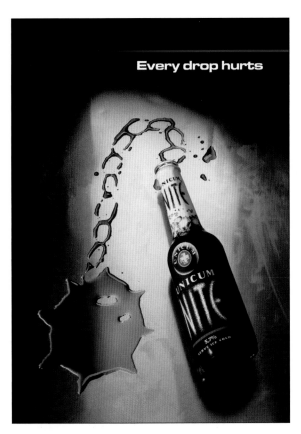

HUNGARY

FINALIST, CAMPAIGN
BBDO BUDAPEST
BUDAPEST

CLIENT Unicum Nite
CREATIVE DIRECTOR Peter Tordai
COPYWRITER Kornel Brassai
ART DIRECTOR Gabor Dinya
ACCOUNT DIRECTOR Zita Nagy
ACCOUNT EXECUTIVE Orsolya Szakacs
PHOTOGRAPHER Laszlo Meszaros

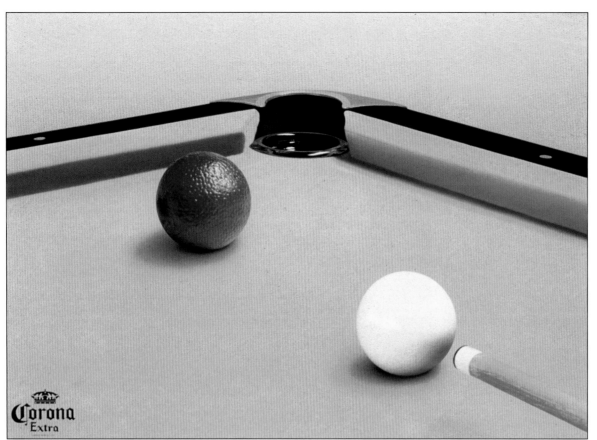

JAPAN

BRONZE WORLD MEDAL, CAMPAIGN

OGILVY & MATHER JAPAN
TOKYO

CLIENT Corona Extra
CREATIVE DIRECTOR Keiichi Uemura
COPYWRITER Rihi, Anne Mariko
ART DIRECTOR Keiichi Uemura
PHOTOGRAPHER Mutsumi Matsunaga
PRODUCTION CO.
Pineapple Associates Inc.

BEVERAGES: NON-ALCOHOLIC

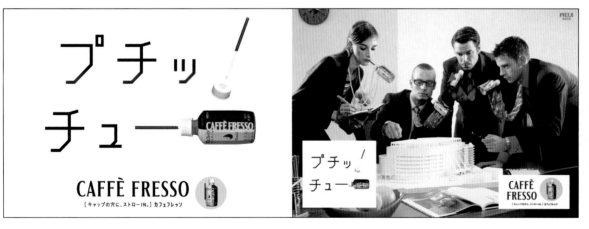

JAPAN

FINALIST, SINGLE

HAKUHODO
TOKYO

CLIENT Meiji Dairies Corporation
ART DIRECTOR Yoshimasa Hiramatsu
COPYWRITER Daisuke Okada
PHOTOGRAPHER Hideyuki Takahashi
DESIGNER Makoto Hasagawa/
Akira Uchiyama/Ryuhei Nakadai
CG Hitoshi Miyamoto
PHOTOGRAPHER Kenichi Ooki

JAPAN

FINALIST, CAMPAIGN

DENTSU INC.
TOKYO

CLIENT Nescafe
CREATIVE DIRECTOR Kazuo Tsutsumi
COPYWRITER Kenji Yokokawa/
Kentaro Shihaku
ART DIRECTOR Shunsaku Takanashi
DESIGNER Takanobu Fukaya
AGENCY PRODUCER Yoshihisa Miyagawa
ACCOUNT EXECUTIVE Akira Kutsuzawa/
Yoko Fukuyama
ADVERTISER'S SUPERVISOR Midori Kaneko
PHOTOGRAPHER M. Hasui

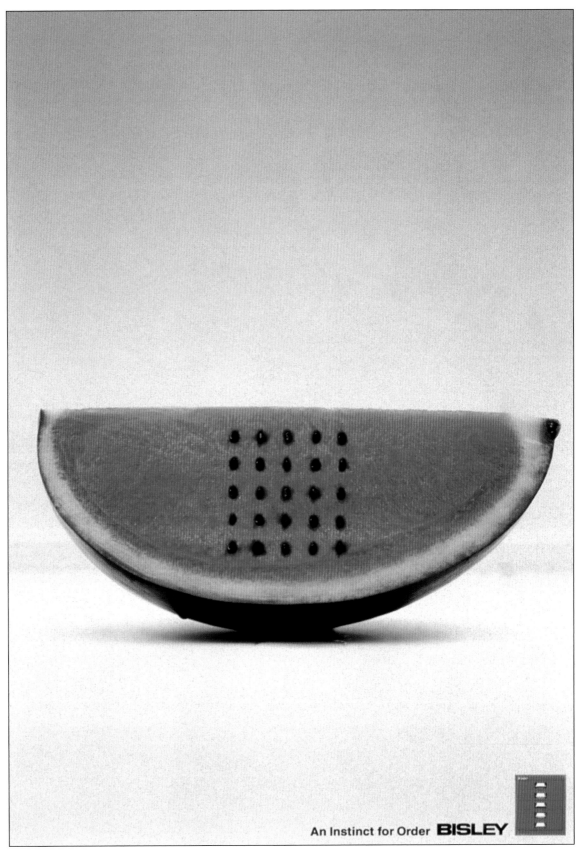

An Instinct for Order **BISLEY**

JAPAN

GOLD WORLD MEDAL, CAMPAIGN

J. WALTER THOMPSON JAPAN LTD.
TOKYO

CLIENT Bisley Cabinet
CHIEF CREATIVE OFFICER Elly Miller
EXECUTIVE CREATIVE DIRECTOR Koichi Ito
ART DIRECTOR Shizu Yamada
COPYWRITER Hiroyuki Jeff Kito
PHOTOGRAPHER Akira Sakamoto/Kazuo Unno

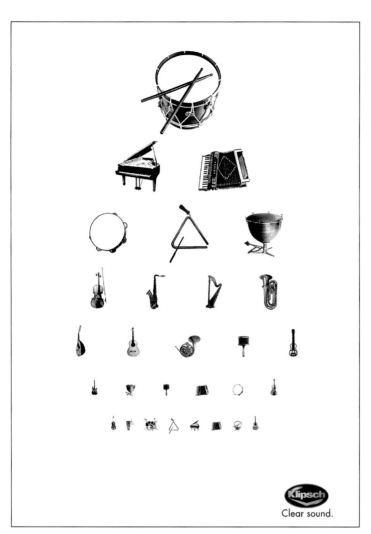

Klipsch
Clear sound.

PHILIPPINES
BRONZE WORLD MEDAL, SINGLE
JIMENEZBASIC ADVERTSING
MAKATI, METRO MANILA

CLIENT Avid
EXECUTIVE CREATIVE DIRECTOR Don Sevilla III
COPYWRITER Noel San Juan
ART DIRECTOR Randy Tiempo
ACCOUNT MANAGER Millette Caudal

CONFECTIONS/SNACKS

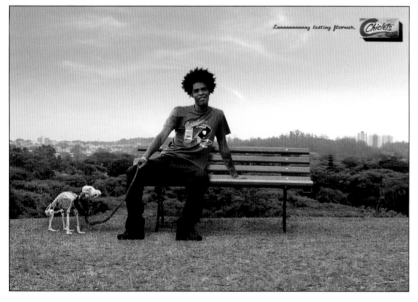

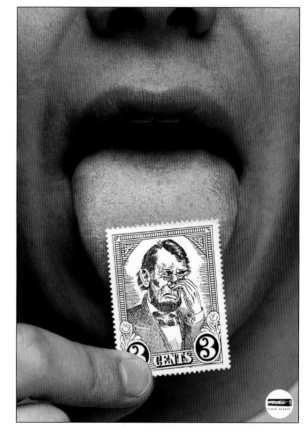

BRAZIL
FINALIST, CAMPAIGN
J WALTER THOMPSON
SÃO PAULO

CLIENT Chiclets
CREATIVE DIRECTOR Marcelo Prista
ART DIRECTOR Rinaldo Ferrarezzi
COPYWRITER Andrea Siqueira

ARGENTINA
FINALIST, SINGLE
CRAVEROLANIS EURO RSCG
BUENOS AIRES

CLIENT Kissmint
GENERAL CREATIVE DIRECTOR Juan Cravero/
Darío Lanis
COPYWRITER Ariel Serkin
ART DIRECTOR Guadalupe González Arias
PHOTOGRAPHER Martín Kohler

BRAZIL

BRONZE WORLD MEDAL, SINGLE

J WALTER THOMPSON

SÃO PAULO

CLIENT Halls
CREATIVE DIRECTOR Marcelo Prista
ART DIRECTOR Luiz Risi
COPYWRITER Luiz Risi

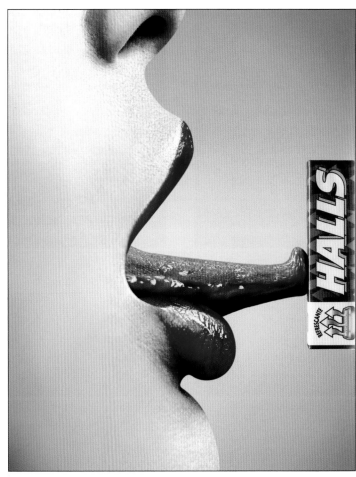

CORPORATE IMAGE/RECRUITMENT

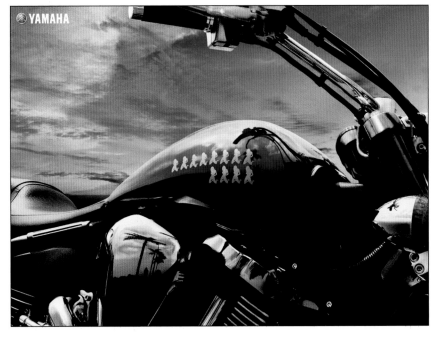

MALAYSIA

FINALIST, SINGLE

DENTSU YOUNG & RUBICAM SDN BHD

KUALA LUMPUR

CLIENT Hong Leong Yamaha Distributors Sdn Bhd
CREATIVE DIRECTOR Edward Ong/Gavin Simpson
ART DIRECTOR Yan Chay/Edward Ong/Neil French
PHOTOGRAPHER Thomas of Barney Studio

HONG KONG

FINALIST, SINGLE

GREY WBA HK LIMITED

HONG KONG

CLIENT Grey Wba HK Limited
CREATIVE DIRECTOR David Lo
DESIGNER David Lo/Liver Ng
COPYWRITER Ophelia Lau
ILLUSTRATOR Ricky Wong
DESIGNER David Lo/Liver Ng

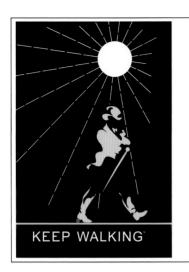 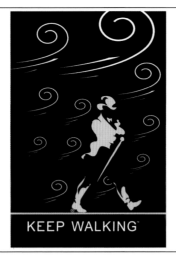 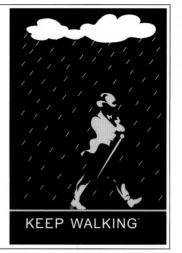

KEEP WALKING KEEP WALKING KEEP WALKING

TAIWAN
FINALIST, SINGLE
LEO BURNETT COMPANY LTD.
TAIPEI

CLIENT Johnnie Walker
CREATIVE DIRECTOR Kenny Choo

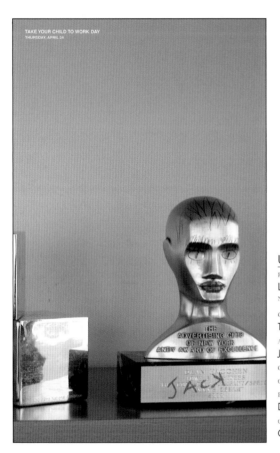

CHILE
FINALIST, SINGLE
WUNDERMAN
SANTIAGO
CLIENT Rock & Pop FM
CREATIVE DIRECTOR
Fabrizio Baracco
COPYWRITER
Fabrizio Baracco
ART DIRECTOR
Andrés Echeverría

USA
FINALIST, SINGLE
LOWE
NEW YORK, NY

CLIENT Lowe/
Take Your Child To Work Day
ART DIRECTOR/PHOTOGRAPHER
Jennifer Rosenthal
COPYWRITER Alexis Webster
CREATIVE DIRECTOR Niko Courtelis
EXECUTIVE CREATIVE DIRECTOR
Dean Hacohen
CHIEF CREATIVE OFFICER
Gary Goldsmith

GERMANY
FINALIST, SINGLE
SAATCHI & SAATCHI GMBH
FRANKFURT

CLIENT Nigeloh Solingen
ART DIRECTOR Nicole Grözinger
COPYWRITER Alexander Priebs
CREATIVE DIRECTOR Eberhard Kirchhoff
ACCOUNT EXECUTIVE Li Jessica Lorenz
PRODUCTION MANAGER Guido Palenschat
PHOTOGRAPHER Thomas Balzer
PRODUCTION Amandus Platt
ART BUYING Angela Barilaro

INDIA

SILVER WORLD MEDAL, SINGLE

J WALTER THOMPSON

MUMBAI

CLIENT Promise Toothpaste
CREATIVE DIRECTOR Jacob Attokaren/
Joseph De Souza

The anti-cavity toothpaste

VENEZUELA

FINALIST, SINGLE

J. WALTER THOMPSON

CARACAS

CLIENT Scholl
ART DIRECTOR Hector Chacon Hansen
CREATIVE DIRECTOR Gustavo Freytez
CREATIVE VP Rafael Ramos
PHOTOGRAPHY Gianni Dalmaso
DESIGN STUDIO Adrian Rodriguez
CLIENT Miguel Arrieta

For smoother skin. NOREFAL™
SKIN REFINING ESSENCE

MALAYSIA

BRONZE WORLD MEDAL, SINGLE

DENTSU YOUNG & RUBICAM SDN BHD

KUALA LUMPUR

CLIENT Norefal Marketing (M) Sdn Bhd
CREATIVE DIRECTOR Gavin Simpson
COPYWRITERS Gavin Simpson/Ong Shi Ping/Hor Yew Pong
ART DIRECTOR Hor Yew Pong/Ong Shi Ping/Gavin Simpson
PHOTOGRAPHER Edmund Leong of Barney Studio

平安夜快樂

Kotex 靠得住

CHINA

FINALIST, SINGLE

EURO RSCG GREAT OCEAN SHANGHAI BRANCH

SHANGHAI

CLIENT Maestro Hair Gel
EXECUTIVE CREATIVE DIRECTOR/COPYWRITER Fred Tong
ASSISTANT CREATIVE DIRECTOR Terence Yuen
ART DIRECTOR Rongrong Liu
COPYWRITER Hong Xu
DESIGNER Yiding Xie

ART NOT AVAILABLE

TAIWAN

FINALIST, SINGLE

OGILVY & MATHER ADVERTISING TAIWAN

TAIPEI

CLIENT Kotex
EXECUTIVE CREATIVE DIRECTOR Murphy Chou
CREATIVE DIRECTOR Murphy Chou

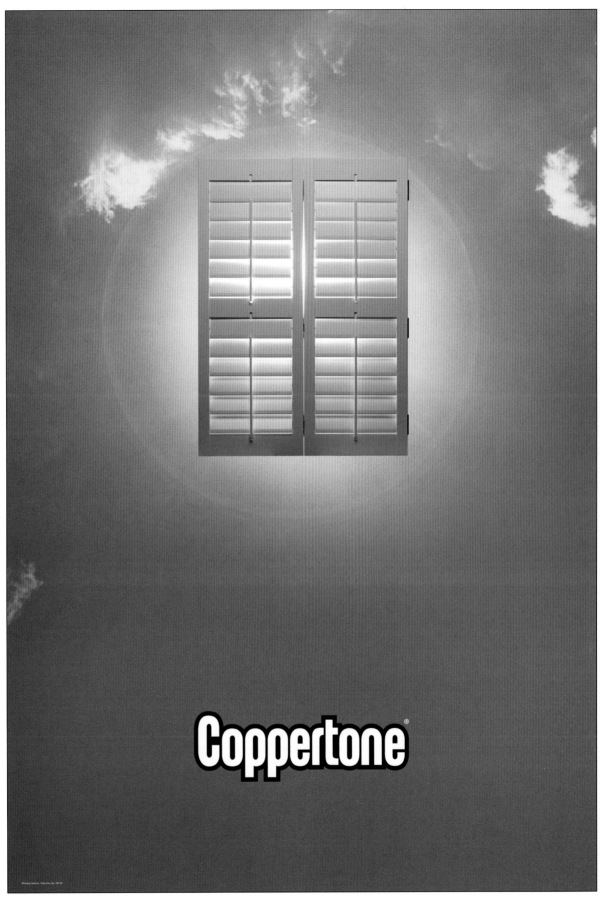

COSMETICS/TOILETRIES 203

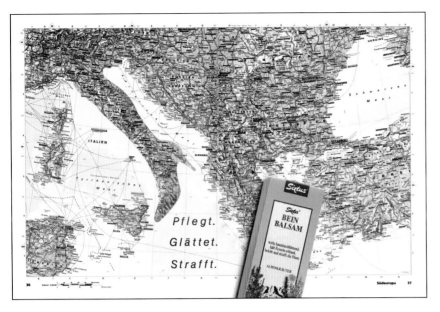

GERMANY

FINALIST, SINGLE
SERVICEPLAN GRUPPE FÜR INNOVATIVE
KOMMUNIKATION GM
MUNICH

CLIENT Sixta Feet Balm
CREATIVE DIRECTOR Ekkehard Frenkler
ART DIRECTOR Bernd Lutieschano
COPYWRITER Björn Neugebauer
ACCOUNT SUPERVISOR Johannes Ahrens
AGENCY SUPERVISOR Anton Becker

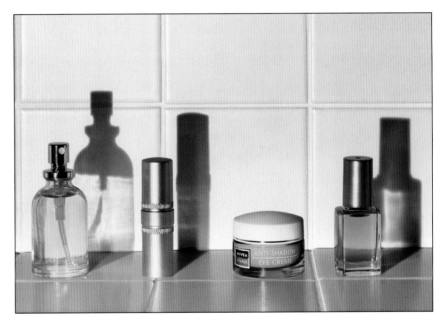

GERMANY

FINALIST, SINGLE
TBWA \
BERLIN

CLIENT Nivea Visage Anti Shadow Eye
CREATIVE DIRECTOR Gerti Eisele/Diana Pauser
ART DIRECTOR Susanne Maschauer
COPYWRITER Susen Gehle
CREATIVE DIRECTOR Manu Salewski
ACCOUNT Christiane Doss
MARKETING DIRECTOR Ralph Gusko
RETOUCHING Helmut Gass

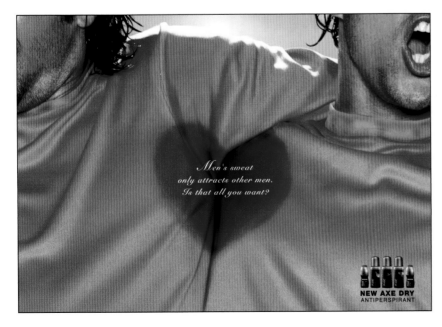

ARGENTINA

FINALIST, SINGLE
VEGAOLMOSPONCE
BUENOS AIRES

CLIENT Axe/Lynx
EXECUTIVE CREATIVE DIRECTOR Hernán Ponce
CREATIVE DIRECTOR Taretto/Vázquez/Batlle/Jáuregui
ART DIRECTOR Mariano Jeger
COPYWRITER Lucas Panizza
BRAND DIRECTOR Vanina Rudaeff

SWEDEN
FINALIST, SINGLE
LOWE BRINDFORS
STOCKHOLM

CLIENT Digital Cameras
ART DIRECTOR Joakim Blondell
COPYWRITER Johan Holmström
ACCOUNT MANAGER Katarina Nielsen
PHOTOGRAPHER Daniel Norrby
TYPOGRAPHER Kjell Benettsson

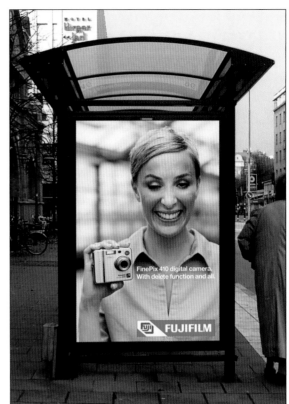

DOT.COM

SPAIN
FINALIST, CAMPAIGN
RUIZ NICOLI LINEAS
MADRID

CLIENT Prisacom todoprivate.com
EXECUTIVE CREATIVE DIRECTOR Paco Ruiz Nicoli
ART DIRECTOR César "Culebra" López
COPYWRITER Paco Ruiz Nicoli
PHOTOGRAPHER Diego Dominguez
ACCOUNT DIRECTOR Cristina Hawkins
ACCOUNT SUPERVISOR Paula Pérez de Tudela
ADVERTISER SUPERVISOR Vicente Sánchez

ENTERTAINMENT & RECREATION

USA
FINALIST, SINGLE
BBDO NEW YORK
NEW YORK, NY

CLIENT NJ Devils

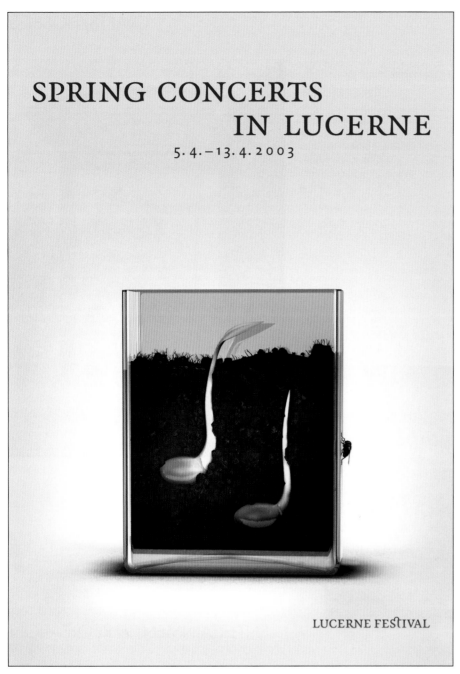

SPRING CONCERTS
IN LUCERNE

5. 4. – 13. 4. 2003

LUCERNE FESTIVAL

SWITZERLAND

SILVER WORLD MEDAL, SINGLE
WIRZ WERBUNG AG
ZÜRICH

CLIENT Lucerne Festival
CREATIVE DIRECTOR Hanspeter Schweizer
ART DIRECTOR Hanna Zimmermann
ACCOUNT SUPERVISOR Andrea Heller
PHOTOGRAPHER Max Grüter
ADVERTISER'S SUPERVISOR Sheila Huber

ARGENTINA

FINALIST, SINGLE
DEL CAMPO NAZCA SAATCHI & SAATCHI
BUENOS AIRES

CLIENT Buenos Aires Zoo
CREATIVE DIRECTOR Chavo D´Emilio/Chanel Basualdo
ART DIRECTOR Iñaki G. del Solar/Daniel Fierro
COPYWRITER Mariano Serkin
ACCOUNT DIRECTOR Pablo Ordoñez
AGENCY PRODUCER Cosme Argerich
PHOTOGRAPHER Julieta García Vazquez
ADVERTISER'S SUPERVISOR Fernando Chaín

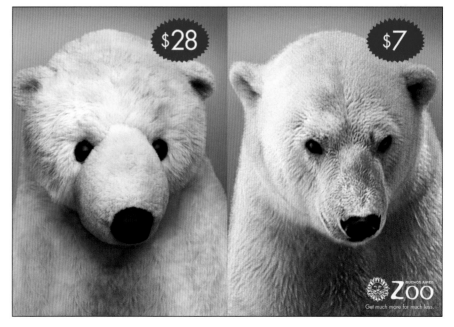

BRONZE WORLD MEDAL, SINGLE

LOUD PTY LTD

SYDNEY

CLIENT Australian Museum
ART DIRECTOR Ian Masek/Scott Thomlinson
CREATIVE DIRECTOR Andy Firth
ART DIRECTOR Ian Masek

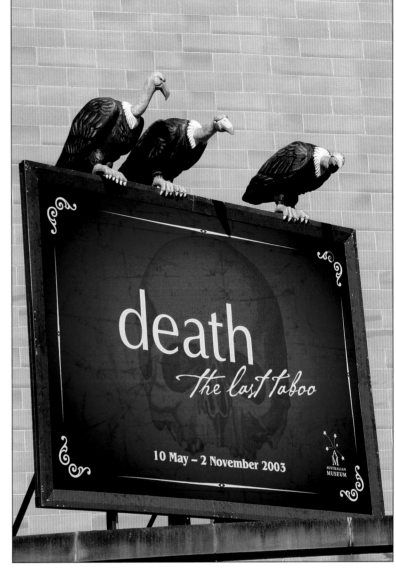

JAPAN

FINALIST, SINGLE

DENTSU KYUSHU INC.

FUKUOKA-CITY

CLIENT Ganbarion/Cyberconnct2/Level-5
ART DIRECTOR Takao Ito
PHOTO EDITOR foton

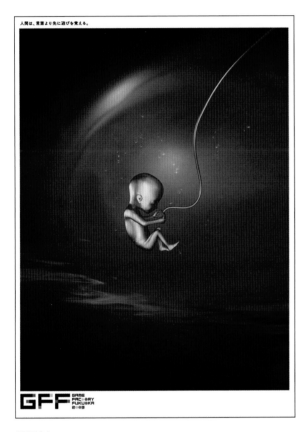

GERMANY

FINALIST, SINGLE

**BOROS GMBH AGENTUR
FÜR KOMMUNIKATION**

WUPPETAL

CREATIVE DIRECTOR Christian Boros

ARGENTINA

GOLD WORLD MEDAL, CAMPAIGN
DEL CAMPO NAZCA SAATCHI & SAATCHI
BUENOS AIRES

CLIENT Buenos Aires Zoo
CREATIVE DIRECTOR Chavo D´Emilio/Chanel Basualdo
ART DIRECTOR Iñaki G. del Solar/Daniel Fierro
COPYWRITER Mariano Serkin
ACCOUNT DIRECTOR Pablo Ordoñez
AGENCY PRODUCER Cosme Argerich
PHOTOGRAPHER Julieta García Vazquez
ADVERTISER'S SUPERVISOR Fernando Chaín

SWEDEN
SILVER WORLD MEDAL, CAMPAIGN
LOWE BRINDFORS
STOCKHOLM

ART DIRECTOR Mitte Blomquist
ART DIRECTOR Magnus Löwenhielm
COPY Monica Hultén
PHOTOGRAPHER Camilla ≈krans
TYPOGRAPHER Margaretha Ekstrand-Almér
ACCOUNT EXECUTIVE Axel Mörner

SWEDEN

FINALIST, SINGLE
STORÅKERS McCANN
STOCKHOLM

CLIENT Moderna Museet
ACCOUNT DIRECTOR Michael Storåkers
ACCOUNT MANAGER Pernille Nylén
ART DIRECTOR Klaudia Carp
COPYWRITER Mia Cederberg

ARGENTINA

FINALIST, SINGLE
SAVAGLIO TBWA
BUENOS AIRES

CLIENT De la Guarda
CREATIVE DIRECTOR Ernesto Savaglio/
Martin Mercado
COPYWRITER Martin Goldberg
ART DIRECTOR Santiago Climent

SINGAPORE

FINALIST, SINGLE
OGILVYONE WORLDWIDE
SINGAPORE

CLIENT Harley-Owners Group Singapore
CREATIVE DIRECTOR Dominic Goldman
COPYWRITER Julianna Neo
ART DIRECTOR Robert Davies
PROJECT MANAGER Pin Fern Yow
PHOTOGRAPHER Roy Zhang

INDIA

GOLD WORLD MEDAL, SINGLE

McCANN ERICKSON INDIA
MAHARASHTRA, MUMBAI

CLIENT Sweetex Low Cal Sweetener
NATIONAL CREATIVE DIRECTOR Prasoon Joshi
ART DIRECTOR Manish Darji
BUSINESS DIRECTOR Neeraja Shiknis
BRAND LEADER Imran Khan
PHOTOGRAPHER Ashish Vaidya

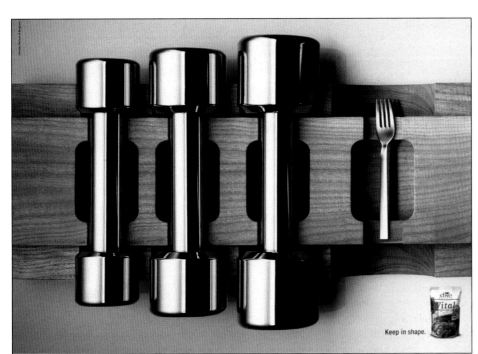

AUSTRIA

FINALIST, SINGLE

DEMNER, MERLICEK & BERGMANN
VIENNA

CLIENT EFKO Pickles
CREATIVE DIRECTOR Harry Bergmann
ART DIRECTOR Bernhard Grafl
COPYWRITER Florian Ludwig
ACCOUNT SUPERVISOR Katharina Fürst
PHOTOGRAPHER/ILLUSTRATOR Staudinger + Franke

USA

BRONZE WORLD MEDAL, CAMPAIGN

YOUNG & RUBICAM NEW YORK
NEW YORK, NY

CLIENT Campbell Soup Company
CREATIVE DIRECTOR James Caporimo/Bob Potesky
ART DIRECTOR Juan Carlos Gutierrez Zorrilla
COPYWRITER Jared Elliott
ILLUSTRATOR Simon Alicea
PHOTOGRAPHER Dennis Blachut
CHIEF EXECUTIVE OFFICER Michael Patti
DIRECTOR OF CREATIVE SERVICES Ken Yagoda

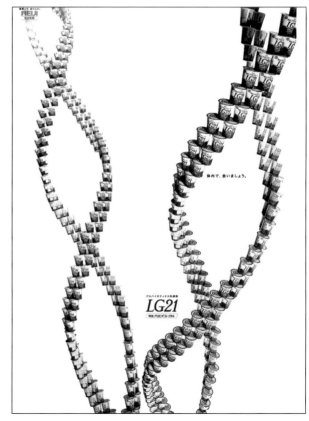

JAPAN

FINALIST, CAMPAIGN

DENTSU INC.
TOKYO

CLIENT MEIJI LG21 Probio Yoghurt
CREATIVE DIRECTOR Masaharu Nakano
COPYWRITER Masato Akaishi/Kazunori Yamada
ART DIRECTOR Emiko Sato
DESIGNER Yasushi Umemura/Akira Okamoto
AGENCY PRODUCER Takashi Miyano
ACCOUNT EXECUTIVE Wataru Tanuma
PHOTOGRAPHER Shinichiro Kaneko
ADVERTISER'S SUPERVISOR Nami Abe

JAPAN

FINALIST, SINGLE

DENTSU INC.

TOKYO

CLIENT Pal Sweet Zero Sugar-Free Sweetener
CREATIVE DIRECTOR Kenichi Yatani/Taihei Okura
COPYWRITER Hiroyuki Hara/Hideki Ichihara
ART DIRECTOR Taihei Okura
ART DIRECTOR Akira Shikiya/Takayuki Murano
AGENCY PRODUCER Yoji Fujii/Takashi Miyano
DESIGNER Yoshiyuki Fujikawa/Masato Iida/
Takashi Yasunaga/Naoyuki Matakawa
ACCOUNT EXECUTIVE Kazuo Miike

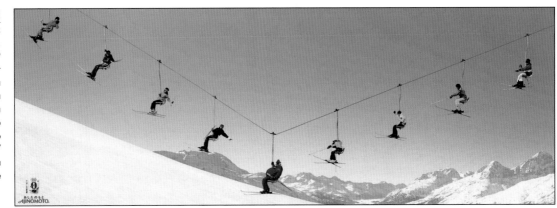

HEALTH/MEDICAL

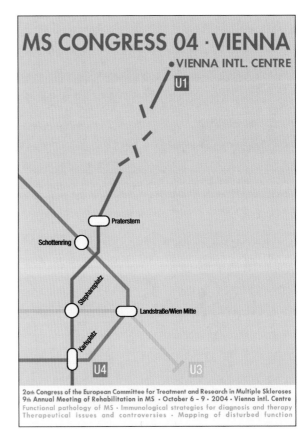

AUSTRIA

FINALIST, SINGLE

BBDO AUSTRIA

VIENNA

CLIENT Multiple Sklerosis
CREATIVE DIRECTOR Markus Enzi
COPYWRITER Bernhard Rems
ART DIRECTOR Emanuela Sarac
PHOTOGRAPHER Albert Handler

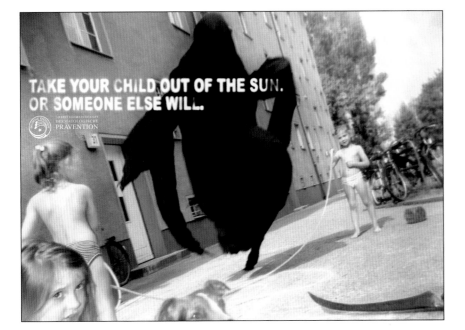

GERMANY

FINALIST, CAMPAIGN

HEIMAT WERBEAGENTUR GMBH

BERLIN

CLIENT ADP e.V. German Cancer Aid
CREATIVE DIRECTOR Guido Heffels/Jürgen Vossen
ART DIRECTOR Tim Schneider
WRITER Thomas Winkler
PHOTOGRAPHER Sven Glage

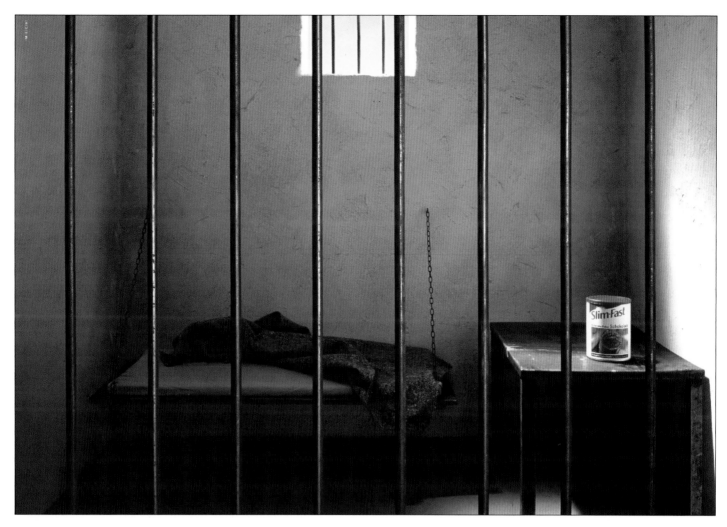

GERMANY

SILVER WORLD MEDAL, SINGLE
M.E.C.H. McCANN-ERICKSON COMMUNICATIONS
HOUSE BERL
BERLIN

CLIENT Slim Fast
EXECUTIVE CREATIVE DIRECTOR Torsten Rieken
ACCOUNT DIRECTOR Katja Metz
ART DIRECTOR Alice Rzepka
COPYWRITER Marcel Linden
ART ASSISTANT Tina Koehler
PHOTOGRAPHER Stefan Boekels

HOUSEHOLD FURNISHINGS

INDIA

FINALIST, SINGLE
MUDRA COMMUNICATIONS PVT. LTD.
NEW DELHI

CLIENT Samsung
COPYWRITER Ambar Chakravarty
ART DIRECTOR Anil Verma
PHOTOGRAPHER Ashish Chawla

ART NOT AVAILABLE

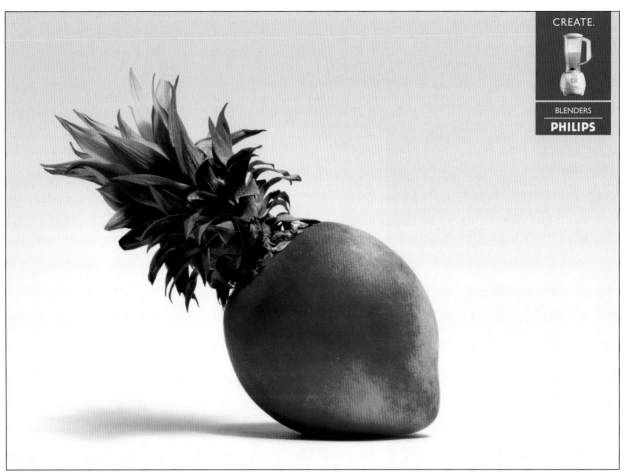

HOUSEHOLD PRODUCTS

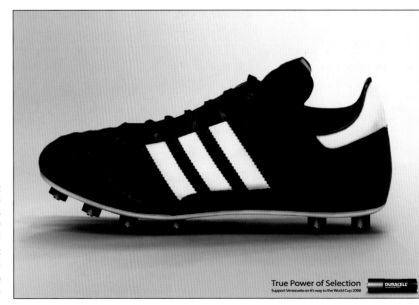

Smelling billboard

Brief:
Launch support of Advance's dog food in Germany.
Positioning as expert for dogs and their feeding.

Solution:
It is a part of Affinity Petcare's strategy to communicate
with it's clients at eye level. To show that this also
applies to the end-comsumers, this billoard has been
developed especially for dogs.
There is Advance dog food assembled invisible at the
back of the billlboard. The flavor is given off through
small holes right at the dogs bowl. Smelling the food
dogs react to the billlboard and snuffle at the mapped
picture of the dog bowl.

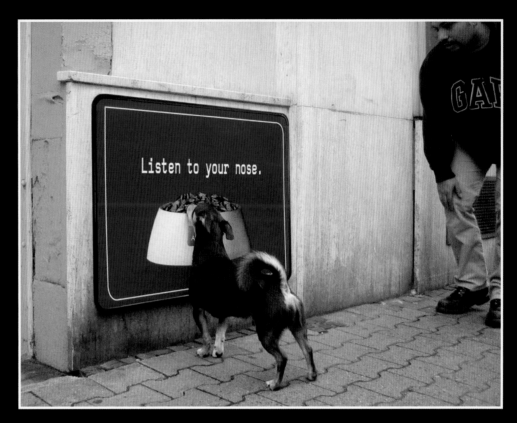

GERMANY

GOLD WORLD MEDAL, SINGLE

MICHAEL CONRAD & LEO BURNETT
FRANKFURT

CLIENT Affinity Petcare, Advance
CREATIVE DIRECTOR Manfred Wappenschmidt
COPYWRITER Hasso von Kietzell
ART DIRECTOR Daniela Skwrna
ACCOUNT SUPERVISOR Jörg Blömeling

GERMANY

FINALIST, SINGLE
DDB GERMANY
BERLIN

CLIENT Power Pritt
CREATIVE DIRECTOR Eric Schoeffler/
Claus Wieners
ART DIRECTOR Sachin Talwalkar
TEXT Claus Wieners
ACCOUNT DIRECTOR Theo Kerstjens/
Michael Ries

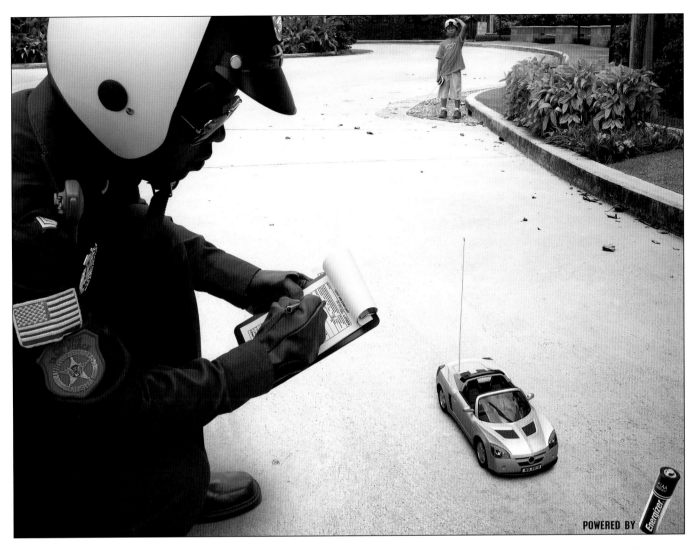

POWERED BY Energizer

THAILAND

SILVER WORLD MEDAL, SINGLE

FAR EAST DDB PLC

BANGKOK

CLIENT Energizer
CREATIVE DIRECTOR Adisakdi Akaracharanya
CREATIVE DIRECTOR/COPYWRITER Chatree U-phathump
ART DIRECTOR Kavin Sitsayanaren
COPYWRITER Amorn Phusitranusorn
CREATIVE DIRECTOR Adisakdi Akaracharanya
CREATIVE DIRECTOR/COPYWRITER Chatree U-phathump
ART DIRECTOR Kavin Sitsayanaren

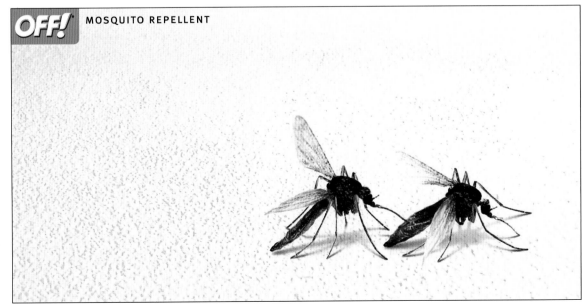

OFF! MOSQUITO REPELLENT

ARGENTINA

FINALIST, SINGLE

PRAGMA/FCB PUBLICIDAD SA

BUENOS AIRES

CLIENT Off!
GENERAL CREATIVE DIRECTOR
Pablo Poncini
CREATIVE DIRECTOR G. Castañeda/
J.C. Bazterrica
COPYWRITER Rodrigo Polignano

GERMANY

BRONZE WORLD MEDAL,
SINGLE
BBDO CAMPAIGN
GMBH
DUESSELDORF

CLIENT
Washing Detergents
CREATIVE DIRECTOR
Carsten Bolk
ART DIRECTOR
Christoph Rodenbüsch

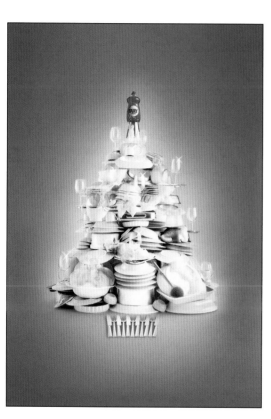

ARGENTINA
FINALIST, SINGLE
LEO BURNETT ARGENTINA
BUENOS AIRES
CLIENT Procter & Gamble Ace

Stare into Ace logo and after a few seconds dirtiness will disappear.
Ace. Whiteness impossible to surpass.

ENGLAND

FINALIST, SINGLE
JONATHAN KNOWLES
PHOTOGRAPHY
LONDON

CLIENT Fairy Liquid
PHOTOGRAPHER Jonathan Knowles
CREATIVE DIRECTOR Dave Alberts
ART DIRECTOR/COPYWRITER Matt Turrell/
Alex Fraser

GERMANY
FINALIST, CAMPAIGN
TBWA \
BERLIN
CLIENT Sidolin
CREATIVE DIRECTOR Kai Röffen
ART DIRECTOR Knut Burgdorf
COPYWRITER Dirk Wilkesmann
PHOTOGRAPHER Martin Müller
ACCOUNT Alexander Milstein

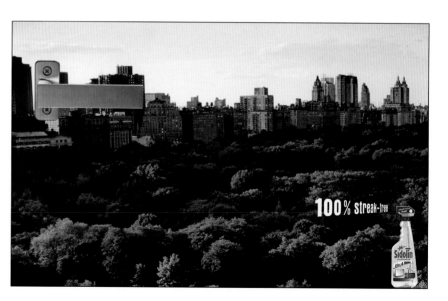

100% streak-free

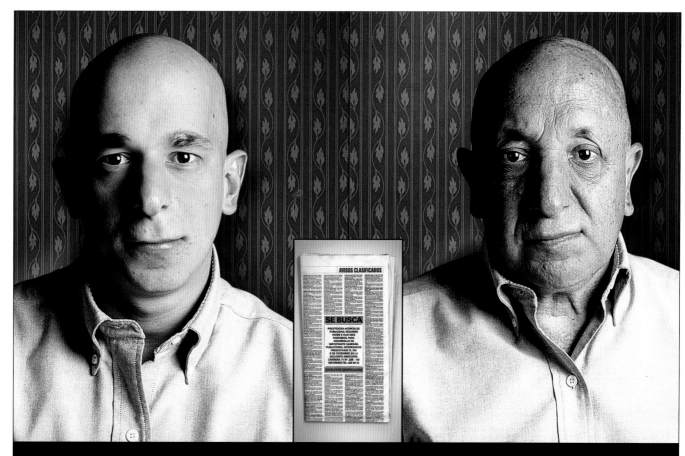

WE FOUND THEM FOR THIS CAMPAIGN, THINK OF WHAT YOU CAN FIND.

EL COLOMBIANO classified ads.

COLOMBIA
SILVER WORLD MEDAL, SINGLE
DDB COLOMBIA
MEDELLIN, ANTIOQUIA
CLIENT El Colombiano Classified Ads
NATIONAL CREATIVE DIRECTOR Maria Teresa Fernandez
CREATIVE Mauricio Guerrero
ART DIRECTOR Bianco Ramirez
PRODUCTION Alex Penagos
CLIENT María José Jaramillo
ACCOUNT DIRECTOR Monica Rivera

MAGAZINES THAT REACH 4,0 MILLION* WOMEN.

FINLAND
FINALIST, CAMPAIGN
HASAN & PARTNERS OY
HELSINKI

CLIENT Sanoma Women Magazines
ART DIRECTOR Magnus Olsson
COPYWRITER Jussi Turhala/Niko Kokonmaki
ACCOUNT DIRECTOR Sirkka Norha
AD ASSISTANT Jan Rudkiewicz
ACCOUNT EXECUTIVE Tarja Malka
CREATIVE DIRECTOR Timo Everi

is sports.

FINLAND

BRONZE WORLD MEDAL, CAMPAIGN
HASAN & PARTNERS OY
HELSINKI

CLIENT Ilta Sanomat
ART DIRECTOR Jouni Luostarinen
COPYWRITER Eka Ruola
CREATIVE DIRECTOR Timo Everi
ACCOUNT MANAGER Frederik Gotthardt
ACCOUNT EXECUTIVE Johanna Hakanen
AD ASSISTANT Kalle Kotila

ARGENTINA

FINALIST, CAMPAIGN
J. WALTER THOMPSON
BUENOS AIRES

CLIENT Editorial Coyuntura/Mercado
EXECUTIVE CREATIVE DIRECTOR Leandro Raposo/
Pablo Stricker
ART DIRECTOR Ariel Abadi
COPYWRITER Sebastian Magariños
CREATIVE DIRECTOR Santiago Lucero/
Pablo Colonnese

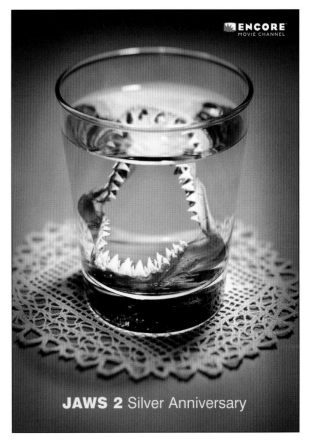

JAWS 2 Silver Anniversary

AUSTRALIA
FINALIST, SINGLE
URSA
SYDNEY
CLIENT Showtime

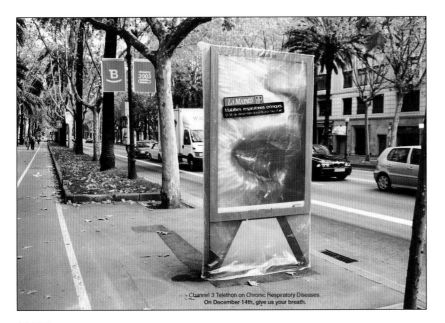

SPAIN
FINALIST, SINGLE
BASSAT OGILVY BARCELONA
BARCELONA

CLIENT Channel 3 Telethon
CREATIVE DIRECTOR Oscar Pla/Camil Roca
ART DIRECTOR Carles Patris
COPYWRITER Karles Querol
ACCOUNT DIRECTOR Enric Pujadas

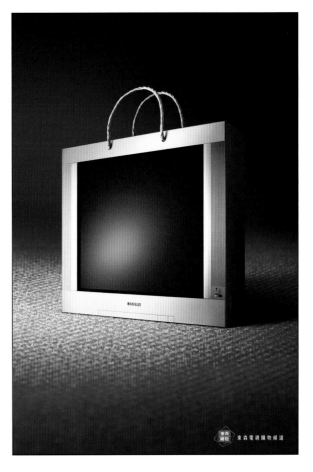

TAIWAN
FINALIST, SINGLE
OGILVY & MATHER ADVERTISING
TAIWAN
TAIPEI

CLIENT Eastern TV Shopping Channel
EXECUTIVE CREATIVE DIRECTOR Murphy Chou
CREATIVE DIRECTOR Murphy Chou/Sean Liang
COPYWRITER Popo Wu
ART DIRECTOR Lean Sun

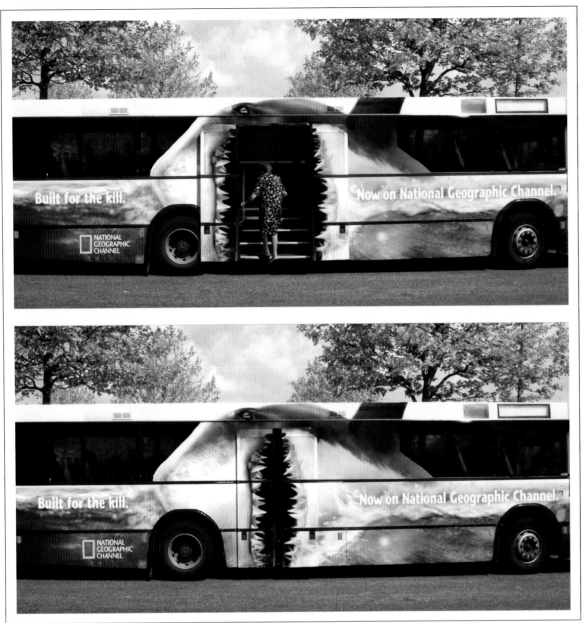

THE NETHERLANDS

SILVER WORLD MEDAL, SINGLE
AMSTERDAM ADVERTISING
AMSTERDAM

CLIENT
National Geographic Channel
CREATIVE DIRECTOR ART Darre van Dijk
CREATIVE DIRECTOR COPY
Piebe Piebenga
ILLUSTRATOR Fulco Smit Roeters

ARGENTINA
FINALIST, SINGLE
SAVAGLIO TBWA
BUENOS AIRES

CLIENT Channel 7
CREATIVE DIRECTOR Ernesto Savaglio/M. Mercado
COPYWRITER Alexis Alvarez/M. Goldberg
ART DIRECTOR S. Climent/P. Russo/G. Miragaya
ACCOUNT SUPERVISOR Luciano Tidone/P. Lopardo

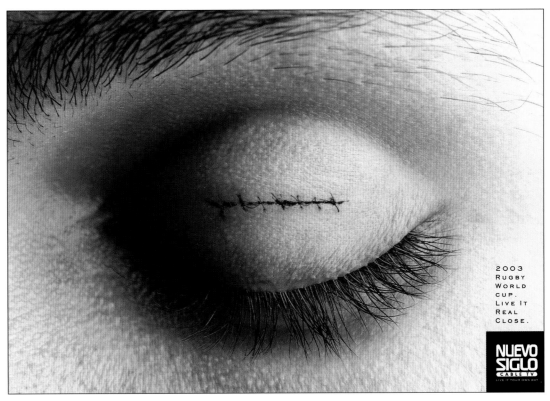

METRO FM IS A NATIONAL RADIO STATION.
THE LOGO WAS MODIFIED FOR THIS YOUTH DAY POSTER
COMMEMORATING THE '76 SOWETO RIOTS.

SOUTH AFRICA

FINALIST, SINGLE

NET#WORK BBDO
JOHANNESBURG

CLIENT Metro FM
CREATIVE DIRECTOR Julian Watt
ART DIRECTOR Trevallyn Hall
COPYWRITER Neo Mashigo

PHARMACEUTICAL

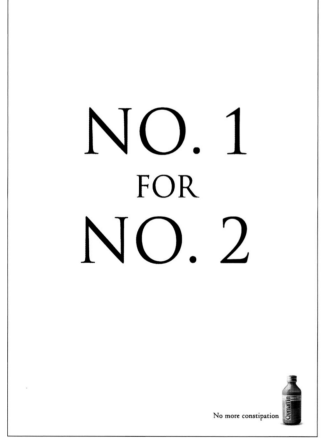

No more constipation

INDIA

FINALIST, SINGLE

R.K. SWAMY BBDO
MUMBAI, MAHARASHTRA

CLIENT Cremaffin
CREATIVE DIRECTOR Vivek Nayyar
SENIOR. CREATIVE DIRECTOR Chandrashekhar Vaidya
COPYWRITER Vivek Nayyar
ART DIRECTOR Chandrashekhar Vaidya

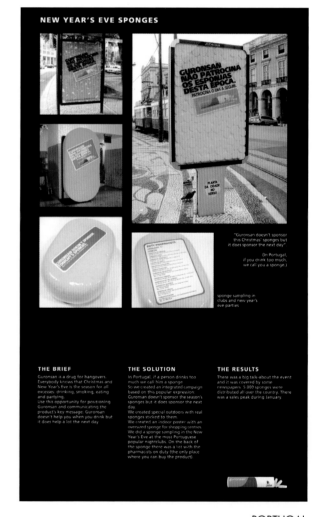

PORTUGAL

FINALIST, CAMPAIGN

TOUCH ME RED CELL PORTUGAL
LISBOA, LISBOA

CLIENT Guronsan
CREATIVE DIRECTOR Susana Albuquerque
COPYWRITER Pedro Batalha
ART DIRECTOR Rui Saraiva
ACCOUNT MANAGER Thamy Ortiz/José Gago

BELGIUM
BRONZE WORLD MEDAL, SINGLE
OGILVY & MATHER
BRUSSELS

CLIENT Jansport
CREATIVE DIRECTOR Phil Van Duynen
ART DIRECTOR Christoph Heinen
COPYWRITER Arnaud Pitz
PHOTOGRAPHER Gusto Productions

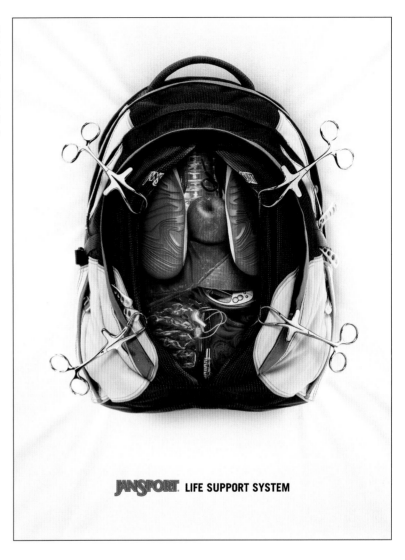

JANSPORT. LIFE SUPPORT SYSTEM

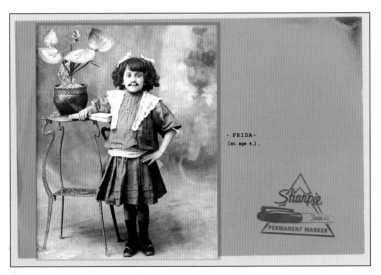

ARGENTINA
FINALIST, SINGLE
OGILVY & MATHER ARGENTINA
BUENOS AIRES

CLIENT Sharpie
GENERAL CREATIVE DIRECTOR Gustavo Reyes
CREATIVE DIRECTOR Sanchez Correa/Campopiano/
Duhalde/Aregger
ART DIRECTOR Fernando Zagales
COPYWRITER Soledad Fernandez Podesta
GENERAL ART DIRECTOR Maximiliano Sanchez Correci
HEAD ACCOUNT Yayo Enriquez

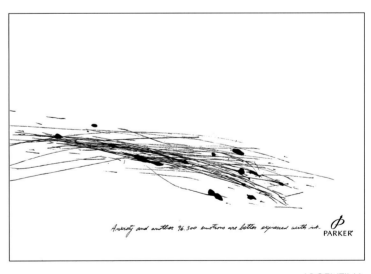

ARGENTINA
FINALIST, SINGLE
OGILVY & MATHER ARGENTINA
BUENOS AIRES

CLIENT Parker
GENERAL CREATIVE DIRECTOR Gustavo Reyes
CREATIVE DIRECTOR Aregger/Campopiano/
Duhalde/Sanchez Correa
ART DIRECTOR F. Zagales/M. Sanchez Correa
COPYWRITER Mariano Duhalde
GENERAL ART DIRECTOR M. Sanchez Correa
HEAD ACCOUNT Yayo Enriquez

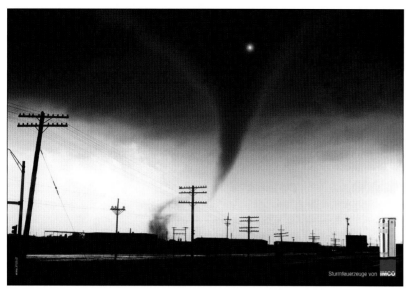

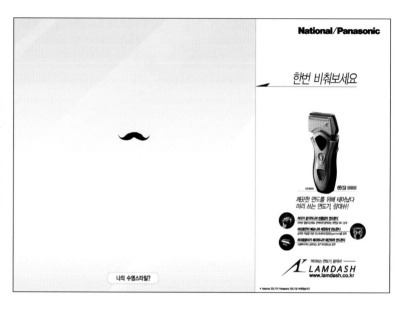

PROFESSIONAL SERVICES

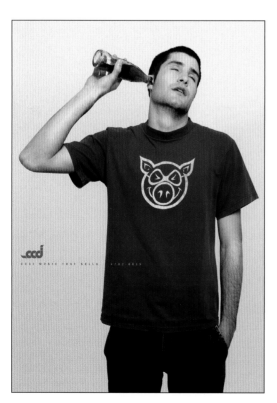

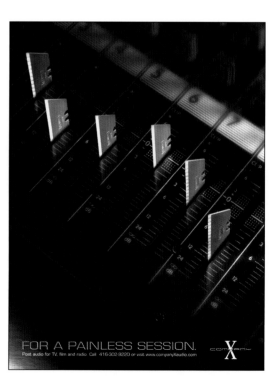

DENMARK

BRONZE WORLD MEDAL, SINGLE

BBDO DENMARK

COPENHAGEN

CLIENT Profil Opticians
ART DIRECTOR Carsten Michelsen

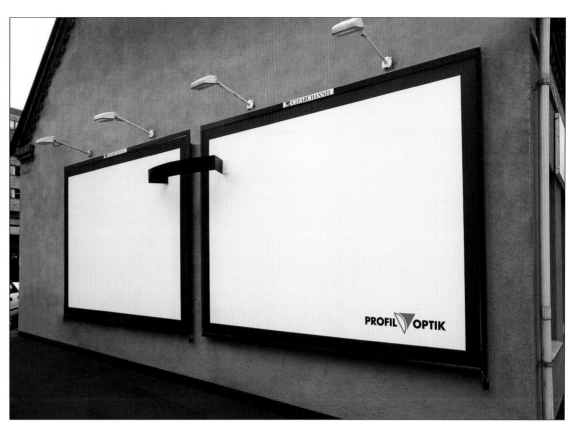

POLITICAL

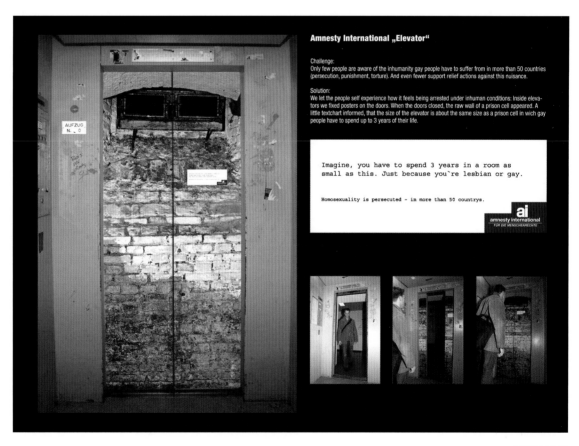

Amnesty International „Elevator"

Challenge:
Only few people are aware of the inhumanity gay people have to suffer from in more than 50 countries (persecution, punishment, torture). And even fewer support relief actions against this nuisance.

Solution:
We let the people self experience how it feels being arrested under inhuman conditions: Inside elevators we fixed posters on the doors. When the doors closed, the raw wall of a prison cell appeared. A little textchart informed, that the size of the elevator is about the same size as a prison cell in wich gay people have to spend up to 3 years of their life.

Imagine, you have to spend 3 years in a room as small as this. Just because you`re lesbian or gay.

Homosexuality is persecuted - in more than 50 countrys.

ai
amnesty international
FÜR DIE MENSCHENRECHTE

GERMANY

BRONZE WORLD MEDAL, SINGLE

MICHAEL CONRAD & LEO BURNETT

FRANKFURT

CLIENT Amnesty International
CREATIVE DIRECTOR Andreas Heinzel/Peter Steger
ART DIRECTOR Klaus Trapp
COPYWRITER Mathias Henkel

RECREATION/SPORTING GOODS

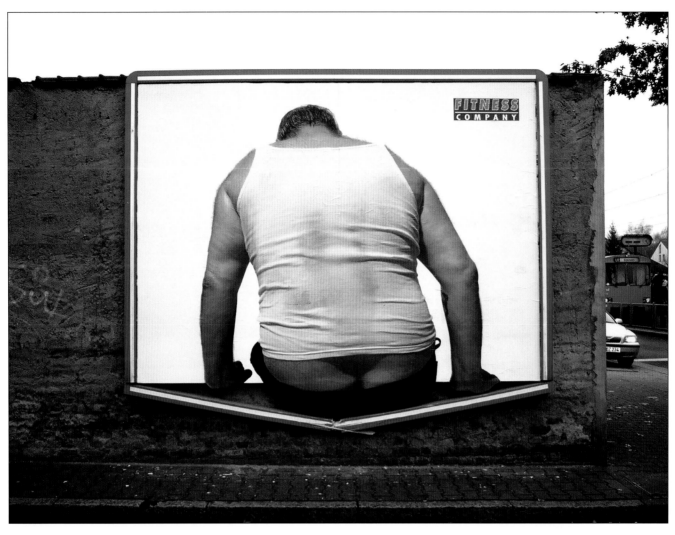

GERMANY

SILVER WORLD MEDAL, SINGLE
PUBLICIS WERBEAGENTUR GMBH
FRANKFURT

CLIENT **Fitness Company**
CREATIVE DIRECTOR **Gert Maehnicke**
ART DIRECTOR **Alan Vladusic**
COPYWRITER **Konstantinos Manikas**
PHOTOGRAPHER **mertphoto.com**
MARKETING DIRECTOR **Stefan Biaesch**

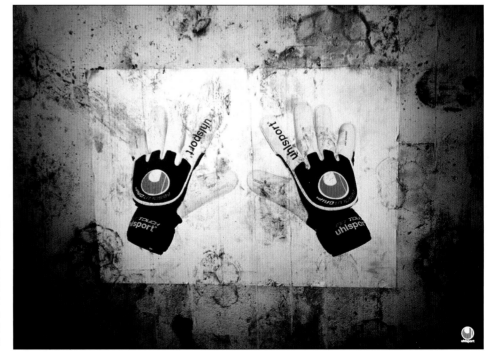

JAPAN

FINALIST, SINGLE
OGILVY & MATHER JAPAN
TOKYO

CLIENT **Uhlsport Brand Ad**
CREATIVE DIRECTOR **Takeshi Suzuki**
ART DIRECTOR **Takeshi Suzuki**
PHOTOGRAPHER **Naoki Tsuruta**
DESIGNER **Takeshi Suzuki**
PRINTING CO. **Asano Seihanjyo**

SWITZERLAND
BRONZE WORLD MEDAL, SINGLE
PUBLICIS ZURICH
ZURICH
CLIENT Sportplausch Wider
CREATIVE DIRECTOR Markus Gut
ART DIRECTOR Ralph Halder
COPYWRITER Tom Zuercher

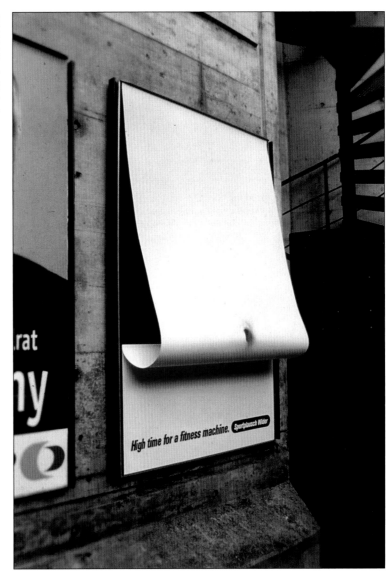

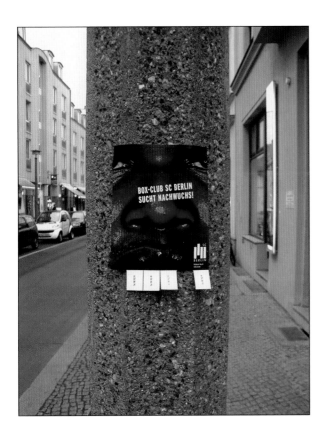

GERMANY
FINALIST, SINGLE
FCB WILKENS GMBH
HAMBURG
CLIENT Sport Club Berlin e.V.
CREATIVE DIRECTOR Waldemar Konopka
COPYWRITER Nadja Al-Mardini
ART DIRECTOR Annabelle Marschall/Nina Mielisch
PRODUCTION MANAGER Gregor C. Blach
ACCOUNT EXECUTIVE Nicole Thomas/Carsten
Riechert

UNITED ARAB EMIRATES
FINALIST, SINGLE
TEAM/YOUNG & RUBICAM ABU DHABI
ABU DHABI
CLIENT Skyline Fitness Club
ART DIRECTOR Krishnagopal Kodoth
COPYWRITER Maria Rego Menezes
CREATIVE DIRECTOR Satyan Nair
GRAPHIC ARTIST Shajil Anthapan

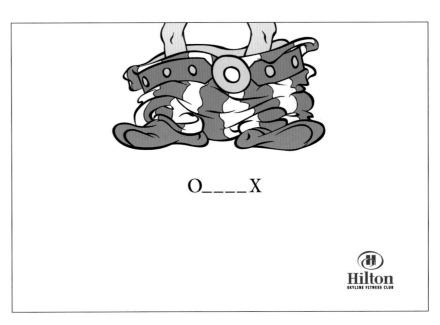

O_ _ _ _X

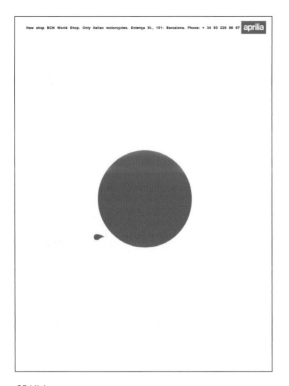

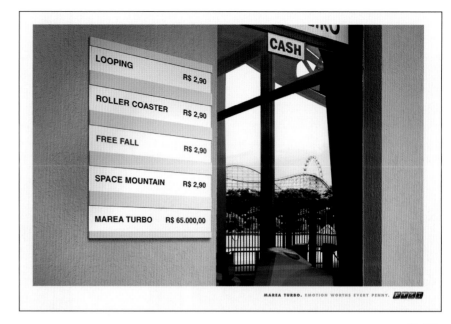

BRAZIL

FINALIST, SINGLE
OGILVY BRASIL
SÃO PAULO

CLIENT Fiat Car Dealers
CREATIVE DIRECTOR Adriana Cury/Virgilio Neves
COPYWRITER Ricardo Ribeiro
ART DIRECTOR Eric Sulzer
PHOTOGRAPHER Alvaro Povoa

SPAIN

FINALIST, SINGLE
LOWE
MADRID

CLIENT Aprilia
EXECUTIVE CREATIVE DIRECTOR Luis López de Ochoa
COPYWRITER Idoia González
ART DIRECTOR Rubén Señor
CLIENT SERVICES DIRECTOR Pieter Schets
ADVERTISER'S SUPERVISOR Lorenzo Marín

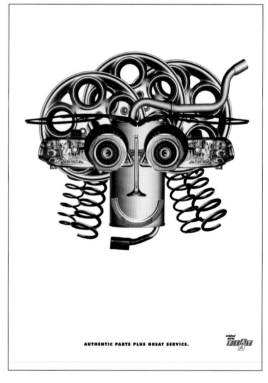

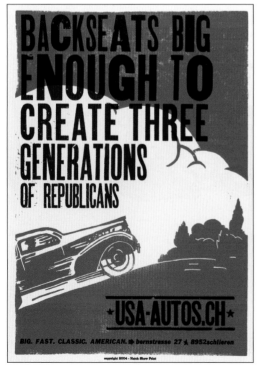

SWITZERLAND

FINALIST, CAMPAIGN
LOWE SWITZERLAND
ZURICH

CLIENT USA Autos
CREATIVE DIRECTOR Keith Loell
ART DIRECTOR Fernando Perez
COPYWRITER Keith Loell
AGENCY PRODUCER Evelyn Doessegger

BRAZIL

FINALIST, CAMPAIGN
OGILVY BRASIL
SÃO PAULO

CLIENT Fiat Original Parts
CREATIVE DIRECTOR Virgilio Neves/Manir Fadel
COPYWRITER Luiz Vicente Simões
ART DIRECTOR Luciana Cani/Fernando Saú
CREATIVE DIRECTOR Adriana Cury
PHOTOGRAPHER Richard Kohout

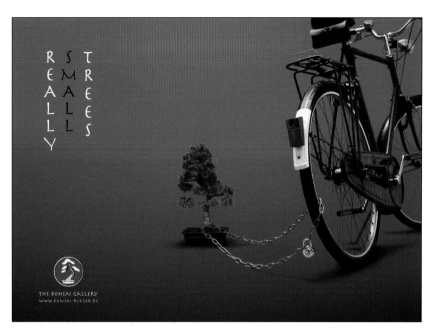

GERMANY

FINALIST, CAMPAIGN

SAATCHI & SAATCHI GMBH

FRANKFURT

CLIENT Bonsai Galery Rüger
COPYWRITER Jörn Welle
ART DIRECTOR Helge Fétz
CREATIVE DIRECTOR
Benjamin Lommel/
Harald Wittig

TOBACCO

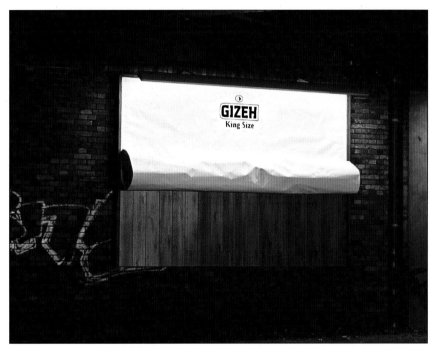

GERMANY

FINALIST, SINGLE

AIMAQ RAPP STOLLE

BERLIN

CLIENT Gizeh
CREATIVE DIRECTOR Oliver Frank
ART DIRECTOR Kathrin Langer/Joern Schwarz
COPYWRITER Jens Hellweg
PHOTOGRAPHER Thomas Schweigert
ACCOUNT SUPERVISOR Ingo Huebner/Robert Stolle
DUMMY CONSTRUCTION Olaf Elling/Christian Schmidt

RETAIL FOOD

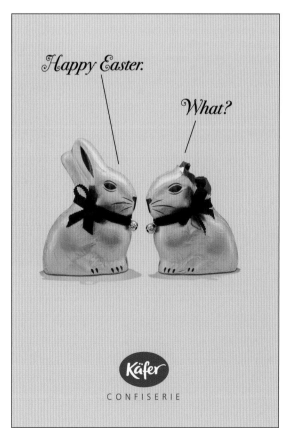

GERMANY

FINALIST, SINGLE

.START GMBH

MUNICH, BAVARIA

CLIENT Feinkost Kaefer Delicatessen
CREATIVE DIRECTOR Marco Mehrwald/
Thomas Pakull
PHOTOGRAPHY Heribert Schindler

RETAIL RESTAURANTS

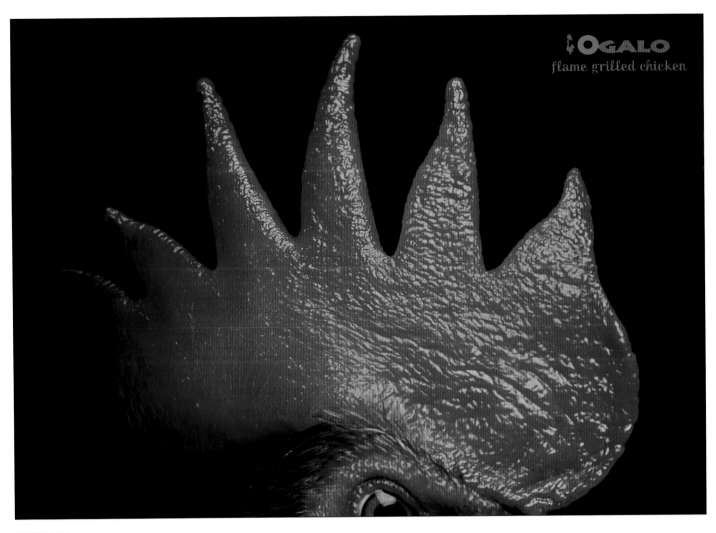

OGALO
flame grilled chicken

AUSTRALIA

SILVER WORLD MEDAL, SINGLE
McCANN ERICKSON
WOOLLOOMOOLOO

CLIENT Ogalo
CREATIVE DIRECTOR Allan Crew
COPYWRITER Dave Heytmann
ART DIRECTOR Dave Heytmann
PHOTOGRAPHER Gary Sheppard

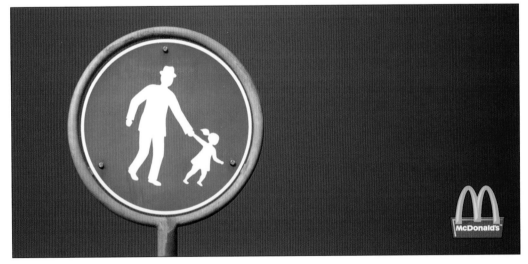

SWITZERLAND

FINALIST, SINGLE
DDB ZURICH
ZURICH

CLIENT McDonalds
CREATIVE DIRECTOR Patrick Lienert
COPYWRITER Patrick Lienert/Martin Kissling
ART DIRECTOR Bruno Zuercher/Daniel Bieri
ILLUSTRATOR Bruno Zuercher
ADVERTISER'S SUPERVISOR Markus Ith/Tashi Buewang
ACCOUNT SUPERVISOR Jean Laporte

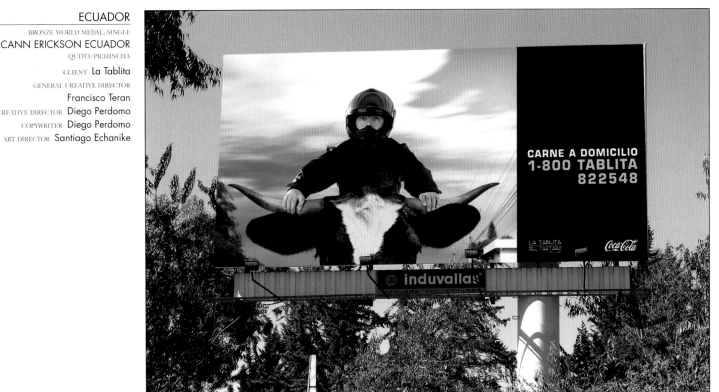

ECUADOR

BRONZE WORLD MEDAL, SINGLE

McCANN ERICKSON ECUADOR

QUITO/PICHINCHA

CLIENT La Tablita

GENERAL CREATIVE DIRECTOR
Francisco Teran

CREATIVE DIRECTOR Diego Perdomo

COPYWRITER Diego Perdomo

ART DIRECTOR Santiago Echanike

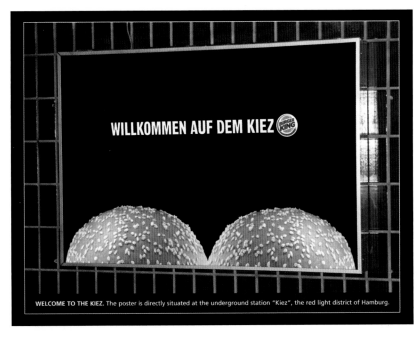

GERMANY

FINALIST, SINGLE

.START GMBH

MUNICH, BAVARIA

CLIENT Burger King GmbH

CREATIVE DIRECTOR Marco Mehrwald/
Thomas Pakull

ART DIRECTOR Sven Achatz

COPYWRITER Marcel Koop

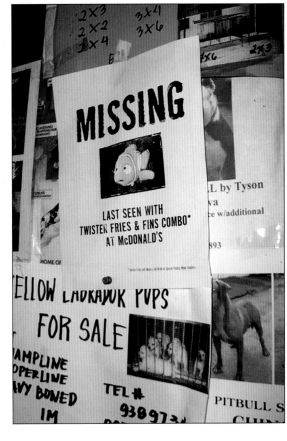

PHILIPPINES

FINALIST, SINGLE

LEO BURNETT MANILA

MAKATI CITY

CLIENT McDonalds

EXECUTIVE CREATIVE DIRECTOR Richard Irvine

GROUP CREATIVE DIRECTOR Edsel Tolentino

COPYWRITER Alvin Tecson

SENIOR ART DIRECTOR Reg Romanillos

SENIOR ACCOUNT MANAGER DIRECTOR Mike Foster

ACCOUNT DIRECTOR Sue Ann Nolido

SENIOR ACCOUNT EXECUTIVE Bobby Saneo

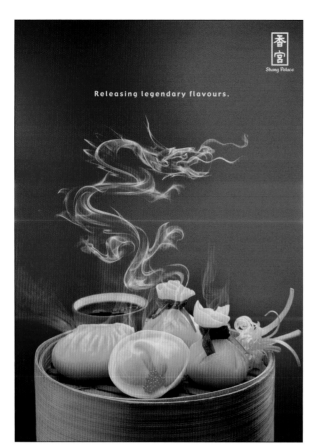

Releasing legendary flavours.

UNITED ARAB EMIRATES

FINALIST, SINGLE
TBWA/ RAAD MIDDLE EAST
DUBAI

CLIENT Shangri-la Hotels
CREATIVE DIRECTOR Kristian Sumners
ART DIRECTOR Nandu Otarkur
COPYWRITER Kristian Sumners
PHOTOGRAPHER Reinhard

SOFT DRINKS

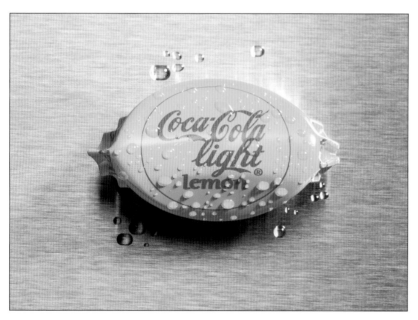

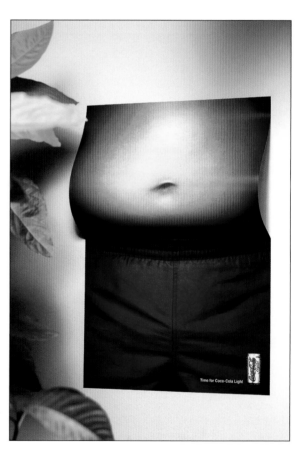

Time for Coca-Cola Light

GERMANY

FINALIST, SINGLE
PUBLICIS WERBEAGENTUR GMBH
FRANKFURT

CLIENT Coca-Cola Light
CREATIVE DIRECTOR Harald Schmitt/Tom Tilliger
ART DIRECTOR Florian Beck
COPYWRITER Shahir Sirry
CHIEF CREATIVE OFFICER Michael Boebel
CLIENT SERVICE DIRECTOR Oliver Lebkuecher
ACCOUNT DIRECTOR Christian Rummel
EDITOR Rob McGuire
PHOTOGRAPHER Tim Thiel
ADVERTISING MANAGER Gregor Gruendgens

THAILAND

FINALIST, SINGLE
LOWE BANGKOK
BANGKOK

CLIENT Coca Cola Light
ART DIRECTOR Vancelee Teng
COPYWRITERS Subun Khow/Justin Pereira
PHOTOGRAPHER/ILLUSTRATOR illusion
ACCOUNT EXECUTIVES Sunny Hermano/Apichai C
PRINT PRODUCER Nuch Lertviwatchai
CREATIVE DIRECTOR Jeffrey Curits

INDIA

BRONZE WORLD MEDAL, SINGLE

McCANN ERICKSON INDIA

MAHARASHTRA, MUMBAI

CLIENT Coca-Cola
NATIONAL CREATIVE DIRECTOR Prasoon Joshi
COPYWRITER Prasoon Joshi
ART DIRECTOR Puneet Kapoor
PHOTOGRAPHER Altaf Khan
BUSINESS DIRECTOR Vishal Mehta
ACCOUNT EXECUTIVE Manokamna Chawla
PRODUCTION HEAD Robert Joseph

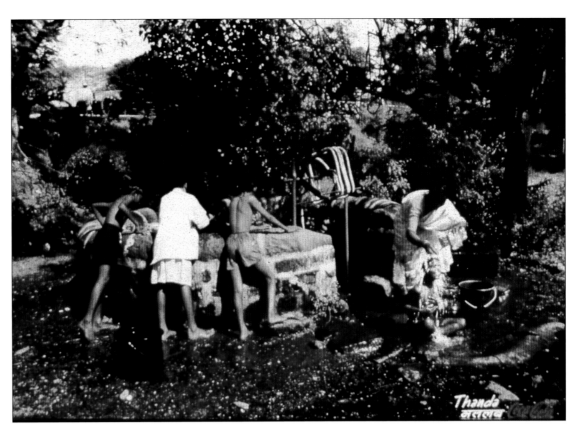

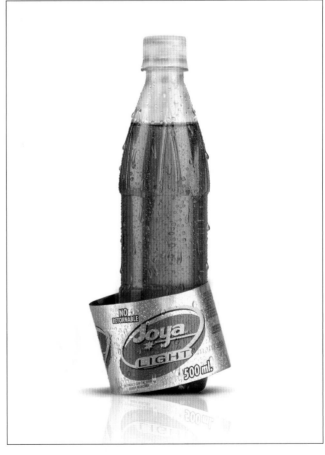

MEXICO

FINALIST, SINGLE

ZONAZERO

MONTERREY, N.L.

CLIENT Joya Light
CREATIVE DIRECTOR Joel Jáuregui/Carlos Ortiz
ART DIRECTOR Ivan Zapata/Carlos Ortiz
COPYWRITER Joel Jáuregui
AGENCY PRODUCER Paulina López
PHOTOGRAPHER Carlos Rodríguez

Footwear

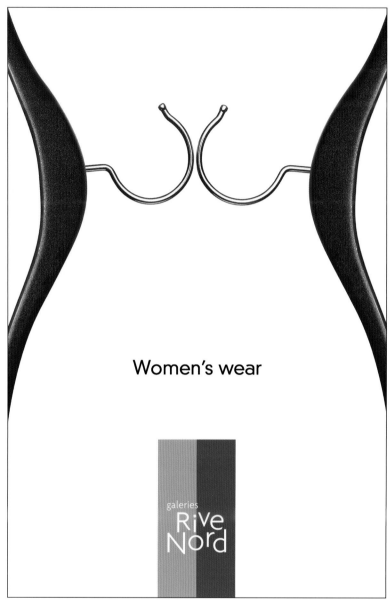

Women's wear

CANADA

SILVER WORLD MEDAL, CAMPAIGN

COSSETTE COMMUNICATION-MARKETING

MONTREAL

CLIENT Galeries Rive-Nord (Shopping Center)
VICE-PRESIDENT, CREATIVE DIRECTOR François Forget
ART DIRECTOR Jonathan Rouxel
COPYWRITER Pascal DeDecker
MARKETING DIRECTOR Karine LaSalle
PHOTOGRAPHER Jean Longpré
ACCOUNT DIRECTOR Benoît Chapellier
ACCOUNT EXECUTIVE France Wong

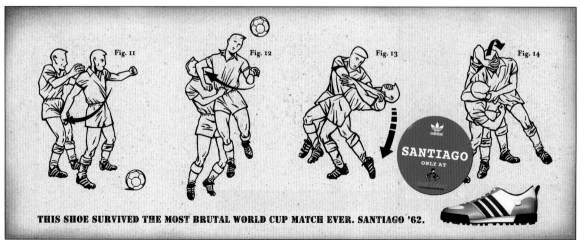

GERMANY

FINALIST, CAMPAIGN

TBWA \

BERLIN

CLIENT Adidas Originals Footlocker
CREATIVE DIRECTOR Kurt Georg Dieckert/
Stefan Schmidt
ART DIRECTOR Boris Schwiedrzik
COPYWRITER Helge Blöck
ART DIRECTOR Thomas Kurzawski
PHOTOGRAPHER Matthias Simon/
Michael Tewes
DESIGNER Christine Taylor
GRAPHIK Diane Bergmann
TYPOGRAPHER Gritt Pfefferkorn
ILLUSTRATOR Felix Reidenbach
ACCOUNT DIRECTOR Kerstin Gold

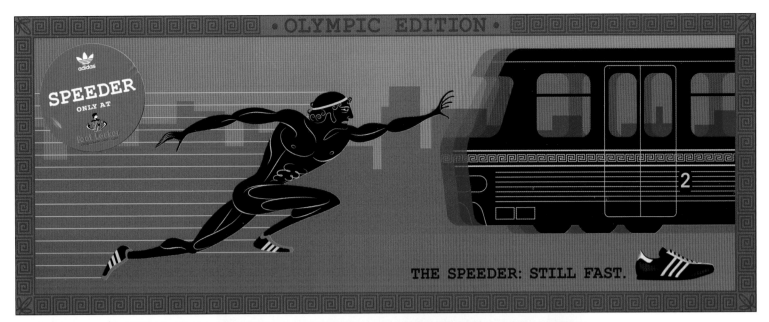

THE SPEEDER: STILL FAST.

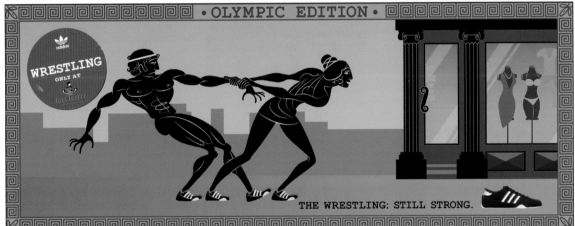

THE WRESTLING: STILL STRONG.

GERMANY
BRONZE WORLD MEDAL, CAMPAIGN
TBWA \
BERLIN

CLIENT Adidas Originals
CREATIVE DIRECTOR Kurt Georg Dieckert/
Stefan Schmidt
ART DIRECTOR Florian Kitzing
COPYWRITER Lennart Witting
ILLUSTRATOR Felix Reidenbach/
Tobias Wandres
ACCOUNT DIRECTOR Kerstin Gold
ACCOUNT Tobias Pagel
CLIENT Contact Hannes Kranzfelder

TELECOMMUNICATIONS

MEXICO
FINALIST, SINGLE
S2 MÉXICO
MÉXICO CITY

CLIENT Unefon
CREATIVE DIRECTOR Eduardo Perez "Spooky"/
Alvaro Zunini/Santiago Chaumont

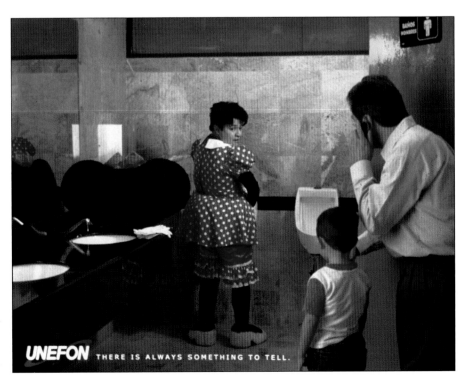

UNEFON THERE IS ALWAYS SOMETHING TO TELL.

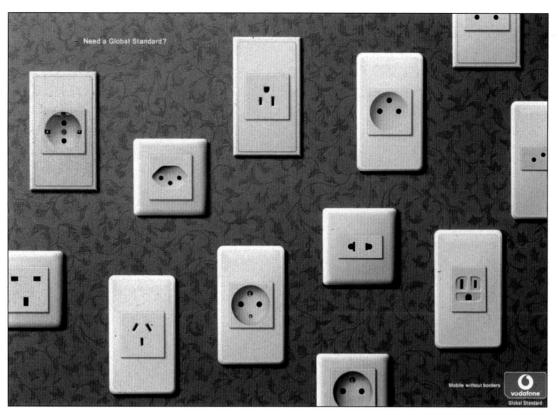

Need a Global Standard?

Mobile without borders

vodafone
Global Standard

JAPAN

BRONZE WORLD MEDAL, CAMPAIGN

J. WALTER THOMPSON JAPAN LTD.
SHIBUYA-KU, TOKYO

CLIENT J-Phone/Vodafone
EXECUTIVE CREATIVE DIRECTOR Koichi Ito
CREATIVE DIRECTOR Koichi Shigaya
ART DIRECTOR Momoko Inoda/
T. Ishikawa/Yoshihisa Suzuki

TOYS/GAMES

frog by an alzheimer patient
PICTIONARY

MEXICO

FINALIST, SINGLE

OGILVY & MATHER MEXICO
MEXICO CITY

CLIENT Pictionary/Mattel
CREATIVE DIRECTOR Marco Colín/
Miguel Ángel Ruiz
COPYWRITER Miguel Ángel Ruiz
ART DIRECTOR Iván Carrasco

car by a stutterer
PICTIONARY

MEXICO

FINALIST, CAMPAIGN

OGILVY & MATHER MEXICO
MEXICO CITY

CLIENT Pictionary/Mattel
CREATIVE DIRECTOR Marco Colín/
Miguel Ángel Ruiz
COPYWRITER Miguel Ángel Ruiz
ART DIRECTOR Iván Carrasco
PHOTOGRAPHER Manolo Santos

BRAZIL

BRONZE WORLD MEDAL, CAMPAIGN

OGILVY BRASIL

SÃO PAULO

CLIENT Fisher Price
CREATIVE DIRECTOR/ART DIRECTOR Virgilio Neves
CREATIVE DIRECTOR/COPYWRITER Manir Fadel
ART DIRECTOR Mariana Valladares
COPYWRITER Leandro Lourenção
ART DIRECTOR Fernanda Salloum
CREATIVE DIRECTOR Adriana Cury
ILLUSTRATOR Daniel Cabalero

TRAVEL/TOURISM

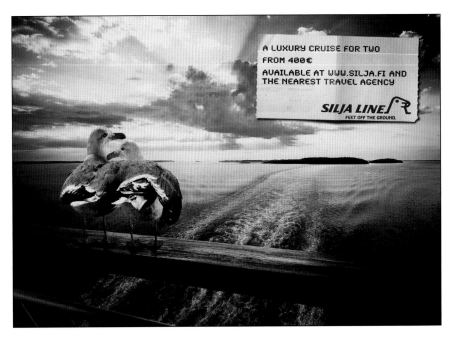

FINLAND

FINALIST, CAMPAIGN

HASAN & PARTNERS OY

HELSINKI

CLIENT Silva Line Cruises
ART DIRECTOR Juha Larsson
COPYWRITER Niko Kokonmaki
CREATIVE DIRECTOR Timo Everi
ACCOUNT MANAGER Elina Tuori/Peter Barmer
ACCOUNT EXECUTIVE Minna Kinnunen
AD ASSISTANT Jan Rudkiewicz

CRAFTS & TECHNIQUES

BEST ART DIRECTION

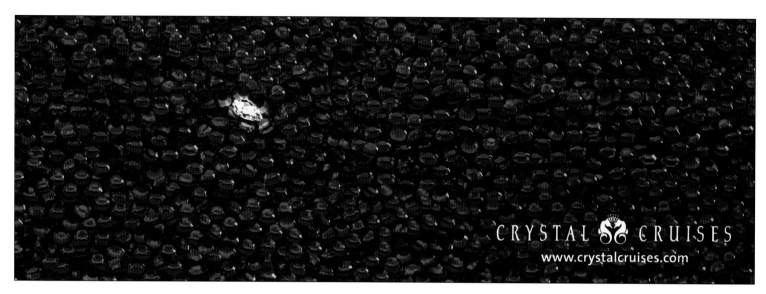

USA

BRONZE WORLD MEDAL, SINGLE

M&C SAATCHI

SANTA MONICA, CA

CLIENT **Crystal Cruises**
ART DIRECTOR **Graham Johnson**
COPYWRITER **Oliver Devaris**
CREATIVE DIRECTOR **Tom McFarlane**
ACCOUNT EXECUTIVE **Jason Riley**
ACCOUNT DIRECTOR **Liz Healy**
PRODUCTION DIRECTOR **Linda Cran**
PHOTOGRAPHER **Kevin Summers**

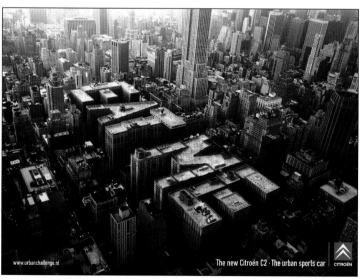

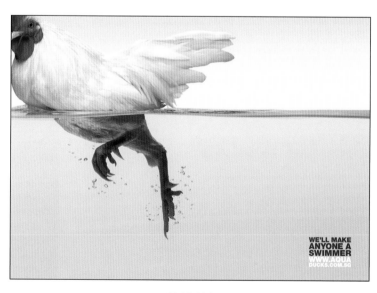

THE NETHERLANDS

FINALIST, SINGLE

EURO RSCG BLRS

AMSTELVEEN

CLIENT **Citroën C2**
CREATIVE DIRECTOR **Martin Boomkens**
ART DIRECTOR **Bert Kerkhof**
COPYWRITER **Ivar van den Hove**
PHOTOGRAPHER **Jaap Vliegenthart**

SINGAPORE

FINALIST, SINGLE

GOSH ADVERTISING PTE LTD

SINGAPORE

CLIENT **Aqua Ducks**
CREATIVE DIRECTOR **Lim Soon Huat**
ART DIRECTOR **James Quek**
PHOTOGRAPHER **Groovy Studio (Lai)**
DIGITAL IMAGING **Procolor Separation (Willie Ang)**

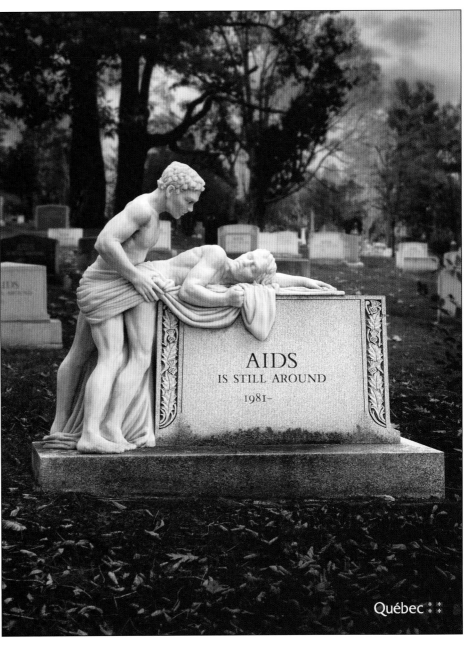

CANADA

MARKETEL
MONTREAL

CLIENT Québec Governments Health and
Social Services Department
VP CREATIVE DIRECTOR Gilles DuSablon
ART DIRECTOR Stéphane Gaulin
COPYWRITER Linda Dawe
ACCOUNT EXECUTIVE Anouk Crevier
PHOTOGRAPHER Aventure Studio

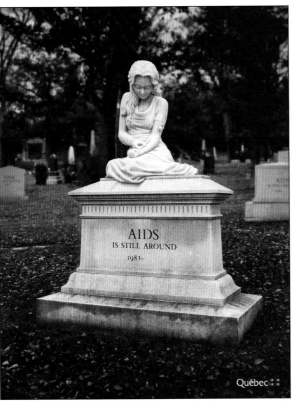

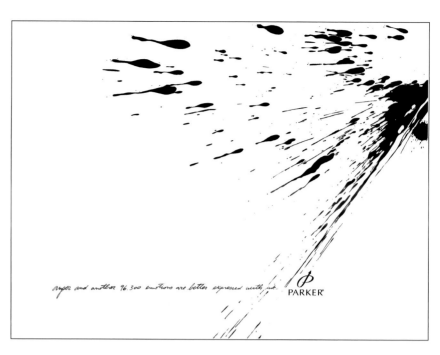

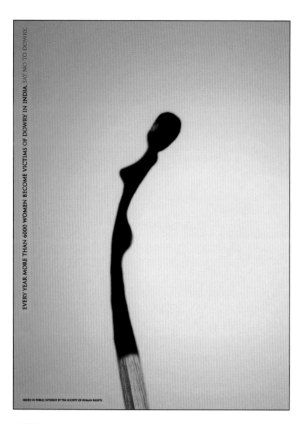

INDIA

FINALIST, SINGLE

R.K. SWAMY BBDO
MUMBAI, MAHARASHTRA

CLIENT Society Of Human Rights
SENIOR CREATIVE DIRECTOR Chandrashekhar Vaidya
COPYWRITER Chandrashekhar Vaidya
ART DIRECTOR Chandrashekhar Vaidya

ARGENTINA

FINALIST, CAMPAIGN

OGILVY & MATHER ARGENTINA
BUENOS AIRES

CLIENT Parker
GENERAL CREATIVE DIRECTOR Gustavo Reyes
CREATIVE DIRECTOR Aregger/Campopiano/
Duhalde/Sanchez Correa
ART DIRECTOR F. Zagales/M. Sanchez Correa
COPYWRITER Mariano Duhalde
GENERAL ART DIRECTOR M. Sanchez Correa
HEAD ACCOUNT Yayo Enriquez

BEST ILLUSTRATION

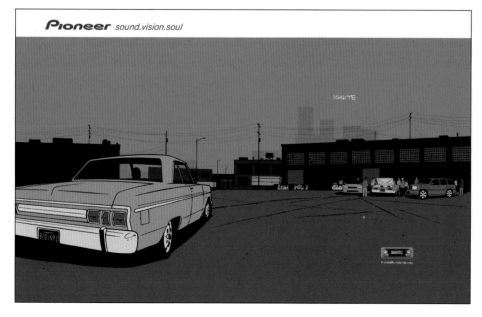

USA

FINALIST, SINGLE

BBDO WEST (SF)
SAN FRANCISCO, CA

CLIENT Pioneer Electronics
CREATIVE DIRECTOR Jim Lesser
ART DIRECTOR Rickie Daghlian/
JR Roberts/Sakol Mongkolkasetarin
ILLUSTRATOR Evan Hecox
COPYWRITER Jim Lesser/Steve Howard
PRINT PRODUCER Erica Jensen

BEST USE OF MEDIUM

TAIWAN

SILVER WORLD MEDAL, SINGLE

OGILVY & MATHER ADVERTISING TAIWAN
TAIPEI

CLIENT Nike Speed
EXECUTIVE CREATIVE DIRECTOR Murphy Chou
CREATIVE DIRECTOR Rich Shiue
COPYWRITER Giant Kung/Kurt Lu
ART DIRECTOR Lii Chiang/Kit Koh

SWITZERLAND

FINALIST, SINGLE

McCANN-ERICKSON SWITZERLAND
ZURICH

CLIENT Cleft Children International
CREATIVE DIRECTOR Dominik Imseng
ART DIRECTOR Sara De Pasquale
COPYWRITER Nemanja Gajic
ACCOUNT DIRECTOR Heike Rindfleisch

CHILE

BRONZE WORLD MEDAL, SINGLE

IDB/FCB S.A.
SANDIAGO

CLIENT Raid
EXECUTIVE CREATIVE DIRECTOR Rodrigo Gómez
CREATIVE DIRECTOR Cristián Vásquez
ART DIRECTOR Aliro Jara
COPYWRITER Laura Charpantier

Transparent Backlight so that it is possible to see the fluorescent tubes mechanism as well as the insects which have died inside after being attracted in by the light.

Raid.

BEST FLEET GRAPHIC

USA

FINALIST, SINGLE

DI GRAPHICS
WHEAT RIDGE, CO

CLIENT Hi-Line Moving Services
HI-LINE, SALES & MARKETING MANAGER Brian Smith
HI-LINE, PRESIDENT Paul Lindstrom
DI GRAPHICS, SALES REPRESENTATIVE Steve Gardner
DI GRAPHICS, GRAPHIC ARTIST Chris Myers

BEST POSTER

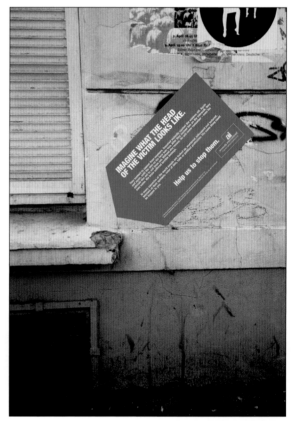

GERMANY

FINALIST, SINGLE

HE SAID SHE SAID
HAMBURG

CLIENT Amnesty International
CREATIVE DIRECTOR Michael Hoinkes
TEXT Michael Hoinkes
ACCOUNT SUPERVISOR Slaven Zubak
CLIENT Rainer Roth

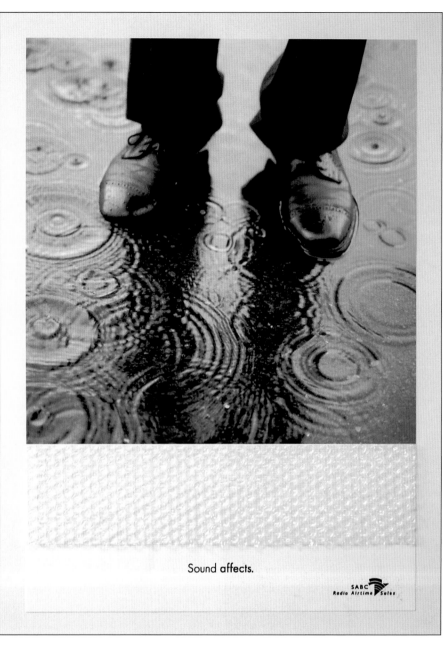

Sound affects.

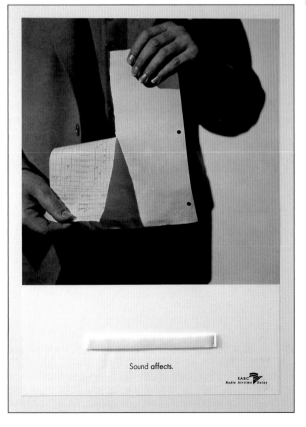

Sound affects.

SOUTH AFRICA

GOLD WORLD MEDAL, CAMPAIGN

TEQUILA JOHANNESBURG

BENMORE, JOHANNESBURG

CLIENT SABC Radio Airtime Sales
ART DIRECTOR George Rautenbach
COPYWRITER Vicki Oudmayer
CREATIVE DIRECTOR Margie Backhouse/Petra Oelofse
PRODUCTION DIRECTOR Julian Walker

GRAND
AWARD

ARGENTINA
GRAND AWARD
BEST POSTER
DEL CAMPO NAZCA SAATCHI & SAATCHI
BUENOS AIRES

CLIENT Buenos Aires Zoo
CREATIVE DIRECTOR Chavo D'Emilio/Chanel Basualdo
ART DIRECTOR Iñaki G. del Solar/Daniel Fierro
COPYWRITER Mariano Serkin
ACCOUNT DIRECTOR Pablo Ordoñez
AGENCY PRODUCER Cosme Argerich
PHOTOGRAPHER Julieta García Vazquez
ADVERTISER'S SUPERVISOR Fernando Chaín

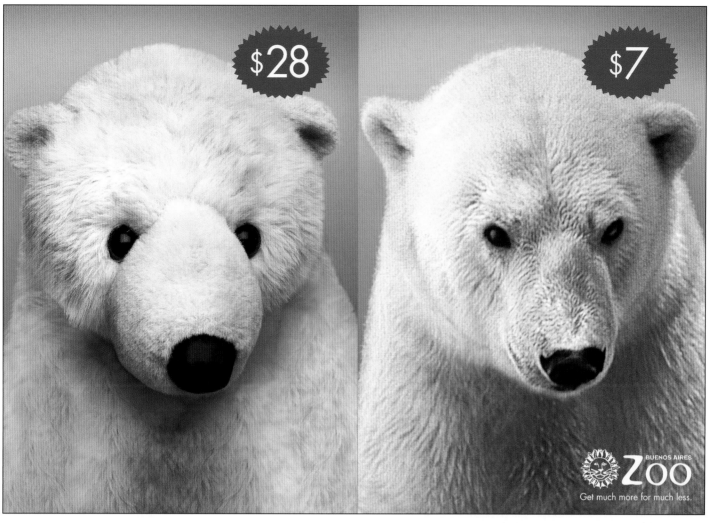

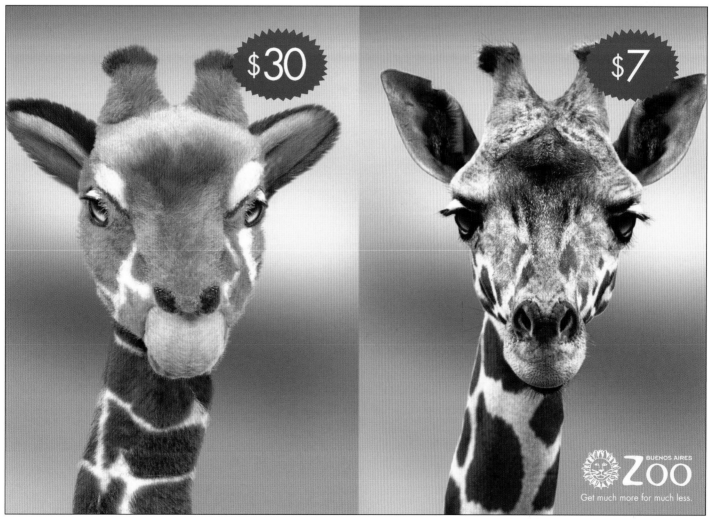

SWITZERLAND

BRONZE WORLD MEDAL, SINGLE

GUYE BENKER
ZÜRICH

CLIENT Die Weltwoche
CREATIVE DIRECTOR André Benker
COPYWRITER Beat Egger
ART DIRECTOR Corinta Cito

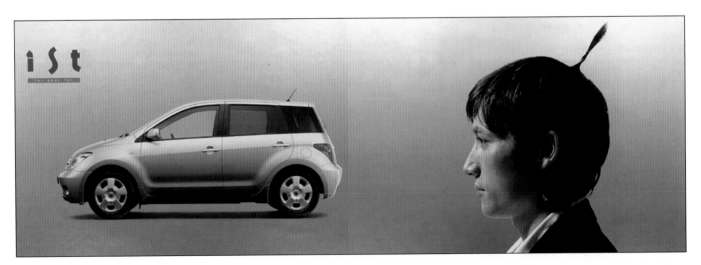

JAPAN

FINALIST, SINGLE

HAKUHODO INC.
MINATO-KU, TOKYO

CLIENT Toyota Ist
CREATIVE DIRECTOR Konje O
ART DIRECTOR Tatsuya Miyake
PHOTOGRAPHER Marco Delogu

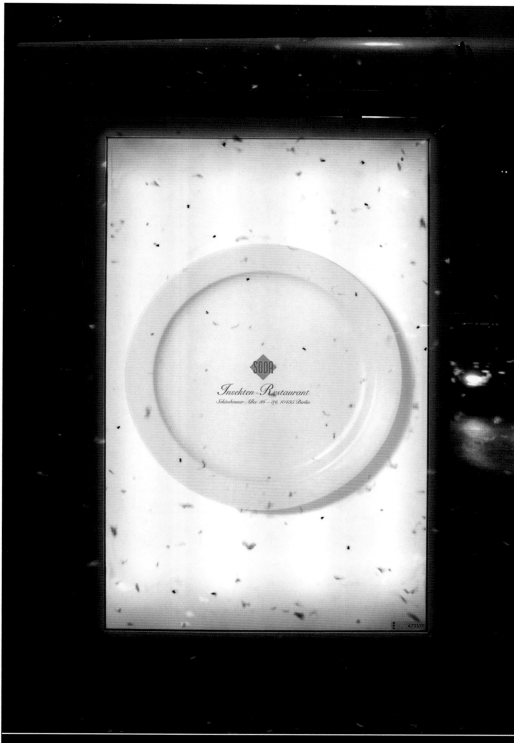

SODA Insect Restaurant: "Eat what's on your plate!"
Actually, all the City Light Poster shows is an empty plate. But at night, the dazzling artificial light attracts moths, butterflies, gnats and other delicacies that end up as a living meal on the china plate of the SODA Insect Restaurant.

GERMANY

SILVER WORLD MEDAL, SINGLE
MICHAEL CONRAD & LEO BURNETT
FRANKFURT

CLIENT B.A.X. Entertainment GmbH
CREATIVE DIRECTOR Hans-Jürgen Kämmerer
COPYWRITER Robert Junker
PHOTOGRAPHER Elisabeth Herrmann
ACCOUNT SUPERVISOR Alexander Schmidt

MEXICO
FINALIST, SINGLE
OGILVY & MATHER MEXICO
MEXICO CITY

CLIENT Gandhi Bookstores
CREATIVE DIRECTOR Marco Colín/José Montalvo
COPYWRITER José Montalvo
ART DIRECTOR Aurora Morfín/Carlos García

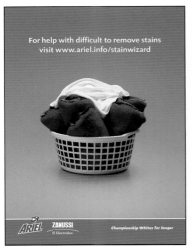

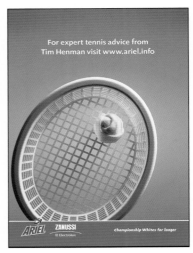

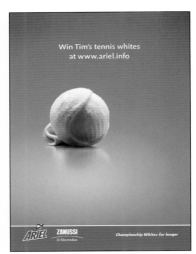

ENGLAND
FINALIST, CAMPAIGN
ARC MARKETING
LONDON

CLIENT Ariel
EXECUTIVE CREATIVE DIRECTOR
Graham Mills/Jack Nolan
COPYWRITER Aaron Martin
ART DIRECTOR Garry Munns
ACCOUNT DIRECTOR Matt Tabb
ACCOUNT EXECUTIVE James Ralley
PRODUCTION Tenacia Horlock

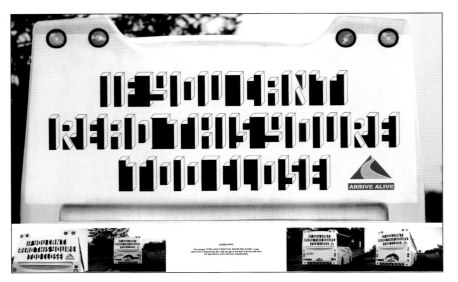

SWITZERLAND
FINALIST, SINGLE
THE DUKES OF URBINO.COM
GLOBAL

CLIENT Department of Transport - Arrive Alive
CREATIVE DIRECTOR Graham Warsop
ART DIRECTOR Liam Wielopolski
COPYWRITER Mick Blore
PRODUCTION MANAGER Belinda Shea

PUBLIC SERVICE

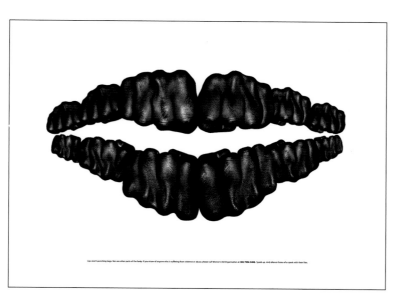

MALAYSIA

FINALIST, SINGLE

OGILVYONE WORLDWIDE SDN BHD
KUALA LAMPUR

CLIENT Womens Aid Organisation
EXECUTIVE CREATIVE DIRECTOR Tan Kien Eng
COPYWRITER Lee Siew Thin
ART DIRECTOR Theresa Tsang Teng/Tan Kien Eng
SENIOR PHOTOGRAPHER Allen Dang/Studio Rom
DIGITAL ARTISIT Leong Tuck Mun/Image Rom

USA

FINALIST, SINGLE

DDB LOS ANGELES
VENICE, CA

CLIENT Manzanar War Relocation Center
CREATIVE DIRECTOR Mark Monteiro
ART DIRECTOR Feh Tarty
COPYWRITER Rob Berland
ACCOUNT MANAGER Jefferson Coombs

MALAYSIA

GOLD WORLD MEDAL, CAMPAIGN

OGILVYONE WORLDWIDE SDN BHD
KUALA LAMPUR

CLIENT Womens Aid Organisation
EXECUTIVE CREATIVE DIRECTOR Tan Kien Eng
COPWRITER Lee Siew Thin
ART DIRECTOR Theresa Tsang Teng/Tan Kien Eng
SENIOR PHOTOGRAPHER Allen Dang/Studio Rom
DIGITAL IMAGING ARTIST Leong Tuck Mun/Image Rom

SEE GRAND AWARD PAGE 253

MALAYSIA

FINALIST, SINGLE

OGILVYONE WORLDWIDE SDN BHD
KUALA LAMPUR

CLIENT Womens Aid Organisation
EXECUTIVE CREATIVE DIRECTOR Tan Kien Eng
COPYWRITER Lee Siew Thin
ART DIRECTOR Theresa Tsang Teng/Tan Kien Eng
SENIOR PHOTOGRAPHER Allen Dang/Studio Rom
DIGITAL IMAGING ARTIST Leong Tuck Mun/Image Rom

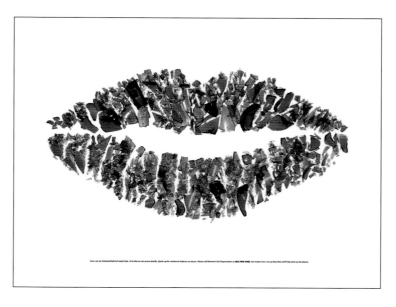

GRAND
AWARD

Public Service

MALAYSIA

GRAND AWARD

BEST PUBLIC SERVICE

OGILVYONE WORLDWIDE SDN BHD

KUALA LAMPUR

CLIENT Womens Aid Organisation
EXECUTIVE CREATIVE DIRECTOR Tan Kien Eng
COPYWRITER Lee Siew Thin
ART DIRECTOR Theresa Tsang Teng/Tan Kien Eng
SENIOR PHOTOGRAPHER Allen Dang/Studio Rom
DIGITAL IMAGING ARTIST Leong Tuck Mun/Image Rom

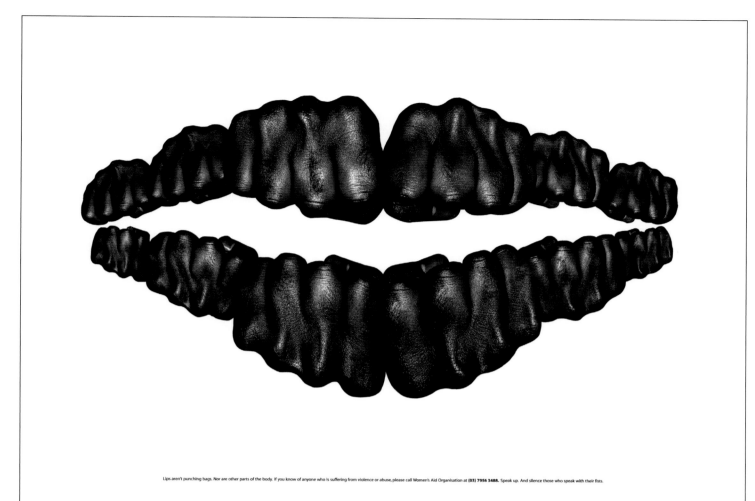

Lips aren't punching bags. Nor are other parts of the body. If you know of anyone who is suffering from violence or abuse, please call Women's Aid Organisation at **(03) 7956 3488.** Speak up. And silence those who speak with their fists.

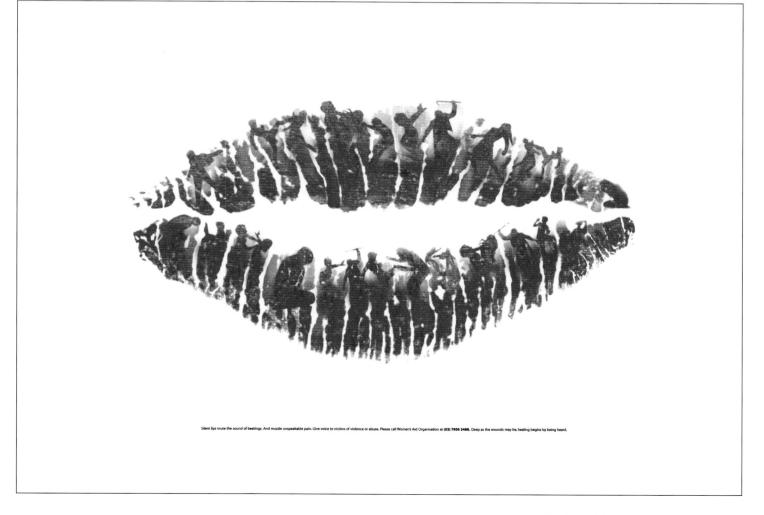

Silent lips mute the sound of beatings. And muzzle unspeakable pain. Give voice to victims of violence or abuse. Please call Women's Aid Organisation at **(03) 7956 3488.** Deep as the wounds may be, healing begins by being heard.

Art is in all of us.

SINGAPORE

FINALIST, SINGLE
CRUSH
SINGAPORE

CLIENT Ministry Of Information And The Arts
CHIEF CREATIVE/COPYWRITER Kelvin Pereira
ART DIRECTOR/PHOTOGRAPHER Rashid Salleh
VISUALISER Loh Seow Khian
ACCOUNT SERVICING Mabel Wee

INTERPERSONAL/INTERGROUP

GAY?

Frankfurt's gay centre
Alte Gasse 36 · 069/133879-30 · www.ag36.de

GERMANY

FINALIST, SINGLE
McCANN-ERICKSON FRANKFURT/
M., GERMANY
FRANKFURT

CLIENT Ag 36 (Aidshilfe Frankfurt e.V.)
CREATIVE DIRECTOR Thomas Auerswald/
Walter Roux
ART DIRECTOR Uli Happel
PHOTOGRAPH Frank Weinert
ACCOUNT DIRECTOR Stefan Geisse

SLOVENIA

FINALIST, SINGLE
AGENCIJA IMELDA D.O.O
LJUBLJANA

CLIENT Dyslexia
CREATIVE DIRECTOR, COPYWRITER
Suna Tancig
DESIGNER Ursa Accetto Rems

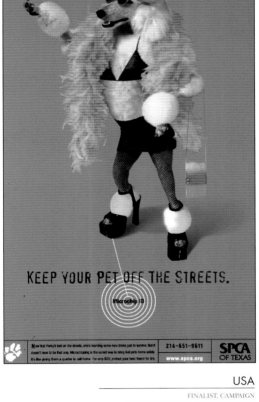

KEEP YOUR PET OFF THE STREETS.

Microchip ID

214-651-9511
www.spca.org

SPCA
OF TEXAS

USA

FINALIST, CAMPAIGN
TRACY LOCKE PARTNERSHIP
DALLAS, TX

CLIENT SPCA
GROUP CREATIVE DIRECTOR April Moore
ART DIRECTOR John Harrell
PHOTOGRAPHER Guillaume Garrigue
COPYWRITER Michael Streiter

PERSONAL DEVELOPMENT

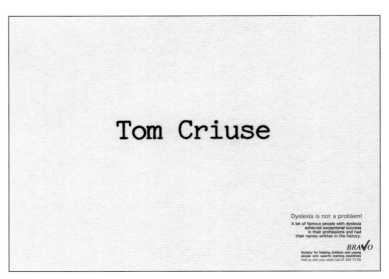

Tom Criuse

Dyslexia is not a problem!
A lot of famous people with dyslexia
achieved exceptional success
in their professions and had
their names written in the history.

BRAVO

Society for helping children and young
people with specific learning disabilities
Visit us with your child Call 01-583 75 50

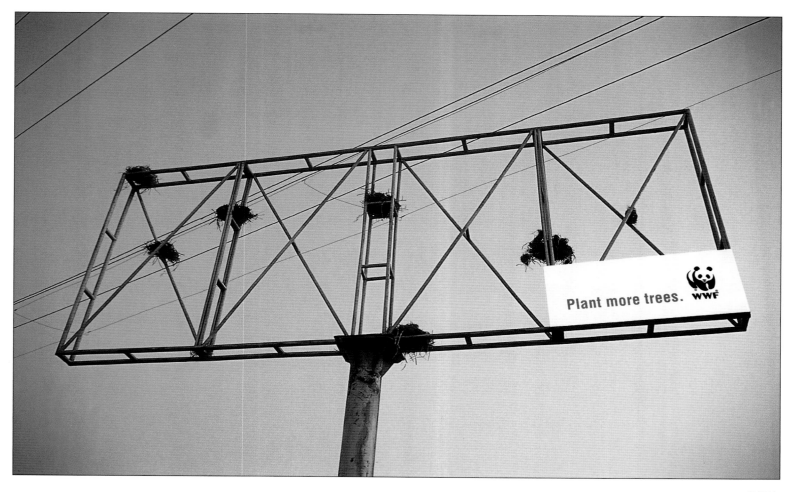

Plant more trees. WWF

INDIA

GOLD WORLD MEDAL, SINGLE

RMG DAVID

NEW DELHI

CLIENT WWF (India)
CREATIVE DIRECTOR Josy Paul
COPYWRITER Amit Nandwani
ART DIRECTOR Rohit Devgun
CLIENT SERVICING Nitin Khanna
BRAND MANAGER Nalin Sharma

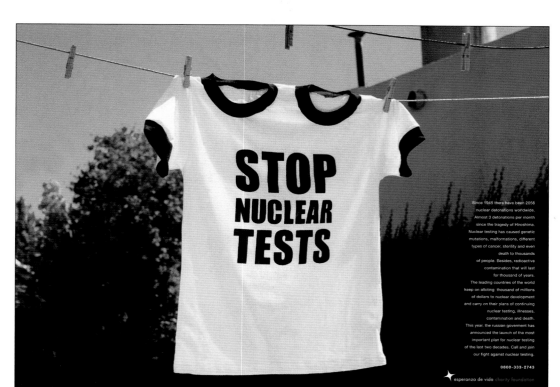

STOP NUCLEAR TESTS

Since 1945 there have been 2056 nuclear detonations worldwide. Almost 3 detonations per month since the tragedy of Hiroshima. Nuclear testing has caused genetic mutations, malformations, different types of cancer, sterility and even death to thousands of people. Besides, radioactive contamination that will last for thousand of years. The leading countries of the world keep on alloting thousand of millions of dollars to nuclear development and carry on their plans of continuing nuclear testing, illnesses, contamination and death. This year, the russian goverment has announced the launch of the most important plan for nuclear testing of the last two decades. Call and join our fight against nuclear testing.

0800-333-2743

esperanza de vida charity foundation

ARGENTINA

BRONZE WORLD MEDAL, SINGLE

CRAVEROLANIS EURO RSCG

BUENOS AIRES

CLIENT Fundación Esperanza De Vida
GENERAL CREATIVE DIRECTOR Juan Cravero/Darío Lanis
COPYWRITER Ariel Serkin/Juan Pablo Lufrano
ART DIRECTOR Diego Sánchez
PHOTOGRAPHER Diana Deak

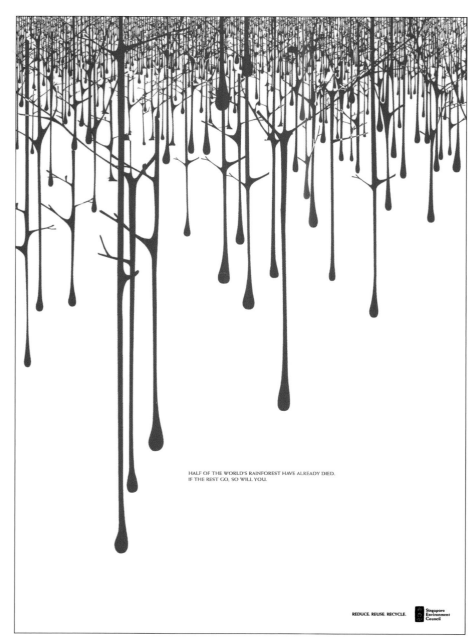

HALF OF THE WORLD'S RAINFOREST HAVE ALREADY DIED.
IF THE REST GO, SO WILL YOU.

REDUCE. REUSE. RECYCLE. Singapore Environment Council

SINGAPORE
SILVER WORLD MEDAL, SINGLE
CRUSH
SINGAPORE

CLIENT Singapore Environment Council
CREATIVE DIRECTOR Kelvin Pereira/Frank Young
ART DIRECTOR/ILLUSTRATOR Katherine Khor
COPYWRITER Uma Rudd Chia
ACCOUNT SERVICING Aisha Lo

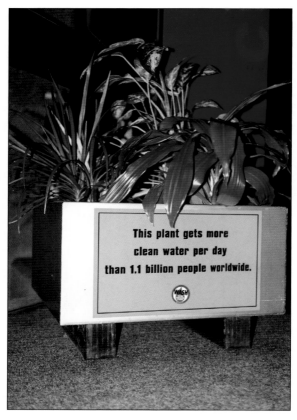

This plant gets more clean water per day than 1.1 billion people worldwide.

SWITZERLAND
FINALIST, SINGLE
McCANN-ERICKSON SWITZERLAND
ZURICH

CLIENT Wash

URUGUAY
SILVER WORLD MEDAL, SINGLE
CORPORACION THOMPSON
MONTEVIDEO

CLIENT Unicef
ART DIRECTOR Leonardo Varela
COPYWRITER Gonzalo Eyherabide
ACCOUNT DIRECTOR Nicolas Dutra
PHOTOGRAPHER Santiago Epstein

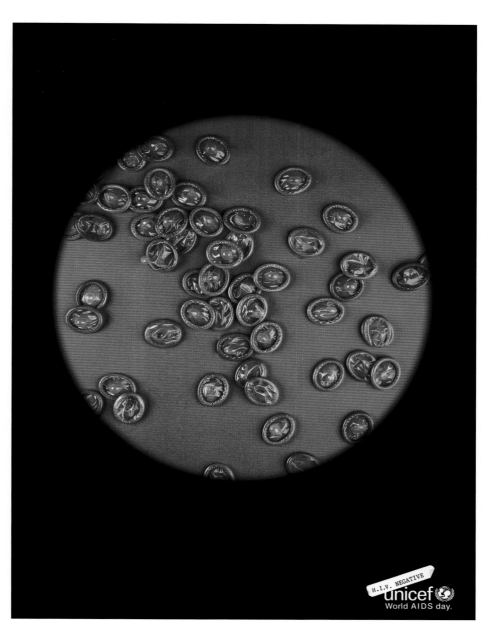

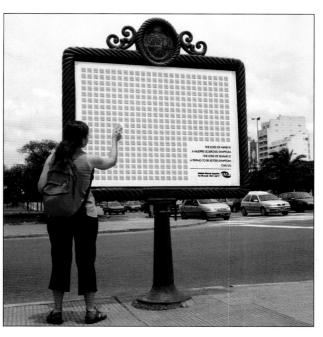

ARGENTINA
FINALIST, SINGLE
J. WALTER THOMPSON
BUENOS AIRES

CLIENT Asociación De Esclerosis Múltiple
EXECUTIVE CREATIVE DIRECTOR Leandro Raposo
CREATIVE DIRECTOR Javier Mentasti/Ramiro Crosio/
Christian Camean
EXECUTIVE CREATIVE DIRECTOR Pablo Stricker

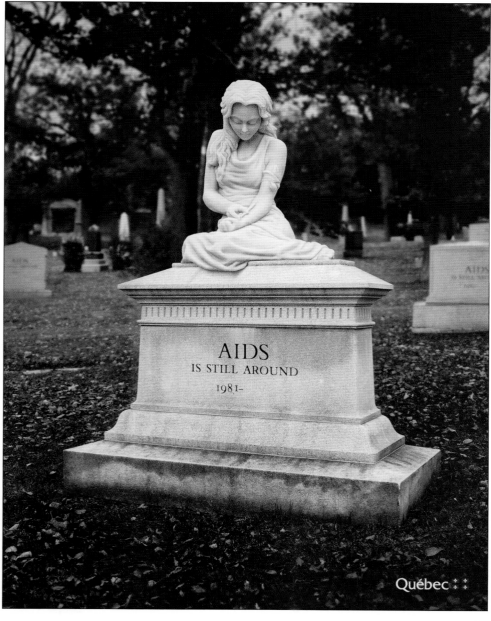

CANADA

GOLD WORLD MEDAL, CAMPAIGN

MARKETEL

MONTREAL

CLIENT Québec Governments Health and Social Services Department
VP CREATIVE DIRECTOR Gilles DuSablon
COPYWRITER Linda Dawe
ART DIRECTOR Stéphane Gaulin
ACCOUNT EXECUTIVE Anouk Crevier
PHOTOGRAPHER Aventure Studio

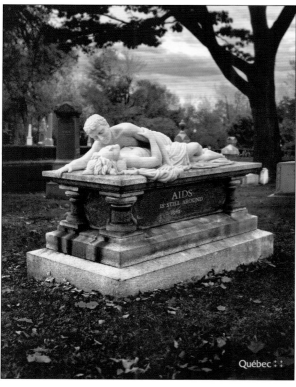

CANADA

BRONZE WORLD MEDAL, CAMPAIGN

MARKETEL

MONTREAL

CLIENT COCQ-Sida

VP CREATIVE DIRECTOR
Gilles DuSablon

COPYWRITER Linda Dawe

ART DIRECTOR Stéphane Gaulin

ACCOUNT EXECUTIVE Anouk Crevier

PHOTOGRAPHER Tilt

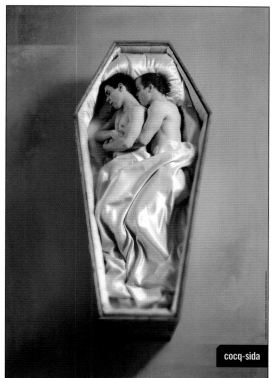

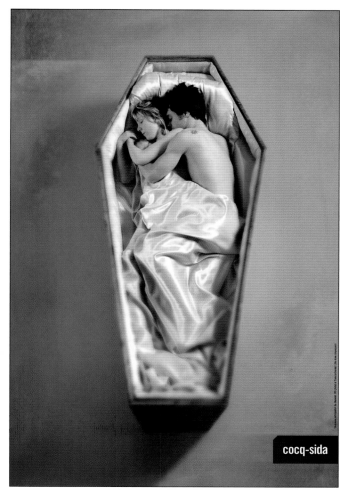

PERSONAL SAFETY

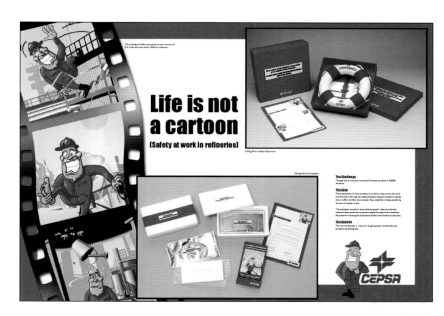

SPAIN

FINALIST, CAMPAIGN

FCB INTEGRATED

MADRID

CLIENT CEPSA

GENERAL CREATIVE DIRECTOR Oscar Rojo

CREATIVE DIRECTOR Luis Ballester

ART DIRECTOR Vicente Curto

COPYWRITER Ricardo de Santiago

ACCOUNT EXECUTIVE Maria Lopez-Barranco

ACCOUNT SUPERVISOR Amelia Perez

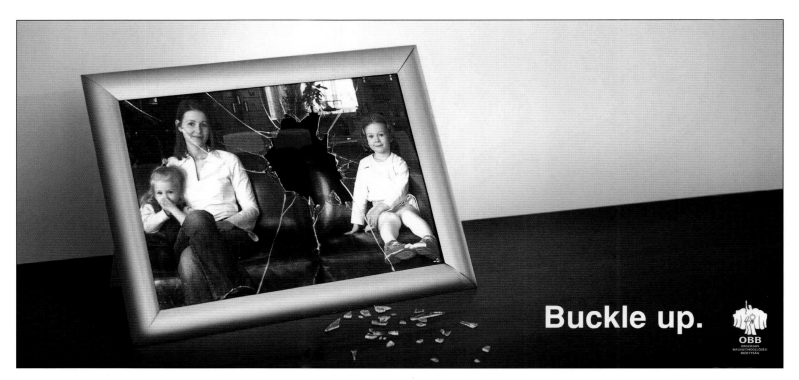

HUNGARY

SILVER WORLD MEDAL, SINGLE
LEO BURNETT BUDAPEST
BUDAPEST

CLIENT National Committee for
Accident Prevention
CREATIVE DIRECTOR Milos Ilic
ART DIRECTOR Chris Hill
COPYWRITER Dezso Nagy/
Vilmos Farkas
PHOTOGRAPHER Csaba Jobbagy
ACCOUNT DIRECTOR Orsolya Hali

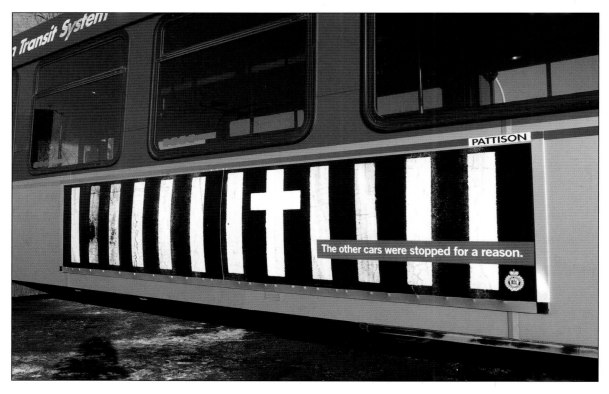

CANADA

BRONZE WORLD MEDAL, SINGLE
DDB CANADA
EDMONTON, ALBERTA

CLIENT Edmonton Police Service
CREATIVE DIRECTOR Eva Polis
ART DIRECTOR Scott Channon
COPYWRITER Eva Polis
ACCOUNT DIRECTOR Martha Jamieson

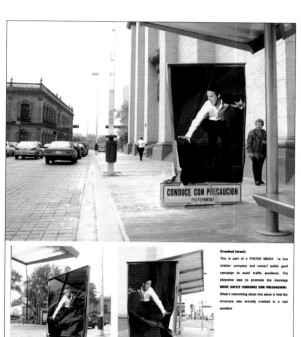

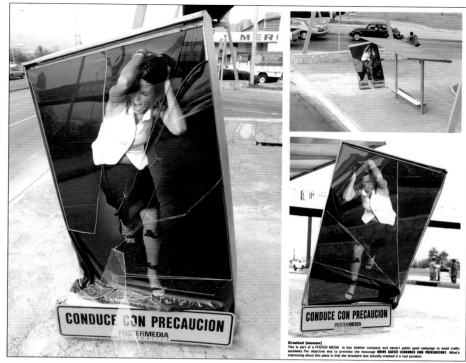

Crashed [woman]:
This is part of a POSTER MEDIA (a bus shelter company and owner) public good campaign to avoid traffic accidents. The objective was to promote the message DRIVE SAFELY (CONDUCE CON PRECAUCION). What's interesting about this piece is that the structure was actually crashed in a real accident.

MEXICO

BRONZE WORLD MEDAL, CAMPAIGN

ZONAZERO
MONTERREY

CLIENT Poster Media
CREATIVE DIRECTOR Joel Jáuregui/Carlos Ortiz
COPYWRITER Joel Jáuregui
ART DIRECTOR Sergio Moreno
AGENCY PRODUCER Paulina López
PHOTOGRAPHER Juan Rodrigo Llaguno

PHILANTHROPIC APPEALS

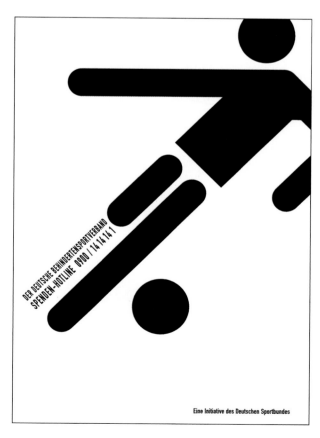

GERMANY

FINALIST, SINGLE

BBDO CAMPAIGN GMBH
DUESSELDORF

CLIENT Deutschen Sportbundes
CREATIVE DIRECTOR Heike Fuhs
COPYWRITER Andreas Steinkemper
ART DIRECTOR Ton Hollander

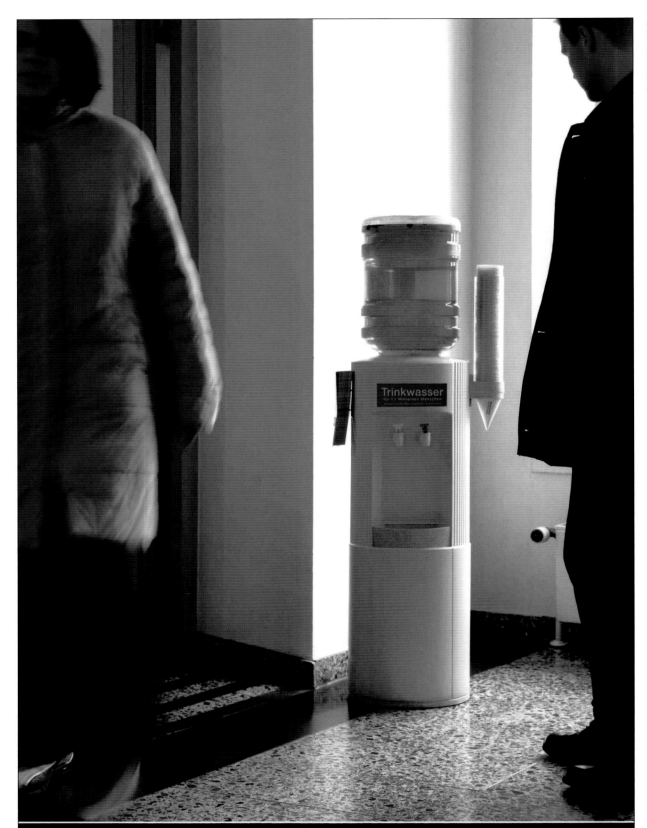

GERMANY

GOLD WORLD MEDAL, SINGLE

MICHAEL CONRAD &
LEO BURNETT

FRANKFURT

CLIENT Unicef

UNICEF: "Waterdispenser"

2003 was the "Year of Drinking Water". To
mark the occasion, UNICEF wanted to remind
people of the fact that 1.1 billion people
worldwide have no access to clean drinking
water. To communicate this, we filled public
water dispensers with the kind of water that
1.1 billion people have to drink every day.
A provocative sign on each dispenser read:
"Drinking Water for 1.1 Billion People. Please
make a donation to UNICEF before you drink".
The bank account number was printed on the
paper cups.

INDIA

SILVER WORLD MEDAL, SINGLE

ADFACTORS ADVERTISING

MUMBAI, MAHARASHTRA

CLIENT The Vatsalya Foundation
CREATIVE DIRECTOR Uday Parkar
COPYWRITER Oruganti Ramesh
PHOTOGRAPHER Atul Patil
GENERAL MANAGER V Subramanian

Often, paper is all that homeless children find to sleep on, in and under. Help us provide them a better shelter.

The Vatsalya Foundation, Anand Niketan, King George V Memorial, Dr E Moses Road, Mahalaxmi (W), Mumbai 400011. Ph: 24962115, Telefax: 24912352, e-mail: vatsalyafdn@vsnl.com, www.thevatsalyafoundation.org

SPAIN

FINALIST, SINGLE

CAYENNE

BARCELONA

CLIENT Acción Contra el Hambre
EXECUTIVE CREATIVE DIRECTOR Emilio Lezaun
ART DIRECTOR Pep Faura

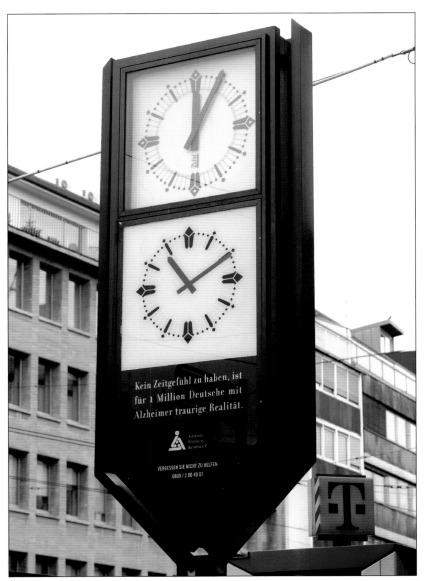

Kein Zeitgefühl zu haben, ist
für 1 Million Deutsche mit
Alzheimer traurige Realität.

VERGESSEN SIE NICHT ZU HELFEN:
0800 / 2 00 40 01

GERMANY
BRONZE WORLD MEDAL, SINGLE
TBWA \
BERLIN

CLIENT Alzheimer Research
CREATIVE DIRECTOR Kai Röffen
ART DIRECTOR Rainer Schmidt
COPYWRITER Donald Tursman
ACCOUNT Silke Schering
MARKETING DIRECTOR Dr. Ellen Wiese

GERMANY
FINALIST, SINGLE
TBWA \
BERLIN

CLIENT Alzheimer Research
CREATIVE DIRECTOR Kai Röffen
ART DIRECTOR Rainer Schmidt
COPYWRITER Donald Tursman
ACCOUNT Silke Schering
MARKETING DIRECTOR Dr. Ellen Wiese

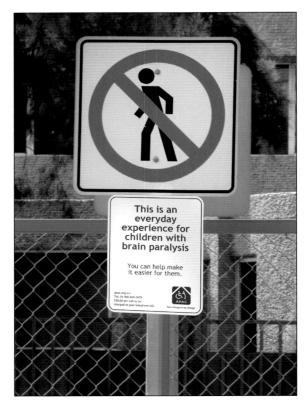

This is an
everyday
experience for
children with
brain paralysis

You can help make
it easier for them.

MEXICO
FINALIST, SINGLE
FOOTE CONE AND BELDING
MEXICO CITY

CLIENT APAC
EXECUTIVE CREATIVE DIRECTOR Yuri Alvarado
CREATIVE DIRECTOR Gustavo Duenas
COPYWRITER Alonso Arias
ART DIRECTOR Agustin Padilla

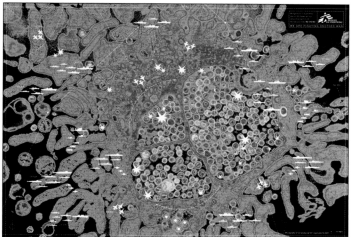

SPAIN

SILVER WORLD MEDAL, CAMPAIGN

McCANN-ERICKSON
MADRID

CLIENT Médicos Sin Fronteras
GENERAL CREATIVE DIRECTOR Nicolás Hollander
ART DIRECTOR Vanessa Sanz
COPYWRITER Isabel López
PRINT PRODUCTION MANAGER Sara Fernández

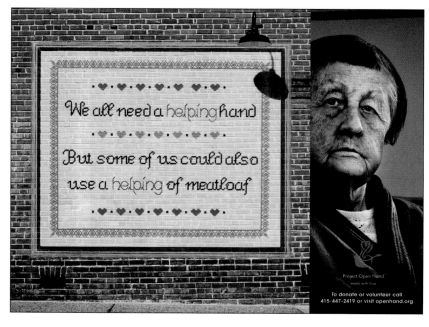

USA

FINALIST, CAMPAIGN
PUBLICIS DIALOG SF
SAN FRANCISCO, CA

CLIENT Project Open Hand
EXECUTIVE CREATIVE DIRECTOR Tom Kavanaugh
COPYWRITER John Munyan
ART DIRECTOR Gregg Foster/David Popino/Lyle Lim

CANADA

BRONZE WORLD MEDAL, CAMPAIGN
PUBLICIS TORONTO
TORONTO

CLIENT Canada Helps.Org
CREATIVE DIRECTOR Duncan Bruce/
Pat Pirisi
ART DIRECTOR Duncan Bruce/
Mark Francolini
WRITER Pat Pirisi
ILLUSTRATOR Simon Newman
PRINT PRODUCER Pat McKeen
ACCOUNT DIRECTOR Brett McIntosh

PROMOTION OF PEACE & HUMAN RIGHTS

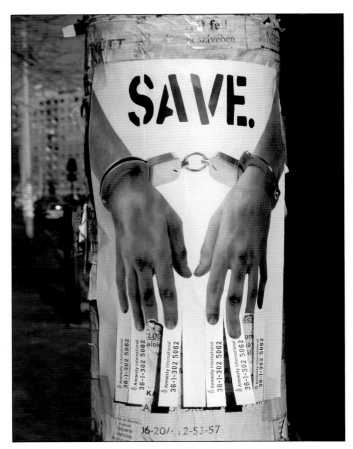

HUNGARY

FINALIST, SINGLE
OGILVY & MATHER
BUDAPEST

CLIENT Amnesty International
ART DIRECTOR/CREATIVE DIRECTOR Dalbir Singh
COPYWRITER Satbir Singh
PHOTOGRAPHER Gabor Fiala

GERMANY

GOLD WORLD MEDAL, CAMPAIGN
HE SAID SHE SAID
HAMBURG

CLIENT **Amnesty International**
CREATIVE DIRECTOR **Michael Hoinkes**
TEXT **Michael Hoinkes**
ACCOUNT SUPERVISOR **Slaven Zubak**
PHOTOGRAPHER **Stephan Försterling**
CLIENT **Rainer Roth**

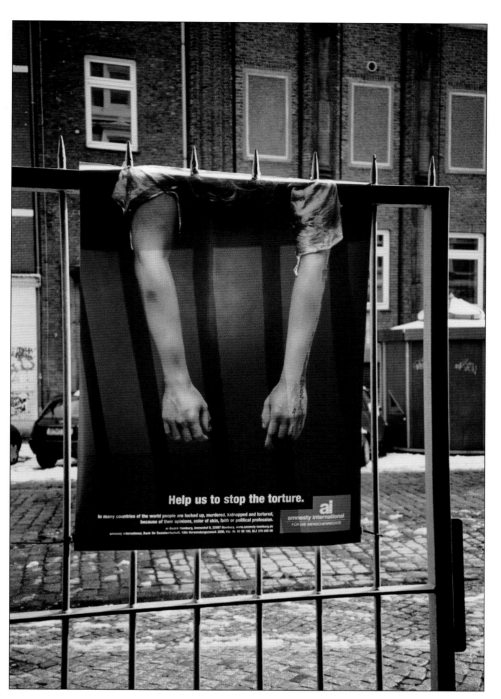

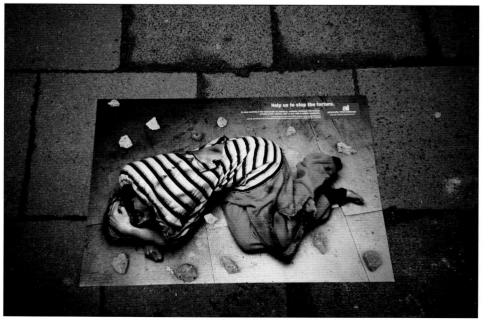

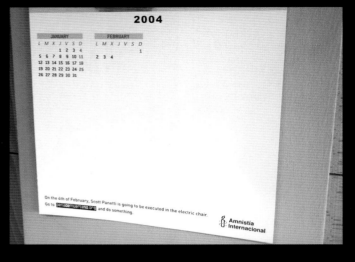

CHALLENGE

The briefing involved making a very low budget campaign against the death penalty.

SOLUTION

As we were working at the start of the year, we decided to give calendars for 2004, showing the people who were going to be executed this year.
In the top part appeared the photo of the condemned prisoner, and below was the calendar for the year 2004, up to the day of their execution. The rest of the days and the months were left blank.

We sent the calendars to the main opinion leaders and they were also handed out in universities, stores, cafés and markets.

WALL CALENDAR

Amnistía Internacional

SPAIN

GOLD WORLD MEDAL, SINGLE
CONTRAPUNTO
MADRID

CLIENT Amnistia Internacional
GENERAL CREATIVE DIRECTOR Antonio Montero
CREATIVE DIRECTOR Carlos S de Andino/C. Jorge
COPYWRITER Sergio S. Caballero/Miguel Madariaga
ART DIRECTOR Enrique Camina/Santiago Winer

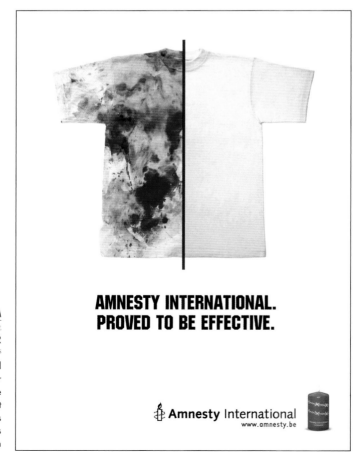

BELGIUM

BRONZE WORLD MEDAL, SINGLE
AIR
BRUSSELS

CLIENT Amnesty International
CREATIVE DIRECTOR Eric Hollander
ART DIRECTOR Didier Vanden Brande
COPYWRITER Benoît Menetret
PHOTOGRAPHER Jurgen Rogiers
ART BUYER Laurence Maes
ACCOUNT DIRECTOR Karen Opdecam

HEADLINE:

IF A KILLER IS SOMEONE WHO KILLS, WHAT'S THE DIFFERENCE WITH THE PERSON WHO KILLS THE KILLER?

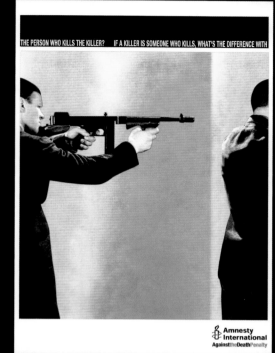 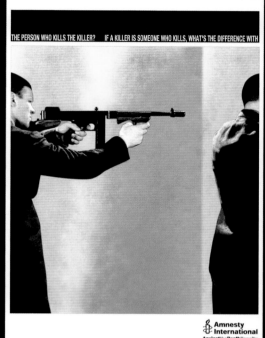

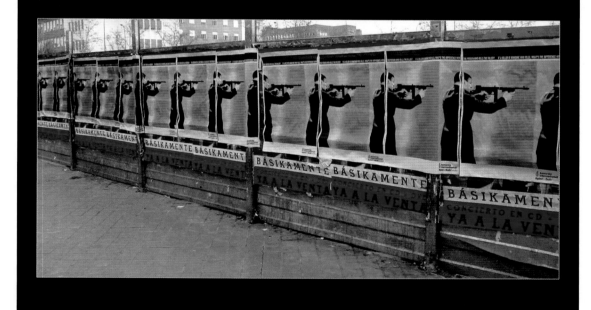

SPAIN

SILVER WORLD MEDAL, SINGLE

CONTRAPUNTO

MADRID

CLIENT Amnistia Internacional
GENERAL CREATIVE DIRECTOR Antonio Montero
EXECUTIVE CREATIVE DIRECTOR Carlos Sanz de Andino
CREATIVE DIRECTOR Carlos Jorge/Felix del Valle
ART DIRECTOR/COPYWRITER Agustin Esteban/Miguel A. Elizalde

FLEET GRAPHICS

FLEET GRAPHICS: TRANSPORTATION

NEW ZEALAND

SILVER WORLD MEDAL, SINGLE
ADMARK VISUAL
IMAGING LTD
HAMILTON

CLIENT Air New Zealand
CEO Air New Zealand Ltd
Ralph Norris
PROJECT MANAGER
Admark Visual Imaging
Lisa Pilling
SENIOR ACCOUNT MANAGER
Designworks, Auckland
Karen Jones
PHOTOGRAPHER Andris Apse

FLEET GRAPHICS: AUTOMOTIVE

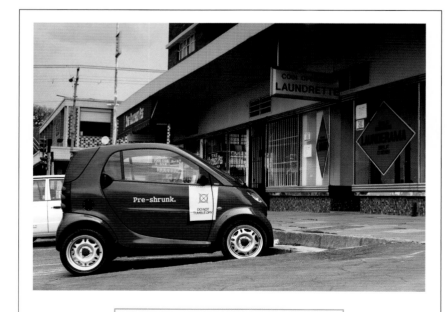

Smart - Transit

This ambient execution was developed for Smart, a few months after its launch into the local market. To create awareness for this new brand, ten Smart cars were branded and parked strategically in relevant locations across the country. ○ smart

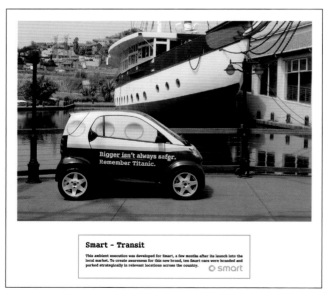

Smart - Transit

This ambient execution was developed for Smart, a few months after its launch into the local market. To create awareness for this new brand, ten Smart cars were branded and parked strategically in relevant locations across the country. ○ smart

SOUTH AFRICA

BRONZE WORLD MEDAL, CAMPAIGN
THE JUPITER DRAWING ROOM
RIVONIA, GAUTENG

CLIENT DaimlerChrysler Smart
CREATIVE DIRECTOR Graham Warsop
ART DIRECTOR Nicola Wilson
COPYWRITERS C. Bechus/S. Anderson/J. Dodd/D. Reid
MARKETING DIRECTOR Leisel Eales

Promotions Marketing

DISPLAY

KOREA

SILVER WORLD MEDAL, SINGLE

KISS CREATIVE CORPORATION
SEOUL

CLIENT Nike Kids
CREATIVE DIRECTOR Byung soo Yoo/
Sung yeol Yang
ART DIRECTOR Yoon Jong Han/
Se Young Kim/Myeng Ho Kim
COPYWRITER Jae Kyu Park/
Eugene Park
ACCOUNT EXECUTIVE Steve S Keum/
Miri Kim
COMPUTER GRAPHICS Jae Jin Lee/
Ji eu Kim

KOREA

FINALIST, SINGLE

KISS CREATIVE CORPORATION
SEOUL

CLIENT Nike
CREATIVE DIRECTOR Byung soo Yoo/Sung yeol Yang
ART DIRECTOR Kevin Bang/Yoon jong Han/Jae jin Lee
COPYWRITER Jae kyu Park/Eugene Park
ACCOUNT EXECUTIVE Steve s Keum/Miri Kim/Siho Joe
COMPUTER GRAPHICS Jae jin Lee/Ji eun Kim

IMAGE AWARENESS

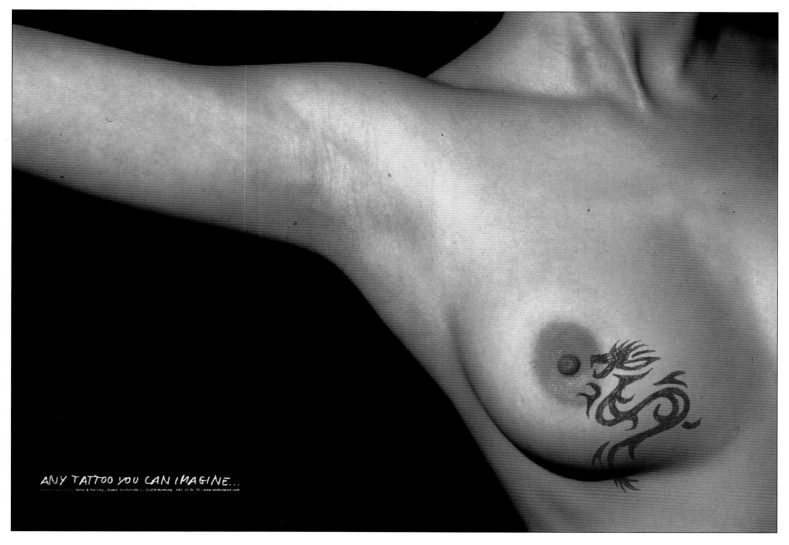

ANY TATTOO YOU CAN IMAGINE...

GERMANY

GOLD WORLD MEDAL, SINGLE

WEIGERTPIROUZWOLF

HAMBURG

CLIENT Endless Pain Tattoo & Piercing Studio
CREATIVE DIRECTOR Kay Eichner/Michael Reissinger
ART DIRECTOR Kaja Franke
COPYWRITER Daniel Hormes

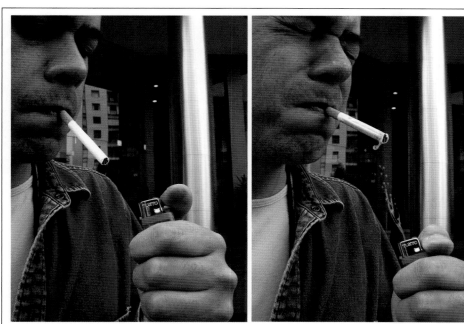

Note: This lighter was given by Nicorette as a merchandise piece on the International Non Smoking Day to people.

MEXICO

FINALIST, SINGLE

BBDO/MEXICO

MEXICO CITY

CLIENT Nicorette
VICE PRESIDENT & CREATIVE DIRECTOR Carl Jones
COPYWRITER Jose Luis Rosales
ART DIRECTOR Jaime Brash

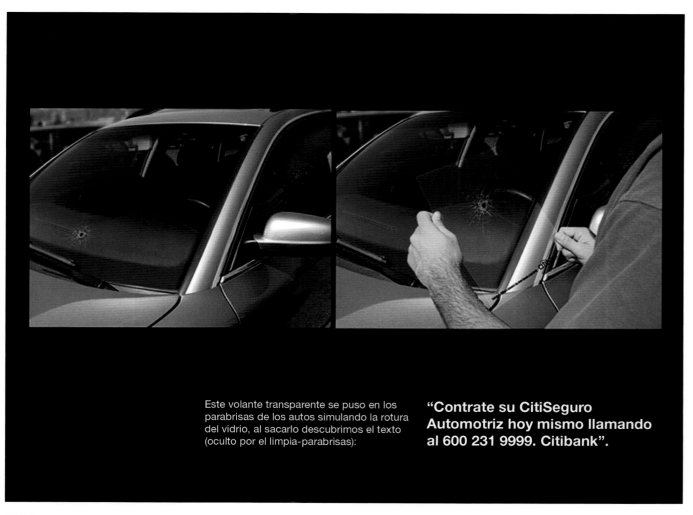

Este volante transparente se puso en los parabrisas de los autos simulando la rotura del vidrio, al sacarlo descubrimos el texto (oculto por el limpia-parabrisas):

"Contrate su CitiSeguro Automotriz hoy mismo llamando al 600 231 9999. Citibank".

CHILE

SILVER WORLD MEDAL, SINGLE
WUNDERMAN
SANTIAGO

CLIENT **Citibank**
CREATIVE DIRECTOR **Fabrizio Baracco**
COPYWRITER **Fabrizio Baracco**
ART DIRECTOR **Denis Coghlan**

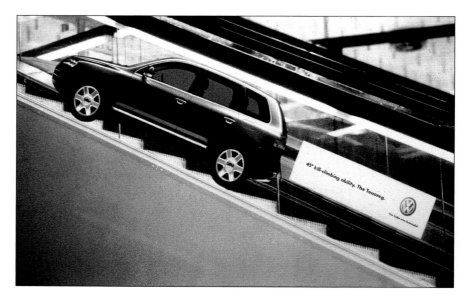

GERMANY
FINALIST, SINGLE
GRABARZ & PARTNER
HAMBURG

CLIENT **VW Touareg**
CREATIVE DIRECTOR **P. Pätzold/R. Nolting**
CHIEF CREATIVE OFFICER **R. Heuel**
ART DIRECTOR **Nina Rühmkorf**
COPYWRITER **Sascha Nestler**
PHOTO **picturesafe GmbH/Hannover**
GRAPHIC ARTIST **Gudrun Quittmann/Julia Elbers**
AGENCY **Grabarz & Partner Werbeagentur GmbH**

a b
c d

BRONZE WORLD MEDAL, SINGLE
J WALTER THOMPSON PUERTO RICO
SAN JUAN, PR

CLIENT Kimberly Clark-Kleenex
CREATIVE DIRECTOR Jaime Rosado
COPYWRITER Lixaida Lorenzo
ART DIRECTOR Johanna Santiago
ACCOUNT EXECUTIVE Benjamín Vélez

"THANK GOODNESS THERE IS KLEENEX.
(LOOK FOR THEM IN YOUR GLOVE COMPARTMENT)"

Kleenex Facial Tissues wanted moms not only to think of Kleenex as a facial tissue but also as an everyday on the go mess cleaner. To achieve this, fake baby food spills were placed in Ford Freestars (a known family vehicle and favorite among moms), inside Ford dealers. When the mom bought the Freestar, the piece was placed on the dashboard of the car before she received it. When she got her hands on the piece and turned it over, she read the message: "THANK GOODNES THERE IS KLEENEX. (LOOK FOR THEM IN YOUR GLOVE COMPARTMENT)". Then she opened the glove compartment and found a large packet of Kleenex.

MALAYSIA
FINALIST, SINGLE
BOZELL WORLDWIDE
PETALING JAYA, SELANGOR

CLIENT The Edge KL Rat Race
CREATIVE DIRECTOR Dharma Somasundram
ART DIRECTOR Wong Shu Kor
COPYWRITER Daniel Loo
COPYWRITER Ronald Ng

IN CASE YOU WERE THINKING ON LETTING A FRIEND DRINK AND DRIVE THIS CHRISTMAS.

In Puerto Rico it is a custom that all the cars that are part of the funeral procession have in their dashboards a sign that says "Funeral". Having this in mind, for Miller's Live Responsibly program, this same sign used in the procession was placed on the windshield of cars parked near, or in front of popular pubs in the metro area. When the person saw the sign and turned it over he/she read the message "In case you were thinking on letting a friend drink and drive this Christmas."

USA
FINALIST, SINGLE
J WALTER THOMPSON PUERTO RICO
SAN JUAN, PR

CLIENT Miller Brewing Company
CREATIVE DIRECTOR Jaime Rosado
COPYWRITER Lixaida Lorenzo
ART DIRECTOR Johanna Santiago
ACCOUNT EXECUTIVE Carlos Laureano

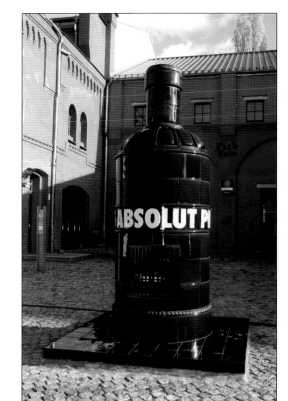

BRAZIL
FINALIST, SINGLE
OGILVY BRASIL
SÃO PAULO

CLIENT Fiat Car Dealers
CREATIVE DIRECTOR/COPYWRITER Adriana Cury
CREATIVE DIRECTOR/ART DIRECTOR Virgilio Neves
CREATIVE DIRECTOR/COPYWRITER Manir Fadel

GERMANY
FINALIST, SINGLE
TBWA \
BERLIN

CLIENT Absolut Vodka
CREATIVE DIRECTOR Sophie Guyon/
Kurt Georg Dieckert/Stefan Schmidt
COPYWRITER Helge Blöck
ART DIRECTOR Boris Schwiedrzik
DESIGN Christine Taylor
ACCOUNT DIRECTOR Kerstin Gold

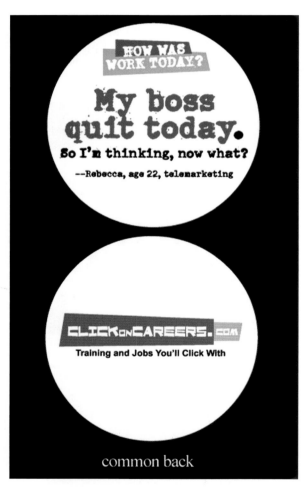

USA
FINALIST, CAMPAIGN
BROGAN & PARTNERS
DETROIT, MI

CLIENT Click On Careers
ART DIRECTOR/COPYWRITER David Ryan
COPYWRITER Melissa Weber

SWITZERLAND
FINALIST, SINGLE
McCANN-ERICKSON
SWITZERLAND
ZURICH

CLIENT Wash

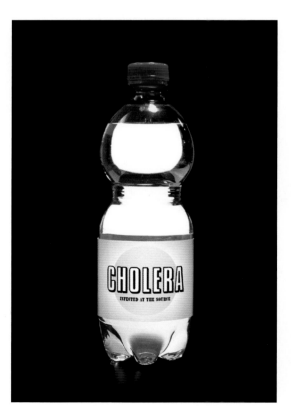

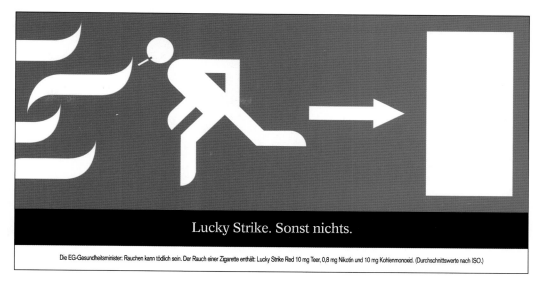

Lucky Strike. Sonst nichts.

Die EG-Gesundheitsminister: Rauchen kann tödlich sein. Der Rauch einer Zigarette enthält: Lucky Strike Red 10 mg Teer, 0,8 mg Nikotin und 10 mg Kohlenmonoxid. (Durchschnittswerte nach ISO.)

GERMANY
FINALIST, SINGLE
KNSK WERBEAGENTUR GMBH
HAMBURG

CLIENT Lucky Strike
CREATIVE DIRECTOR Michael Barche
ART DIRECTOR Vera Hampe
DESIGNER Martin Augner
COPYWRITER Olaf Hörning

TRADE PROMOTION

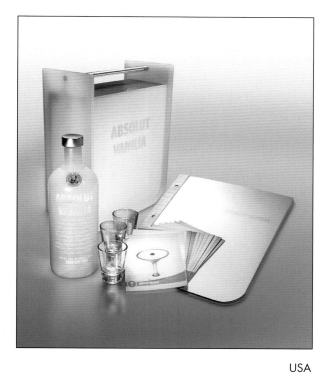

TAIWAN

FINALIST, SINGLE
PUBLIC TELEVISION SERVICE FOUNDATION
TAIPEI

CLIENT The Legend of Eileen Chang/The Quill
CREATIVE DIRECTOR Shao-Chun Huang
GENERAL CREATIVE DIRECTOR Yu-Hsien Su
PROJECT MANAGER Shiu-Ju Lin
COPY DIRECTOR Lolina Chou
CREATIVE DIRECTOR Shao-Chun Huang
GENERAL CREATIVE DIRECTOR Yu-Hsien Su
PROJECT MANAGER Shiu-Ju Lin
COPY DIRECTOR Lolina Chou
ART DIRECTOR Meny-Chyon Rau
PHOTOGRAPHER Min-Sheng Chuang
ILLUSTRATOR Lin-Hsien Juan

USA
FINALIST, SINGLE
G2 WORLDWIDE
NEW YORK, NY

CLIENT The Absolut Spirits Company
PARTNER, ACCOUNT MANAGEMENT Andi Spolan
PHOTOGRAPHER Martin Wonnacott

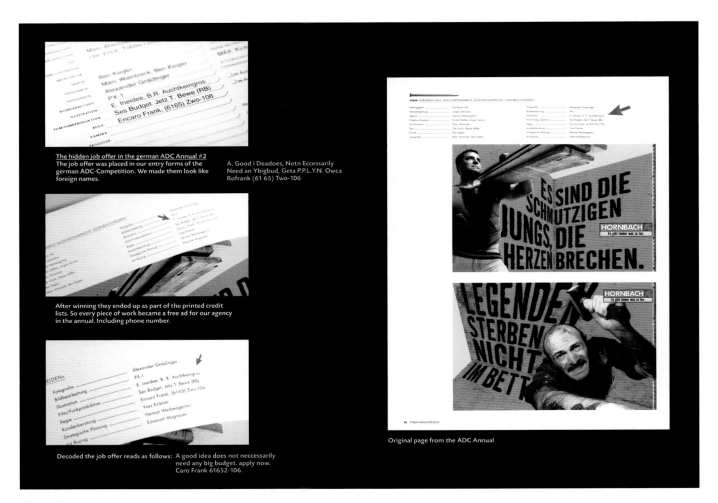

The hidden job offer in the german ADC Annual #2
The job offer was placed in our entry forms of the german ADC-Competition. We made them look like foreign names.

A. Good i Deadoes, Notn Eccessarily Need an Ybigbud, Geta P.P.L.Y.N. Owca Rofrank (61 65) Two-106

After winning they ended up as part of the printed credit lists. So every piece of work became a free ad for our agency in the annual. Including phone number.

Original page from the ADC Annual

Decoded the job offer reads as follows: A good idea does not neccessarily need any big budget. apply now. Caro Frank 61652-106.

GERMANY

SILVER WORLD MEDAL, SINGLE

HEIMAT WERBEAGENTUR GMBH
BERLIN

CLIENT HEIMAT Werbeagentur GmbH
CREATIVE DIRECTOR Guido Heffels/Jürgen Vossen
EDITORIAL ADC Office Germany
CREATIVE TEAM Ian Mackay/Antonio Schlump

USA

FINALIST, SINGLE

THECORBETT ACCEL HEALTHCARE GROUP
CHICAGO, IL.

CLIENT Patanol
CHIEF CREATIVE OFFICER John Scott
CREATIVE DIRECTOR Jamie Pfaff
COPYWRITER Terry Smith/Jeff Sherman
ART DIRECTOR Greg Gwynne

GERMANY

BRONZE WORLD MEDAL, SINGLE
DDB GERMANY
BERLIN

CLIENT Pattex
CREATIVE DIRECTOR Thorsten Altmann/Jan Kempski
SENIOR ART DIRECTOR Thomas Schwarz
SENIOR COPYWRITER Tim Jacobs
PHOTOGRAPHER Packshot Boys
ACCOUNT MANAGER Claire Gansmüller
MANAGEMENT SUPERVISOR Michael Ries
GRAPHIC ART Vera Lorenz

SPECIAL EVENTS

SWEDEN

FINALIST, SINGLE
HAPPY FORSMAN & BODENFORS
GOTHENBURG

CLIENT Polar Music Prize
CREATIVE DIRECTOR Anders Komestedt
ART DIRECTOR Lisa Careborg
PRODUCTION MANAGER Therése Edvardsson

GERMANY

FINALIST, CAMPAIGN
RTS RIEGER TEAM
LEINFELDEN-ECHTERDINGEN

CLIENT RTS Rieger Team
CREATIVE DIRECTOR Boris Pollig
GRAPHIC DESIGN Kerstin Böhner
E-BUSINESS Nico Weckerle
E-BUSINESS Martin Wezel

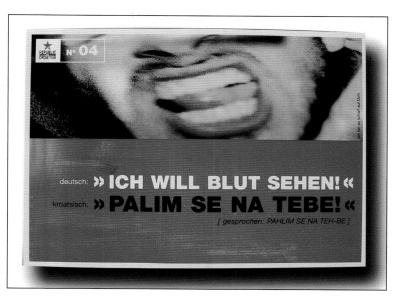

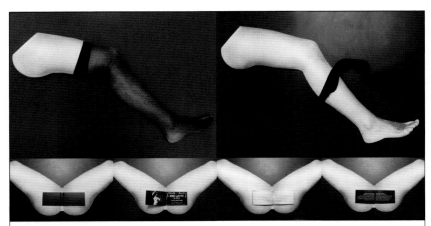

LEGS

BRIEF: In an old and aristocratic French mansion, after the death of its owner, some old pornographic movies dating back to the beginning of last century were found. His widow gave them to the French Cinematography Association and a film was edited with these shorts, some of which were animated. "Golfos y Picardías [de antaño]" ["The good old naughty days"] was shown to the press and critics as a curious historic document during the San Sebastian International Film Festival and then it was premiered as a film in commercial movie theatres. The client requested a piece to address the critics and distributors to raise expectations and for the media to talk about the movie in magazines and TV shows.

SOLUTION: Well, the first goal was to find a different and spectacular way to make this book at a time when critics and reporters were constantly receiving advertising materials from numerous production companies and film distributors. On the other hand, the agency didn´t count with a big production budget to develop this piece. And that´s how these pieces were born. Black morbid panty hose covering naked legs, when these panties are removed, the legs become the cover to a book and when you open them they reveal a black line, a censorship element under which the pages containing information about the movie appear.

RESULTS: The movie raised a lot of expectations before its launch in the festival, the piece created by the agency ran out and it was even solicited by media that had not been invited to the event. Before the premier of the movie, it was cited by numerous media outlets and the movie was very successful despite its genre.

SPAIN

SILVER WORLD MEDAL, SINGLE

ZAPPING MADRID
MADRID

CLIENT Festival de Cannes 2002
CREATIVE DIRECTOR Uschi Henkes
CREATIVE DIRECTOR Urs Frick
ART DIRECTOR Victor Gomez
COPY WRITER Mercedes Lucena

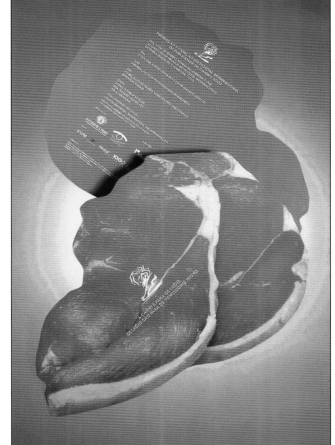

BRAZIL

BRONZE WORLD MEDAL, SINGLE

100% DESIGN
SAO PAULO

CLIENT PS Carneiro Eventos
CREATIVE DIRECTOR Renata Melman/
Patricia Oliveira
DESIGNER Alessandro Avila

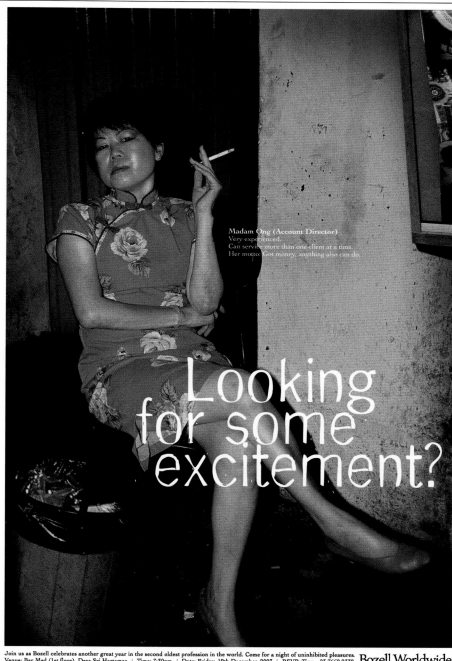

Madam Ong (Account Director)
Very experienced.
Can service more than one client at a time.
Her motto: Got money, anything also can do.

Looking for some excitement?

Join us as Bozell celebrates another great year in the second oldest profession in the world. Come for a night of uninhibited pleasures. **Bozell Worldwide**
Venue: Bar Med (1st floor), Desa Sri Hartamas | Time: 7:30pm | Date: Friday, 19th December, 2003 | RSVP: Ting – 03 7660 2332

MALAYSIA

GOLD WORLD MEDAL, CAMPAIGN

BOZELL WORLDWIDE

PETALING JAYA, SELANGOR

CLIENT Bozell Year-End Bash
CREATIVE DIRECTOR Peter Chan
ART DIRECTOR Wong Shu Kor/Lee Foong Pen
COPYWRITER Daniel Loo

D-Lo (Senior Account Manager)
6 years experience.
Prowls the streets of Shah Alam on weekdays.
Can sell very well.

Wanna have some fun?

Join us as Bozell celebrates another great year in the second oldest profession in the world. Come for a night of uninhibited pleasures. **Bozell Worldwide**
Venue: Bar Med (1st floor), Desa Sri Hartamas | Time: 7:30pm | Date: Friday, 19th December, 2003 | RSVP: Ting – 03 7660 2332

MIXED MEDIA PROMOTION

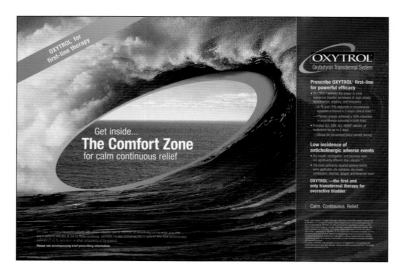

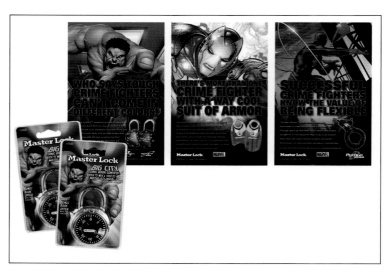

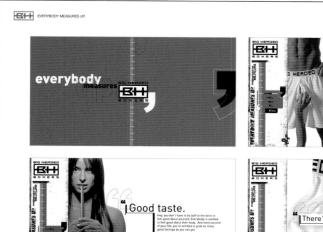

BRONZE WORLD MEDAL, CAMPAIGN

DAILEY INTERACTIVE

WEST HOLLYWOOD, CA

CLIENT Big Headed Boxers

AGENCY Dailey Interactive

CREATIVE DIRECTOR Ron Taft

COPYWRITER Ron Taft

PHOTOGRAPHER Ron Taft

ART DIRECTOR Ron Taft

PHOTOGRAPHER Ron Taft

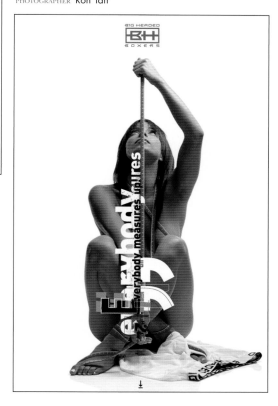

USA

FINALIST, CAMPAIGN

BBDO DETROIT

TROY, MI

CLIENT Detroit Creative
Directors Council

SENIOR GRAPHIC DESIGNER
Scott Markel

SENIOR ART DIRECTOR
Don Defilippo

GRAPHIC DESIGNER John Stoll

MEDIA KIT

USA

FINALIST, SINGLE

KOLAR ADVERTISING AND MARKETING

AUSTIN, TX

CLIENT 3M Visual Systems

ART DIRECTOR Terry Ilse

COPYWRITER Bud Hasert

ACCOUNT TEAM Whitney Harlan/
Anjleen Gumer/John Elmore

GRAND AWARD

Promotions
Marketing

JAPAN

GRAND AWARD
BEST GUERILLA ADVERTISEMENT
HAKUHODO INC.
TOKYO

CLIENT The Mainichi Newspapers
CREATIVE DIRECTOR Kazuto Fukushima
ART DIRECTOR Kotaro Hirano
COPYWRITER Itaru Yoshizawa
WRITER Seiichi Okura
ACCOUNT EXECUTIVE Masafumi Tsumura/
Joji Shimizu
DESIGNER Yuichi Hosobuchi

FREE POCKET CALENDAR

Amnistía Internacional

CHALLENGE:

The briefing was to run a campaign, on a very low budget, against the death penalty.

SOLUTION:

Taking advantage of the fact that it was the start of the year, we decided to create pocket calendars with the people who were going to be executed in 2004. On one side was the portrait of a prisoner on death row, on the other, the 2004 calendar as far as the date of his or her execution. The rest of the days and months are blank.

We gathered over 20,000 signatures, thanks to which a person's life was saved. Edward Capetillo's execution was suspended.

SPAIN

GOLD WORLD MEDAL, SINGLE

CONTRAPUNTO

MADRID

CLIENT Amnistia Internacional
GENERAL CREATIVE DIRECTOR Antonio Montero
CREATIVE DIRECTOR Carlos S de Andino/Carlos Jorge
COPYWRITER Sergio S. Caballero/Miguel Madariaga
ART DIRECTOR Enrique Camina/Santiago Winer

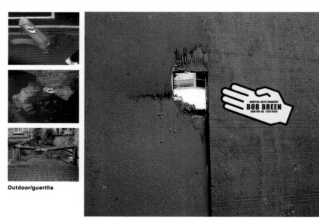

Outdoor/guerilla

Outdoor/Guerilla:
Bob Breen Martial Arts Academy "I'll Smash your Face In"

The Brief
The Bob Breen Martial Arts Academy is based in East London near the offices of 20:20 London. It is a small academy with 3 teachers led by Bob. The area is notoriously tough.

The idea
Bob teaches you how to fight. These hand-sized stickers were placed on broken fences, busted walls and dented cars on the streets around his academy. Dozens of New Year Resolutionists decided to give their slacker lifestyle the chop and sign up with Bob.

The Results
A stand-out campaign for 50 quid in printing and some lessons in self-defence. And 36 more users at £40 per month. That's £1,440.

Direct response door drop
We took it upon ourselves to target business addresses in the vicinity with a door drop campaign. Dozens of Yellow Pages were 'ripped' in half and contained a Bob Breen bookmark inserted next to Bob's ad.

ENGLAND

FINALIST, SINGLE

20:20 LONDON LTD

LONDON

CLIENT Bob Breen Karate Academy
CREATIVE DIRECTOR Peter Riley
CREATIVE Hugo Bierschenk/Dean Woodhouse

20:20LONDON

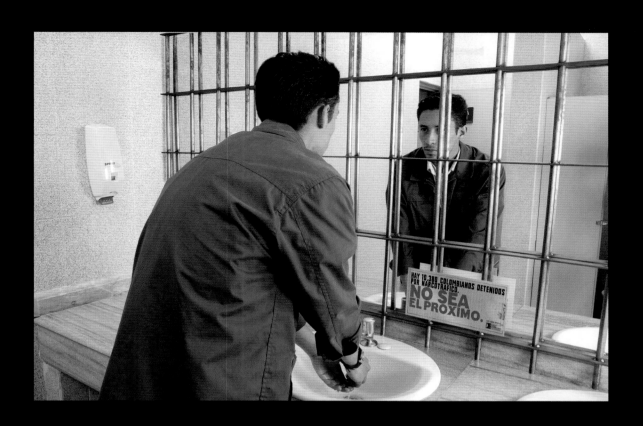

THIS MESSAGE WAS PLACED IN THE BATHROOMS OF MAJOR COLOMBIAN AIRPORTS.

Text: There are 10.300 colombians held prisoner because of drug trafficking.
DON'T BE THE NEXT ONE. DON'T BE A MULE.
DNE (National Drug-enforcement Directive)

COLOMBIA

GOLD WORLD MEDAL, SINGLE

J. WALTER THOMPSON COLOMBIA

BOGOTA, CUNDINAMARCA

CLIENT **DNE National Drug-Enforcement Directive**
CREATIVE DIRECTOR **Rodrigo Torres**
COPYWRITER **Alejandro Barrera**
ART DIRECTOR **Juan Carlos Espitia**

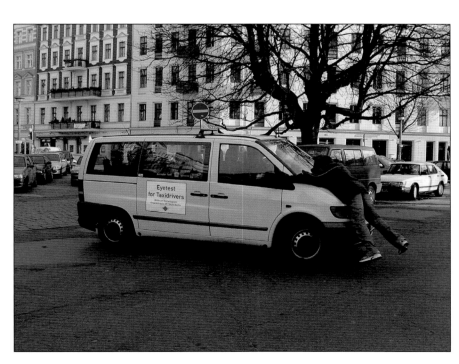

GERMANY

FINALIST, SINGLE

AIMAQ RAPP STOLLE

BERLIN

CLIENT **Brille am Kollwitzplatz**
CREATIVE DIRECTOR **Oliver Frank**
ART DIRECTOR **Kathrin Langer/Christian Schuetze**
COPYWRITER **Jens Hellweg**
GRAPHIC DESIGN **Danny Baarz**
ACCOUNT SUPERVISOR **Andreas Naber**
DOCUMENTATION **Jens Krisinger**

Advil Case

Opportunity

Because of heavy rains during green season, the streets on the east side of the city of San José, Costa Rica are covered with potholes and are rarely repaired promptly, thus giving drivers headaches for many weeks.

Action

A team of six people painted splashes with messages around 22 of these busy-street potholes.

Insight

When drivers accidentally fall into potholes, the driver usually says something like: Ouch! or Ayyy!

Idea

To reaffirm that Advil will relieve all kinds of pain.

The Streets

Taking Action

Aftermath
One week later, the municipality began fixing the streets.

COSTA RICA

SILVER WORLD MEDAL, SINGLE
McCANN ERICKSON COSTA RICA
SAN JOSE

CLIENT Advil
CREATIVE VP Ignacio Gomez
CREATIVE DIRECTOR Alan Carmona
ART DIRECTOR Ronny Villalobos
DESIGN G. Calderon/C. Rivera/C. Leñero
MEDIA ACCOUNT Marcela Brenes

GERMANY

FINALIST, SINGLE
AIMAQ RAPP STOLLE
BERLIN

CLIENT Parachute School A-Z
CREATIVE DIRECTOR Oliver Frank
ART DIRECTOR Oliver Fermer
COPYWRITER Martin Grafl
GRAPHIC DESIGN Hanna Keller
ACCOUNT SUPERVISOR Daniela Mueller

OPENING SOON.
OUT IN AFRICA GAY & LESBIAN FILM FESTIVAL.

JUDGES NOTE

This chained up closet was installed in the foyer of Cinema Nouveau two weeks prior to the opening night of the Out In Africa Gay and Lesbian Film Festival. Cinema-goers were caught unaware by the random knocking and screaming heard from within (Audio CD and MP3 attached). The actual recordings were looped with five minute intervals, not only to create the illusion that people were actually locked inside but to catch onlookers by surprise.

TRIVIA

One night, after the cinema had been closed, concerned diners at a nearby restaurant called centre security in a panic, thinking someone had been locked inside one of the theatres. After much confusion, they realised what they were hearing was nothing but a looped recording.

SOUTH AFRICA
SILVER WORLD MEDAL, SINGLE
THE JUPITER DRAWING ROOM
RIVONIA, GAUTENG

CLIENT Nedbank Cinema Nouveau -
Gay & Lesbian Film Festival
CREATIVE DIRECTOR Graham Warsop
ART DIRECTOR Jonathan Deeb
COPYWRITER Stephanie Van Niekerk
MARKETING MANAGER Sarah Denyer
PHOTOGRAPHER Clive Steward
ACCOUNT SUPERVISOR Gillian Smith
PRODUCTION MANAGER Belinda Shea

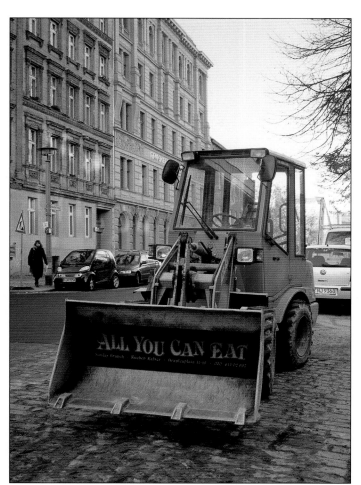

GERMANY
FINALIST, SINGLE
AIMAQ RAPP STOLLE
BERLIN

CLIENT Kuchen Kaiser
CREATIVE DIRECTOR Oliver Frank
ART DIRECTOR Tim Belser
COPYWRITER Alexander Ardelean

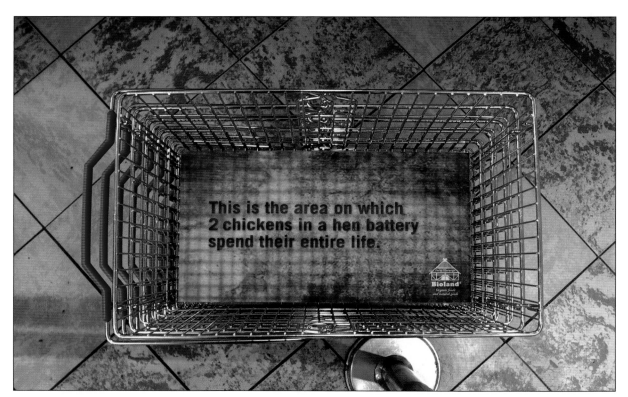

This is the area on which 2 chickens in a hen battery spend their entire life.

GERMANY
BRONZE WORLD MEDAL, SINGLE
GRABARZ & PARTNER
HAMBURG

CLIENT Hof Harwege
CREATIVE DIRECTOR R. Heuel/
D. Siebenhaar/P. Pätzold
ART DIRECTOR Alexander Hesslein
COPYWRITER Ralf Heuel
GRAPHIC ARTIST Jasmin Remmers
AGENCY Grabarz & Partner
Werbeagentur GmbH

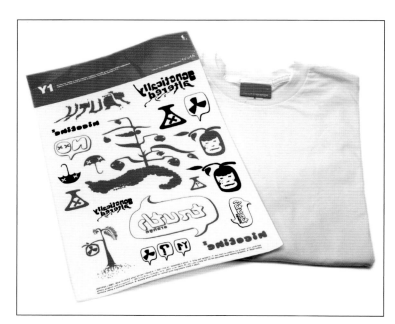

USA
FINALIST, SINGLE
ARNOLD WORLDWIDE
BOSTON, MA

CLIENT American Legacy Foundation
DESIGNER Adam Larson
CHIEF CREATIVE OFFICER Ron Lawner
EXECUTIVE CREATIVE DIRECTOR Pete Favat/Alex Bogusky
CREATIVE DIRECTOR Roger Baldacci/Tom Adams

GERMANY
FINALIST, SINGLE
GRABARZ & PARTNER
HAMBURG

CLIENT International Society For Human Rights
CREATIVE DIRECTOR R. Heuel/D. Siebenhaar/
P. Pätzold
ART DIRECTOR Julia Elbers/Maik Kähler
COPYWRITER Ralf Heuel/Christoph Nann
GRAPHIC ARTIST Julia Elbers/Roman Becker
AGENCY Grabarz & Partner Werbeagentur GmbH

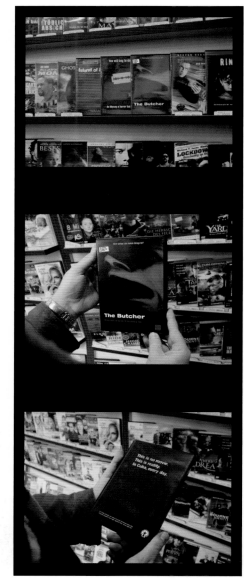

INDIA

BRONZE WORLD MEDAL, SINGLE

MUDRA COMMUNICATIONS PVT. LTD.

NEW DELHI, DELHI

CLIENT Dainik Jagran
ART DIRECTOR Sandeep Basu/Amitava Sengupta
COPYWRITER Saurabh Dasgupta

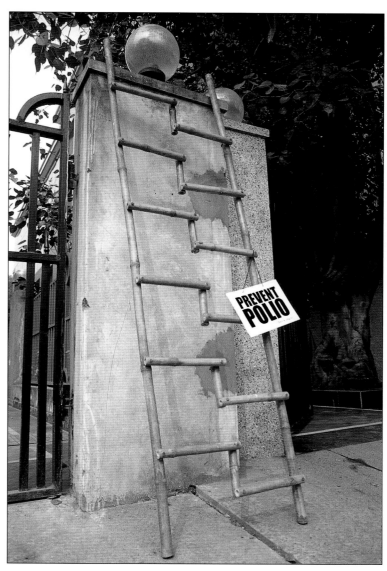

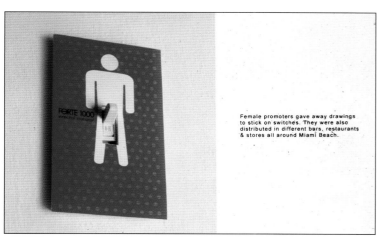

Female promoters gave away drawings
to stick on switches. They were also
distributed in different bars, restaurants
& stores all around Miami Beach.

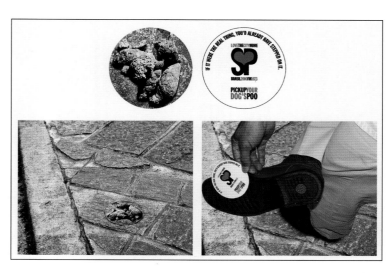

USA

FINALIST, SINGLE

CONCEPT CAFÉ

MIAMI, FL

CLIENT Forte 1000
CREATIVE DIRECTOR Salvador Veloso
COPYWRITER Salvador Veloso
ART DIRECTOR Claudio Vera

BRAZIL

FINALIST, SINGLE

DUEZT EURO RSCG COMUNICAÇÕES

SAO PAULO

CLIENT Rádio Brasil 2000
CREATIVE DIRECTOR Zuza Tupinambá
ART DIRECTOR Martan
ACCOUNT DIRECTOR Cléa Klouri
PHOTOGRAPHER Marcelo Darlan/Marcelo Barone

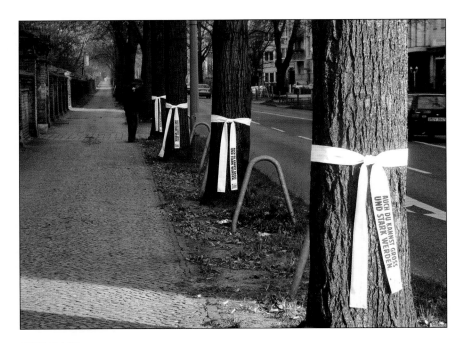

GERMANY

FINALIST, SINGLE

FCB WILKENS GMBH
HAMBURG

CLIENT Dokan Karate School
CREATIVE DIRECTOR Waldemar Konopka/Patrick Thiede
COPYWRITER Pieter Blume/Waldemar Konopka
ART DIRECTOR Robert Körtge/Nina Mielisch
PRODUCTION MANAGER Guido Wallmann
ACCOUNT EXECUTIVE Nicole Thomas

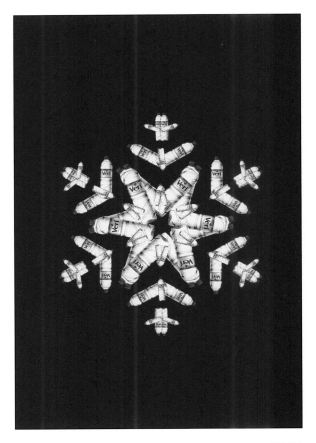

SPAIN

FINALIST, SINGLE

FERRATER, CAMPINS, MORALES
BARCELONA

CLIENT Agua De Veri

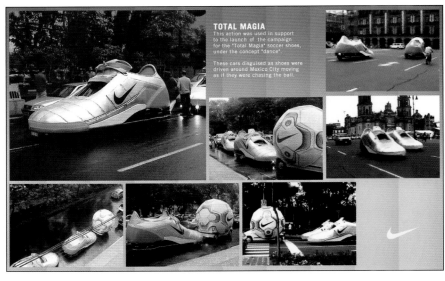

GERMANY

FINALIST, SINGLE

**H2E HOEHNE HABANN ELSER,
WERBEAGENTUR GMBH**
BADEN-WÜRTTEMBERG

CLIENT Lotto
CREATIVE DIRECTOR Thomas Fiederer
JUNIOR ART DIRECTOR Nana Pöhner

MEXICO

FINALIST, SINGLE

J WALTER THOMPSON DE MEXICO, S.A.
MEXICO CITY

CLIENT Nike
GENERAL CREATIVE DIRECTOR Carlos Betancourt
CREATIVE DIRECTOR/ART DIRECTOR Miguel Brito
CREATIVE DIRECTOR/ART DIRECTOR Pablo Armijo
CREATIVE DIRECTOR Paola Figueroa

GERMANY

FINALIST, SINGLE

GRABARZ & PARTNER
HAMBURG

CLIENT VW Touareg
CREATIVE DIRECTOR R. Nolting/P. Pätzold
CHIEF CREATIVE OFFICER R. Heuel
ART DIRECTOR Nina Rühmkorf/Jan Knauss
GRAPHIC ARTIST Björn Erbslöh/Julia Elbers
AGENCY Grabarz & Partner Werbeagentur GmbH

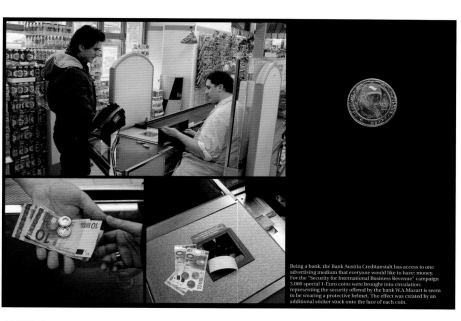

Being a bank, the Bank Austria Creditanstalt has access to one advertising medium that everyone would like to have: money. For the "Security for International Business Revenue" campaign 3.000 special 1-Euro coins were brought into circulation: representing the security offered by the bank W.A.Mozart is seem to be wearing a protective helmet. The effect was created by an additional sticker stuck onto the face of each coin.

AUSTRIA

FINALIST, SINGLE

JUNG VON MATT/
DONAU WERBEAGENTUR GMBH
VIENNA, VIENNA

CLIENT Bank Austria Creditanstalt
CREATIVE DIRECTOR Gerd Schulte-Doeinghaus
COPYWRITER Christoph Gaunersdorfer
ART DIRECTOR Christian Hummer-Koppendorfer
ACCOUNT SUPERVISOR P. Hoerlezeder/R. Hofmeister

The main medium for the „The Power of Astonishment" theatre festival campaign is a guerrilla action that sends 15.000 eyes rolling through Vienna. To be exact, 15.000 table tennis balls printed as eyes with pupils, and text. The text states concisely what it's all about:„The power of astonishment" – The Dolls Theatre Festival – will make your eyes fall out as well as where and when the festival is taking place. Billposters, adverts and free cards document the action and show in which corners, alleyways and other parts of Vienna the eyes have rolled to.

AUSTRIA

FINALIST, SINGLE

JUNG VON MATT/
DONAU WERBEAGENTUR GMBH
VIENNA, VIENNA

CLIENT Theater Ohne Grenzen
CEO/CREATIVE DIRECTOR Andreas Putz
CREATIVE DIRECTOR Gerd Schulte-Doeinghaus
ART DIRECTOR/GRAPHICS Georg Feichtinger
ACCOUNT SUPERVISOR Rita Hofmeister
CONCEPT/COPYWRITER Christoph Gaunersdorfer

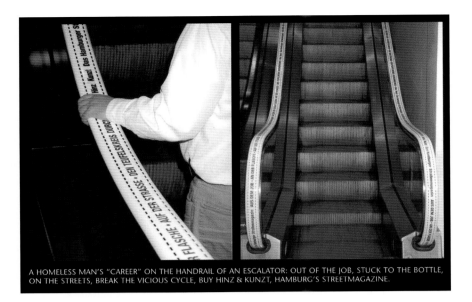

A HOMELESS MAN'S "CAREER" ON THE HANDRAIL OF AN ESCALATOR: OUT OF THE JOB, STUCK TO THE BOTTLE, ON THE STREETS, BREAK THE VICIOUS CYCLE, BUY HINZ & KUNZT, HAMBURG'S STREETMAGAZINE.

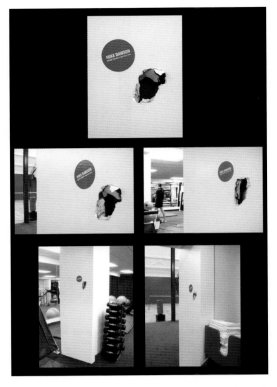

GERMANY

FINALIST, SINGLE

KOLLE REBBE WERBEAGENTUR GMBH
HAMBURG

CLIENT Hinz & Kunzt
CREATIVE DIRECTOR C. Everke/S. Hardieck
COPYWRITER M. Ludynia/M. Büttner
ART DIRECTOR M. Wilker/K. Heyn
INSTALLATION Norman Rosnersky
ACCOUNT SUPERVISOR I. Bestehorn/U. Scheinert

CANADA

FINALIST, SINGLE

MARKETEL
MONTREAL

CLIENT Mike Dawson
VP CREATIVE DIRECTOR Gilles DuSablon
COPYWRITER Linda Dawe
ART DIRECTOR Stéphane Gaulin
ACCOUNT EXECUTIVE Anouk Crevier

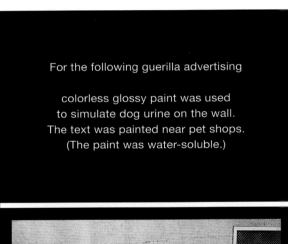

For the following guerilla advertising

colorless glossy paint was used
to simulate dog urine on the wall.
The text was painted near pet shops.
(The paint was water-soluble.)

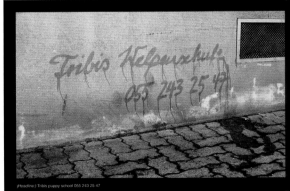

(Headline:) Tribis puppy school 055 243 25 47

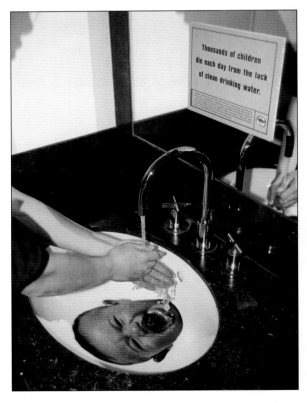

SWITZERLAND

FINALIST, SINGLE

MATTER & PARTNER AG FÜR KOMMUNIKATION
ZURICH

CLIENT Tribis
CREATIVE DIRECTOR Philipp Skrabal
COPYWRITER Michael Kathe
ART DIRECTION Ondrej Maczko
ACCOUNT SUPERVISOR Anita Haberthür/Chris Schwarz
ADVERTISER'S SUPERVISOR Franziska Tribelhorn

SWITZERLAND

FINALIST, SINGLE

McCANN-ERICKSON SWITZERLAND
ZURICH

CLIENT Wash

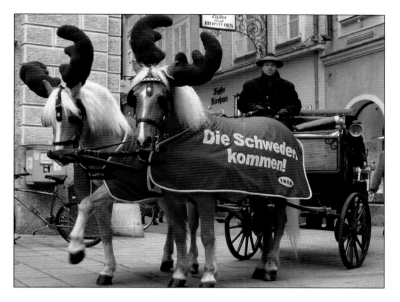

AUSTRIA

FINALIST, SINGLE

McCANN-ERICKSON VIENNA
VIENNA

CLIENT Ikea Opening Salzburg
CREATIVE DIRECTOR Bernd Misske
ART DIRECTOR Wolfgang Krasny
COPYWRITER Barbara Steiner
ACCOUNT MANAGER Sabine Deinhofer

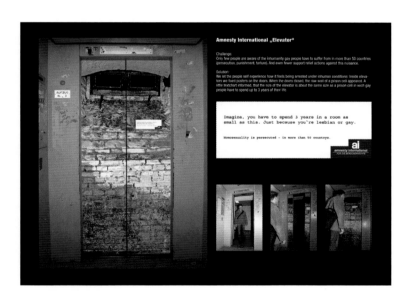

GERMANY

FINALIST, SINGLE

MICHAEL CONRAD & LEO BURNETT
FRANKFURT

CLIENT Amnesty International
CREATIVE DIRECTOR Andreas Heinzel/Peter Steger
ART DIRECTOR Klaus Trapp
COPYWRITER Mathias Henkel

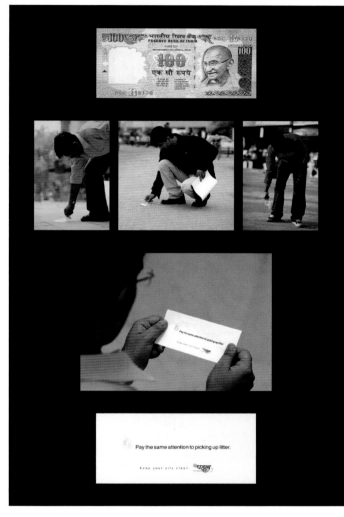

INDIA

FINALIST, SINGLE

MUDRA COMMUNICATIONS PVT. LTD.
NEW DELHI

CLIENT Dainik Jagran
COPYWRITER Kapil Dhawan
ART DIRECTOR Arnab Chatterjee

INDIA

FINALIST, SINGLE

MUDRA COMMUNICATIONS PVT. LTD.
NEW DELHI

CLIENT Sidh
ART DIRECTOR Anil Verma
COPYWRITER Ambar Chakravarty

ART NOT AVAILABLE

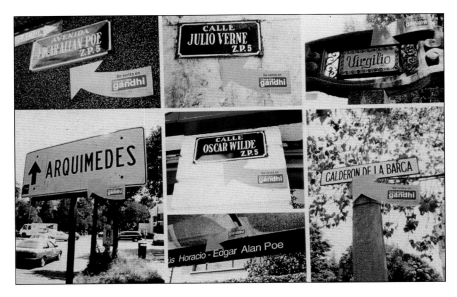

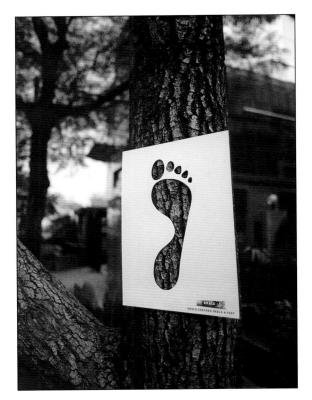

MEXICO

FINALIST, SINGLE

OGILVY & MATHER MEXICO
MEXICO CITY

CLIENT Gandhi Bookstores
CREATIVE DIRECTOR Marco Colín/José Montalvo
COPYWRITER José Montalvo
ART DIRECTOR Aurora Morfín/Carlos García

INDIA

FINALIST, SINGLE

MUDRA COMMUNICATIONS PVT. LTD.
NEW DELHI

CLIENT Krack Foot Repair Cream
COPYWRITER Kapil Dhawan
ART DIRECTOR Arnab Chatterjee/Divya Mehra

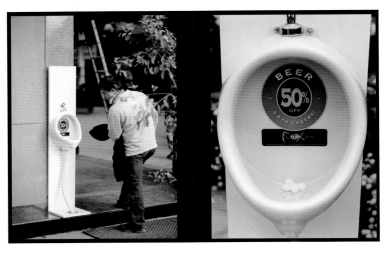

INDIA

FINALIST, SINGLE

MUDRA COMMUNICATIONS PVT. LTD.
NEW DELHI

CLIENT Felix Lounge Bar
COPYWRITER Kapil Dhawan
ART WINDOWS Arnab Chatterjee

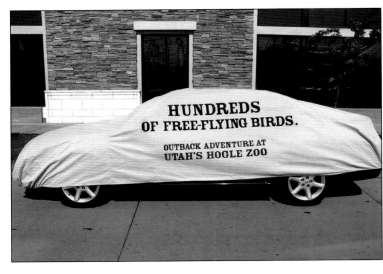

USA

FINALIST, SINGLE

RICHTER7
SALT LAKE CITY, UT

CLIENT Utahs Hogle Zoo
ART DIRECTOR Ryan Anderson
COPYWRITER/CREATIVE DIRECTOR Gary Sume
EXECUTIVE CREATIVE DIRECTOR Dave Newbold
PRODUCTION MANAGER Mary Ann Giles
ACCOUNT MANAGER Kirsten Kazcka
ACCOUNT SUPERVISOR Tal Harry

ARGENTINA

FINALIST, SINGLE

SAVAGLIO TBWA
BUENOS AIRES

CLIENT Autoboutique Rentals
CREATIVE DIRECTOR Savaglio/Alvarez/Climent
COPYWRITER Marcelo Seoane/Alexis Alvarez
ART DIRECTOR S. Climent/P. Perez Salvo/P. Carrera
ACCOUNT SUPERVISOR Dolores Caballero/L. Tidone
PHOTOGRAPHER Abadi Coscia

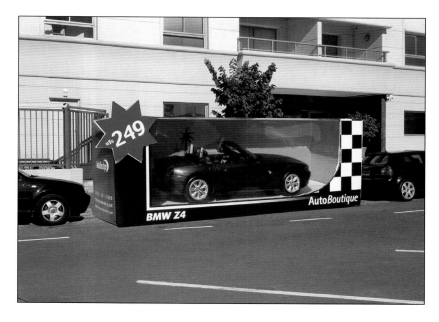

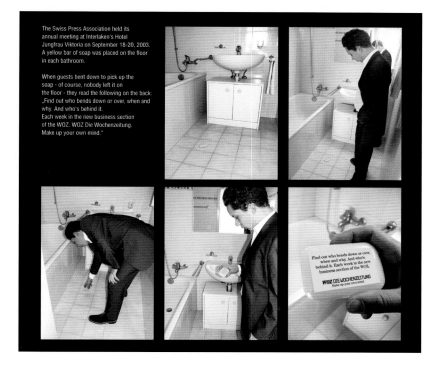

SWITZERLAND

FINALIST, SINGLE

SPILLMANN/FELSER/LEO BURNETT
ZURICH

CLIENT WOZ
CREATIVE DIRECTOR Martin Spillmann
COPYWRITER Jürg Brechbühl
ART DIRECTOR Raul Serrat
ACCOUNT DIRECTOR Peter Schäfer

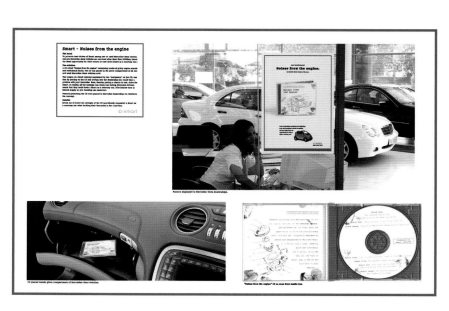

SOUTH AFRICA

FINALIST, SINGLE

THE JUPITER DRAWING ROOM
RIVONIA, GAUTENG

CLIENT DaimlerChrysler Smart
CREATIVE DIRECTOR Graham Warsop
ART DIRECTOR Christan Boshoff
COPYWRITER Gavin Williams
MARKETING DIRECTOR Leisel Eales
ILLUSTRATOR Julian Dell
ACCOUNT SUPERVISOR Trudy Miller
PRODUCTION MANAGER Belinda Shea

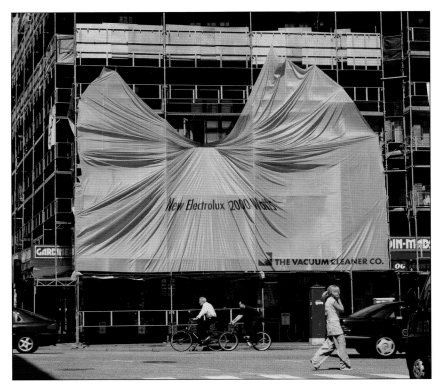

DENMARK

YOUNG & RUBICAM COPENHAGEN

COPENHAGEN

CLIENT Støvsugerbanden/The Vacuum Cleaner Co.
COPYWRITER Ole Caspersen

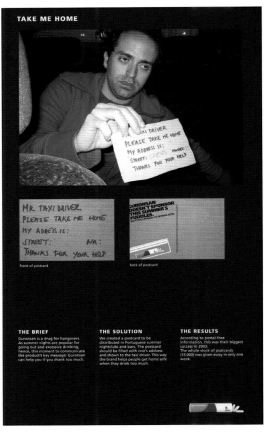

THE BRIEF
Guronsan is a drug for hangovers. As summer nights are popular for going out and excessive drinking, hence, this moment to communicate the product's key message: Guronsan can help you if you drank too much.

THE SOLUTION
We created a postcard to be distributed in Portuguese summer nightclubs and bars. The postcard should be filled with one's address and shown to the taxi driver. This way the brand helps people get home safe when they drink too much.

THE RESULTS
According to postal-free information, this was their biggest success in 2003. The whole stock of postcards (15.000) was given away in only one week.

PORTUGAL

TOUCH ME RED CELL PORTUGAL

LISBOA

CLIENT Guronsan
CREATIVE DIRECTOR Susana Albuquerque
COPYWRITER Pedro Batalha
ART DIRECTOR Rui Saraiva
ACCOUNT MANAGER Thamy Ortiz
ART DIRECTOR Leonor Rasteiro

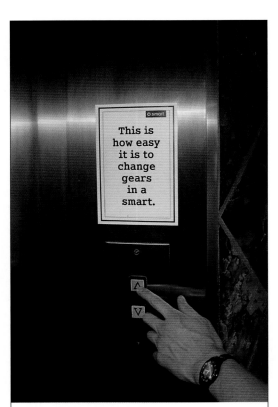

Smart - Lift

As part of the launch campaign (day of the launch) for smart, 3 large skyscrapers in the business district agreed to allow us to place these posters on all floors (by elevators) to be seen by lawyers, stockbrokers etc. who worked in the office towers.

○ smart

SOUTH AFRICA

THE JUPITER DRAWING ROOM

RIVONIA, GAUTENG

CLIENT DaimlerChrysler Smart
CREATIVE DIRECTOR Graham Warsop
ART DIRECTOR Dave Reid
COPYWRITER David Reid
ACCOUNT SUPERVISOR Trudy Miller
PRODUCTION MANAGER Belinda Shea

JAPAN

HAKUHODO INC.

TOKYO

CLIENT The Mainichi Newspapers
CREATIVE DIRECTOR Kazuto Fukushima
ART DIRECTOR Kotaro Hirano
COPYWRITER Itaru Yoshizawa
COPYWRITER Seiichi Okura
ACCOUNT EXECUTIVE Masafumi Tsumura/Joji Shimizu
DESIGNER Yuichi Hosobuchi

SEE GRAND AWARD PAGE 285

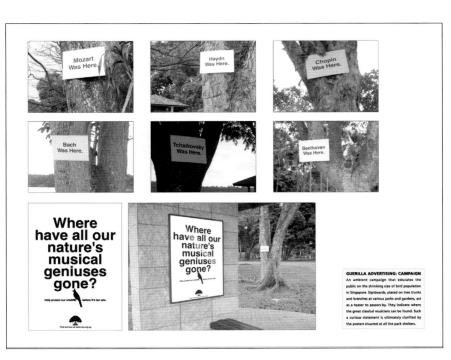

SINGAPORE

FINALIST, CAMPAIGN

AD PLANET GROUP SINGAPORE

SINGAPORE

CLIENT Nature Society Singapore
CREATIVE DIRECTOR Leo Teck Chong/Calvin Loo
COPYWRITER Catherine Phua/Giap Lim/Leo Teck Chong
ART DIRECTOR Leo Teck Chong/Khoo Meng Hau
AGENCY PRODUCER Eddie Eng
ACCOUNT MANAGER Mathew Qwah
PRODUCTION MANAGER Patricia Tan

MEXICO

FINALIST, CAMPAIGN

J WALTER THOMPSON DE MEXICO, S.A.

MEXICO CITY

CLIENT Nike

GENERAL CREATIVE DIRECTOR Carlos Betancourt
CREATIVE DIRECTOR/ART DIRECTOR Miguel Brito
CREATIVE DIRECTOR/COPYWRITER Pablo Armijo
CREATIVE DIRECTOR Alejandro Vázquez/
Saúl Escobar/Manuel Techera/
Enrique Codesido/Adrián Brizuela

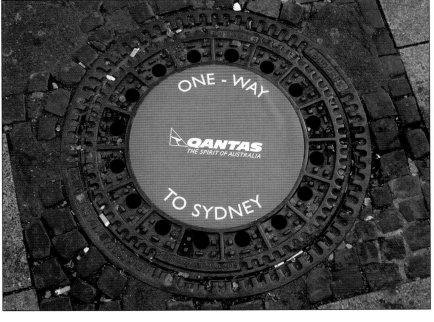

GERMANY

FINALIST, CAMPAIGN

PUBLICIS WERBEAGENTUR GMBH

FRANKFURT

CLIENT Qantas Airways
CREATIVE DIRECTOR Gert Maehnicke
ART DIRECTOR Alan Vladusic
COPYWRITER Hasso von Kietzell
CLIENT SERVICE DIRECTOR Hans Heller
ACCOUNT MANAGER Florian Zenk
ACCOUNT DIRECTOR Andreas Dresch

TRADE & MANUFACTURING

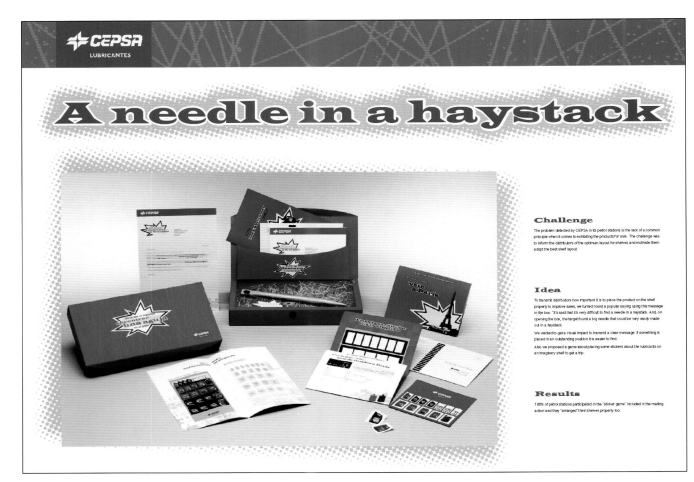

SPAIN

SILVER WORLD MEDAL,
SINGLE
FCB INTEGRATED
MADRID

CLIENT CEPSA
GENERAL CREATIVE
DIRECTOR Oscar Rojo
CREATIVE DIRECTOR
Luis Ballester/
Jesus Santiuste
COPYWRITER
Ricardo de Santiago
ACCOUNT EXECUTIVE
Maria Lopez-
Barranco

OTHER

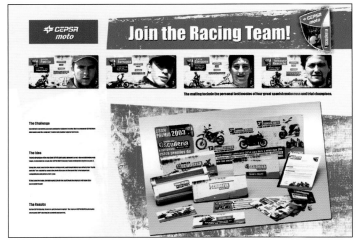

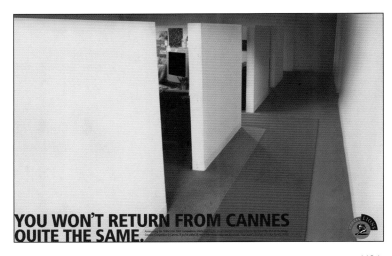

SPAIN

FINALIST, SINGLE
FCB INTEGRATED
MADRID

CLIENT CEPSA
GENERAL CREATIVE DIRECTOR Oscar Rojo
CREATIVE DIRECTOR Luis Ballester
ART DIRECTOR Mario Barba
COPYWRITER Ricardo de Santiago
ACCOUNT EXECUTIVE Maria Lopez-Barranco

USA

FINALIST, SINGLE
LOWE
NEW YORK, NY

CLIENT USA Today/Team USA Young Cannes Creative Competition
CREATIVE SUPERVISOR/COPYWRITER Stephen Lundberg
ART DIRECTOR/PHOTOGRAPHER Rebecca Peterson
EXECUTIVE CREATIVE DIRECTOR Dean Hacohen
CHIEF CREATIVE OFFICER Gary Goldsmith

DIRECT MAIL

SPAIN

SILVER WORLD MEDAL, SINGLE

FCB INTEGRATED
MADRID

CLIENT **BBVA**

GENERAL CREATIVE DIRECTOR
Oscar Rojo

CREATIVE DIRECTOR
Jesus Santiuste/
Luis Ballester

COPYWRITER
Veronica Fontana

ACCOUNT EXECUTIVE
Almudena Ramirez

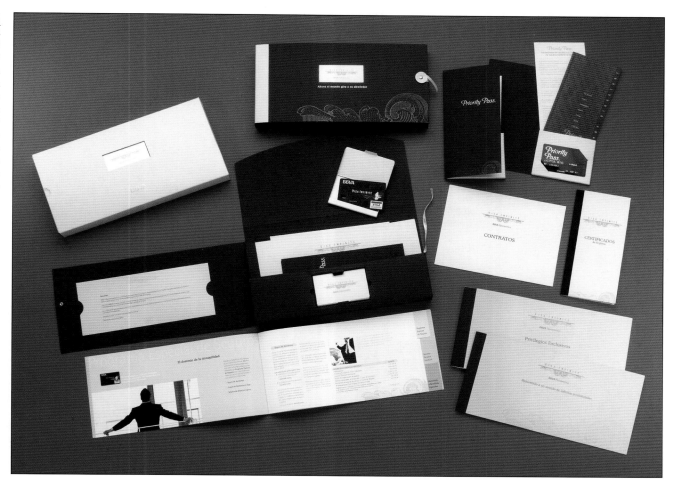

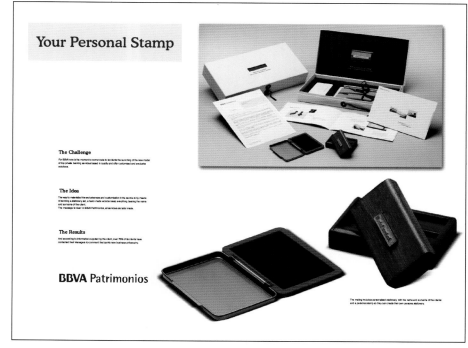

SPAIN

FINALIST, SINGLE

FCB INTEGRATED
MADRID

CLIENT **BBVA**

GENERAL CREATIVE DIRECTOR Oscar Rojo

CREATIVE DIRECTOR Jesus Santiuste/Luis Ballester

COPYWRITER Veronica Fontana

ACCOUNT EXECUTIVE Almudena Ramirez

How to wrap Christmas with our brand.

Brief:
ING Financial Group asked for a print ad to run in newspapers during December to wish people a Merry Christmas.

Solution:
Instead of the ad, a wrapping paper was developed and distributed as a press insert and was also given away for free outside shopping centers so people could not only get a good will message, but use it to wrap their gifts as well.

Results:
It was a very successful effort that helped increase awareness among users and nonusers. And best of all, not only did the message come across in an unexpected way, but the piece itself became very useful for the holidays. Our brand was present below 400,000 people's Christmas trees through out December.

Copy:
Some wrappings help you protect all that life gives you as a present.
Merry Christmas and a Happy New Year.
ING Financial Group

ING COMERCIAL AMERICA

MEXICO
BRONZE WORLD MEDAL, SINGLE
LEO BURNETT MEXICO, S.A. DE C.V.
MEXICO CITY

CLIENT **ING Commercial America**
CREATIVE SERVICES DIRECTOR **Emilio Solis**
CREATIVE GROUP DIRECTOR **Diana Vazquez**
ASSOCIATE CREATIVE DIRECTOR **Joanna Lopez**
ART DIRECTOR **Lesley Valderrama**
ACCOUNT DIRECTOR **Igor Kuchar**

MEXICO
FINALIST, SINGLE
OGILVYONE
MEXICO CITY

CLIENT **American Express**
CREATIVE DIRECTOR **Jorge Dominguez**
ART DIRECTOR **Mariana Ortiz**
COPYWRITER **A. Quintana**

NORWAY
FINALIST, SINGLE
McCANN DIREKTE MRM
OSLO

CLIENT **Eurocard Gold**
CREATIVE DIRECTOR & COPYWRITER
Erik Ingvoldstad
ART DIRECTOR **Charlotte Havstad**
ACCOUNT EXECUTIVE **Tone Bøygard**
ACCOUNT DIRECTOR **Jorunn Aarskog**

ENGLAND

FINALIST, SINGLE
TRUE NORTH
MANCHESTER

CLIENT Bank Of Scotland
CREATIVE DIRECTOR Ady Bibby

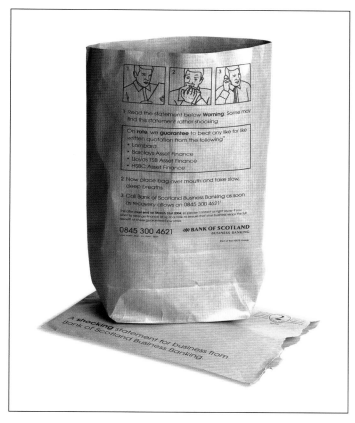

AUSTRALIA

FINALIST, CAMPAIGN
HAMMOND & THACKERAY
MELBOURNE, VICTORIA

CLIENT National Bank Agribusiness
ART DIRECTOR Ben Brocklesby
COPYWRITER Mark Bell
RURAL DIRECTOR Andrew Gill

CONSUMER PRODUCTS/SERVICES

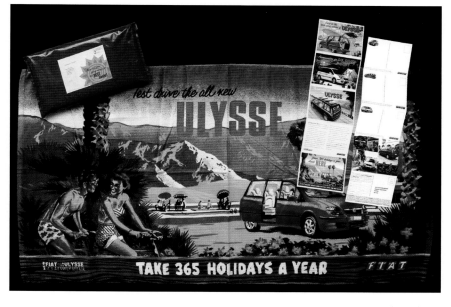

ENGLAND

FINALIST, SINGLE
ARC MARKETING
LONDON

CLIENT Fiat
EXECUTIVE CREATIVE DIRECTOR Graham Mills/Jack Nolan
COPYWRITER Aaron Martin
ART DIRECTOR Garry Munns
ACCOUNT DIRECTOR Anya Tinklin
PRODUCTION Tenacia Horlock
ILLUSTRATOR Metin Salih

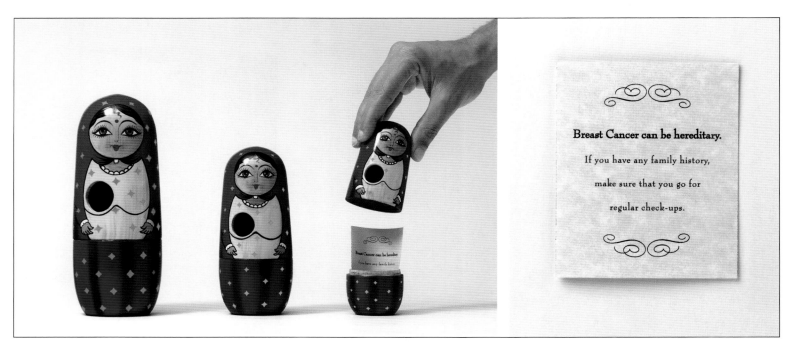

Breast Cancer can be hereditary.

If you have any family history,

make sure that you go for

regular check-ups.

INDIA

GOLD WORLD MEDAL, SINGLE

McCANN ERICKSON INDIA
MAHARASHTRA, MUMBAI

CLIENT Lucknow Cancer Institute
NATIONAL CREATIVE DIRECTOR Prasoon Joshi
COPYWRITER Rahul Mathew
ART DIRECTOR Puneet Kapoor
PLANNING Abu Malik

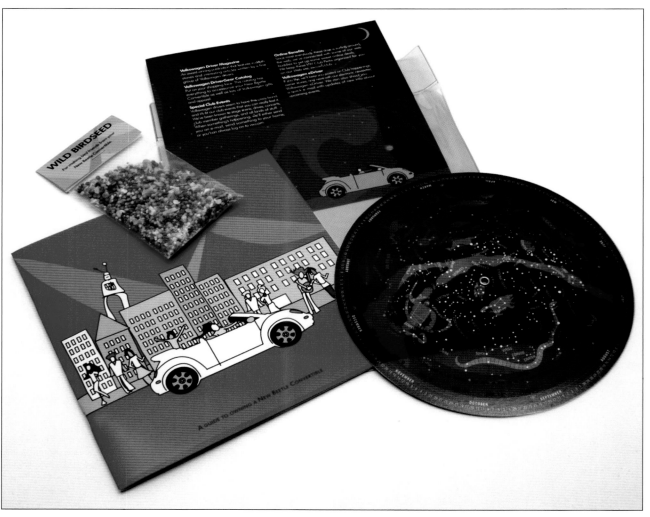

USA

SILVER WORLD MEDAL, SINGLE

ARNOLD WORLDWIDE
BOSTON, MA

CLIENT Volkswagen
COPYWRITER
Susan Ebling Corbo
ART DIRECTOR Adele Ellis
CHIEF CREATIVE OFFICER
Ron Lawner
EXECUTIVE CREATIVE DIRECTOR
Alan Pafenbach
CREATIVE DIRECTOR
Chris Bradley
ILLUSTRATOR Adele Ellis
PRODUCTION MANAGER
Aidan Finnan
ART PRODUCER Amy Shaw

SILVER WORLD MEDAL, SINGLE
DEC
BARCELONA
CLIENT NÚÑEZ I NAVARRO
CREATIVE DIRECTOR Eduard Baldrís
ART DIRECTOR Alberto Delgado
COPYWRITER Helena Marzo
ACCOUNT EXECUTIVE Berta Giménez

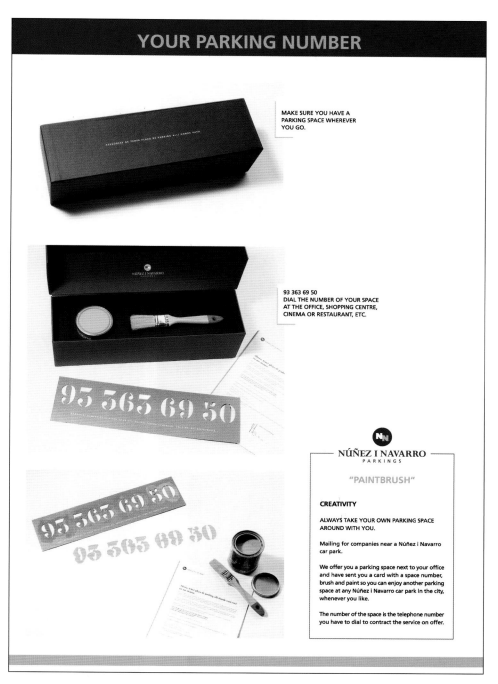

YOUR PARKING NUMBER

MAKE SURE YOU HAVE A
PARKING SPACE WHEREVER
YOU GO.

93 363 69 50
DIAL THE NUMBER OF YOUR SPACE
AT THE OFFICE, SHOPPING CENTRE,
CINEMA OR RESTAURANT, ETC.

NÚÑEZ I NAVARRO
PARKINGS

"PAINTBRUSH"

CREATIVITY

ALWAYS TAKE YOUR OWN PARKING SPACE
AROUND WITH YOU.

Mailing for companies near a Núñez i Navarro
car park.

We offer you a parking space next to your office
and have sent you a card with a space number,
brush and paint so you can enjoy another parking
space at any Núñez i Navarro car park in the city,
whenever you like.

The number of the space is the telephone number
you have to dial to contract the service on offer.

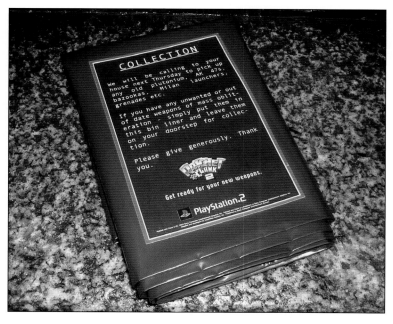

IRELAND

FINALIST, SINGLE
CAWLEY NEA TBWA
DUBLIN
CLIENT Playstation 2 Ratchet & Clank 2
ART DIRECTOR Martin Cowman
COPYWRITER Alan Kelly

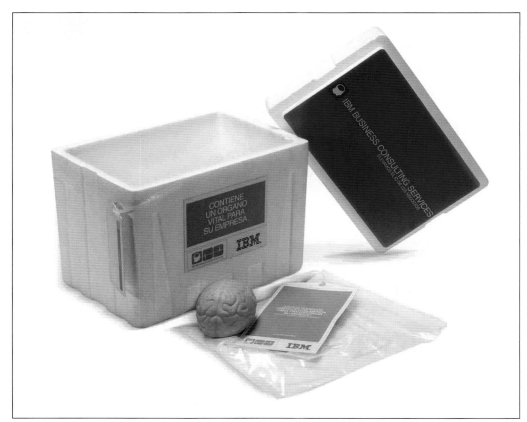

MEXICO

BRONZE WORLD MEDAL, SINGLE

OGILVYONE
MEXICO CITY

CLIENT IBM
CREATIVE DIRECTOR Jorge Dominguez
ART DIRECTOR Juan C. Guerrero
COPYWRITER Gerardo Rangel/Javier Saenz

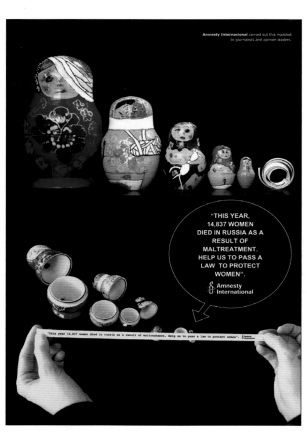

INITIATIVE HAMBURG SPORTS

THE BRIEF

Develop a direct mailing for existing members of hamburgian sports clubs that will increase their interest in playing darts and joining the clubs.

THE IDEA

Dramatize in a humorous way of what a really good dart player is capable of. For instance, getting the message (learn how to play good darts) across even without using a pen, but the darts.
So we kept the mailing almost empty, just with a small printed contact address in the lower part.

THE RESULTS

91% of the recipients liked the idea of the mailing.
The visiting guests rate in the concerning dart clubs increased by 45%.
The new members rate in the concerning dart clubs increased by 23%.

GERMANY

FINALIST, SINGLE

FCB WILKENS GMBH
HAMBURG

CLIENT Hamburger Sportbund e.V.
CREATIVE DIRECTOR Marcus Kaspar
CREATIVE DIRECTOR Stefan Schwarz
ART DIRECTOR Marcus Kaspar

SPAIN

FINALIST, SINGLE

CONTRAPUNTO
MADRID

CLIENT Amnistia Internacional
GENERAL CREATIVE DIRECTOR Antonio Montero
CREATIVE DIRECTOR Carlos S de Andino/Carlos Jorge
COPYWRITERS Jorge Mª Rodrigo/Belen de Azcarate
ART DIRECTOR Belen de Azcarate/Jorge Mª Rodrigo

GERMANY

FINALIST, SINGLE

LEONHARDT & KERN WERBUNG GMBH
STUTTGART

CLIENT Leonhardt & Kern
CREATIVE DIRECTOR Uli Weber
ART DIRECTOR Joerg Bauer
PRODUCER Annette Vieser

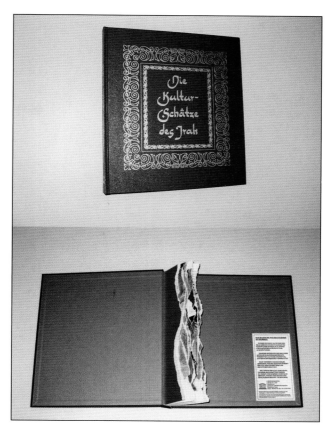

GERMANY

FINALIST, SINGLE

HEYE & PARTNER
HAMBURG

CLIENT Deutsche UNESCO Kommission
MANAGEMENT Ralf Höpfner/Reinhard Crasemann
COPYWRITER Candan Sasmaz
ART DIRECTOR Michael Theuner

MEXICO

FINALIST, SINGLE

OGILVYONE
MEXICO CITY

CLIENT SAP
CREATIVE DIRECTOR Jorge Dominguez
ART DIRECTOR Verenice Pereyra
COPYWRITER Alejandro De Icaza/Miguel Bautista

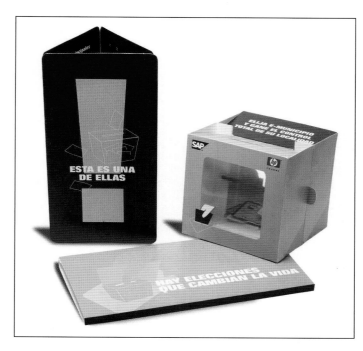

MEXICO

FINALIST, SINGLE

OGILVYONE
MEXICO CITY

CLIENT SAP
CREATIVE DIRECTOR Jorge Dominguez
ART DIRECTOR Paulina Espinoza
COPYWRITER Alejandro De Icaza/Miguel Bautista

UNITED ARAB EMIRATES

FINALIST, SINGLE

OGILVY ONE MIDDLE EAST
DUBAI

CLIENT Jaguar
CREATIVE DIRECTOR Paddy Maclachlan
ART DIRECTOR Prem Rajan
COPYWRITER Paddy Maclachlan

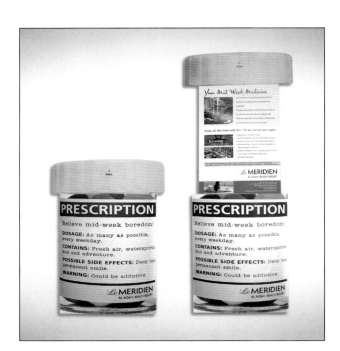

UNITED ARAB EMIRATES

FINALIST, SINGLE

PROMOSEVEN RELATIONSHIP MARKETING
DUBAI

CLIENT Le Meridien Al Aqah Beach Resort
CREATIVE DIRECTOR Mark Shadwell
ART DIRECTOR Scott Clephane
ACCOUNT MANAGER Hemesh Chandavarkar

MALAYSIA

FINALIST, SINGLE

OGILVYONE WORLDWIDE SDN BHD
KUALA LAMPUR

CLIENT Guinness Anchor Marketing Sdn Bhd
EXECUTIVE CREATIVE DIRECTOR Tan Kien Eng
ART DIRECTOR Theresa Tsang Teng
COPYWRITER Poon See Hian/Irene Tan/Tan Kien Eng
DESIGNER Connie Kuah
PRODUCTION MANAGER Koh Kiam Seng
CLIENT SERVICE DIRECTOR Alex C K Lee
ACCOUNT DIRECTOR Charmaine Yong/Joyelyn Wong/
Tan Seow Ping
ACCOUNT MANAGER Anita Ang

NORWAY

FINALIST, SINGLE

McCANN DIREKTE MRM
OSLO

CLIENT Ullevaal Business Class
CREATIVE DIRECTOR AND COPYWRITER Erik Ingvoldstad
ART DIRECTOR Charlotte Havstad
ACCOUNT EXECUTIVE Tone Bøygard
ACCOUNT DIRECTOR Morten Grusd
MANAGING DIRECTOR Helge Wold

ART NOT AVAILABLE

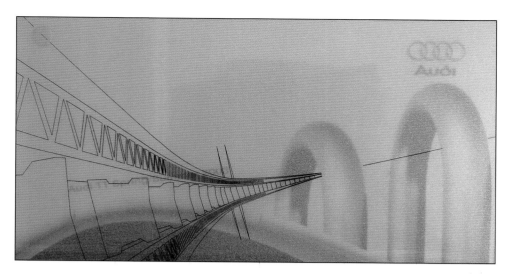

GERMANY
FINALIST, SINGLE
PHILIPP UND KEUNTJE GMBH
HAMBURG
CLIENT Audi AG Ingolstadt
CREATIVE DIRECTOR Matthias Harbeck
ART DIRECTOR Katrin Oeding
COPYWRITER Anke Gröner
DESIGNER Michel Fong

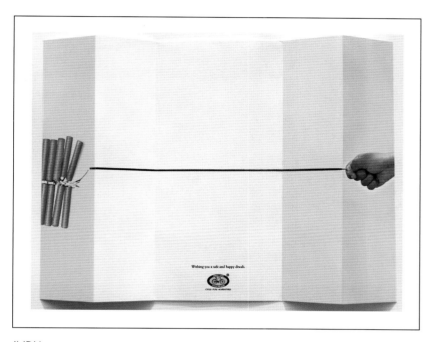

INDIA
FINALIST, SINGLE
MUDRA COMMUNICATIONS
PRIVATE LIMITED
BANGALORE, KARNATAKA
CLIENT Cycle

GERMANY
FINALIST, SINGLE
RMG:CONNECT
FRANKFURT
CLIENT smart forfour
ART DIRECTOR Christine Bader
COPYWRITER Stephanie Magin
EXECUTIVE CREATIVE DIRECTOR Christoph Mayer

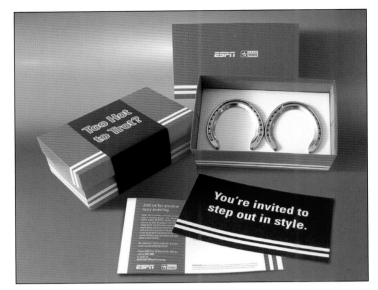

CHILE

FINALIST, SINGLE

SEPIA
SANTIAGO

CLIENT Puerto San Antonio
CREATIVE DIRECTOR Jaime Navarro
COPYWRITER Claudio Venegas
ART DIRECTOR Ricardo Calfuquir

SINGAPORE

FINALIST, SINGLE

TEQUILA SINGAPORE
SINGAPORE

CLIENT ESPN Star Sports
CREATIVE DIRECTOR Ron Fielding
SENIOR ART DIRECTOR Patrick Yam
COPYWRITER Ron Fielding

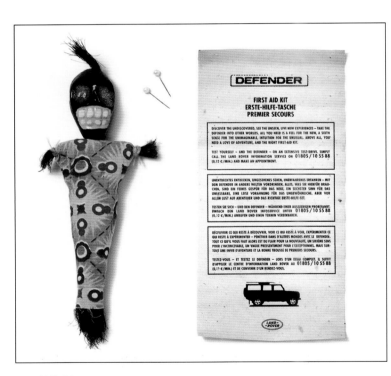

GERMANY

FINALIST, SINGLE

WUNDERMAN GMBH & CO. KG
FRANKFURT

CLIENT Land Rover Deutschland GmbH
ASSOCIATE CREATIVE DIRECTOR Markus Kraatz/
Michael Schuster
SENIOR ART DIRECTOR Peter Ahr
SENIOR COPYWRITER Oliver Glitz
CHIEF CREATIVE OFFICER Joerg Puphal
MANAGEMENT SUPERVISOR Lars Winterstein

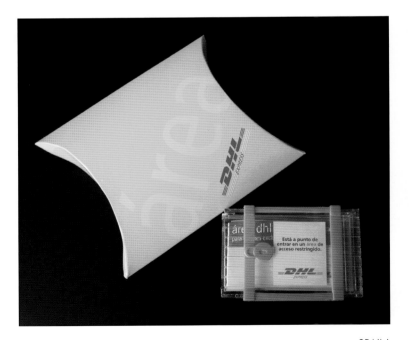

SPAIN

FINALIST, SINGLE

WUNDERMAN
MADRID

CLIENT DHL
ACCOUNT DIRECTOR Valle Lopez-Quesada
ACCOUNT SUPERVISOR Gonzalo Ocio

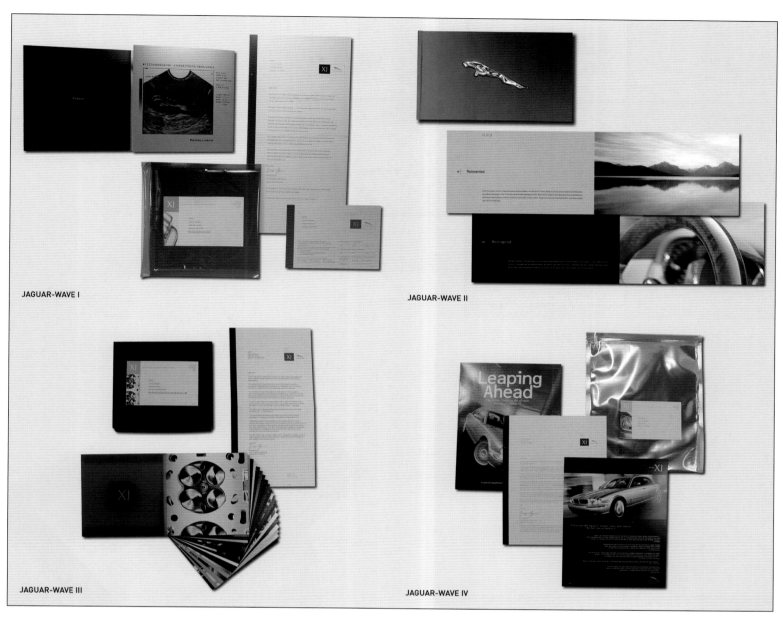

JAGUAR-WAVE I

JAGUAR-WAVE II

JAGUAR-WAVE III

JAGUAR-WAVE IV

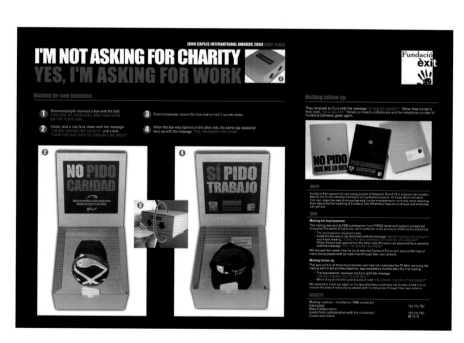

USA

GOLD WORLD MEDAL, CAMPAIGN

WUNDERMAN

IRVINE, CA

CLIENT Jaguar North America
CREATIVE DIRECTOR Anthony DiBiase
ACD/ART DIRECTOR Lane Mott
SENIOR ART DIRECTOR Imke Daniel
COPYWRITER David George
PRODUCTION MANAGER Jamie Cooke
SENIOR COPYWRITER Cameron Young
ACCOUNT DIRECTOR Jeff Browe
MANAGEMENT SUPERVISOR Jason Maloney
ACCOUNT SUPERVISOR Beth Bilock
ACCOUNT EXECUTIVE Christy Rashti
ASST. ACCOUNT EXECUTIVE Julie Patterson
ACCOUNT SUPERVISOR Cristie Stoneham
OPERATIONS PROJECT MANAGER Maria Rivier

SPAIN

FINALIST, CAMPAIGN

DEC

BARCELONA

CLIENT Fundació Èxit
CREATIVE DIRECTOR Valen Soto
ART DIRECTOR Valen Soto
COPY Helena Marzo
ACCOUNT EXECUTIVE Berta Giménez

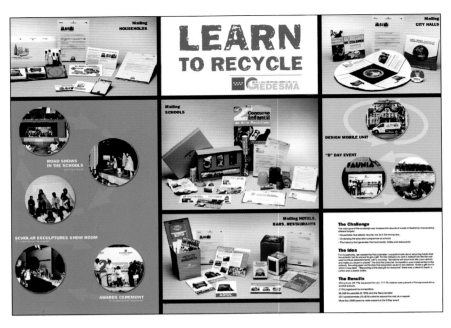

SPAIN

FINALIST, CAMPAIGN

FCB INTEGRATED
MADRID

CLIENT Gedesma
GENERAL CREATIVE DIRECTOR Oscar Rojo
CREATIVE DIRECTOR Luis Ballester
ART DIRECTOR Mario Barba/Gabriel Bañeres
COPYWRITER Ricardo de Santiago
ACCOUNT SUPERVISOR Amelia Perez

UNITED ARAB EMIRATES

FINALIST, CAMPAIGN
LOWE
DUBAI

CLIENT Emirates SkyCargo
CREATIVE DIRECTOR Nirmal Diwadkar
COPYWRITER Ash Chagla
ART DIRECTOR S.M. Ziyad
ACCOUNT MANAGEMENT Dalia Kadhim

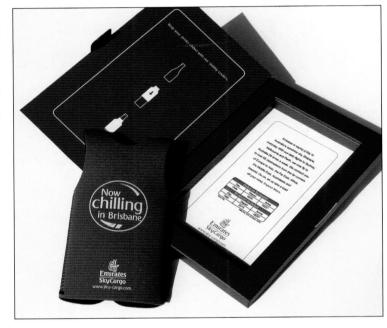

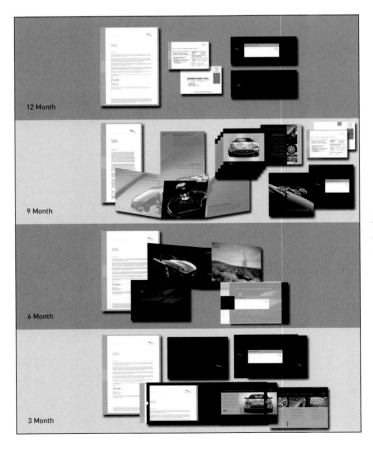

USA

FINALIST, CAMPAIGN
WUNDERMAN
IRVINE, CA

CLIENT Jaguar North America
CREATIVE DIRECTOR Anthony DiBiase
SENIOR ART DIRECTOR Kurt Brushwyler
SENIOR COPYWRITER Cameron Young
PRODUCTION MANAGER Jamie Cooke
SENIOR ART DIRECTOR Imke Daniel
COPYWRITER David George
ACCOUNT DIRECTOR Jeff Browe
MANAGEMENT SUPERVISOR Jason Maloney
ACCOUNT SUPERVISOR Cristie Stoneham
ACCOUNT EXECUTIVE Cassie Reed
OPERATIONS PROJECT MANAGER Maria Rivier
DATABASE PROJECT MANAGER James Broman

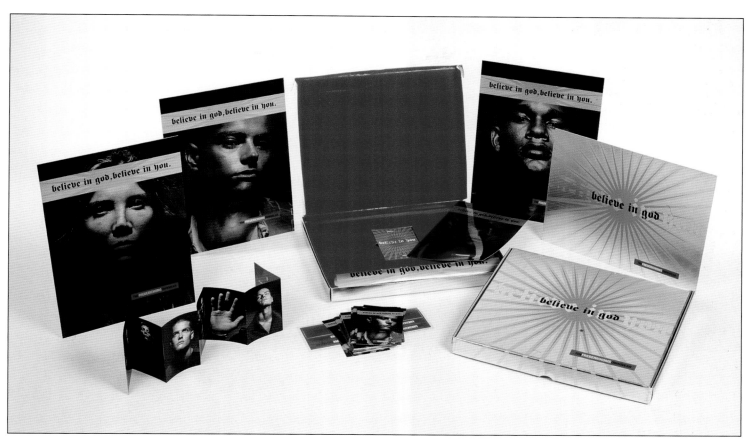

SPAIN

SILVER WORLD MEDAL, SINGLE
PEP VALLS ESTUDI
BARCELONA

CLIENT Pep Valls Estudi
GRAPHIC DESIGNER Lluís Velàzquez
PHOTOGRAPHY Roger Velàzquez
PRODUCTION Joan Soler/Ramon Bertran

INDIA
FINALIST, SINGLE
ALOK NANDA AND COMPANY
MUMBAI, MAHARASHTRA

CLIENT Kaya Skin Clinic
CREATIVE DIRECTOR Alok Nanda/
Prasanna Sankhe
COPYWRITER Alok Nanda
ART DIRECTOR Prasanna Sankhe
BUSINESS MANAGER Reena Chhabra

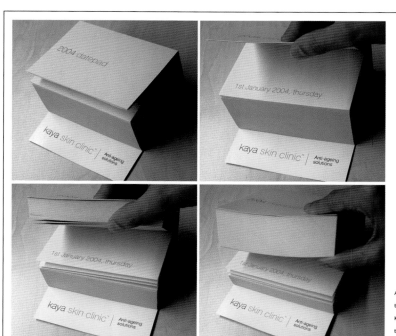

A datepad which was sent as a direct mailer to the regular clientele. A simple demonstration of Kaya skin clinic's promise: You won't age with the passing days. The date does not change on any of the 365 pages.

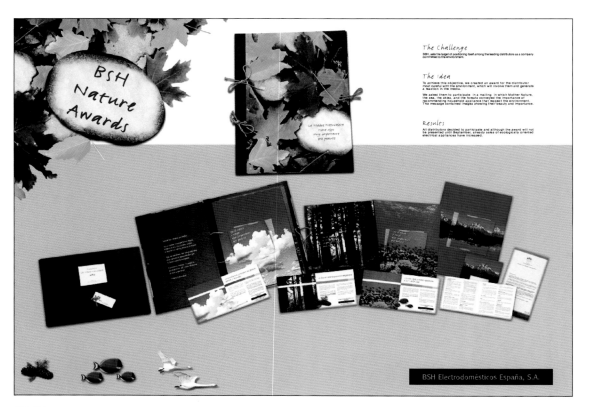

SPAIN

BRONZE WORLD MEDAL, SINGLE

FCB INTEGRATED
MADRID

CLIENT BSH Electrodomesticos España
GENERAL CREATIVE DIRECTOR Oscar Rojo
CREATIVE DIRECTOR Luis Ballester/Jesus Santiuste
ART DIRECTOR/PROGRAMMING Goyo Serna
COPYWRITER Ricardo de Santiago
ACCOUNT MANAGER Jose Maria Ortiz
ACCOUNT SUPERVISOR Sonia Vinuesa

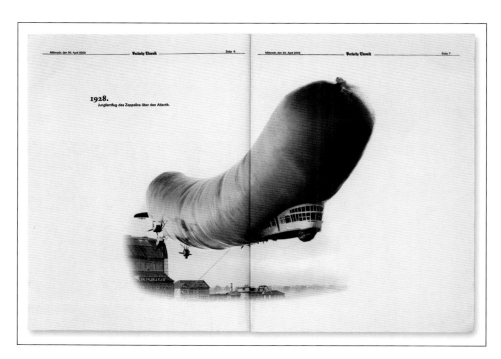

GERMANY

FINALIST, SINGLE
ROBERT GERLACH
STUTTGART

CLIENT Metzgerei Gerlach
ART DIRECTOR Robert Gerlach
COPYWRITER Robert Gerlach
PHOTOGRAPHER Tou Grammersurf
3-D ILLUSTRATOR Ruben Ranke

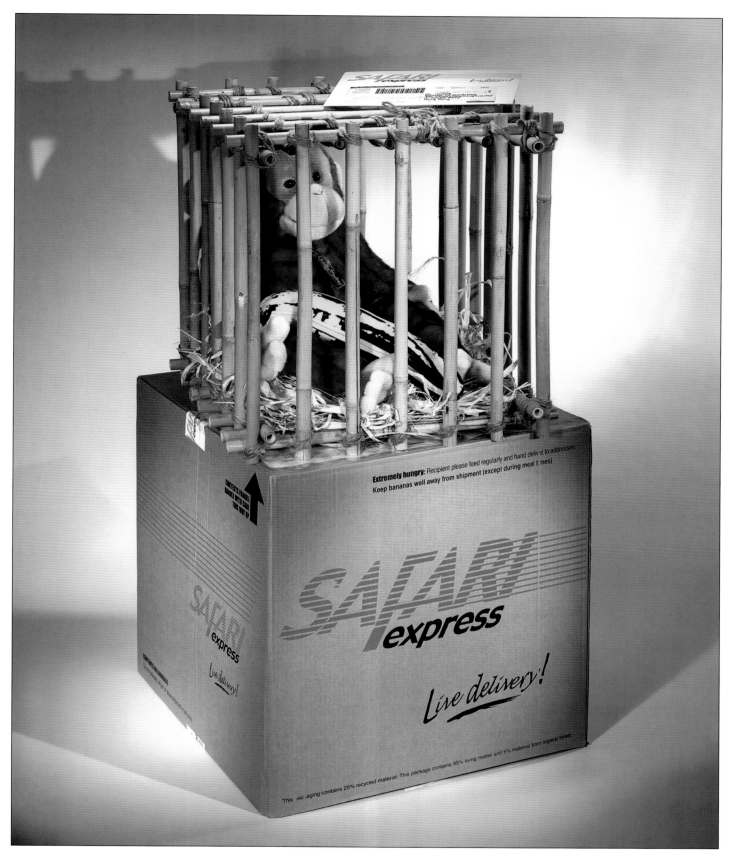

HONG KONG

GOLD WORLD MEDAL, SINGLE

OGILVYONE WORLDWIDE HONG KONG

HONG KONG

CLIENT OgilvyOne Worldwide Hong Kong
EXECUTIVE CREATIVE DIRECTOR Shane Weaver
PRINCIPAL CONSULTANT Anna Lamont
HEAD OF ART Laifong Siew

AUSTRIA

SILVER WORLD MEDAL, SINGLE

DEMNER, MERLICEK & BERGMANN
VIENNA

CLIENT Media 1, Mediaplanning And Buying
CREATIVE DIRECTOR Joachim Glawion
ART DIRECTOR Francesco Bestagno
COPYWRITER Joachim Glawion/Florian Ludwig
ACCOUNT SUPERVISOR Nicole Ess/Eva Fiala
PHOTOGRAPHER/ILLUSTRATOR Staudinger + Franke

GERMANY

FINALIST, SINGLE

EURO RSCG LÜBKE PREY GMBH
MUNICH, BAVARIA

CLIENT Studio Thomas von Salomon
CREATIVE DIRECTOR ART Oliver Helligrath
CREATIVE DIRECTOR COPYWRITER Michael Brepohl
COPYWRITER Tina van der Tak
PHOTOGRAPHER Thomas von Salomon

BRONZE WORLD MEDAL, SINGLE
HAPPY FORSMAN & BODENFORS
GOTHENBURG

CLIENT Arctic Paper
ACCOUNT EXECUTIVE Catarina Akerblom
CREATIVE DIRECTOR Andreas Kornestedt
ART DIRECTOR Andreas Kittel/Lisa Careborg
PRODUCTION MANAGER Cecilia Holmstrom
DESIGNER Lara Bohinc

KOREA

FINALIST, SINGLE
CRAYON
SEOUL

CLIENT Crayon
CREATIVE DIRECTOR/COPYWRITER Dongwon Lee
ART DIRECTOR Yunjeong Lee
DESIGNER Jihwan Lee/Eunsil Park

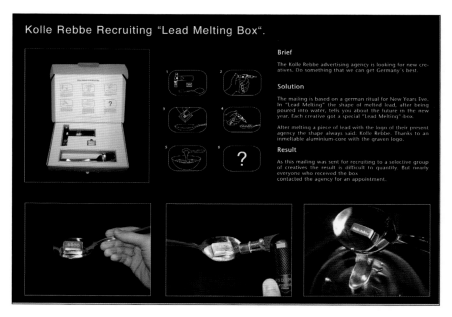

Kolle Rebbe Recruiting "Lead Melting Box".

Brief
The Kolle Rebbe advertising agency is looking for new creatives. Do something that we can get Germany's best.

Solution
The mailing is based on a german ritual for New Years Eve. In "Lead Melting" the shape of melted lead, after being poured into water, tells you about the future in the new year. Each creative got a special "Lead Melting"-box.

After melting a piece of lead with the logo of their present agency the shape always said: Kolle Rebbe. Thanks to an inmeltable aluminium-core with the graven logo.

Result
As this mailing was sent for recruiting to a selective group of creatives the result is difficult to quantify. But nearly everyone who received the box
contacted the agency for an appointment.

GERMANY
FINALIST, SINGLE
KOLLE REBBE WERBEAGENTUR GMBH
HAMBURG

CLIENT Kolle Rebbe Agency
CREATIVE DIRECTOR S. Hardieck/C. Everke
ART DIRECTOR Marjorieth Sanmartin
COPYWRITER Sebastian Oehme
AGENCY PRODUCER Öti Warnecke

*Wish you a Merry Christmas?
Why should we. Why do we have to do anything
for Christmas. It's only one day! Just because
of something that's supposed to have happened a
million years ago or whatever. Jesus Christ.
Can't we all just get on with life like normal?
Why does everyone have to be so bloody happy at
Christmas. Anyway, if you need us, we're in our
studio. And can you knock before you come in.
Some privacy would be nice, if that's not too much
to ask. And we're not tidying it up.*

TO ALL OUR FRIENDS, A VERY MERRY CHRISTMAS
OUR LAST ONE AS A TEENAGER

THE 20TH ANNIVERSARY OF LEWIS MOBERLY

ENGLAND

FINALIST, SINGLE

LEWIS MOBERLY
LONDON

CLIENT **Lewis Moberly**
DESIGN DIRECTOR **Mary Lewis**
COPYWRITER **Christian Stacey**
DESIGNER/TYPOGRAPHER **Christian Stacey**

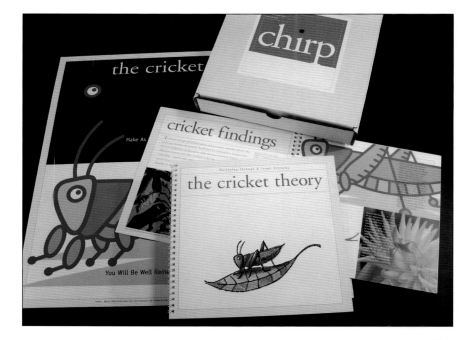

USA

FINALIST, SINGLE

NOLEN & ASSOCIATES, INC.
ATLANTA, GA

CLIENT **Nolen & Associates, Inc**
ACCOUNT EXECUTIVE **Pam Nolen**
DESIGNER/CO-CREATIVE DIRECTOR/ILLUSTRATOR **Ed Young**
COPYWRITER/CO CREATIVE DIRECTOR **David Harrell**
PRINTER **Graphic Press**
PHOTOGRAPHER **Sling Shot**

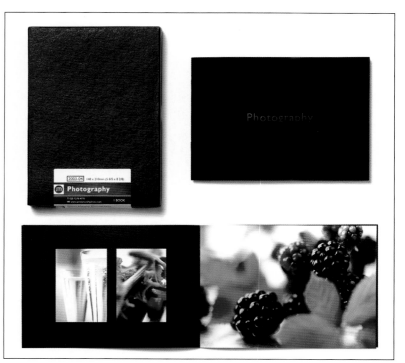

ENGLAND

FINALIST, SINGLE

PEMBERTON & WHITEFOORD
MARYLEBONE, LONDON

CLIENT **James Murphy Photography**
ART DIRECTOR **Simon Pemberton**
DESIGNER **Simon Pemberton**
PHOTOGRAPHER **James Murphy**

GREECE

FINALIST, SINGLE

RED DESIGN CONSULTANTS

ATHENS

CLIENT Bakaliko
CREATIVE DIRECTOR Rodanthi Senouka
MANAGING DIRECTOR Gina Senouka
CLIENT SERVICE DIRECTOR Dina Mylona
DESIGNER Rodanthi Senouka/
Sofia Georgopoulou/Georgos Perdikoulis
COPYWRITER Giannis Antonopoulos

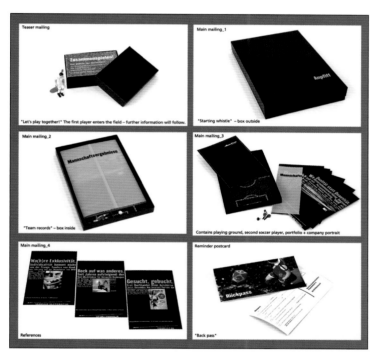

GERMANY

FINALIST, SINGLE

SPORTIVE COMMUNICATIONS

MARTINSRIED

CLIENT Sportive Communications
GENERAL MANAGER Klaus Kitzmueller
CREATIVE DIRECTOR Andreas Timm
ART DIRECTOR Kuno Alberth

SPAIN

FINALIST, CAMPAIGN

VISUAL

DONOSTIA, GIPUZKOA

CLIENT Visual Ad Agency
CREATIVE DIRECTOR Oscar Bilbao
COPYWRITER Oscar Bilbao
CREATIVE DIRECTOR Iñigo Burgui
ART DIRECTOR Iñigo Burgui

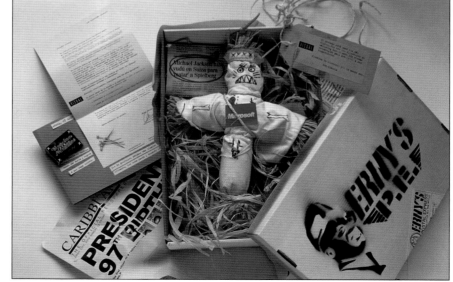

TRADE & MANUFACTURING

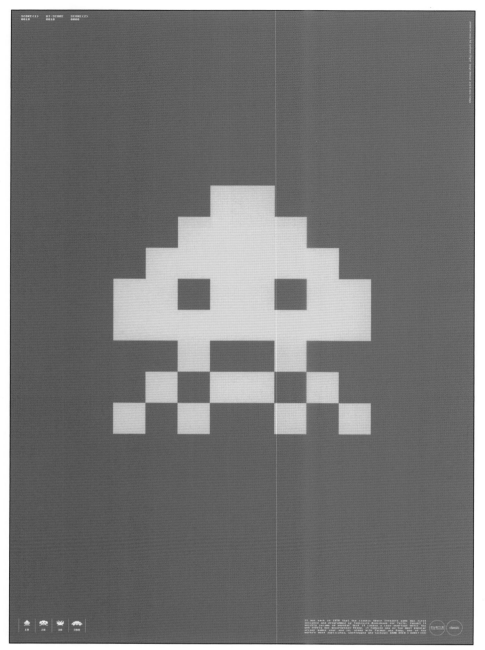

ENGLAND

SILVER WORLD MEDAL, SINGLE

ELMWOOD DESIGN
LEEDS, WEST YORKSHIRE

CLIENT Curtis Fine Papers
CREATIVE DIRECTOR Richard Scholey
DESIGNER Paul Sudron/Graham Sturzaker
COPYWRITER Jayne Workman
PHOTOGRAPHER Scott Mitchell

THE NETHERLANDS

FINALIST, SINGLE

DATAGOLD
ROTTERDAM

CLIENT GTI
CREATIVE DIRECTOR Patrick van der Heijden/
J. Tebbe
COPYWRITER Jeroen Tebbe
ART DIRECTOR Patrick van der Heijden
ILLUSTRATOR Ron Kegel

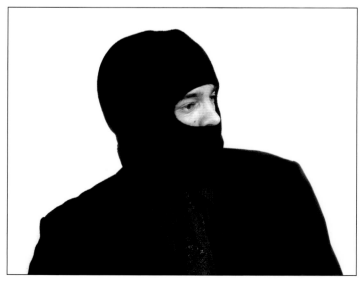

USA

BRONZE WORLD MEDAL, SINGLE

FCBI

NEW YORK, NY

CLIENT **Dex**
EXECUTIVE CREATIVE DIRECTOR **Heather Higgins**
GROUP CREATIVE DIRECTOR **Harvey Cohen**
ART DIRECTOR **Charles Rouse**
COPYWRITER **Will Adam**
CREATIVE DIRECTOR **Felix Burgos**

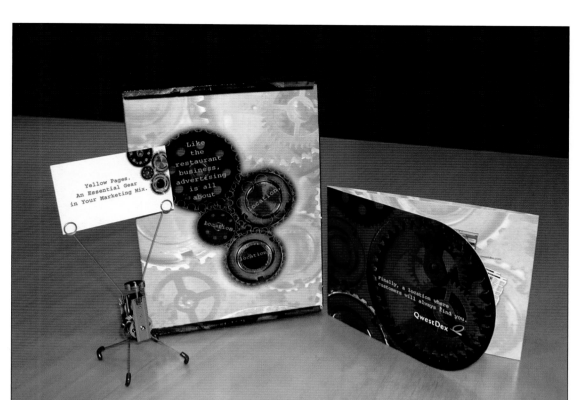

CHILE

BRONZE WORLD MEDAL, SINGLE

SEPIA

SANTIAGO

CLIENT **Ventisquero Winnery**
CREATIVE DIRECTOR **Jaime Navarro**
COPYWRITER **Alberto Osorio/Claudio Venegas**
CLIENT **Melanie Whatmore**

USA

FINALIST, SINGLE

DONAHOE PUROHIT MILLER
ADVERTISING
CHICAGO, IL

CLIENT Dermik Laboratories

CANADA

FINALIST, SINGLE

DDB CANADA
EDMONTON, ALBERTA

CLIENT 24th ACE Awards
CREATIVE DIRECTOR Eva Polis
ART DIRECTOR Jeff Sylvester/Pilot Design
COPYWRITER Eva Polis

PERU

FINALIST, SINGLE

GREY DIRECT
LIMA 18

CLIENT La Positiva
CREATIVE DIRECTOR Ricardo Zevallos Gambetta
COPYWRITER Diego Guzmán
ART DIRECTOR Renzo Sanguinetti
ACCOUNT SUPERVISOR Silvana Antoniazzi
PRODUCER Ricardo Portales
ART WORK Milhuar Suclla
GENERAL MANAGER (CLIENT) Manuel Ferreyros
MARKETING MANAGER (CLIENT) Martín Burga

USA

FINALIST, SINGLE

FCBI
NEW YORK, NY

CLIENT Dex
EXECUTIVE CREATIVE DIRECTOR Heather Higgins
GROUP CREATIVE DIRECTOR Harvey Cohen
CREATIVE DIRECTOR Felix Burgos
COPYWRITER Rebecca Reese
ART DIRECTOR Tamara Robbins

GERMANY

FINALIST, CAMPAIGN
WUNDERMAN GMBH & CO. KG
FRANKFURT

CLIENT Deutsche Lufthansa AG
EXECUTIVE CREATIVE DIRECTOR Erik Backes
CREATIVE DIRECTOR Cornel Frey
ART DIRECTOR Joern Schaefer
SENIOR COPYWRITER Uwe Schatz
CHIEF CREATIVE OFFICER Joerg Puphal
ACCOUNT DIRECTOR Barbara Frankl
DEPT. MANAGER PRODUCTION Petra Schaefer

GERMANY

FINALIST, SINGLE
WUNDERMAN GMBH & CO. KG
FRANKFURT

CLIENT Deutsche Lufthansa AG
EXECUTIVE CREATIVE DIRECTOR Erik Backes
CREATIVE DIRECTOR Cornel Frey
ART DIRECTOR Joern Schaefer
CHIEF CREATIVE OFFICER Joerg Puphal
ACCOUNT MANAGER Jasmin Ramezan
PRODUCER Bianka Elbert

USA

FINALIST, SINGLE
TORRE LAZUR McCANN
PARSIPPANY, NJ

CLIENT Aciphex
VP EXECUTIVE CREATIVE DIRECTOR Scott Watson
VP CREATIVE DIRECTOR/ART Jennifer Alampi
VP CREATIVE DIRECTOR/COPY Marcia Goddard
ART SUPERVISOR Jennifer Fajnor
COPY SUPERVISOR Katharine Imbro
SENIOR ART DIRECTOR AnneMarie Aneses
ACCOUNT GROUP SUPERVISOR Lisa Desbien
ACCOUNT EXECUTIVE Patricia Narcise
TRAFFIC Stephanie Lake
DIGITAL IMAGING GROUP Rich Gallo

SWEDEN

FINALIST, SINGLE
HAPPY FORSMAN & BODENFORS
GOTHENBURG

CLIENT Arctic Paper
ACCOUNT EXECUTIVE Catarina Akerblom
CREATIVE DIRECTOR Andreas Kornestedt
ART DIRECTOR Andreas Kittel/Lisa Careborg
PRODUCTION MANAGER Sara Linde
COPYWRITER Bjorn Engstrom
PHOTOGRAPHER Patrik Andersson

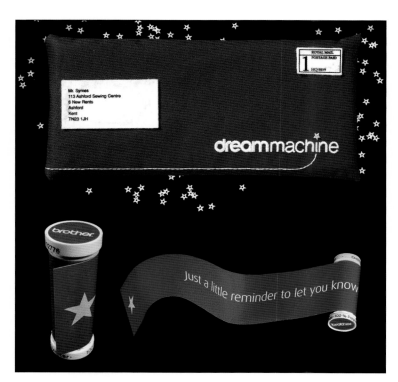

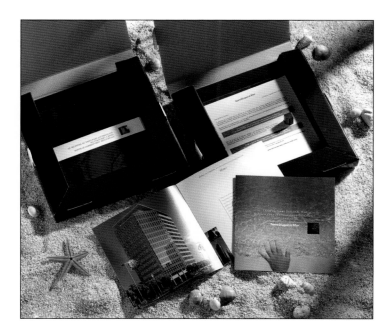

ENGLAND
FINALIST, CAMPAIGN
TEQUILA\MANCHESTER
MANCHESTER

CLIENT Brother Super Galaxie
CREATIVE DIRECTOR Richard Sharp
HEAD OF COPY Jeremy Clark
ACCOUNT DIRECTOR Adam Zavalis
SENIOR PRODUCTION MANAGER Helen Swinyard
DEPUTY CREATIVE DIRECTOR Sam Yearsley
ACCOUNT MANAGER Emma Colquitt

SPAIN
FINALIST, CAMPAIGN
CP COMUNICACION PROXIMITY-PROXIMITY
WORLDWIDE
MADRID

CLIENT Hines - Torre Diagonal Mar
SUPERVISOR DIRECTOR Amanda Muñiz
ART DIRECTOR Gerard Thomas
PRODUCTION MANAGER Jose Maria Merchan
PRODUCER Iban Fernandez
CREATIVE DIRECTOR Albert Muñoz
COPYWRITER Maria Chica
ART DIRECTOR Paul Paixa
TECNICHAL DIRECTOR Serafin Malmierca

OTHER

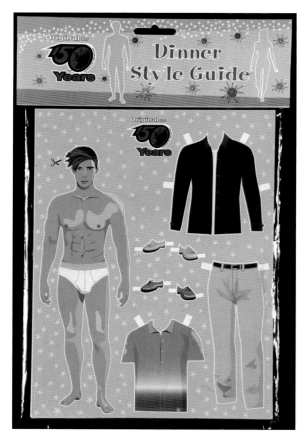

MALAYSIA
FINALIST, SINGLE
BATES (MALAYSIA) SDN BHD
KUALA LUMPUR

CLIENT Levis 150th Anniversary
EXECUTIVE CREATIVE DIRECTOR Ajay Thrivikraman
ART DIRECTOR Yeoh Oon Hoong
COPYWRITER Joseph Anthony
DESIGNER Lum Sooh Kuan
ACCOUNT EXECUTIVE Joleyn Chin
SENIOR MANAGER-PRODUCTION OPERATIONS Wong Chee Mun

SPECIALTY ADVERTISING

USA

BRONZE WORLD MEDAL, SINGLE
ARRAS GROUP
CLEVELAND, OH

CLIENT **Simmons**
CREATIVE DIRECTOR **Terrence Pacifico**
SENIOR MARKETING INTEGRATION MANAGER **Jennifer Ginnetti**
ART DIRECTOR **Jennifer Grimes**
DIRECTOR OF PRODUCTION SERVICES **Rick Braun**
COPYWRITER **Jim Karr**

USA

FINALIST, SINGLE
BBDO DETROIT
TROY, MI

CLIENT **Jeep**
ASSOCIATE CREATIVE DIRECTOR **Tom Helland**
SENIOR GRAPHIC DESIGNER **Toni Button**
GRAPHIC DESIGNER **Michael Bartello**

Flu flies.

There is only one way to protect yourself against flu: get your vaccination on time.

Consult your medical doctor for your tailor-made mercury and preservative free vaccine. **Care. Before it's there.**

www.fluflies.com
* virus-strains, circulating in the past years

Flu Vaccination
The Quality Lines

CHIRON|VACCINES

GERMANY

SILVER WORLD MEDAL, CAMPAIGN
LÜDERS BBDO
COLOGNE

CLIENT Chiron Vaccines
CREATIVE DIRECTOR Klaus Lüders
CEO Dr. Stefanie Clemen
PRODUCT MANAGER Sabine Feig/Volker Husslein
ADVERTISING MANAGER Dragos Stroica
ART DIRECTOR Andrea Unterbusch/Ulrike Appel

Before flu lands on you: protective vaccination!

Vaccination against viral flu is not mandatory but it is unequivocally recommended by the experts. The next flu season is sure to come. Do you want to risk the possibility of being sick for a number of weeks, or even put your life at risk?

Vaccination against flu is quick to administer and well tolerated. The vaccination itself certainly does not trigger off a bout of the flu! Get your vaccination as soon as possible – after all, everyone is at risk.

Every year a new vaccine: Flu viruses keep changing. Each year, new types of virus can originate. The World Health Organisation (WHO) observes this development precisely and informs the manufacturers of vaccines as soon as it recognises the new flu viruses.

The new vaccines are produced each year to match the WHO recommendation precisely. Even if the viruses do not alter for a season, you must refresh your vaccine protection. This is the only way to be armed against the next bout of flu.

Consult your medical doctor or chemist when this year's vaccine arrives.

* virus-strains, circulating in the past years

USA

FINALIST, SINGLE
ARRAS GROUP
CLEVELAND, OH

CLIENT Simmons
CREATIVE DIRECTOR Terrence Pacifico
SENIOR ART DIRECTOR Jeff Spencer
INTEGRATION MANAGER Becky DasVarma
DIRECTOR OF PRODUCTION SERVICES Rick Braun

USA

GOLD WORLD MEDAL, SINGLE
@RADICAL.MEDIA
NEW YORK, NY

CREATIVE DIRECTOR Rafael Esquer

ENGLAND

SILVER WORLD MEDAL, SINGLE

LIKE A RIVER

MANCHESTER

CLIENT **Like A River**
CREATIVE DIRECTOR **Rob Taylor/Peter Rogers**
ART DIRECTOR **Philip Pitcher**
WRITER **Rob Taylor**

ENGLAND

BRONZE WORLD MEDAL, SINGLE

THE CHASE

MANCHESTER

CLIENT **Dave Warbuton**
DESIGNER **Simon Andrews**

Web Site Advertising & Design

AUSTRIA

BRONZE WORLD MEDAL, SINGLE

DEMNER, MERLICEK & BERGMANN

VIENNA

CLIENT Demner, Merlicek & Bergmann
CREATIVE DIRECTOR Mariusz Jan Demner
ART DIRECTOR Francesco Bestagno
COPYWRITER Cosima Reif
ACCOUNT SUPERVISORS Isabella Schiefer/Thomas May
NEW MEDIA AGENCY www.getdesigned.at

GERMANY

FINALIST, SINGLE

SCHOLZ & VOLKMER GMBH

WIESBADEN

CREATIVE DIRECTOR Anette Scholz
ART DIRECTION Jörg Waldschütz/Christa Heinold
CONCEPTION Jörg Waldschütz/Christa Heinold/Anette Scholz
SCREENDESIGN Jörg Waldschütz/Dennis Oswald/Marion Stolz
FLASH PROGRAMMING Sebastian Klein/Mario Dold/Jan Schlag
PROGRAMMIERUNG Natascha Becker
PROJECT LEADER Alexander Bregenzer/Christoph Kehren
PROJECT ASSISTANT Kirstin Saufhaus
COPYWRITING Ingo Maurer und Team
PROJECT LEADER CLIENT Hagen Sczech/Flavia Thumshirn
TECHNICAL LEADER Thorsten Kraus

BRAND BUILDING/PROMOTION

KOREA

GOLD WORLD MEDAL, SINGLE

POSTVISUAL.COM
SEOUL

CLIENT **The Uninvited**
ART DIRECTOR **Euna Seol**
PRODUCER **Jungwon Lee**
CONTENTS PLANNER **Saein Lee**
MEDIA PLANNER **Hoosung Kim**
DESIGNER **Jungin Lee**
PROGRAMMER **Bongjun Kim**
MARKETING DIRECTOR (BOM FILM) **Clair Byun**
MARKETING MANAGER (BOM FILM) **Hg Park/
Jihee Hur**
MARKETING (BOM FILM) **Jackie Lee**

MALAYSIA

FINALIST, SINGLE

OGILVYONE WORLDWIDE SDN BHD
KUALA LAMPUR

CLIENT **Nokia 3300**
EXECUTIVE CREATIVE DIRECTOR **Tan Kien Eng**
SENIOR PROJECT MANAGER **Ken Chin**
ART DIRECTOR **Kenneth Lam**
SENIOR COPYWRITER **Valerie Chen**
ACCOUNT MANAGER **Michelle Tan**
ACCOUNT EXECUTIVE **Jeanne Chin**
DESIGNER **Ting Ting Hook**

GERMANY

SILVER WORLD MEDAL, SINGLE

SCHOLZ & VOLKMER GMBH
WIESBADEN

CLIENT Mercedes-Benz
CREATIVE DIRECTION Heike Brockmann
SCREEN DESIGN Jenny Fitz
FLASH PROGRAMMING Duc Thien Bui
BACKEND-PROGRAMMING Thorsten Kraus
COPY Andreas Henke
PROJECT MANAGEMENT Christoph Kehren
PROJECT MANAGEMENT CLIENT Sven Dörrenbächer
FILM-PRODUCTION BM8

USA

FINALIST, SINGLE

LYNCH2
ELGIN, IL

CLIENT Calphalon
CREATIVE DIRECTOR Stephen Lynch
ART DIRECTOR Brian Ehlers
DESIGNER Dennis Basch
FLASH ENGINEER Dan Spezanno

ENGLAND

BRONZE WORLD MEDAL, SINGLE

ARC MARKETING
LONDON

CLIENT Fiat
EXECUTIVE CREATIVE DIRECTOR
Graham Mills/Jack Nolan
COPYWRITER Martin Duckworth
ART DIRECTOR Martin Garnaud
DESIGN DIRECTOR Matt Watts
PROGRAMMER Matt Bryson
ACCOUNT DIRECTOR
Rikke Wichman-Bruun

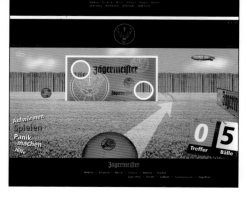

KOREA

FINALIST, SINGLE

POSTVISUAL.COM
SEOUL

CLIENT The Scandal
ART DIRECTOR Euna Seol
PRODUCER Jungwon Lee
DESIGNER Euna Seol
MEDIA PLANNER Hoosung Kim
PROGRAMMER Sangjin Yoon/Taehyun Her
MARKETING DIRECTOR (BOM FILM) Clair Byun
MARKETING MANAGER (BOM FILM) Hg Park/Jihee Hur
MARKETING (BOM FILM) Jackie Lee

GERMANY

FINALIST, SINGLE

BERGER BAADER HERMES/DIGITAL
MUNICH

CLIENT Jägermeister
CREATIVE DIRECTOR Matthias Berger
ACCOUNT EXECUTIVE Björn Sternsdorf
ART DIRECTOR Markus Beige
MULTIMEDIA DIRECTOR Jörg Janda
CONCEPT Shailia Stephens
COPYWRITER Tim Sobczak
SCREENDESIGNER Tobias Mayer
FLASH DESIGNER Thomas Reppa
TECHNICAL DIRECTOR Jörg Müller
BACKEND PROGRAMMING Mischa Landwehr
FLASH PROGRAMMING Regina Müller
PROJECT MANAGEMENT Katrin Bergfeld
PHOTOGRAPHER Ongart Köcher-Onnom
VIDEO PRODUCTION Die Sterne, Munich
SOUND AND MUSIC Neue Westpark Studios

ENGLAND

FINALIST, SINGLE

START CREATIVE LTD
LONDON

CLIENT Virgin Atlantic
DIGITAL MEDIA CREATIVE DIRECTOR Julian Wild
ART DIRECTOR Bob Ramirez
DESIGNER Ryan Collins/Dan Potter
LEAD DEVELOPER Danny Bull

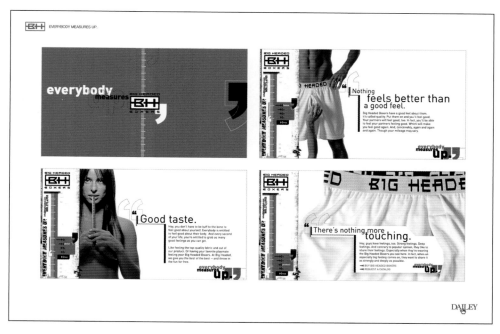

DIRECT RESPONSE

UNITED ARAB EMIRATES

FINALIST, SINGLE

PROMOSEVEN RELATIONSHIP MARKETING
DUBAI

CLIENT Le Meridien Al Aqah Beach Resort
CREATIVE DIRECTOR Mark Shadwell
ART DIRECTOR Scott Clephane
SENIOR PROGRAMMER Abdul Khadar

EVENT PROMOTION

CHILE

FINALIST, SINGLE

J. WALTER THOMPSON CHILENA SAC.
SANTIAGO

CLIENT Negrita
EXECUTIVE CREATIVE DIRECTOR Rodrigo Richards
CREATIVE DIRECTOR Enrique Zúñiga
ART DIRECTOR Karl Neumann
COPYWRITER Antonio Jeno/Nicolás López

BRAND BUILDING/PROMOTION • DIRECT RESPONSE • EVENT PROMOTION 333

GERMANY

BRONZE WORLD MEDAL, SINGLE
NORDPOL HAMBURG AGENTUR FUER
KOMMUNIKATION GMBH
HAMBURG

CLIENT Asics
CREATIVE DIRECTOR Ingo Fritz
ART DIRECTOR Gunther Schreiber
DESIGN Dominik Anweiler/Mark Höfler
COPYWRITER Ingmar Bartels
ACCOUNT EXECUTIVE Axel Schüler-Bredt
SENIOR MARKETING MANAGER Carsten Unbehauen
PR MANAGER Remco Rietvink

CANADA

FINALIST, SINGLE
TATTOO DIRECT + DIGITAL
TORONTO, ONTARIO

CLIENT Franklin Templeton Investments
PRESIDENT/CHIEF CREATIVE OFFICER Fransi Weinstein
CLIENT Service Partner Allison Laux
ASSOCIATE CREATIVE DIRECTOR Jim Wortley
DESIGN & ANIMATION John Bacic - Pixelworx
PRESIDENT/CHIEF CREATIVE OFFICER Fransi Weinstein
CLIENT SERVICE PARTNER Allison Laux
ASSOCIATE CREATIVE DIRECTOR Jim Wortley
COPYWRITER Scott McKay

SWEDEN

GOLD WORLD MEDAL, SINGLE

FORSMAN & BODENFORS

GOTHENBURG

CLIENT Volvo Cars Sweeden
COPYWRITER F. Nilsson/J. Nelson/O. Askelöf
ART DIRECTOR Martin C/Andreas M/Mikko T/Anders E
AGENCY PRODUCER Mathias Appelblad
PRODUCTION COMPANY Koko Kaka Entertainment
PHOTOGRAPH Peter Gehrke
DESIGNER Lars Johansson

UNITED ARAB EMIRATES

BRONZE WORLD MEDAL, CAMPAIGN

OGILVY ONE MIDDLE EAST

DUBAI

CLIENT American Express
CREATIVE DIRECTOR Paddy
Maclachlan/Gary Chan
ART DIRECTOR Gary Chan/Fletch Wong

JAPAN

SILVER WORLD MEDAL, SINGLE
DAIKO ADVERTISING INC.
TOKYO

CLIENT Nike/Play
CREATIVE DIRECTOR/COPYWRITER Takuya Sato
PRODUCER Hideyuki Arifuku
ART DIRECTOR/WEB DESIGNER Shinji Nemoto
ILLUSTRATOR Jun Tsuzuki
ACCOUNT EXECUTIVE Ryuta Onishi
MUSIC Susie

JAPAN

FINALIST, SINGLE
DAIKO ADVERTISING INC.
TOKYO

CLIENT Nike ACG Nike Air Tumalo
CREATIVE DIRECTOR Mitsuhisa Aoyama
CREATIVEDIRECTOR/COPYWRITER Takuya Sato
EXECUTIVE PRODUCER Shin-Ichi Ito
ART DIRECTOR/WEB DIRECTOR Hiroshi Eda
ART DIRECTOR Yasuhito Imai
PRODUCER Atsushi Sasaki
PHOTOGRAPHER Tsutomu Umezawa
MUSIC Yutaka Fukuoka
ACCOUNT EXECUTIVE Ryuta Onishi
PRODUCTION MANAGER Mihoko Nakano/Masayoshi Kato

GERMANY

BRONZE WORLD MEDAL, SINGLE

NORDPOL HAMBURG AGENTUR FUER KOMMUNIKATION GMBH

HAMBURG

CLIENT Das Taxi
CREATIVE DIRECTOR Ingo Fritz
ART DIRECTOR Gunther Schreiber
DESIGN Dominik Anweiler/Mark Höfler
ACCOUNT EXECUTIVE Niklas Franke
MARKETING MANAGER Christiane Moje-Nolte

SERVICE ADVERTISING

USA

FINALIST, SINGLE

HORNALL ANDERSON DESIGN WORKS

SEATTLE, WA

CLIENT Nordstrom
ART DIRECTOR Chris Sallquist
DESIGNERS Hillary Radbill/Gannon Curran
PRODUCER Michele Hill
PROGRAMMER Taka Suzuki
COPYWRITER Amy Bosch

DESIGN: PACKAGING DESIGN

BEVERAGES-ALCOHOLIC

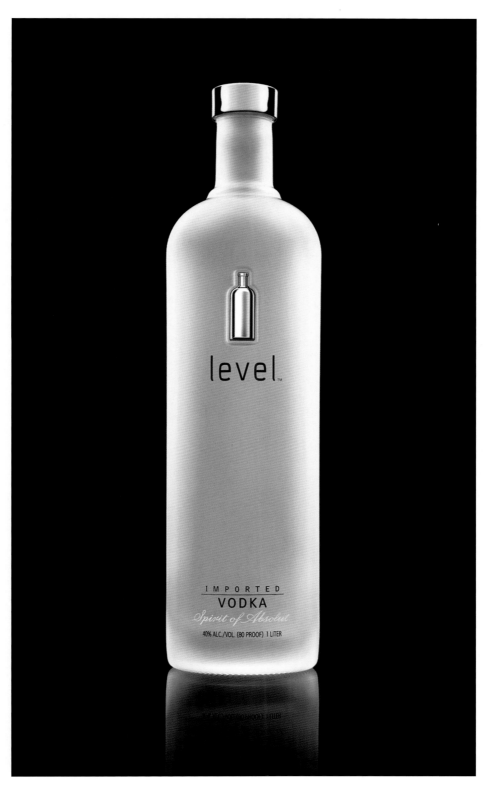

ENGLAND

SILVER WORLD MEDAL, SINGLE

PEARLFISHER INTERNATIONAL DESIGN
LONDON

CLIENT Absolut
DESIGNER Natalie Chung
PRODUCTION MANAGER Darren Foley
CREATIVE DIRECTOR Shaun Bowen
ACCOUNT MANAGER Eva Dieker

ENGLAND

FINALIST, SINGLE

DARE!

LEEDS, WEST YORKSHIRE

USA

FINALIST, SINGLE

HORNALL ANDERSON DESIGN WORKS

SEATTLE, WA

CLIENT Widmer Brothers
ART DIRECTOR Jack Anderson/Larry Anderson
DESIGNERS Larry Anderson/Jay Hilburn/Elmer dela Cruz/
Bruce Stigler/Dorothee Soechting/Don Stayner
COPYWRITER Dylan Tomine
ILLUSTRATOR Jay Hilburn

USA

FINALIST, SINGLE

DYNAMIC BEVERAGES, LLC

WESTPORT, CT

CLIENT Orange V Orange Flavored Vodka
BRAND DEVELOPER Dave Schmier
CREATIVE VISIONARY Kenyon Weiss
BRAND BUILDER Dave Schmier

ENGLAND

FINALIST, SINGLE

RANDAK DESIGN CONSULTANTS LTD

GLASGOW

CLIENT DIRECTOR Charles Randak
CREATIVE DIRECTOR Lin Gibbon
SENIOR DESIGNER Paul McGonigal

USA

FINALIST, SINGLE

STERLING GROUP
NEW YORK, NY

CLIENT Origin
CHIEF CREATIVE OFFICER Marcus Mewitt
VP DESIGN DIRECTOR Stephanie Godkin

GERMANY

FINALIST, SINGLE

PARTNERPOOL
KREATIVMARKETING GMBH
MUNCHEN, BAVARIA

CLIENT Tucher Crown

USA

FINALIST, CAMPAIGN

CAHAN &
ASSOCIATES
SAN FRANCISCO, CA

CLIENT jstar Brands
CREATIVE DIRECTOR/
ART DIRECTOR Bill Cahan
ART DIRECTOR/DESIGNER
Michael Braley
BOTTLE DESIGN
Todd Simmons

USA

FINALIST, SINGLE

WALLACE CHURCH, INC.
NEW YORK, NY

CLIENT Zygo
CREATIVE DIRECTOR Stan Church
DESIGNER Lawrence Haggerty

ENGLAND

GOLD WORLD MEDAL, CAMPAIGN

PEARLFISHER INTERNATIONAL DESIGN

LONDON

CLIENT **Waitrose**
CREATIVE DIRECTOR **Jonathan Ford**
DESIGNER **Mark Christou**
TYPOGRAPHER **Peter Horridge**
ACCOUNT MANAGER **Kerry Bolt**

ENGLAND

FINALIST, SINGLE

WILLIAMS MURRAY HAMM

LONDON

CLIENT **Chien De Garde**
CREATIVE DIRECTOR **Garrick Hamm**
DIRECTOR **Richard Murray**
DESIGNER **Clare Poupard**
TYPOGRAPHER **Clare Poupard**
PHOTOGRAPHER **Elliott Erwitt**

SILVER WORLD MEDAL,
CAMPAIGN
REKLAMBYRÅN SWE
STOCKHOLM
CLIENT **V&S Group**
CREATIVE DIRECTOR
Greger Ulf Nilson
ART DIRECTOR
Greger Ulf Nilson
DESIGNER
Greger Ulf Nilson
MARKETING DIRECTOR, CLIENT
Lars Torstensson
PHOTOGRAPHER **Dawid**
GRAPHIC DESIGNER
Oscar Snidare
PRODUCTION MANAGER
Bitte Söderlind
MARKETING DIRECTOR, CLIENT
Lars Torstensson

USA

FINALIST, CAMPAIGN
LYNCH2
ELGIN, IL.

CLIENT **Whiskey Run Creek**
CREATIVE DIRECTOR **Stephen Lynch**
ART DIRECTOR **Brian Ehlers**

ENGLAND

BRONZE WORLD MEDAL, CAMPAIGN

DESIGN BRIDGE

LONDON, UK

CREATIVE DIRECTOR, 2D Steve Eliott
CREATIVE DIRECTOR - 3D Neil Hirst
DESIGNER Rob Riley
ACCOUNT DIRECTOR Fiona Florence

ENGLAND

FINALIST, CAMPAIGN

DESIGN BRIDGE

LONDON, UK

GROUP CREATIVE DIRECTOR
Graham Shearsby
DESIGN DIRECTOR
Antonia Hayward
EXECUTIVE CHAIRMAN
Sir William Goodenough

ENGLAND

FINALIST, SINGLE

**WILLIAMS
MURRAY HAMM**

LONDON

CLIENT Drink Me

APPAREL/ACCESSORIES

ENGLAND

FINALIST, CAMPAIGN

PEARLFISHER INTERNATIONAL DESIGN

LONDON

CLIENT Thirty Seven Degrees
CREATIVE PARTNER Karen Welman/Shaun Bowen
DESIGNER Hazel Flores
REALISATION Alex Man

JAPAN

SILVER WORLD MEDAL, CAMPAIGN

TUGBOAT

TOKYO

CLIENT G,G,Tea
CREATIVE DIRECTOR Yasumichi Oka/Tugboat
ART DIRECTOR Seijo Kawaguchi/Tugboat
AGENCY PRODUCER Runako Satoh
DESIGNER Toshihiro Hyodo/Minoru Fuwa
PRODUCER Noriaki Ogawa

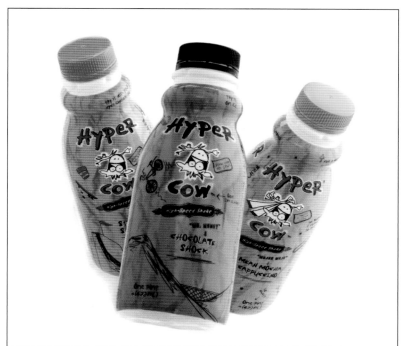

USA

FINALIST, SINGLE

BAMBOO

MINNEAPOLIS, MN

CLIENT Hyper Cow
CREATIVE DIRECTOR Kathy Soranno
LEAD DESIGNER Jenney Stevens
COPYWRITER Judith Aigner

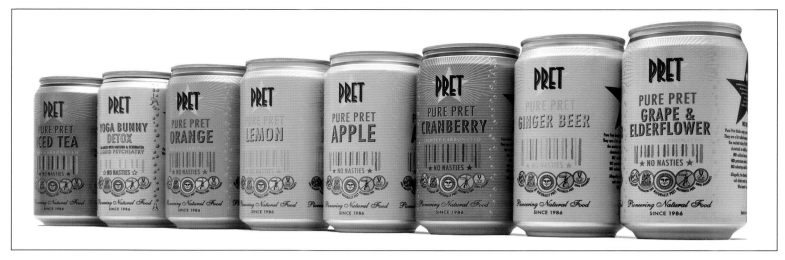

ENGLAND

BRONZE WORLD MEDAL, CAMPAIGN

THE FORMATION CREATIVE CONSULTANTS LTD
LONDON

CLIENT Pret A Manger
CREATIVE DIRECTOR Adrian Kilby
DESIGNER Adrian Kilby
TYPOGRAPHER Simon Hargreaves
COPYWRITER Julian Metcalfe
PRINTER Crown Cork & Seal

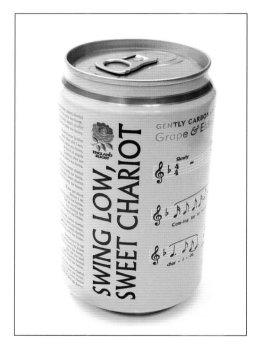

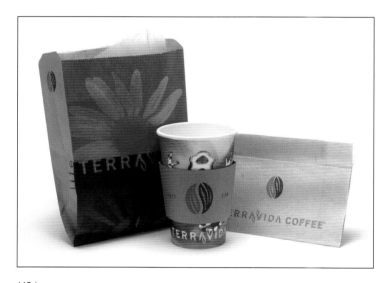

USA

FINALIST, CAMPAIGN

HORNALL ANDERSON DESIGN WORKS
SEATTLE, WA

CLIENT TerraVida Coffee
ART DIRECTOR Jack Anderson
DESIGNERS Sonja Max/James Tee/Tiffany Place/
Jana Nishi/Elmer dela Cruz
COPYWRITER Pamela Mason-Davey

ENGLAND
FINALIST, SINGLE

THE FORMATION CREATIVE
CONSULTANTS LTD
LONDON

CLIENT R.F.U.
CREATIVE DIRECTOR Adrian Kilby
DESIGNER Adrian Kilby
TYPOGRAPHER Simon Hargreaves
PRINTER ADL LTD

JAPAN
FINALIST, CAMPAIGN

TUGBOAT
TOKYO

CLIENT Fire
CREATIVE DIRECTOR Yasumichi Oka/Tugboat
ART DIRECTOR Seijo Kawaguchi/Tugboat
AGENCY PRODUCER Runako Satoh/Tugboat
DESIGNER Toshihiro Hyodo/Minoru Dodo
PRODUCER Noriaki Ogawa

USA

SILVER WORLD MEDAL, SINGLE
THIBIANT INTERNATIONAL, INC.
CHATSWORTH, CA

CLIENT **Thibiant Beverly Hills**
ART DIRECTOR **Judith Ann Blair**

JAPAN

FINALIST, CAMPAIGN
POLA CHEMICAL INDUSTRIES
TOKYO

ART DIRECTOR **Takeshi Usui**
DESIGNER **Nobuyuki Shirai/Taishi Ono/Kentaro Ito**

FOODS/SNACKS/CONFECTIONS

SOUTH AFRICA

BRONZE WORLD MEDAL, SINGLE
CROSS COLOURS
JOHANNESBURG, GAUTENG

CLIENT Nandos
DESIGN DIRECTOR Shona Dankwerts
COPYWRITER Craig Wapnick
CREATIVE DIRECTOR Joanina Pastoll/Janine Rech

SOUTH AFRICA

FINALIST, SINGLE
CROSS COLOURS
JOHANNESBURG, GAUTENG

CLIENT Nandos
DESIGN DIRECTOR Shona Dankwerts
COPYWRITER Criag Wapnick
CREATIVE DIRECTOR Joanina Pastoll/Janine Rech

DENMARK

FINALIST, SINGLE
ENVISION
AARHUS

CLIENT Belloliva
ART DIRECTOR Mette Soee
PHOTOGRAPH Lykke Rump

JAPAN

GOLD WORLD MEDAL, CAMPAIGN

SAZABY.INC

TOKYO

CLIENT Afternoon Tea Tearoom
DESIGNER Chihoko Tamura
PLANNER Makiko Sakashita

SILVER WORLD MEDAL, CAMPAIGN
LEWIS MOBERLY
LONDON

CLIENT Panini
CREATIVE DIRECTOR Mary Lewis
DESIGNER/ILLUSTRATOR Hideo Akiba
ILLUSTRATOR Fiona Verdon-Smith
ART DIRECTOR Sonja Frick

JAPAN
FINALIST, SINGLE
TOKYO GREAT VISUAL INC
TOKYO

CLIENT Akebono
CREATIVE DIRECTOR Hisamoto Naito
ART DIRECTOR Hisamoto Naito
DESIGNER Reiko Maruyama

ENGLAND

SILVER WORLD MEDAL, CAMPAIGN
PEMBERTON & WHITEFOORD
MARYLEBONE, LONDON

ART DIRECTOR **Simon Pemberton**
DESIGNER **John Ward**
DEAD OF DESIGN @ TESCO STORES **Jeremy Lindley**
PHOTOGRAPHY **James Murphy**

JAPAN

FINALIST, SINGLE
TOKYO GREAT VISUAL INC
TOKYO

CLIENT **Akebono**
CREATIVE DIRECTOR **Hisamoto Naito**
ART DIRECTOR **Hisamoto Naito**
TYOPOGRAPHER **Yukio Nakagawa**
DESIGNER **Reiko Maruyama**

ENGLAND

BRONZE WORLD MEDAL, CAMPAIGN
WILLIAMS MURRAY HAMM
LONDON

CLIENT Hill Station
CREATIVE DIRECTOR Garrick Hamm
DESIGNER Fiona Curran
ACCOUNT DIRECTOR Sarah Westwood
PHOTOGRAPHER Paul Williams
TYPOGRAPHER Fiona Curran

ENGLAND

FINALIST, CAMPAIGN
WILLIAMS MURRAY HAMM
LONDON

CLIENT Jaffa Cakes
CREATIVE DIRECTOR Garrick Hamm
DESIGNER Gareth Beeson
ACCOUNT DIRECTOR Panna Patel
WRITER Richard Murray
ILLUSTRATOR Simon Critchley

USA

FINALIST, CAMPAIGN
HORNALL ANDERSON DESIGN WORKS
SEATTLE, WA

CLIENT ZipSticks
ART DIRECTOR Mary Hermes
DESIGNER Andrew Smith
ILLUSTRATORS Andrew Smith/John Anderle
COPYWRITER Pamela Mason-Davey

ENGLAND

FINALIST, CAMPAIGN

PEARLFISHER INTERNATIONAL DESIGN
LONDON

CLIENT West Country Cheeses
CREATIVE DIRECTOR Shaun Bowen
PRODUCTION MANAGER Darren Foley
DESIGNER Lisa Simpson
ACCOUNT MANAGER Kerry Bolt

DENMARK

FINALIST, CAMPAIGN

SCANAD
AARHUS

CLIENT cKohberg
CREATIVE DIRECTOR/COPYWRITER Henry Rasmussen
ART DIRECTOR/DESIGNER Lasse Moller Jensen
ACCOUNT MANAGER Pia Daniel
MARKETING MANAGER Michael Rydder
ACCOUNT DIRECTOR Jesper Soderberg

OFFICE EQUIPMENT/SUPPLIES

USA

FINALIST, CAMPAIGN

OFFICE DEPOT
DELROY BEACH, FL

CLIENT Christopher Lowell
GLOBAL CREATIVE DIRECTOR DESIGN
Office Depot/Walter Porras

HONG KONG

SILVER WORLD MEDAL, CAMPAIGN

E-LINK DESIGN & COMMUNICATIONS
LIMITED

HONG KONG

CLIENT Wai Yuen Tong
CREATIVE DIRECTOR Patrick Heung
ACCOUNT SUPERVISOR Ip Fung Kau

SOFTWARE/ELECTRONICS

VENEZUELA
BRONZE WORLD MEDAL, SINGLE
OGILVY & MATHER VENEZUELA
CARACAS

CLIENT DJ Charlieboy
GENERAL CREATIVE DIRECTOR Mabel Ruiz
CREATIVE DIRECTOR Carlos Gonzalez
ART DIRECTOR Carlos Gonzalez

TAIWAN
FINALIST, SINGLE
PUBLIC TELEVISION SERVICE FOUNDATION
TAIPEI

CLIENT Crystal Boys/VCD Set
CREATIVE DIRECTOR Shao-Chun Huang
GENERAL CREATIVE DIRECTOR Yu-Hsien Su
PROJECT MANAGER Hsing-Chen Tsai
COPY DIRECTOR Lolina Chou
ILLUSTRATOR Min-Sheng Chuang
DIRECTOR OF MARKETING DEPT. Helen Yu
DIRECTOR OF PRODUCTION DEPT. Chi-Long Lin

JAPAN
FINALIST, SINGLE
TOKYO GREAT VISUAL INC
MINATO-KU, TOKYO

CLIENT HumanTouch
CREATIVE DIRECTOR Kengo Iizuka
ART DIRECTOR Kengo Iizuka
DESIGNER Kengo Iizuka
ILLUSTRATOR Kengo Iizuka

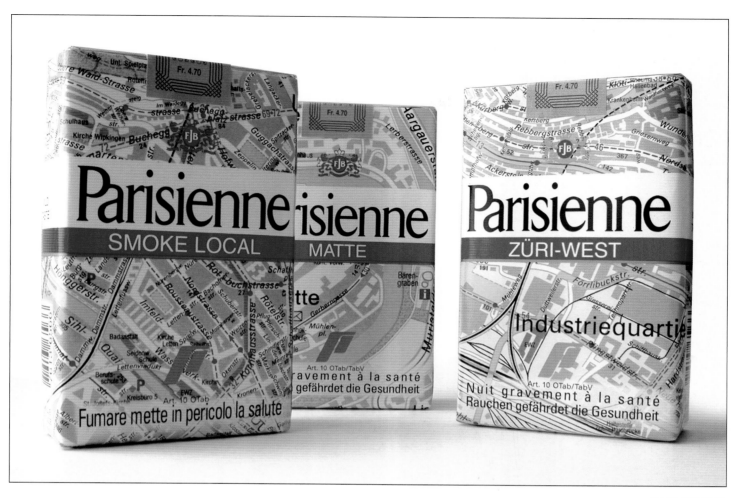

SWITZERLAND

SILVER WORLD MEDAL, CAMPAIGN
SULZER, SUTTER AG
ZÜRICH

CLIENT Britsh American Tobacco Switzerland SA Parisienne
CREATIVE DIRECTOR Francis Sulzer/Felix Dammann
COPYWRITER Adrian Hoenicke
ART DIRECTOR Stephan Huwiler
ACCOUNT SUPERVISOR Peter Krebs/Jasna Smojvir

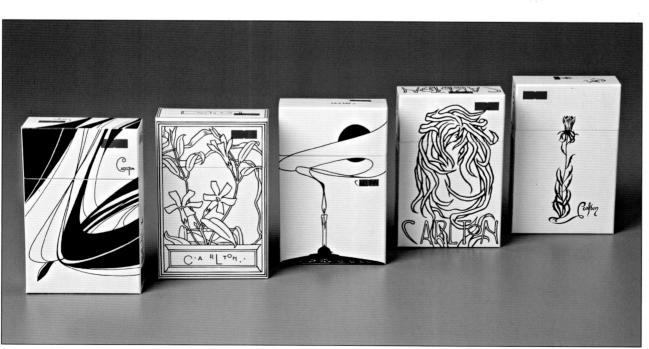

BRAZIL

BRONZE WORLD MEDAL, SINGLE
DPZ
SAO PAULO

CLIENT
Carlton Limited Edition

CREATIVE DIRECTOR
Carlos Silverio/
Francesc Petit

ART DIRECTOR
Jacqueline Lemos/
Alberto Kim

COPYWRITER
Mariana D'Horta/
João Paulo Magalhães

GRAND AWARD

Design

GERMANY

GRAND AWARD
BEST DESIGN

STRICHPUNKT
STUTTGART

CLIENT Papierfabrik Scheufelen
CREATIVE DIRECTOR Jochen Rädeker/
Kirsten Dietz
DESIGNER Felix Widmaier
PHOTOGRAPHER Jan Steinhilber
DESIGNER Tanja Günther
COPYWRITER Jochen Rädeker

 Scheufelen

DIARY --
I'M ALL YOURS. // 2004

'04

PhoeniXmotion

-- Heartbeat Moments --
FEEL ME // SEE ME // TOUCH ME //

DESIGN: COMPANY LITERATURE

ANNUAL REPORT

GERMANY

GOLD WORLD MEDAL, SINGLE

STRICHPUNKT

STUTTGART

CLIENT 4 MBO International Electronic AG
CREATIVE DIRECTOR Jochen Rädeker/Kirsten Dietz
DESIGNER Stephanie Zehender
WRITER Uli Sackmann

SINGAPORE

SILVER WORLD MEDAL, SINGLE

EQUUS DESIGN CONSULTANTS PTE LTD
SINGAPORE

CLIENT Craft Print International Ltd
CREATIVE DIRECTOR Andrew Thomas
SENIOR DESIGNER Chung Chi Ying
DESIGNER Gan Mong Teng

ENGLAND

BRONZE WORLD MEDAL, SINGLE

THE CHASE
MANCHESTER

CLIENT D&AD
CREATIVE DIRECTOR Harriet Devoy

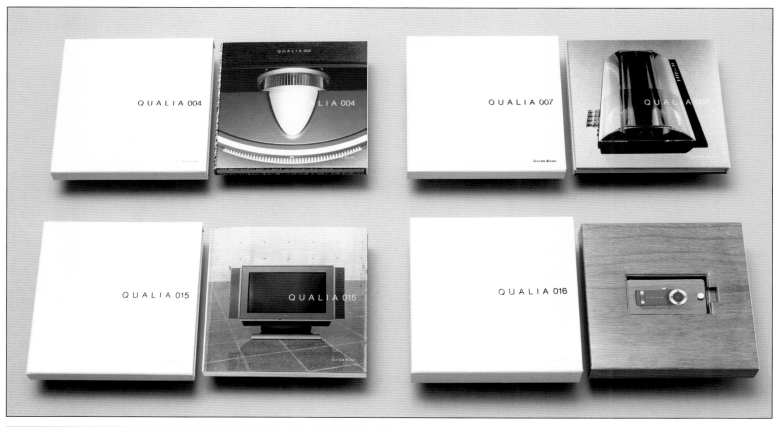

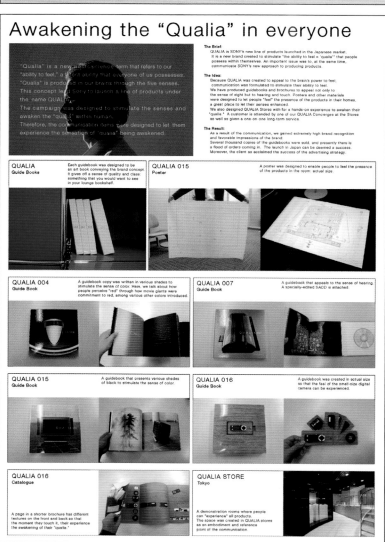

Awakening the "Qualia" in everyone

"Qualia" is a new neuro-science term that refers to our "ability to feel," a latent ability that everyone of us possesses. "Qualia" is produced in our brains through the five senses. This concept led Sony to launch a line of products under the name QUALIA.
The campaign was designed to stimulate the senses and awaken the "qualia" within humans.
Therefore, the communication items were designed to let them experience the sensation of "qualia" being awakened.

The Brief:
QUALIA is SONY's new line of products launched in the Japanese market. It is a new brand created to stimulate "the ability to feel = 'qualia'" that people possess within themselves. An important issue was to, at the same time, communicate SONY's new approach to producing products.

The Idea:
Because QUALIA was created to appeal to the brain's power to feel, communication was formulated to stimulate their ability to feel. We have produced guidebooks and brochures to appeal not only to the sense of sight but to hearing and touch. Posters and other materials were designed to let people "feel" the presence of the products in their homes, a great place to let their senses enhanced.
We also designed QUALIA Stores with for a hands-on experience to awaken their "qualia." A customer is attended by one of our QUALIA Concierges at the Stores as well as given a one-on-one long-term service.

The Result:
As a result of the communication, we gained extremely high brand recognition and favorable impressions of the brand.
Several thousand copies of the guidebooks were sold, and presently there is a flood of orders coming in. The launch in Japan can be deemed a success. Moreover, the client as acclaimed the success of the advertising strategy.

QUALIA Guide Books — Each guidebook was designed to be an art book conveying the brand concept. It gives off a sense of quality and class; something that you would want to see in your lounge bookshelf.

QUALIA 015 Poster — A poster was designed to enable people to feel the presence of the products in the room; actual size.

QUALIA 004 Guide Book — A guidebook copy was written in various shades to stimulate the sense of color. Here, we talk about how people perceive "red" through how movie giants were commitment to red, among various other colors introduced.

QUALIA 007 Guide Book — A guidebook that appeals to the sense of hearing. A specially-edited SACD is attached.

QUALIA 015 Guide Book — A guidebook that presents various shades of black to stimulate the sense of color.

QUALIA 016 Guide Book — A guidebook was created in actual size so that the feel of the small-size digital camera can be experienced.

QUALIA 016 Catalogue — A page in a shorter brochure has different textures on the front and back so that the moment they touch it, their experience the awakening of their "qualia."

QUALIA STORE Tokyo — A demonstration rooms where people can "experience" all products. The space was created in QUALIA stores as an embodiment and reference point of the communication.

JAPAN

GOLD WORLD MEDAL, CAMPAIGN
HAKUHODO IN PROGRESS
TOKYO

SENIOR BRAND PLANNER Yo Ukai
COPYWRITER Toshiyuki Konishi
ART DIRECTOR Atsushi Kaneko
COPYWRITER Yuichiro Motozumi
CREATIVE DIRECTOR Teruhiko Ando/Miki Matsui
STRATEGIC PLANNER Keisuke Sugimoto
ART DIRECTOR Yasuko Kaneko
ACCOUNT DIRECTOR Hiroaki Mori
GRAPHIC DESIGNER Shinya Mochinaga/Yasumitsu Nakajima
PHOTOGRAPHER Tetsuya Morimoto/Mikiya Takimoto

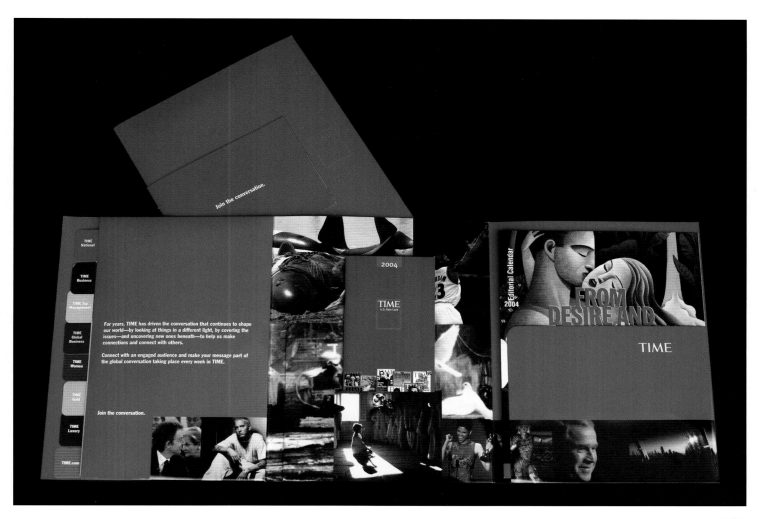

USA
SILVER WORLD MEDAL, SINGLE
TIME MAGAZINE
NEW YORK, NY

ART DIRECTOR **Mike Iadanza**
WRITER **Gloria Fallon**
CREATIVE DIRECTOR **Liza Greene**

USA
BRONZE WORLD MEDAL, SINGLE
PIVOT DESIGN, INC.
CHICAGO, IL

CLIENT **Brooks Brothers**
CREATIVE DIRECTOR **Brock Haldeman**
DESIGNER **Liz Haldeman/Jill Kristen Misawa**
PRODUCER **The History Factory**
WRITER **John Cooke**

ENGLAND

FINALIST, SINGLE
THE CHASE
MANCHESTER

CLIENT Royal Mail
CREATIVE DIRECTOR Harriet Devoy

USA
FINALIST, SINGLE
JOCK McDONALD FILM
SAN FRANCISCO, CA

CLIENT Hemlock Printers
PHOTOGRAPHER Jock McDonald
ART DIRECTOR Laurie Carrigan

SERVICE BOOKLET/BROCHURE

ENGLAND

BRONZE WORLD MEDAL, SINGLE
THE CHASE
MANCHESTER

CLIENT Preston Council
CREATIVE DIRECTOR Ben Casey
DESIGNER Claire Anderton

BROTHER BEAR / PRESS BOOK

SOLUTION: A folded package mimicking the way in which hunters used to traditionally fold animal skins. In opening the package you notice that the bear skin is also the cover of the book and that the only way you can read it is to lay down on the bear skin. (Includes instructions)

SPAIN

SILVER WORLD MEDAL, SINGLE
ZAPPING MADRID
MADRID

CLIENT Disney
CREATIVE DIRECTOR Uschi Henkes/
Manolo Moreno/Urs Frick
DESIGNER Jenny Nerman

KOREA

FINALIST, SINGLE
601 BISANG
SEOUL

PRODUCT CATALOG

PAIN

Suppression of stimulus activates pain centre of the brain, gyrus postcentralis (Fig. 7).

Fig. 7

"An unpleasant sensory and emotional experience associated with actual or potential tissue damage, or described in terms of such damage. The sensation of pain is accompanied by physiological symptoms such as high pulse rate and blood pressure or sweating."

SPEED LIMIT 25 M.P.H.

GERMANY

GOLD WORLD MEDAL, SINGLE

PHILIPP UND KEUNTJE GMBH

HAMBURG

CLIENT **Automobili Lamborghini S.p.A.**
CREATIVE DIRECTOR **Diether Kerner/Oliver Handlos**
ART DIRECTOR **Elke von Ditfurth-Siefken/Katrin Oeding**
COPYWRITER **Jens Daum**
ACCOUNT EXECUTIVE **Tanja Heier**

JAPAN

FINALIST, SINGLE

TOKYO GREAT VISUAL INC

TOKYO

CLIENT **Bals Corporation**
CREATIVE DIRECTOR **Kengo Iizuka**
ART DIRECTOR **Kengo Iizuka**
DESIGNER **Kengo Iizuka**
PHOTOGRAPHER **Yutaka Mori**
DESIGNER **Reiko Maruyama/ Nobuhiko Ueno/Tomohito Shukunami**
ILLUSTRATOR **Kengo Iizuka**

MINI COLLECTION. 03/04.

GERMANY
SILVER WORLD MEDAL, SINGLE
.START GMBH
MUNICH, BAVARIA

CLIENT Mini Collection
CREATIVE DIRECTOR M. Mehrwald/T. Pakull/S. Hempel
ART DIRECTOR Isabell Handl/Eva Maria Schaefer
COPYWRITER Anja Moritz
PHOTOGRAPHY Markus Roessle

MEIN ERSTES TOR

goool

GERMANY
BRONZE WORLD MEDAL, SINGLE
NORDPOL HAMBURG AGENTUR FUER
KOMMUNIKATION GMBH
HAMBURG

CLIENT Goool Sportswear
CREATIVE DIRECTOR Lars Ruehmann
ART DIRECTOR Gunther Schreiber
COPYWRITER Ingmar Bartels
PHOTOGRAPHER Alciro Theodoro Da Silva
JUNIOR ART DIRECTOR Christoph Bielefeldt
TYPOGRAPHER Bertrand Kirschenhofer
ACCOUNT SUPERVISOR Mathias Mueller-Using
CONSULTANT Niklas Franke
CLIENT Willi Kuehne

PRESS KIT/MEDIA PACK

SPAIN

GOLD WORLD MEDAL, SINGLE

ZAPPING MADRID
MADRID

CLIENT Zapping
CREATIVE DIRECTOR Uschi Henkes/
Manolo Moreno/Urs Frick

NON-PROFIT ORGANIZATION

KOREA

BRONZE WORLD MEDAL, SINGLE

601 BISANG
SEOUL

CLIENT VIDAK
ART DIRECTOR/DESIGNER Kum-Jun Park
DESIGNER Jin-Ho Choi/Seung-Youn Nam/
Joong-Gyu Kang/Jong-In Jung/Ji-Won Kim
ILLUSTRATOR Hak-Soon Hong
PHOTOGRAPHER Suk-Joon Jang/Byung-Soo Kim/
Chang-Hyun Kim

JAPAN

GOLD WORLD MEDAL, SINGLE

SHIMADA DESIGN INC.
OSAKA, OSAKA

ART DIRECTOR **Tamotsu Shimada**
PHOTOGRAPHER(COVER COLLAGE) **Koichi Okuwaki**
DESIGNER **Tamotsu Shimada/Miyuki Ameniya**
COPYWRITER(TRANSLATION) **Shinya Kamimura**
PUBLISHER **Suntory Museum, Osaka**

GERMANY

BRONZE WORLD MEDAL, SINGLE

SPRINGER & JACOBY DESIGN
HAMBURG

CLIENT **Mustang Jeans**
CREATIVE DIRECTOR **Uli Gürtler**
ART DIRECTOR **Alexander Rötterink**
COPYWRITER **Jens Ringena/Matthias Storath**
MANAGING DIRECTOR **Frank Bachmann**

CREATIVITY VERSUS FEAR

As part of the Creative Club's advertising meeting where the Year's best work is awarded, conferences and roundtables were held under the theme "creativity vs. fear". For this occasion, the Creative Club created and published a book containing the work of the club's members, art directors and copywriters from almost every agency. The work included in the book was all inspired on "creativity vs. fear" expressing everybody's own take on the subject. This is history's first book with a pair of wings.

SPAIN

SILVER WORLD MEDAL, SINGLE
ZAPPING MADRID
MADRID

CLIENT **Zapping**
CREATIVE DIRECTOR **Uschi Henkes**
DESIGNER **Marcos Fernandez**

ANNOUNCEMENT/INVITATION/CARD

USA
FINALIST, SINGLE
@RADICAL.MEDIA
NEW YORK, NY

CREATIVE DIRECTOR **Rafael Esquer**
PRODUCER **Geoff Reinhard**

BRAZIL

GOLD WORLD MEDAL, SINGLE

TEQUILA\BR
SÃO PAULO

CLIENT Absolut Vodka
CREATIVE VP José Luiz Mendieta
CREATIVE SUPERVISOR Débora Tenca
ART DIRECTOR Achilles Milan
ABSOLUT VODKA\BR MANAGER Ana Claudia Saba
ACCOUNT DIRECTOR Serge Lories
ACCOUNT MANAGER Gustavo Pereira
GRAPHIC PRODUCER Sabrina Inui
PRODUCER Rogério Mendes

PHILIPPINES

FINALIST, SINGLE

DDB PHILIPPINES, INC.
PASIG CITY

CLIENT DDB Philippines

SOUTH AFRICA

SILVER WORLD MEDAL, SINGLE
TEQUILA JOHANNESBURG
BENMORE, JOHANNESBURG

CLIENT **MTN**
SENIOR GRAPHIC DESIGNER **Wendy Bakewell**
COPYWRITER **Hagan De Villiers**
CREATIVE DIRECTOR **Margie Backhouse/Petra Oelofse**
PRODUCTION MANAGER **Mandy McDonald**

ENGLAND

FINALIST, SINGLE
ELMWOOD DESIGN
LEEDS, WEST YORKSHIRE

CLIENT **BBC Talent**
CREATIVE DIRECTOR **Richard Scholey**
DESIGNER **Kevin Blackburn**

If you work here, you have a costume.

Corn on the cob

Portfolio taco

The Lowe Halloween Party
Thursday, October 30, 2003
5:30 p.m. at the downtown office
40 West 23rd Street

ENGLAND

FINALIST, SINGLE

TRUE NORTH

MANCHESTER

CLIENT Will Shaddock Photography

ENGLAND

FINALIST, SINGLE

LIKE A RIVER

MANCHESTER

CLIENT Crossley & Lomas
CREATIVE DIRECTOR Rob Taylor/Peter Rogers
ART DIRECTOR Philip Pitcher
COPYWRITER Philip Pitcher

CANADA
FINALIST, SINGLE
SYZYGY MARKETING
OAKVILLE, ONTARIO

CLIENT Commerce Court
CREATIVE DIRECTOR Egon Springer
ART DIRECTOR/COPYWRITER Egon Springer
ACCOUNT DIRECTOR Cheryl Cardon
PRODUCER Joe Bellaera
STUDIO McCabe Neill Jaggers
ILLUSTRATOR Rob Jaggers

USA
FINALIST, SINGLE
WALLACE CHURCH, INC.
NEW YORK, NY

CLIENT Invitation To Company Party

GERMANY
FINALIST, SINGLE
UNIVERSAL STUDIOS NETWORKS DEUTSCHLAND GMBH
MÜNCHEN

CLIENT 13th Street
HEAD OF MARKETING, 13TH STREET Esther Henze
AGENCY Ereignisbuero

>> open your mind.

2004

GERMANY

SILVER WORLD MEDAL, SINGLE
BRUCE B. GMBH
STUTTGART, BADEN-WÜRTTEMB

CLIENT smart gmbh
COMPANIES Bruce B./recom, Stuttgart
CREATIVE DIRECTION Thorsten jasper Weese
CREATIVE DIRECTION Thomas Waschke/Thomas Elser
ARTWORK recom GmbH
ART DIRECTION T. j. Weese/Thomas Waschke
PHOTOGRAPHY studio challenge/smart archive

GERMANY

FINALIST, SINGLE
H2E HOEHNE HABANN ELSER, WERBEAGENTUR GMBH
BADEN-WÜRTTEMBERG

CLIENT Mercedes-Benz
CREATIVE DIRECTOR Jens Schmidt/Peter Herrmann
COPYWRITER Patric Velten
ART DIRECTOR Raimund Niederwieser/Thomas Maguin
JUNIOR ART DIRECTOR Heidi Frank
ACCOUNT SUPERVISOR Sabine Jüngling/Sandra Bürkle

INDIA

FINALIST, SINGLE
EVEREST INTEGRATED COMMUNICATIONS
NEW DELHI

CLIENT Samujh Physio
NATIONAL CREATIVE DIRECTOR Milind Dhaimade
CREATIVE DIRECTOR Manas Nanda/Janmenjoy Mohanty
ART DIRECTOR Sumonto Ghosh

ART NOT AVAILABLE

MEMENTO ME*

GERMANY

FINALIST, SINGLE

SCHOLZ & VOLKMER GMBH

WIESBADEN

CREATIVE DIRECTION Michael Volkmer
ART DIRECTOR Philipp Bareiss
COPYWRITER Judith Schütz

ROMANIA

FINALIST, SINGLE

OLYMPIC DDB ROMANIA

BUCHAREST

CLIENT Alpha Bank Romania
CREATIVE DIRECTOR Bradut Florescu
COPYWRITER Corina Plesea
ART DIRECTOR Andrei Circu
COPYWRITER Catalin Manciuc/Irina Codreanu
ACCOUNT MANAGER Diana Stancu

GERMANY

GOLD WORLD MEDAL, SINGLE

STRICHPUNKT

STUTTGART

CLIENT Papierfabrik Scheufelen
CREATIVE DIRECTOR Jochen Rädeker/Kirsten Dietz
DESIGNER Felix Widmaier
PHOTOGRAPHER Jan Steinhilber
DESIGNER Tanja Günther
COPYWRITER Jochen Rädeker

SEE GRAND AWARD PAGE 359

HONG KONG

FINALIST, SINGLE

STAR GROUP LTD.

HUNG HOM, KOWLOON

CLIENT Phoenix
ART DIRECTOR, DESIGNER Cat Lam
DESIGNER Stephen So
PHOTOGRAPER Andrew Tang

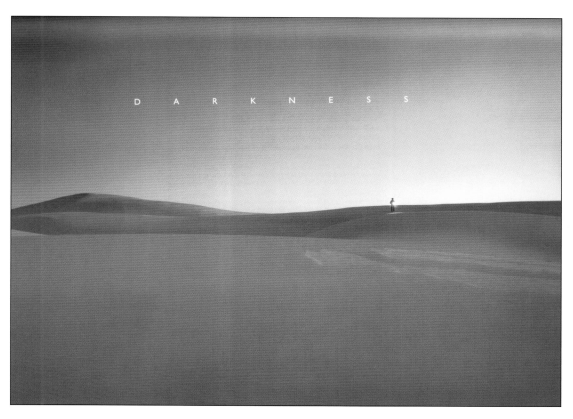

DARKNESS

JAPAN

BRONZE WORLD MEDAL, SINGLE

TUGBOAT
TOKYO

CLIENT Mag-Lite
CREATIVE DIRECTOR Seijo Kawaguchi/Tugboat
ART DIRECTOR Seijo Kawaguchi/Tugboat
COPYWRITER Sho Akiyama
PHOTOGRAPHER Tamotsu Fujii
AGENCY PRODUCER Runako Satoh
DESIGNER Toshihiro Hyodo/Minoru Fuwa
PRODUCER Noriaki Ogawa

JAPAN

FINALIST, SINGLE

C CO.,LTD.
TOKYO

CLIENT NTT Comware
CREATIVE DIRECTOR Masaru Ikeya/Katsuji Kobayashi
ART DIRECTOR Setsue Shimizu
COPYWRITER Kozo Koshimizu
PHOTOGRAPHER Nobuo Nakamura
PRODUCER Nobuko Sumimoto
DESIGNER Raita Kimura

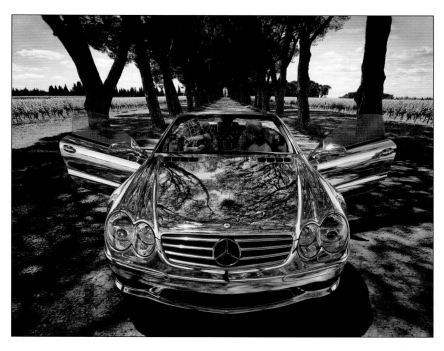

GERMANY

FINALIST, SINGLE

HENNEKA PHOTOGRAPHY
STUTTGART

CLIENT Mercedes-Benz Passenger Cars

ENGLAND

FINALIST, SINGLE
MYTTON WILLIAMS
BATH, BANES

CLIENT Mytton Williams
CREATIVE DIRECTOR Bob Mytton
DESIGN DIRECTOR Peter Greenwood
GRAPHIC DESIGNER Matt Judge/Steph Weekes

ENGLAND

FINALIST, SINGLE
NE6 DESIGN CONSULTANTS
NEWCASTLE UPON TYNE

CLIENT Statex Colour Print
CREATIVE DIRECTOR Alan Whitfield
ARTWORK Gary Charrlton/Paul Scott
PHOTOGRAPHY Peter Skelton
ILLUSTRATION Sarah Ogilvy
PHOTOGRAPHY Michael Baister

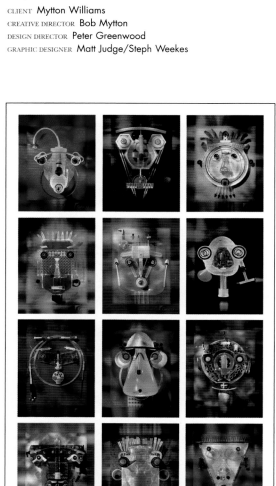

Characterizations
in Cell Culture

The sculptural assemblages in this calendar are constructed of paraphernalia found
in life science research laboratories and biomanufacturing facilities. These lighthearted
works of art were created to honor and amuse the people who use GIBCO™ cell culture
products. We hope they brighten every day of your year.

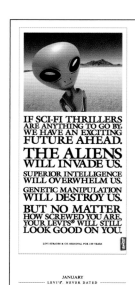

IF SCI-FI THRILLERS
ARE ANYTHING TO GO BY,
WE HAVE AN EXCITING
FUTURE AHEAD.
THE ALIENS
WILL INVADE US.
SUPERIOR INTELLIGENCE
WILL OVERWHELM US.
GENETIC MANIPULATION
WILL DESTROY US.
BUT NO MATTER
HOW SCREWED YOU ARE,
YOUR LEVI'S® WILL STILL
LOOK GOOD ON YOU.

JANUARY
LEVI'S®. NEVER DATED

IT HAS HAPPENED
FURTIVELY ON HAYSTACKS.
IT HAS HAPPENED IN THE
BACKSEATS OF CARS.
IT HAS EVEN HAPPENED
BETWEEN A PRESIDENT
AND AN INTERN.
IT HAS HAPPENED WITH
FETISHES, BONDAGE
AND TORTURE, TOO.
THERE'S NO TELLING
WHAT YOU MIGHT GET INTO
WHEN YOU GET OUT OF YOUR LEVI'S®.

OCTOBER
LEVI'S®. NEVER DATED

SAMUEL COLT'S SIX-SHOOTERS
HANG ON A MUSEUM WALL.
FREUD'S THEORY IS
ANTIQUATED,
LENIN'S REVOLUTION IS
ABANDONED,
KENNEDY'S CAMELOT
LIES IN RUINS.
LIZ'S SEVEN HUSBANDS
ARE FORGOTTEN,
AND LAST MONTH'S PIN-UP
IS CONSIGNED
TO THE ARCHIVES.
WHILE YOUR LEVI'S® ONLY FADED.

JUNE
LEVI'S®. NEVER DATED

USA

FINALIST, SINGLE
MARTIN-SCHAFFER, INC.
BETHESDA, MD

CLIENT GIBCO Cell Culture
CREATIVE DIRECTOR/WRITER Tina Martin
ART DIRECTOR/DESIGNER Steve Cohn
PHOTO ASSEMBLAGE/PHOTOGRAPHER Bill Deuster
PRODUCTION MANAGEMENT Karen Falk
ACCOUNT MANAGEMENT Mita Schaffer

INDIA

FINALIST, SINGLE
J WALTER THOMPSON
BANGALORE, KARNATAKA

CLIENT Levis
CREATIVE DIRECTOR/WRITER Mukund Sharma
ART DIRECTOR Vivek Kakkad
SENIOR ACCOUNT REPRESENTATIVE Menaka Menon
ACCOUNT DIRECTOR Dennis Koshy
VICE PRESIDENT & CSD Rajesh Gangwani
AVP & SENIOR CREATIVE DIRECTOR Prahlad Nanjappa
AVP & STRATEGIC PLANNING DIRECTOR Ramprasad
SENIOR VP & GENERAL MANAGER Dhunji Wadia

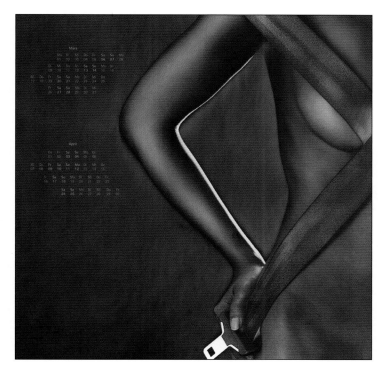

GERMANY

FINALIST, SINGLE
PUBLICIS WERBEAGENTUR GMBH
FRANKFURT

CLIENT Renault Safety
CHIEF CREATIVE OFFICER Michael Boebel
ART DIRECTOR Denise Overkamp
COPYWRITER Alexander Haase
GROUP ACCOUNT DIRECTOR Daniel Dormeyer
ACCOUNT MANAGER Nicole Reichl
MANAGER MARKETING COMM. Joerg Alexander Ellhof
ADVERTISING MANAGER Astrid Kauffmann
MARKETING DIRECTOR Frank Lagarde
PROJECT MANAGER René Joosten
STUDENT/ACADEMY U5, MUNICH Saskia Beck
STUDENT/ACADEMY U5, MUNICH Catho Paschke
STUDENT/ACADEMY U5, MUNICH Edi Thedens

GREECE

FINALIST, SINGLE
STEPHANOS KARYDAKIS S.A.
PERISTERI, ATHENS

CLIENT Stephanos Karydakis Printing House
CEO Stephanos Karydakis
GENERAL MANAGER George Karydakis
CREATIVE DIRECTOR Kostis Papamatheakis
PR/MARKETING MANAGER Prokopis Karydakis

ENGLAND

FINALIST, SINGLE
TUCKER CLARKE-WILLIAMS CREATIVE
MANCHESTER

CLIENT Tucker Clarke-Williams Creative
CREATIVE DIRECTOR Paul Heaton
PHOTOGRAPHER Robert Walker/David Walker
ILLUSTRATOR Michael O'Shaughnessy/Pip
Stanley/Brent Hardy Smith/Jemma Herbert
PHOTOGRAPHER Daniel Walmsley
COPYWRITER Tony Gamble
ARTIST Stephen Lindley/Martin Nash

CORPORATE IDENTITY/BRANDING

LOGO-CORPORATE

SPAIN
BRONZE WORLD MEDAL, SINGLE
KITCHEN
MADRID

GREECE
FINALIST, SINGLE
BRANDEXCEL SA
MAROUSI, ATHENS

CLIENT Centric Multimedia
CREATIVE DIRECTOR Elias Hydreos
SENIOR DESIGNER Aris Goubouros
CLIENT SERVICE DIRECTOR Vasso Stefou
MANAGING DIRECTOR Lia Nikopoulou-Proedrou

GERMANY
FINALIST, SINGLE
CREATIV PARTNER AGENTUR
FUER WERBUNG GMBH
DUSSELDORF

CLIENT Catwalk
CREATIVE DIRECTOR Ben Ruenger
ART DIRECTOR Mareike Uphaus
PRODUCTION Viola Reymann

ENGLAND
FINALIST, SINGLE
ELMWOOD DESIGN
LEEDS, WEST YORKSHIRE
CLIENT Serious**
CREATIVE DIRECTOR Richard Scholey
DESIGNER Kevin Blackburn
COPYWRITER Roger Horberry

GERMANY
FINALIST, SINGLE
SPRINGER&JACOBY DESIGN
HAMBURG
CLIENT Planetarium Hamburg
CREATIVE DIRECTOR Uli Gürtler
ART DIRECTOR Reiner Fiedler
COPYWRITER Corinna Berghoff

SLOVENIA
FINALIST, SINGLE
FUTURA DDB D.O.O.
LJUBLJANA
CREATIVE DIRECTOR Miha Grobler

GERMANY
FINALIST, CAMPAIGN
IGELSTUDIOS GMBH
BERLIN
CLIENT Dachkonzept 25
ART DIRECTOR Jens Lausenmeyer
TYPOGRAPHER Jens Lausenmeyer
IDEA SUPPLIER Jens Lausenmeyer

ENGLAND
FINALIST, SINGLE
THE FORMATION CREATIVE
CONSULTANTS LTD
LONDON
CLIENT Mute Marmalade
CREATIVE DIRECTOR Adrian Kilby
DESIGNER Jo Bartlam
ILLUSTRATOR Richard Davison

LOGO-TRADEMARK

Licensing Style Guide 2

GREECE
BRONZE WORLD MEDAL, CAMPAIGN
HELLAS PRESS S.A./KARAMELLA
ATHENS
CLIENT Athens 2004 Style Guides

ENGLAND
FINALIST, SINGLE
TAXI STUDIO LIMITED
ABBOTS LEIGH, BRISTOL
DESIGNER Luke Manning
CREATIVE DIRECTOR Spencer Buck
ART DIRECTOR Ryan Wills

ENGLAND

GOLD WORLD MEDAL, SINGLE

TRUE NORTH

MANCHESTER

CLIENT The Association Of Photographers
CREATIVE DIRECTOR Ady Bibby
SENIOR DESIGNER Stuart Price
DESIGNER Matt Maurer

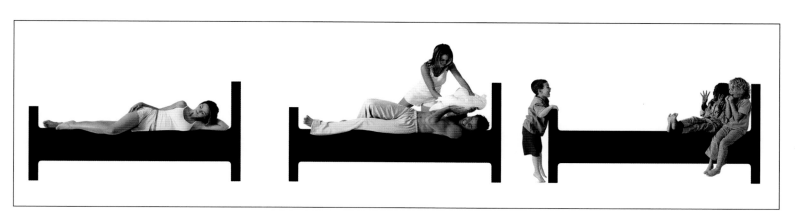

ENGLAND

SILVER WORLD MEDAL, SINGLE

THE CHASE

MANCHESTER

CLIENT Layeeze Beds
ART DIRECTOR Peter Richardson

LETTER/STATIONERY

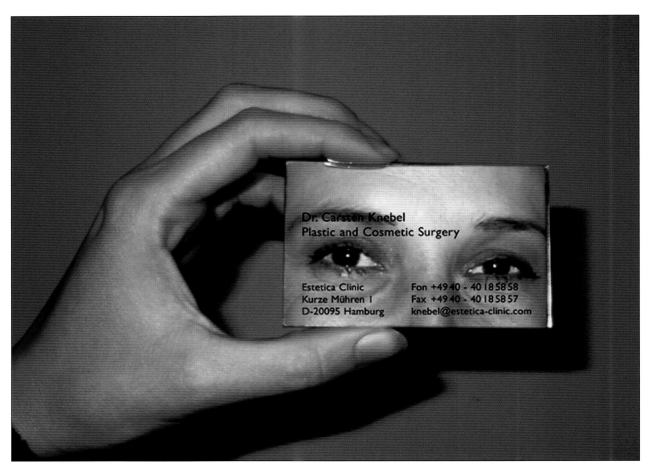

GERMANY

SILVER WORLD MEDAL, SINGLE

M.E.C.H.
McCANN-ERICKSON
COMMUNICATIONS
HOUSE BERL

BERLIN

CLIENT Estetica Clinic

EXECUTIVE CREATIVE DIRECTOR
Torsten Rieken

ART DIRECTOR Alice Rzepka

ACCOUNT DIRECTOR Katja Metz

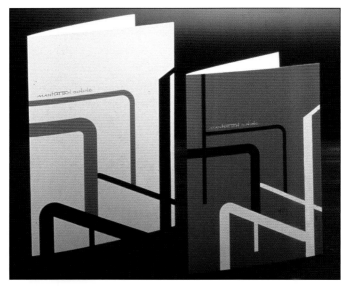

CORPORATE IMAGE BROCHURE

JAPAN

FINALIST, CAMPAIGN

GRAPHICS & DESIGNING INC.

TOKYO

CLIENT Manhattan Dining

ART DIRECTOR Toshihiro Onimaru

DESIGNER Toshihiro Onimaru

DESIGN FIRM Graphics & Designing Inc.

CLIENT Will Planning Inc.

GERMANY

FINALIST, SINGLE

GRAMM
WERBEAGENTUR GMBH

DÜSSELDORF

CLIENT Sennheiser

MANAGING DIRECTOR
Uwe Koebbel

DIRECTOR CLIENT SERVICES
Matthias Heft

SINGAPORE

SILVER WORLD MEDAL, SINGLE

EQUUS DESIGN
CONSULTANTS PTE LTD
SINGAPORE

CLIENT
Colourscan Co Pte Ltd

CREATIVE DIRECTOR
Andrew Thomas

DESIGNER Gan Mong Teng

SHOPPING BAGS

JAPAN

SILVER WORLD MEDAL, SINGLE

TUGBOAT
TOKYO

CLIENT Franc Franc

CREATIVE DIRECTOR
Yasumichi Oka, Tugboat

ART DIRECTOR
Seijo Kawaguchi/Tugboat

AGENCY PRODUCER
Runako Satoh/Tugboat

DESIGNER Toshihiro Hyodo/
Minoru Fuwa

PRODUCER Noriaki Ogawa

CRAFT CATEGORIES

BEST PHOTOGRAPHY

USA

BRONZE WORLD MEDAL, SINGLE
CHEMISTRI
TROY, MI

CLIENT Cadillac
EXECUTIVE CREATIVE DIRECTOR Gary Topolewski
CREATIVE DIRECTOR Will Perry
COPYWRITER Susan Zweig
ART DIRECTOR Tom Kozak/Sarah Trent
PHOTOGRAPHER Torfi
DESIGN DIRECTOR Gloria Ajlouny
DESIGNER Sarah Trent

BEST ILLUSTRATION

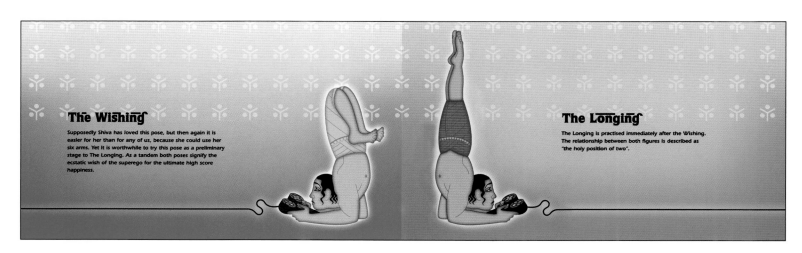

GERMANY

FINALIST, SINGLE
TBWA \
BERLIN

CLIENT Sony PlayStation2
CREATIVE DIRECTOR Kurt Georg Dieckert
CREATIVE DIRECTOR Stefan Schmidt
COPYWRITER Helge Blöck
DESIGNER Christine Taylor
GRAPHIK Diane Bergmann
TYPOGRAPHY Diane Bergmann
ILLUSTRATOR Jana Reidenbach

ENGLAND

BRONZE WORLD MEDAL, CAMPAIGN

WILLIAMS MURRAY HAMM

LONDON

CLIENT Hill Station
CREATIVE DIRECTOR Garrick Hamm
DESIGNER Fiona Curran
TYPOGRAPHER Fiona Curran
ACCOUNT DIRECTOR Sarah Westwood
PHOTOGRAPHER Paul Williams

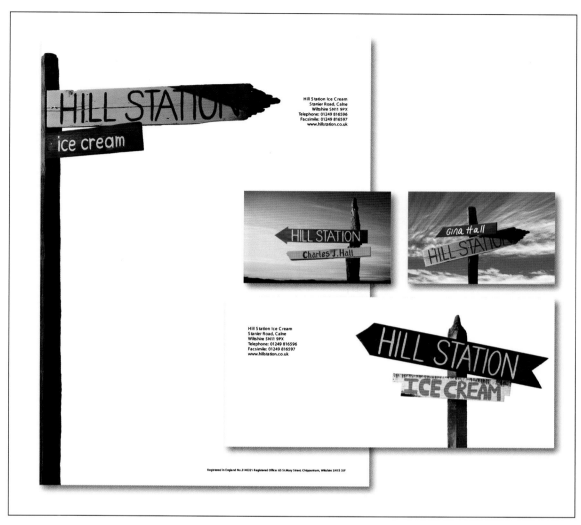

BEST WRITING

ENGLAND

FINALIST, SINGLE

START CREATIVE LTD

LONDON

CLIENT Virgin Atlantic
HEAD OF COPY Dan Radley
COPYWRITER Glenn Law
CREATIVE DIRECTOR Martin Muir
SENIOR DESIGNER Sarah Jackson

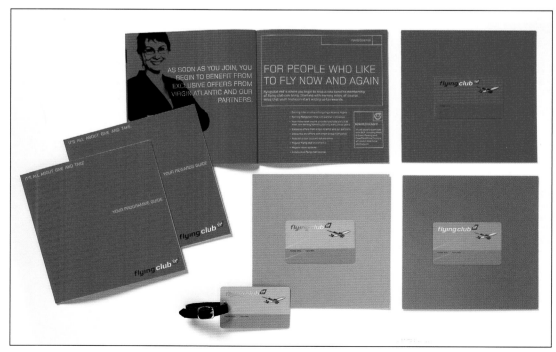

BEST ART DIRECTION

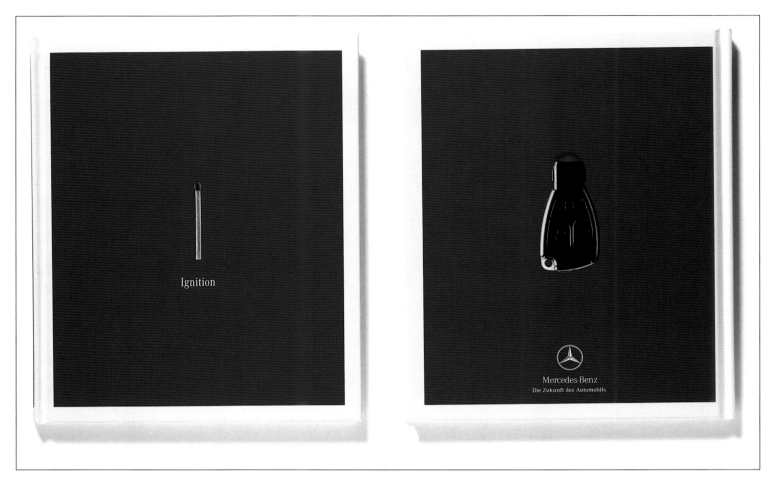

Ignition

Mercedes-Benz
Die Zukunft des Automobils.

GERMANY

SILVER WORLD MEDAL, SINGLE
STRICHPUNKT
STUTTGART

CLIENT DaimlerChrysler
CREATIVE DIRECTOR Jochen Rädeker
ART DIRECTOR Felix Widmaier/Kirsten Dietz
PHOTOGRAPHER Jan Steinhilber
WRITER Hans-Dieter Pfundtner/Karl Böhm

USA

FINALIST, SINGLE
DAE ADVERTISING
SAN FRANCISCO, CA

CLIENT Southwest Airlines
CREATIVE DIRECTOR Kendal Yim
ART DIRECTOR Kendal Yim
SENIOR DESIGNER Miranda Poon

BRONZE WORLD MEDAL, SINGLE
STRICHPUNKT
STUTTGART

CLIENT 4MBO International Electronic AG
CREATIVE DIRECTOR Jochen Rädeker/Kirsten Dietz
DESIGNER Stephanie Zehender
WRITER Uli Sackmann/Jochen Rädeker

USA

FINALIST, SINGLE
CHEMISTRI
TROY, MI

CLIENT Cadillac
EXECUTIVE CREATIVE DIRECTOR Gary Topolewski
CREATIVE DIRECTOR Will Perry
COPYWRITER Susan Zweig
ART DIRECTOR Tom Kozak/Sarah Trent
DESIGN DIRECTOR Gloria Ajlouny
DESIGNER Sarah Trent
PHOTOGRAPHER Torfi

BEST DESIGN

GERMANY
BRONZE WORLD MEDAL, SINGLE
LEONHARDT & KERN WERBUNG GMBH
STUTTGART
CLIENT Leonhardt & Stamps
CREATIVE DIRECTOR Uli Weber
ART DIRECTOR Joerg Bauer
PRODUCER Annette Vieser

GERMANY
GOLD WORLD MEDAL, SINGLE
STRICHPUNKT
STUTTGART
CLIENT Papierfabrik Scheufelen
CREATIVE DIRECTOR Jochen Rädeker/Kirsten Dietz
DESIGNER Felix Widmaier
PHOTOGRAPHER Jan Steinhilber
DESIGNER Tanja Günther
COPYWRITER Jochen Rädeker

SEE GRAND AWARD PAGE 359

SWEDEN
FINALIST, SINGLE
HAPPY FORSMAN & BODENFORS
GOTHENBURG
CLIENT Arctic Paper
ACCOUNT EXECUTIVE Catarina Akerblom
CREATIVE DIRECTOR Anders Kornestedt
ART DIRECTOR Lisa Careborg/Andreas Kittel
PRODUCTION MANAGER Cecilia Holmstrom
COPYWRITER Bjorn Engstrom
PHOTOGRAPHER Jesper Sundelin

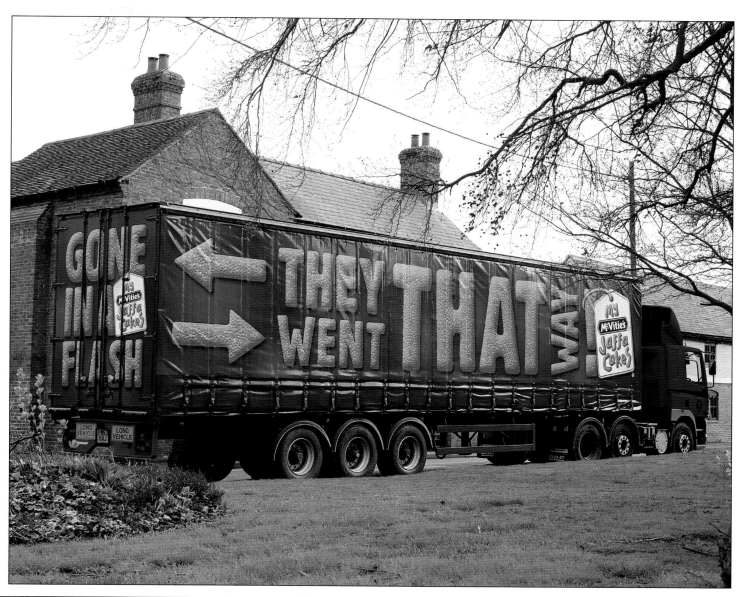

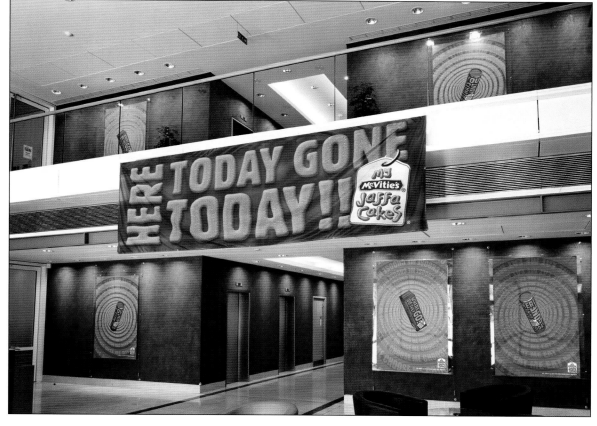

ENGLAND

SILVER WORLD MEDAL, CAMPAIGN
WILLIAMS MURRAY HAMM
LONDON

CLIENT Jaffa Cakes
CREATIVE DIRECTOR Garrick Hamm
DESIGNER Gareth Beeson
COPYWRITER Richard Murray
ACCOUNT DIRECTOR Panna Patel
ILLUSTRATOR Simon Critchley

GERMANY

FINALIST, SINGLE

LIGALUX

HAMBURG

CLIENT Fischer Appelt Kommunikation GmbH
CREATIVE DIRECTOR Petra Matouschek
WEIHNACHTSMAILING 2003 Ligalux GmbH

SWEDEN

FINALIST, SINGLE

REKLAMBYRÅN SWE

STOCKHOLM

CLIENT Anders Krisár
ART DIRECTOR Greger Ulf Nilson
PHOTOGRAPHER Anders Krisár

ENGLAND

FINALIST, SINGLE

MARK DENTON

LONDON

CLIENT Blink
DESIGNER Mark Denton
TYPOGRAPHER Andy Dymock

ENGLAND

FINALIST, CAMPAIGN

WILLIAMS MURRAY HAMM

LONDON

CLIENT Hill Station
CREATIVE DIRECTOR Garrick Hamm
DESIGNER Fiona Curran
ACCOUNT DIRECTOR Sarah Westwood
PHOTOGRAPHER Paul Williams

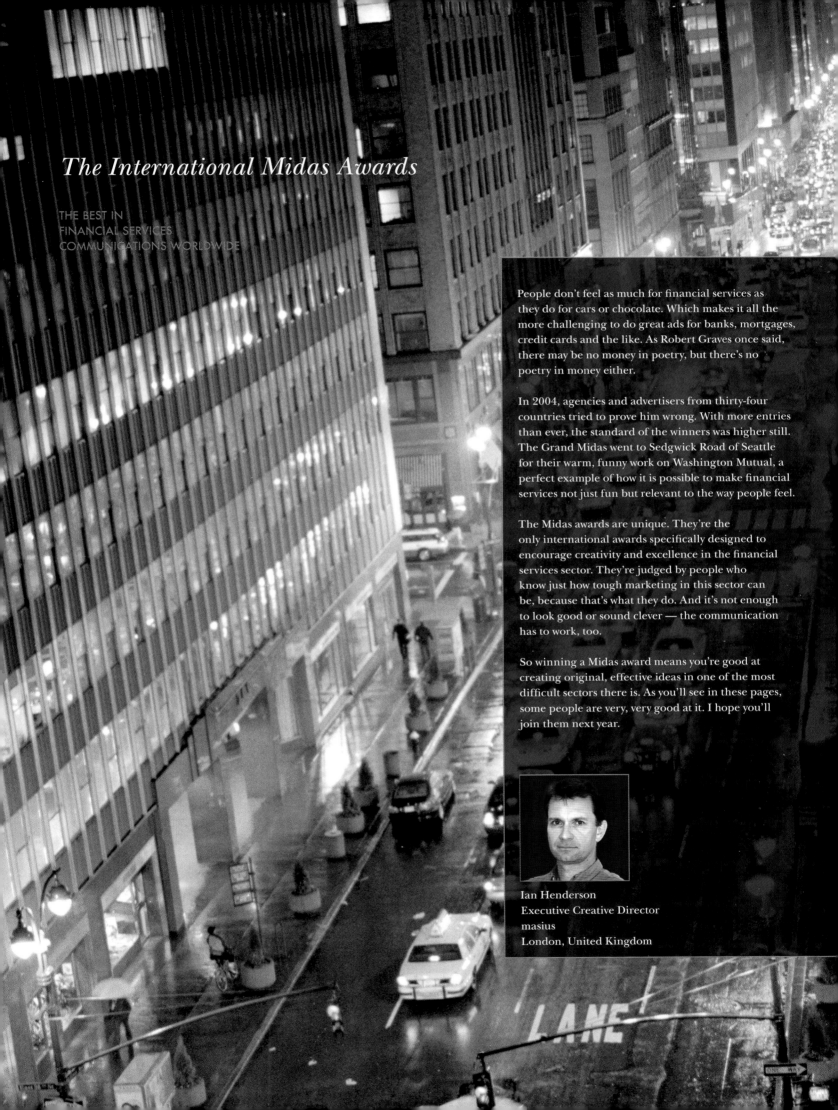

The International Midas Awards

THE BEST IN
FINANCIAL SERVICES
COMMUNICATIONS WORLDWIDE

People don't feel as much for financial services as they do for cars or chocolate. Which makes it all the more challenging to do great ads for banks, mortgages, credit cards and the like. As Robert Graves once said, there may be no money in poetry, but there's no poetry in money either.

In 2004, agencies and advertisers from thirty-four countries tried to prove him wrong. With more entries than ever, the standard of the winners was higher still. The Grand Midas went to Sedgwick Road of Seattle for their warm, funny work on Washington Mutual, a perfect example of how it is possible to make financial services not just fun but relevant to the way people feel.

The Midas awards are unique. They're the only international awards specifically designed to encourage creativity and excellence in the financial services sector. They're judged by people who know just how tough marketing in this sector can be, because that's what they do. And it's not enough to look good or sound clever — the communication has to work, too.

So winning a Midas award means you're good at creating original, effective ideas in one of the most difficult sectors there is. As you'll see in these pages, some people are very, very good at it. I hope you'll join them next year.

Ian Henderson
Executive Creative Director
masius
London, United Kingdom

MIDAS BOARD OF
DISTINGUISHED JUDGES AND ADVISORS

2004 MIDAS PRELIMINARY JUDGES

Izaskun Alonso Jauregui
AGORANET
BILBAO, VIZCAYA, SPAIN

Antonio Alvarez
BBDO MEXICO
MEXICO CITY, MEXICO

Paul Anderson
CITIGATE ALBERT FRANK
LONDON, ENGLAND

Sam Anderson
UNUMPROVIDENT
DORKING, ENGLAND

Anders Andersson
PRIVATE AFFAVER
STOCKHOLM, SWEDEN

Oscar Astier Yerecui
ARISTA INTERACTIVE
SAN SEBASTIEN, SPAIN

Michael Barche
KNSK WERBEAGENUR GMBH
HAMBURG, GERMANY

Susan Berris
McCANN ERICKSON
NEW YORK, USA

Jaime Brash Espinoza
BBDO MEXICO
MEXICO CITY, MEXICO

Mariano Peres Carrero
EONE/EURO RSCG
MADRID, SPAIN

Jose Luis Rosales Delgado
BBDO MEXICO
MEXICO CITY, MEXICO

Christoph Everke
VASATA/SCHROEDER GMBH
HAMBURG, GERMANY

Stefan Fischer
BRITISH AMERICAN TOBACCO
HAMBURG, GERMANY

Lars Grünberger
L. GRÜNBERGER MARKETING KB
SALTSJOBADEN, SWEDEN

Tilman Heitbriuh
BAHLSEN GMBH & CO. KG
HANNOVO, GERMANY

Ian Henderson
MASIUS
LONDON, ENGLAND

Candice Hodgson
BRADFORD & BINGLEY PLC
BINGLEY, ENGLAND

Johan Jager
OGILVY SWEDEN
STOCKHOLM, SWEDEN

Carl Jones
BBDO MEXICO
MEXICO CITY, MEXICO

Erik Lewenhaupt
OGILVY FINANCIAL COMMUNICATION
STOCKHOLM, SWEDEN

Wilfried Massa
LAUDESBANK BADEA-GAUTTEMBERG
STUTTGART, GERMANY

Mark McCall
FINANCIAL DYNAMICS
NEW YORK, USA

Maroulla Paul7
BLACK BOX
LONDON, ENGLAND

Eduard Pou I Vila
DOUBLEYOU
BARCELONA, SPAIN

Peter Powell
MASIUS
NEW YORK, USA

Stephan F. Rebbe
KOLLE REBBE
HAMBURG, GERMANY

Torun Reinhammar
NEWS AGENCY DIREKT
STOCKHOLM, SWEDEN

Pere Rosales
ELOGIA
BARCELONA, SPAIN

Hayes Roth
LANDOR
NEW YORK, USA

Carles Sanabre Vives

Magma3, SCCL
BARCELONA, SPAIN

Wolfgang Sasse
KNSK, BBDO ADVERTISING AGENCY GMBH
HAMBURG, GERMANY

Sylvia Schwartz
TIAA-CREF
NEW YORK, USA

Jorge Soldevila
BBDO MEXICO
MEXICO CITY, MEXICO

Matthew Waldman
REUTERS
NEW YORK, USA

Anne Westwood
CITIGATE ALBERT FRANK
LONDON, ENGLAND

GRAND MIDAS TROPHY

Products and
Services

USA

GRAND MIDAS CAMPAIGN
SEDGWICK RD.
SEATTLE, WA

CLIENT Washington Mutual
MEDIUM TV
CREATIVE DIRECTOR Steve Johnston
COPYWRITER Scott Stripling
ART DIRECTOR Jimmy Ashworth
AGENCY PRODUCER Margaret Overley
DIRECTOR Craig Gillespie
PRODUCER Brian Latt
PRODUCTION COMPANY MJZ
EDITOR David Brixton
EDITING COMPANY The Whitehouse
ACCOUNT EXECUTIVE Jennifer Exoo
POST PRODUCTION The Mill/London

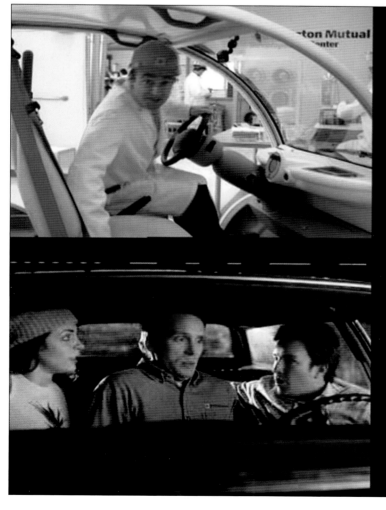
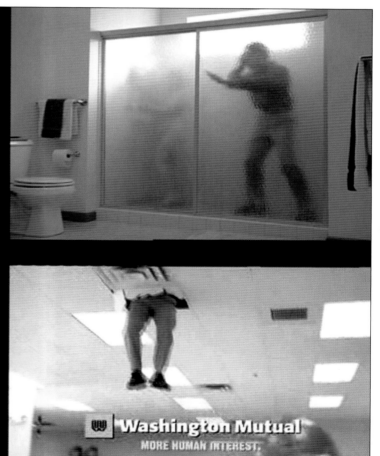

PRODUCTS & SERVICES

ACCOUNTING, AUDIT AND TAX SERVICE

ANNCR: How to quit your job the California way. Like dude with the tie. I like quit. The little girl way: I'm gonna quit, nah, nah, nah, nah, nah. The action hero way: I won't be back. The breakup way: Boss, I quit. I'm leaving you for another boss. The godfather way: (gunshot in the background). The godfather 2 way: (2 gunshots in the background). The no show way: Has anyone seen Jane? The pig latin way: I way ikquy irkjay. The Uncle Leo way: Hey Dan, pull my finger (fart sound). I quit (laughing). Now that you know how to quit your job we'll show you how to get a better one. Enroll in Jackson Hewitt's income tax school and in just 12 weeks you'll learn to prepare taxes like a pro, earn extra money, get a part time job, or start a new career. So enroll in the Jackson Hewitt tax school and give your boss 12 weeks notice.
Jackson Hewitt, preparing you to prepare taxes.

USA
GOLD MIDAS SINGLE
DEVITO/VERDI
NEW YORK, NY

CLIENT Jackson Hewitt Tax Service
MEDIUM Radio
CREATIVE DIRECTOR Sal DeVito
COPYWRITER John DeVito/Michael Danko
AGENCY PRODUCER Barbara Michelson
PRESIDENT Ellis Verdi
ACCOUNT EXECUTIVE Andrew Brief
VP OF MARKETING Jackson Hewitt/Peter Tahinos

USA
FINALIST SINGLE
COIL COUNTS FORD & CHENEY
CHICAGO, IL

CLIENT Grant Thornton
MEDIUM Radio
CD/COPYWRITER George Kase
PRODUCER Ron Coil

USA
FINALIST SINGLE
DEVITO/VERDI
NEW YORK, NY

CLIENT Jackson Hewitt Tax Service
MEDIUM Radio
CREATIVE DIRECTOR Sal DeVito
COPYWRITER Anthony Decarolis/Erik Fahrenkopf
AGENCY PRODUCER Barbara Michelson
PRESIDENT Ellis Verdi
ACCOUNT EXECUTIVE Andrew Brief
VP OF MARKETING Jackson Hewitt/Peter Tahinos

USA
FINALIST CAMPAIGN
DEVITO/VERDI
NEW YORK, NY

CLIENT Jackson Hewitt Tax Service
MEDIUM TV
CREATIVE DIRECTOR Sal DeVito
COPYWRITER John DeVito
ART DIRECTOR Michael Danko
AGENCY PRODUCER Barbara Michelson
PRESIDENT Ellis Verdi
ACCOUNT EXECUTIVE Andrew Brief
VP OF MARKETING Jackson Hewitt/Peter Tahinos

USA

GOLD MIDAS SINGLE
SEDGWICK RD.
SEATTLE, WA

CLIENT **Washington Mutual**
MEDIUM **TV**

USA	USA	CANADA
FINALIST SINGLE	FINALIST SINGLE	FINALIST SINGLE
BRANDON ADVERTISING	**BRANDON ADVERTISING**	**FCB TORONTO**
MYRTLE BEACH, SC	MYRTLE BEACH, SC	TORONTO, ONTARIO
CLIENT **Horry County State Bank**	CLIENT **Horry County State Bank**	CLIENT **TD Canada Trust**
MEDIUM **TV**	MEDIUM **TV**	MEDIUM **TV**
EVP/CREATIVE DIRECTOR **Tom Collins**	EVP/CREATIVE DIRECTOR **Tom Collins**	SENIOR ART DIRECTOR **Ed Lea**
COPYWRITER **Bruce Albaneese**	COPYWRITER **Bruce Albaneese**	SENIOR WRITER **Mary Secord**
ART DIRECTOR **Rick Bryant**	ART DIRECTOR **Rick Bryant**	BROADCAST PRODUCER **Pam Portsmouth**
PRODUCTION **Chuck Stokes/Stages**	PRODUCTION **Chuck Stokes/Stages**	EXECUTIVE V.P., CREATIVE DIRECTOR **Robin Heisey**
		ACCOUNT DIRECTOR **Andy Houghton**

CANADA
SILVER MIDAS SINGLE
FCB TORONTO
TORONTO, ONTARIO

CLIENT **TD Canada Trust**
MEDIUM **TV**
GROUP CREATIVE DIRECTOR **Rick Pregent**
SENIOR ART DIRECTOR **Ed Lea**
BROADCAST PRODUCER **Pam Portsmouth**
EXECUTIVE V.P., CREATIVE DIRECTOR **Robin Heisey**
ACCOUNT MANAGER **Shalini Kapur**

USA
FINALIST SINGLE
SEDGWICK RD.
SEATTLE, WA

CLIENT **Washington Mutual**
MEDIUM **TV**
CREATIVE DIRECTOR **Steve Johnston**
COPYWRITER **Scott Stripling**
ART DIRECTOR **Jimmy Ashworth**
AGENCY PRODUCER **Margaret Overley**
DIRECTOR **Craig Gillespie**
PRODUCER **Brian Latt**
PRODUCTION COMPANY **MJZ**
EDITOR **David Brixton**
EDITING COMPANY **The Whitehouse**
ACCOUNT EXECUTIVE **Jennifer Exoo**
POST PRODUCTION **The Bill/London**

GERMANY
FINALIST SINGLE
FIRST FRAME
FILM UND TV PRODUKTION GMBH
MÜNCHEN

CLIENT **Deutscher Sparkassen Verlag GmbH**
MEDIUM **TV**
EXECUTIVE PRODUCER **Sven von Niessen**
DIRECTOR **Kilian von Keyserlingk**
CAMERAMAN **Claus Bagger Sørensen**
MUSIC/SOUND DESIGN **FloriDan Studios**
ADVERTISING AGENCY **Jung von Matt, Alster**
EDITOR **Kilian von Keyserlingk**
AGENCY PRODUCER **Marc Ròta**
GAFFER **Marc Wassermann**

AUSTRIA
FINALIST SINGLE
OGILVY GROUP AUSTRIA
VIENNA

CLIENT **Raiffeisen Bausparkasse**
MEDIUM **TV**
CREATIVE DIRECTOR **Alexander Zelmanovics**
ART DIRECTOR **Mag. Dieter Pivrnec**
MANAGEMENT SUPERVISOR **Michael Kapfer-Giuliani**
MARKETING DIRECTOR **Mag. Martin Sardelic**
MARKETING **Geraldine Hübl**

USA
FINALIST SINGLE
RENEGADE MARKETING GROUP
NEW YORK, NY

CLIENT **HSBC**
MEDIUM **TV**
SVP/DIRECTOR OF GUERRILLA MARKETING **Trip Hunter**
SVP/CREATIVE DIRECTOR **Martin Bihl**
ACCOUNT SUPERVISOR **Kate Kaplan**
PROJECT MANAGER **Yuki Iwatani**
ART DIRECTOR **Allen Meyer**

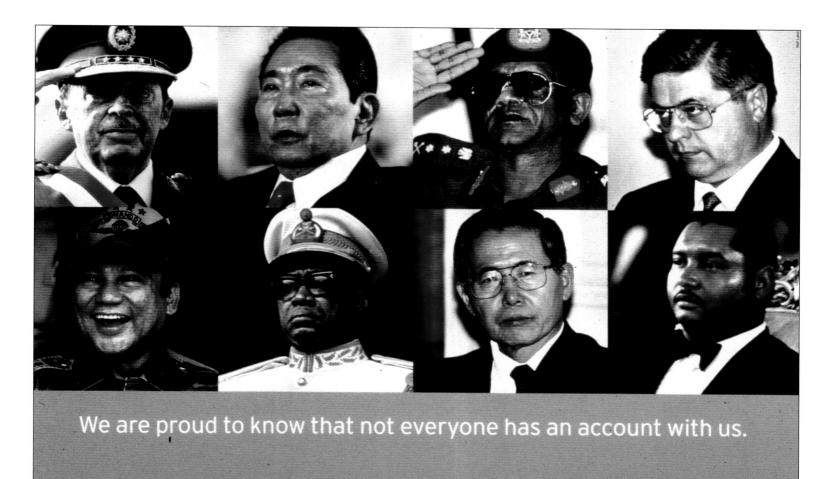

We are proud to know that not everyone has an account with us.

A bank also benefits from business it does not do. With this motto, Bank Coop has become completely uninteresting for a certain type of clientele. However, should you be interested in attractive bonus interest rates, fair mortgage offers or sustainable stock funds, you will be in good company with us. We look forward to almost every phone call: 0800 88 99 66. Or www.bankcoop.ch

 bank coop The clean Swiss bank.

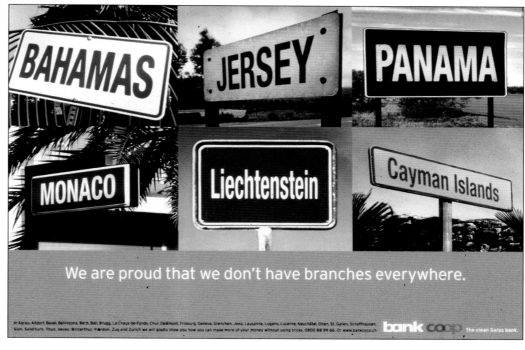

We are proud that we don't have branches everywhere.

In Aarau, Altdorf, Basel, Bellinzona, Bern, Biel, Brugg, La Chaux-de-Fonds, Chur, Delémont, Fribourg, Geneva, Grenchen, Jona, Lausanne, Lugano, Lucerne, Neuchâtel, Olten, St. Gallen, Schaffhausen, Sion, Solothurn, Thun, Vevey, Winterthur, Yverdon, Zug and Zurich we will gladly show you how you can make more of your money without using tricks. 0800 88 99 66. Or www.bankcoop.ch **bank coop** The clean Swiss bank.

SWITZERLAND

GOLD MIDAS CAMPAIGN
RUF LANZ WERBEAGENTUR AG
ZÜRICH

CLIENT Bank Coop
MEDIUM Newspaper
CREATIVE DIRECTOR Danielle Lanz/Markus Ruf
COPYWRITER Thomas Schoeb/Markus Ruf
ART DIRECTOR Danielle Lanz
ACCOUNT SUPERVISOR Marcus Gretener
ADVERTISER'S SUPERVISOR Christoph Loeb

Because home is the only place you should be rushing to at the end of the day.

7 days a week. | Early in the morning.
Late at night.
Even weekends. | It's just what you'd expect from Florida's Most Convenient Bank.

BankAtlantic

For locations and hours, call 1-888-7-DAY-BANK, or visit BankAtlantic.com

FDIC

Because lunch breaks were made for eating, not banking.

7 days a week. | Early in the morning.
Late at night.
Even weekends. | It's just what you'd expect from Florida's Most Convenient Bank.

BankAtlantic

For locations and hours, call 1-888-7-DAY-BANK, or visit BankAtlantic.com

FDIC

USA

SILVER MIDAS CAMPAIGN
ZIMMERMAN PARTNERS ADVERTISING
FT. LAUDERDALE, FL

CLIENT BankAtlantic
MEDIUM Newspaper
COPYWRITER Bree Housley
ART DIRECTOR Matt Davis
CREATIVE DIRECTOR Matt Davis

USA

FINALIST SINGLE
SEDGWICK RD.
SEATTLE, WA

CLIENT Washington Mutual
MEDIUM TV
CREATIVE DIRECTOR Steve Johnston
COPYWRITER Scott Stripling
ART DIRECTOR Jimmy Ashworth
AGENCY PRODUCER Margaret Overley
DIRECTOR Craig Gillespie
PRODUCER Brian Latt
PRODUCTION COMPANY MJZ
DAVID BRIXTON David Brixton
EDITING COMPANY The Whitehouse
ACCOUNT EXECUTIVE Jennifer Exoo
POST PRODUCTION The Mill/London

USA

FINALIST SINGLE
SEDGWICK RD.
SEATTLE, WA

CLIENT Washington Mutual
MEDIUM TV
CREATIVE DIRECTOR Steve Johnston
COPYWRITER Scott Stripling
ART DIRECTOR Jimmy Ashworth
AGENCY PRODUCER Margaret Overley
DIRECTOR Craig Gillespie
PRODUCER Brian Latt
PRODUCTION COMPANY MJZ
EDITOR David Brixton
EDITING COMPANY The Whitehouse
ACCOUNT EXECUTIVE Jennifer Exoo
POST PRODUCTION The Mill/London

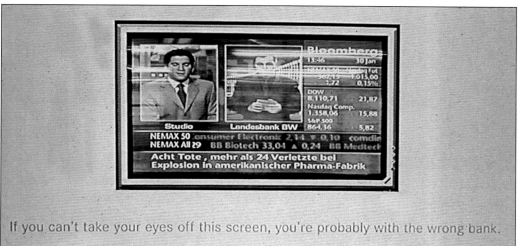

If you can't take your eyes off this screen, you're probably with the wrong bank.

SWITZERLAND

FINALIST CAMPAIGN
JUNG VON MATT/LIMMAT AG
ZURICH

CLIENT Julius Bär
MEDIUM Mixed-Media
CREATIVE DIRECTORS Alexander Jaggy/Urs Schrepfer
ART DIRECTOR Axel Eckstein
COPYWRITERS Alexander Jaggy/Markus Rottmann
ACCOUNT MANAGERS Rolf Helfenstein/Sacha Baer

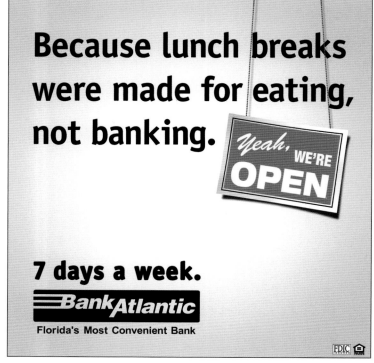

USA

FINALIST SINGLE
ZIMMERMAN PARTNERS ADVERTISING
FT. LAUDERDALE, FL

CLIENT BankAtlantic
MEDIUM Newspaper
COPYWRITER Bree Housley
ART DIRECTOR Matt Davis
CREATIVE DIRECTOR Matt Davis

Do you think of yourself as an average kind of woman? I don't

There's one private bank that realises you're unique. Instead of expecting you to adapt to inflexible solutions, we tailor our products and services to meet your very specific needs.

Kredietbank (Suisse) SA Geneva +41-22 311 63 22, Lugano +41-91 911 06 30, Basel +41-61 274 18 18

FOCUS ON THE INDIVIDUAL

SWITZERLAND
FINALIST CAMPAIGN
YOUNG & RUBICAM
BUSINESS COMMUNICATIONS
GENEVA

CLIENT **KBS Private Bank**
MEDIUM **Poster**
CREATIVE DIRECTOR **Bob Heron**
ART DIRECTOR **Karcsi Berczy**
GROUP ACCOUNT DIRECTOR **Tim Nettleton**
MANAGING DIRECTOR (CLIENT) **Ahmet Eren**

USA
FINALIST CAMPAIGN
HANNA & ASSOCIATES
SPOKANE, WA

CLIENT **Sterling Savings Bank**
MEDIUM **TV**
CREATIVE DIRECTOR/VP **John Baechler**
SRVP/MARKETING DIRECTOR **Terri Krohn**
ASSOCIATE CREATIVE DIRECTOR **Monte Mindt**

USA
FINALIST CAMPAIGN
BRAINS ON FIRE
GREENVILLE, SC

CLIENT **Carolina First**
MEDIUM **TV**
CREATIVE DIRECTOR **Scott Gould**
ART DIRECTOR **Robbin Phillips**
DIRECTOR **Steve Colby/Pogo Pictures**
PRODUCER **Lesley Harris/Pogo Pictures**
MUSIC **Hummingbird Productions**
ACCOUNT MANAGER **Marion Mann**

SWITZERLAND
FINALIST CAMPAIGN
RUF LANZ WERBEAGENTUR AG
ZÜRICH

CLIENT **Bank Coop**
MEDIUM **TV**
CREATIVE DIRECTOR **Danielle Lanz/Markus Ruf**
COPYWRITER **Thomas Schoeb**
ART DIRECTOR **Danielle Lanz**
PRODUCTION COMPANY **Condor Communications**
DIRECTOR **Martin A. Fueter**
AGENCY PRODUCER **Lilo Killer**
ACCOUNT SUPERVISOR **Marcus Gretener**
ADVERTISER'S SUPERVISOR **Christoph Loeb**

BELGIUM
FINALIST CAMPAIGN
VVL BBDO
BRUSSELS

CLIENT **KBC Banking & Insurance**
MEDIUM **TV**
COPYWRITER **Karel Dejonghe**
ART DIRECTOR **Jean-François Dooms**
DIRECTOR **Toon Aerts**
CREATIVE DIRECTOR **Jan Baert**
PRODUCER **Ruben Goots**
RTV PRODUCER **Myriam Maes**
ACCOUNT DIRECTOR **Karel Vinck**
ACCOUNT EXECUTIVE **Patrick Clymans**
COMMUNICATION MANAGER **Eddy Wouters**

BELGIUM
FINALIST CAMPAIGN
VVL BBDO
BRUSSELS

CLIENT **KBC Banking & Insurance**
MEDIUM **TV**
COPYWRITER **Koen Nuyts**
ART DIRECTOR **Tony Naudts**
DIRECTOR **Annemie Vandeputte**
CREATIVE DIRECTOR **Jan Baert**
RTV PRODUCER **Myriam Maes**
ACCOUNT DIRECTOR **Karel Vinck**
PRODUCER **Isabelle Henrickx**
ACCOUNT EXECUTIVE **Patrick Clymans**
COMMUNICATION MANAGER **Paul Daels**

avoid unnecessary exposure

The naked truth behind private equity deals is rarely a pretty sight. Of the 85% of acquisitions that fail, most were doomed from the start. With market, management, customer and competitive analysis, we'll make sure you don't get caught with your pants down. For more information call Kit Lisle at 703.860.3355 or email kit@acclaropartners.com

acclaro
do diligence

CORPORATE IMAGE

If it costs an arm and a leg, don't buy two.

citi
Live richly.

citi.com

HANGOVER INTERNATIONAL
HOTEL & CLUB
GLOSSOP

TEL 08457 465 123
WWW.HANGOVER-INTERNATIONAL.COM
GLOSSOP RESORT

XMAS FUNCTION ROOM BOOKING ON 20/12/02
BY CROSSLEY LOMAS LTD

BUFFET DELUXE	0000873627	£2,995.00
FOSTERS X4	0000367482	£8.60
STELLA ATR X6	0000475834	£14.40
G&T X2	0000374851	£6.20
JACOB CRK X1	0000284582	£12.00
CARLING X8	0000583721	£16.80
DIET COKE X1	0000784272	£0.90
VK STRW X2	0000849242	£5.00
SMIRNOFF ICE X4	0000757658	£10.00
DRY MARTINI X1	0000658727	£2.30
JOHN/SMIT X4	0000976983	£8.40
FOSTERS X4	0000367482	£8.60
STELLA ATR X6	0000475834	£14.40
PURE ORANGE X1	0000857371	£1.00
WDK IRON/B X4	0000457672	£10.00
BUD/W BOT X8	0000681364	£20.80
BECKS BOT X2	0000173765	£10.00
RED STRP X6	0000375721	£15.00
G & T X2	0000374851	£6.20
RED 1992	0000237381	£19.99
FOSTERS X4	0000367482	£8.60
CARLING X8	0000583721	£16.80
SMIRNOFF ICE X6	0000757658	£15.00
BIG D PEANUT X1	0000736521	£0.50
PORK SCRATCH X1	0000374618	£0.60
RED STRP X6	0000375721	£15.00
DIET COKE X1	0000784272	£0.90
JOHN/SMIT X4	0000976983	£8.40
WDK BLUE X8	0000457672	£20.00
FOSTERS X4	0000367482	£8.60
STELLA ATR X6	0000475834	£14.40
DRY MARTINI X1	0000658727	£2.30
VK LIME X2	0000849242	£5.00
PURE ORANGE X1	0000857371	£1.00
G & T X2	0000374851	£6.20
BUD/W BOT X8	0000681364	£20.80
JACOB CRK X1	0000284582	£12.00
JOHN/SMIT X4	0000976983	£8.40
BIG D PEANUT X1	0000736521	£0.50
SCAMPI FR X1	0000987362	£0.50
SEA/BR PRWN X2	0000783620	£1.10
FOSTERS X4	0000367482	£8.60
RED 1992	0000237381	£19.99
VK LIME X2	0000849242	£5.00
STELLA ATR X6	0000475834	£14.40
FOSTERS X4	0000367482	£8.60
FOSTERS X4	0000367482	£8.60
BECKS BOT X2	0000173765	£10.00
DIET COKE X1	0000784272	£0.90
CARLING X8	0000583721	£16.80
CARLING X8	0000583721	£16.80
SMIRNOFF ICE X4	0000757658	£10.00
JOHN/SMIT X4	0000976983	£8.40
RED STRP X6	0000375721	£15.00
DRY MARTINI X1	0000658727	£2.30
STELLA ATR X6	0000475834	£14.40
JACOB CRK X2	0000284582	£24.00
BUD/W BOT X8	0000681364	£20.80
FOSTERS X4	0000367482	£8.60
STELLA ATR X6	0000475834	£14.40
PURE ORANGE X1	0000857371	£1.00
G&T X2	0000374851	£6.20
JACOB CRK X1	0000284582	£12.00
CARLING X8	0000583721	£16.80
VK STRW X2	0000849242	£5.00
SMIRNOFF ICE X4	0000757658	£10.00
JOHN/SMIT X4	0000976983	£8.40
VODKA CHASER X8	0000578382	£19.60
VODKA CHASER X6	0000578382	£14.70
VODKA CHASER X6	0000578382	£14.70
VODKA CHASER X6	0000578382	£14.70
WHISKEY SHOT X2	0000683672	£6.40
WHISKEY SHOT X2	0000683672	£6.40
VODKA CHASER X6	0000578382	£14.70
VODKA CHASER X6	0000578382	£14.70
TEQUILA SLAM X9	0000673655	£21.60
TEQUILA SLAM X9	0000673655	£21.60
VODKA CHASER X8	0000578382	£19.60
SEX ON BEACH X2	0000788474	£10.40
ORGASM X2	0000784625	£10.80
ORGASM X2	0000784625	£10.80
HARVEYW/BANG X2	0000768734	£10.40
RUSSIAN MULE X2	0000674622	£10.80
BLK RUSSIAN X2	0000784737	£10.40
BLOODY MARY X2	0000784771	£10.80
SCREWDRIVER X2	0000768374	£10.40
SCREWDRIVER X2	0000768374	£10.40
LONG ISLAND X2	0000238573	£10.60
TEQUILA SHOT X9	0000673655	£21.60
DOUBLE ROOM X1	0000787473	£80.00
DOUBLE ROOM X1	0000787473	£80.00
DOUBLE ROOM X1	0000787473	£80.00
DOUBLE ROOM X1	0000787473	£80.00
DOUBLE ROOM X1	0000787473	£80.00
PHONE CHARGE		
NO. 0800 696969		£32.35
DOUBLE ROOM X1	0000787473	£80.00
DOUBLE ROOM X1	0000787473	£80.00
DOUBLE ROOM X1	0000787473	£80.00
TV SAT CHG		
CHANNEL XXX99	0000874637	£6.00
DOUBLE ROOM X1	0000787473	£80.00
DOUBLE ROOM X1	0000787473	£80.00
DOUBLE ROOM X1	0000787473	£80.00
PHONE CHARGE		
0800 'BARBARA'	0000874637	£8.95
DOUBLE ROOM X1	0000787473	£80.00
DOUBLE ROOM X1	0000787473	£80.00
DELX DOUBLE X1	0000885723	£100.00
DELX DOUBLE X1	0000885723	£100.00
ROOM SERVICE		
BOLLINGER	0000677845	£60.00
DOUBLE ROOM X1	0000787473	£80.00
DOUBLE ROOM X1	0000787473	£80.00
ROOM SERVICE		
STRAWBERRIES/CRM	0000067436	£6.50
DOUBLE ROOM X1	0000787473	£80.00
DOUBLE ROOM X1	0000787473	£80.00
DELX DOUBLE X1	0000885723	£100.00

21/12/02

FULL ENGLISH X40	0000573684	£278.00
	TOTAL	£5,993.63
	CARD	£5,993.63

VISA
ACCOUNT NO. 4793-01/03
AUTHORISATION NO. 987952

THANK YOU FOR YOUR CUSTOM, LOOK
FORWARD TO SEEING YOU AGAIN
NEXT DECEMBER

5 012701 112311

Text on invitation (img_2):

YOU ARE HEREBY INVITED TO THE CROSSLEY
LOMAS CHARTERED ACCOUNTANTS CHRISTMAS
PARTY AT THE OLD GLOVE WORKS, GEORGE ST,
GLOSSOP ON:

20TH DECEMBER 2003

PROOF OF THE SUCCESS OF LAST YEARS
EVENT IS ATTACHED. LOOK FORWARD TO
SEEING YOU THERE.

RSVP
joanne_lomas@hotmail.com
OR PHONE 07831 440560

THE FUN STARTS AT 8PM

GOLD MIDAS SINGLE
LIKE A RIVER
MANCHESTER

CLIENT Crossley & Lomas Chartered Accountants
MEDIUM Direct Mail
CREATIVE DIRECTORS Rob Taylor/Peter Rogers
ART DIRECTOR Philip Pitcher
WRITER Philip Pitcher

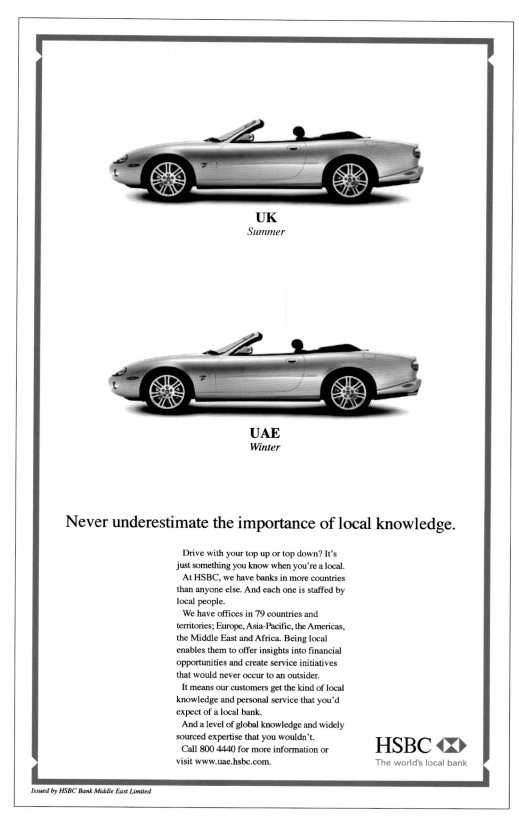

UK
Summer

UAE
Winter

Never underestimate the importance of local knowledge.

Drive with your top up or top down? It's just something you know when you're a local.

At HSBC, we have banks in more countries than anyone else. And each one is staffed by local people.

We have offices in 79 countries and territories; Europe, Asia-Pacific, the Americas, the Middle East and Africa. Being local enables them to offer insights into financial opportunities and create service initiatives that would never occur to an outsider.

It means our customers get the kind of local knowledge and personal service that you'd expect of a local bank.

And a level of global knowledge and widely sourced expertise that you wouldn't.

Call 800 4440 for more information or visit www.uae.hsbc.com.

HSBC ⟨X⟩
The world's local bank

Issued by HSBC Bank Middle East Limited

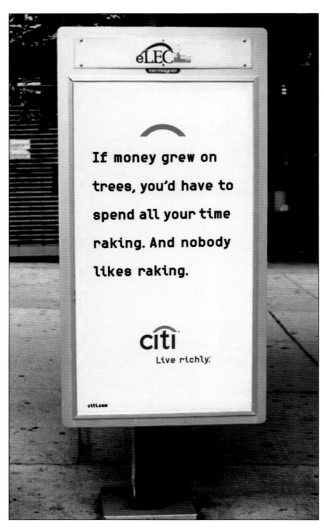

USA

FINALIST CAMPAIGN

CITIGROUP, INC.
MINNEAPOLIS, MN

CLIENT Citibank
MEDIUM Billboard
CREATIVE DIRECTOR David Lubars
GROUP CREATIVE DIRECTOR John Matejczyk/Steve Driggs
ART DIRECTOR Steve Driggs
COPYWRITER Mike Smith/Colin Corcoran

AUSTRIA

FINALIST CAMPAIGN

FOR SALE VIENNA
VIENNA

CLIENT Österreichische Bundesbahnen
(Austrian Railways)
MEDIUM Newspaper

USA

FINALIST CAMPAIGN

CITIGROUP, INC.
MINNEAPOLIS, MN

CLIENT Citibank
MEDIUM Mixed-Media
CREATIVE DIRECTOR David Lubars
GROUP CREATIVE DIRECTOR John Matejczyk/Steve Driggs
ART DIRECTOR Steve Driggs
COPYWRITER John Matejczyk/Mike Smith/Colin Corcoran
ART DIRECTOR Chris Toland
PRODUCTION COMPANY @radical media
DIRECTOR Errol Morris

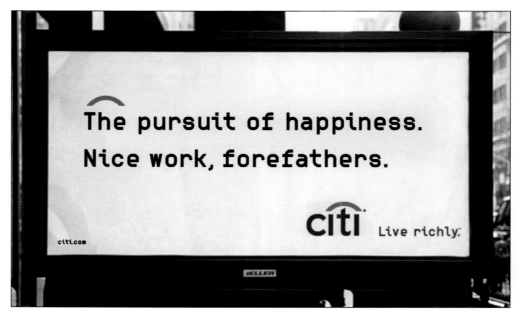

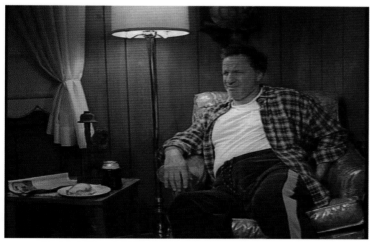

USA

GOLD MIDAS SINGLE
CITIGROUP, INC.
MINNEAPOLIS, MN

CLIENT Citibank Card
MEDIUM TV
CREATIVE DIRECTOR David Lubars
COPYWRITER Ryan Peck
ART DIRECTOR Steve Driggs/Steve Sage
GROUP CREATIVE DIRECTOR John Matejczyk/Steve Driggs
AGENCY PRODUCER Rob van de Weteringe Buys
DIRECTOR Kevin Thomas
PRODUCTION COMPANY Thomas Thomas Films
EDITOR Andre Betz

USA

FINALIST SINGLE
BBDO NEW YORK
NEW YORK, NY

CLIENT Visa
MEDIUM TV
CHEIF CREATIVE DIRECTOR Ted Sann
SR. EXEC. CREATIVE DIRECTOR Jimmy Siegel
CREATIVE DIRECTOR Cheryl Van Ooyen
AGENCY PRODUCER John Lacey
SR. CREATIVE DIRECTOR Jimmy Siegel
BBDO MUSIC PRODUCER Rani Vaz
PRODUCTION COMPNAY Backyard
DIRECTOR Rob Pritts
MUSIC HOUSE Tone Farmer
COMPOSER/LYRICIST Ray Loewy
EDITING HOUSE Mad River Post
EDITOR Jason MacDonald

USA

FINALIST SINGLE
BBDO NEW YORK
NEW YORK, NY

CLIENT Visa
MEDIUM TV
CHEIF CREATIVE OFFICER Ted Sann
SR. EXEC. CREATIVE DIRECTOR Jimmy Siegel
ASSOC. CREATIVE DIR. Brian McDermott/Ron Palumbo
AGENCY PRODUCER Peter Feldman
PRODUCTION COMPANY HKM
ART DIRECTOR Steven Block/Ron Palumbo

NORWAY

SILVER MIDAS SINGLE

McCANN DIREKTE MRM PARTNERS
OSLO

CLIENT Eurocard Gold

MEDIUM Direct Mail

CREATIVE DIRECTOR AND
COPYWRITER Erik Ingvoldstad

ART DIRECTOR
Charlotte Havstad

ACCOUNT MANAGER
Tone Bøygard

ACCOUNT DIRECTOR
Jorunn Aarskog

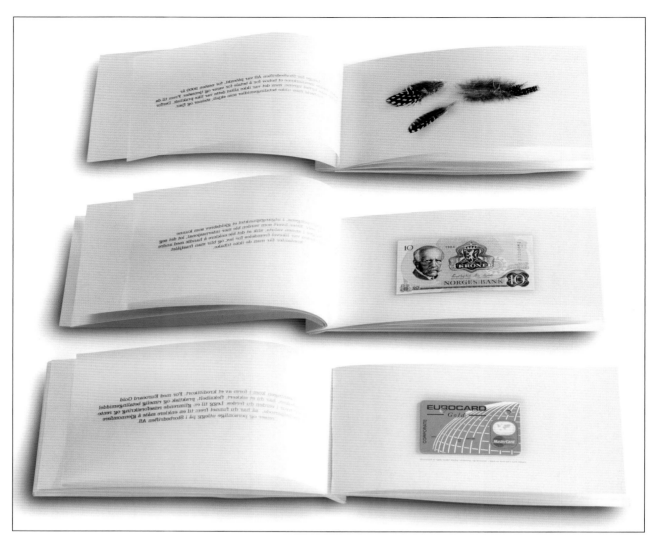

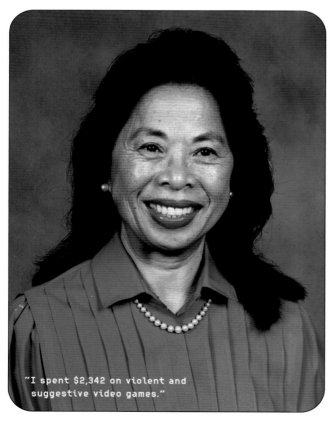

"I spent $2,342 on violent and suggestive video games."

USA

FINALIST SINGLE

CITIGROUP, INC.
MINNEAPOLIS, MN

CLIENT Citibank Identity Theft

MEDIUM Magazine

CREATIVE DIRECTOR David Lubars

GROUP CREATIVE DIRECTOR John Matejczyk/Steve Driggs

ART DIRECTOR Steve Sage

COPYWRITER John Matejczyk

PHOTOGRAPHER Stephanie Rau

swim class:

hockey camp:

being able to let go: priceless

MasterCard

mastercard.com

gas:

monday morning quarterbacks:

MasterCard

mastercard.com

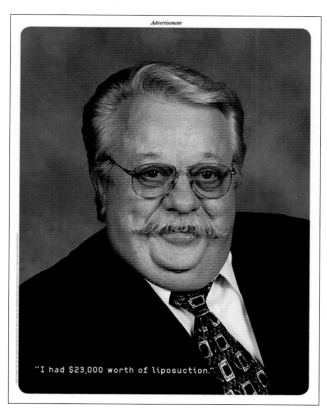

"I had $23,000 worth of liposuction."

USA
FINALIST CAMPAIGN
CITIGROUP, INC.
MINNEAPOLIS, MN

CLIENT Citibank Identity Theft
MEDIUM Mixed-Media
CREATIVE DIRECTOR David Lubars
GROUP CREATIVE DIRECTOR John Matejczyk/Steve Driggs
COPYWRITER Ryan Peck/John Matejczyk
ART DIRECTOR Steve Sage/Steve Driggs
AGENCY PRODUCER Rob van de Weteringe Buys
PRODUCTION COMPANY Thomas Thomas Films
DIRECTOR Kevin Thomas
PHOTOGRAPHER Stephanie Rau

Remember, today's must-haves often become tomorrow's what-was-I-thinkings.

A credit card is a powerful tool. By all means have fun, just don't go overboard. usecreditwisely.com is one of the many resources Citi offers to help you know the rules, be informed, and spend wisely.

1-888-CITICARD
citicards.com

citi
Live richly.

USA
FINALIST CAMPAIGN
CITIGROUP, INC.
MINNEAPOLIS, MN

CLIENT Citibank
MEDIUM Mixed-Media
CREATIVE DIRECTOR David Lubars
GROUP CREATIVE DIRECTOR Harvey Marco
COPYWRITER Dean Buckhorn
ART DIRECTOR Harvey Marco/Steve Driggs
COPYWRITER Scott Cooney/Greg Hahn
DIRECTOR Craig Gillespie
PRODUCTION COMPANY MJZ
AGENCY PRODUCER Rob van de Weteringe Buys

USA
FINALIST CAMPAIGN
CITIGROUP, INC.
MINNEAPOLIS, MN

CLIENT Citibank Card
MEDIUM TV
CREATIVE DIRECTOR David Lubars
COPYWRITER Ryan Peck
ART DIRECTOR Steve Driggs/Steve Sage
GROUP CREATIVE DIRECTOR John Matejczyk/Steve Driggs
AGENCY PRODUCER Rob van de Weteringe Buys
DIRECTOR Kevin Thomas
PRODUCTION COMPANY Thomas Thomas Films
EDITOR Andre Betz

ARGENTINA
FINALIST SINGLE
MCCANN-ERICKSON ARGENTINA
BUENOS AIRES

CLIENT Mastercard
MEDIUM TV
CREATIVE DIRECTOR Martín Mercado/Fabián Maison
PRODUCTION COMPANY Huinca Cine
DIRECTOR Charlie Mainardi
CLIENT Gonzalo Carriquiri/Fernanda Lloret
MUSIC HOUSE Raya

USA
FINALIST SINGLE
CITIGROUP, INC.
MINNEAPOLIS, MN

CLIENT Citibank Card
MEDIUM TV
CREATIVE DIRECTOR David Lubars
COPYWRITER Ryan Peck
ART DIRECTOR Steve Driggs/Steve Sage
GROUP CREATIVE DIRECTOR John Matejczyk/ Steve Driggs
AGENCY PRODUCER Rob van de Weteringe Buys
DIRECTOR Kevin Thomas
PRODUCTION COMPANY Thomas Thomas Films
EDITOR Andre Betz

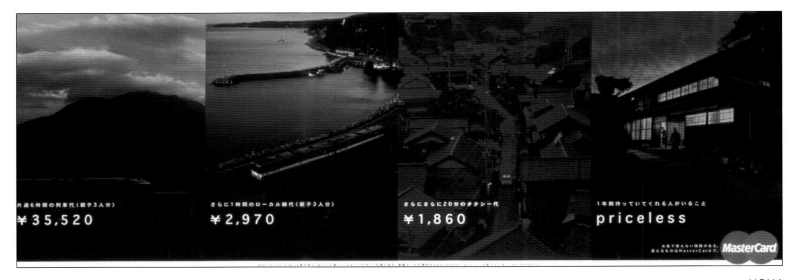

JAPAN

FINALIST CAMPAIGN
McCANN-ERICKSON
TOKYO

CLIENT MasterCard
MEDIUM Poster
CREATIVE DIRECTOR Kazuya Mototani
ART DIRECTOR Keiichiro Fukushima/
Masayuki Yokokawa
COPYWRITER Hiroshi Kagawa

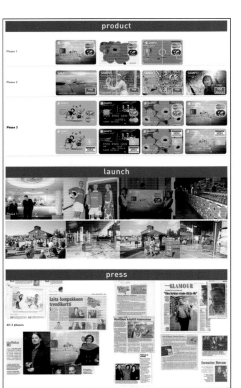

FINLAND

FINALIST CAMPAIGN
McCANN HELSINKI
HELSINKI

CLIENT Sampo
MEDIUM Mixed-Media
MANAGING DIRECTOR Mikko Leisti
ACCOUNT DIRECTOR Esa-Pekka Nykänen
PROJECT MANAGER Mari Suomalainen
ART DIRECTOR Soile Lemettinen
GRAPHIC DESIGNER Jussi Moilanen
HEAD OF GROUP MARKETING AND CRM Pekka Törmälä
DIRECTOR Minna Suo

FINANCIAL EXCHANGE

ENGLAND

FINALIST SINGLE
WFCA INTEGRATED
TUNBRIDGE WELLS, KENT

CLIENT Western Union
MEDIUM Magazine
CREATIVE DIRECTOR Greg Phitidis
COPYWRITER Greg Phitidis
ART DIRECTOR Darby Roberts

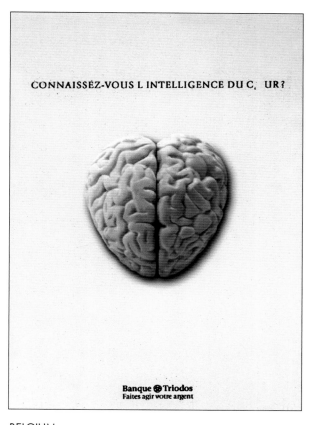

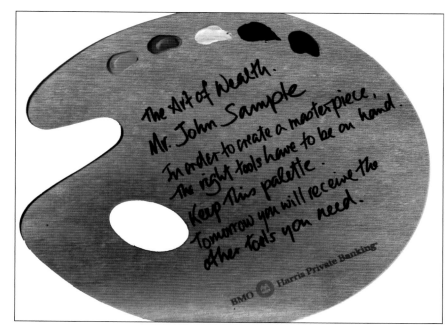

BELGIUM

FINALIST SINGLE
QUATTRO SAATCHI & SAATCHI
BRUSSELS

CLIENT Triodos Bank
MEDIUM Newsletter
CREATIVE DIRECTOR Jan Cordemans
ART DIRECTOR Geert Joostens
COPY WRITER Dirk Rodriguez
ACCOUNT DIRECTOR Toon de Baere

CANADA

FINALIST SINGLE
AMW DIRECT AND INTERACTIVE
TORONTO, ONTARIO

CLIENT BMO Harris Private Banking
MEDIUM Direct Mail
VICE PRESIDENT Marlene St. Jean
WRITER Tim Elmy
CREATIVE DIRECTOR Andrew Sookrah
BMO Harris Private Banking Eva Innes

FINANCIAL SOFTWARE

USA

FINALIST SINGLE
REUTERS
NEW YORK, NY

CLIENT Reuters
MEDIUM Corporate Identity
CREATIVE DIRECTOR Matthew Waldman
SVP GLOBAL MARKETING Azhar Rafee
ART DIRECTOR Joel Williamson/Darren Newton/
Ka Pang/Jenya Spektor

INVESTMENT ADVISORS

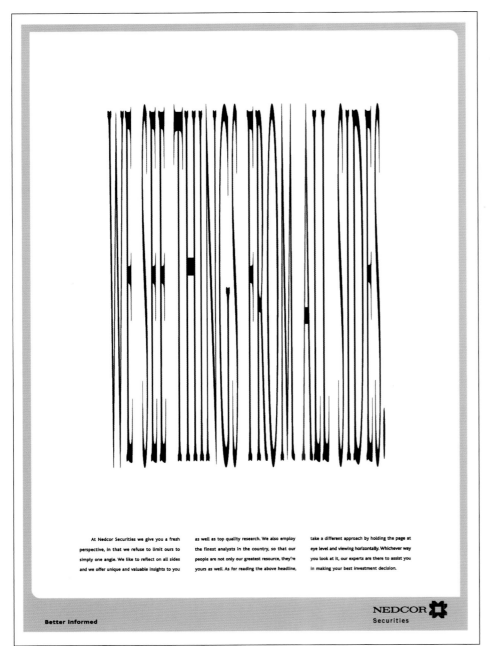

INSURANCE

AUSTRIA
SILVER MIDAS SINGLE
FCB KOBZA ADVERTISING AGENCY
VIENNA
CLIENT Allianz
MEDIUM Promotions Marketing
CREATIVE DIRECTOR Bernd Fliesser
COPYWRITER Patrik Partl/Gerald Lauffer
ILLUSTRATOR Birgit Grabner
ART DIRECTOR Goran Golik

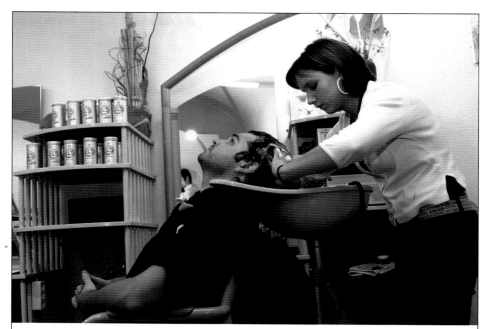

5 Jahre früher zurücklehnen.
Mit der Allianz Frühpension.

Weil ich noch viel vorhab. >>

Allianz ⑪
Versicherung Vorsorge Vermögen

SINGAPORE
FINALIST SINGLE
PRECIOUS
SINGAPORE
CLIENT Prudential Assurance Malaysia Berhad
MEDIUM TV
CREATIVE DIRECTOR Nick Gordon
COPYWRITER Nick Gordon
ART DIRECTOR Kirsten Ackland
DIRECTOR Farouk Aljoffery
PRODUCER Planet Films Perin Petrus
EDITOR Liquid Terrence Emmanuel
COMPOSER 2am Anton Morgan
CLIENT Lee Kay Loon/Radziah Ismail

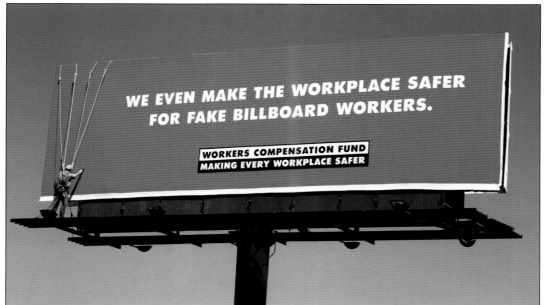

USA

FINALIST SINGLE
RICHTER7
SALT LAKE CITY, UT

CLIENT Workers Compensation Fund
MEDIUM Billboard
ART DIRECTOR Ryan Anderson
COPYWRITER/CREATIVE DIRECTOR Gary Sume
EXECUTIVE CREATIVE DIRECTOR Dave Newbold
PRODUCTION MANAGER Mary Ann Giles
ACCOUNT MANAGER Caryn Waterman
ACCOUNT SUPERVISOR Tal Harry

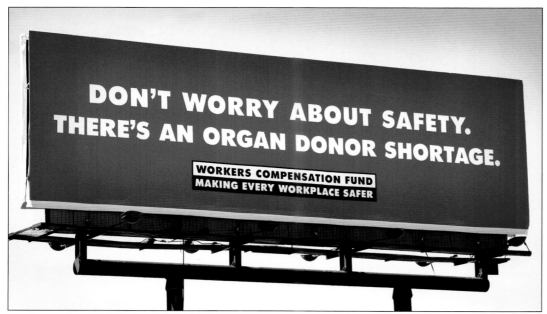

USA

FINALIST SINGLE
RICHTER7
SALT LAKE CITY, UT

CLIENT Workers Compensation Fund
MEDIUM Billboard
ART DIRECTOR Ryan Anderson
COPYWRITER/CREATIVE DIRECTOR Gary Sume
EXECUTIVE CREATIVE DIRECTOR Dave Newbold
PRODUCTION MANAGER Mary Ann Giles
ACCOUNT MANAGER Caryn Waterman
ACCOUNT SUPERVISOR Tal Harry

USA

FINALIST SINGLE
SAS
CARY, NC

CLIENT SAS
MEDIUM CD-ROM
PRODUCER Jim Simmons
ART DIRECTOR Jeanne Salas
TITLE ENGINEER Johnathan Eshleman
AUDIO DESIGN Jesse Olley

ISRAEL

FINALIST SINGLE

SHALMOR AVNON AMICHAY/Y&R

TEL AVIV

CLIENT Direct Insurance

MEDIUM TV

CREATIVE DIRECTOR Gideon Amichay/Yoram Levi

COPYWRITER Erez May-Tal

ART DIRECTOR Gal Zakay

PRODUCTION COMPANY Ishay Hadas Production

PRODUCER Ishay Hadas

DIRECTOR Rani Carmeli

AGENCY PRODUCER Shira Robas

PHOTOGRAPHER Avi Karpick

POST PRODUCTION Broadcast

ISRAEL

GOLD MIDAS CAMPAIGN

SHALMOR AVNON AMICHAY/Y&R

TEL AVIV

CLIENT Direct Insurance

MEDIUM TV

CREATIVE DIRECTOR Gideon Amichay/Yoram Levi

COPYWRITER Erez May-Tal

ART DIRECTOR Gal Zakay

PRODUCTION COMPANY Gefen Production

PRODUCER Eyal Gefen/Amir Melamed

DIRECTOR Shahar Segal

AGENCY PRODUCER Shira Robas/Lilach Gur Arieye

PHOTOGRAPHER Mano Kadosh

POST PRODUCTION JCS

If you're still scratching your head after talking to us, it's dandruff.

Safeco Insurance
Uncomplicate.™

If we had our way,
fine print would be this big.

Safeco Insurance
Uncomplicate.™

USA

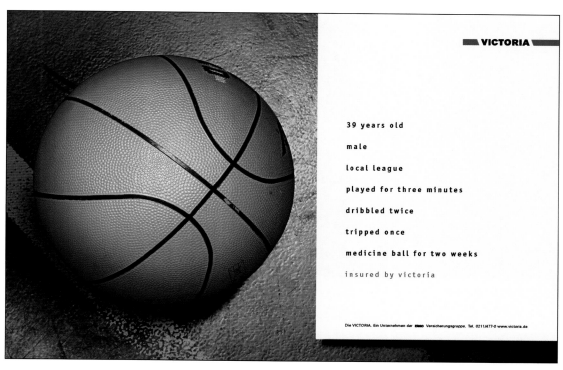

39 years old

male

local league

played for three minutes

dribbled twice

tripped once

medicine ball for two weeks

insured by victoria

Die VICTORIA. Ein Unternehmen der ERGO Versicherungsgruppe. Tel. 0211/477-0 www.victoria.de

GERMANY
FINALIST CAMPAIGN
EILER & RIEMEL GMBH
MUNICH

CLIENT Victoria Versicherungen
MEDIUM Magazine
CREATIVE DIRECTOR Robert Schenk
COPYWRITER Eva Goede
ART DIRECTOR Michael Matzke
ACCOUNT EXECUTIVE Katharina Wiehrdt
CUSTOMER CONSULTANT Hanna Stadler
DTP Bernd Esser
DTP Inske Remmert
MARKETING DIRECTOR Hans Fabry
MARKETING SPECIALIST Ulrike Jochum

GERMANY
FINALIST CAMPAIGN
ELEPHANT SEVEN GMBH
HAMBURG

CLIENT Allianz Versicherungs-AG
MEDIUM Web Ad
CREATIVE DIRECTOR Oliver Viets/Paul Apostolou
HEAD OF MARKETING COMMUNICATIONS Jens R. Erichsen
HEAD OF E-MARKETING Michael Lerz
ACCOUNT DIRECTOR Matthias Muehlenhoff
PROJECT MANAGER Matthias Wagener
ART DIRECTOR Sven Giese/Kai Becker

USA
FINALIST CAMPAIGN
THE KAPLAN THALER GROUP
NEW YORK, NY

CLIENT AFLAC
MEDIUM TV
EXECUTIVE CREATIVE DIRECTOR Linda Kaplan Thaler
CREATIVE DIRECTOR/ART DIRECTOR Eric David
CREATIVE DIRECTOR/COPYWRITER Tom Amico
ACCOUNT DIRECTOR David Findel

GERMANY

FINALIST CAMPAIGN
McCANN-ERICKSON FRANKFURT
FRANKFURT

CLIENT Winterthur Insurance
MEDIUM Newspaper
CREATIVE DIRECTOR Erich Reuter
SENIOR ART DIRECTOR Nadine Mueller
SENIOR COPYWRITER Gabriela Rossbach
MANAGEMENT SUPERVISOR Anja Dietze
ASSISTANT VICE PRESIDENT Corinne Manser
PHOTOGRAPHER Jo Magrean

USA

FINALIST CAMPAIGN
PUBLICIS IN THE WEST
SEATTLE, WA

CLIENT Safeco Insurance
MEDIUM Magazine
PRESIDENT EXEC. CREATIVE DIRECTOR Bob Moore
JUNIOR ART DIRECTOR Ying Wu
JUNIOR COPYWRITER Jean Wiseman
SENIOR ACCOUNT EXECUTIVE Amy Masterson
PRODUCTION SUPERVISOR Pete Anderson

LENDING

AUSTRIA

FINALIST CAMPAIGN
CCP HEYE WERBEAGENTUR GMBH
VIENNA

CLIENT Kommunalkredit
MEDIUM Magazine
CREATIVE DIRECTOR Gerhard Plakolm/Michael Huber
ART DIRECTOR Alena Kalteis

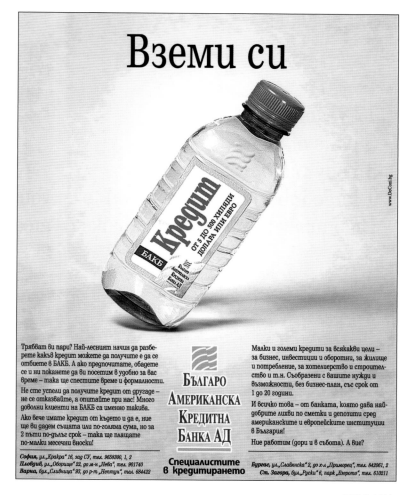

17 years old.
5 pairs of jeans.
3 body piercings.
1 large inheritance to pass on to your son.
Unfortunately, right now he thinks 'great assets' mean a D cup.

You've inherited some money. And you'd like to leave it to your teenage son. The problem is, if he were to inherit it now, he'd be more likely to invest in his wardrobe than in his future. By placing it in a family trust, your inheritance could be invested and your son could gain an income from its earnings at an age you deem appropriate. At Public Trust, we've got over 130 years of trust experience. As a result, our specialist team of lawyers, accountants and advisors can offer tailor made solutions to any family situation, no matter how complicated it may be. We provide ongoing specialist services to help manage and protect your assets and wealth, whatever the future brings. And don't worry, if a family trust isn't right for your situation, we'll let you know if there's a better option. For more information and your free copy of our Family Trust Guide, call us on 0800 505 405 or visit www.publictrust.co.nz. One of our family trust specialists will then call you to answer any further questions you may have. Because when it comes to your family's future, a family trust from Public Trust can help ensure you make the most of your assets, big or small.

 YOUR WORD IS LAW **public**TRUST

FOR MORE INFORMATION ON FAMILY TRUSTS CALL 0800 505 405

1 failed marriage.
2 fantastic kids.
1 amazing new husband.
1 little devil of a stepson.
If you die, make sure your hard earned assets don't go to hell.

You've worked hard to look after your kids. And although there's a fantastic new man in your life, they're still your number one priority. Unfortunately, if something happens to you, everything you've put aside for your children's future may have to be shared with their hellraiser of a stepbrother. If you have a family trust, you can help ensure that your wealth will support your children (and only your children) in the future. At Public Trust, we've got over 130 years of trust experience. As a result, our specialist team of lawyers, accountants and advisors can offer tailor made solutions to any family situation, no matter how complicated it may be. We provide ongoing specialist services to help manage and protect your assets and wealth, whatever the future brings. And don't worry, if a family trust isn't right for your situation, we'll let you know if there's a better option. For more information and your free copy of our Family Trust Guide, call us on 0800 505 405 or visit www.publictrust.co.nz. One of our family trust specialists will then call you to answer any further questions you may have. Because when it comes to your family's future, a family trust from Public Trust can help ensure they'll never have to go through hell.

YOUR WORD IS LAW **public**TRUST

FOR MORE INFORMATION ON FAMILY TRUSTS CALL 0800 505 405

NEW ZEALAND

SILVER MIDAS CAMPAIGN
FCB NEW ZEALAND
AUCKLAND

CLIENT Public Trust
MEDIUM Magazine
CREATIVE DIRECTOR Murray Watt
COPYWRITER Kirsten Rutherford
ART DIRECTOR Alf Nadin

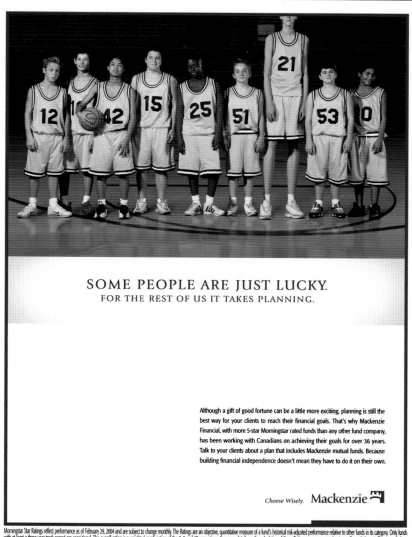

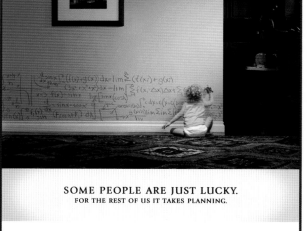

CANADA
GOLD MIDAS CAMPAIGN
LOWE ROCHE
TORONTO, ONTARIO

CLIENT Mackenzie Financial
MEDIUM Newspaper
CREATIVE DIRECTOR Geoffrey Roche
ART DIRECTOR Marc Melanson/
Tom Hurd/Israel Diaz
WRITER Brent Choi
PHOTOGRAPHER George Simhoni
RETOUCHER Brad Palmz

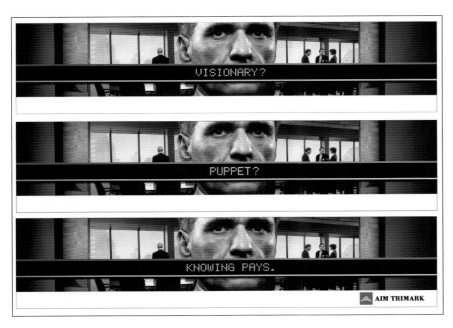

CANADA

FINALIST CAMPAIGN

AIM TRIMARK
TORONTO, ONTARIO

CLIENT **AIM Trimark**
MEDIUM **Mixed-Media**
CREATIVE DIRECTOR **Marc Stoiber**
COPYWRITER **Michael Clowater**
ART DIRECTOR **David Rhodes**
VP MARKETING/AIM TRIMARK **Karla Congson**
ASSOCIATE CREATIVE DIRECTOR **Chris Torbay**
GOUP ACCOUNT DIRECTOR **Nathalie Burstein-Woods**
STRATEGIC PLANNER **Greg Pellett**
ACCOUNT SUPERVISOR **Brad Cressman**

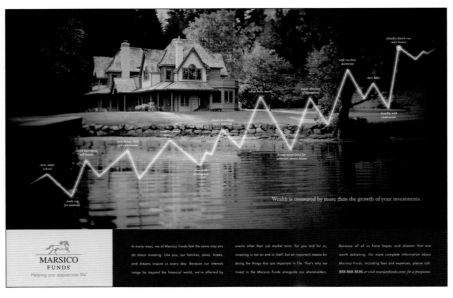

USA

FINALIST CAMPAIGN

THE INTEGER GROUP
LAKEWOOD, CO

CLIENT **Marsico Funds**
MEDIUM **Magazine**
CREATIVE DIRECTOR **John Marquis/Michael Krauss**
ART DIRECTOR **Brett Matarazzo**
COPYWRITER **Scott Forbes**
ACCOUNT DIRECTOR **Robyn Abel**
ACCOUNT MANAGER **Ryan Lindholm**

CANADA

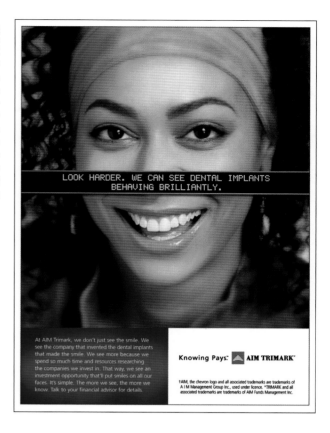

RETIREMENT FINANCIAL SERVICES

GERMANY

USA

SPONSORSHIP

USA

SOUTH AFRICA

CORPORATE COMMUNICATIONS

ANNUAL REPORT

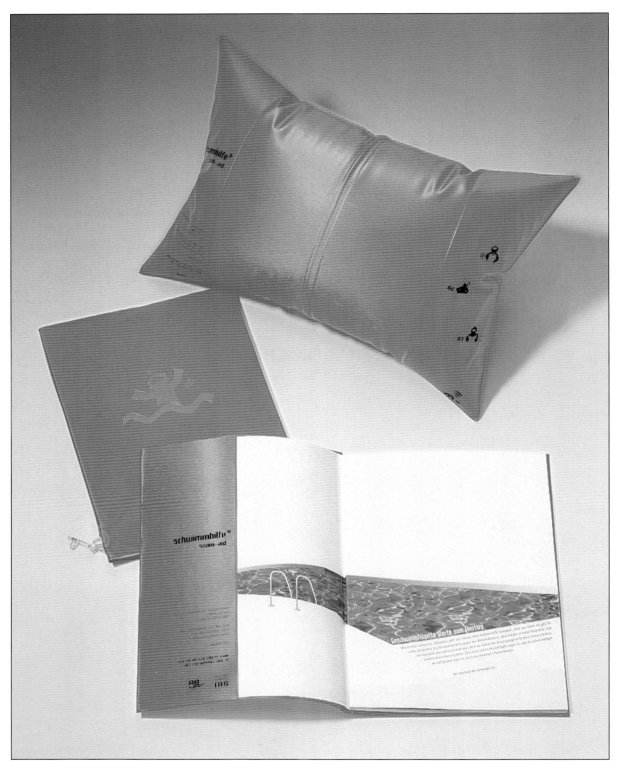

GERMANY

GOLD MIDAS SINGLE
ANTWERPES & PARTNER AG
COLOGNE

MEDIUM Annual Report
CREATIVE DIRECTOR Dr. Frank Antwerpes
CORPORATE COMMUNICATIONS MANAGER Tanja Mumme
ART DIRECTOR Siggi Koch
ILLUSTRATOR Isabelle Kundoch
ASSISTANT Stefanie Rohde

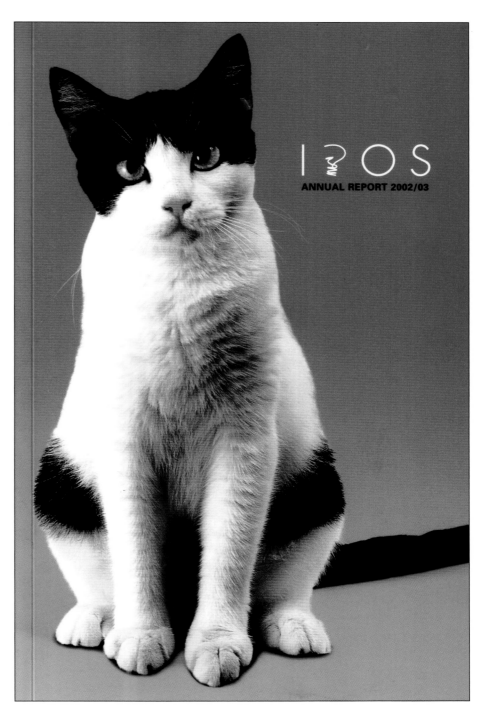

NEO
FOR
MA

2002 Annual Report

USA

FINALIST SINGLE
CAHAN & ASSOCIATES
SAN FRANCISCO, CA

CLIENT Neoforma Inc.
MEDIUM Annual Report
CREATIVE DIRECTOR/ART DIRECTOR Bill Cahan
ART DIRECTOR/DESIGNER Michael Braley
PHOTOGRAPHER Jock McDonald
COPYWRITER Kathy Cooper Parker

SINGAPORE

SILVER MIDAS SINGLE
EPIGRAM
SINGAPORE

CLIENT Intellectual Property Office Of Singapore
MEDIUM Annual Report
DESIGN STUDIO Epigram
DESIGNER Christopher Shie
PHOTOGRAPHER Yee-Ling Koh

USA

FINALIST SINGLE
THE CHARLES SCHWAB CORPORATION
SAN FRANCISCO, CA

CLIENT Charles Schwab
MEDIUM Annual Report
VICE PRESIDENT Glen Mathison
SR. MANAGER Brad Walton

ENGLAND

FINALIST SINGLE
PEARLFISHER INTERNATIONAL DESIGN
LONDON

CLIENT Creative Education Corporation PLC
MEDIUM Annual Report
CREATIVE DIRECTOR Shaun Bowen
ACCOUNT MANAGER Kerry Bolt
DESIGNER Sarah Carr
PRODUCTION MANAGER Darren Foley
CREATIVE DIRECTOR Shaun Bowen

EMPLOYEE COMMUNICATIONS

USA

FINALIST SINGLE
LABOV & BEYOND MARKETING
COMMUNICATIONS INC.
FORT WAYNE, IN

CLIENT Audi Financial Services
MEDIUM Brochure
ACCOUNT MANAGER Ginger Hollister
ART DIRECTOR Shane Starr
GRAPHIC DESIGNER Dabid Buenrostro
PRODUCTION MANAGER Jim Baum
GRAPHIC DESIGNER Kristine Carmack/
Audrey Bollinger
WRITER Hollie Harris

Unlikely combinations work.

If it wasn't for the cow, cheese would still be grass. When you join E&Y, you'll find yourself in a very diverse team. One that blends different experience, expertise and knowledge. To it, you'll bring ideas and drive; your team mates will supply the rest. You'll be amazed by what you can contribute and learn. And by what together, you can produce.

Call 0800 123 456.

ey.com

ERNST & YOUNG
Quality In Everything We Do

© Ernst & Young 2003

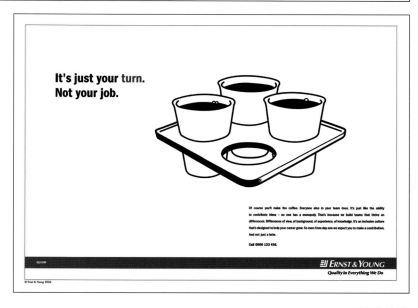

**It's just your turn.
Not your job.**

Of course you'll make the coffee. Everyone else in your team does. It's just like the ability to contribute ideas – no one has a monopoly. That's because we build teams that thrive on differences. Differences of view, of background, of experience, of knowledge. It's an inclusive culture that's designed to help your career grow. So even from day one we expect you to make a contribution. And not just a latte.

Call 0800 123 456.

ey.com

ERNST & YOUNG
Quality In Everything We Do

© Ernst & Young 2003

ENGLAND

GOLD MIDAS CAMPAIGN
MASIUS
LONDON

CLIENT Ernst & Young
MEDIUM Newspaper
CREATIVE DIRECTOR Ian Henderson
ART DIRECTOR Ian Otway
COPYWRITER Peter Powell

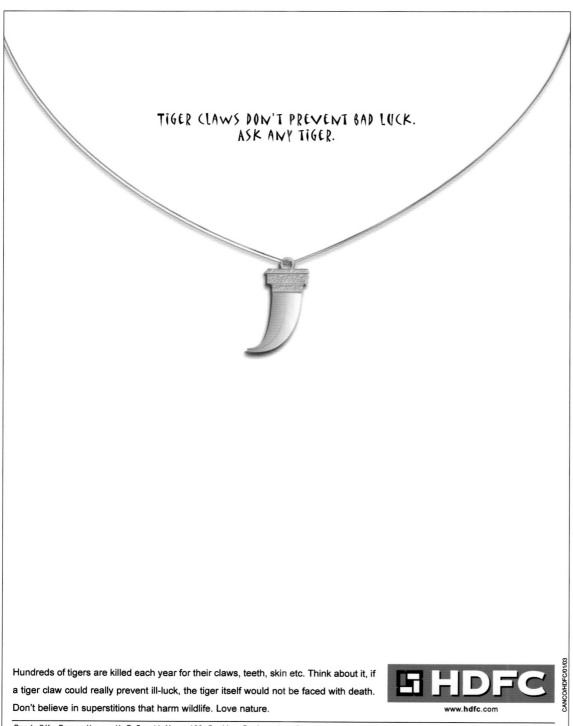

TIGER CLAWS DON'T PREVENT BAD LUCK.
ASK ANY TIGER.

Hundreds of tigers are killed each year for their claws, teeth, skin etc. Think about it, if a tiger claw could really prevent ill-luck, the tiger itself would not be faced with death. Don't believe in superstitions that harm wildlife. Love nature.

HDFC

www.hdfc.com

CANCO/HDFC/01/03

Regd. Off.: Ramon House, H. T. Parekh Marg, 169, Backbay Reclamation, Churchgate, Mumbai 400 020. Tel.: 56316050, 22820282, 22836255.

INDIA

GOLD MIDAS SINGLE
CANCO ADVERTISING
MUMBAI

CLIENT HDFC
MEDIUM Magazine
CREATIVE DIRECTOR Ramesh Narayan
COPYWRITER Neelam Lakhani
ART DIRECTOR Dhananjay Khotpal

SINGAPORE

FINALIST SINGLE
CRUSH
SINGAPORE

CLIENT Eastern Insurance
MEDIUM TV
CREATIVE DIRECTOR Kelvin Pereira
ART DIRECTOR Kelvin Pereira/Jonathon Foo
COPYWRITER Kelvin Pereira
PRODUCTION COMPANY Passion Pictures

Best Use of Medium

BEST MAGAZINE ADVERTISEMENT

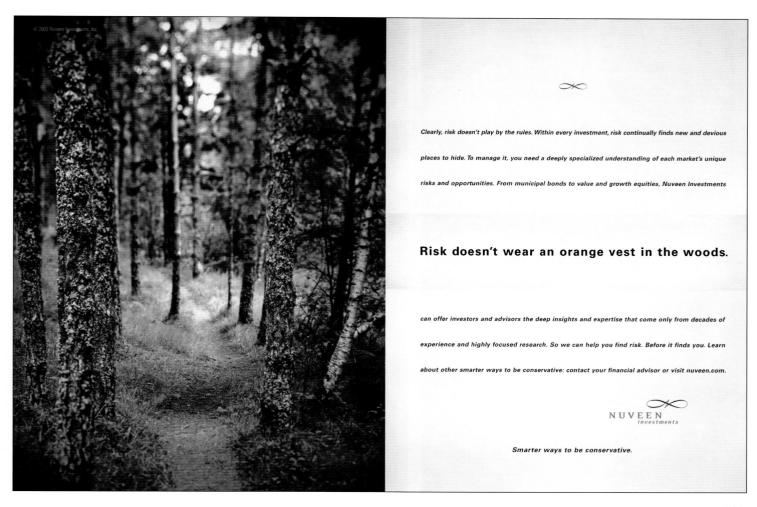

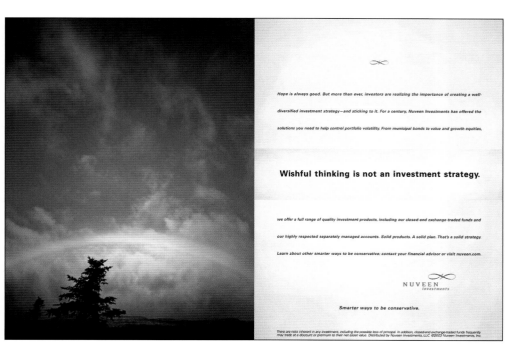

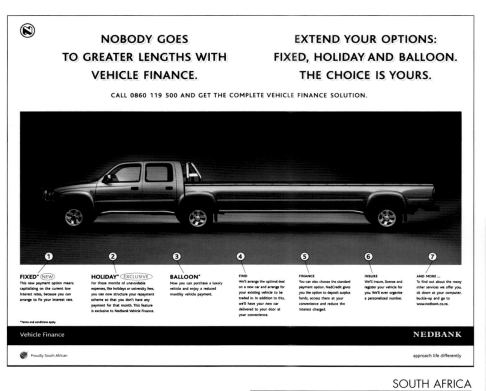

SOUTH AFRICA

FINALIST SINGLE

THE JUPITER DRAWING ROOM SOUTH AFRICA

JOHANNESBURG, GAUTENG

CLIENT Nedbank
MEDIUM Magazine
CREATIVE DIRECTOR Edirn Altern/Dennis Hoines
ART DIRECTOR Nicola Wilson
COPYWRITER Sam Koenderman
ACCOUNT SUPERVISOR Nicole Bruce
PRODUCTION MANAGER Belinda Shea
TYPOGRAPHER Edirn Altern
PHOTOGRAPHER Darren Chatz
ADVERTISER'S SUPERVISOR Michelle Sarjod

BEST TRANSIT

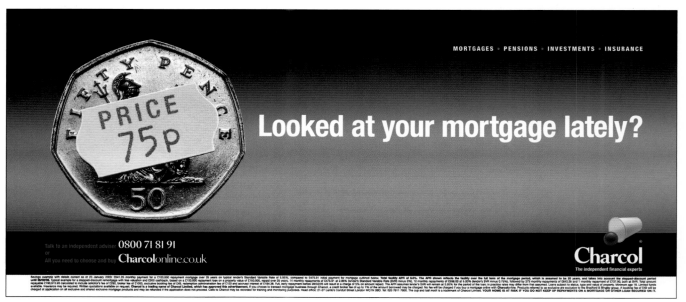

ENGLAND

FINALIST SINGLE

MASIUS

LONDON

CLIENT Charcol
MEDIUM Transit
CREATIVE DIRECTOR
Ian Henderson
COPYWRITER
Surrey Garland
ART DIRECTOR
John Griffin
PHOTOGRAPHER
David Gill

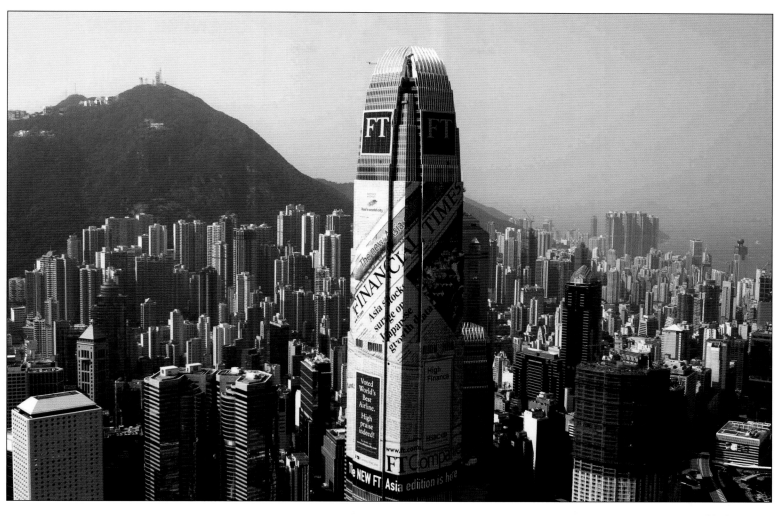

HONG KONG

GOLD MIDAS SINGLE
DOREMUS & COMPANY
HONG KONG

CLIENT The Financial Times Asia Edition
MEDIUM Place-Based Media
CREATIVE DIRECTOR Vijayan Ganesh
ASSOCIATE CREATIVE DIRECTOR Den Tan
SENIOR ART DIRECTOR Danny Wong
MANAGING DIRECTOR Richard Beccle
DIRECTOR OF CLIENT SERVICES Angela Watkins
ASSOCIATE ACCOUNT DIRECTOR Maggie Wong
PRODUCTION MANAGER Victor Mak

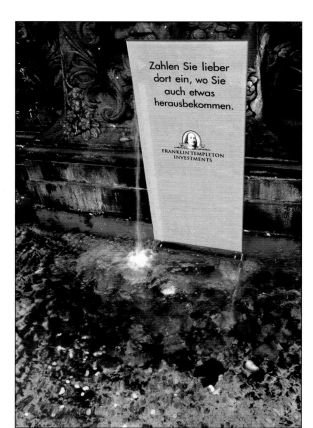

GERMANY

FINALIST SINGLE
SERVICEPLAN GRUPPE FÜR INNOVATIVE
KOMMUNIKATION GM
MUNICH, GERMANY

CLIENT Franklin Templeton Investments
MEDIUM Place-Based Media
CREATIVE DIRECTOR Ekkehard Frenkler
ART DIRECTOR Bernd Lutieschano
COPYWRITER Björn Neugebauer
ACCOUNT MANAGER Andre Gebel
MARKETING MANAGER Stefanie Strunk

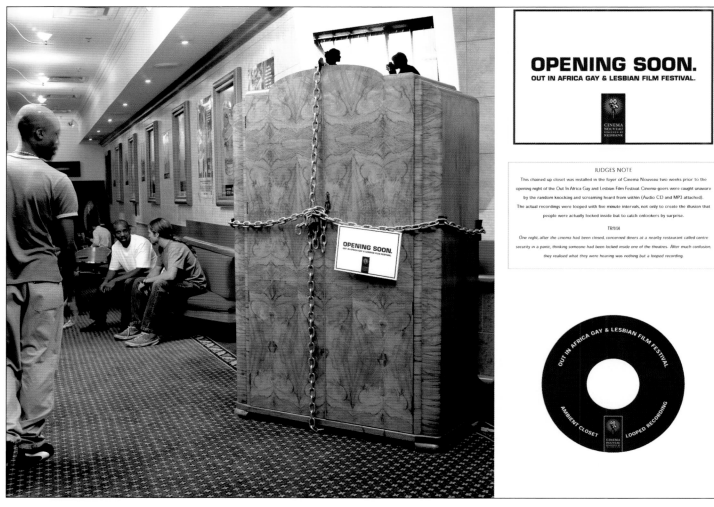

SOUTH AFRICA

SILVER MIDAS SINGLE
THE JUPITER DRAWING ROOM SOUTH AFRICA
JOHANNESBURG, GAUTENG

CLIENT Nedbank
MEDIUM Place-Based Media
CREATIVE DIRECTOR Graham Warsop
ART DIRECTOR Jonathan Deeb
COPYWRITER Stephanie Van Niekerk
PRODUCTION MANAGER Belinda Shea
ACCOUNT SUPERVISOR Gillian Smith
MARKETING MANAGER Sarah Denyer

BEST WEB SITE

GERMANY
FINALIST SINGLE
DIE FIRMA GMBH
WIESBADEN

CLIENT Nassauische Sparkasse
MEDIUM Web Site
DIRECTOR Christoph Kepper
CREATIVE DIRECTOR Marco Fischer
DESIGNER Susa Wilhelm/Jochen Fritz/Tomasz Sawicki
PROGRAMMER Sebastian Beigel/Kim Lang

GERMANY

FINALIST SINGLE
DIE FIRMA GMBH
WIESBADEN

CLIENT Heller
MEDIUM Web Site
PROJECT MANAGER Christoph Paul Kremers
CREATIVE DESIGNER/DESIGNER Marco Fischer/Susanne Wilhelm
ENGINEER Kim Lang
COPYWRITER Joachim Thomas

USA

FINALIST SINGLE
ICF CONSULTING
FAIRFAX, VA

CLIENT ICF Consulting
MEDIUM Web Site
WEB CONTENT MANAGER Carolyn Wixson Haga
WEBMASTER Rottman M. Mendez
DEVELOPER Cornelio Mendoza/Kishore Carey
DESIGNER Alliant Studios
CORPORATE DEVELOPMENT DIRECTOR Doug Beck
MARKETING DIRECTOR Faith Welling
INFORMATION SYSTEMS DIRECTOR Jim Seufert
MANAGER, INFORMATION SYSTEMS Kavosh Soltani

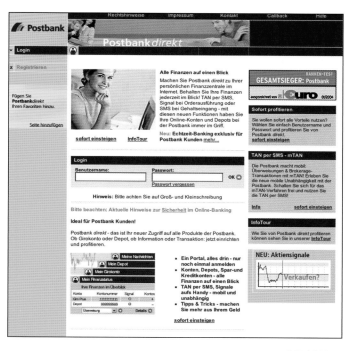

USA

FINALIST SINGLE
IMIRAGE, INC.
ALLENTOWN, PA

CLIENT Mack Trucks
MEDIUM Web Site

GERMANY

FINALIST SINGLE
MEDIAMAN GMBH
MAINZ

CLIENT Deutsche Postbank AG
MEDIUM Web Site
CREATIVE DIRECTOR Thomas Bech
SENIOR CONCEPTER Roland Gräf
FLASH DEVELOPER Patrick Ulrich
ACCOUNT MANAGER Nina Koeder

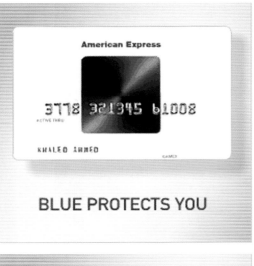

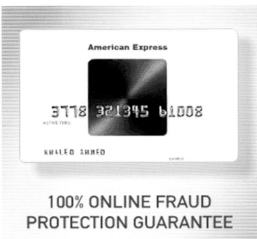

UNITED ARAB EMIRATES

GOLD MIDAS CAMPAIGN
OGILVYONE MIDDLE EAST
DUBAI

CLIENT American Express Blue
MEDIUM Web Ad
CREATIVE DIRECTORS Gary Chan/
Paddy MacLachlan
COPYWRITER Paddy MacLachlan
ART DIRECTORS Gary Chan/Fletch Wong
DESIGNER Wing Hong Wong
DEVELOPER Roger Miller

USA

FINALIST SINGLE
THE Y&R GROUP/WUNDERMAN
DEARBORN, MI

CLIENT Ford Credit
MEDIUM Web Site
EXECUTIVE CREATIVE DIRECTOR Fred Stafford
DIGITAL CREATIVE DIRECTOR Eric Livingston
ASSOCIATE CREATIVE DIRECTOR Doug Claggett
WRITER Jason Gitlin
GROUP ACCOUNT DIRECTOR James Risk
MANAGEMENT SUPERVISOR Krysty Sagnia

USA
GOLD MIDAS SINGLE
SEDGWICK RD.
SEATTLE, WA
CLIENT Washington Mutual
MEDIUM TV

USA

FINALIST SINGLE
SEDGWICK RD.
SEATTLE, WA

CLIENT Washington Mutual
MEDIUM TV
CREATIVE DIRECTOR Steve Johnston
COPYWRITER Forrest Healy
ART DIRECTOR Dave Sakamoto
AGENCY PRODUCER Jane Jacobsen
DIRECTOR Craig Gillespie
PRODUCER Brian Latt
PRODUCTION COMPANY MJZ
EDITOR Katz
EDITING COMPANY Cosmo Street
MUSIC COMPANY Ravenswork
ACCOUNT EXECUTIVE Cindy Dunbar

USA

FINALIST SINGLE
CITIGROUP, INC.
MINNEAPOLIS, MN

CLIENT Citibank
MEDIUM TV
CREATIVE DIRECTOR David Lubars
GROUP CREATIVE DIRECTOR John Matejczyk/
Steve Driggs
COPYWRITER Ryan Peck
ART DIRECTOR Steve Driggs/Steve Sage
AGENCY PRODUCER Rob van de Weteringe Buys
PRODUCTION COMPANY Thomas Thomas Films
DIRECTOR Kevin Thomas

USA

FINALIST SINGLE
CITIGROUP, INC.
MINNEAPOLIS, MN

CLIENT Citibank
MEDIUM TV
CREATIVE DIRECTOR David Lubars
GROUP CREATIVE DIRECTOR John Matejczyk/
Steve Driggs
COPYWRITER Ryan Peck
ART DIRECTOR Steve Driggs/Steve Sage
AGENCY PRODUCER Rob van de Weteringe Buys
PRODUCTION COMPANY Thomas Thomas Films
DIRECTOR Kevin Thomas

USA

GOLD MIDAS CAMPAIGN
CITIGROUP, INC.
MINNEAPOLIS, MN

CLIENT Citibank
MEDIUM TV
CREATIVE DIRECTOR David Lubars
GROUP CREATIVE DIRECTOR John Matejczyk/Steve Driggs
COPYWRITER Ryan Peck
ART DIRECTOR Steve Driggs/Steve Sage
AGENCY PRODUCER Rob van de Weteringe Buys
PRODUCTION COMPANY Thomas Thomas Films
DIRECTOR Kevin Thomas

USA

FINALIST SINGLE
SEDGWICK RD.
SEATTLE, WA

CLIENT Washington Mutual
MEDIUM TV
CREATIVE DIRECTOR Steve Johnston
COPYWRITER Scott Stripling
ART DIRECTOR Jimmy Ashworth
AGENCY PRODUCER Margaret Overley
DIRECTOR Craig Gillespie
PRODUCER Brian Latt
PRODUCTION COMPANY MJZ
EDITOR David Brixton
EDITING COMPANY The Whitehouse
ACCOUNT EXECUTIVE Jennifer Exoo
POST PRODUCTION The Mill/London

JAPAN

FINALIST CAMPAIGN
McCANN-ERICKSON
TOKYO

CLIENT MasterCard
MEDIUM TV
CREATIVE DIRECTOR Kazuya Mototani
ART DIRECTOR Masaya Abe/Keiichiro Fukushima
COPYWRITER Hiroshi Kagawa

SOUTH AFRICA

GOLD MIDAS CAMPAIGN
CROSS COLOURS
JOHANNESBURG

CLIENT First National Bank Home Loans
MEDIUM Mixed-Media

CANADA

BEST CORPORATE CALENDAR

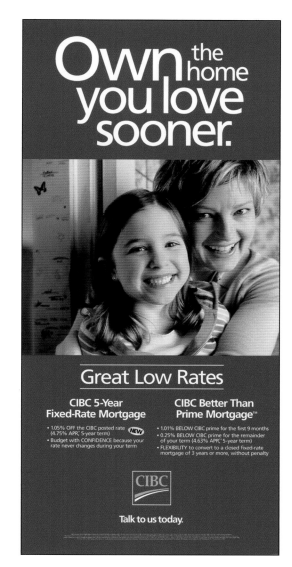

CANADA

USA

BEST RADIO COMMERCIAL

CRAFT & TECHNIQUES

BEST ART DIRECTION

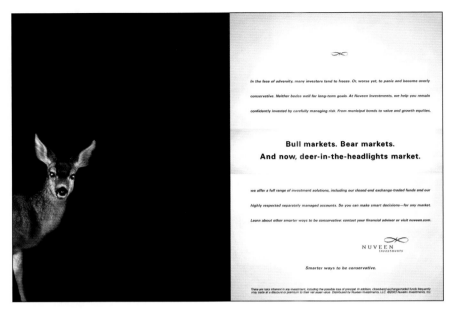

USA

FINALIST CAMPAIGN
FALLON
MINNEAPOLIS, MN

CLIENT Nuveen Investments
MEDIUM Magazine
CREATIVE DIRECTOR Bruce Bildsten/Mike Gibbs
ART DIRECTOR Scott O'Leary
COPYWRITER Dean Buckhorn
GROUP ACCOUNT DIRECTOR David Sigel
ACCOUNT DIRECTOR Steve Prentice

ENGLAND

FINALIST SINGLE
CITIGATE ALBERT FRANK
LONDON

CLIENT Investec Private Bank
MEDIUM TV
CREATIVE DIRECTOR Paul Anderson
COPYWRITER Jeremy Payne

SWEDEN

FINALIST CAMPAIGN
ELIXIR
GÖTEBORG

CLIENT Volvo Truck Cards
MEDIUM Magazine
CREATIVE DIRECTOR Mats Hansson
COPYWRITER Leif Fredén
GRAPHIC DESIGNER Richard Kempe
ACCOUNT MANAGER Lars Magnusson
PHOTOGRAPHER Anette Ericsson
CLIENT VOLVOFINANS Maria Carnemo

BEST CORPORATE IDENTITY

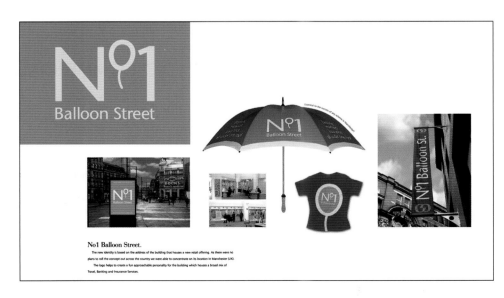

ENGLAND

FINALIST SINGLE
LIKE A RIVER
MANCHESTER

CLIENT Co-operative Group
MEDIUM Corporate Identity

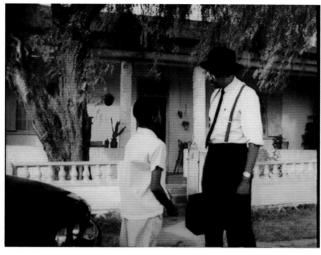

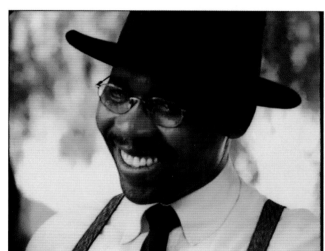

SOUTH AFRICA

GOLD MIDAS SINGLE
THE JUPITER DRAWING ROOM SOUTH AFRICA
JOHANNESBURG, GAUTENG

CLIENT Nedbank
MEDIUM TV
CREATIVE DIRECTOR Graham Warsop
ART DIRECTOR Jonathan Deeb
COPYWRITER Graham Warsop
CLIENT SERVICE SUPERVISOR Gillian Smith
PRODUCER Linda Notelovitz
DIRECTOR Miles Goodall
AGENCY PRODUCER Santa Asbury
MARKETING MANAGER Sarah Denyer

USA

FINALIST SINGLE
WASHINGTON MUTUAL
SEATTLE, WA

CLIENT Washington Mutual
MEDIUM Calendar
CREATIVE DIRECTOR Rayne Beaudoin
COPYWRITER Terrie Shattuck
CLIENT Beverly Bailey/Colleen Huebner

BEST GRAPHIC DESIGN

GERMANY

SILVER MIDAS SINGLE

STRICHPUNKT

STUTTGART

CLIENT 4MBO International Electronic AG
MEDIUM Annual Report
CREATIVE DIRECTOR Jochen Rädeker
ART DIRECTOR Kirsten Dietz

GERMANY

FINALIST SINGLE

STRICHPUNKT

STUTTGART

CLIENT Schlott Gruppe AG
MEDIUM Annual Report
CREATIVE DIRECTOR Jochen Rädeker
ART DIRECTOR Kirsten Dietz
DESIGNER Stephanie Zehender
PHOTOGRAPHER Andreas Langen/Kai Loges

USA

FINALIST SINGLE

BANKERS LIFE AND CASUALTY COMPANY

CHICAGO, IL

CLIENT Bankers Life and Casualty Company
MEDIUM Calendar
ART DIRECTOR Nathan Post
GRAPHIC DESIGNER Tammy Babcock/
Tiffany Connolly

SEE PAGE 443

BEST ELECTRONIC DESIGN

BEST SPECIAL EFFECTS

SOUTH AFRICA

SUBURBAN FILMS
CAPE TOWN

CLIENT Investec Private Bank
MEDIUM TV
PRODUCTION COMPANY Suburban Films, South Africa
DIRECTOR/CINEMATOGRAPHER Miles Goodall
POST PRODUCTION COMPANY The Refinery
VISUAL EFFECTS SUPERVISOR Hilton Treves
EXECUTIVE PRODUCER Linda Notelovitz
ADVERTISING AGENCY Citigate Albert Frank, London
CREATIVE DIRECTOR Paul Anderson
AGENCY PRODUCER Alexis Roberts
EDITING COMPANY Flying Films, Cape Town
EDITOR Isa Jacobson
EDIT BOX Charmaine Greyling, The Refinery
FLAME Marco Raposo de Barbosa, The Refinery
DIGITAL MATT PAINTINGS Robin Muir, The Refinery
HENRY ARTIST Lara Hollis, The Refinery
SENIOR 3D TECHNICAL DIRECTOR Sandy Sutherland

BEST CINEMATOGRAPHY

USA
FINALIST SINGLE
BARNETT COX & ASSOCIATES
SAN LUIS OBISPO, CA

CLIENT Heritage Oaks Bank
MEDIUM TV
CREATIVE DIRECTOR John Mackey
DIRECTOR John Stanier
PRODUCTION COMPANY Plural Productions

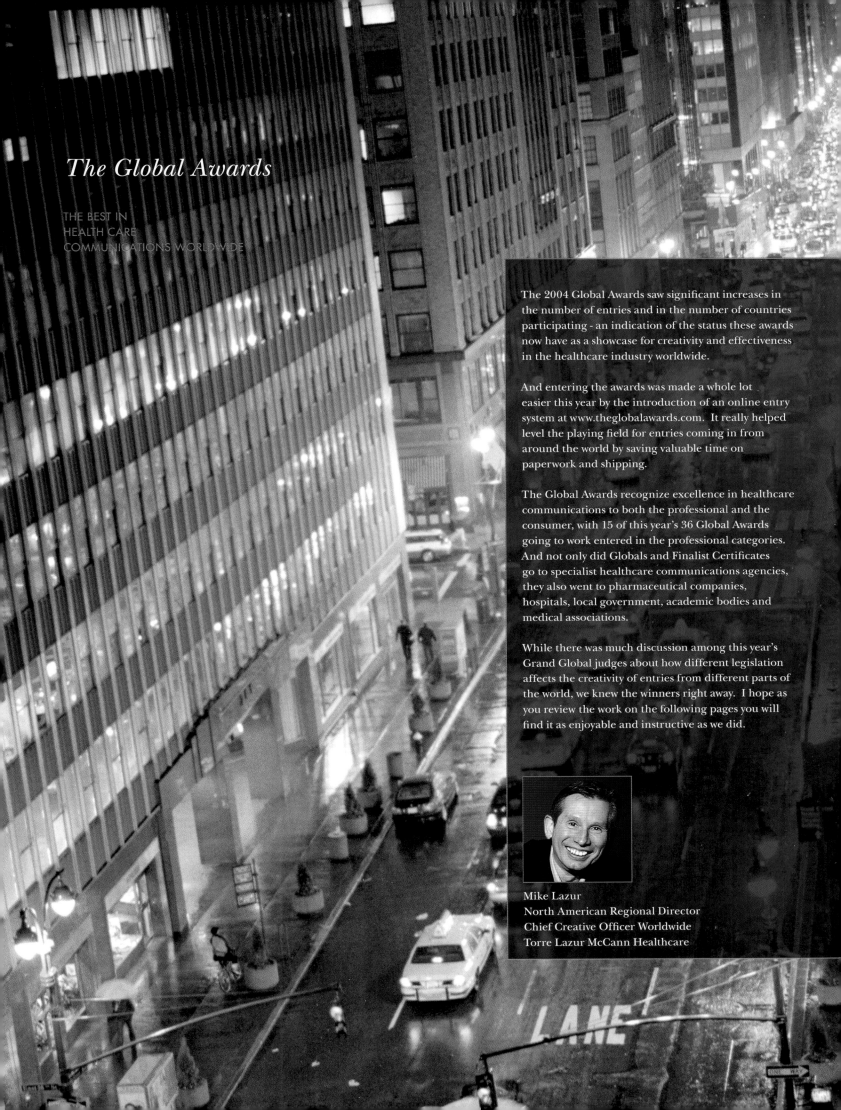

The Global Awards

THE BEST IN
HEALTH CARE
COMMUNICATIONS WORLDWIDE

The 2004 Global Awards saw significant increases in the number of entries and in the number of countries participating - an indication of the status these awards now have as a showcase for creativity and effectiveness in the healthcare industry worldwide.

And entering the awards was made a whole lot easier this year by the introduction of an online entry system at www.theglobalawards.com. It really helped level the playing field for entries coming in from around the world by saving valuable time on paperwork and shipping.

The Global Awards recognize excellence in healthcare communications to both the professional and the consumer, with 15 of this year's 36 Global Awards going to work entered in the professional categories. And not only did Globals and Finalist Certificates go to specialist healthcare communications agencies, they also went to pharmaceutical companies, hospitals, local government, academic bodies and medical associations.

While there was much discussion among this year's Grand Global judges about how different legislation affects the creativity of entries from different parts of the world, we knew the winners right away. I hope as you review the work on the following pages you will find it as enjoyable and instructive as we did.

Mike Lazur
North American Regional Director
Chief Creative Officer Worldwide
Torre Lazur McCann Healthcare

THE GLOBALS BOARD OF
DISTINGUISHED JUDGES AND ADVISORS

THE GLOBALS PRELIMINARY JUDGES

Javier Agudo
BATES HEALTHWORLD SPAIN
MADRID, SPAIN

Enrique Alda
HEALTHWORLD MADRID
MADRID, SPAIN

JT Andexler
DIGITAS
CHICAGO, IL

Leigh Ann Tibak
TORRE LAZUR McCANN
PARSIPPANY, NJ

Andrew Antoniou
GREY WORLDWIDE
SYDNEY, AUSTRALIA

Michele Beaulieu
BIOGENTIS
MONTREAL, CANADA

Juliette Bednarl
TORRE LAZUR McCANN
PARSIPPANY, NJ

Shirin Bridges
EURO RSCG LIFE CENTRAL
CHICAGO, IL

Phil Brown
CURTIS, JONES & BROWN
BALMAIN, AUSTRALIA

Michael Comeau
SWISS HERBAL REMEDIES LTD.
RICHMOND HILL, ONTARIO

Pierre Coo
TORRE LAZUR McCANN
PARSIPPANY, NJ

Mario Daigle
ALLARD JOHNSON
MONTREAL, CANADA

Anthony Diorio
GOBLE & ASSOCIATES
CHICAGO, IL

Brad Downing
SAATCHI & SAATCHI
SYDNEY, AUSTRALIA

Kal Dreisziger
ALLARD JOHNSON
MONTREAL, CANADA

Marion Dreyfus
DREYFUS COMMUNICATIONS
NEW YORK, NY

Peter Finlayson
MEDICUS CANADA
TORONTO, ONTARIO

Hugh Fitzhardinge
MCCANN HEALTHCARE
SYDNEY, AUSTRALIA

Claire Fontaine
AVENTIS
MONTREAL, CANADA

Brendan Gately
EURO RSCG LIFE CENTRAL
CHICAGO, IL

Jose Gomez
TORRE LAZUR
PARSIPPANY, NJ

Carlos Groba
EURO RSCG LIFE
MADRID, SPAIN

Julie Guay
AVENTIS PHARMA
MONTREAL, CANADA

Sandra Gulbicki
TORRE LAZUR McCANN
PARSIPPANY, NJ

Fred Haas
GREY WORLDWIDE
SYDNEY, AUSTRALIA

Laurie Harrington
KPR
NEW YORK, NY

Tracey Henry
MEDICUS
LONDON, ENGLAND

John Hill
PAN COMMUNICATIONS
RICHMOND UPON THAMES, SURREY,
ENGLAND

Ron Hudson
ANDERSON DDB
TORONTO, ONTARIO

Gary Kahn
KAHN VOICEOVERS
NEW YORK, NY USA

Ingrid Kasper
UNITED NATIONS
NEW YORK, NY USA

Steve Kost
ALLARD JOHNSON
MONTREAL, QUEBEC, CANADA

Wai Kwok
GREY WORLDWIDE
SYDNEY, NSW, AUSTRALIA

June Laffey
GREY HEALTHCARE
MILSONS POINT, NSW, AUSTRALIA

Mike Lazur
TORRE LAZUR McCANN HEALTHCARE
WORLDWIDE
PARSIPPANY, NJ USA

Josee Lefebvre
ALLARD JOHNSON
MONTREAL, QUEBEC, CANADA

Mark Lemieux
PFIZER CONSUMER HEALTH
TORONTO, ONT CANADA

Gerrard Malcolm
INSIGHT
AUCKLAND, NEW ZEALAND

Denis Mamo
URSA
SYDNEY, NSW, AUSTRALIA

Juliet Martinez
TORRE LAZUR McCANN
PARSIPPANY, NJ USA

Cameron McCleery
McCLEERY McCANN HEALTHCARE
TORONTO, ONTARIO,

James McGuire
WILLIAMS LABADIE
CHICAGO, IL USA

Ruth Moreto Martinez
HEALTHWORLD
MADRID, SPAIN

Rick Mosseri
ALLARD JOHNSON
MONTREAL, QUEBEC, CANADA

Andrea Mulder
GLAXOSMITHKLINE
MISSISSAUGA, ONTARIO,

Andrew Nairn
HEALTH WORLD
NORTH SYDNEY, AUSTRALIA

Michael Norton
EURO RSCG LIFE WORLDWIDE
NEW YORK, NY

Prue Oxford
WELLMARK COMMUNICATIONS
SOUTH YARRA, AUSTRALIA

Joseph Paumi
WATERMARK SCIENCE
NEW YORK, NY

Victor Petrenko
HEALTHWISE
TORONTO, CANADA

Tamara Photiadis
TORRE LAZUR McCANN
PARSIPPANY, NJ

Mauricio Queiroz
WHITE PROPAGANDA
SÃO PAULO, BRAZIL

Richard Rayment
JUNCTION 11 ADVERTISING
LONDON, ENGLAND

Matt Reid
TORRE LAZUR McCANN HEALTHCARE
LONDON, ENGLAND

Steve Robson
H+T
NEUTRAL BAY, AUSTRALIA

Rob Rogers
SUDLER & HENNESSEY
NORTH SYDNEY, AUSTRALIA

Natalie Rozman
MERCK
KIRKLAND, CANADA

Gord Schwab
OGILVY HEALTHWORLD
TORONTO, CANADA

David Sharpe
EURO RSCG LIFE
TORONTO, CANADA

Rick Smith
TORRE LAZUR McCANN CANADA
TORONTO, CANADA

Pierre St. Amand
ALLARD JOHNSON
MONTREAL, CANADA

Daniel St. Pierre
ROCHE DIAGNOSTICS
MONTREAL, CANADA

Phil Staff
IMMACULATE UK
LONDON, ENGLAND

Gus Tejerina
WUNDERMAN
NEW YORK, NY

Danielle Termiri
TORRE LAZUR McCANN
PARSIPPANY, NJ

Gabrielle Tjaden
KPR
NEW YORK, NY USA

Andrew Tompkins
GREY WORLDWIDE
SYDNEY, AUSTRALIA

Hugo Trudel
AVENTIS
MONTREAL, CANADA

Tim VanOudenaren
TORRE LAZUR McCANN
PARSIPPANY, NJ

Diane Vinch
INTRAMED EDUCATIONAL GROUP
NEW YORK, NY

Chris Waller
CURTIS, JONES & BROWN
BALMAIN, SYDNEY, AUSTRALIA

Chris Weber
CORBETTACCEL
CHICAGO, IL

Alvaro Ximenez De Olaso
LILLY
MADRID, SPAIN

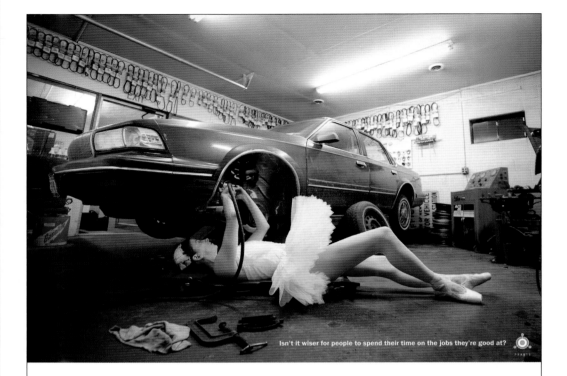

Isn't it wiser for people to spend their time on the jobs they're good at?

Not everyone is right for every job.

Take patient recruitment. If you want to increase
your number of qualified candidates, talk to Praxis.
We're experts at combining the science of clinical
research with the art of effective communications.
It's no wonder why completing a study weeks early
is no big deal for us.

For more information, including our case histories,
we invite you to visit www.gopraxis.com or call
615.312.8207.

Praxis. The science of reaching people.

USA

GRAND GLOBAL: PROFESSIONAL
CROWLEY WEBB AND ASSOCIATES
BUFFALO, NY

CLIENT Praxis
SENIOR VP, CREATIVE David Buck
SENIOR ART DIRECTOR Pete Reiling
DESIGNER Kevin Karn
WRITER Jackie Warner
PHOTOGRAPHER Rhea Anna

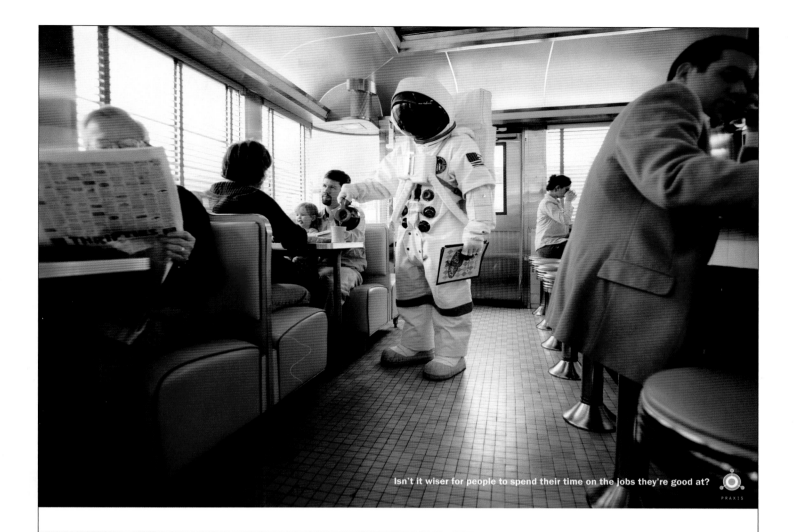

Isn't it wiser for people to spend their time on the jobs they're good at?

If you want something done right,

bring in the experts.

For patient recruitment, that means Praxis.

We're experts at combining the science of clinical

research with the art of effective communications.

It's no surprise to anyone who knows us that we've

often completed a study weeks early.

For more information, including our case histories,

we invite you to visit www.gopraxis.com or call

615.312.8207.

Praxis. The science of reaching people.™

Communication to the Healthcare Professional: Print Media

ADMINISTRATIVE/MANAGEMENT

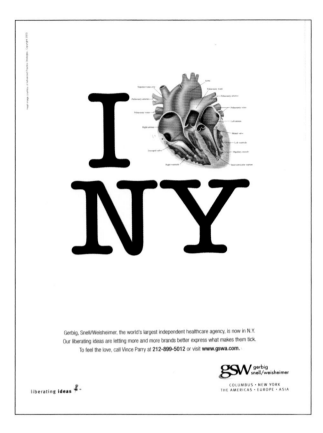

USA
FINALIST, SINGLE
GSW WORLDWIDE
WESTERVILLE, OH

CREATIVE DIRECTOR Marc Sapp
CHIEF CREATIVE OFFICER Bruce Rooke
GROUP ART SUPERVISOR Jeff Schatz
FINAL ART SPECIALIST Amy Klemt

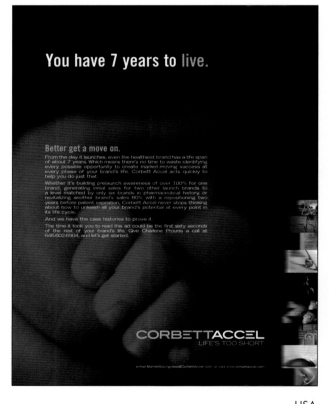

USA
FINALIST, CAMPAIGN
CORBETT ACCEL HEALTHCARE GROUP
CHICAGO, IL

CLIENT Corbett Accel Healthcare Group
CHIEF CREATIVE OFFICER John Scott
SENIOR ART DIRECTOR Orin Kimball

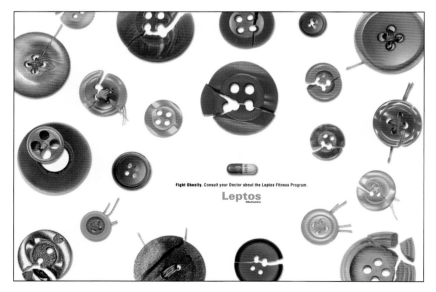

INDIA
FINALIST, SINGLE
SSC&B LINTAS PVT. LTD.
MUMBAI

CLIENT Leptos
PRESIDENT Ajay Chandwani
CREATIVE DIRECTOR Umesh Bhagat
COPYWRITER Namita Kuruvilla
ILLUSTRATOR Yashwant Sawant

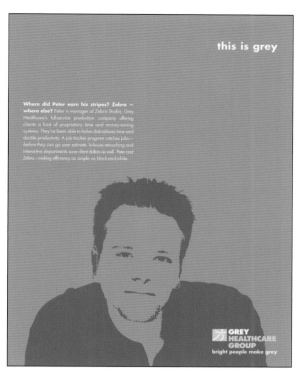

this is grey

**Where did Peter earn his stripes? Zebra —
where else?** Peter is manager of Zebra Studio, Grey Healthcare's full-service production company offering clients a host of proprietary time- and money-saving systems. They've been able to halve disk-release time and double productivity. A job tracker program catches jobs—before they can go over estimate. In-house retouching and interactive departments save client dollars as well. Peter and Zebra—making efficiency as simple as black-and-white.

GREY
HEALTHCARE
GROUP
bright people make grey

USA

FINALIST, CAMPAIGN
GREY HEALTHCARE GROUP
NEW YORK, NY

CREATIVE DIRECTOR Karin Miksche/
Leanne Budreau
STUDIO Kevin Hogan

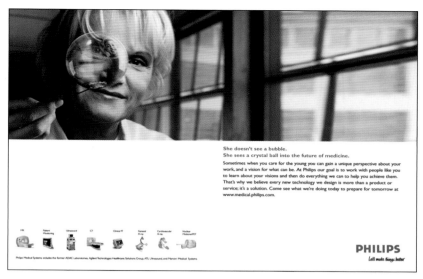

She doesn't see a bubble.
She sees a crystal ball into the future of medicine.

Sometimes when you care for the young you can gain a unique perspective about your work, and a vision for what can be. At Philips our goal is to work with people like you to learn about your visions and then do everything we can to help you achieve them. That's why we believe every new technology we design is more than a product or service; it's a solution. Come see what we're doing today to prepare for tomorrow at www.medical.philips.com

PHILIPS
Let's make things better

USA

FINALIST, CAMPAIGN
MASIUS
NEW YORK, NY

CLIENT Philips Medical Systems
CREATIVE DIRECTOR Bill Connors
ART DIRECTOR Gene Campanelli
PHOTOGRAPHER Rens Van Mierlo

BLOOD AGENTS

ANTI-INFECTIVE

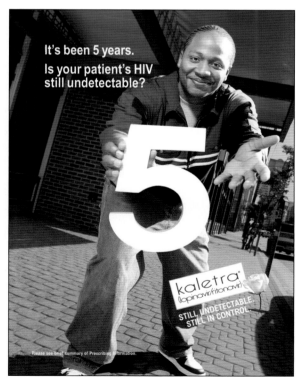

It's been 5 years.
Is your patient's HIV
still undetectable?

5

kaletra
(lopinavir/ritonavir)
STILL UNDETECTABLE.
STILL IN CONTROL.

Please see brief summary of Prescribing Information.

USA

FINALIST, SINGLE
TORRE LAZUR CHICAGO
CHICAGO, IL

CLIENT Kaletra

more life*

DENMARK

FINALIST, CAMPAIGN
LEO PHARMA
BALLERUP-COPENHAGEN

CLIENT innohep (R)
GROUP PORTOLIO MANGER COAGULATION Anne Marie Melchior
CREATIVE DIRECTOR, TRIBAL DDB Thomas Wibroe
COPYWRITER, TRIBAL DDB Birgitte Agergaard
PROJECT MANAGER, TRIBAL DDB Lina Wennevold
DIRECTOR, TRIBAL DDB Tomas Gorrissen
MANAGER GROUP BRANDING & EVENTS Anne V. Andersen
CREATIVE RESPONSIBLE, LEO PHARAMA Ulla Korgard
INFORMATION & COORDINATION MANAGER Christian Enggard
PHOTOGRAPHER Ebbe Forup

CARDIOVASCULAR

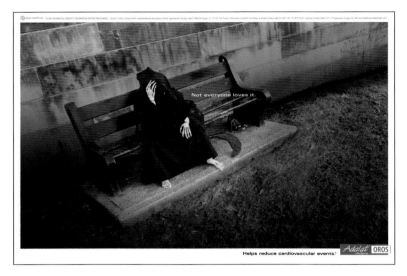

Not everyone loves it.

Helps reduce cardiovascular events.¹ Adalat OROS

AUSTRALIA

FINALIST, SINGLE

McCANN HEALTHCARE
SYDNEY

CLIENT Adalat
CREATIVE DIRECTOR Hugh Fitzhardinge/Grant Foster
WRITER Alex Tagaroulias
ART DIRECTOR Grant Foster
PRODUCT MANAGER Richard Petrie
ACCOUNT DIRECTOR Susan Oliver
PHOTOGRAPHER Julian Watt
DESIGNER Bridget Pooley

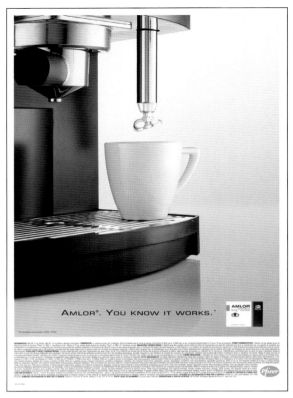

AMLOR®. YOU KNOW IT WORKS.®

AMLOR

BELGIUM

FINALIST, CAMPAIGN

DDB HEALTH BELGIUM
BRUSSELS

CLIENT Pfizer - Amlor
CREATIVE MANAGEMENT K. Corrigan/D. van Doormaal
CREATIVE TEAM Sandrine Felot/Emmanuel Colin
ACCOUNT TEAM May Bogaert/Katrien Verhofstadt
CLIENT TEAM Nathalie Gonnissen/Eric Van Nieuwenhuyze
CLIENT Fabrice Claisse
PHOTOGRAPHER Pascal Habousha
ART BUYER Gisèle Kuperman

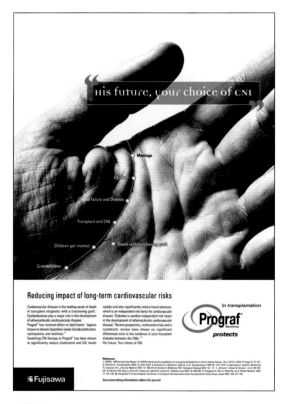

his future, your choice of CNI

Reducing impact of long-term cardiovascular risks

In transplantation
Prograf
protects

Fujisawa

ITALY

FINALIST, SINGLE

SUDLER & HENNESSEY INTERNATIONAL
MILANO

CLIENT Prograf

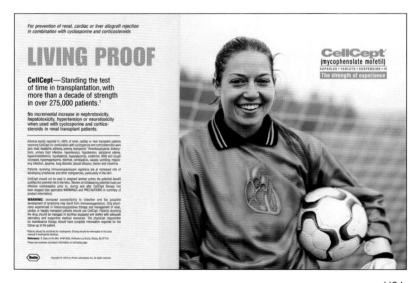

For prevention of renal, cardiac or liver allograft rejection
in combination with cyclosporine and corticosteroids

LIVING PROOF

CellCept—Standing the test
of time in transplantation, with
more than a decade of strength
in over 275,000 patients.¹

CellCept (mycophenolate mofetil)
CAPSULES • TABLETS • SUSPENSION • IV
The strength of experience

USA

FINALIST, CAMPAIGN

HEALTHWORLD
NEW YORK, NY

CLIENT Cellcept
CREATIVE DIRECTOR Steve Witt
ART DIRECTOR Tiffany Handshoe
ACCOUNT MANAGEMENT Dona Just

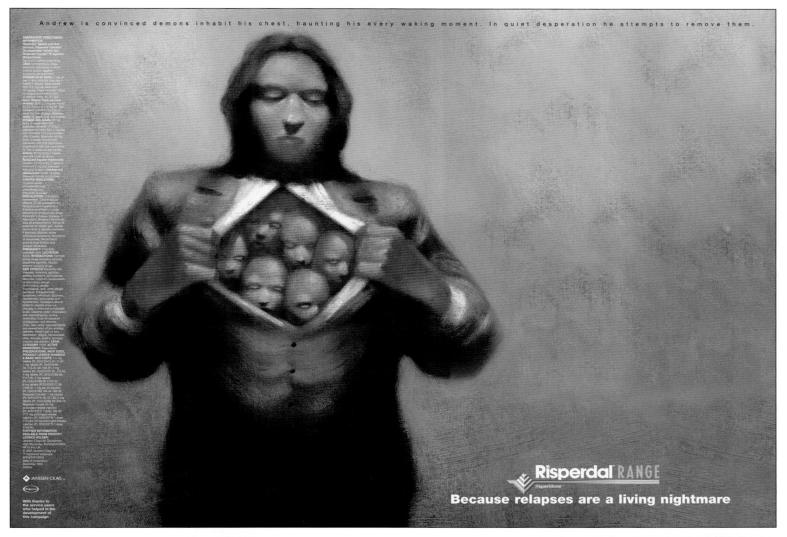

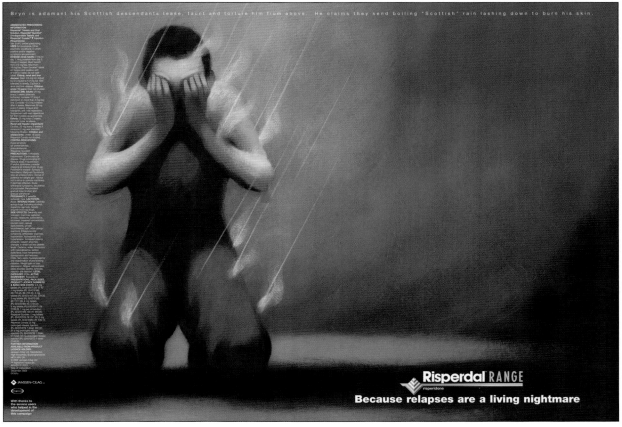

ENGLAND

GLOBAL AWARD, CAMPAIGN
JUNCTION 11 ADVERTISING
WEYBRIDGE, SURREY

CLIENT Risperdal
COPYWRITER Richard Rayment
ART DIRECTOR John Timney
CREATIVE DIRECTOR
Richard Rayment/John Timney
ILLUSTRATOR Mark Moran
STUDIO MANAGER Liz Spencer
ACCOUNT MANAGER Anna Scott
CLIENT SERVICES DIRECTOR
Richard Hart
PRODUCT MANAGER
Nick Georgiou/
Lisa Meddows-Taylor
MARKETING MANAGER John Bacon

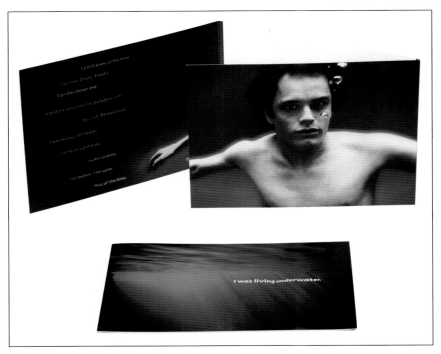

AUSTRALIA

FINALIST, SINGLE

McCANN HEALTHCARE
SYDNEY

CLIENT Solian
CREATIVE DIRECTOR Hugh Fitzhardinge/Grant Foster
COPYWRITER Hugh Fitzhardinge
ART DIRECTOR Grant Foster
PRODUCT MANAGER Adrian Dunstan
SENIOR ACCOUNT MANAGER Claire Pope
PHOTOGRAPHER Tim Bauer
DESIGNER Bridget Pooley

COMPLEMENTARY MEDICINE

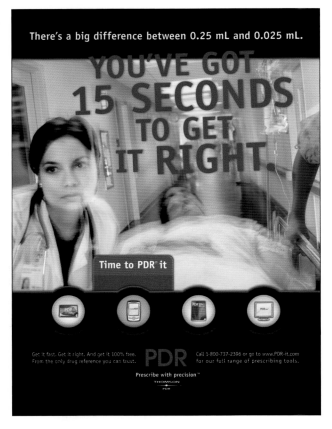

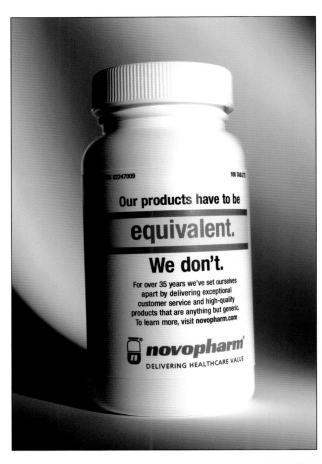

USA

FINALIST, SINGLE

THE CEMENTWORKS
NEW YORK, NY

CLIENT PDR
SVP, DIRECTOR OF CLIENT SERVICES Ed Cowen
VP, ASSOCIATE CREATIVE DIRECTOR, ART David Garson
SENIOR COPYWRITER Stephanie Berman
ART DIRECTOR Joseph Johnson

CANADA

FINALIST, CAMPAIGN

CUNDARI INTEGRATED ADVERTISING
TORONTO

CLIENT Novopharm
ART DIRECTOR Scott Annandale
COPYWRITER Cory Eisentraut
ACCOUNT DIRECTOR Darren Stallman
VP, CREATIVE DIRECTOR Fred Roberts
EXECUTIVE VP, MANANGING DIRECTOR Ken Stallman
ACCOUNT SUPERVISOR Jennifer Hillier/Jennifer Milbury

Sniffs out the best stories

Medical OBSERVER Weekly
BRINGS LIFE TO MEDICINE

DERMATOLOGICAL

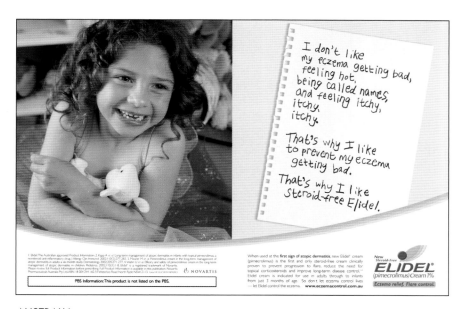

I don't like my eczema getting bad, feeling hot, being called names, and feeling itchy, itchy, itchy.

That's why I like to prevent my eczema getting bad.

That's why I like steroid-free Elidel.

New Steroid-Free **ELIDEL** (pimecrolimus) Cream 1%
Eczema relief. Flare control.

NOVARTIS

PBS Information: This product is not listed on the PBS.

HORMONES

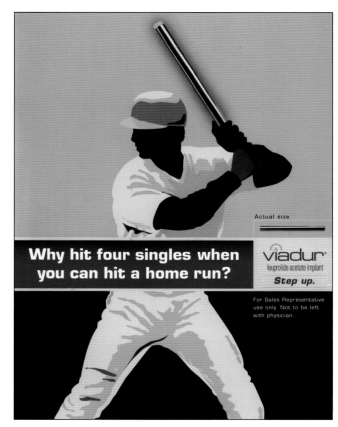

Why hit four singles when you can hit a home run?

viadur leuprolide acetate implant
Step up.

Actual size

For Sales Representative use only. Not to be left with physician.

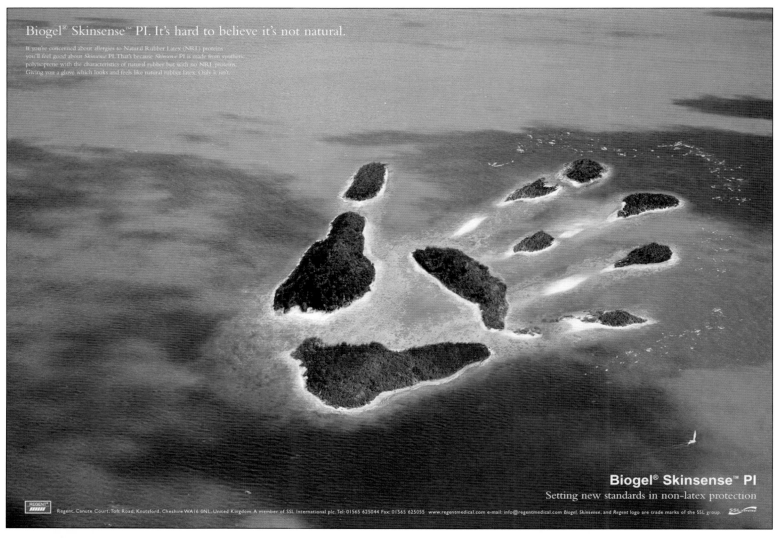

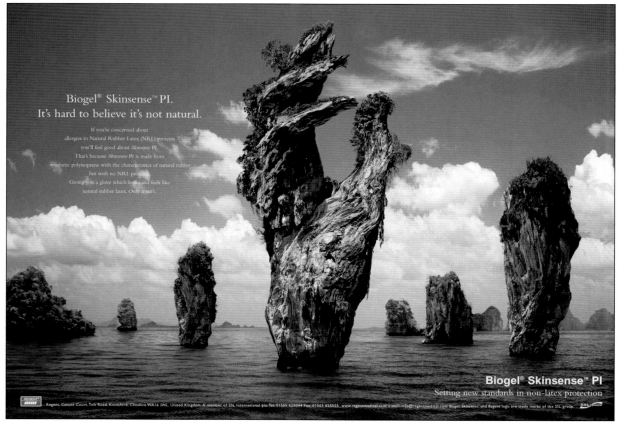

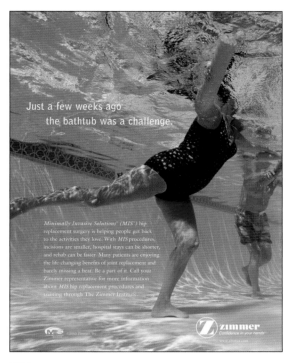

Just a few weeks ago
the bathtub was a challenge.

Minimally Invasive Solutions (MIS) hip replacement surgery is helping people get back to the activities they love. With MIS procedures, incisions are smaller, hospital stays can be shorter, and rehab can be faster. Many patients are enjoying the life-changing benefits of joint replacement and barely missing a beat. Be a part of it. Call your Zimmer representative for more information about MIS hip replacement procedures and training through The Zimmer Institute.

Zimmer
Confidence in your hands

USA

FINALIST, SINGLE

BIGGS-GILMORE COMMUNICATIONS
KALAMAZOO, MI

CLIENT **Zimmer**
CREATIVE DIRECTOR/ART DIRECTOR **Marino Puhalj**
CREATIVE DIRECTOR **Andy Gould**
COPYWRITER **Maggie Reynolds**
DESIGNER **P. Catherine Wester**

AUSTRALIA

FINALIST, SINGLE

WELLMARK
SOUTH YARRA, MELBOURNE

CLIENT **Kodak Health Imaging**
COPYWRITER **Jill Giese**
ART DIRECTOR **Lyn Jenkin**
CREATIVE DIRECTOR **Prue Oxford**

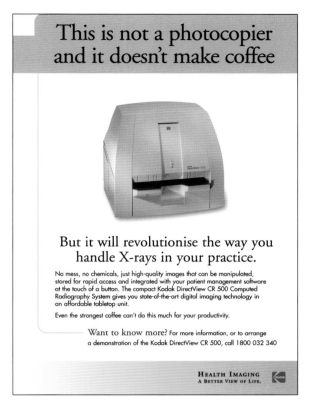

This is not a photocopier and it doesn't make coffee

But it will revolutionise the way you handle X-rays in your practice.

No mess, no chemicals, just high-quality images that can be manipulated, stored for rapid access and integrated with your patient management software at the touch of a button. The compact Kodak DirectView CR 500 Computed Radiography System gives you state-of-the-art digital imaging technology in an affordable tabletop unit.

Even the strongest coffee can't do this much for your productivity.

Want to know more? For more information, or to arrange a demonstration of the Kodak DirectView CR 500, call 1800 032 340

HEALTH IMAGING
A BETTER VIEW OF LIFE.

MUSCULOSKELETAL

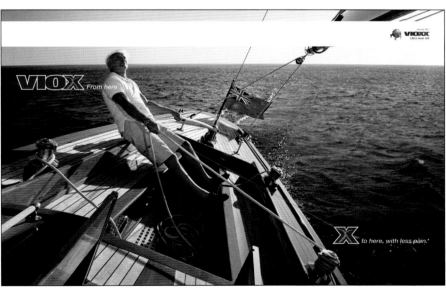

VIOX *From here*

X *to here, with less pain.*

AUSTRALIA

FINALIST, CAMPAIGN

URSA COMMUNICATIONS
MCMAHONS POINT

CLIENT **Vioxx**
CREATIVE DIRECTOR **Denis Mamo**
ART DIRECTOR **Paul Rauch**
COPYWRITER **Alex Tagaroulias**
PHOTOGRAPHER **Ross Honeysett**
ART DIRECTOR **Paul Rauch**
PRODUCTION MANAGER **Nestor Moreno**
SENIOR ACCOUNT MANAGER **Tam Nguyen**
GROUP ACCOUNT DIRECTOR **Richard Wylie**
DESIGNER **Jonathan Petley**

Lasting strength.
Lasting dedication.

CELEBREX is indicated for relief of the signs and symptoms of osteoarthritis and adult rheumatoid arthritis; and for the management of acute pain in adults.

CELEBREX is contraindicated in patients with known hypersensitivity to celecoxib; in patients who have demonstrated allergic-type reactions to sulfonamides; and in patients who have experienced asthma, urticaria, or allergic-type reactions after taking aspirin or other NSAIDs.

Serious GI toxicity such as bleeding, ulceration, and perforation can occur with or without warning symptoms in patients treated with NSAIDs.

Most common side effects were dyspepsia, diarrhea, and abdominal pain, and were generally mild to moderate.

Please see brief summary of prescribing information on adjacent page.

CELEBREX
(CELECOXIB CAPSULES)
Proven strength that lasts

USA

FINALIST, CAMPAIGN

GREY HEALTHCARE GROUP
NEW YORK, NY

CLIENT **Celebrex**
CREATIVE DIRECTOR **Mary Saigh-Kukle**
ART DIRECTOR **Eric Bet**
COPYWRITER **Susan Pinke**
PHOTOGRAPHER **Brad Harris**

RESPIRATORY

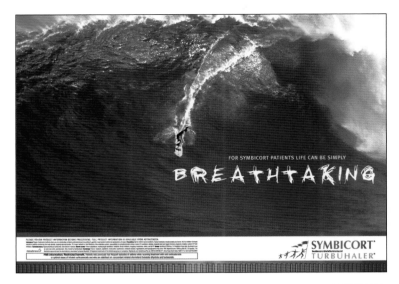

PATHOLOGY AND SIMILAR SERVICES

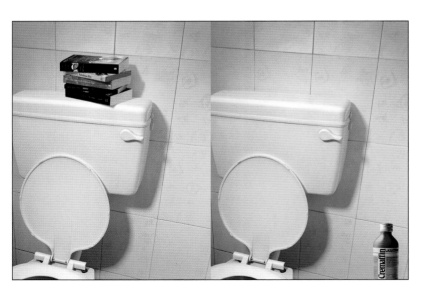

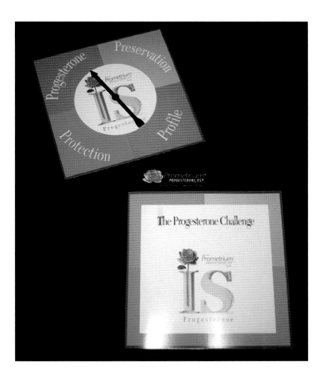

USA

FINALIST, SINGLE

ABELSON-TAYLOR

CHICAGO, IL

CLIENT Prometrium

VP, CREATIVE GROUP DIRECTOR Angela Lustig

ASSOCIATE CREATIVE DIRECTOR Ted Goeglein

SENIOR ART DIRECTOR Donna Calomino

COPYWRITER Jeff Baffico

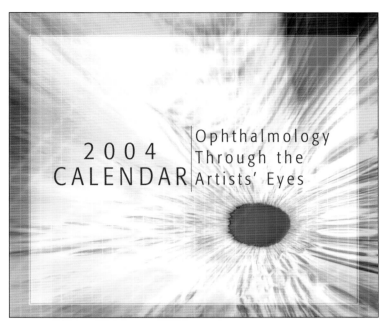

BRAND REMINDERS

USA

FINALIST, SINGLE

PACE INC.

PARSIPPANY, NJ

CLIENT Pfizer Ophthalmics

SR. VP, CREATIVE DIRECTOR, COPY Sharon McCarroll

SR. ART DIRECTOR Kristin Acuna

GROUP COPY SUPERVISOR Charles Nidenberg

SR. VP, CREATIVE DIRECTOR, ART Dainius Jaras

VP, GROUP DIRECTOR, COPY Jeffrey Hughes

SENIOR ART DIRECTOR Kristin Acuna

PHYSICIAN & PHOTOGRAPHER Karl Brasse, MD

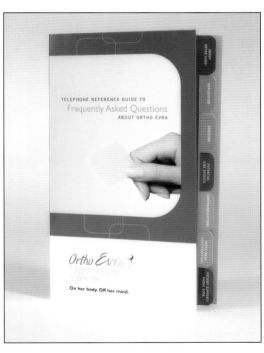

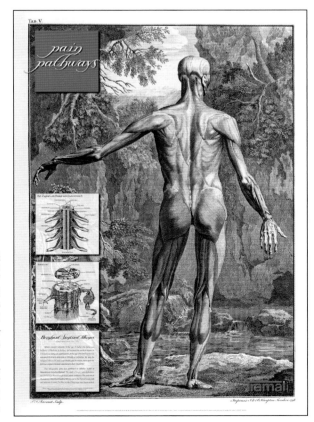

USA

FINALIST, SINGLE

INTEGRATED COMMUNICATIONS CORP.

PARSIPPANY, NJ

CLIENT ORTHO EVRA

VP/ASSOCIATE CREATIVE DIRECTOR/ART Beth Goozman

VP/ASSOCIATE CREATIVE DIRECTOR/COPY Karan Bredenbeck

SR. ART DIRECTOR Mary O'Halloran

VP/ASSOCIATE CREATIVE DIRECTOR, ART Beth Goozman

PRODUCTION MANAGER Maurice Arce

AUSTRALIA

FINALIST, SINGLE

SUDLER & HENNESSEY
MELBOURNE

MELBOURNE, VICTORIA

CLIENT Tramal

ADVERTISING AGENCY

Sudler & Hennessey Melbourne

SENIOR COPYWRITER David Bacon

SENIOR ART DIRECTOR Mark Webster

ILLUSTRATORS B.S. Albinus/
Craig McGill

CLIENT Sue McFadden

USA

FINALIST, SINGLE
TORRE LAZUR McCANN
PARSIPPANY, NJ

CLIENT Aciphex
SENIOR ART DIRECTOR Annemarie Aneses
ART SUPERVISOR Jennifer Fajnor
COPY SUPERVISOR LeighAnne Tibak/Katharine Imbro
EXECUTIVE VP, CREATIVE DIRECTOR Scott Watson
VP CREATIVE DIRECTOR - ART Jennifer Alampi
VP CREATIVE DIRECTOR - COPY Marcia Goddard
ACCOUNT EXECUTIVE Patty Narcise
TRAFFIC Stephanie Lake
DIGITAL IMAGING GROUP Darren Westley
PRODUCTION MANAGER Pat Norman
ACCOUNT GROUP SUPERVISOR Lisa Desbien

IRELAND

FINALIST, CAMPAIGN
BOLD
CROSSGUNS BRIDGE

CLIENT Affex
BRAND MANAGER Barry O'Sullivan
CREATIVE DIRECTOR Siobhan Lonergan/Paula McKenna
DESIGNER Joe Clarke/Daragh OíToole/Lana OíFlynn

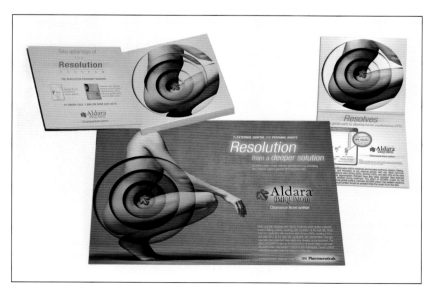

USA

FINALIST, CAMPAIGN
KPR
NEW YORK, NY

CLIENT Aldara
SVP, GROUP CREATIVE DIRECTOR Mitch Siegel
ART DIRECTOR Annie Yoo
SVP, GROUP CREATIVE DIRECTOR Letty Albarran
VP, COPY GROUP SUPERVISOR Mary Jo Schnatter
SVP, CREATIVE DIRECTOR Bernie Steinman

WE LIVE

USA
FINALIST, SINGLE
CALIFORNIA PACIFIC MEDICAL CENTER
SAN FRANCISCO, CA

CLIENT California Pacific Medical Center
DIRECTOR COMMUNICATIONS Cynthia Chiarappa
DESIGNER Chen Design Associates
PUBLICATIONS MANAGER Cindy Dove
WRITER Susan Sharpe
PHOTOGRAPHER Todd Hito
PROJECT MANAGER Tanya Farrell
PROJECT MANAGER, FOUNDATION Marsha Daniels

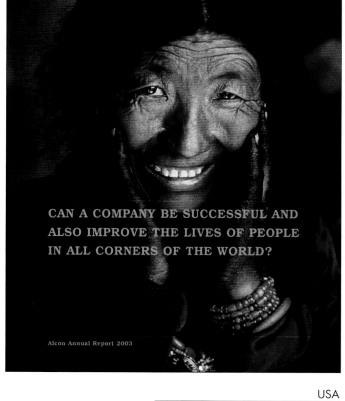

CAN A COMPANY BE SUCCESSFUL AND ALSO IMPROVE THE LIVES OF PEOPLE IN ALL CORNERS OF THE WORLD?

Alcon Annual Report 2003

USA
FINALIST, SINGLE
CAHAN & ASSOCIATES
SAN FRANCISCO, CA

CLIENT Alcon Laboratories
CREATIVE DIRECTOR/ART DIRECTOR Bill Cahan
ART DIRECTOR/DESIGNER/COPYWRITER Bob Dinetz
PHOTOGRAPHER Todd Hido
COPYWRITER Kathy Cooper Parker
PHOTOGRAPHER Steve McCurry
PHOTOGRAPHER Ian Spanier

gentium

a new healthcare research company

ITALY
FINALIST, SINGLE
GENTIUM SPA
VILLA GUARDIA, COMO

CLIENT Gentium
VP/CEO Laura Iris Ferro MD

USA
FINALIST, SINGLE
ARNOLD SAKS ASSOCIATES
NEW YORK, NY

CLIENT Hospital for Special Surgery
ART DIRECTOR Arnold Saks
GRAPHIC DESIGNER Lisa Corcoran
EDITOR-IN-CHIEF Josh Friedland
MANAGING EDITOR Linda Errante
PHOTOGRAPHER Robert Essel

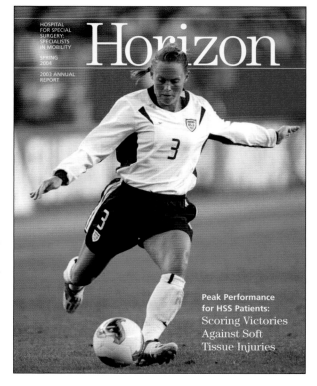

Horizon

HOSPITAL FOR SPECIAL SURGERY: SPECIALISTS IN MOBILITY SPRING 2004 2003 ANNUAL REPORT

Peak Performance for HSS Patients: Scoring Victories Against Soft Tissue Injuries

USA

ABELSON-TAYLOR
CHICAGO, IL

CLIENT Aranesp
VP, CREATIVE GROUP DIRECTOR Stephen Neale
ASSOCIATE CREATIVE DIRECTOR Kaye Kilgore
ART DIRECTOR Debbie Lim
SR. COPYWRITER Mary Jane Myers

CANADA
LXB COMMUNICATION MARKETING
QUÉBEC CITY

CLIENT Axcan Pharma S.A
SENIOR VP EUROPEAN COMM. OPERATIONS Patrick L. McLean
MANAGING DIRECTOR Rainer Wulf
SUPERVISOR, PHARMACEUTICAL SERVICES Victoria Nachef
ART DIRECTOR Martin Dessureaux
COPYWRITER Peter MacMillan
PRINTER Intramédia
GRAPHIC DESIGNER Shane Neville/Marie-Ève Nadeau
PHOTOGRAPHER Jose Bouthillette/Christian Fleury

USA

**STRATAGEM HEALTHCARE
COMMUNICATIONS**
SAN FRANCISCO, CA

CLIENT Allegretto Wave
CREATIVE DIRECTOR/COPYWRITER
Patricia Malone
SENIOR ART DIRECTOR
Audrey Moh
PRODUCTION MANAGER
Martha Lightcap
ACCOUNT SERVICES
Susan Hempstead

USA
PIVOT DESIGN, INC.
CHICAGO, IL

CLIENT Children's Memorial
Hospital, Chicago
CREATIVE DIRECTOR
Brock Haldeman
DESIGNER David Altholz/
Liz Haldeman
PHOTOGRAPHER
Russell Ingram Photography
PRINTER Active Graphics

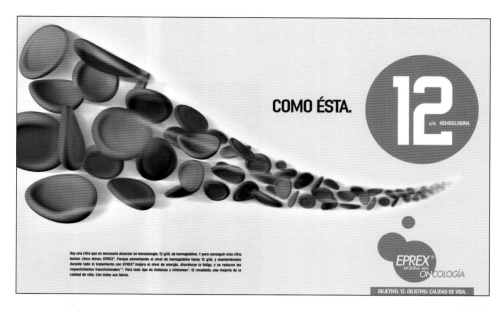

SPAIN

FINALIST, SINGLE
HEALTHWORLD SPAIN
MADRID

CLIENT Eprex
CHIEF CREATIVE OFFICER Javier Agudo
ART DIRECTOR Natalia Naranjo
JANSSEN CILAG'S UNIT BUSINESS MANAGER Xavier Moix

USA

FINALIST, SINGLE
THE NANCEKIVELL GROUP
MINNEAPOLIS, MN

CLIENT Possis Medical, Inc.
PRESIDENT Jim Nancekivell
CREATIVE DIRECTOR Brian Prentice
CHIEF FINANCIAL OFFICER Eapen Chacko

USA

FINALIST, SINGLE
THE NANCEKIVELL GROUP
MINNEAPOLIS, MN

CLIENT American Medical Systems
PRESIDENT Jim Nancekivell
V.P. AND CREATIVE DIRECTOR Frank James
V.P., FINANCE Jim Call

DETAIL/SALES AID

AUSTRALIA

GLOBAL AWARD, SINGLE
McCANN HEALTHCARE
SYDNEY

CLIENT **Solian**
WRITER **Hugh Fitzhardinge**
ART DIRECTOR **Grant Foster**
SR. ACCOUNT MANAGER **Claire Pope**
PRODUCT MANAGER **Adrian Dunstan**
PHOTOGRAPHER **Tim Bauer**
DESIGNER **Bridget Pooley**
SENIOR ACCOUNT DIRECTOR **Elly Price**

USA

FINALIST, SINGLE
ABELSON-TAYLOR
CHICAGO, IL

CLIENT **Gliadel Wafers**
VP, CREATIVE GROUP DIRECTOR **Josh Vizek**
ASSOCIATE CREATIVE DIR **Brad Graetz/Jim Clarke**
ART DIRECTOR **Tommaso Lesnick**
COPYWRITER **Joanne Casey**

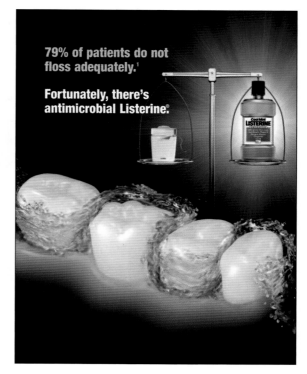

USA

FINALIST, SINGLE
ADAIR-GREENE HEALTHCARE
COMMUNICATIONS
ATLANTA, GA

CLIENT ROSAC Cream with Sunscreens
CREATIVE DIRECTOR Rita Brett
ART DIRECTOR Sally Matthews
COPYWRITER Linda Donnelly
DESIGNER Leslye Wilkins
PRINT PRODUCTION Chris Hamacheck
SENIOR ACCOUNT EXECUTIVE Tim Fergus

USA

FINALIST, SINGLE
ADIENT
PARSIPPANY, NJ

CLIENT Listerine
EXEC. VP CCO MANAGING PARTNER Rich Norman
VP GROUP CREATIVE DIRECTOR Bill Tsiakaros
GROUP COPY SUPERVISOR Tracy Wetstein
SENIOR ART DIRECTOR Anthony Martins
ASST. ART DIRECTOR Dorian Demski
VP ACCOUNT SUPERVISOR Jennifer Cerulli
DIGITAL DESIGNER Studio McBeth

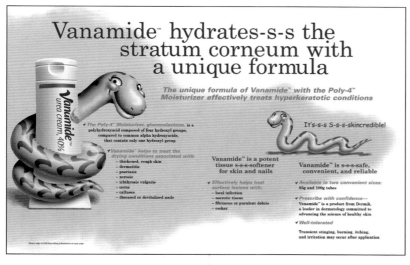

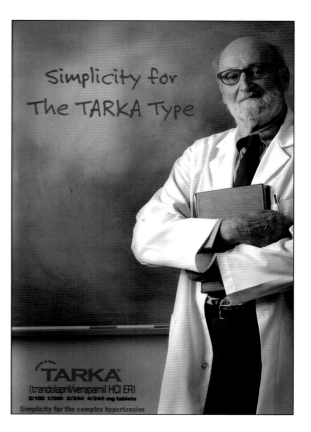

USA

FINALIST, SINGLE
DONAHOE PUROHIT MILLER
CHICAGO, IL

CLIENT Vanamide
VP CREATIVE/ADVERTISING Jay Doniger
ACCOUNT SUPERVISOR Shana Robinson
ART DIRECTOR Heidi Osterhout
COPYWRITER Dick Jacobs
PRODUCT MANAGER Chris Siegel

USA

FINALIST, SINGLE
EURO RSCG LIFE RIVERWORKS
LAMBERTVILLE, NJ

CLIENT Tarka
GROUP COPY SUPERVISOR Gail Johnson
ARTIST Janet Sullivan
PRODUCT MANAGER Jashdeep Brar
ACCOUNT EXECUTIVE Matt
Schneider/Lindsey Martin
ART DIRECTOR Mary Rose Migliazza
MEDICAL STRATEGIST Jason Fontana Ph.D
PHOTOGRAPHER Marty Umans

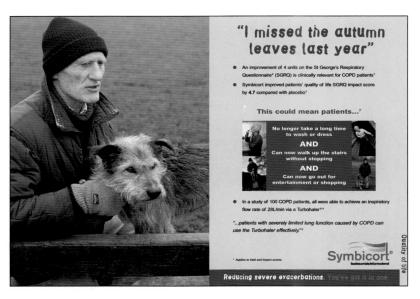

ENGLAND

FINALIST, SINGLE
LEC ADVERTISING
COWLEY, UXBRIDGE

CLIENT Symbicort
CREATIVE DIRECTOR Phil Cox
ART DIRECTOR Chris MacKintosh
WRITER Jack Dolan
PHOTOGRAPHER Chris Holland
CLIENT Kate Higham

USA

FINALIST, SINGLE
INTEGRATED COMMUNICATIONS CORP.
PARSIPPANY, NJ

CLIENT ORTHO EVRA/Ortho Tri-Cyclen Lo
VP/ASSOCIATE CREATIVE DIRECTOR/ART Beth Goozman
VP/ASSOCIATE CREATIVE DIRECTOR/COPY Karan Bredenbeck
GROUP ART SUPERVISOR Ken Zierler
PHOTOGRAPHER Caroline Knopf/Chris Kilkus
DIGITAL COMPOSITION Chromewerk Graphics

USA

FINALIST, SINGLE
INTEGRATED COMMUNICATIONS CORP.
PARSIPPANY, NJ

CLIENT ORTHO EVRA/Ortho Tri-Cyclen Lo
VP/ASSOCIATE CREATIVE DIRECTOR/ART Beth Goozman
VP/ASSOCIATE CREATIVE DIRECTOR/COPY Karan Bredenbeck
GROUP ART SUPERVISOR Ken Zierler
PHOTOGRAPHER Caroline Knopf
DIGITAL COMPOSITION Chromewerk Graphics
PHOTOGRAPHER Chris Kilkus

ITALY

FINALIST, SINGLE
SUDLER & HENNESSEY
INTERNATIONAL
MILANO

CLIENT Cypher Select

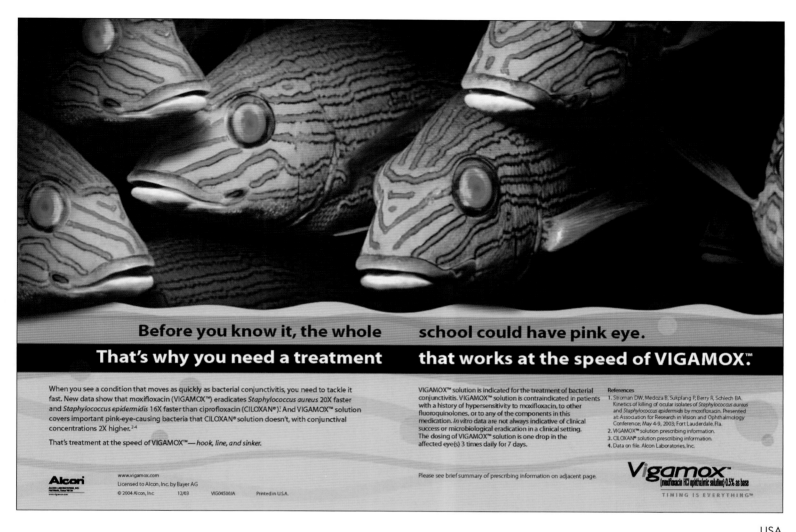

Before you know it, the whole school could have pink eye.

That's why you need a treatment that works at the speed of VIGAMOX.™

When you see a condition that moves as quickly as bacterial conjunctivitis, you need to tackle it fast. New data show that moxifloxacin (VIGAMOX™) eradicates *Staphylococcus aureus* 20X faster and *Staphylococcus epidermidis* 16X faster than ciprofloxacin (CILOXAN®). And VIGAMOX™ solution covers important pink-eye-causing bacteria that CILOXAN® solution doesn't, with conjunctival concentrations 2X higher.[2-4]

That's treatment at the speed of VIGAMOX™— *hook, line, and sinker.*

VIGAMOX™ solution is indicated for the treatment of bacterial conjunctivitis. VIGAMOX™ solution is contraindicated in patients with a history of hypersensitivity to moxifloxacin, to other fluoroquinolones, or to any of the components in this medication. *In vitro* data are not always indicative of clinical success or microbiological eradication in a clinical setting. The dosing of VIGAMOX™ solution is one drop in the affected eye(s) 3 times daily for 7 days.

References
1. Stroman DW, Medoza B, Sukplang P, Berry R, Schlech BA. Kinetics of killing of ocular isolates of *Staphylococcus aureus* and *Staphylococcus epidermidis* by moxifloxacin. Presented at: Association for Research in Vision and Ophthalmology Conference; May 4-9, 2003; Fort Lauderdale, Fla.
2. VIGAMOX™ solution prescribing information.
3. CILOXAN® solution prescribing information.
4. Data on file. Alcon Laboratories, Inc.

Alcon
ALCON LABORATORIES, INC.
Fort Worth, Texas 76134

www.vigamox.com
Licensed to Alcon, Inc. by Bayer AG
© 2004 Alcon, Inc. 12/03 VIG04500JA Printed in U.S.A.

Please see brief summary of prescribing information on adjacent page.

Vigamox™
(moxifloxacin HCl ophthalmic solution) 0.5% as base
TIMING IS EVERYTHING™

USA
GLOBAL AWARD
CORBETT ACCEL HEALTHCARE GROUP
CHICAGO, IL

CLIENT Vigamox
GROUP CREATIVE DIRECTOR Eric Loeb
ART DIRECTOR Greg Gwynne
COPYWRITER Lisa Holmes/Terry Smith

TAXUS™ *Express²™*
Paclitaxel-Eluting Coronary Stent System

Boston
Scientific

The Power
and the Proof

USA
FINALIST, SINGLE
SEIDLER BERNSTEIN INC.
CAMBRIDGE, MA

CLIENT Boston Scientific
CREATIVE DIRECTOR Jo Seidler
SENIOR DESIGNER Alla Litovchenko/
Keith Ward
COPYWRITER Scott Whittler

USA

FINALIST CERTIFICATE

ABELSON-TAYLOR

CHICAGO, IL

CLIENT Neulasta

VP, CREATIVE GROUP DIRECTOR Angela Lustig

ASSOCIATE CREATIVE DIRECTOR Annie Barton/Ted Goeglein

SR. ART DIRECTOR Jeannette Tiano-Milligan

SR. COPYWRITER Jim Haupt

USA

FINALIST CERTIFICATE

TORRE LAZUR McCANN

PARSIPPANY, NJ

CLIENT Paxil

VP CREATIVE DIRECTOR/ART Jennifer Alampi

VP CREATIVE DIRECTOR/COPY Marcia Goddard

COPY SUPERVISOR Katharine Imbro

SENIOR ART DIRECTOR Debra Feath

EXECUTIVE VP CREATIVE DIRECTOR Scott Watson

VP ACCOUNT GROUP SUPERVISOR Tatiana Lyons

ACCOUNT EXECUTIVE Stacy Duskin

PRODUCTION SUPERVISOR Mike Lenert

DIGITAL IMAAGING GROUP Darren Westley

ACCOUNT COORDINATOR Brea Ranft

TRAFFIC Grace Krusnik

ACCOUNT COORDINATOR Brea Ranft

USA

FINALIST CERTIFICATE

CORBETT ACCEL HEALTHCARE GROUP

CHICAGO, IL

CLIENT Levoxyl

GROUP CREATIVE DIRECTOR Phil Adams

COPYWRITER Joanna Friel-Wimmer

ART DIRECTOR Michael Franzese

Because
she thinks
the world
of him

For patients like Edward living with Parkinson's disease, it's the simple tasks that are important, like helping to fix his granddaughter's bike.[1] However, living with PD makes it increasingly difficult to do even the simplest things in life.[1] REQUIP can help. With REQUIP, patients like Edward are able to maintain their ability to perform activities of daily living while significantly reducing the risk of dyskinesia vs L-dopa.[2]

Make a difference for your patients with Parkinson's disease.

Safety and effectiveness in the pediatric population have not been established.

REQUIP has been associated with sedating effects, including somnolence, and the possibility of falling asleep while engaged in activities of daily living, including operation of a motor vehicle. Syncope or symptomatic hypotension may occur more frequently during initial treatment or with an increase in dose. Hallucinations may occur at any time during treatment. REQUIP may potentiate the dopaminergic side effects of L-dopa and may cause and/or exacerbate pre-existing dyskinesias.

FOR THE TREATMENT OF PARKINSON'S DISEASE

REQUIP®
ropinirole HCl

Please see brief summary of complete Prescribing Information on adjacent page.

gsk GlaxoSmithKline

ORANGE CARD

A Progressive Therapy
for a Progressive Disease

DIRECT MAIL

USA
FINALIST, SINGLE
CLINICAL CONNEXION
NEWTOWN, PA

CLIENT **Janssen Pharmaceutica**
CREATIVE DIRECTOR **Jim Welsh**
GRAPHIC DESIGNER **Jennifer Jacobs**
SENIOR COPYWRITER **Jill St. Ambrogio**
GROUP ACCOUNT MANAGER **Amy Singer**
PRODUCT MANAGER, JANSSEN PHARMACEUTICA **John Kobus**
AGA **Diane Bach/Michael Stolar**

USA
FINALIST, SINGLE
FRY HAMMOND BARR
ORLANDO, FL

CLIENT **Fry Hammond Barr**
CREATIVE DIRECTOR **Tim Fisher**
COPYWRITER **Tim Fisher**
ART DIRECTOR **Sean Brunson**
PHOTOGRAPHER **John Bateman**

SPAIN
FINALIST, SINGLE
GLOBAL HEALTHCARE
BARCELONA

CLIENT **Global Healthcare**
CREATIVE DIRECTOR **Berta Loran**
ART DIRECTOR **Xavier Rambla**
ART DIRECTOR Jr **Borja Coll**
COPYWRITER **Berta Loran**

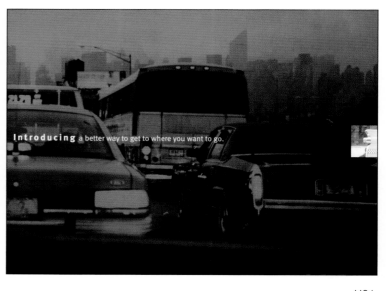

USA
FINALIST, SINGLE
GSW WORLDWIDE
WESTERVILLE, OH

CREATIVE DIRECTOR **Marc Sapp**
CHIEF CREATIVE OFFICER **Bruce Rooke**
ARMSTRONG/WHITE **Bruno Homan**
GROUP ART SUPERVISOR **Jeff Schatz**

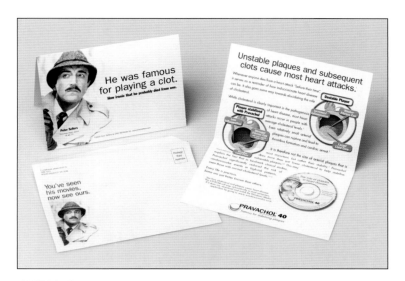

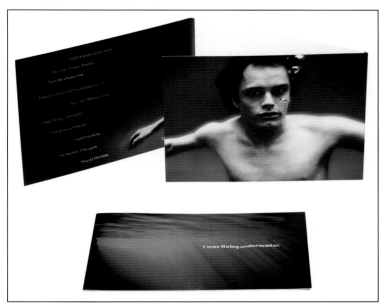

AUSTRALIA

FINALIST, SINGLE

McCANN HEALTHCARE
MELBOURNE

SOUTH MELBOURNE, VIC

CLIENT Pravachol
COPYWRITER Anthony Foy
ART DIRECTOR Sean Riley
CREATIVE DIRECTOR Anthony Foy
MAC ARTIST Amber Gibb

AUSTRALIA

FINALIST, SINGLE

McCANN HEALTHCARE

SYDNEY

CLIENT Solian
WRITER Hugh Fitzhardinge
ART DIRECTOR Grant Foster
SR. ACCOUNT MANAGER Claire Pope
PRODUCT MANAGER Adrian Dunstan
CREATIVE DIRECTOR Hugh Fitzhardinge/
Grant Foster
PHOTOGRAPHER Tim Bauer
DESIGNER Bridget Pooley

AUSTRALIA

FINALIST, SINGLE

McCANN HEALTHCARE
MELBOURNE

SOUTH MELBOURNE, VICTORIA

CLIENT Actonel
COPYWRITER Chris Singh
ART DIRECTOR Sean Riley
MAC ARTIST Amber Gibb
CREATIVE DIRECTOR Anthony Foy
ILLUSTRATOR David Dunstan

AUSTRALIA

FINALIST, SINGLE

McCANN HEALTHCARE

SYDNEY

CLIENT Epilim
CREATIVE DIRECTOR Hugh Fitzhardinge
WRITER Alex Tagaroulias
ART DIRECTOR Grant Foster
CREATIVE DIRECTOR Grant Foster
ACCOUNT DIRECTOR David Chriswick
SR. ACCOUNT MANAGER Claire Pope
DESIGNER Bridget Pooley

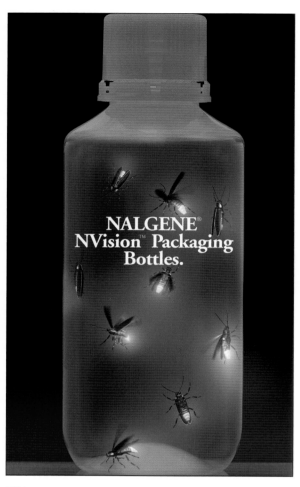

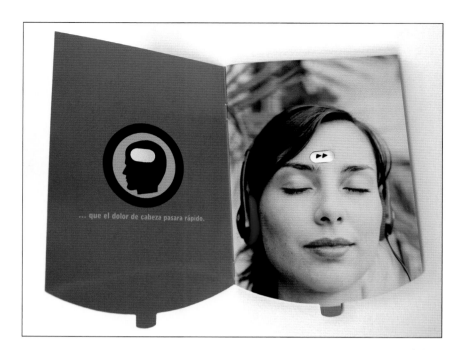

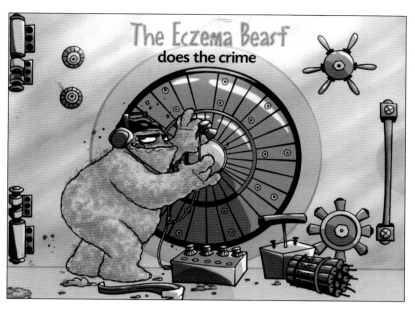

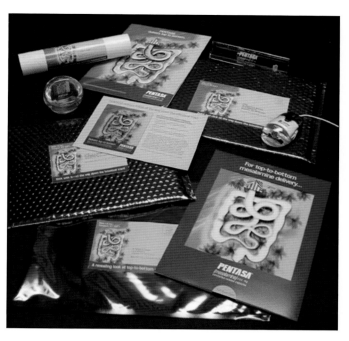

USA

FINALIST, SINGLE
WILLIAMS-LABADIE
CHICAGO, IL

CLIENT Protopic
VP. CREATIVE DIRECTOR James McGuire
SR. ART DIRECTOR Laura Banick
COPYWRITER Brandi Homan
ACCOUNT SUPERVISOR Lynne Morris

USA

FINALIST, CAMPAIGN
ABELSON-TAYLOR
CHICAGO, IL

CLIENT Pentasa
VP. CREATIVE GROUP DIRECTOR Angela Lustig
ASSOCIATE CREATIVE DIRECTOR Annie Barton
ART DIRECTOR Suzanne Cronacher/Verna Semenik
COPYWRITER Barbara Delonnay/Margaret Reich

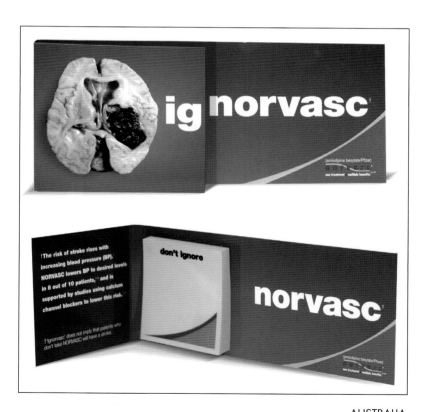

USA

FINALIST, CAMPAIGN
ABELSON-TAYLOR
CHICAGO, IL

CLIENT Prevacid
VP. CREATIVE GROUP DIRECTOR Stephen Neale
ASSOCIATE CREATIVE DIRECTOR Barry Levine
SENIOR ART DIRECTOR Ed Fong
COPYWRITER Joseph Tiu

AUSTRALIA
FINALIST, SINGLE
SUDLER & HENNESSEY SYDNEY
NORTH SYDNEY

CLIENT Norvasc

NEW ZEALAND

FINALIST, CAMPAIGN

INSIGHT

AUCKLAND

CLIENT Flixotide ? GlaxoSmithKline
ART DIRECTOR Margaret Murray
COPYWRITER Gerrard Malcolm
PRODUCT MANAGER Jeroen van der Lans
ACCOUNT DIRECTOR David Anderson

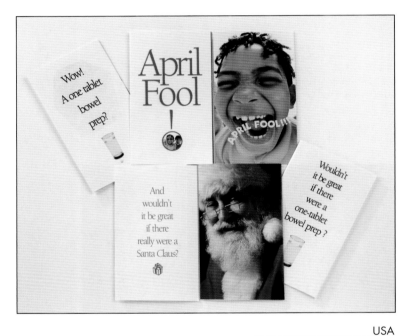

USA

FINALIST, CAMPAIGN

BOWER MARKETING INC.

GREENSBORO, NC

CLIENT Fleet Phospho-Soda
CREATIVE DIRECTOR Earle Bower
ART DIRECTOR Linda Tavernise

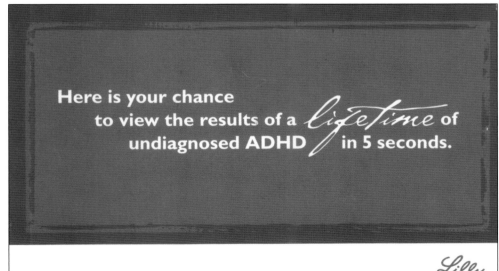

USA

FINALIST, CAMPAIGN

GSW WORLDWIDE

WESTERVILLE, OH

CLIENT Strattera
CREATIVE DIRECTOR Keith Cowgill
GROUP COPY SUPERVISOR Denise Leo
GROUP ART SUPERVISOR Sharon Brady
ART DIRECTOR Elenie Poulos/Kim Potterf
COPYWRITER Angie Evans/Felix Secreto
BROADCAST PRODUCER Rob Gibbons
CREATIVE SERVICES SUPERVISOR Lynn Dinsmore
VIDEO PRODUCTION SOS Productions

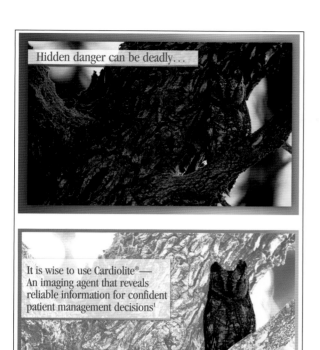

Hidden danger can be deadly...

It is wise to use Cardiolite® —
An imaging agent that reveals
reliable information for confident
patient management decisions[1]

Cardiolite®
Kit for the Preparation of
Technetium Tc99m Sestamibi for Injection

USA

FINALIST, CAMPAIGN
THE HAL LEWIS GROUP, INC.
PHILADELPHIA, PA

CLIENT Cardiolite
CREATIVE DIRECTOR Marvin Bowe
GROUP ART SUPERVISOR Christina Stehr
GROUP COPY SUPERVISOR William Goldberg
DESIGNER Olga Ioukhanova

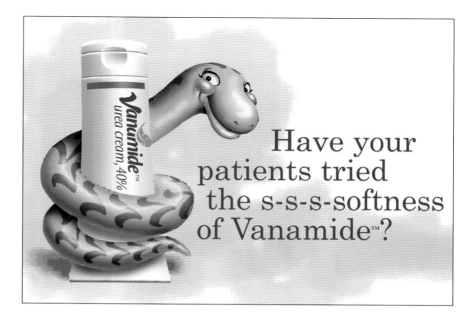

Vanamide™
urea cream, 40%

Have your
patients tried
the s-s-s-softness
of Vanamide™?

USA

FINALIST, CAMPAIGN
DONAHOE PUROHIT MILLER
CHICAGO, IL

CLIENT Vanamide
VP CREATIVE/ADVERTISING Jay Doniger
ACCOUNT SUPERVISOR Shana Robinson
ART DIRECTOR Heidi Osterhout
COPYWRITER Dick Jacobs
VP CREATIVE/ADVERTISING Jay Doniger
ACCOUNT SUPERVISOR Shana Robinson
PRODUCT MANAGER Chris Siegel

listen
listen

USA

FINALIST, CAMPAIGN
GSW WORLDWIDE
WESTERVILLE, OH

CLIENT Strattera/Eli Lilly and Company
CREATIVE DIRECTOR Keith Cowgill
GROUP COPY SUPERVISOR Denise Leo
GROUP ART SUPERVISOR Sharon Brady
ART DIRECTOR Elenie Poulos
COPYWRITER Felix Secreto/Steve Fletcher
PHOTOGRAPHER Andrea Mandel

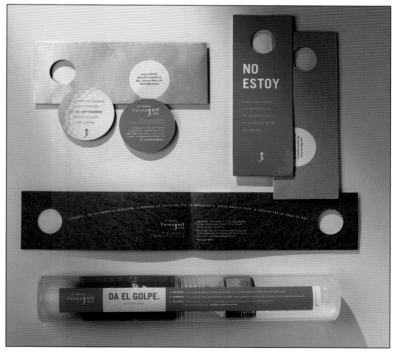

SPAIN

FINALIST, CAMPAIGN
GLOBAL HEALTHCARE
BARCELONA

CLIENT Global Healthcare
CREATIVE DIRECTOR Berta Loran
ART DIRECTOR Xavier Rambla
COPYWRITER Berta Loran

GLOBAL AWARD, SINGLE
PAN ADVERTISING
SURREY

CLIENT **Respimat Soft Mist Inhaler**
CREATIVE DIRECTOR **Steve Pinn**
SENIOR COPYWRITER **Jerry Neville-Jones**
ACCOUNT MANAGER **Sarah Hurn**
MANAGING DIRECTOR **Ben Davies**

USA

FINALIST, SINGLE
KPR
NEW YORK, NY

CLIENT **EMD Oncology**
SVP, ASSOC. CREATIVE DIRECTOR **James T. Walsh**
ART SUPERVISOR **Jonathan Gough**
ART DIRECTOR **Kate Kellam**
SVP, COPY GROUP SUPERVISOR **Nancy Richman**
SVP MANAGEMENT SUPERVISOR **Jack Dorsey**
SVP, CREATIVE DIRECTOR **Bernie Steinman**

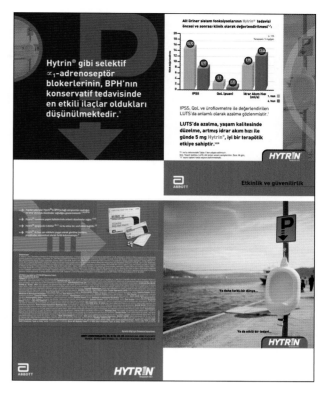

USA

FINALIST, CAMPAIGN

ADINFINITUM

NEW YORK, NY

CLIENT Longjiang River Health Products
CEO & PRESIDENT Sue Taggart

TURKEY

GLOBAL AWARD, CAMPAIGN

HEALTHY PEOPLE BY GREY WORLDWIDE

ISTANBUL

CLIENT Hytrin/Abbott
COPYWRITER Turker Kurtonur/Aysin Akbulut
ART DIRECTOR Didem Kotas
PHOTOGRAPHER Batu Tezyuksel
GRAPHIC DESIGNER Serkan Korkut Buyuk/Sakine Golbasi
CREATIVE GROUP DIRECTOR Tevfik Sems Naipoglu
ACCOUNT EXECUTIVE Burcu Ozbek

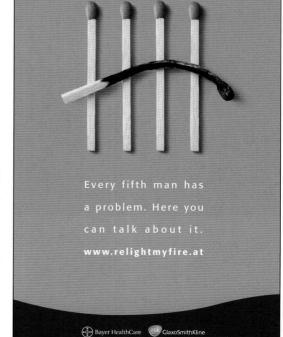

AUSTRIA

FINALIST, CAMPAIGN

BBDO AUSTRIA

VIENNA

CLIENT Levitra
CREATIVE DIRECTOR Dr. Markus Enzi
ART DIRECTOR Richard Kaim
COPYWRITER Bernhard Rems
STRATEGIC PLANNING Dr. Angelika Trachtenberg
ACCOUNT MANAGER Roberta Mrkvicka
ART DESIGN Carina Kos
CLIENT/PRODUCT MANAGER MAG. Marcus Dietmayer
CLIENT/PRODUCT MANAGER DIPL.-ING. Alexander Barta
CLIENT/PRODUCT MANAGER MAG. Daniela Lang

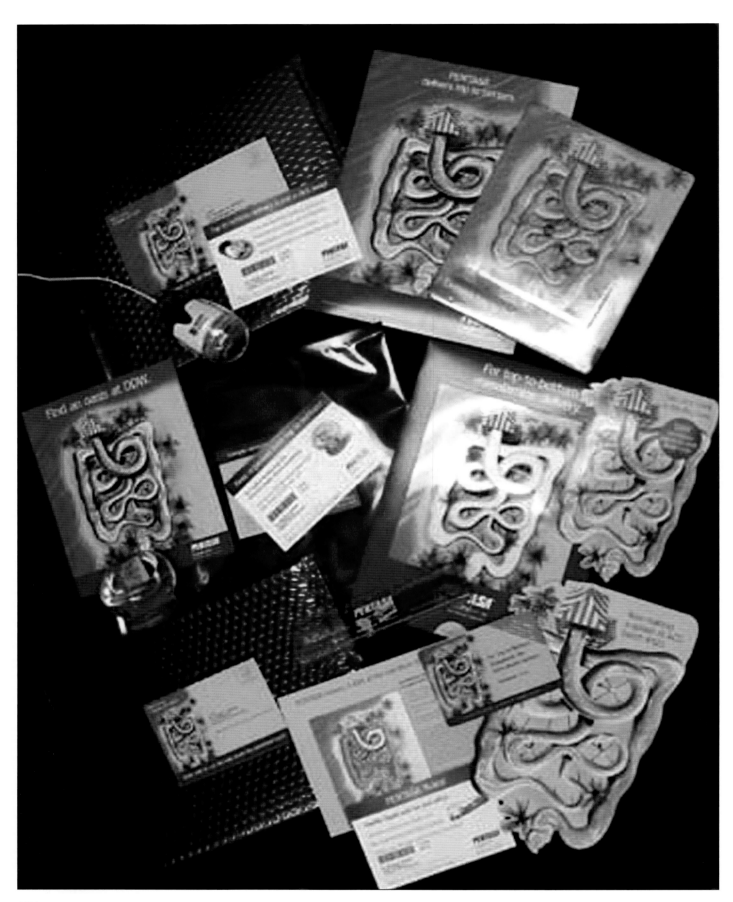

USA

GLOBAL AWARD, CAMPAIGN

ABELSON-TAYLOR

CHICAGO, IL

CLIENT Pentasa
VP, CREATIVE GROUP DIRECTOR Angela Lustig
ASSOCIATE CREATIVE DIRECTOR Annie Barton
ART DIRECTOR Suzanne Cronacher/Verna Semenik
COPYWRITER Barbara Delonnay/Margaret Reich

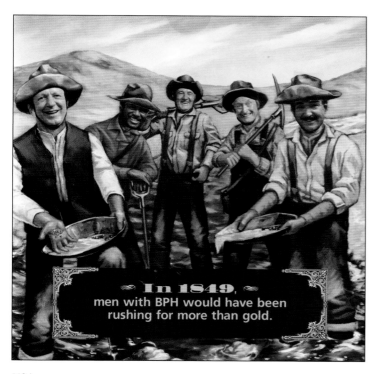

In 1849, men with BPH would have been rushing for more than gold.

USA

FINALIST, CAMPAIGN

EURO RSCG LIFE CHELSEA
NEW YORK, NY

CLIENT Flomax
GLOBAL CHIEF CREATIVE OFFICER Cary Lemkowitz
VP/ASSOC. CD/SVP/SENIOR CD Caroline Burton/Roy Tuck
ART SUPERVISOR Cindy Ho
COPY SUPERVISOR Michael Patterson

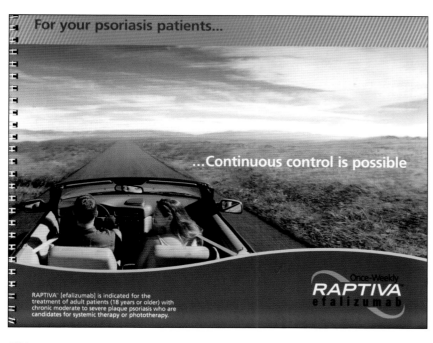

For your psoriasis patients...

...Continuous control is possible

RAPTIVA efalizumab
Once-Weekly

RAPTIVA™ [efalizumab] is indicated for the treatment of adult patients (18 years or older) with chronic moderate to severe plaque psoriasis who are candidates for systemic therapy or phototherapy.

USA

FINALIST, CAMPAIGN

GSW WORLDWIDE
WESTERVILLE, OH

CLIENT Raptiva
CREATIVE DIRECTOR Tina Fascetti
CREATIVE DIRECTOR Bill Fillipp
ART DIRECTOR Rhonda Fullerton
COPYWRITER Deanna Geibel
PHOTOGRAPHER Peter Leverman
RETOUCHING Armstrong White
ART BUYER Kate Spanos

USA

FINALIST, CAMPAIGN

ABELSON-TAYLOR
CHICAGO, IL

CLIENT Aranesp
VP, CREATIVE GROUP DIRECTOR Stephen Neale
ASSOC CREATIVE DIRECTOR Kaye Kilgore/Josh Vizek
ART DIRECTOR Debbie Lim
COPYWRITER Mary Jane Myers/Bill Boyd

USA

FINALIST, CAMPAIGN

FLEET PHARMACEUTICALS
LYNCHBURG, VA

CLIENT Fleet Phospho-soda
DIRECTOR OF MARKETING Raymond Pennino

USA

FINALIST, CAMPAIGN

GSW WORLDWIDE
WESTERVILLE, OH

CLIENT Evista
SENIOR ART DIRECTOR Dennis Leahy
COPYWRITER Jim Willis
CREATIVE PROJECT MANAGER Jamie Mateljan
ACCOUNT EXECUTIVE Chris Bedell
ART DIRECTOR Stephanie Stone

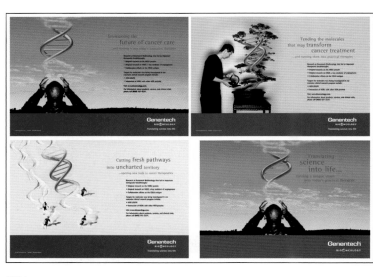

USA

FINALIST, CAMPAIGN

HAMILTON COMMUNICATIONS GROUP
CHICAGO, IL

CLIENT Abbott Molecular Diagnostics - Cystic Fibrosis ASR
ACCOUNT MANAGER Jesse Johanson
CREATIVE DIRECTOR Faith Thoma
DESIGNER Jim Haag
WRITER Shari Andersson
PRODUCTION MANAGER Denise Mazurek
ABBOTT GLOBAL MARKETING MANAGER Christopher Jowett

USA

FINALIST, CAMPAIGN

HARRISON AND STAR
NEW YORK, NY

CLIENT Genentech BioOncology
EXECUTIVE CREATIVE DIRECTOR Kevin McShane
CREATIVE DIRECTOR Marjorie Vincent/Laura Praiss Kim
GROUP ART SUPERVISOR Beth Russo
EXECUTIVE CREATIVE DIRECTOR Kevin McShane

USA

FINALIST, CAMPAIGN

HARRISON AND STAR
NEW YORK, NY

CLIENT Genentech BioOncology
ART DIRECTOR Arthur Anderson
SENIOR ART DIRECTOR Jennifer Fox
EXECUTIVE CREATIVE DIRECTOR Kevin McShane
COPY SUPERVISOR Micheal Norkin
CREATIVE DIRECTOR Laura Praiss Kim/Marjorie Vincent
GROUP ART SUPERVISOR Beth Russo
COPY SUPERVISOR Kevin McShane/Michael Norkin

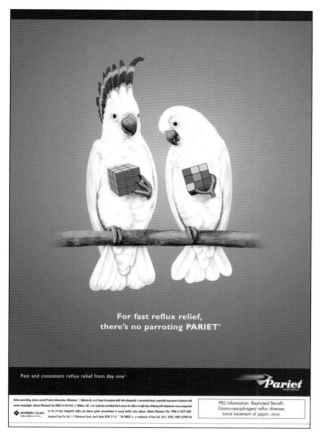

For fast reflux relief,
there's no parroting PARIET®

Fast and consistent reflux relief from day one

Pariet

AUSTRALIA

FINALIST, CAMPAIGN
HEALTH WORLD
NORTH SYDNEY

CLIENT Pariet
CEO/STRATEGIST G. Edwards
CREATIVE DIRECTOR A. Nairn
ACCOUNT DIRECTOR S. Skelton
MARKETING MANAGER J. Ryan
PRODUCT MANAGER K. Johns

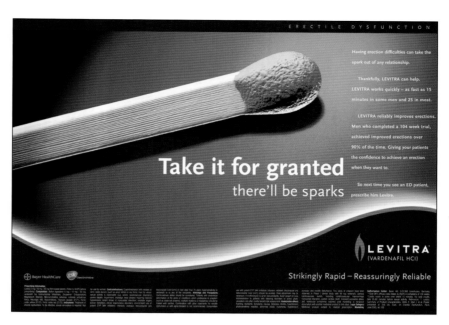

ERECTILE DYSFUNCTION

Having erection difficulties can take the spark out of any relationship.

Thankfully, LEVITRA can help. LEVITRA works quickly – as fast as 15 minutes in some men and 25 in most.

LEVITRA reliably improves erections. Men who completed a 104 week trial, achieved improved erections over 90% of the time. Giving your patients the confidence to achieve an erection when they want to.

So next time you see an ED patient, prescribe him Levitra.

Take it for granted
there'll be sparks

LEVITRA
(VARDENAFIL HCI)

Strikingly Rapid – Reassuringly Reliable

ENGLAND

FINALIST, CAMPAIGN
MEDICUS LONDON
LONDON

CLIENT Levitra
CREATIVE DIRECTOR Nolan Willis
ART DIRECTOR Jamie Latham
MANAGING DIRECTOR Becky Cawthorn-Smith
ACCOUNT MANAGER Katie Bright
GRAPHIC ARTWORKER Fadia Dekoune
ACCOUNT MANAGER Katie Bright

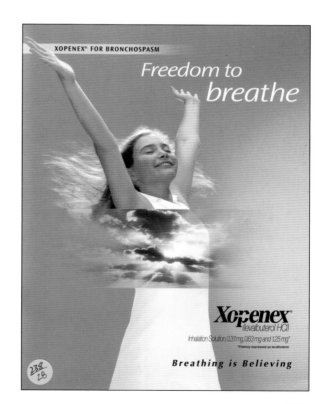

XOPENEX® FOR BRONCHOSPASM

Freedom to breathe

Xopenex
(levalbuterol HCl)
Inhalation Solution 0.31 mg, 0.63 mg and 1.25 mg*
*Potency expressed as levalbuterol.

Breathing is Believing

AUSTRALIA

FINALIST, CAMPAIGN
WELLMARK
SOUTH YARRA, MELBOURNE

CLIENT GlaxoSmithKline
WRITER Maia Sargeant
DESIGNER Patrick Jones
CREATIVE DIRECTOR Prue Oxford

USA

FINALIST, CAMPAIGN
TORRE LAZUR COMMUNICATIONS
EAST HANOVER, NJ

CLIENT Xopenex
ART DIRECTOR Gary Hickman
COPYWRITER Kathryn Lieberthal
VP, EXEC CREATIVE DIR, COPY Tracy Blackwell
VP, EXEC CREATIVE DIR, ART Juan Ramos

COMMUNICATION TO THE HEALTHCARE PROFESSIONAL: VIDEO, AUDIO, NEW MEDIA, OTHER FILM

COMPUTER BASED

USA

GLOBAL AWARD, SINGLE

ESTCO MEDICAL
BETHESDA, MD

CLIENT GE Healthcare
DIRECTOR OF INTERACTIVE Tim Conlon
CREATIVE DIRECTOR Chris Ivey
PRESIDENT John Estafanous
SENIOR EDITOR Kasra Ghanbari

USA

FINALIST, SINGLE

CCG METAMEDIA, INC.
NEW YORK, NY

CLIENT Zocor/Cozaar
VP, PRODUCTION Lenny Bishop
ACCOUNT DIRECTOR Teresa Day
VP, EDITORIAL DIRECTOR Ralph Bonheim
ART DIRECTOR Andrea Varalli
ANIMATOR Boris Polonsky
PRODUCER Joseph Speiser

USA

FINALIST, SINGLE

INTEGRATED COMMUNICATIONS CORP.
PARSIPPANY, NJ

CLIENT Dipentum

GROUP ART SUPERVISOR Ken Zierler

VP/ASSOCIATE CREATIVE DIRECTOR/COPY Kathy Ackerman

ANIMATOR/ILLUSTRATOR Keith Kaznot

USA

FINALIST, SINGLE

GREY HEALTHCARE GROUP
NEW YORK, NY

CLIENT Phase Five

ART DIRECTOR Steve Miceli

ANIMATION/FLASH Steve Miceli

USA

FINALIST, SINGLE

GSW WORLDWIDE
WESTERVILLE, OH

CLIENT Genentech Growth Hormone

ART DIRECTOR Dave Ragan

ARTIST J.D. King

COPYWRITER Cindi Acker-Hein

DESIGNER Scott Gracan

ASSOCIATE CREATIVE DIRECTOR Keith Flint

GROUP ART SUPERVISOR Sharon Brink

CREATIVE DIRECTOR Bill Fillipp

ACCOUNT DIRECTOR Matt Brown

ACCOUNT SUPERVISOR Trent Donohue

PRODUCTION DIRECTOR Melissa Storer

ANIMATION/PRODUCTION Blue Diesel

ART NOT AVAILABLE

USA

FINALIST, SINGLE

INTRAMED EDUCATIONAL GROUP
NEW YORK, NY

CLIENT Rocephin

SENIOR PROGRAM DIRECTOR Jason Justiniano

PROGRAM DIRECTOR Edward Salvador

MEDICAL EDITOR Marcus Vanderheyden

ART DIRECTOR Doug Stern

USA

FINALIST, SINGLE
LOWE BOZELL McADAMS
FORT LEE, NJ

CLIENT **Ultane**
VP/GROUP COPY SUPERVISOR **Anthony Greco**
CREATIVE DIRECTOR/ART **Kevin Thompson**
DEVELOPER **Hans Kaspersetz**

USA

FINALIST, SINGLE
SHAW SCIENCE PARTNERS
ATLANTA, GA

USA

FINALIST, SINGLE
NSIGHT, INC.
SWAMPSCOTT, MA

CLIENT **Philips Medical Systems**
WRITER/PRODUCER **Elizabeth Cohen**
PRODUCTION COMPANY **The Troupe Modern Media Design**

USA

FINALIST, SINGLE
MEDSN, INC.
JERSEY CITY, PA

CLIENT **Zyprexa**
PROJECT MANAGER **Roger Moody**
WRITER **Geoffrey O'Brien**
ART DIRECTOR **Ian Williams**
DESIGNER AND ANIMATOR **Ryan Kamins**
PACKAGING DESIGN **Ayoma de Alwis/Jon Asaoka**
PROGRAMMING **Tarun Mathur/Arnold Biffna**
AUDIO PRODUCER **Donovan Miller**
AUDIO ENGINEER **Larson Shepherd**

ART NOT AVAILABLE

TO LEARN MORE ABOUT OUR POLLEN CHAMBER STUDY, STOP IN THE ALLEGRA BOOTH NOW

USA
GLOBAL AWARD, SINGLE
ABELSON-TAYLOR
CHICAGO, IL

CLIENT Allegra
CREATIVE DIRECTOR Scott Hansen
ASSOCIATE CREATIVE DIRECTOR Noah Lowenthal
FREELANCE COPYWRITER Richard Verne
ASSISTANT PROJECT MGR, INTERACTIVE Tony Wei

USA
FINALIST, SINGLE
SHAW SCIENCE PARTNERS
ATLANTA, GA

USA

FINALIST, CAMPAIGN
THE CEMENTWORKS
NEW YORK, NY

CLIENT **Spiriva**
VP, GROUP ACCOUNT DIRECTOR **Andrea Bast**
VP, ASSOCIATE CREATIVE DIRECTOR **Keith Lima**
SENIOR ACCOUNT MANAGER **Janine Annechino**

USA

FINALIST, SINGLE
PHASE FIVE COMMUNICATIONS
NEW YORK, NY

CLIENT **CellCept**
VP, GROUP SCIENTIFIC SUPERVISOR **Colin Evans, PhD**
ACCOUNT SUPERVISOR **Denise Touchet**
CREATIVE DIRECTOR **Rob Rogers**
ART DIRECTOR **Joseph Ferrazano**
PRODUCTION COORDINATOR **Jamar Hunter**

USA

FINALIST, CAMPAIGN
VOX MEDICA
PHILADELPHIA, PA

CLIENT Abbott Oncology
CREATIVE DIRECTOR Hybrid- Jeff Johnson
HEAD ANIMATOR- HYBRID Mike Medicine Horse
ASSOCIATE ANIMATOR-HYBRID John Franz-Wichlacz
SENIOR COPYWRITER-VOX MEDICA Chris Curran
SENIOR GRAPHIC DESIGNER-VOX MEDICA Cheryl Foley
CREATIVE DIRECTOR-VOX MEDICA Dave Raube
GROUP ACCOUNT SUPERVISOR-VOX MEDICA Rhoda Dunn

USA

FINALIST, SINGLE
PHOTOSOUND COMMUNICATIONS
PRINCETON, NJ

CLIENT OMNIC and Vesicare
ACCOUNT DIRECTOR Caroline Johnson
PROJECT MANAGER Sarah Phillips
EXHIBIT DESIGNER Richard Fortnam
HEAD OF DESIGN Clare Birkbeck

USA

FINALIST, SINGLE
SHAW SCIENCE
PARTNERS
ATLANTA, GA

PRODUCT OR SERVICE FILM

USA
GLOBAL AWARD, SINGLE
IMED STUDIOS/KLEMTNER
AMES, IA

CLIENT Astra Zeneca Neuroscience

USA

FINALIST, SINGLE

GREENVILLE HOSPITAL SYSTEM

GREENVILLE, SC

CLIENT Greenville Hospital system
EXECUTIVE PRODUCER Jay Babcock
PRODUCER Sarah Hart
EDITOR Tom Nesbitt
VIDEOGRAPHER Alan Francis/Emery Stapleton

ENGLAND

FINALIST, SINGLE

THE MEDICAL MULTIMEDIA COMPANY
(MMC)

LONDON

CREATIVE DIRECTOR Richard Hackett
GRAPHIC DESIGNER Hugo Paice

USA

FINALIST, SINGLE

MEDSN, INC.

JERSEY CITY, PA

CLIENT Reyataz
PROJECT MANAGER Prashant Rao
PROJECT MANAGER Quentin Ball
MEDICAL WRITER John Meisner, MD
ART DIRECTOR AND STORYBOARDS Allen Levinson
MEDICAL ILLUSTRATOR AND ANIMATOR
Chris Nadolski
ANIMATOR AND POST-PRODUCTION Ryan Kamins
ILLUSTRATOR AND ANIMATOR Tye Woods
SOUND EFFECTS AND MASTERING Donovan Miller
AUDIO ENGINEER Larson Shepard
ORIGINAL MUSIC SCORE Scott Pagter

Cordis **Cypher** *select*™
Sirolimus-eluting Coronary Stent

ITALY

GLOBAL AWARD, SINGLE
SUDLER & HENNESSEY
INTERNATIONAL
MILANO

CLIENT Cypher

USA

FINALIST, SINGLE
MOUNTAIN VIEW GROUP, LTD.
ATLANTA, GA

CLIENT GE Healthcare
EXECUTIVE PRODUCER James Tusty
DIRECTOR Tom Gliserman
PRODUCER Maureen Castle/Stephen Pruitt
ORIGINAL MUSIC 100% Sound
DIRECTOR OF PHOTOGRAPHY
Tim Glover/Craig Braden
POST PRODUCTION Lab 601

USA

FINALIST, SINGLE
ABELSON-TAYLOR
CHICAGO, IL

CLIENT Herceptin
CREATIVE DIRECTOR Scott Hansen
ART DIRECTOR Eric Pernod
COPYWRITER Marissa Ori/Kitty Malik
INTERACTIVE PRODUCER Ed St. Peter

USA

FINALIST, SINGLE
INTERLINK HEALTHCARE
COMMUNICATIONS
LAWRENCEVILLE, NJ

CLIENT Bayer Oncology
CREATIVE DIRECTOR Jon Male/Dave Renner
ART DIRECTOR/DESIGNER Greg Librizzi
COPYWRITER Kevin Moffitt
PRODUCTION COMPANY Inside Productions

INTERNET WEBSITE

USA

GLOBAL AWARD, SINGLE

CROWLEY WEBB AND ASSOCIATES
BUFFALO, NY

CLIENT Praxis
SR.VP. CREATIVE David Buck
SR. INTERACTIVE ART DIRECTOR Pete Reiling
SR. COPYWRITER Matt Low
DESIGNER Kevin Karn
ANIMATION IBC Digital

USA

FINALIST, SINGLE

ABELSON-TAYLOR
CHICAGO, IL

CLIENT Ambien
CREATIVE DIRECTOR Scott Hansen/Noah Lowenthal
PROGRAMMING Julie Crotty-Tye/Steve Tolin
COPYWRITER Marissa Ori
INTERACTIVE PRODUCER Ed St. Peter/Paul Tursky

USA

FINALIST, SINGLE

ELRO Corporation
NEW YORK, NY

CLIENT The Masters Circle
ADVERTISING AGENCY ELRO Corporation
PRESIDENT Elliot Goykhman
ART DIRECTOR Anton Borzov/Igor Krizhanovsky
PRODUCTION COMPANY ELRO Corporation
DESIGNER Taras Goncharuk
LEAD PROGRAMMER Valeriy Shvets
PROGRAMMER Maxim Khaikin/Evgeniy Kelyarsky
FLASH PROGRAMMER Andrew Shpack

USA

FINALIST, SINGLE

IMIRAGE
ALLENTOWN, PA

CLIENT Teva Pharmaceuticals USA

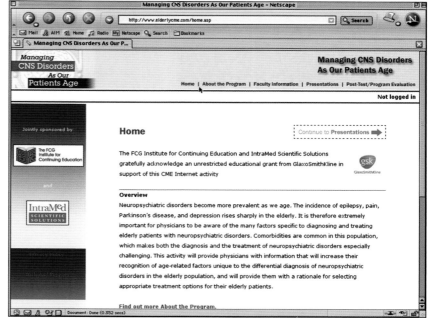

USA

FINALIST, SINGLE

INTRAMED SCIENTIFIC SOLUTIONS
NEW YORK, NY

CLIENT Lamictal/lamotrigine
SENIOR EDUCATION DIRECTOR Suzie Boulos
EDUCATION COORDINATOR Dayle Nolan
VP AND ASSOCIATE CREATIVE Siu Yuen Chan
ACCOUNT SUPERVISOR DIRECTOR Celeste Kolanko

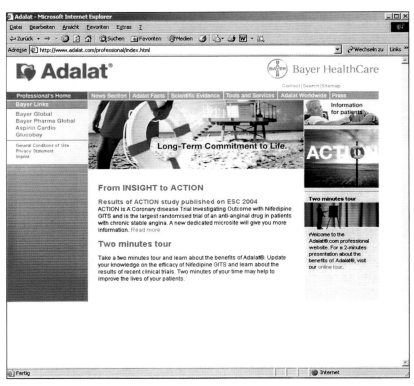

FINALIST, SINGLE

PROXIMITY COMMUNICATIONS

DÜSSELDORF

CLIENT Bayer Adalat

ACCOUNT SUPERVISION Dr. Tillman Bardt

ACCOUNT MANAGEMENT Claudia Guntermann

CREATIVE DIRECTION Susanne Pohle

ART DIRECTION Michael Blendow

PRODUCT OR SERVICE AUDIO

AUSTRALIA

FINALIST, SINGLE

STELLARADIO

GLEBE

CLIENT Baxter-Biosciences

DIRECTOR/AUDIO ENGINEER Bradley Power

SENIOR PRODUCER Vanessa Erickson

AGENCY CREATIVE DIRECTOR Mike Doyle

PRODUCTION ASSISTANT Chantelle Mercieca

TV COMMERCIAL

USA

FINALIST, SINGLE

FRY HAMMOND BARR

ORLANDO, FL

CLIENT Parrish Medical

CREATIVE DIRECTOR Tim Fisher

COPYWRITER Tom Kane

BROADCAST PRODUCER Melissa Cooney

SPAIN

FINALIST, SINGLE

HEALTHWORLD SPAIN

MADRID

CLIENT Xal-Ease

CREATIVE DIRECTOR Raquel Mizrahi

PFIZER OPHTH. UNIT BUSINESS MANAGER
Juan Manuel Martìn

USA

FINALIST, SINGLE

QUIET MAN NEW YORK

NEW YORK, NY

CLIENT GE

VISUAL EFFECTS EXECUTIVE PRODUCER Amy Taylor

VISUAL EFFECTS PRODUCER Steve Holiner

INFERNO ARTIST Johnnie Semerad

INFERNO ARTIST Mindy Dubin

SR. EXEC. CREATIVE DIRECTOR Michael Patti

SR. CREATIVE DIRECTOR Don Schneider

CHIEF CREATIVE OFFICER Ted Sann

COPYWRITER Michael Patti

ART DIRECTOR Don Schneider

AGENCY PRODUCER Regina Ebel/Stacey Suplizio

DIRECTOR Joe Pytka

EDITOR Sherri Margulies

COMMUNICATION TO THE CONSUMER: PRINT MEDIA

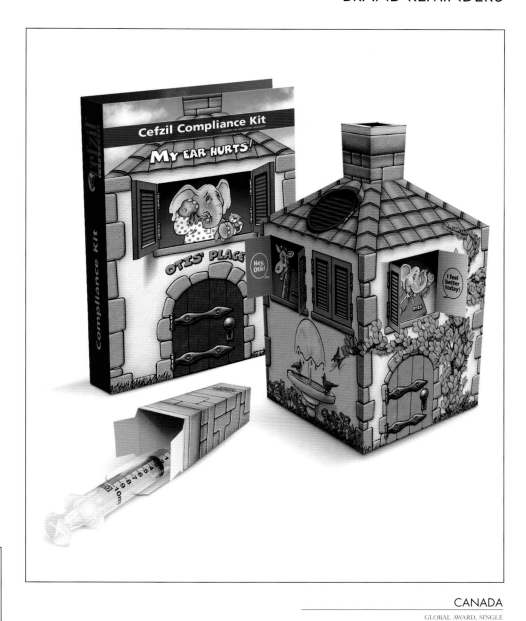

CANADA

GLOBAL AWARD, SINGLE
ACADEMIE OGILVY
MONTREAL

CLIENT Cefzil
CREATIVE DIRECTOR Steve Crawford
ART DIRECTOR Benoit St-Laurent
COPYWRITER Marie-JosÈe Trudel
ILLUSTRATORS Benoit St-Laurent, Serge Rousseau
PRODUCT MANAGER Nathalie Guilbault

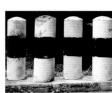

A great smile is closer than you think

SINGAPORE

FINALIST, CAMPAIGN
ALAPAPA
SINGAPORE

CLIENT SmileWorks
SENIOR ART DIRECTOR Eryk Tam
SENIOR COPYWRITER Lynn Chiam

BROCHURE

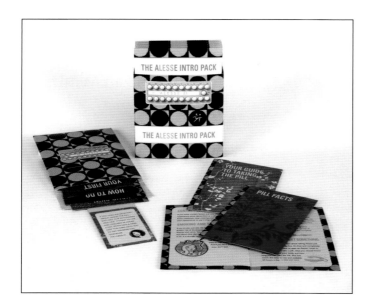

CANADA

FINALIST, SINGLE

ANDERSON DDB HEALTH & LIFESTYLE

TORONTO

CLIENT **Alesse**

CREATIVE DIRECTOR **Ron Hudson**

Art Director **Monica Clara**

COPYWRITER **Jed Churcher**

ILLUSTRATOR **Julia Breckenreid**

USA

FINALIST, SINGLE

HAGGMAN

MANCHESTER, MA

CLIENT **Duncan Lodge**

CREATIVE DIRECTOR **Eric Haggman**

ART DIRECTOR **Katie Pensak**

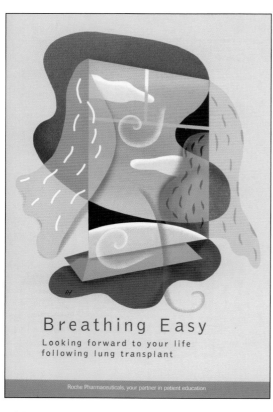

USA

FINALIST, SINGLE

DONAHOE PUROHIT MILLER

CHICAGO, IL

CLIENT **Cellcept**

PROJECT DIRECTOR **Jeanne Prater**

CREATIVE DIRECTOR **MaryJoe Leverette**

ART DIRECTOR **Jeff Turek**

THE NETHERLANDS

FINALIST, SINGLE

EYELAND DESIGN NETWORK

WINTERSWIJK

CLIENT **Augenklink Ahaus**

CREATIVE DIRECTOR **Guido Schulte**

MD/OPHTHALMIC SURGEON **Karl Brasse**

PHD **Walter Pfeifer**

USA
FINALIST, SINGLE
GSW WORLDWIDE
WESTERVILLE, OH
CLIENT Genentech Growth Hormone
ART DIRECTOR Ben Denton/Matt Brown
ASSOCIATE CREATIVE DIRECTOR Keith Flint
PRODUCTION DIRECTOR Melissa Storer
CREATIVE DIRECTOR Bill Fillipp

USA
FINALIST, SINGLE
ARNOLD SAKS ASSOCIATES
NEW YORK, NY
CLIENT North Shore-Long Island
Jewish Health System
ART DIRECTOR Arnold Saks
GRAPHIC DESIGNER Molly Wakeman
DIRECTOR PUBLIC RELATIONS Terence Lynam
PHOTOGRAPHER Bill Gallery

USA
FINALIST, SINGLE
HAGGMAN
MANCHESTER, MA
CLIENT Gentle Touch
CREATIVE DIRECTOR Eric Haggman
ART DIRECTOR Katie Pensak

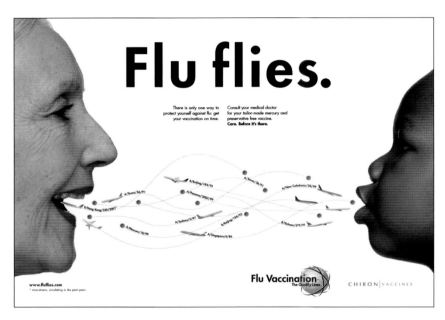

DIRECT MAIL

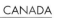

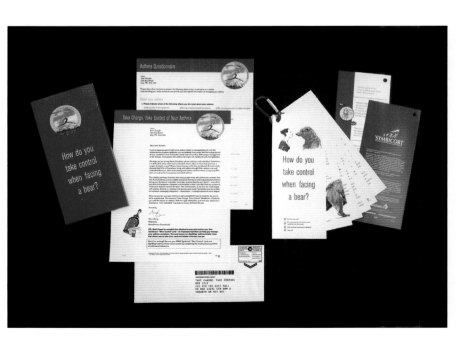

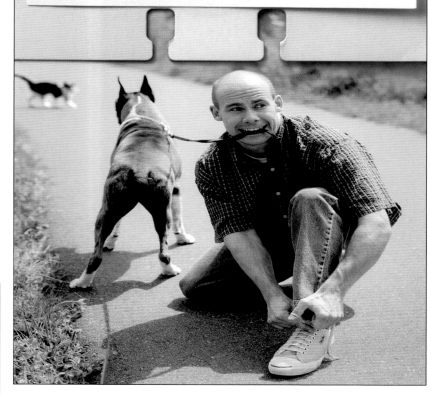

SPECIALISTS IN _Joint Rehabilitation_

It can come in an instant. Or over the course of many years. But no matter how long you've lived with bone or joint pain, take it to the only area hospital that specializes in orthopaedics. And nothing else. We've combined the best specialists with the best equipment and the best rehab facilities to provide fast, complete recoveries. For more info, visit ohow.org or call 414-961-6800. We're located at 575 West River Woods Parkway in Glendale (off Port Washington Road, south of Hampton).

ORTHOPAEDIC · HOSPITAL · OF WISCONSIN

USA

GLOBAL AWARD, CAMPAIGN
MEYER & WALLIS
MILWAUKEE, WI

CLIENT Orthopaedic Hospital Of Wisconsin
ART DIRECTOR Greg Huff/Jim Brooks
CREATIVE DIRECTOR Tom Dixon
PRODUCTION MANAGER Lynn Becker

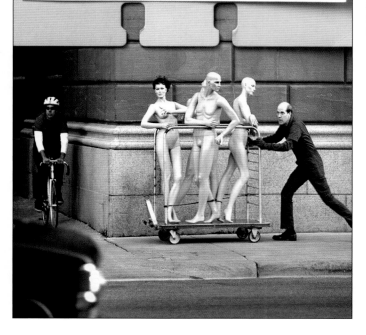

SPECIALISTS IN _Bone & Joint Repair_

It can come in an instant. Or over the course of many years. But no matter how long you've lived with bone or joint pain, take it to the only area hospital that specializes in orthopaedics. And nothing else. We've combined the best specialists with the best equipment and the best rehab facilities to provide fast, complete recoveries. For more info, visit ohow.org or call 414-961-6800. We're located at 575 West River Woods Parkway in Glendale (off Port Washington Road, south of Hampton).

ORTHOPAEDIC · HOSPITAL · OF WISCONSIN

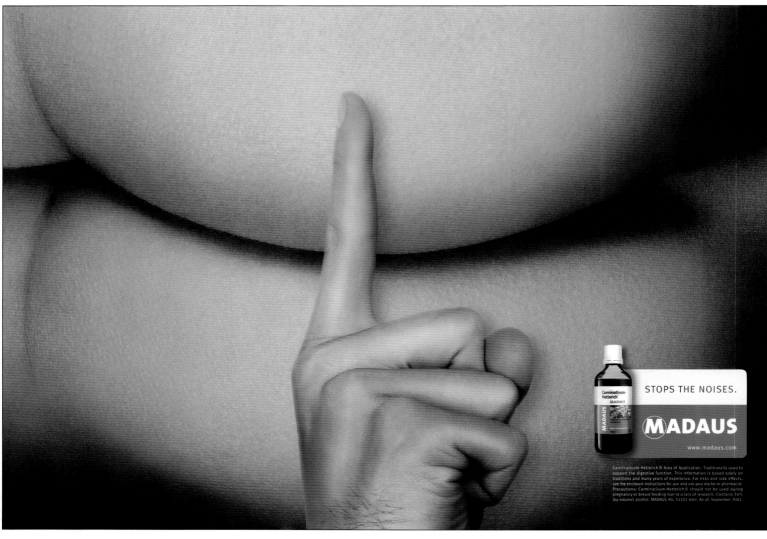

STOPS THE NOISES.

GERMANY
GLOBAL AWARD, SINGLE
BBDO CAMPAIGN GMBH
DUESSELDORF

CLIENT Carminativum Hetterich Madaus
CREATIVE DIRECTOR Michael Ohanian/
Carsten Bolk
COPYWRITER Andreas Walter
ART DIRECTOR Jacques Pense
ACCOUNT DIRECTOR Sabine Beck
ACCOUNT EXECUTIVE Astrid Mittelstrass
PHOTOGRAPHER Ralf Gellert
MAKE-UP Susan Swoboda
POST Cathrin Bauendahl

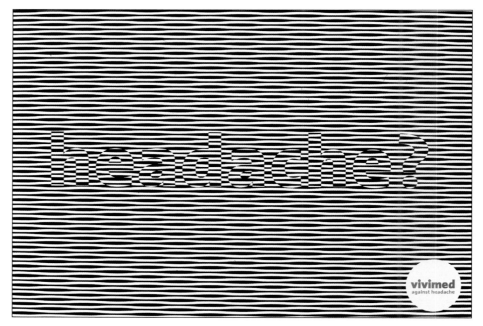

GERMANY
FINALIST, SINGLE
AIMAQ RAPP STOLLE
BERLIN

CLIENT Vivimed
CREATIVE DIRECTOR Oliver Frank
ART DIRECTOR Tim Belser
ACCOUNT SUPERVISOR Jeanette Wilbois/
Andreas Rapp

A 49% chance of a girl.
A 51% chance of a boy.
And a 30% risk of genital thrush.
Your body undergoes the weirdest
changes during pregnancy. You have
probably experienced both hot flashes and
pyrosis. Not to mention sudden changes in mood
and eating habits. You feel feminine with its up- and
downsides. No wonder. Your body is packed with female
sex hormones. The huge amounts of estrogen are responsible
for a disturbance in the natural pH-balance of your vagina. This
leads to a bigger risk of thrush. As a matter of fact there is a 30%
risk that you will experience it during your pregnancy. That is a risk
that is more than twice as big as normal. But don't let these facts ruin
your happy circumstances. Thrush is NOT harmful to your baby as long as
it is growing safely in your womb. Thrush is not harmful to you either - a little
inconvenient at most. You will find a white odorless discharge from your vagina.
And it will most probably start to itch. Talk to your doctor for a verification of your
diagnosis. He or she will probably tell you about a one day treatment, called Canesten, that will
kill the thrush and remove the itching. - But it does not have to come this far. In fact, you can do a
few things to prevent yourself from getting it in the first place. Wash your underwear at minimum 60
degrees centigrade. And don't use excess amounts of soap in and around your vagina. If you
should get thrush during your pregnancy don't use the applikator; inject the vaginal
tablet with a finger instead and use the creme around your vagina. Your
doctor or pharmacy can tell you a lot more if you have any
questions. Good luck with the delivery.

ONE LESS PROBLEM

DENMARK
FINALIST, SINGLE
BBDO DENMARK
COPENHAGEN

CLIENT Canesten
COPYWRITER Jesper Hansen
ART DIRECTOR Ulrik Michelsen
ACCOUNT EXECUTIVE Camilla Mahncke

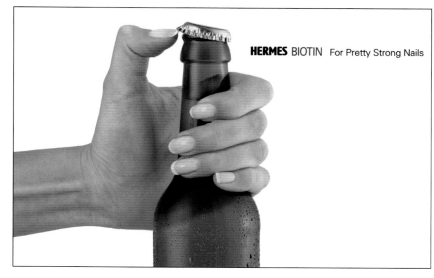

HERMES BIOTIN For Pretty Strong Nails

GERMANY
FINALIST, SINGLE
**SAINT ELMO'S AGENTUR FUER
KREATIVE ENERGIE GMBH**
MUNICH

CLIENT Hermes Biotin
CREATIVE DIRECTOR Arwed Berendts
ART DIRECTOR Daniela Snow/Term Shon
COPYWRITER Chris Boje
CLIENT Brigitta Hackmann/Romy Sahr
ART Martina Greiner
MANAGING DIRECTOR Feodor von Wedel
ACCOUNT MANAGER Susanne Erd
MARKETING MANAGER Brigitta Hackmann
PRODUCT MANAGER Romy Sahr

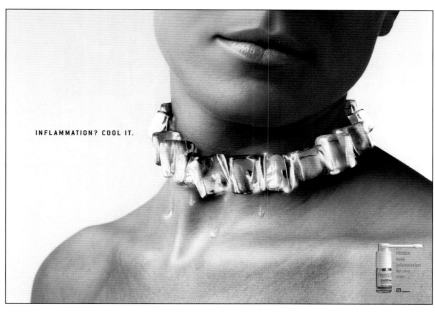

INFLAMMATION? COOL IT.

ITALY
FINALIST, SINGLE
SUDLER & HENNESSEY MILAN
MILANO

CLIENT Froben
CREATIVE DIRECTOR Bruno Stucchi/Angelo Ghidotti
COPYWRITER Lorenzo Chiesa
ART DIRECTOR Erik Emilio Garaventa
PHOTOGRAPHER Occhiomagico

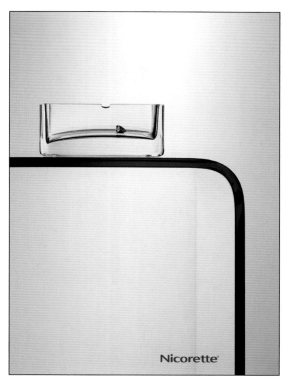

Nicorette

UNITED ARAB EMIRATES
FINALIST, SINGLE
TEAM Y & R
DUBAI

CLIENT Nicorette
EXECUTIVE CREATIVE DIRECTOR Sam Ahmed
ART DIRECTOR Komal Bedi - Sohal
COPYWRITER Gordon Ray
PHOTOGRAPHER Chad Henning

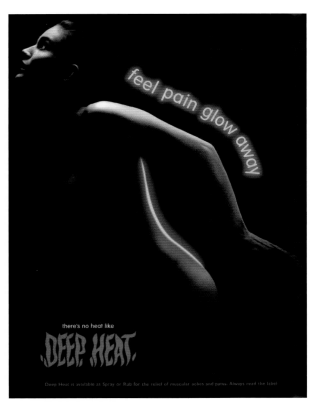

feel pain glow away

there's no heat like

DEEP HEAT.

Deep Heat is available as Spray or Rub for the relief of muscular aches and pains. Always read the label

ENGLAND

FINALIST, CAMPAIGN
ACUMEN PARTNERS
LONDON

CLIENT Deep Heat
ART DIRECTOR P.J. Hurst
COPYWRITER William Lawrence
TYPOGRAPHER Ray Craigie
PHOTOGRAPHER Sanders Nicolson

We know kids hate to tie their shoes.

merthiolate The antiseptic that knows about cuts and scrapes.

MEXICO

FINALIST, CAMPAIGN
BBDO/MEXICO
MEXICO CITY

CLIENT Merthiolate
CREATIVE DIRECTOR Carl Jones/Antonio Alvarez
ART DIRECTOR Antonio Alvarez
COPY Fernando Carrera

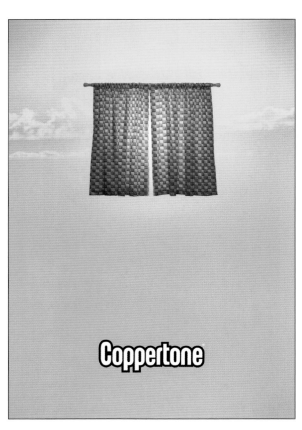

Coppertone

CANADA

FINALIST, CAMPAIGN
FOOTE, CONE & BELDING
TORONTO
TORONTO

CLIENT Coppertone
GROUP CREATIVE DIRECTOR
Rick Pregent
ART DIRECTOR Ed Lea
DIRECTOR OF PRINT PRODUCTION
Margaret Freitas
EXECUTIVE V.P., CREATIVE DIRECTOR
Robin Heisey
PHOTOGRAPHER Eden Rob

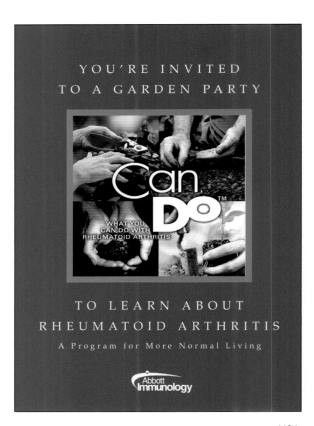

YOU'RE INVITED
TO A GARDEN PARTY

Can DO™

WHAT YOU
CAN DO WITH
RHEUMATOID ARTHRITIS

TO LEARN ABOUT
RHEUMATOID ARTHRITIS
A Program for More Normal Living

Abbott
Immunology

USA

FINALIST, CAMPAIGN
TORRE LAZUR CHICAGO
CHICAGO, IL

CLIENT Humira

AUSTRIA

GLOBAL AWARD, SINGLE

LOWE GGK

VIENNA

CLIENT Alzheimer Patients
CREATIVE DIRECTOR Walther Salvenmoser
ART DIRECTOR Walther Salvenmoser
COPYWRITER Walther Salvenmoser
PHOTOGRAPHER Stock Getty Images
TYPOGRAPHER Blaupapier/Helmut Kansky

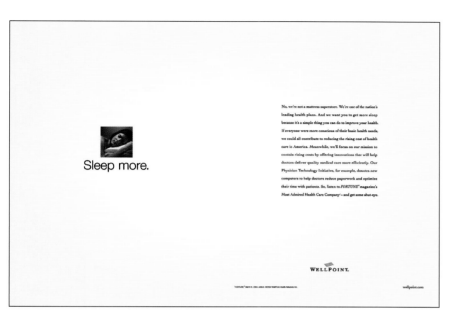

Sleep more.

No, we're not a mattress superstore. We're one of the nation's leading health plans. And we want you to get more sleep because it's a simple thing you can do to improve your health. If everyone were more conscious of their basic health needs, we could all contribute to reducing the rising cost of health care in America. Meanwhile, we'll focus on our mission to contain rising costs by offering innovations that will help doctors deliver quality medical care more efficiently. Our Physician Technology Initiative, for example, donates new computers to help doctors reduce paperwork and optimize their time with patients. So, listen to *FORTUNE* magazine's Most Admired Health Care Company* – and get some shut-eye.

WELLPOINT.

wellpoint.com

You think a
marathon is tough?
Try running one with
heart disease.

For residents of Eastern Orange County who are diagnosed with heart disease, the nearest cardiac catheterization lab is 26 miles away – roughly the distance of a marathon. These cath labs are vital to the health of a community, saving lives by helping to detect clogged arteries which cause heart attacks.

The sad truth is that this distance creates a real barrier to proper diagnosis and treatment.

Want proof? Take the fact that residents of Orange County are 28% more likely to die prematurely *(in the age range of 35 to 74)* of heart disease than Dutchess County residents. Coincidentally, Dutchess is home to three approved cath labs, despite a population that is 60,000 fewer than Orange County.

And still, no cardiac cath labs for Orange County. St. Luke's Cornwall Hospital is leading the fight for cath labs for our communities, because we believe we should come in second place to no one, especially when lives are at risk.

Go to www.stlukescornwallhospital.org to learn more and let us know how you feel about being 26 miles away from this essential service.

It's a matter of life and death.

St. LUKE'S
CORNWALL
HOSPITAL

Cornwall • Newburgh
(845)568-2561
www.stlukescornwallhospital.org

USA

FINALIST, CAMPAIGN

RPA

SANTA MONICA, CA

CLIENT Wellpoint
COPYWRITER Todd Carey
ART DIRECTOR Curt Johnson
CREATIVE DIRECTOR David Smith/Joe Baratelli
DIRECTOR OF CREATIVE SERVICES Larry Postaer

USA

FINALIST, CAMPAIGN

TRUMPET

NEW ORLEANS, LA

CLIENT St. Luke's Cornwall Hospital
CO-CREATIVE DIRECTOR Pat McGuinness/Robbie Vitrano
ACCOUNT MANAGER Jim Gradl/Malcolm Schwarzenbach
VP, DEVELOPMENT AND MARKETING Sue Sullivan
ADMINISTRATION DIRECTOR, MARKETING AND PUBLIC AFFAIRS
Kristin Jensen

USA

FINALIST, SINGLE

MEMORIAL HERMANN HEALTHCARE SYSTEM

HOUSTON, TX

CLIENT Cardiovascular Services
MARKETING DIRECTOR Sharon Messimer
SENIOR GRAPHIC DESIGN SPECIALIST Michaele O'Dwyer
WHITEWAVE INCORPORATED Jennifer Paniagua

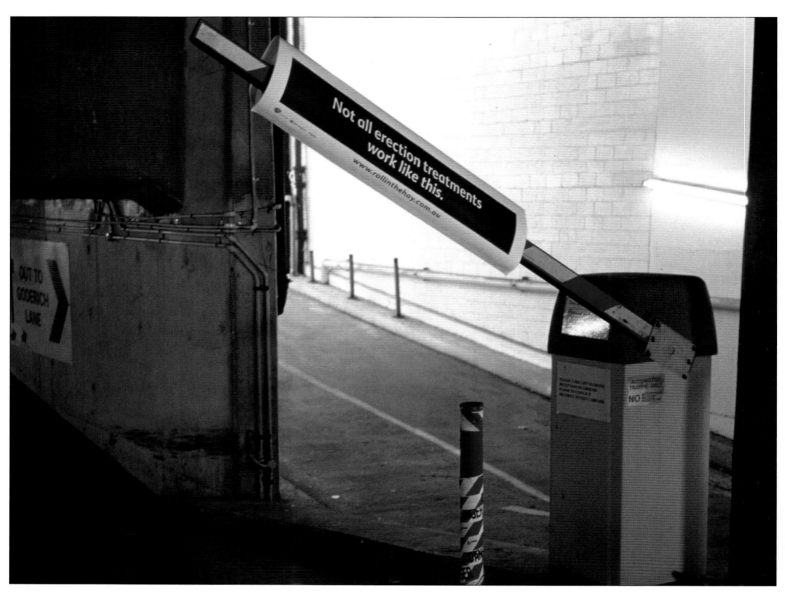

AUSTRALIA

GLOBAL AWARD, SINGLE
McCANN HEALTHCARE
SYDNEY

CLIENT Levitra
CREATIVE DIRECTOR Hugh Fitzhardinge/Grant Foster
WRITER Hugh Fitzhardinge
ART DIRECTOR Grant Foster
WRITER Alex Tagaroulias
PRODUCTION Damien Hancock
DESIGNER Bridget Pooley

USA

FINALIST, SINGLE
CRUZ/KRAVETZ IDEAS
CULVER CITY, CA

CLIENT Bayer
ADVERTISING AGENCY Cruz/Kravetz IDEAS
CREATIVE DIRECTOR Maite D'Amico
ART DIRECTOR Mariana Milgram
COPYWRITER German Libenson
PHOTOGRAPHER Bob D'Amico

IT'S A NEW ERA OF CANCER TREATMENT AT A PLACE

WHERE HOPE LIVES

COMPREHENSIVE
Cancer Center®
Community Hospital of the Monterey Peninsula

USA

FINALIST, CAMPAIGN

ANDA-BURGHARDT ADVERTISING
MONTEREY, CA

CLIENT Comprehensive Cancer Center
at Community Hospital
PRESIDENT Jeff Burghardt

USA

FINALIST, SINGLE

SAN JOSE MEDICAL CENTER
SAN JOSE, CA

CLIENT SJMC Public Affairs Leslie Kelsay
ART DIRECTOR Nate Digre
COPYWRITER Wendy Satterlund
ACCOUNT EXECUTIVES Nanci Williams/Amy Choice
SJMC PUBLIC AFFAIRS Leslie Kelsay
PRINT AND APPLICATION Giant Impressions

Keep your eyes in shape.

The Vision People™
vsp.com/houston

USA

FINALIST, CAMPAIGN

HOFFMAN/LEWIS
SAN FRANCISCO, CA

CLIENT Vision Service Plan
CREATIVE DIRECTOR Sharon Krinsky
ART DIRECTOR James Cabral
COPYWRITER Scott Leeper

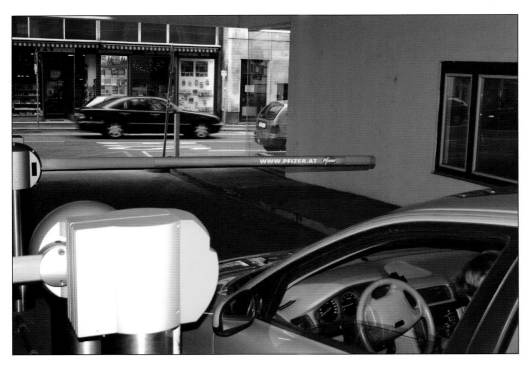

AUSTRIA

FINALIST, CAMPAIGN

FCB KOBZA ADVERTISING AGENCY
VIENNA

CLIENT Pfizer
CREATIVE DIRECTOR Rudi Kobza
ART DIRECTOR Goran Golik
COPYWRITER Gerald Lauffer
ILLUSTRATOR Birgit Grabner
PRODUCER Hanna Tangerner

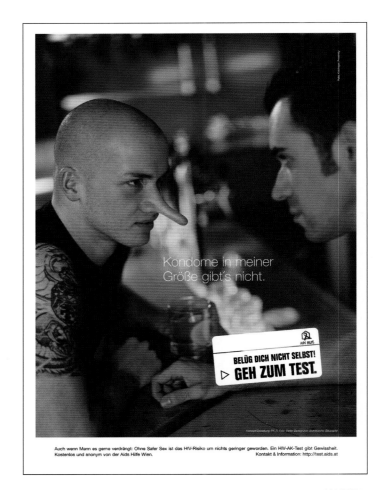

AUSTRIA
FINALIST, CAMPAIGN

PALLA, KOBLINGER-PROXIMITY
VIENNA

CLIENT Aids Hilfe Wien
CREATIVE HEAD Roman Sindelar
CREATIVE DIRECTOR Erich Enzenberger
ART DIRECTOR Philipp Jandl
PHOTOGRAPHER Stefan Badegruber
CLIENT SERVICE DIRECTOR Alexander M‚hr
COPYWRITER Erich Enzenberger

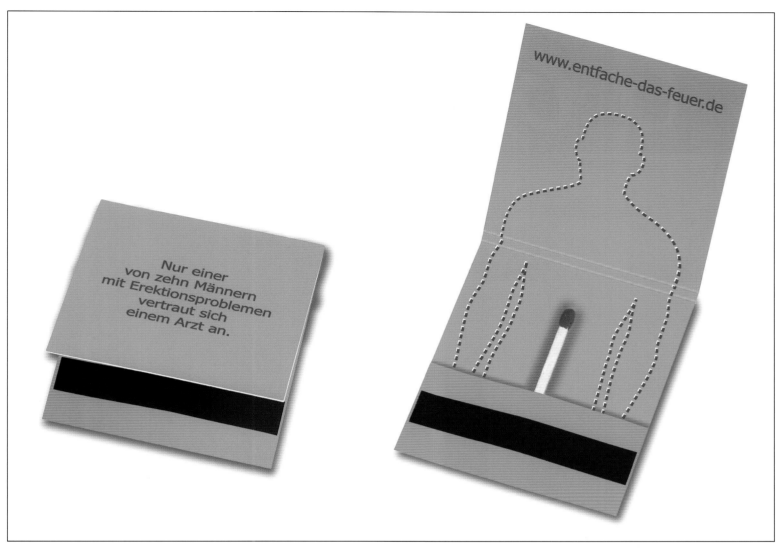

Nur einer von zehn Männern mit Erektionsproblemen vertraut sich einem Arzt an.

www.entfache-das-feuer.de

GERMANY

GLOBAL AWARD, SINGLE

ANGELA LIEDLER GMBH

FREIBURG

CLIENT Erectile Dysfunction / ISG
CREATIVE DIRECTOR Jeremy Bird
COPYWRITER Jeremy Bird / Dirk Ross
GRAPHICS Markus Matuschyk
ACCOUNT DIRECTOR Dr. Monika Schulte
ACCOUNT SUPERVISOR Rolf Miebach

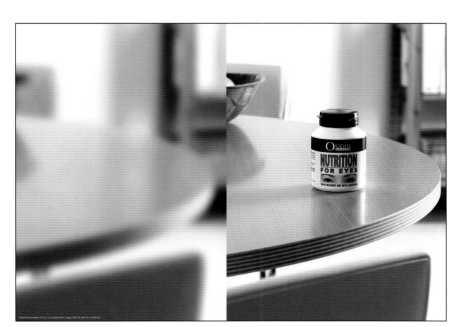

SINGAPORE

FINALIST, SINGLE

VIBES COMMUNICATIONS PTE LTD

TOA PAYOH

CLIENT Ocean Health Nutrition For Eyes
CREATIVE DIRECTOR Ronald Wong
ART DIRECTOR Ronald Wong
COPYWRITER Ronald Wong
PHOTOGRAPHER (J-Studio) Lee Jen

MIXED MEDIA CAMPAIGN

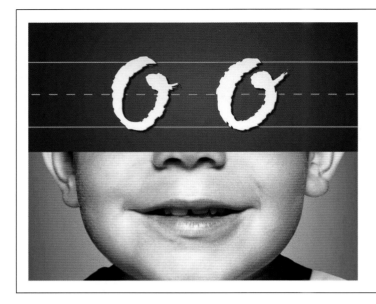

85% of what a child learns comes from what they see.

That's why seeing a VSP doctor is so important. Our uniquely qualified eyecare specialists can diagnose and treat conditions that may be keeping your child from achieving their full potential. In fact, studies show that 60 percent of students identified as problem learners have undetected vision problems. Fortunately, you can give your child the finest eyecare available. By including VSP as part of your family's overall health and wellness plan, you'll have access to regular exams, prescription eyewear, advanced care and more. Which is certainly something worth learning about. To schedule a professional eye exam with your local VSP doctor, and to see about VSP coverage, **call 1-800-CALL-VSP or visit vsp.com/houston today.**

The Vision People
VSP
vsp.com/houston

USA

FINALIST, CAMPAIGN
HOFFMAN/LEWIS
SAN FRANCISCO, CA

CLIENT **Vision Service Plan**
CREATIVE DIRECTOR **Sharon Krinsky**
ART DIRECTOR **James Cabral**
COPYWRITER **Scott Leeper**

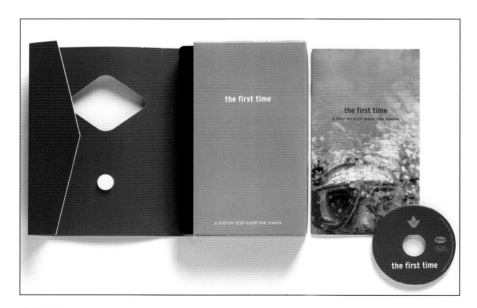

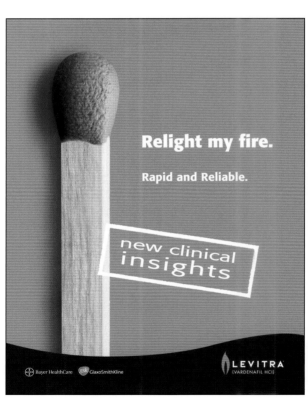

Relight my fire.

Rapid and Reliable.

new clinical insights

Bayer HealthCare GlaxoSmithKline

LEVITRA
(VARDENAFIL HCl)

CANADA

FINALIST, CAMPAIGN
TAXI
TORONTO

CLIENT **Viagra**
CREATIVE DIRECTOR **Steve Mykolyn**
GRAPHIC DESIGNER **Clare McGoldrick**
DOP/EDIT **Chopper Pictures**
MOTION GRAPHICS **Ken Reddick/Pete OíNeil**
SOUND **Simon Edwards**

AUSTRIA

FINALIST, CAMPAIGN
BBDO AUSTRIA
VIENNA

CLIENT **Levitra**
CREATIVE DIRECTOR **Dr. Markus Enzi**
ART DIRECTOR **Richard Kaim**
COPYWRITER **Bernhard Rems**
STRATEGIC PLANNING **Dr. Angelika Trachtenberg**
ACCOUNT MANAGER **Roberta Mrkvicka**
ART DESIGN **Carina Kos**
CLIENT PRODUCT MANAGER **Mag. Marcus Dietmayer**
CLIENT PRODUCT MANAGER **Dipl.Ing. Alexander Barta**
CLIENT PRODUCT MANAGER **Mag. Daniela Lang**

COMMUNICATION TO THE CONSUMER/PATIENT:
VIDEO, AUDIO, INTERACTIVE

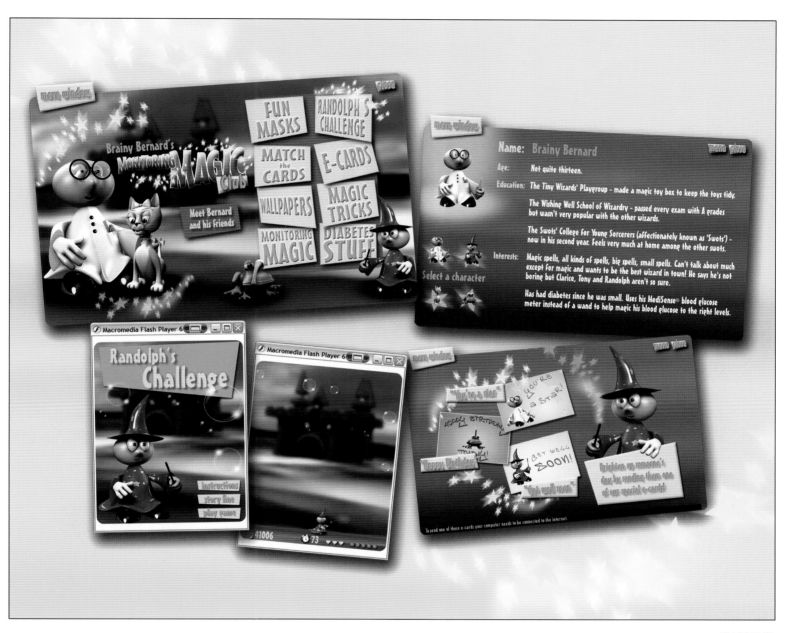

ENGLAND

GLOBAL AWARD, SINGLE

HALESWAY ADVERTISING AND MARKETING

ANDOVER, HAMPSHIRE

CLIENT Abbott Laboratories - MediSense Products

PROGRAMMING AND 3D MODELLING Tony Knibb

DESIGN AND 3D MODELLING Simon Barton

COPYWRITER Liz Rawlingson

CREATIVE DIRECTOR Neil Padgett

ACCOUNT MANAGER Ian Richardson

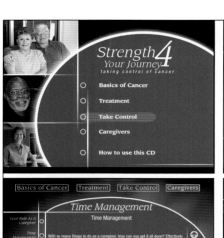

USA

FINALIST, SINGLE

W5 CREATIVE
ORLANDO, FL

CLIENT Ortho Biotech Products
SENIOR PROGRAM DIRECTOR Mary McGovern
PROGRAM MANAGER Maureen Crowley
EXECUTIVE PRODUCER Chris Berger
PRODUCER Tim Trombitas
MANAGING PROGRAMMER Mike Giblisco
ART DIRECTOR AJ O'Toole
COORDINATING PRODUCER Debbie Almeter-Lloyd
PACKAGING DESIGN & POST PRODUCTION Brandi Besher
PROJECT MANAGER Kristin Lindfors

USA

FINALIST, SINGLE

SPRINGBOARD BRAND & CREATIVE STRATEGY
ARLINGTON HEIGHTS, IL

CLIENT North Mississippi Medical Center
CREATIVE DIRECTOR Rob Rosenberg
CLIENT EXECUTIVE Greg Strahan

USA

FINALIST, SINGLE

VISIBLE PRODUCTIONS, INC.
FORT COLLINS, CO

CLIENT Deramaxx

USA

GLOBAL AWARD, SINGLE
SHARP HEALTHCARE
SAN DIEGO, CA

SR. V.P. OF MARKETING AND COMMUNICATIONS Diane Gage
VICE PRESIDENT OF CUSTOMER STRATEGY Sonia Rhodes
V.P. OF MARKETING AND ADVERTISING Todd Miller
MANAGER OF ADVERTISING AND CRM Jared Solomon
SR. V.P. OF MARKETING AND COMMUNICATIONS Diane Gage
VICE PRESIDENT OF CUSTOMER STRATEGY Sonia Rhodes
V.P. OF MARKETING AND ADVERTISING Todd Miller
MANAGER OF ADVERTISING AND CRM Jared Solomon
DIRECTOR Arnie Lerner
BROADCAST PRODUCTION MANAGER June Satler
EDITOR Chryss Terry
AGENCY Rich Badami & Associates
EXECUTIVE PRODUCER Rich Badami
PRODUCTION COMPANY The Dakota Group

USA

FINALIST, SINGLE
LLKFB
NEW YORK, NY

CLIENT Pfizer Cox-2 (Bextra And Celebrex)
SVP/GROUP ACCOUNT DIRECTOR Ross Quinn
EVP/CHIEF CREATIVE OFFICER Joe Cupani
PRESIDENT Loreen Babcock

USA

FINALIST, SINGLE
NELSON COMMUNICATIONS
PRINCETON, NJ

CLIENT Betaseron
EXEC VP/CREATIV DIRECTOR Cathy Fenster
SR VP/ASSOC CREATIVE DIR, COPY Liz Hooker
ACCOUNT SUPERVISOR Melanie Jenter
SR PRODUCT MANAGER Cheryl Kerr
EXEC VP, CREATIVE DIRECTOR Cathy Fenster
SR VP/ASSOC CREATIVE DIR Liz Hooker
VP/MANAGEMENT SUPERVISOR Stephen Piotrowski
ACCOUNT SUPERVISOR Melanie Jenter
SR VP/ ASSOC CREATIVE DIR Jeffrey Hicken
SR PRODUCT MANAGER Cheryl Kerr

GRAND
GLOBAL

Communication
to the Consumer:
Film, Video, Audio

MEXICO

GRAND GLOBAL BEST CONSUMER
BBDO/MEXICO
MEXICO CITY

CLIENT Alka-Seltzer
CREATIVE DIRECTOR Carl Jones/Jose Luis Rosales
ART DIRECTOR Jaime Brash
COPY Jose Luis Rosales
AGENCY PRODUCER Alba Savona
PRODUCTION COMPANY Panagea
DIRECTOR Leo Sanchez

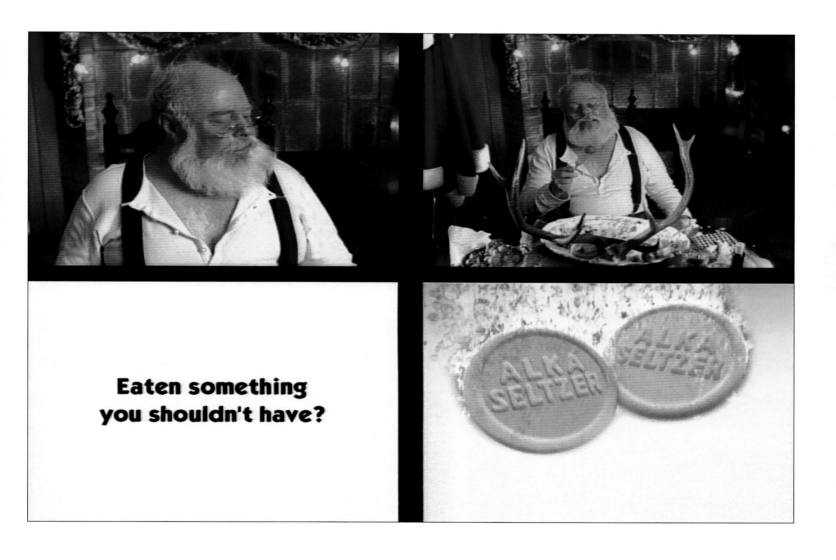

Eaten something you shouldn't have?

Medlock Medical, Tubiton house, Brook St, Oldham OL1 3HS, United Kingdom. Designed by The Foundry

ENGLAND

GLOBAL AWARD, SINGLE
THE FOUNDRY
ALTRINCHAM, CHESHIRE

CLIENT Medlock Medical Ltd/Epaderm
CREATIVE DIRECTOR Kevin Murphy
ART DIRECTOR Stuart Simpson
WRITER Steve Yelland
IT DIRECTOR Ian Mckay
WEB PROGRAMMER Alex Hardy
ACCOUNT DIRECTOR Zoe Connolly
WEB ARCHITECTURE Dave Stewart

GERMANY
FINALIST, SINGLE
ARGONAUTEN360 GMBH
BERLIN

CLIENT Schering
CREATIVE DIRECTOR Sven Kuester
ACCOUNT DIRECTOR Anja Schuerholz
INFORMATION ARCHITECT DIRECTOR Reinhard Dassel
SENIOR ONLINE PRODUCER Stephan Lempert
SENIOR ART DIRECTOR Ruth Heinzelmann
ART DIRECTOR Alexandra Plaschnick
MANAGING DIRECTOR Gudrun Kramer

USA

FINALIST, SINGLE

AVENUE-E HEALTH STRATEGIES

NEW YORK, NY

CLIENT NovoLog

MANAGING DIRECTOR Anthony Manson

DIRECTOR OF TECHNOLOGY Bob Paine

SENIOR WEB DESIGNER William Martino

ACCOUNT EXECUTIVE Abby Berman

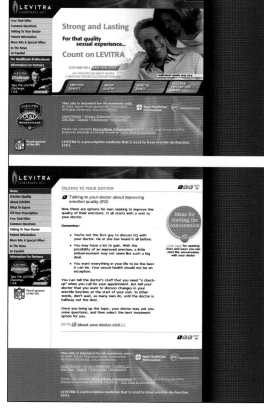

USA

FINALIST, SINGLE

CADIENT GROUP

CONSHOHOCKEN, PA

CLIENT LEVITRA

GLAXOSMITHKLINE Louis Sanquini

GLAXOSMITHKLINE William Meisle

BAYER PHARMACEUTICALS Marci Hanlon

BAYER PHARMACEUTICALS Lee Barstow

CADIENT GROUP Michael Konin

CADIENT GROUP Melissa Brown

USA

FINALIST, SINGLE

CONTENT STRATEGIES, INC.

NATICK, MA

CLIENT GlaxoSmithKline

ART NOT AVAILABLE

JAPAN

FINALIST, SINGLE

DENTSU INC.

MINATO-KU, TOKYO

CLIENT Fumakilla A Pollen Blocker At Nose

CREATIVE DIRECTOR Masayoshi Niwa

ART DIRECTOR Masayoshi Niwa

TECHNICAL DIRECTOR Hiroki Nakamura

PROGRAMMER Masumi Mizuno

ACCOUNT EXECUTIVE Emiko Kimura

FUMAKILLA CO., LTD. Kazuki Kawashima

THE YOMIURI SHIMBUN Takashi Kunimoto

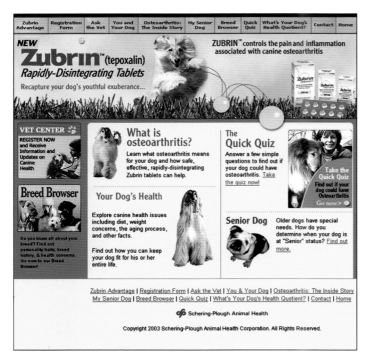

USA

FINALIST, SINGLE
IMIRAGE
ALLENTOWN, PA

CLIENT Schering-Plough Zubrin Brand

USA

FINALIST, SINGLE
GUIDANT CORPORATION
ST. PAUL, MN

DIRECTOR E-MARKETING Carol Lindahl
PROJECT MANAGER, E-MARKETING Tim Matti/Jeff Benson
WEB EDITOR, E-MARKETING Marikay Klein
ASSOCIATE, E-MARKETING David Burns/Melissa Paris
WEB DEVELOPER, E-MARKETING Christian Johnson
WEB DESIGNER, E-MARKETING Todd Mercil

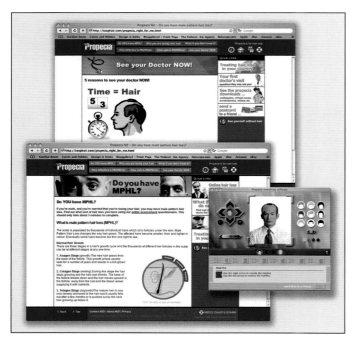

NEW ZEALAND

FINALIST, SINGLE
INSIGHT
AUCKLAND

CLIENT Propecia - Merck Sharp & Dohme
WEB DESIGN Paul Wager/ David Williams
COPYWRITERS Gerrard Malcolm/ Ian Power
ACCOUNT DIRECTOR Ian Power
PRODUCT MANAGER Alexander de Monchy

USA

FINALIST, SINGLE
IMED STUDIOS
AMES, IA
CLIENT Wyeth Vaccines

USA

FINALIST, SINGLE

INTEGRATED COMMUNICATIONS CORP.
PARSIPPANY, NJ

CLIENT Tetanus.Org
VP/GROUP ART SUPERVISOR Enrique Heredia
SR. ART DIRECTOR Suzanne Elward
SR. COPYWRITER Diana Stewart

USA

FINALIST, SINGLE

RONIN ADVERTISING GROUP
COCONUT GROVE, FL

CLIENT Sarasota Memorial Healthcare System
EXECUTIVE CREATIVE DIRECTOR John Swisher
ASSOCIATE CREATIVE DIRECTOR Meryl Rothstein
COPY CREATIVE DIRECTOR Ann Trondle-Price
DESIGN DIRECTOR James Guest
PHOTOGRAPHER Tom Cwenar
AGENCY PRODUCER Erin Holmes
INTERACTIVE CREATIVE DIRECTOR Jeff Myers
INTERACTIVE DIRECTOR Ron Santillo

USA

FINALIST, SINGLE

MILLER SYSTEMS/PRIORITY HEALTHCARE
BOSTON, MA

CLIENT Miller Systems
VP MARKETING, PRIORITY HEALTHCARE Alex Gramling
CEO, MILLER SYSTEMS Seth Miller

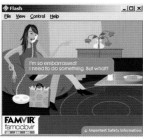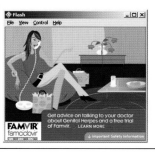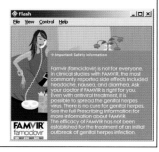

USA

FINALIST, SINGLE

OGILVYONE
NEW YORK, NY

CLIENT Famvir
CREATIVE DIRECTOR Aurelio Saiz
ART DIRECTOR Cynthia Dauzier
COPYWRITER Jay Zasa
ILLUSTRATOR Jamie Bennett
ACCOUNT MANAGEMENT Rachel Rapaport/
Diana Julian
PROJECT MANAGEMENT Mark Cibort/
Troy Kelley
MULTIMEDIA Slobodan Mileta/
Mark Hofschneider

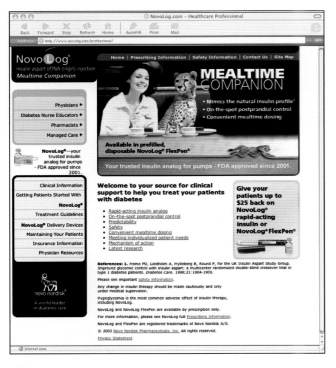

USA

FINALIST, SINGLE

SENTRIX
SHORT HILLS, NJ

CLIENT **NovoLog**

ASSOCIATE CREATIVE DIRECTOR, ART **Bruce Mikula**

ASSOCIATE CREATIVE DIRECTOR, COPY **Jeffrey Perino**

COPY SUPERVISOR **Nicole Busch-Moshiri**

SENIOR ART DIRECTOR **Mary Ann DeFrancesco**

ACCOUNT SERVICES **Jenna Zamelsky/Anthony Manson**

DESIGN **William Martino**

USA

FINALIST, SINGLE

SURVEILLANCE DATA INC.
PLYMOUTH MEETING, PA

CLIENT **Allegra**

VICE PRESIDENT **Peter Jensen**

CREATIVE DIRECTOR **David Stoetzer**

CHIEF PROGRAMMER **Brian Metzger**

PRODUCT MANAGER **Dan Hoffman**

USA

FINALIST, SINGLE

SIMSTAR
PRINCETON, NJ

CLIENT **Pegasys**

USA

FINALIST, SINGLE

STRATEGIC DOMAIN
NEW YORK, NY

CLIENT **Nasacort AQ**

MANAGING PARTNER **Michael Peroff/Rick Robinson**

CREATIVE DIRECTOR **Bart Slomkowski**

SENIOR ART DIRECTOR **Liz Murphy**

SOLUTIONS MANAGER **Brian Stevens**

SENIOR PROJECT MANAGER **Michael Goitein**

COORDINATOR **Jocelyn Wendt**

FINALIST, SINGLE
WUNDERMAN
NEW YORK, NY

CLIENT Pfizer For Living
CHEIF CREATIVE OFFICER Joel Sobelson
CREATIVE DIRECTOR Jane Walsh
ASSOCIATE CREATIVE DIRECTOR Joan Rentz
PROGRAMMER Michael Mosely
SENIOR ART DIRECTOR Stephanie Dines
COPYWRITER Scott Storrs
INTERACTIVE CHANNEL STRATEGIST Chris DiClerico
ACCOUNT DIRECTOR Derek Stubbs
MANAGEMENT SUPERVISOR Julia Burke
ACCOUNT SUPERVISOR Kelly Diercksen
WEB DEVELOPER Solutions Inc.
CAMPAIGN MANAGER Jason Lowenhar

USA

FINALIST, CAMPAIGN
Y&R BRANDS/RTC RELATIONSHIP MARKETING
WASHINGTON, DC

CLIENT Deep Vein Thrombosis (DVT)
VP, CREATIVE DIRECTOR Dawn Panzeca
CREATIVE DIRECTOR Harold Kaplan
VP, ACCOUNT DIRECTOR Mike Goldin
SENIOR PARTNER Susie Choi
EVP, MANAGING DIRECTOR PHARMACEUTICALS Jeff Ross
MANAGING PARTNER Robert Grammitica
EVP, CREATIVE DIRECTOR Matt Conor
COPYWRITER Paul Henkel
ART DIRECTOR Courtney Thompson
CREATIVE DIRECTOR Woody Swain
INTERACTIVE CREATIVE DIRECTOR Steven Tortorici
INTERACTIVE ART DIRECTOR Sten Petersen
ASSOCIATE CREATIVE DIRECTOR Paul Safsel
SR. ACCOUNT EXECUTIVE Lanie Mann
ASSOCIATE PARNTER Gaurav Bhatia

USA

FINALIST, SINGLE
SIMSTAR
PRINCETON, NJ

CLIENT Rhinocort Aqua

TV: MEDICAL PRODUCT COMMERCIAL

MEXICO
GRAND GLOBAL BEST CONSUMER
BBDO/MEXICO
MEXICO CITY

CLIENT Alka-Seltzer
CREATIVE DIRECTOR Carl Jones/Jose Luis Rosales
ART DIRECTOR Jaime Brash
COPY Jose Luis Rosales
AGENCY PRODUCER Alba Savona
PRODUCTION COMPANY Panagea
DIRECTOR Leo Sanchez

SEE GRAND GLOBAL PAGE 523

CHINA
FINALIST, SINGLE
SUXIA & HUGE ADVERTISING
GUANGZHOU

CLIENT Xiang Yao
CREATIVE DIRECTOR Su Xia
COPYWRITER Luo Lei
AGENCY PRODUCER Liu Zhi Yong
ART DIRECTOR Shi Hai Ying
DIRECTOR OF SUXIA FILM PRODUCTION Su Xia
PRODUCTION CO. PRODUCER Zhang Qian Ping
AGENCY PRODUCER Liu Zhi Yong
CAMERAMAN Li Da Hui
EDITOR Chen Xue Liang

CANADA
FINALIST, SINGLE
PUBLICIS WELLCARE
MONTREAL

CLIENT Nicorette
VP CREATIVE DIRECTOR Brian Leaman
SENIOR COPYWRITER Gerry Winek
VP, CLIENT SERVICE Lesli Green
ACCOUNT SUPERVISOR Nancy Wiesenfeld
GENERAL MANAGER Sharon Gallant
PRODUCER Annick d'Auteuil
TEAM LEADER, PFIZER Nicolas Pépin
BRAND MANAGER, PFIZER Yelena Mironova

USA
FINALIST, SINGLE
DDB CHICAGO
CHICAGO, IL

CLIENT Triaminic
EXECUTIVE CREATIVE DIRECTOR Richard DiLallo
CREATIVE DIRECTOR David Klehr
ASSOCIATE CREATIVE DIRECTOR Nick Marrazza
ART DIRECTOR Sarah Reaves
PRODUCER Melissa Barany
DIRECTOR Eric Steinman
PRODUCTION COMPANY Headquarters
MUSIC HOUSE Spank

MEXICO
FINALIST, SINGLE
FCB WORLD WIDE, S.A. DE C.V.
MEXICO CITY

CLIENT Sal De Uvas Picot

CANADA
FINALIST, SINGLE
COSSETTE COMMUNICATION-MARKETING
MONTREAL

CLIENT Schering Canada Inc.

USA
FINALIST, SINGLE
LLKFB
NEW YORK, NY

CLIENT Detrol LA
SVP/GROUP ACCOUNT DIRECTOR Ross Quinn
ART SUPERVISOR Christian Gorrie
COPY SUPERVISOR Tim Leavitt
PRESIDENT Loreen Babcock
VP/CHIEF CREATIVE OFFICER Joseph Cupani

AUSTRALIA
FINALIST, SINGLE
McCANN HEALTHCARE
SYDNEY

CLIENT Telfast
WRITER/CREATIVE DIRECTOR Hugh Fitzhardinge
ART DIRECTOR Cathryn Charleston
CREATIVE DIRECTOR Grant Foster
PRODUCER Amanda Cain
DIRECTOR Lizzie Gardiner
ACCOUNT MANAGER Claire Pope

TAIWAN
FINALIST, SINGLE
OGILVY & MATHER TAIWAN
TAIPEI

CLIENT Kotex
EXECUTIVE CREATIVE DIRECTOR Murphy Chou
ART DIRECTOR Murphy Chou
COPYWRITER Murphy Chou

MEXICO
FINALIST, SINGLE
FCB WORLD WIDE, S.A. DE C.V.
MEXICO CITY

CLIENT Tempra Forte

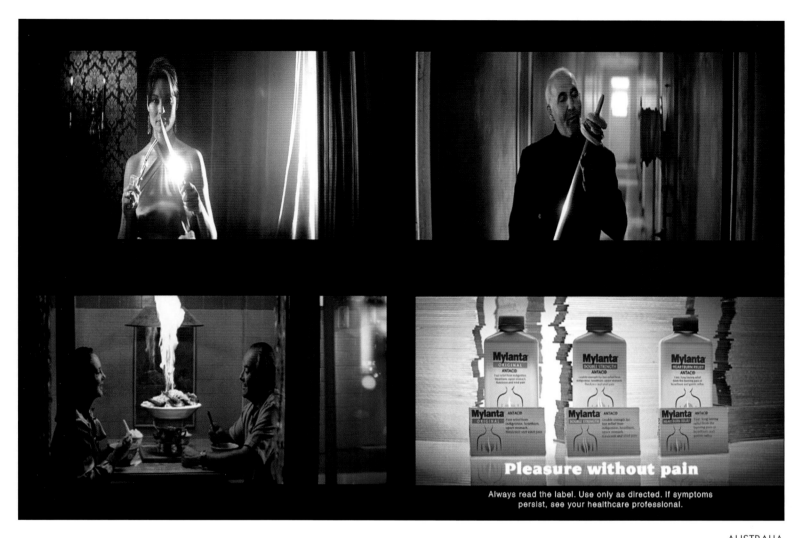

Pleasure without pain

Always read the label. Use only as directed. If symptoms persist, see your healthcare professional.

AUSTRALIA

GLOBAL AWARD, SINGLE
BATEY KAZOO
SYDNEY

CLIENT Mylanta
CREATIVE DIRECTOR/WRITER Russell Smyth
ART DIRECTOR Michael Malherbe
AGENCY PRODUCER John Lamble
ACCOUNT DIRECTOR Adrianne Nixon
ACCOUNT PLANNER Peter Barnes
PRODUCTION COMPANY The Sweet Shop
PRODUCER Cindy Kavanagh
DIRECTOR OF PHOTOGRAPHY Nigel Bluck
DIRECTOR Jess Bluck
EDITOR Original Cut
MUSIC AND SOUND Ken Francis
POST PRODUCTION Perpetual Engineering

USA

FINALIST, CAMPAIGN
HENDERSON ADVERTISING
GREENVILLE, SC

CLIENT St. Joseph's/
Candler Health Care System
EXECUTIVE CREATIVE DIRECTOR Andy Mendelsohn
COPYWRITER Rocky French
ART DIRECTOR Ted Pate

USA

FINALIST, SINGLE
TRONE ATLANTA
ATLANTA, GA

CLIENT Children's Healthcare of Atlanta
CREATIVE DIRECTOR/ART DIRECTOR Brad Ramsey
CREATIVE DIRECTOR/WRITER Jeff Cole
COPYWRITER Mike Brady
PRODUCER Halle Griffey
ACCT. SUPERVISOR Dianne Cooper

USA

FINALIST, SINGLE
TRONE ATLANTA
ATLANTA, GA

CLIENT Children's Healthcare of Atlanta
CREATIVE DIRECTOR/WRITER Jeff Cole
CREATIVE DIRECTOR/ART DIRECTOR Brad Ramsey
COPYWRITER Mike Brady
PRODUCER Halle Griffey
ACCT. SUPERVISOR Dianne Cooper

USA

FINALIST, CAMPAIGN
TRONE ATLANTA
ATLANTA, GA

CLIENT Children's Healthcare of Atlanta
CREATIVE DIRECTOR/ART DIRECTOR Brad Ramsey
CREATIVE DIRECTOR/WRITER Brad Ramsey
COPYWRITER Mike Brady
PRODUCER Halle Griffey
ACCT. SUPERVISOR Dianne Cooper

DENMARK

FINALIST, SINGLE
TBWA\COPENHAGEN
COPENHAGEN

CLIENT Minirin
COPYWRITER Claus Eriksen
CREATIVE DIRECTOR Asbjørn Nors
ANIMATOR Morten Bartholdy/Sonne Film
COMPOSER Simon West
PRODUCER Anders Lundgren

USA	USA	USA
FINALIST, SINGLE	FINALIST, SINGLE	FINALIST, SINGLE
EBEL PRODUCTIONS	**BRUCE DOWAD ASSOCIATES**	**RDW GROUP INC**
CHICAGO, IL	LOS ANGELES, CA	PROVIDENCE, RI
CLIENT Medica Health Plans	CLIENT MD Anderson Cancer Center	CLIENT Blue Cross Blue Shield of Rhode Island
DIRECTOR Bob Ebel	DIRECTOR Bruce Dowad	EXECUTIVE CREATIVE DIRECTOR Jeff Patch
EXECUTIVE PRODUCER Lisa Masseur	EXECUTIVE PRODUCER Jessica Carlson	SENIOR ART DIRECTOR Jeff Dahlberg
EDITOR Mike Johnson	CREATIVE DIRECTOR/ART DIRECTOR Jeff Hopfer	SENIOR COPYWRITER Wendy Boffi
EXECUTIVE CREATIVE DIRECTOR Jennifer Johnson	PRODUCER J.R. Dixon	PRODUCTION SUPERVISOR Tony Aguilar
ASSOCIATE CREATIVE DIRECTOR/COPYWRITER	DIRECTOR OF PHOTOGRAPHY Paul Cameron	PRODUCER Zeke Bowman
Johnny Mackin	LINE PRODUCER Jay Shapiro	DIRECTOR/DP Tami Reiker
PRODUCER Wendy Johnson-Ness	PRODUCTION DESIGNER Lauryn LeClere	EXECUTIVE PRODUCER Mark Hankey
DIR. OF CLIENT SERVICES Kim Thelen	EDITOR Enrique Aguirre	LINE PRODUCER Cynthia Gengras
SEN. ACCOUNT EXECUTIVE Libby Engelsma	COMPOSER Tobias Enhus	

USA	USA	USA
FINALIST, CAMPAIGN	FINALIST, CAMPAIGN	FINALIST, CAMPAIGN
ROCKETT BURKHEAD & WINSLOW	**MARCUS THOMAS**	**NOBLE BBDS**
RALEIGH, NC	CLEVELAND, OH	MILWAUKEE, WI
CLIENT Duke University Health System	CLIENT Akron Children's Hospital	CLIENT Ministry Healthcare
EXECUTIVE VP/CREATIVE DIRECTOR Michael Winslow	CREATIVE DIRECTOR/COPYWRITER Joanne Kim	CREATIVE DIRECTOR/AD/PRODUCER
VP, ASSOCIATE CREATIVE DIRECTOR Mike Allen	ART DIRECTOR Laura Seidel	Michael Wheaton
VP, DIRECTOR OF BROADCAST PRODUCTION	CLIENT Carol Wallace	WRITER/ASSOCIATE CREATIVE DIRECTOR Alex Mohler
Herb Campbell	DIRECTOR Richard Goldstone	DIRECTOR Mark Schimmel
SENIOR ART DIRECTOR John Loftin	PRODUCTION HOUSE Cornerstone Pictures	SR. ACCOUNT EXECUTIVE Amy Hoell
SENIOR VP, PARTNER Walt Clarke	EDIT HOUSE Post Blur	PRODUCTION COMPANY
ACCOUNT EXECUTIVE Margaret Harkness		Crescent Moon Films New York
PROJECT MANAGER Jodi McKeon		CINEMATOGRAPHER Patricio Suarez

USA	USA	USA
FINALIST, SINGLE	FINALIST, CAMPAIGN	FINALIST, SINGLE
AMERICAN CANCER SOCIETY	**TIERNEY COMMUNICATIONS**	**TIERNEY COMMUNICATIONS**
ATLANTA, TX	PHILADELPHIA, PA	PHILADELPHIA, PA
CLIENT Smoking Cessation	CLIENT Independence Blue Cross	CLIENT Independence Blue Cross
NATIONAL VP, CORPORATE COMMUNICATIONS	ECD Kelly Simmons	ECD Kelly Simmons
Greg Donaldson	CD/CW Patrick Hardy	CD/CW Patrick Hardy
ADVERTISING MANAGER Jenny Max	SR. AD Glenn Stevens	SR. AD Glenn Stevens
NATIONAL DIRECTOR, CREATIVE STRATEGY	AGENCY PRODUCER Carolyn Perlow	AGENCY PRODUCER Carolyn Perlow
Amy Swygert	PRODUCTION COMPANY Coppos Films	PRODUCTION COMPANY Coppos Films
EVP, EXECUTIVE CREATIVE DIRECTOR John Carter	DIRECTOR Brian Aldrich	DIRECTOR Brian Aldrich
DIRECTOR Neil Tardio	EXEC. PRODUCER Joanne Ferarro	EXEC. PRODUCER Joanne Ferarro
SVP, ASSOCIATE CREATIVE DIRECTOR	EDITORIAL COMPANY Bug Editorial	EDITORIAL COMPANY Bug Editorial
Lara Baldwin/Paige Bryars	EDITOR Mike Colleta	EDITOR Mike Colleta
VP ACCOUNT DIRECTOR Talley Hultgren	MANAGEMENT DIRECTOR Erin Kuhls	MANAGEMENT DIRECTOR Erin Kuhls
SENIOR ACCOUNT EXECUTIVE Amy Axford	ACCOUNT DIRECTOR Hal Vincent	ACCOUNT DIRECTOR Hal Vincent
PRODUCER Janet Mason	VP. CORPORATE COMMUNICATIONS Kathie Lister	VP. CORPORATE COMMUNICATIONS Kathie Lister
EDITOR Bob Frisk		

RADIO: MEDICAL PRODUCT COMMERCIAL

RADIO: MEDICAL SERVICE COMMERCIAL

MEXICO	AUSTRALIA	USA
FINALIST, SINGLE	FINALIST, SINGLE	FINALIST, SINGLE
FCB WORLD WIDE, S.A. DE C.V.	**STELLARADIO**	**TRONE ATLANTA**
MEXICO CITY	GLEBE	ATLANTA, GA
CLIENT Sal De Uvas Picot	CLIENT Baxter-Biosciences	CLIENT Children's Healthcare of Atlanta
EXECUTIVE CREATIVE VICE PRESIDENT Yuri Alvarado	DIRECTOR/AUDIO ENGINEER Bradley Power	CREATIVE DIRECTOR Jeff Cole/Brad Ramsey
CREATIVE VICE PRESIDENT Gustavo DueÒas	SENIOR PRODUCER Vanessa Erickson	COPYWRITER Brian Sack
CREATIVE DIRECTOR Hector Pallares	AGENCY CREATIVE DIRECTOR Mike Doyle	PRODUCER Tommy Smeltzer
COPY Hector Pallares/Samuel Beltran	PRODUCTION ASSISTANT Chantelle Mercieca	ACCT. SUPERVISOR Dianne Cooper

PRINT ADVERTISEMENT

USA

FINALIST, SINGLE
DDB CHICAGO
CHICAGO, IL

CLIENT Transderm Scop
EXECUTIVE CREATIVE DIRECTOR Richard DiLallo
CREATIVE DIRECTOR David Klehr
ASSOCIATE CREATIVE DIRECTOR Janet Webber
PRINT PROJECT MANAGER Rose Reinke

DENMARK

FINALIST, SINGLE
BBDO DENMARK
COPENHAGEN

CLIENT Canesten
COPYWRITER Jesper Hansen
ART DIRECTOR Ulrik Michelsen
ACCOUNT EXECUTIVE Camilla Mahncke

GERMANY

FINALIST, SINGLE
TILLMANNS, OGILVY & MATHER
DUESSELDORF

CLIENT BKK Bundesverband
CREATIVE DIRECTOR Volker Kuwertz
SENIOR ART DIRECTOR Thomas Bullinger
COPYWRITER Markucs Haefs
ACCOUNT DIRECTOR Friederike Hecker

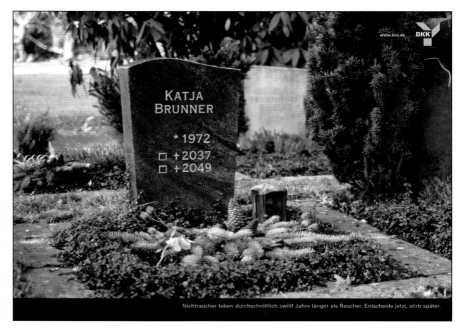

SPAIN

FINALIST, SINGLE
TORRELAZUR-McCANN
MADRID

CLIENT Renu Multiplus/Bausch & Lomb
ADVERTISING AGENCY Torrelazur-McCann
CREATIVE DIRECTOR Daniel Pownall-Benitez
COPYWRITER Mar Ribera
GRAPHIC DESIGNER Jose Antonio Andrés
ART DIRECTOR Ricardo Platón

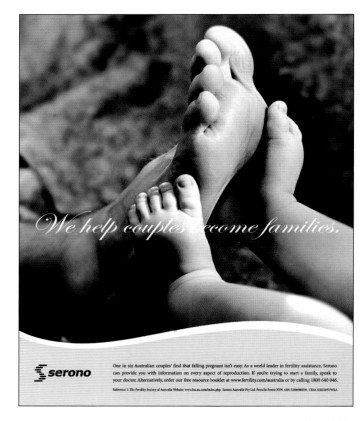

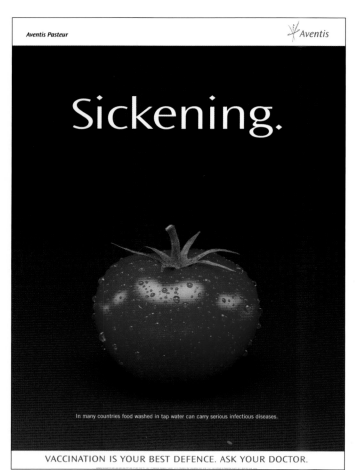

AUSTRALIA

FINALIST, CAMPAIGN
URSA COMMUNICATIONS
MCMAHONS POINT

CLIENT Serono
CREATIVE DIRECTOR Denis Mamo
ART DIRECTOR Kon Marinis
COPYWRITER Dom Tych
PHOTOGRAPHER Tim Bauer
MANAGING DIRECTOR Nigel Cowan
ACCOUNT DIRECTOR Linda Fagan

AUSTRALIA

FINALIST, CAMPAIGN
HEALTH WORLD
NORTH SYDNEY

CLIENT Aventis Pasteur
CEO/STRATEGIST G. Edwards
CREATIVE DIRECTOR A. Nairn
HEAD OF COPY S. Heggie
ACCOUNT DIRECTOR S. Skelton
PRODUCT MANAGER R. Jacobson

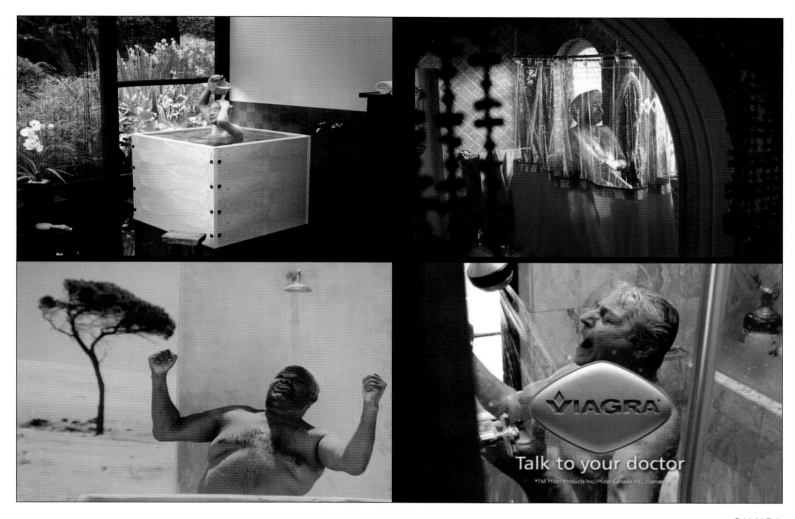

CANADA

GLOBAL AWARD, SINGLE

TAXI
TORONTO

CLIENT Pfizer Canada Viagra
CREATIVE DIRECTOR Zak Mroueh
ASSOCIATE CREATIVE DIRECTOR Lance Martin
WRITER Michael Mayes
AGENCY PRODUCER Louise Blouin (TAXI)
PRODUCER Aerin Barnes (Madd Films, Toronto)
PRODUCER Kirsten Bowman (Big Picture Film Co., S.A.)
DIRECTOR Kevin Donovan
EDITOR Andy Ames (Panic & Bob)
COLOURIST/TRANSFER Bill Ferwerda (Notch)
GRAPHICS/ONLINE CONFORM Dave Giles (AXYZ)
ACCOUNT DIRECTOR Catherine Marcolin

IRELAND

FINALIST, SINGLE
GENESIS ADVERTISING
BELFAST

CLIENT Health Promotion Agency
for Northern Ireland
CREATIVE DIRECTOR Stanley Davidson
COPYWRITER Michael Keenain
DIRECTOR Phil Crothers
PRODUCER Micky O'Neill

SCOTLAND

FINALIST, SINGLE
THE BRIDGE
GLASGOW

CLIENT NHS Health Scotland
COPYWRITER Paul Mason/Jonathan d'Aguilar
ART DIRECTOR Mark Harrison/
Jonathan d'Aguilar

USA

FINALIST , SINGLE
BRUCE DOWAD ASSOCIATES
LOS ANGELES, CA

CLIENT Patanol
DIRECTOR Bruce Dowad
EXECUTIVE PRODUCER Jessica Carlson
CREATIVE DIRECTOR/ART DIRECTOR Ray Behar
PRODUCER Ida Lew
COPYWRITER Emilia Reisner
DIRECTOR OF PHOTOGRAPHY Paul Cameron
LINE PRODUCER Leora Glass
PRODUCTION DESIGNER Lauryn LeClere
EDITOR Enrique Aguirre
VFX SUPERVISOR Andy MacDonald
COMPOSER Paul Bessenbacher

USA

FINALIST, SINGLE
McCANN ERICKSON NEW YORK
NEW YORK, NY

CLIENT Paxil CR
SENIOR VICE PRESIDENT, GROUP DIRECTOR Gary Chu
VICE PRESIDENT, MGMT. REPRESENTATIVE
Sharon Johnson
ART DIRECTOR Ryan Hose
COPYWRITER Meg Rogers
EXECUTIVE VICE PRESIDENT Andrew Schirmer
EXECUTIVE PRODUCER Hugh Herbert Burns
ACCOUNT SUPERVISOR Tamar Arslanian
ACCOUNT EXECUTIVE Jason Reed
ASSISTANT ACCOUNT EXECUTIVE Sarah Speck

AUSTRALIA

FINALIST, SINGLE
GREY HEALTHCARE GROUP
MELBOURNE, VICTORIA

CLIENT Seretide
SENIOR COPYWRITER Kate Lightfoot
SENIOR ART DIRECTOR Tim Brierley
GROUP ACCOUNT DIRECTOR Christina Hughes
ANIMATOR David Johnson
BRAND MANAGER Michael Grant
PRODUCER Meagan McCartney

MIXED MEDIA CAMPAIGN

When Sharon was diagnosed with colon cancer, Mike initially thought the nearest hospital would be the best choice. Then he did a little research and discovered that because Sharon would have to undergo surgery and chemotherapy, she should have the most experienced care available—from Sarasota Memorial. With the region's most advanced technology and a caring, compassionate approach, Sharon's oncology team helped them replace fear with hope. And for Mike, that hit closer to home than anything else.

If you found out your wife had cancer, would you trust her care to *just any hospital?*

There's so much more to a hospital than where it's located, especially when it comes to cancer. We have the region's most experienced oncology team, the latest detection and therapeutic technologies and a strong affiliation with H. Lee Moffitt Cancer Center and Research Institute. And the compassionate, healing care you and your family need to stay focused on recovery. Call (941) 917-7777 or visit www.smh.com. Before you make the decision of a lifetime.

SARASOTA MEMORIAL
HEALTH CARE SYSTEM
A decision as important as life itself.

USA

FINALIST, CAMPAIGN

RONIN ADVERTISING GROUP
COCONUT GROVE, FL

CLIENT Sarasota Memorial Healthcare System
EXECUTIVE CREATIVE DIRECTOR John Swisher
ASSOCIATE CREATIVE DIRECTOR Meryl Rothstein
COPY CREATIVE DIRECTOR Ann Trondle-Price
DESIGN DIRECTOR James Guest
PHOTOGRAPHER Tom Cwenar
AGENCY PRODUCER Erin Holmes
INTERACTIVE CREATIVE DIRECTOR Jeff Myers
INTERACTIVE DIRECTOR Ron Santillo

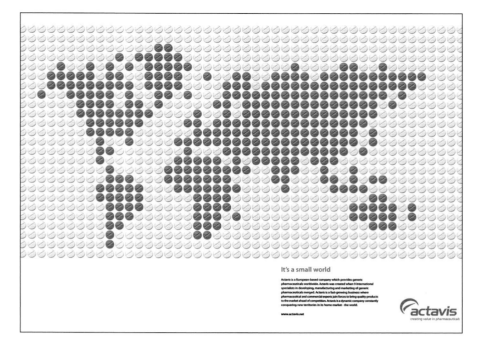

It's a small world

Actavis is a European-based company which provides generic pharmaceuticals worldwide. Actavis was created when 9 international specialists in developing, manufacturing and marketing of generic pharmaceuticals merged. Actavis is a fast-growing business where pharmaceutical and commercial experts join forces to bring quality products to the market ahead of competition. Actavis is a dynamic company constantly conquering new territories in its home market - the world.
www.actavis.net

actavis
creating value in pharmaceuticals

ICELAND

FINALIST, CAMPAIGN

THE WHITE HOUSE
REYKJAVIK

CLIENT Actavis
CREATIVE DIRECTOR Sverrir Bjornsson/Stefan Einarsson
ART DIRECTOR Emil Valgeirsson/Bjarki Ludviksson
ACCOUNT EXECUTIVE Hrafnhildur Juliusdottir
COPYWRITER Anna Agustsdottir
MARKETING MANAGER Elisabet Hjaltadottir/Bjorn Adalsteinsson

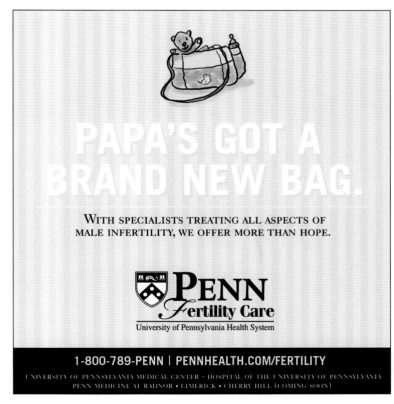

PAPA'S GOT A BRAND NEW BAG.

WITH SPECIALISTS TREATING ALL ASPECTS OF
MALE INFERTILITY, WE OFFER MORE THAN HOPE.

PENN
Fertility Care
University of Pennsylvania Health System

1-800-789-PENN | PENNHEALTH.COM/FERTILITY

UNIVERSITY OF PENNSYLVANIA MEDICAL CENTER · HOSPITAL OF THE UNIVERSITY OF PENNSYLVANIA
PENN MEDICINE AT RADNOR · LIMERICK · CHERRY HILL (COMING SOON)

USA

FINALIST, CAMPAIGN

UNIVERSITY OF PENNSYLVANIA HEALTH SYSTEM
PHILADELPHIA, PA

CLIENT Penn Fertility Care
MARKETING COORDINATOR/EDITOR J. Rebecca Stewart

GRAND GLOBAL

Craftsmanship

ENGLAND

GRAND GLOBAL BEST CRAFT

JUNCTION 11 ADVERTISING

WEYBRIDGE, SURREY

CLIENT Risperdal
COPYWRITER Richard Rayment
ART DIRECTOR John Timney
CREATIVE DIRECTOR Richard Rayment/John Timney
ILLUSTRATOR Mark Moran
STUDIO MANAGER Liz Spencer
ACCOUNT MANAGER Anna Scott
CLIENT SERVICES DIRECTOR Richard Hart
PRODUCT MANAGER Nick Georgiou/Lisa Meddows-Taylor
MARKETING MANAGER John Bacon

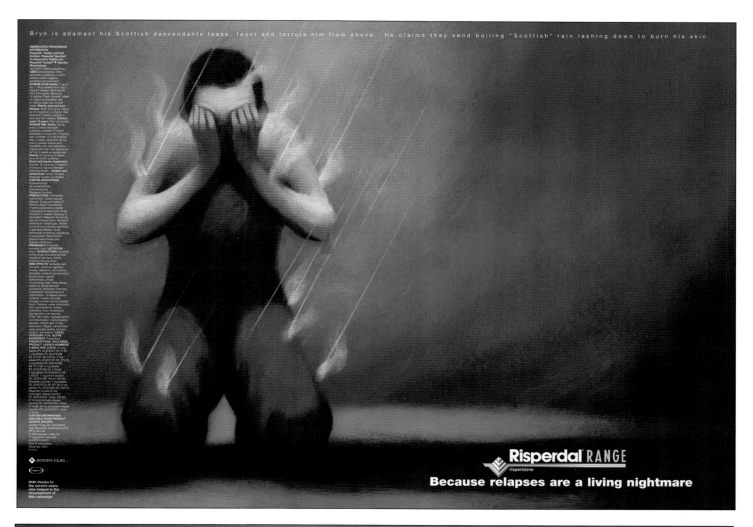

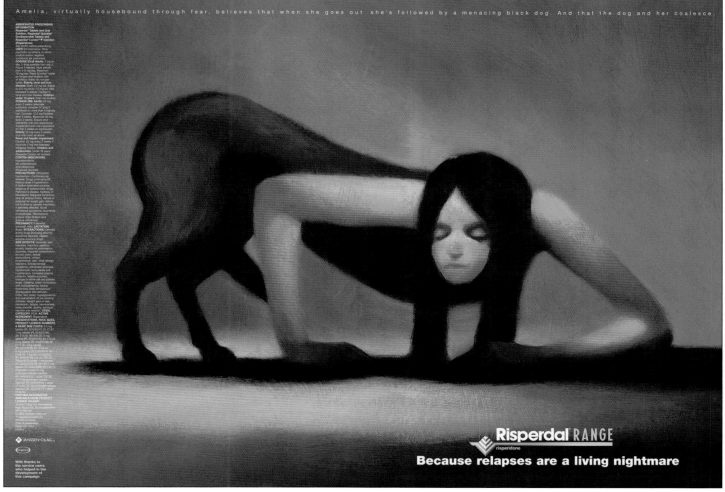

CRAFTMANSHIP

ART DIRECTION & DESIGN

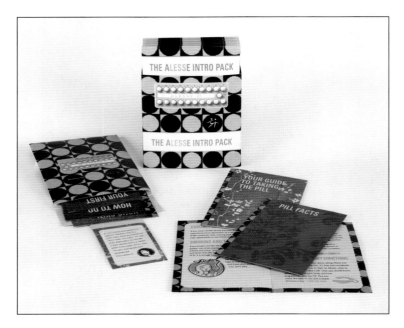

CANADA

FINALIST, SINGLE

ANDERSON DDB HEALTH & LIFESTYLE
TORONTO

CLIENT Alesse
CREATIVE DIRECTOR Ron Hudson
ART DIRECTOR Monica Clara
COPYWRITER Jed Churcher
ILLUSTRATOR Julia Breckenreid

THE NETHERLANDS

FINALIST, SINGLE

POSTPANIC
AMSTERDAM

CLIENT DSM Pharmaceuticals
DIRECTOR Mischa Rozema
SPECIAL FX DIRECTOR Jules Tervoort
PRODUCER Ania Markham
DSM CORPORATE COMMUNICATIONS John McLaren/
Rob Dirix/Berry Oonk

USA

FINALIST, SINGLE

SAN JOSE MEDICAL CENTER
SAN JOSE, CA

CLIENT SJMC Public Affairs Leslie Kelsay
ART DIRECTOR Nate Digre
COPYWRITER Wendy Satterlund
ACCOUNT EXECUTIVES Amy Choice/Nanci Williams

COMPUTER-GENERATED GRAPHICS

COPYWRITING

ILLUSTRATION

PHOTOGRAPHY

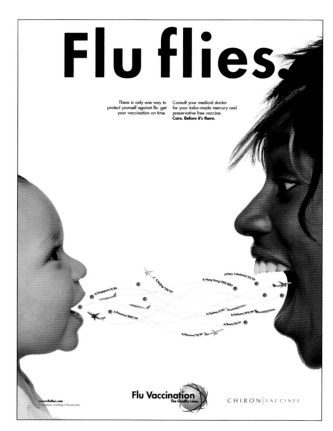

GERMANY

GLOBAL AWARD, CAMPAIGN

MICHAEL CONRAD & LEO BURNETT

FRANKFURT

CLIENT Dr. Med. Dent. Kaia Hallscheidt
CREATIVE DIRECTOR Uwe Marquardt/Kerrin Nausch
ART DIRECTOR Bernd Knothe/Aki Röll
PRINT PRODUCER Monika Nikot

ROCHESTER
GENERAL
HOSPITAL
HOME OF THE
Rochester Heart Institute

USA
FINALIST, SINGLE
PARTNERS + NAPIER
ROCHESTER, NY

CLIENT Via Health
V.P., MARKETING & PUBLIC RELATIONS
Diane Ewing
ART DIRECTOR Donna Korff
ACCOUNT SUPERVISOR Laura Conn/
Kimberly Jones

InstitutoRoche
para las Soluciones Integrales de Salud

SPAIN
FINALIST, SINGLE
PHARMA CONSULT SERVICES
MADRID

CLIENT Instituto Roche
CREATIVE DIRECTOR Sebastián De La Serna
ART DIRECTOR Javier Rodríguez De Santiago

PACKAGE DESIGN

CANADA
FINALIST, SINGLE
ACADEMIE OGILVY
MONTREAL

CLIENT Cefzil
CREATIVE DIRECTOR Steve Crawford
ART DIRECTOR Benoit St-Laurent
COPYWRITER Marie-Josée Trudel
ILLUSTRATORS Benoit St-Laurent, Serge Rousseau
PRODUCT MANAGER Nathalie Guilbault

USA

GLOBAL AWARD, SINGLE
GSW WORLDWIDE
WESTERVILLE, OH

CLIENT **Genentech Growth Hormone**
ART DIRECTOR **Dave Ragan**
PRODUCTION DIRECTOR **Melissa Storer**
ACCOUNT DIRECTOR **Matt Brown**
ACCOUNT SUPERVISOR **Trent Donohue**
ASSOCIATE CREATIVE DIRECTOR **Keith Flint**
CREATIVE DIRECTOR **Bill Fillipp**

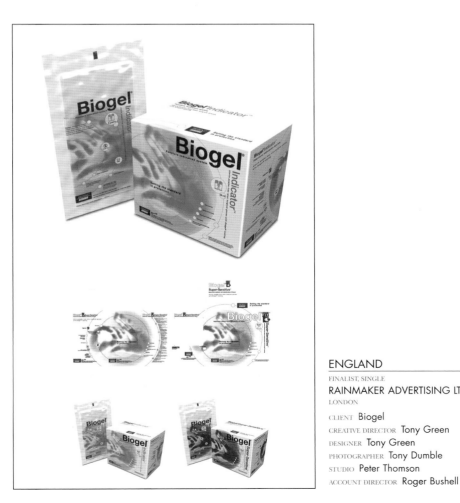

ENGLAND

FINALIST, SINGLE
RAINMAKER ADVERTISING LTD
LONDON

CLIENT **Biogel**
CREATIVE DIRECTOR **Tony Green**
DESIGNER **Tony Green**
PHOTOGRAPHER **Tony Dumble**
STUDIO **Peter Thomson**
ACCOUNT DIRECTOR **Roger Bushell**

REAL LIFE MODEL MAKING

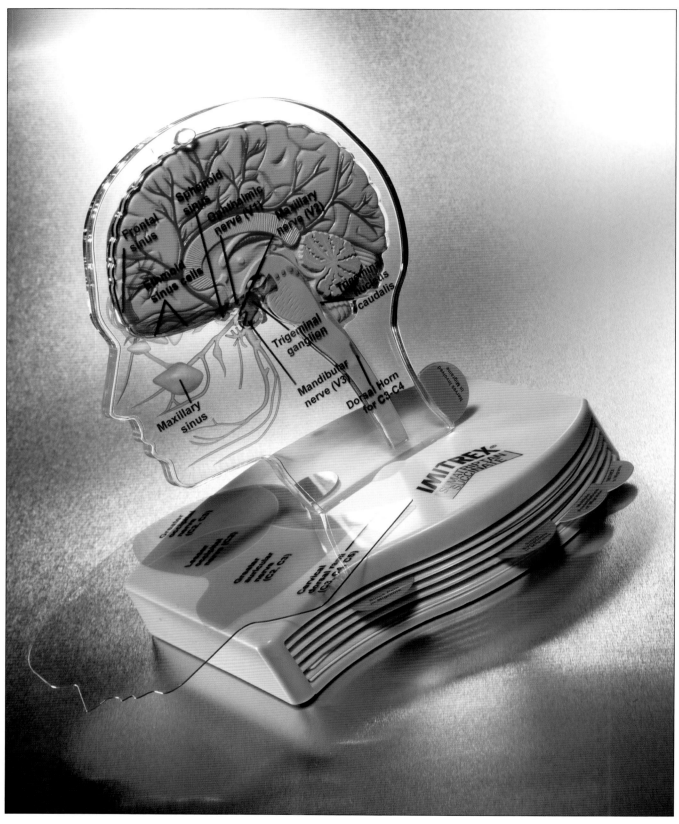

USA

GLOBAL AWARD, SINGLE
PHARMADESIGN INC.
WARREN, NJ

CLIENT **Imitrex**
ACCOUNT DIRECTORS **Jonathan Coe/Joseph Caramico**
PRODUCT MANAGER **Stacy Duren**
CLIENT **GlaxoSmithKline/Veasey Ad Ventures, Inc.**
INDUSTRIAL DESIGN TEAM **Mitchell Tung/Richard Costa**
PRODUCTION MANAGER **Michael Hayden**

SOCIAL COMMITMENT: CONSUMER EDUCATION

BROCHURE

USA
FINALIST, SINGLE
HIGHMARK INC.
PITTSBURGH, PA
SENIOR GRAPHIC DESIGNER Adam L. Isovitsch
GRAPHIC DESIGNER Amy J. Davis

USA
FINALIST, SINGLE
RTC RELATIONSHIP MARKETING
WASHINGTON, DC
CLIENT Levitra
VP, CREATIVE GROUP DIRECTOR Dawn Panzeca
ASSOCIATE CREATIVE DIRECTOR Kwame DeRoche
ART DIRECTOR Natalie Letsky
ASSOCIATE ACCOUNT DIRECTOR John Hamilton
SENIOR ACCOUNT EXECUTIVE Kai Musielak
ASSOCIATE ACCOUNT EXECUTIVE Asha Datta
VP, PRODUCTION SERVICES Lauren Boyd
DEPUTY DIRECTOR, MEN'S HEALTH MARKETING Marci Hanlon
PRODUCT MANAGER, LEVITRA Lou Sanquini
MANAGER, INTEGRATED SOLUTIONS Bill Meisle

DIRECT MAIL

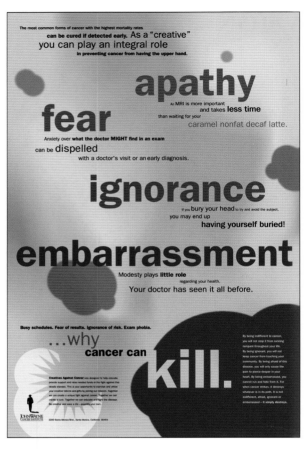

FILM/VIDEO

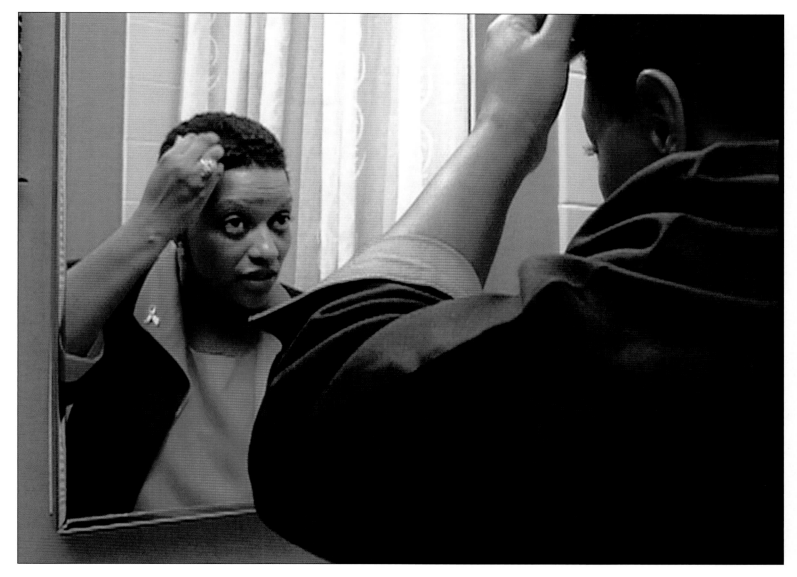

USA

GLOBAL AWARD, SINGLE
HOGGARD FILMS
ALEXANDRIA, VA

EXECUTIVE PRODUCER Steven Hoggard
PRODUCER/DIRECTOR/WRITER Daphna Rubin
ASSOCIATE PRODUCER Jacob Laufer
EDITOR Barr Weissman
DIRECTOR OF PHOTOGRAPHY David J. Goulding
PRODUCTION MANAGER Michael Amouri
AUDIO RECORDIST Paul Rusnak/Jeff Hayash
NARRATOR Tracy Thorne

USA

FINALIST, SINGLE
POMONA VALLEY HOSPITAL MEDICAL CENTER
POMONA, CA

CLIENT Pomona Valley Hospital Medical Center
DIRECTOR, MARKETING AND PUBLIC RELATIONS Kathy Roche
PRODUCER/DIRECTOR John Pipes
COMMUNITY SERVICES COORDINATOR Frank Garcia
MARKETING COMMUNICATIONS MANAGER Kathy Perkins-Smerdel
DIRECTOR, MARKETING AND PUBLIC RELATIONS Kathy Roche
PRODUCER/DIRECTOR John Pipes
COMMUNITY SERVICES COORDINATOR Frank Garcia
MARKETING COMMUNICATIONS MANAGER Kathy Perkins-Smerdel

USA

FINALIST, CAMPAIGN
PALIO COMMUNICATIONS
SARATOGA SPRINGS, NY

CLIENT Combivir
CREATIVE DIRECTOR Guy Mastrion/Todd LaRoche
ART DIRECTOR Ken Messinger
COPYWRITER Paul Harrington
PRODUCTION COMPANY Leigh Devine Productions
POST PRODUCTION Salamandra Images

BELGIUM

GRAND GLOBAL BEST SOCIAL COMMITMENT

LEO BURNETT BELGIUM

BRUSSELS

CLIENT 2003 Year Of The Handicapped ANLH-ABMM
CREATIVE DIRECTOR Andre Rysman
COPYWRITER Gregory Ginterdaele
ART DIRECTOR Marie-Laure Clinquennois-Dupont
BRAND MANAGER - ANLH Cleon Angelo/Jean-Marie Huet

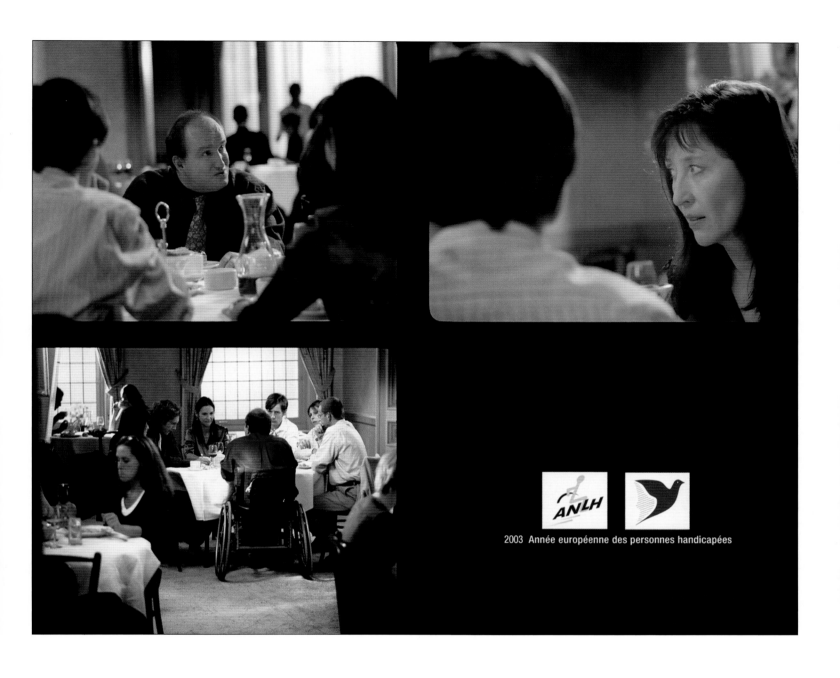

2003 Année européenne des personnes handicapées

WOMEN
HEALTHFUL LIVING

MARCH 2004
FREE PUBLICATION

ALL ABOUT
HRT
MENOPAUSE
SYMPTOMS

HEALTH
TAI-CHI
MORE THAN JUST A
DANCE

INTERVIEW
the secrets of
Rosa
VILLACASTÍN

SPAIN

GLOBAL AWARD, SINGLE
MK MEDIA, S.L.
MADRID
CLIENT EFFIK
CREATIVE DIRECTOR Javier Jato
ART DIRECTOR Ivan Roig
MEDICAL MANAGER Oscar Esteban
CONSULTANT Alberto Gonzalez/Elena Moreno

GERMANY
GLOBAL AWARD, SINGLE
McCANN ERICKSON FRANKFURT
FRANKFURT

CLIENT AG36
CREATIVE DIRECTOR Thomas Auerswald/Walter Roux
ART DIRECTOR Uli Happel
PHOTOGRAPHER Frank Weinert
ACCOUNT DIRECTOR Stefan Geisse
IMAGE ARTWORKS Typo Wenz Artworks

SWITZERLAND
FINALIST, SINGLE
EURO RSCG ZURICH
ZURICH

CLIENT Novartis/Voltaren Dolo
SENIOR BRAND MANAGER Monika Brütsch
CREATIVE DIRECTOR Frank Bodin
ART DIRECTOR Marcel Schlaefle
ACCOUNT DIRECTOR Peter Zeller

AND WHAT ARE YOU BRINGING HOME TO HIM?

Protect yourself. And others. www.muenchner-aidshilfe.de

GERMANY

GLOBAL AWARD, CAMPAIGN
.START
MUNICH, BAVARIA

CLIENT Muenchner AIDS-Hilfe e.V.
CREATIVE DIRECTORS Marco Mehrwald/
Thomas Pakull/Stefan Hempel
ART DIRECTOR Isabell Handl
COPYWRITER Anja Moritz
PHOTOGRAPHY Andrea Ruester
ACCOUNT DIRECTOR Nick Stasch
MARKETING DIRECTOR Thomas Niederbuehl
MARKETING MANAGER Alexander Kluge

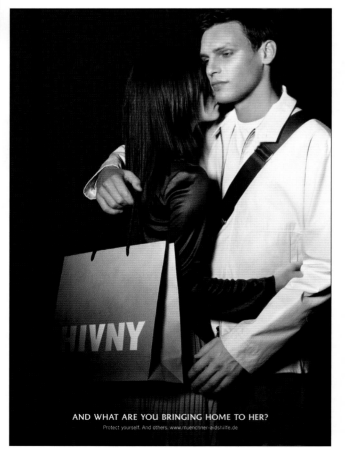

AND WHAT ARE YOU BRINGING HOME TO HER?

Protect yourself. And others. www.muenchner-aidshilfe.de

This is a composite diagram of a hypothetical digital healthcare enterprise that shows how innovation and integration of technology can turn your organization into a high-performance delivery system.

GERMANY

FINALIST, SINGLE

HE SAID SHE SAID
HAMBURG

CLIENT Blutspendedienst Hamburg
CREATIVE DIRECTOR Michael Hoinkes
ILLUSTRATION Michael Hoinkes
CLIENT Prof. Dr. Med. A. Poschmann

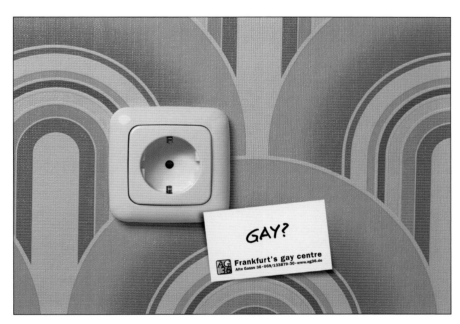

GAY?

AG Frankfurt's gay centre
36 Alte Gasse 36 · 069/133879-30 · www.ag36.de

GERMANY

FINALIST, SINGLE

McCANN ERICKSON FRANKFURT
FRANKFURT

CLIENT AG36
CREATIVE DIRECTOR Thomas Auerswald/Walter Roux
ART DIRECTOR Uli Happel
PHOTOGRAPHER Frank Weinert
ACCOUNT DIRECTOR Stefan Geisse
IMAGE ARTWORKS Typo Wenz Artworks

INDIA

FINALIST, CAMPAIGN

SSC&B LINTAS PVT. LTD.
MUMBAI

CLIENT The Vegetarian Society
PRESIDENT Ajay Chandwani
CREATIVE DIRECTOR Nishad Ramachandran/
Satish Ambewadikar
PHOTOGRAPHER Atul Patil
ILLUSTRATOR Yashwant Sawant

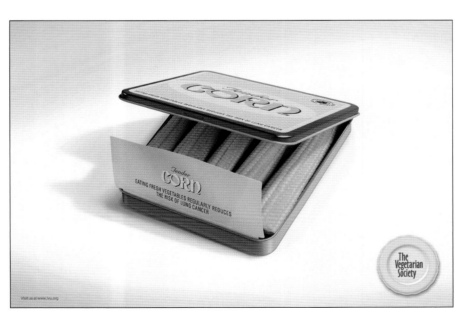

PRINT ADVERTISEMENT

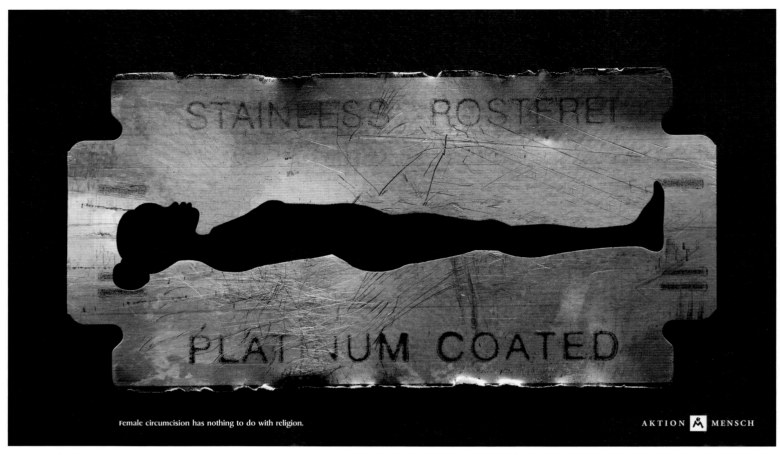

Female circumcision has nothing to do with religion.

AKTION MENSCH

AUSTRIA
GLOBAL AWARD, SINGLE
LOWE GGK
VIENNA

CLIENT Aktion Mensch
CREATIVE DIRECTOR Walther Salvenmoser/
Athanassois Stellatos
ART DIRECTOR/COPYWRITER Walther Salvenmoser
PHOTOGRAPHER Oliver Jiszda
ILLUSTRATOR Ken Sakurai-Karner
TYPOGRAPHER Viennapaint/Christian Ruff

PHILIPPINES
FINALIST, SINGLE
DENTSU PHILIPPINES, INC
MAKATI CITY

CLIENT Comprilex, Rimaped, Zinaplex Anti TB Medicines
VP/CLUSTER HEAD PEDIATRICA, INC. Lorenzo L. Barros
VP/GM PEDIATRICA, INC. Ezar F. de Guia
PRESIDENT, DENTSU PHILS. Nonna P. Nanagas
SVP/ECD, DENTSU PHILS. Bonnie S. Melocoton
MKTG. MGR., PEDIATRICA, INC. Jose A. Peralta
BRAND MGR., PEDIATRICA, INC. Dennis L. Uy
GROUP ACCOUNT DIRECTOR, DENTSU PHILS. Titus S. Arce
COPY GROUP HEAD, DENTSU PHILS. Monique A. Sibal
ASSO. ART DIRECTOR, DENTSU PHILS. Mae S. Quinones
SR. ACCOUNT MANAGER, DENTSU PHILS. Cristina L. Robles
PRINT PRODUCER, DENTSU PHILS. Dennis U. Carlos
GRAPHIC ARTIST, DENTSU PHILS. Angelito G. Tan, Jr.

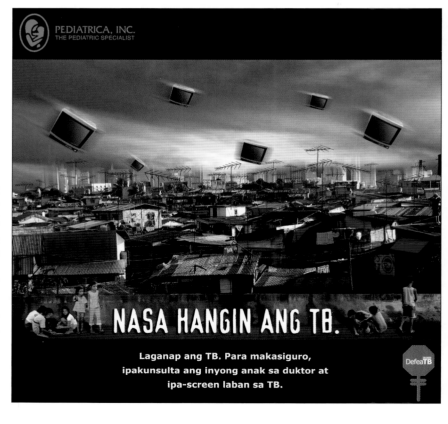

PEDIATRICA, INC.
THE PEDIATRIC SPECIALIST

NASA HANGIN ANG TB.

Laganap ang TB. Para makasiguro,
ipakunsulta ang inyong anak sa duktor at
ipa-screen laban sa TB.

DefeatTB

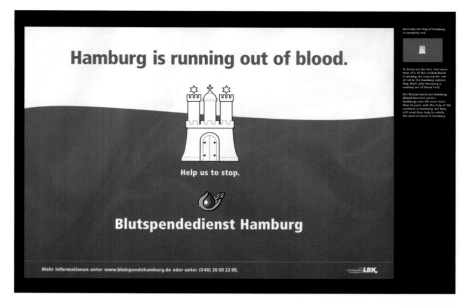

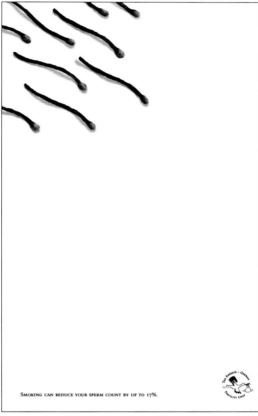

SMOKING CAN REDUCE YOUR SPERM COUNT BY UP TO 17%.

UNITED ARAB EMIRATES
FINALIST, SINGLE
HEALTHWORLD PANGULF
DUBAI
CLIENT Emirate German Fertility Clinic

GERMANY
FINALIST, SINGLE
HE SAID SHE SAID
HAMBURG
CLIENT Blutspendedienst Hamburg
CREATIVE DIRECTOR Michael Hoinkes
ILLUSTRATION Michael Hoinkes
CLIENT Prof. Dr. Med. A. Poschmann

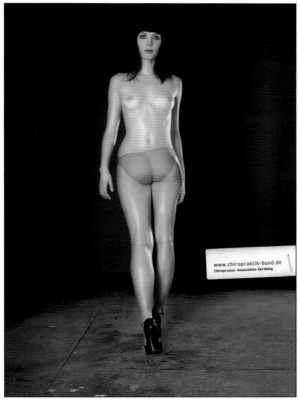

GERMANY
FINALIST, SINGLE
.START
MUNICH, BAVARIA
CLIENT Bund Deutscher Chiropraktiker e.V.
CREATIVE DIRECTORS Marco Mehrwald/Thomas Pakull
ART DIRECTOR Isabell Handl
COPYWRITER Anja Moritz
PHOTOGRAPHY Anja Frers
ACCOUNT MANAGER Simona Stueckle
MARKETING DIRECTOR Kurt Jürgen Schwarz

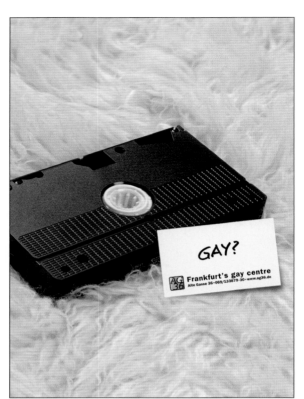

GERMANY

FINALIST, SINGLE

McCANN ERICKSON
FRANKFURT

FRANKFURT

CLIENT AG36
CREATIVE DIRECTOR Thomas
Auerswald/Walter Roux
ART DIRECTOR Uli Happel
PHOTOGRAPHER Frank Weinert
ACCOUNT DIRECTOR Stefan Geisse
IMAGE ARTWORKS
Typo Wenz Artworks

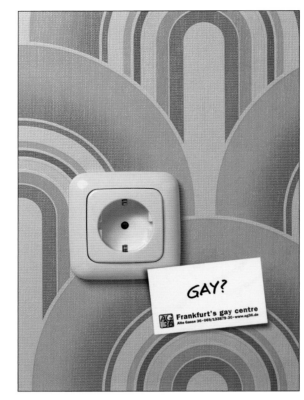

GERMANY

FINALIST, SINGLE

McCANN ERICKSON FRANKFURT

FRANKFURT

CLIENT AG36
CREATIVE DIRECTOR Thomas Auerswald/Walter Roux
ART DIRECTOR Uli Happel
PHOTOGRAPHER Frank Weinert
ACCOUNT DIRECTOR Stefan Geisse
IMAGE ARTWORKS Typo Wenz Artworks

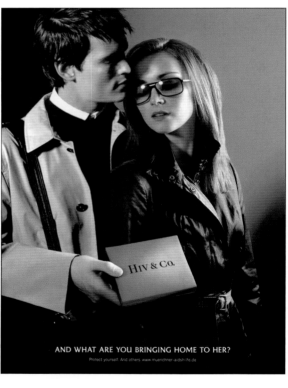

GERMANY

FINALIST, CAMPAIGN

.START

MUNICH, BAVARIA

CLIENT Muenchner AIDS-Hilfe e.V.
CREATIVE DIRECTORS Marco Mehrwald/
Thomas Pakull/Stefan Hempel
ART DIRECTOR Isabell Handl
COPYWRITER Anja Moritz
PHOTOGRAPHY Andrea Ruester
ACCOUNT DIRECTOR Nick Stasch
MARKETING DIRECTOR Thomas Niederbuehl
MARKETING MANAGER Alexander Kluge

USA

FINALIST, CAMPAIGN

DEVITO FITTERMAN
ADVERTISING

NEW YORK, NY

CLIENT World Hunger Year
(WHY)
CREATIVE DIRECTOR
Chris DeVito
CREATIVE SUPERVISOR/COPYWRITER
Ryan Cote
ART DIRECTOR Fabio Costa
ADVERTISING AGENCY PARTNER
Frank DeVito/
Betty Fitterman

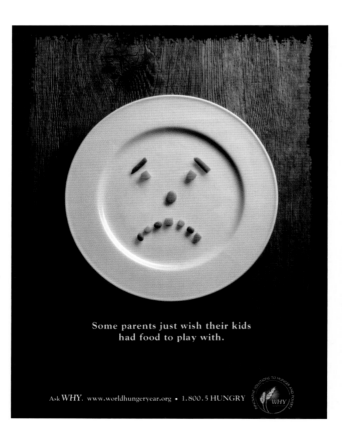

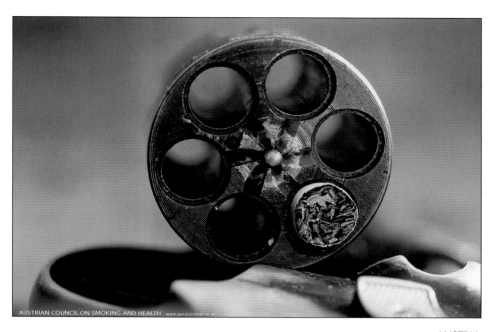

AUSTRIA

FINALIST, SINGLE

LOWE GGK

VIENNA

CLIENT Austrian Council on Smoking & Health
CREATIVE DIRECTOR Walther Salvenmoser
ART DIRECTOR/ACCOUNT DIRECTOR Walther Salvenmoser
PHOTOGRAPHER Dieter Brasch/Stock:Contrastphoto
TYPOGRAPHER Blaupapier/Viennapaint

PUBLIC RELATIONS PACKAGE

SPAIN

FINALIST, SINGLE

PHARMA CONSULT SERVICES, S.A.

BARCELONA

CLIENT Vitalinea
CREATIVE DIRECTOR Maria Jose Mateo
COPYWRITER Maria Jose Mateo
TECHNICAL ADVISER Marta Olmos
ACCOUNT DIRECTOR Maria Rosa Nuñez
GENERAL DIRECTOR Alba Guzmán

USA

FINALIST, SINGLE

CREATIVE PRIORITY

NEW YORK, NY

CLIENT Novartis
EXECUTIVE CREATIVE DIRECTOR DJ Haddad
CREATIVE DIRECTOR Jean Tate
CEO Dana Farbo

TV ANNOUNCEMENT

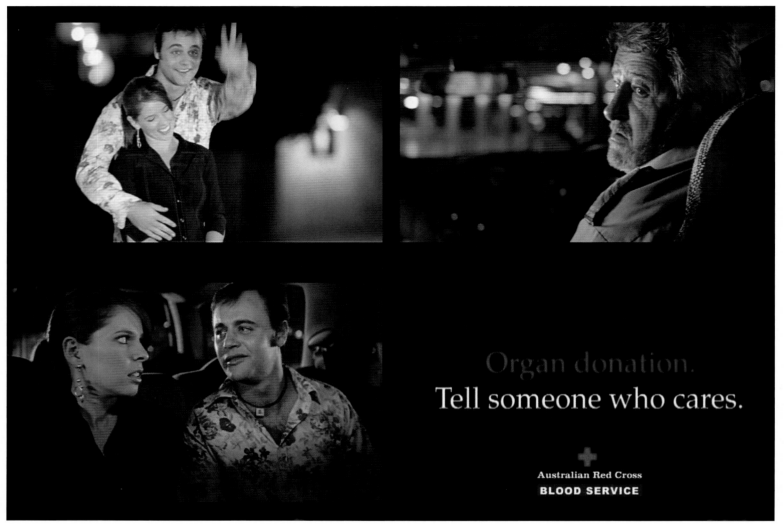

Organ donation.
Tell someone who cares.
Australian Red Cross
BLOOD SERVICE

AUSTRALIA

GLOBAL AWARD, SINGLE
BATEY KAZOO
SYDNEY

CLIENT **Red Cross**
CREATIVE DIRECTOR/WRITER **Russell Smyth**
ART DIRECTOR **Michael Malherbe**
AGENCY PRODUCER **Fred Madderom**
ACCOUNT DIRECTOR **Celeste Singleton**
WRITER **Dennis Koutologenis**
DIRECTOR **Ben Weir**
PRODUCTION COMPANY **Republic**
PRODUCER **Mike Carlton**
EDITOR **Louis Byrne-Smith (Cutting Commments)**
DIRECTOR OF PHOTOGRAPHY **Russell Boyd**
MUSIC/SOUND **Stellar Sound**
POST PRODUCTION **Frame Set & Match**

ENGLAND

GLOBAL AWARD, SINGLE
TYNE AND WEAR HEALTH ACTION ZONE
NEWCASTLE UPON TYNE

CLIENT **NHS**
CAMPAIGNS DIRECTOR **Elaine Wilson**
PRODUCER DENE FILMS **Steve Salam**
SMOKE FREE NORTH EAST **Judith McMorran**

SPAIN

FINALIST, SINGLE
LOWE FMRG
BARCELONA

CLIENT **Spanish Heart Foundation**
EXEC CREATIVE DIRECTOR **Virgilio Ferrer**
(Lowe FMRG)
ART DIRECTOR **Sergi Mila (Lowe FMRG)**
CREATIVE DIRECTOR **Eva Aparicio (Lowe FMRG)**
ACCOUNT DIRECTOR **Elizabeth Hurtado**
(Lowe FMRG)
FILM DIRECTOR **Gabe Ibañez (Tesauro)**
PRODUCER **Miki Heras (Tesauro)**

USA

FINALIST, SINGLE
MASIUS
NEW YORK, NY

CLIENT
American Gastroenterological Association
CREATIVE DIRECTOR **Bill Connors**
DIRECTOR **David McNamara**
AGENCY PRODUCER **Chris Theilo**
COPYWRITER **Bill Connors**
ART DIRECTOR **Gene Campanelli**
PRODUCTION COMPANY **Maysles Shorts**
POST PRODUCTION **Wild Child**
PRODUCER **Margaret Lopez Ambronsoni**

USA

FINALIST, SINGLE
HENDERSON ADVERTISING
GREENVILLE, SC

CLIENT **St. Joseph's/**
Candler Health Care System
EXECUTIVE CREATIVE DIRECTOR **Andy Mendelsohn**
COPYWRITER **Andy Mendelsohn**
ART DIRECTOR **J. J. Puryear**

MIXED MEDIA CAMPAIGN

USA

GRAND GLOBAL BEST FILM/VIDEO
DONAHOE PUROHIT MILLER, INC
CHICAGO, IL

CLIENT Dermik Laboratories/Dermik Laboratories
VP CREATIVE DIRECTOR Jay Doniger
COPYWRITER Jay Doniger
DIRECTORS Jay Doniger/Corky Arnold
PRODUCER Steve Gellman

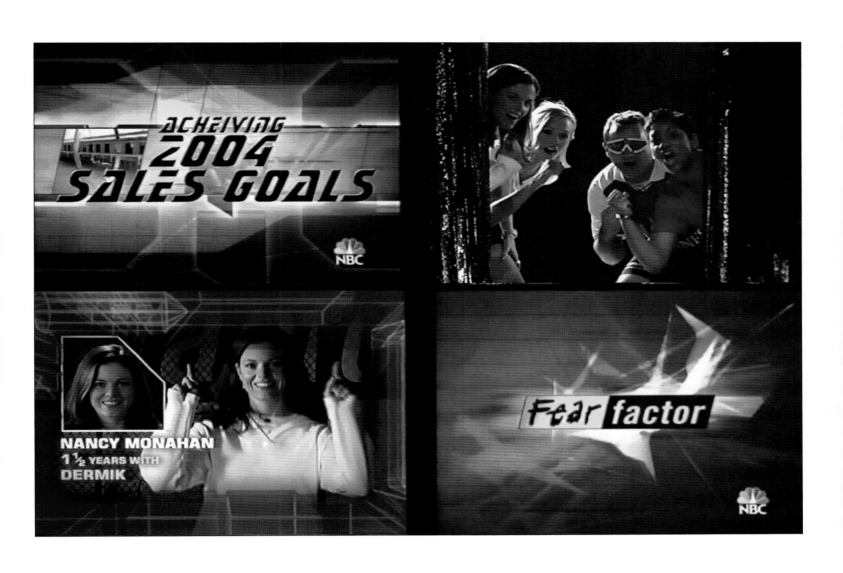

Social Commitment:
Healthcare Professional Education

BROCHURE

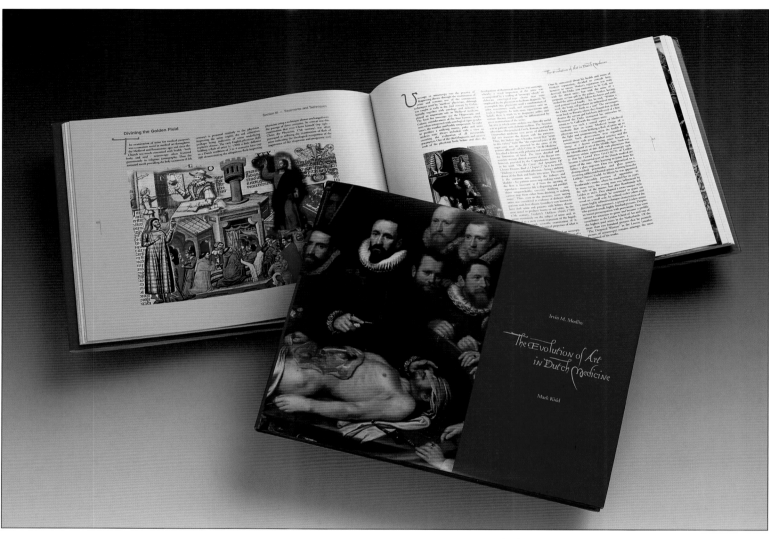

ITALY

GLOBAL AWARD, SINGLE
SUDLER & HENNESSEY INTERNATIONAL
MILANO

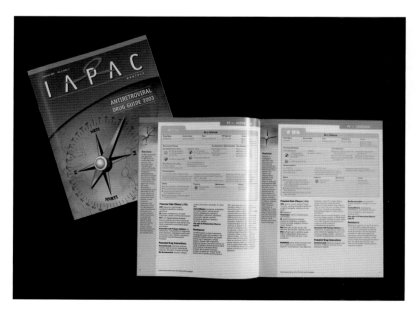

<div align="right">

CANADA

FINALIST, SINGLE
MEDICUS CANADA
TORONTO

CLIENT **IAPAC**
COPYWRITER **Lindsay Craik/Anna Frick**
ART DIRECTOR **Chantal Innes**
CREATIVE DIRECTOR **Paul Hurren**
CHIEF EXECUTIVE OFFICER **Jose Zuniga**
ACCOUNT SUPERVISOR **Anna Frick**
ACCOUNT DIRECTOR **Brian Hujdich**
PRODUCTION DIRECTOR **Lynn 'Baker' Deagle**
ROYALTY FREE PHOTOGRAPHY **Getty Images**

</div>

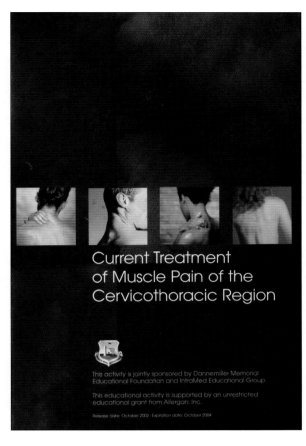

Current Treatment
of Muscle Pain of the
Cervicothoracic Region

This activity is jointly sponsored by Dannemiller Memorial
Educational Foundation and IntraMed Educational Group.

This educational activity is supported by an unrestricted
educational grant from Allergan, Inc.

Release date: October 2002. Expiration date: October 2004

CME NON-ACCREDITED PROGRAM

A Guide to Introducing Biologic Therapies
for Psoriasis Into Clinical Practice

IPF
INVESTIGATORS MEETING

SATURDAY, MAY 22, 2004
ORLANDO MUSEUM OF ART

INTERMUNE®

PRINT ANNOUNCEMENT

USA

FINALIST, CAMPAIGN

MEYER & WALLIS
MILWAUKEE, WI

CLIENT American Heart Association
ART DIRECTOR Greg Huff
CREATIVE DIRECTOR Tom Dixon
PRODUCTION MANAGER Lynn Becker

CME ACCREDITED PROGRAM

USA

FINALIST, SINGLE

ADVANCED, THE MARKET
DEVELOPMENT COMPANY
LAMBERTVILLE, NJ

ART DIRECTOR Michael Piperno
COPYWRITER Mathew Hasson
CREATIVE DIRECTOR Michael Morris

USA

FINALIST, SINGLE

AMERICAN MEDICAL ASSOCIATION
FOUNDATION
CHICAGO, IL

CLIENT Health Literacy
EXECUTIVE DIRECTOR Kathleen MacArthur

DIRECTOR, COMMUNITY HEALTH
Joanne Schwartzberg, MD
DIRECTOR OF PROGRAMS Barbara Correll

USA

FINALIST, SINGLE

AXIS HEALTHCARE COMMUNICATIONS LLC
YARDLEY, PA

CLIENT Janssen Pharmaceutica Products, L.P.
VP, CREATIVE SERVICES Karen L. Gatta
CREATIVE DIRECTOR Karen Smith
SENIOR ART DIRECTOR Heather Sailer
PROGRAM MANAGER Gregg Levy

USA

FINALIST, SINGLE

INFLEXXION, INC.
NEWTON, MA

PROJECT MANAGER Diane Johnson, M.P.H.
DESIGNER George Varga
DEVELOPER Johanna Newell/Ben Tremblay
PROJECT MANAGER Shalini Tendulkar, Sc.M.
RESEARCH COORDINATOR Mike Ward
V.P., PRODUCT DEVELOPMENT Emil Chiauzzi, Ph.D.
DIRECTOR OF MULTIMEDIA DEVELOPMENT Todd DeAngelis

USA

FINALIST, SINGLE

EURO RSCG LIFE CENTRAL
CHICAGO, IL

CLIENT Ethyol (amifostine)
MANAGING DIRECTOR Susan Fultz
CREATIVE DIRECTOR Shirin Bridges
SENIOR COPYWRITER Amy Blevins
ART DIRECTOR Brian Catral
GROUP ACCOUNT SUPERVISOR Kate McBreen

USA

FINALIST, SINGLE

CARDINAL HEALTH
WAYNE, NJ

CLIENT Remicade
CREATIVE DIRECTOR Eric Hoch
GRAPHIC DESIGNER Kirsten Rakow
ART SUPERVISOR Amy Lapides

USA

FINALIST, SINGLE

INTRAMED SCIENTIFIC SOLUTIONS

NEW YORK, NY

CLIENT Lamictal

ART DIRECTOR Siu Chan

SENIOR EDUCATION DIRECTOR Suzie Boulos

EDUCATAION MANAGER Dayle Nolan

ART DIRECTOR Siu Chan

USA

FINALIST, SINGLE

PRECEPT MEDICAL COMMUNICATIONS

BERKELEY HEIGHTS, NJ

PROGRAM DIRECTOR Denise Dugan

ASSOC. MEDICAL DIRECTOR Amy Duguay, PhD

ART DIRECTOR Dipali Lips

VP, SR. PROGRAM DIRECTOR Lisa Emusov

MANAGING DIRECTOR Donna Michalizysen

GRANTOR Biogen Idec

SPONSOR American Academy of Dermatology

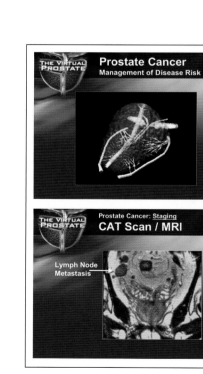

USA

FINALIST, SINGLE

PRECEPT MEDICAL COMMUNICATIONS

BERKELEY HEIGHTS, NJ

EDUCATION DIRECTOR Ann Sikora

VICE PRESIDENT Adam Margolis

ART DIRECTOR Dipali Lips

MANAGER, PRODUCTION SERVICES Lauren Orsetti

DESIGNER John Webber

EDUCATION MANAGER Peggy Bergh

USA

FINALIST, SINGLE

ROCKPOINTE CORPORATION

WASHINGTON, DC

CLIENT Finasteride (Proscar)

MANAGER Richard Weimer

PROJECT MANAGER Melissa Wallace

WEB DEVELOPMENT Amy Kline

COPYWRITER Elizabeth Blackwell

USA

FINALIST, CAMPAIGN

AXIS HEALTHCARE COMMUNICATIONS LLC
YARDLEY, PA

CLIENT Centocor, Inc.
VP, CREATIVE SERVICES Karen L. Gatta
CREATIVE DIRECTOR Karen Smith
COPYWRITER Elayne Baker

USA

FINALIST, CAMPAIGN

AXIS HEALTHCARE COMMUNICATIONS LLC
YARDLEY, PA

CLIENT Cephalon, Inc.
VP, CREATIVE SERVICES Karen L. Gatta
CREATIVE DIRECTOR Karen Smith
DESIGNER Colleen Hohman
COPYWRITER Beth Kline/Michelle Giordano

USA

FINALIST, CAMPAIGN

AXIS HEALTHCARE COMMUNICATIONS LLC
YARDLEY, PA

CLIENT Cell Therapeutics, Inc.
VP, CREATIVE SERVICES Karen L. Gatta
SENIOR ART DIRECTOR Heather Sailer
MEDICAL DIRECTOR Denise LaTemple

USA

FINALIST, CAMPAIGN

AXIS HEALTHCARE
COMMUNICATIONS LLC
YARDLEY, PA

CLIENT Cell Therapeutics, Inc.
VP, CREATIVE SERVICES Karen L. Gatta
SENIOR ART DIRECTOR Heather Sailer
MEDICAL DIRECTOR Denise LaTemple

USA

FINALIST, CAMPAIGN

DONAHOE PUROHIT MILLER
CHICAGO, IL

CLIENT Amaryl
MGR, MEDICAL EDUCATION - METABOLISM Rajul Saraiya, RpH
PROJECT DIRECTOR Elizabeth Leopardi, RN
EVP, CREATIVE Monica Noce Kanarek
DIR. CLINICAL COMMUNICATIONS Theresa M. Vera, PhD
ART DIRECTOR Cristina Rutter/Sheila Herman
PRODUCER Linda Garland/Scott Taradesh
EVP, CREATIVE Monica Noce Kanarek
DIR. CLINICAL COMMUNICATIONS Theresa M. Vera, PhD
PROJECT DIRECTOR Elizabeth Leopardi, RN

USA

FINALIST, CAMPAIGN

VOX MEDICA
PHILADELPHIA, PA

CLIENT Institute for Continuing Healthcare Education
ART DIRECTOR Connie Stinson
SENIOR PRODUCTION MANAGER Cynthia Pellegrini
ASSISTANT DIRECTOR, CLIENT SERVICES Sandra Davidson
GROUP DIRECTOR Gerard Maher
ASSOCIATE TRAFFIC MANAGER Trisha Clark
SENIOR ACCREDITATION MANAGER Beth Brillinger

USA

FINALIST, CAMPAIGN

HELIX MEDICAL COMMUNICATIONS
SAN DIEGO, CA

CLIENT Raptiva (efalizumab)
CREATIVE DIRECTOR - ART Habeeba Clark
CREATIVE DIRECTOR - COPY Kristen Grant
CLIENT SERVICES MANAGER Eric Schramm
MEDICAL DIRECTOR Evelyn Albu
MANAGING DIRECTOR Lynn Nye
EDITOR Bonnie Nickel
STUDIO Lynda Lang
PRODUCTION MANAGER Mary Rose Ardolino

USA

FINALIST, SINGLE

AXIS HEALTHCARE COMMUNICATIONS LLC
YARDLEY, PA

CLIENT Cephalon, Inc.
VP, CREATIVE SERVICES Karen L. Gatta
CREATIVE DIRECTOR Karen Smith
SENIOR DESIGNER Tina Galdi
COPYWRITER Beth Kline/Michelle Giordano

USA

FINALIST, SINGLE

AXIS HEALTHCARE COMMUNICATIONS LLC
YARDLEY, PA

CLIENT Orqis Medical
VP, CREATIVE SERVICES Karen L. Gatta
SENIOR ART DIRECTOR Heather Sailer
DESIGNER Jennifer Sexton

USA

FINALIST, CAMPAIGN

EMBRYON
SOMERVILLE, NJ

CLIENT Rebif
EXECUTIVE DIRECTOR CREATIVE SERVICES
Gina Halupka
PRODUCTION DIRECTOR Arlene Bisulk
ART DIRECTOR EJ Wood

USA
GLOBAL AWARD, SINGLE
FAT BOX
REDWOOD CITY, CA

CLIENT **Oculex Pharmaceuticals**
EXECUTIVE PRODUCER **Rachel Russell**
PRODUCER **Rachel Russell**
3D ANIMATOR **Mike Hulme**

USA
FINALIST, SINGLE
IMED STUDIOS/KLEMTNER
AMES, IA
CLIENT **Seroquel – Astra Zeneca**

THE NETHERLANDS
FINALIST, SINGLE
STORM SCOTT CREATIVE MEDIA AGENCY
EINDHOVEN

CLIENT
PharmaPartners eHealth Information Concept
MARKETING MANAGER
Paul de Lugt, PharmaPartners
PROJECT LEADER
Egbert van Gelder, PharmaPartners
CREATIVE DIRECTOR
Jerome Schellekens, Storm Scott
EXECUTIVE PRODUCER
Caroline van 't Ooster, Storm Scott
ART DIRECTOR **Hester van de Vorst, Storm Scott**

ISRAEL
FINALIST, SINGLE
TELEMEDIA COMMUNICATIONS & JCS ID
TEL-AVIV

CLIENT
Teva Pharmaceutical Industries & Aventis
PRODUCER **Yariv Gibli**
DIRECTOR **Nissan Belkin**
PRODUCTION COMPANY
Telemedia Communications & JCSID

USA
FINALIST, CAMPAIGN
KPR
NEW YORK, NY

CLIENT **Risperdal**
SVP, CREATIVE DIRECTOR **Bernie Steinman**
VP, ASSOC. CREATIVE DIRECTOR **Scott Frank**
ART GROUP SUPERVISOR **Regina Regan**
COPY GROUP SUPERVISOR **Sal Diana**
PRODUCER, DIRECTOR **Dennis Conroy**

AUSTRALIA
SUDLER & HENNESSEY SYDNEY
NORTH SYDNEY

CLIENT Somac (Pfizer Australia)
HEAD OF COPY Adam Taor
HEAD OF ART Peter Ryan
SOMAC SNR PRODUCT MANAGER Glenn Cross
SOMAC PRODUCT MANAGER Adam Maguire
ILLUSTRATOR Jan di Silva
ACCOUNT DIRECTOR Michael Clayton
ACCOUNT MANAGER Tara Mills
SOMAC SNR PRODUCT MANAGER Glenn Cross
SOMAC PRODUCT MANAGER Adam Maguire
STUDIO MANAGER Grant Hendren
TYPOGRAPHER Scotty Laverick

AUSTRALIA
HAMMOND AND THACKERAY
SYDNEY

CLIENT Johnson & Johnson Medical
CREATIVE DIRECTOR Matt Gill
ART DIRECTOR Barry Pooley
COPYWRITER Stephen Sparke
ACCOUNT DIRECTOR Anne De Fraine
PLANNER Rob Pizzey
STUDIO MANAGER Steven Rogers
PRODUCTION Nancy Hanna
DESIGNER James Wadley

ENGLAND
TORRE LAZUR McCANN HEALTHCARE
LONDON

CLIENT Nurofen For Children
ART DIRECTOR Craig Chester
COPYWRITER Matt Macland
PHOTOGRAPHER John Turner
ACCOUNT SUPERVISOR Joanna Rainbow
CREATIVE DIRECTOR Don Nicolson
PRODUCTION DIRECTOR Peter Searle

PUBLIC RELATIONS PACKAGE

USA

FINALIST, SINGLE

HILL HOLLIDAY HEALTH SCIENCE
COMMUNICATIONS
BOSTON, MA

CLIENT Boston Scientific Corporation
SVP, ACCOUNT DIRECTOR Katie Wester

SALES FORCE EDUCATION

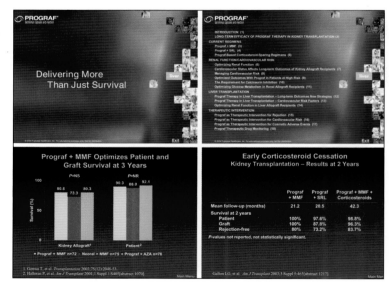

USA

FINALIST, SINGLE

ABELSON-TAYLOR
CHICAGO, IL

CLIENT Aloxi
CREATIVE DIRECTOR Rob Kienle/Scott Hansen
ASSOCIATE CREATIVE DIRECTOR Andy McAfee
ART DIRECTOR Eric Pernod
INTERACTIVE PRODUCER Ed St. Peter

CANADA

FINALIST, SINGLE

THE SYNAPSE GROUP
BURLINGTON, ON

CLIENT Prograf, Fujisawa Healthcare, Inc.
WRITERS Marcia Bos/Jim Gamble/Carolynn Pietrangeli
CREATIVE DIRECTOR Cindy Mersky
ART DIRECTORS Christopher Bassels/Thoby Princep

MIXED MEDIA CAMPAIGN

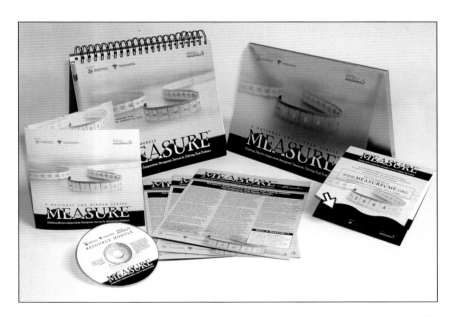

ART DIRECTORS